THE CLOISTERS

Studies in Honor of
the Fiftieth Anniversary

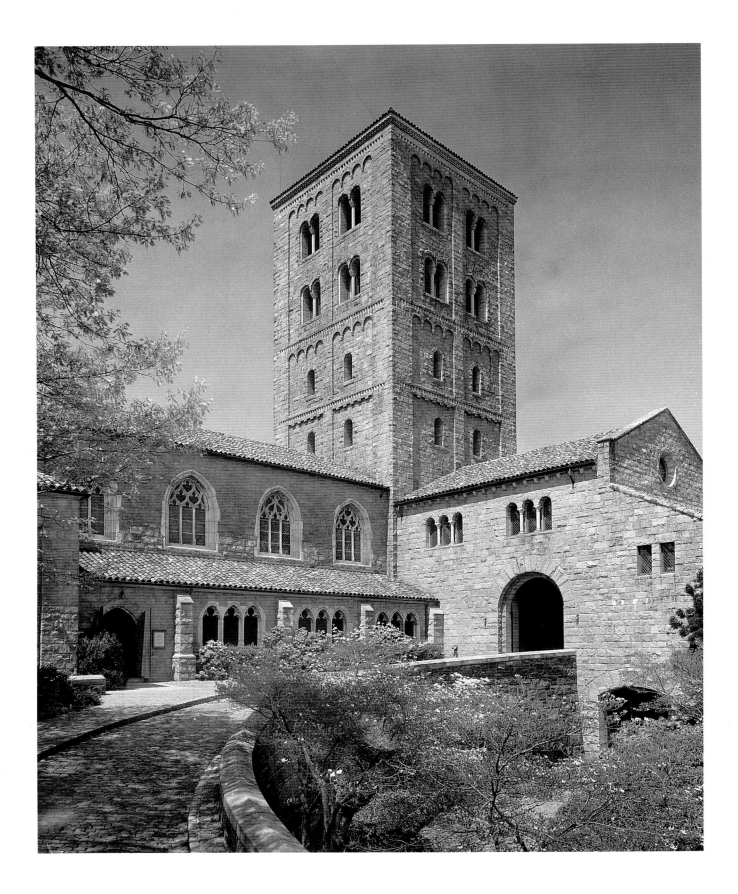

THE CLOISTERS

Studies in Honor of
the Fiftieth Anniversary

Edited by Elizabeth C. Parker

with the assistance of

Mary B. Shepard

The Metropolitan Museum of Art
in association with
The International Center of Medieval Art

The publication of this volume of studies in honor of the
fiftieth anniversary of The Cloisters was made possible by
grants from the Samuel H. Kress Foundation, The Louis and
Anne Abrons Foundation, Abby R. Simpson, and a very
generous anonymous donor.

Published by The Metropolitan Museum of Art, New York
John P. O'Neill, Editor in Chief
Barbara Burn, Executive Editor
Georgette Byk Felix, Editor
Michael Shroyer, Designer
Matthew Pimm, Production
Maps by Wilhelmina Reyinga-Amrhein

Type set by The Metropolitan Museum of Art
Printed and bound by Malloy Lithographing, Inc., Ann Arbor,
Michigan

Frontispiece: The Cloisters, view from the Upper Drive
(photo: Museum)

Jacket: The Three Magi from the *Adoration of the Magi*
(1986.285.1). Stained-glass panel (ca. 1390) from the choir of
the Austrian castle chapel at Ebreichsdorf (photo: Museum)

Library of Congress Cataloging-in-Publication Data

The Cloisters : studies in honor of the fiftieth anniversary /
 edited by Elizabeth C. Parker with the assistance of
 Mary B. Shepard.
 p. cm.
 Papers presented at an international symposium, held
 Oct. 21–22, 1988 at the Metropolitan Museum of Art, jointly
 sponsored by the Cloisters and the International Center of
 Medieval Art.
 Includes bibliographical references.
 ISBN 0-87099-635-5
 1. Art, Medieval—Congresses. 2. Art—New York (N.Y.)—
Congresses. 3. Cloisters (Museum)—Congresses. I. Parker,
Elizabeth C. II. Shepard, Mary B. III. Metropolitan Museum
of Art (New York, N.Y.) IV. International Center of Medieval
Art. V. Cloisters (Museum)
N5963.N4C583 1992
709.02—dc20 91-41336
 CIP

Contents

ABBREVIATIONS

MMAB: The Metropolitan Museum of Art Bulletin
MMJ: Metropolitan Museum Journal
PL: Migne, J. P. *Patrologia Latina,* 221 vols. (Paris, 1844–64)

Foreword

In announcing the 1938 opening of The Metropolitan Museum of Art's new branch museum devoted to medieval art, the *New York Herald-Tribune* acclaimed The Cloisters as "a new beauty spot for New Yorkers . . . a medieval shrine in a Manhattan setting." The mastery with which modern and medieval architectural elements were combined to create this unique environment for the exhibition of medieval works of art was lauded by *The New York Times* as reflecting "rare scholarly, imaginative, [and] creative skill." Now, fifty-four years later, The Cloisters continues to fulfill both these roles: it is at once a place of tranquillity and beauty as well as an active center of scholarship. From its inception, with the founding gift by John D. Rockefeller, Jr., of George Gray Barnard's collection, Rockefeller's later bequest of the magnificent Unicorn Tapestries, and his generous financial support, The Cloisters has been distinguished by the remarkable quality of the works of art it houses. Significant recent acquisitions, ranging from a group of Langobardic reliefs to the radiant panels of Austrian stained glass from the fourteenth-century castle chapel at Ebreichsdorf, attest to its continuing vitality. The Cloisters Collection is ever expanding—ever enriching visitors' perspectives of medieval art.

The present volume of essays published in honor of The Cloisters' Fiftieth Anniversary continues in this tradition, demonstrating both the breadth of The Cloisters Collection and the truly international character of scholarly exchange. Many organizations and individuals have shared in supporting both the symposium and the production of this volume, including The Samuel H. Kress Foundation, The Louis and Anne Abrons Foundation, Abby R. Simpson, The Marilyn M. Simpson Charitable Trust, and a very generous anonymous donor. With the publication of these papers in honor of The Cloisters we hope to pay tribute to the legacy of scholarly achievement over the past fifty years and, more importantly, to spur new and provocative research.

Philippe de Montebello
Director

Preface

THE I.C.M.A. AND THE CLOISTERS

The close affiliation between The Cloisters and the International Center of Medieval Art goes back nearly thirty-five years, to the very origins of the Center, which began in 1952 as the Centre International d'Études Romanes.[1] In 1956 Eugène Benoît Gentil, President of the C.I.E.R. and an international businessman who was the administrator of the well-known Saint-Gobain glass company and president of the New York branch of the French Chamber of Commerce, decided to internationalize the organization by establishing affiliates in other countries. He transformed the American Committee of the French organization into the International Center of Romanesque Art (I.C.R.A.), "la section nord américaine du C.I.E.R."

The original purpose of the new American Center was modest: cultural tourism. It was led by a pair of honorary chairs: James J. Rorimer, Curator of Medieval Art and Director of The Cloisters, and His Excellency M. Henri Bonnet. As was true of the C.I.E.R., membership included prominent business-men, scholars, and museum directors. By the 1960s the Center gradually became a more exclusively scholarly organization, jointly sponsoring with The Cloisters occasional lectures by American and European scholars. In 1961 some of its scholar members (including James Rorimer and Meyer Schapiro) attempted to launch a Census of Roman-esque Art in the United States, whose published catalogue was to concentrate at first on the so-called minor arts, today's *ars sacra*, the photographs for which were to be housed at the Institute of Fine Arts. Regrettably, that project seems to have withered on the vine. However, in 1963 the Center first issued a bulletin entitled *Gesta*, dedicated to "general aspects" of Romanesque art.

Soon thereafter the I.C.R.A. members decided to expand their scope to include the Gothic period.

By January 1966, the Center's name had been legally changed to the International Center of Medieval Art. By then *Gesta* began to appear twice a year and it published articles by scholars from the United States and Europe. The following year Professor Walter Cahn launched the Census of Romanesque Sculpture in American Collections; its installments have appeared in *Gesta* and are now nearing completion.

It was the jet-setting George Nebolsine, one of the founders of the International Center of Romanesque Art, who helped convince Thomas P. F. Hoving, then a Curator of Medieval Art at The Cloisters, to take over the leadership of the International Center and to transfer its formal headquarters from the Institute of Fine Arts to The Cloisters. This move took place in 1969. Today, the office of the I.C.M.A. remains at The Cloisters, and, thanks to the generosity of William Wixom, its space was recently expanded.

This collaboration has resulted in a remarkable series of joint ventures. Except for the "Renaissance of the Twelfth Century" exhibition and symposium held in Providence in 1969, which the Center cosponsored with Brown University, it is with The Cloisters that the I.C.M.A. has cooperated in the following activities: the symposium for "The Year 1200" exhibition held in 1970; public lecture series in 1971 and 1973, organized by the I.C.M.A. and held at the Museum; the "Paradisus Claustralis" sympo-sium at The Cloisters in 1972 (the papers published in *Gesta* in 1973); the "Secular Spirit" symposium held in conjunction with the exhibition at The Cloisters and chaired by Harry Bober; a symposium, again organized by Harry Bober, in conjunction with the "Treasures of Early Irish Art" exhibition of 1977–78; a special double issue of *Gesta* published in 1979 in conjunction with "The Age of Spirituality"

exhibition of 1977–78. In 1981, in connection with the exhibition at The Cloisters, the I.C.M.A. cosponsored with Columbia University a symposium on "Abbot Suger and Saint-Denis" (its papers were edited by Paula Gerson and published by the Metropolitan Museum); in 1982 the exhibition of the Raymond Pitcairn collection at The Cloisters, an accompanying conference, and a catalogue written by Jane Hayward of The Cloisters and Walter Cahn; and, most recently, in 1988, the jointly sponsored symposium celebrating the fiftieth anniversary of The Cloisters.

So clearly rooted in its past association, the success and international prestige of the I.C.M.A. can only continue to grow through sustained interaction and cooperation with The Cloisters. Thus, the I.C.M.A. is pleased and honored to cosponsor this volume of papers by symposium participants and staff of the Medieval Department and The Cloisters to commemorate The Cloisters' fiftieth anniversary.

<div align="right">

W. Eugene Kleinbauer
*Past President, International
Center of Medieval Art*

</div>

Note

1. See François Bucher, "*Semper Resurget:* Analecta of the International Center of Medieval Art," *Gesta* 25/2 (1986), pp. 167–70, for an account of the early history of the I.C.M.A.

Preface

The Fiftieth Anniversary of The Cloisters in 1988 witnessed a number of special commemorative events. Particularly important for the visiting public was the spring celebration of the enlargement and reinstallation of the museum's Treasury, made possible through the generosity of Hélène and Michel David-Weill, and a complete relabeling of all works of art throughout the building. The international scholarly symposium, jointly sponsored by the International Center of Medieval Art, was the culminating event of the anniversary year. Over 650 scholars, students, and members of the public gathered in the Grace Rainey Rogers Auditorium at The Metropolitan Museum of Art on October 21 and 22, 1988, to hear the presentation of papers by distinguished medievalists. The present volume, also jointly sponsored by the International Center of Medieval Art, publishes these papers, together with additional contributions by members of the Museum staff.

The Cloisters is renowned for its extraordinary collection of European art of the Middle Ages. There, architectural elements and ensembles, stained glass, tapestries, sculpture, furniture, and objects from church treasuries are united in a harmonious and evocative setting. While these works represent the artistic creation of more than eight centuries, the collection's main emphasis is on Romanesque and Gothic objects dating from the twelfth through the early sixteenth centuries. Thus it is appropriate that the keynote articles present significant aspects of the vast research conducted in these areas over the past fifty years. The history, development, and character of The Cloisters as a museum of medieval art in the New World are the focus of two articles, one by a French colleague, the other by an American medievalist and Curator Emeritus of the Metropolitan Museum's staff. Although written from different perspectives, both articles testify to the integral part The Cloisters has played in the study of medieval art in the last half century. Not the least of this has been in its distinguished history of exhibitions and symposia. Another aspect of this role has been determined by the development of the collection itself. The largest group of essays, then, focuses on individual objects in The Cloisters Collection. These studies analyze their subjects by using a variety of methods. Several articles set forth the state of research on a particular subject and reformulate key but still open questions. Early and recent historical backgrounds are aired. New or refined attributions, enriched stylistic and iconographical understandings, reinterpretations of original contexts, compositions, patronage, and functions have profoundly enhanced our perception of these works of art. Collectively, these contributions demonstrate the vitality of medieval studies. In reading over the essays, it is particularly gratifying to see the clear interdependence and cooperation of many of the scholars, as evidenced in the frequent acknowledgments that appear in the notes.

This leads to my own acknowledgments. Mary B. Shepard first proposed a symposium as a fitting tribute to The Cloisters Anniversary and was key in the organization of both the symposium and this volume. We are most fortunate that Elizabeth C. Parker agreed to serve as the editor of the published essays. She was tireless and perceptive in her reading, and all the essays have benefited significantly from her suggestions. Deep gratitude is also due to John O'Neill, Barbara Burn, Teresa Egan, and Georgette Felix of the Editorial Department and their staff; to

Lisa Nolan, for assistance in preparing several typescripts and in securing needed photographs. Profound thanks also go to Michelle Biondi, Barbara Drake Boehm, Lisbeth Castelnuovo-Tedesco, Sarah Evans, Lauren Jackson-Beck, Gregor Kalas, Rebecca Leuchak, Allison Merrill, Gail Meyers, Joanne Murphy, John Ricco, and Terri Taggart, for helping to make this publication possible. Special thanks go to all of the readers of the individual papers, who assisted Elizabeth Parker with timely advice and suggestions.

Above all, I would like to thank Philippe de Montebello, Director of The Metropolitan Museum of Art, for his encouragement and support in the publication of this volume and all other aspects of the Fiftieth Anniversary of The Cloisters.

William D. Wixom
Chairman of the Department of Medieval Art and The Cloisters

COLORPLATES

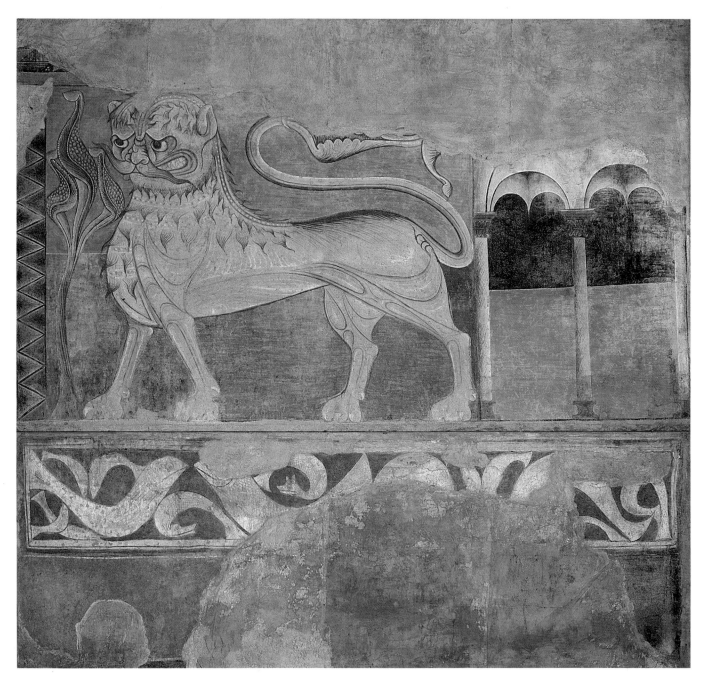

1. Lion fresco, San Pedro de Arlanza, Spain, early 13th century. The Metropolitan Museum of Art, The Cloisters Collection, 1931 (31.38.1a,b) (photo: Museum)

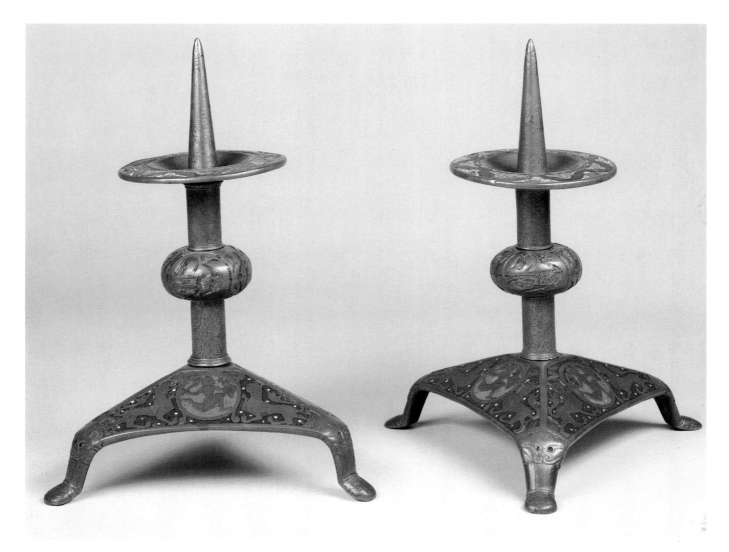

2. Pair of candlesticks, *champlevé* enamel on copper-gilt, H. 9⁵/₁₆ in. (23.7 cm). Limoges, France, ca. 1180. The Metropolitan Museum of Art, The Cloisters Collection, 1947 (47.101.37, 38) (photo: Museum)

3. Ornamental stained-glass panel from the Abbey Church of Saint-Remi, Reims, ca. 1170–80 (type R.O. 5). The Metropolitan Museum of Art, Gift of George D. Pratt, 1926 (26.218.1) (photo: Museum)

5. Scene from the Life of St. Germain of Paris: St. Germain appearing to a monk in a dream. Stained-glass panel from the Abbey of Saint-Germain-des Prés, Paris, France, ca. 1247-50. The Metropolitan Museum of Art, The Cloisters Collection, 1973 (1973.262.1) (photo: Museum)

4. Reliquary chest, Canterbury, England, ca. 1200-1207, copper: shaped, engraved, chased, and gilded; feet cast, 7 x 10 x 4½ in. (17.8 x 25.4 x 11.4 cm). The Metropolitan Museum of Art, The Cloisters Collection, 1980 (1980.417) (photo: Museum)

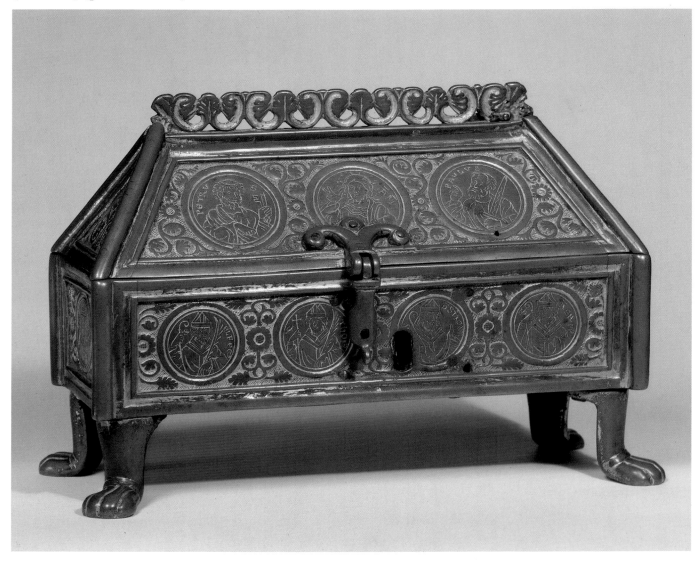

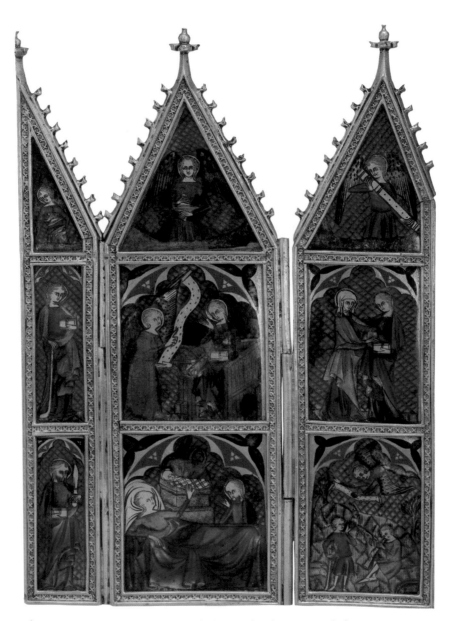

6. Detail from the Reliquary of Elizabeth of Hungary, left interior
wing: silver gilt, translucent enamel, and paint, Paris, France,
ca. 1320-40. The Metropolitan Museum of Art, The Cloisters
Collection, 1962 (62.96) (photo: Museum)

7. Scenes from the Life of Christ. Stained-glass panels
presently installed at The Cloisters. From the castle
chapel, Ebreischsdorf, Austria, ca. 1390. The Metro-
politan Museum of Art, The Cloisters Collection, 1936
(36.39.1,2); The Cloisters Collection, 1986
(1986.285.1-13); The Cloisters Collection, 1987
(1987.40.1,2) (photos: Museum)

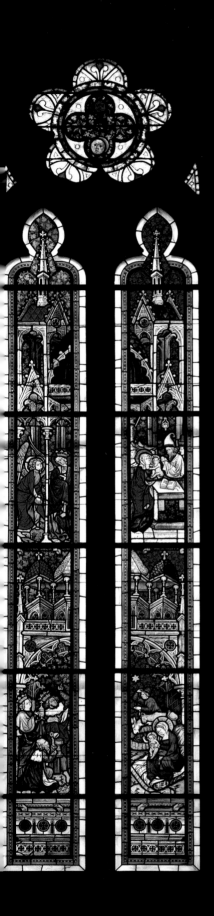

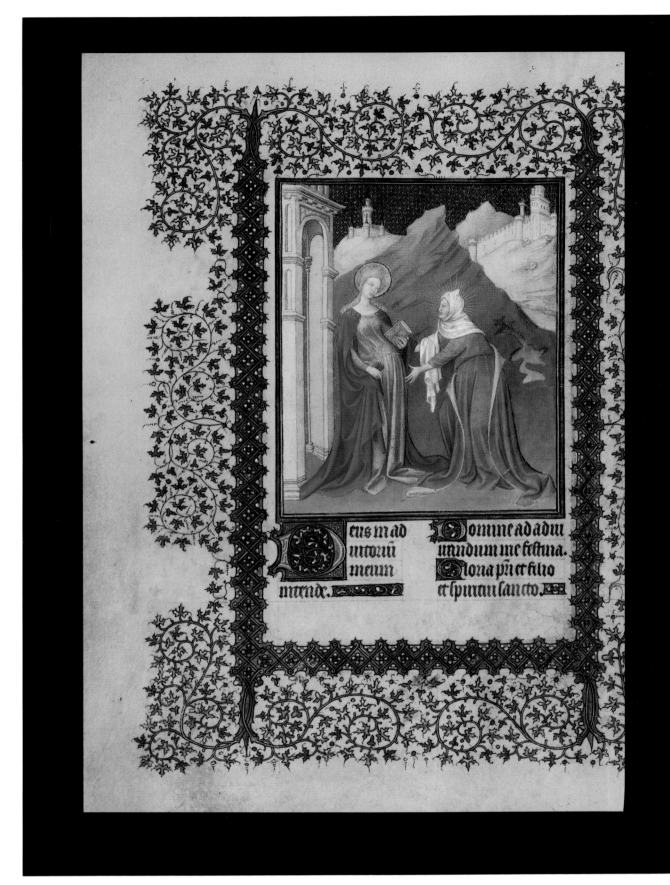

8. The Limbourg Brothers, The Visitation, fol. 42v, *The Belles Heures of Jean Duke of Berry,* ink, tempera, and gold leaf on vellum, Paris, France, 1405-08/09. The Metropolitan Museum of Art, The Cloisters Collection, 1954 (54.1.1) (photo: Museum)

THE CLOISTERS

Studies in Honor of
the Fiftieth Anniversary

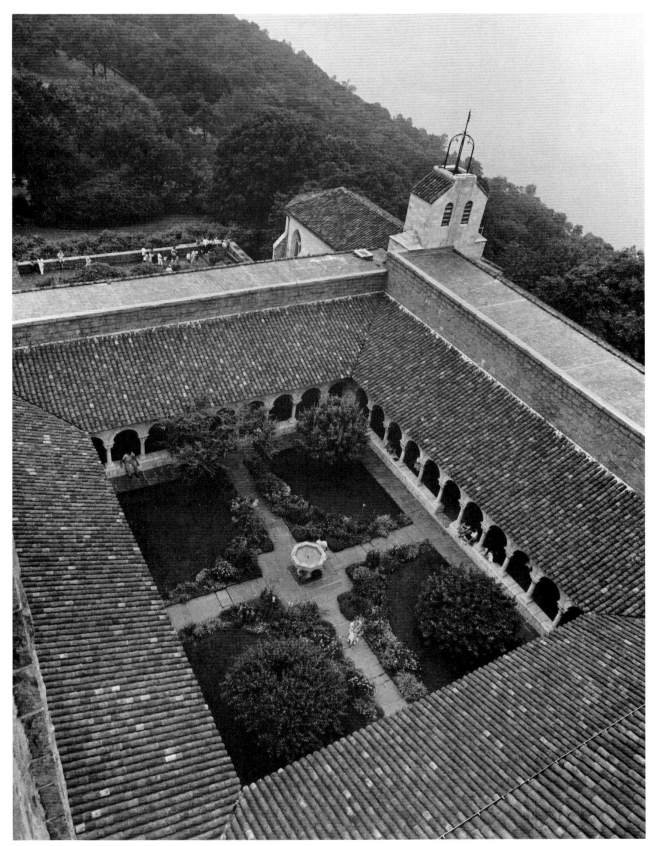

Fig. 1. Cloister, Saint-Michel-de-Cuxa. The Metropolitan Museum of Art, The Cloisters (photo: Museum)

The Monumental Arts
of the Romanesque Period:
Recent Research

THE ROMANESQUE CLOISTER

Ilene H. Forsyth

The Fiftieth Anniversary of The Cloisters afforded a unique opportunity to reflect upon the many advances in our understanding of early medieval art during the last half century. At the same time the invitation to assess the present state of research concerning Romanesque art, in a paper at the symposium honoring that anniversary, was a daunting challenge. When the International Center of Medieval Art recently surveyed its member medievalists with a questionnaire, it was discovered that scholars who consider themselves specialists in Romanesque art far outnumber those of any other medieval period.[1] And of course there are many other specialists in the field not represented by this survey who have contributed significantly to our literature. Dorothy Glass and Thomas Lyman needed hundreds of pages just to cite the work of sculpture specialists in their recent, weighty bibliographies.[2] Within the parameters of a symposium paper, it would have been overly ambitious to attempt discussion of even a representative sampling of the many excellent scholarly works produced during the fifty-year life of The Cloisters or even during the last five years,[3] or to attempt reference to many different media, or to the many countries which would be important to an exhaustive review of our current knowledge of the Romanesque period. Also, our field has stimulated modes of research which range widely, from the profoundly theoretical to the meticulously archaeological. Any individual evaluation of this entire gamut would probably be too loose or would perhaps lose to polemic what might be gained as insight from such an overview.

To avoid the inevitable superficiality of a comprehensive survey, I have chosen to be selective. I have endeavored to give some cohesion to my selection by focusing on my own biases, namely, the monumental arts of architecture and sculpture, principally of France (which means that I refer to some twelfth-century monuments

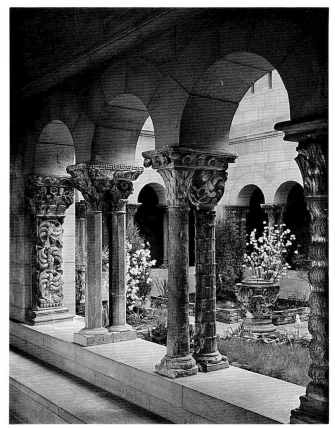

Fig. 2. Cloister, Saint-Guilhem-le-Désert. The Metropolitan Museum of Art, The Cloisters (photo: Museum)

which others might prefer to label Gothic). Other symposiasts have dealt in their papers with wall painting and the decorative arts from other areas of the medieval world. As I have limited myself to France, I have been conscious of having been deeply influenced by, as well as heir to, a tradition of Francophilism, which evinced itself in the preferences of early collectors and students in the field and which manifests itself to this day in our museum galleries—at The Cloisters and elsewhere—and which also shapes perceptions in our university classrooms. Mist-shrouded, gorgeous sites, such as Canigou, as well as elusive and remote locations, such as Cuxa, entice with their tranquillity and fascinate with their enigmas. More than fifty years ago the intriguing attraction of the graceful arcades of such medieval cloisters captivated many connoisseurs in this country, such as George Gray Barnard, John D. Rockefeller, Jr., and James J. Rorimer, who

drew early attention to these elegant Romanesque stones.[4] As it is their legacy at The Cloisters that occasioned these symposium papers, I have chosen to take the French Romanesque cloister as the focal theme of my paper, concentrating my comments on the narrow sense of the term—*cloister,* which means the covered passage or gallery encompassing an open court, the cloister garth, which was the nexus of the claustral complex, rather than the monastery, abbey, or *collégiale* as a whole.[5] The religious of these various establishments will be considered as the people of the cloisters under discussion and no attempt will be made here to distinguish among the various monastic and canonic orders. The cloister was a locale common to them all. After a brief review of what we have learned about the Romanesque cloister from recent research, I shall suggest directions that future research might fruitfully follow on this subject.

The Romanesque cloister was a secluded as well as a lovely space (Figs. 1, 2). Churches and other parts of conventual complexes might be shared with lay visitors, but the cloister was for incumbents only—a totally private place. As such it distinctively expressed the ambiguity of the cloistered life by melding the outdoor, garden environment of the garth with some of the most private, individual activities of the Romanesque religious in its gallery. It was a place of certain freedoms, respite from the rigors of the *Opus Dei;* a free space where air, sunshine, warmth, water, and greenery, all suggested the theme of paradise and lifted the heart. And yet it was also a place of freedom's antithesis, a totally enclosed, shut, immured space; a prison, a desert, in metaphor, yet the place where "although the body is shut in, all doors are open to the spirit";[6] a place where peregrinations in the modern sense were adamantly restricted but where the monk might, indeed should, make a "spiritual pilgrimage."[7] As the heart of the typical monastery, the cloister was the locus for various monastic activities, some very mundane, such as washing and *locutio,* and others seriously spiritual and individual, such as reading and meditation, in the monk's *lectio divina,* to which I will return.

As its adornment was not intended for a public audience, the cloister especially deserves the attention of art historians. Here was a coherent, closed, architectural unit with a clear plan. Here were the arts of architecture and sculpture felicitously

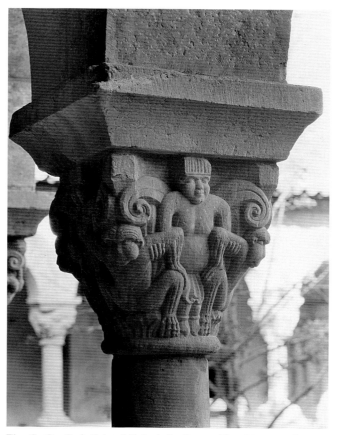

Fig. 3. Capital, Saint-Michel-de-Cuxa. The Metropolitan Museum of Art, The Cloisters Collection, 1925 (25.120.634) (photo: Museum)

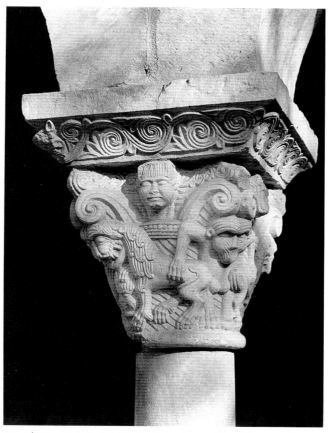

Fig. 4. Capital, Saint-Michel-de-Cuxa. The Metropolitan Museum of Art, The Cloisters Collection, 1925 (25.120.582) (photo: Museum)

blended in historiated arcades. Here were four-sided capitals, columns, and piers offering variegated new fields for sculpture, challenging the ingenuity of sculptors and narrators, and resulting in some of the most sustained and complicated narrative cycles of early medieval art.[8] Many new themes and cycles were developed there (apocalyptic, hagiographic, monastic).[9] Foliage there could be elegantly elaborated in endlessly fascinating variation, and fantasy and whimsy could also range in designs featuring anthropomorphized beasts or fabled grotesques (Figs. 3, 4). The cloister thus presents an excellent locus for scholarly study, the very thing medievalists of modern, theoretical bent might wish, for scholars can be sure that in the cloister there was a highly particularized and literate audience. It was where the commissioners of a work of art and the consumers of that art were most clearly identical, and where we can be sure these two groups

were not offhand or casual in their interest but keenly engaged by the art around them, and also where the functions of ritual and liturgy enmeshed with art in the unity of the Romanesque religious life.[10] Facades and even naves of the period's churches perforce presupposed a broader audience, patrons and viewers being different, and thus might be more difficult for us to interpret correctly.

Particularly effective stimulants to the study of cloisters were the symposium held at The Cloisters in 1972 and a conference at Cuxa on the cloisters of the *midi* in 1975.[11] In papers by Alfred Frazer and Walter Horn in 1972 and by Jacques Bousquet and Mario Roberti in 1975 from these meetings, we have studies of the origins and early development of monastic plans. Medieval descriptions and graphic renditions of early cloisters and their accessory structures, such as chapter houses, have been signaled in the literature and have provided further

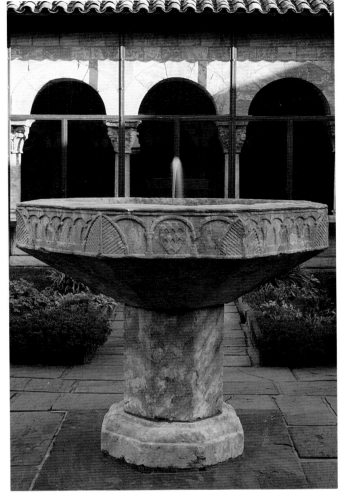

Fig. 5. Cloister fountain, Saint-Genis-des-Fontaines, now in the Cuxa Cloister. The Metropolitan Museum of Art, The Cloisters Collection, 1926 (26.79) (photo: Museum)

know how to resolve the date of the Conques tympanum.[13] Nor are we sure of the date of the remains of its cloister, which is probably early twelfth century.[14] Indeed, increasing skepticism abounds as to whether differing views regarding now-classic conundrums in the field (temporal priority for Spain or Toulouse; the date of the Cluny ambulatory capitals; the dates of the Beaulieu tympanum, the Vézelay portals, the Santiago *Puerta,* and the Silos cloister) will ever reach consensus.[15] Éliane Vergnolle has put it succinctly: "Beyond the establishment of a relative chronology, which is already problematic, rises the much larger question of dating. When it is considered as an end in itself, dating crystallizes overall positions and establishes the debate on a superficial level, substituting implicit judgments for a reflection upon the profound nature of the work."[16] She adds that the question of dating can, nevertheless, not be avoided in the end because it is at the heart of the aim of the historian. My suggestion here is that we should not lose sight of the aim of ultimately securing chronologies, but that we might constructively put preoccupation with dating in abeyance for a bit as we expand our knowledge of both major and minor monuments by recombining the scattered pieces,[17] and as we explore new methods for furthering our research, particularly on cloisters. For models of the latter we might look closely at the advances made by historians in other fields,[18] lest fixations regarding dating increase their stranglehold on our own issues. Single-minded concern about the lack of agreement in the scholarship regarding dates of major Romanesque monuments may intimidate new students to the field and may lead to paralysis and stagnation. Indeed, it may be one reason for our apparently slow progress on some other critical concerns.

As we put back together the scattered puzzle pieces that make up such Romanesque cloisters as Cluny, Vézelay, or Saint-Guilhem-le-Désert (Fig. 2),[19] study of the functions of cloisters, claustral furnishings, and accessory conventual structures seems particularly promising. At Conques the restored basin from the claustral garth has been studied, as have others from Saint-Genis-des-Fontaines (Fig. 5), Cuxa, and Poblet, by scholars including Xavier Barral i Altet and Walter Cahn,[20] yet other lavabos, as at Pontigny, and more especially fountain houses, as at Fontenay and Le Thoronet, merit further study, considering their symbolic and

information about them. Yet a full understanding of the Romanesque cloister is still rather elusive. We have no generic study of cloisters, no corpus, not even a checklist; there is no architectural study known to me which goes much beyond Viollet-le-Duc's entry of 1868.[12]

What we still do *not* know about important Romanesque cloisters is appalling. This is in part because of the widespread destruction, scattering, and reuse of the claustral stones themselves in the years following the French Revolution, but it may also be in part owing to problems of dating which vex us. As Marcel Durliat so poignantly said in 1974 with regard to facade sculpture, we simply do not

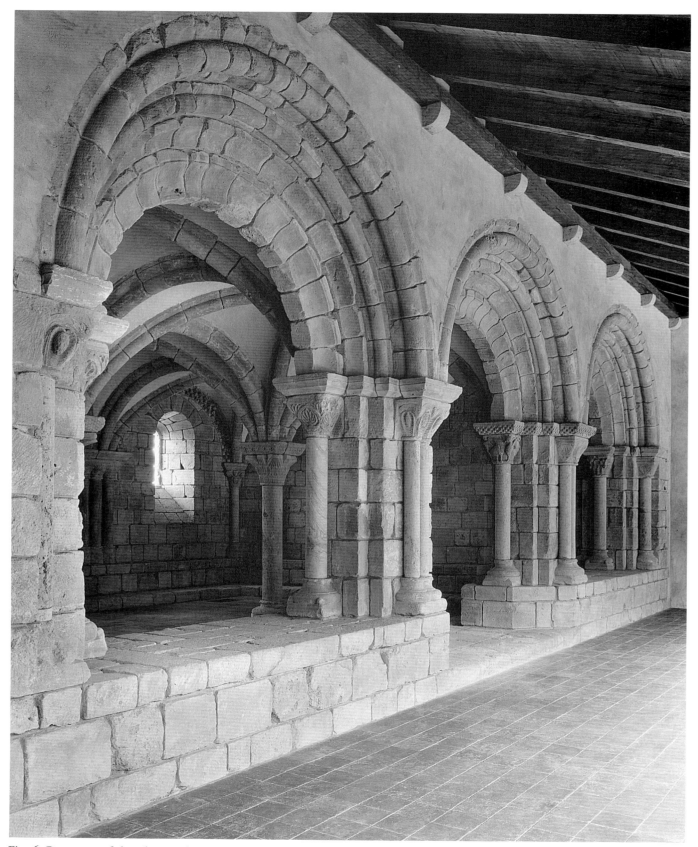

Fig. 6. Doorway of the chapter house, Notre-Dame-de-Pontaut. The Metropolitan Museum of Art, The Cloisters Collection, 1935 (35.50) (photo: Museum)

ideological importance to the claustral site.[21]

Although some work is now being undertaken on refectories and kitchens serving French monasteries,[22] the "iconography of the architecture"—to use Richard Krautheimer's term—of fountains or *lavatoria* in relation to refectories, and of refectories themselves in England, has recently absorbed Peter Fergusson, to digress briefly outside of France. In his excellent work on Rievaulx and Byland abbeys, perhaps more appropriately termed "Early Gothic," he models another promising area of study.[23] He explores the significance of changes affecting the alignments of these and related Cistercian refectories within their monastic complexes, and he provides enlightening insights regarding their two-story form and their multilighted and arcaded interior articulation. These are seen as springing from the ritual and quasi-liturgical needs of the monks, involving particularly their strict adherence to the Benedictine rule, their emulation of the *vita apostolica* through the practice of the *mandatum fratrum* at the lavers enframing the entrance to the refectory, and the actualization of the *cenaculum* in Jerusalem through the reenactment of the apostolic meal within the refectory itself.

With regard to the Romanesque chapter house, it is amazing also that we do not know more, considering its critical role in chapter business and in the daily life of monks and canons. Excellently preserved *exempla* are available for our study, in Worcester, Mass., from Le Bas-Neuil, and at The Cloisters, from Pontaut (Fig. 6), and at a number of other sites in France, for example, at Catus, Marcilhac, Mauriac, and Saint-Michel-en-Thiérache.[24] In their report on the archaeology of monasticism, Sheila Bonde and Clark Maines indicated the twelve or more chapter houses that have recently been subject to excavation and study.[25] In addition, references by medieval authors, such as Marbod of Rennes and Peter of Blois, and chapter books, which sometimes survive, provide useful information on the functions of these spaces. The customaries are also helpful: the Customs of Farfa has been important for our glimpse of the chapter house of Cluny.[26] These and other texts inspired Léon Pressouyre's pathfinding work on the decoration of chapter house facades.[27] The insight presented by him, that Benedictine concerns, including monastic discipline, might be reflected in chapter house iconography, as at Boscherville, is extremely telling.[28]

Working through antiquarian documents, Linda Seidel produced a provocative study of the Toulouse sculptures of apostles that were once thought to articulate the embrasures of the lost chapter house portal of Saint-Étienne.[29] I think Seidel correctly questions the portal assemblage created by Du Mège for the Musée des Augustins, where the Saint-Étienne sculptures are housed. The question of whether these paired apostles originally graced the *interior* of the chapter house, as suggested by Seidel, is still a fruitful topic for discussion, particularly in the light of recent research on the cloister and chapter house of Saint-Étienne by Kathryn Horste.[30] Although the apostolic emphasis of these carvings may be meaningful as a theme in relation to the function of the chapter room, general principles that might possibly have regulated the interior decoration of chapter houses are still unknown.[31]

As to the arcaded courtyard itself, the cloister proper, one in particular, Moissac, has enjoyed devoted attention since well before 1938. Masterfully studied by Meyer Schapiro in 1931 and well dated to about 1100, it has been used as a benchmark for our thinking about Romanesque cloisters—whether correctly or not may now be posed. With regard to its use in dating stylistically related sculptures, it provides correctly, to my view, a *terminus post quem* for the capitals of the early workshop at La Daurade,[32] and the cloister assists us significantly with the relative dating of sculptures at Toulouse, Loarre, Jaca, and a number of other sites—I think even Silos. Moissac's formal qualities have been brilliantly delineated by Schapiro; its iconography, however, needs further probing, as its extraordinarily inventive narrative methods and its sophisticated use of inscriptions warrant sustained attention.[33]

The enigma of Moissac's overall thematic program, if indeed there is one, continues both to lure and to frustrate us. Its iconographic themes, which include Old Testament and New Testament subjects, lives of saints, both apostolic and local, and explicit monastic subjects, along with some implicit ones, seem randomly intermixed with birds, beasts, and some of the most elegant foliage of the period. The principles underlying this selection of subjects have not yet been unequivocally discerned. Most useful in making some sense of the selections, such as depictions of the miracles of the "man of God" Benedict, has been the study of cloister programs in relation to monastic concerns by Léon

Pressouyre, which has inspired succeeding contributions.[34]

Further penetration of these matters at Moissac will bring profit as will fuller study of the component themes themselves. The cloister's hagiographic and apostolic cycles are particularly deserving of study, especially in relation to the depictions of such saints' lives at related sites.[35] Its apocalyptic themes are now being more intensively investigated; they have been taken up by Mireille Mentré and Peter Klein, among others.[36] Yet, the Moissac cloister—despite the distinguished studies of Schapiro and the respectful attention of these others—is capable of rewarding further scholarly effort.[37]

With regard to the role often implicitly imputed to Moissac, as a paradigm for Cluniac cloisters, a firm revision of our thinking is in order. That is an intriguing result of the recent study of remains from the destroyed cloisters of the famous Burgundian abbeys of Cluny and Vézelay when seen in relation to the writings of St. Bernard of Clairvaux. A new view of the cloister at Vézelay emerges from the catalogue of sculptures detached from the abbey, published in 1984 by Lydwine Saulnier and Neil Stratford.[38] Although the sculptures which can be indisputably assigned to the Vézelay cloister are limited to a few pieces (Fig. 7), the authors argue persuasively that the entire cloister was devoid of carved figures and that its arcades were similar in form to the Romanesque gallery that survives at Auxerre.[39] If this hypothesis is correct, as it appears to be, the Vézelay cloister would have had galleries with alternating single and double foliate capitals and ornamental rosettes in the spandrels of the arcades. Stratford would date it about 1135 to 1145.

Stratford has also shown now that the destroyed Cluny cloister likewise lacked figured designs. Interestingly varied foliate capitals and fragments of spandrels decorated with medallions are among the *membra disjecta* he is studying. These are dated by Stratford not to the abbacy of Pons but "probably later," in the 1120s or 1130s. As there is thus no evidence from either the Cluny or Vézelay cloister for fabulous creatures of the sort that provoked the ire of St. Bernard (which have been imagined by numerous scholars to have been carvings at Cluny),[40] we may ask afresh what sculpture Bernard had in mind when he wrote his diatribe in the *Apologia*. Conrad Rudolph reviewed this question in his recent dissertation and in a paper for the International

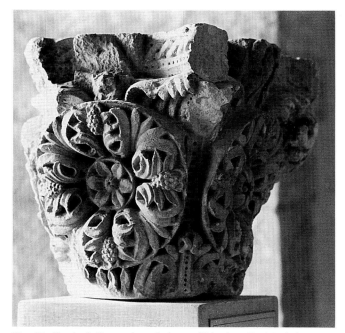

Fig. 7. Capital, from the cloister. Vézelay, La Madeleine (photo: author)

Center's symposium on Cluny held in 1986.[41] A further question follows: whether the cloisters of Moissac and La Daurade, usually used to illustrate Bernard's complaint and to imagine the lost Burgundian courtyards, can be called "typically Clunisian." Actually, they show very different conceptions of capital design with rich ranges of monstrous forms, complex iconographies, and elaborately figured narratives. These questions reopen earlier consideration of the decoration of typical Romanesque cloisters. But can we now be sure there were typical cloisters? Do the primarily or exclusively foliate arcades, for example at Auxerre, Salles, and Vienne, which seem related to Cluny and Vézelay and help limn these lost cloisters for us, represent a reaction to Bernard's criticism, or to the impact of spreading Cistercian artistic ideas? Do they indicate an aesthetic of a date slightly later in the century? There are hardly good answers, considering the many heavily figured capital series of various later twelfth-century periods and places, at Arles, Avignon, Châlons-sur-Marne, Saint-Pons-de-Thomières, Savigny, and Tournus, to cite only a few.[42] Great diversity in programs for the capital sculpture of Romanesque cloisters seems the inevitable conclusion.

9

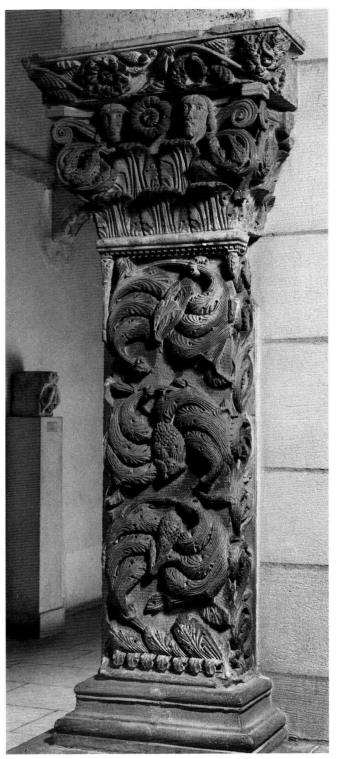

Fig. 8. Pilaster, from the cloister, Saint-Guilhem-le-Désert. The Metropolitan Museum of Art, The Cloisters Collection, 1925 (25.120.119) (photo: Charles T. Little)

Indeed, novelty and individuality mark the decoration of columns and piers in cloisters as well as the design of their capitals. Piers might be figured, as at Moissac and Aix-en-Provence, or historiated, as at Arles. The reliefs recently discovered at Saint-Avit-Sénieur appear to have decorated the piers of the cloister there, thus representing extended, figured cycles with zodiacal and apocalyptic themes.[43] Piers might also be ornamented with fanciful foliage and elegant rinceaux, as at Aix-en-Provence or at Saint-Guilhem (Fig. 8).[44] Imaginative, decorative patterns also enlivened the column shafts of many late-twelfth-century arcades, as at Saint-André-le-Bas, Vienne.[45] The cloister of Saint-Martin, Savigny, though smashed ruthlessly and its sculptures scattered widely in the aftermath of the Revolution, had monolithic capital-columns of virtuoso form, as in the example on loan to The Cloisters, both with regard to its shaft and with regard to its capital, which depicts the Adoration of the Magi (Fig. 9).[46] Another Savigny shaft of particular interest presents an Emmaus scene in the capital and elegant spirals and vines about the column, and others show playful manipulation of intermeshing capital and shaft designs.[47] Viollet-le-Duc's comment about the "regularity" of Romanesque cloisters seems contraried by examples such as these.

The original disposition of the unusually bold shafts in Savigny's claustral arcade cannot yet be exactly established. There was no canonic regulating system for Romanesque cloisters, nor can we even discern dominant patterns in the arrangements of the supports of surviving claustral arcades that might aid us with a reconstruction. Instead, we again find amazing variety in the setting out of the columns and piers. Double or single files of columns, or alternations of these, as at Moissac, along with more complex schemes of piers enframing short rows of one or more columns, as at Fontenay, or, as in the case of Savigny, massive columnar supports seemingly intermingling with slighter ones in varied rhythms—all these schemes can be found.[48] This is an important matter with regard to Toulouse. A detailed 1780 plan of the lost cloister of Saint-Étienne, recently published by Kathryn Horste, introduces particularly reliable information about its arcades. The pre-Revolutionary plan clearly shows an alternation of double and single columnar supports and indicates engaged columns at the corner piers. The drawing thus casts serious doubt

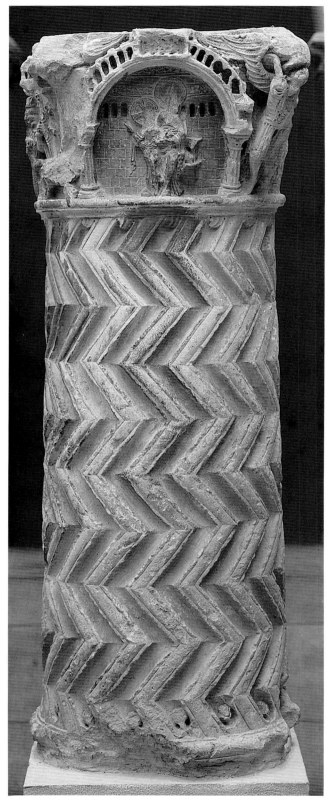

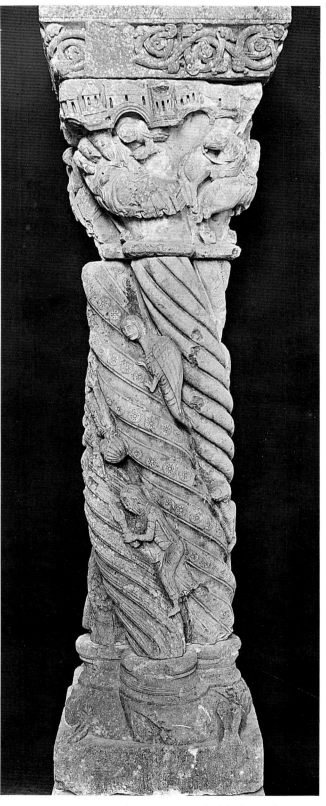

Fig. 9. Capital-column, from the cloister, Saint-Martin, Savigny. Anonymous Loan (L.1979.95) (photo: Museum)

Fig. 10. Historiated colonnettes, probably from the cloister, Abbey of Notre-Dame, Coulombs. Paris, Musée du Louvre (photo: Giraudon/Art Resource, N.Y.)

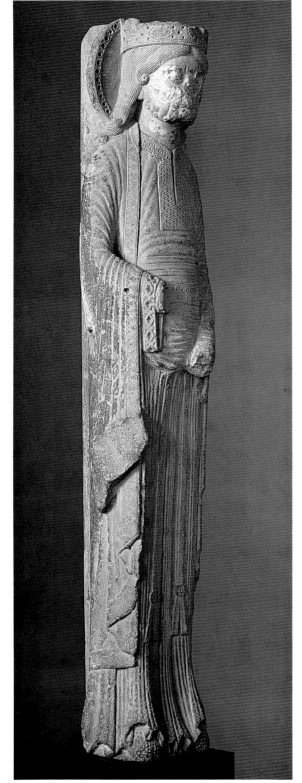

Fig. 11. Statue column, from the cloister, Saint-Denis. The Metropolitan Museum of Art Purchase, Joseph Pulitzer Bequest, 1920 (20.157) (photo: Museum)

on the usefulness of the Delor lithograph—published about 1840, long after the destruction of the cloister, about 1812—which shows a few arcades of the cloister in its ruinous condition. The lithograph has frequently been cited in the past as support for the presumption of twin-columned, strictly foliate arcades for the Saint-Étienne cloister. If the lithograph is to be dismissed as totally unreliable, as Horste says, and her argument is very persuasive, the entire question of the arrangements of this claustral ensemble may be reconsidered. Indeed, the 1780 plan opens the possibility that the Saint-Étienne arcades included the famous historiated capitals surviving in the Musée des Augustins, which have heretofore been thought ruled out of that location by the evidence of the strictly foliate capitals in the lithograph.[49]

Compound cloister supports are also intriguing. Bundles of three colonnettes were used at La Daurade.[50] Such bundled colonnettes were twisted into spirals at Aix, recalling Silos. The bundles were both turned and historiated at Coulombs (Fig. 10), and elaborately anthropomorphized at Châlons.[51] The use of anthropomorphizing columns and piers for cloister arcades has been called a relatively late development and that seems so.[52] Full, standing figures addorsed to columns survive from numerous cloisters, from Aix, Saint-Sauveur, Saint-Bertrand-de-Comminges, Châlons,[53] and, most interesting for discussion of recent research, from the cloister of Saint-Denis (Fig. 11).

Fifty years ago the Metropolitan's elegant king from that cloister was considered of "unknown origin." In 1955 Vera Ostoia identified it with the column statues from Saint-Denis, illustrated by Monfaucon in his *Monumens*. Excitement about this work has been generated since by a number of scholars: Pamela Blum, Charles Little, Pierre Quarré, Willibald Sauerländer, William Wixom, to cite only a few, and now most recently by Léon Pressouyre.[54] With sure instincts and an incomparable knowledge of twelfth-century sculpture, Pressouyre has enabled us finally to envision the forms of the Saint-Denis cloister: to see its columnar figures as very different in conception from the column statues of the facade (one need only compare the king from the facade, in the Walters Art Gallery in Baltimore, to see the striking change in proportions, the gentler surface treatment, and the moderation of tone in the later work of the king from the cloister, or study the head

of the queen from the facade which is now in the Musée de Cluny in relation to the cloister king); he has also enabled us to visualize the cloister's arcades by assembling the surviving bases, columns, and capitals and publishing a catalogue of them; and he has enabled us to grasp the correctness of a late date for this group of sculptures and thus to understand better this phase of late-Romanesque–early-Gothic lithic art.[55] As Pressouyre convincingly argues, it is probably not a Sugerian phase, but more likely from about the 1160s. That makes lucid sense of related works, such as Saint-Germain-des-Prés and the Dijon sculptures, namely the refectory relief, along with the affiliated works from Châlons.

As to an iconographic program in the Saint-Denis cloister, at present only hypotheses can be put forward. They turn on the fact that although some fine human heads appear, most eloquently in the Musée de Cluny and Rouen capitals, no sculptured narratives have been identified. Surviving pieces suggest instead a series of robust foliate and animal designs. Some show impressive use of the drill as well as the chisel, both of which penetrate the drum of the capital deeply and aid forms to project saliently from it.[56] Such salience adds a realism that is sometimes enhanced by the alignment of principal expressive motifs, such as heads of humans and of beasts, with the projecting corners of the capital.

Matters regarding the cloisters of major sites are therefore still often open-ended. In 1960, when the International Center of Medieval Art was in its infancy, Meyer Schapiro gave a lecture at the Institute of Fine Arts, in which he pointed to directions our field might fruitfully follow. He noted that at that time there was no published collection of illustrations covering Romanesque sculpture equivalent to that afforded by the volumes of Esperandieu, say, covering Gallo-Roman remains. He called for the creation of a photo archive and he called also for a scholarly corpus or census of Romanesque *membra disjecta* beginning with detailed study of such sculptures in American collections. Such a goal was also enjoined by other distinguished founders and supporters of the Center.[57] Since 1967, twenty-six installments, some in many parts, studying Romanesque sculptures in America, many theretofore very little known, have been published and the series is almost complete.[58] That we have this manifold fulfillment of Schapiro's suggested goal is in the main owing to the presiding

Fig. 12. The Death of Samson, capital from the cloister, Saint-Martin, Savigny. The Ernest Brummer Collection, Durham, North Carolina, Duke University Museum of Art (photo: courtesy of Duke University Museum of Art)

genius of Walter Cahn. Although aided by assistants who were responsible for some of the installments (Linda Seidel, Dorothy Glass, Marilyn Stokstad, William Wixom, Amy Vandersall, Kathryn Horste, David Simon, Lisbeth Castelnuovo-Tedesco, and Charles Little, along with other members of the Metropolitan staff), Walter Cahn is clearly the major person—the Goldschmidt, as it were—to whom all students of Romanesque art will forever owe deep gratitude for the success of this most worthy project. Around the time of Schapiro's lecture, the founders of the Center called for a journal to publish these and other researches, at first principally Romanesque, then all of medieval art; it was named *Gesta*. Its positive impact on scholarship is obvious and is immediately apparent in the current research in the field.[59] Special issues, particularly those devoted to symposia, on the cloister and on Cluny, have

substantially spurred progress in the field as has the symposium devoted to Saint-Denis, also sponsored by the Center.[60] Exhibitions, sponsored by many different institutions and often accompanied by weighty catalogues, have also been major in stimulating recent research.[61]

Study of the findings embodied in these various scholarly vehicles affords several observations that affect our understanding of Romanesque cloisters. One is that art historians have begun investigating more intensively the subject of "the early medieval artist at work" as scholarship has become increasingly concerned with the process of creating a work of art. Some scholars have long been keenly interested in the craft of sculptors and have studied their individual chisel marks, the traces of their gifted hands on the wood or on the stone.[62] With fruitful result, Edson Armi has recently taught us to be much more sensitive to the hands of both masons and sculptors, and he has thus enabled us to distinguish the important innovations of indigenous styles of carving in Romanesque Burgundy.[63] There has been interest in depictions of the artist at work at least since Virginia Egbert published significant data on this topic, and lately particular attention has been given to portrayals of sculptors wielding their tools.[64] As I have long been preparing a file on this subject, I would like to add, parenthetically, that in every case known to me thus far, the sculptor is shown working in his shop. I know of no instance of him wielding his chisel from a scaffolding, which adds support to my own view that most of the Romanesque sculptures we study were atelier productions.

The exhibitions of both *Rhein und Maas* and *Ornamenta Ecclesiae* were organized topically so that the sculptor's craft could be singled out for special attention.[65] The Rennes conference, now being published in large volumes under the editorship of Xavier Barral i Altet, also elicited important cues on the making of sculpture, in papers by Jean-Claude Bonne, Thomas Lyman, Neil Stratford, Nicole Thierry, and others.[66] Beatriz Mariño, who is preparing a thesis on the subject of the artist at work, under Serafín Moralejo Álvarez, stirred her audience in Kalamazoo during the 1988 congress when she showed the Palencia archivolt of Revilla de Santullán, which depicts the Last Supper.[67] The sculptor not only included himself in the scene, showing himself hastily finishing with his chisel the carving of the cloth covering the table at which the

apostles sit, but he also depicted a book spread open behind him, toward which he turns and looks as he executes his carving. I do not believe that this sculptor is looking at a model book. Rather, the book seems present in order to authenticate the source of the Last Supper episode in holy writ; the text thus provides the written witness that serves as pendant to the visible witness created by the sculptor.[68] This detail provides a useful clue for students of Romanesque claustral sculpture, a clue to which I will return below.

Understanding of the creative process is complicated in our field by the varied opinions held by scholars regarding the relative independence of the Romanesque artist in his creative work. Some time ago, Walter Cahn discoursed with great wit on the conceptual poles of freedom and constraint for the medieval artist by relating these to historiographic contexts, from Vasari's critical view of the medieval artist's "propensity for impulsive and unguided action," through the alternating views of the Romantic Movement, to Focillon's formulations of rational and fantastic principles as complementary opposites, governing designs inexorably, as it were, yet according to coherent and definable laws.[69] The freedom-constraint dichotomy will probably ever be with us. In a recent review of scholarship in the early-medieval field, we read that there has been "misplaced concern with the creative artist," that it was continuity in art that was urged "rather than innovation," and that "reformulation" is more important than "invention" to the art of the period.[70] If this view can possibly be considered valid with regard to some types of medieval art (namely manuscript illumination, which is said by the author to be "principally an act of duplication"), it is certainly belied in our field, I believe, by the improvisation so evident in Romanesque sculpture itself. At the opposite extreme are recent theorists who see images as free-floating signifiers. Whether images carved in stone can be thought of as behaving like texts, which are said to inscribe their verbal precursors on themselves, needs further discussion.[71]

Still other scholars, seeking a more contextual approach, consider the Romanesque audience and its priorities the important thing.[72] Surely all can agree to the importance of the reception of the sculpted work of art. Even in the cloister, sculpture was, after all, a somewhat public art in the sense that the "receiver" was a member of a social as well as

religious community. Especially cumbersome in attempting to understand the reception, however, is that although the "receiver" and the patron belonged to the same group, there is no agreement among scholars about the role the carver played in relation to his patron, whether he was totally guided in his work or whether he freely invented the form of his product. Most scholars seem to think that the selection of themes, at least, was the prerogative of the patron (the constraint) and the presentation of them was the artist's affair (his/her freedom).[73] Even so, there are scholars who insist that the sculptor must always have had a specific pictorial model to guide him with iconography and was, in effect, incapable of any significant iconographic or formal invention.[74]

There is ample evidence to the contrary. Even with usual biblical subjects, in the Romanesque period thematic meaning often inheres so deeply in the form of the work itself that it is impossible to distinguish "iconography" and "style" in a conventional art-historical manner. For example, among Moissac's porch sculptures, the standard episode in the Infancy cycle, the Visitation, has lilting, willowy forms that are themselves heavily charged with reference: the vitality, indeed the pregnancy, of the flexed, lifting and sinking knees, shoulders, and elbows; the communion, of answering shapes, fabric flourishes, and gestures; the awe, as revelation springs from the touch and is tenderly understood by the nod; and above all the concept of *chaste fertility,* embodied in thin, lanky, unviolated limbs— all these inventions lodged deeply, as Schapiro demonstrates, in the forms themselves.[75] Many other examples—including a number from cloister sculpture—could be cited, such as the famous Saint-Étienne Salome, eloquently discussed by Seidel; the apostle John rushing to the tomb, from La Daurade; or the memorable and unique suicide of Samson from Savigny (Fig. 12).[76] As to nonscriptural subjects, invention is more obviously rampant. The fanciful creatures and dynamic flora often seem to us iconographically incoherent (Figs. 3, 4). In the niggard mention we have of them in literary sources, these delightful and preposterous animal and vegetal shapes, which inhabit and energize both peripheral and central worlds of Romanesque sculpture, are attributed to the inventive musings of artists. The *Pictor in Carmine*'s author complains, as did St. Bernard, of the centaurs, chimaeras, monkeys, and

other "ignoble fancies" in the art of his time and then says clearly: "It is the criminal presumption of painters that has gradually introduced these sports of fantasy, which the church ought not to have countenanced." He adds that it is thus necessary "to curb the licence of painters."[77] The comments of Lucas of Tuy, signaled by Creighton Gilbert, are a bit later but have a similar ring in that Lucas also complains of "false novelties" that he attributes to painters as he is exasperated by their ambition to represent the unrepresentable.[78] Lucas also rails at excesses in carvings, such as sculptures of demons, indicating that he does not restrict his indictments to painters alone. In these medieval comments there is kinship with Vasari's enlightening remark: "Painters express the concepts of their own minds better than those of other people."[79] Although these statements are few, they underscore the force of the artist's invention observable in the forms themselves.

It may well be hopeless to search for deep, hidden meanings in such fanciful inventions, if they are irretrievably lost along with the oral traditions that might help explain them, or if indeed the inventions are merely pleasant or unpleasant, decorative drolleries.[80] Lucas speaks of animals, birds, and serpents as permissible adornments that have "ornamental beauty only." To interpret Lucas's tolerance of these as evidence of the nonsymbolic function of such images, as Gilbert does, seems valid but also seems as incomplete as the usual interpretations given to Bernard's classic statement. "If Bernard claimed them useless and meaningless, how can we hope to grasp their sense?" is the usual refrain. But rather than being meaningless, is it not possible that in some cases these fabulous figures represented ruminations, sometimes ribald, which were so fully charged with allusion to meaning that this was the very reason for their impugnation as dangerous distractions to concentrated meditation? Surely if they were totally neutral they would not have been so annoying. If they were neither so ubiquitous nor so central, it would be easier to dismiss them. It is clear that toward the end of the century their fashion abated as more systematic iconographies, with typological schemes, such as advanced by the *Pictor* author, took over—as pointed out by Pressouyre in 1972.[81]

In 1960 Meyer Schapiro made another recommendation, calling for greater attention to the interest and usefulness of theological writings by

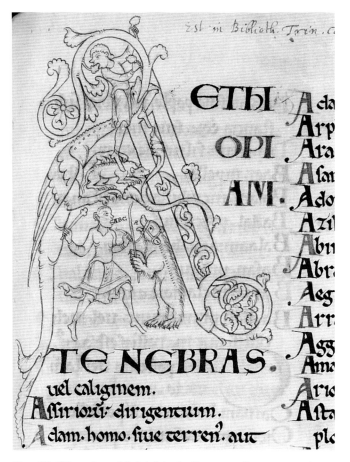

Fig. 13. Historiated Initial A. St. Jerome, Commentaries on Books of the Old Testament, Cambridge, Trinity College Library, MS 0.4.7, fol. 75r (photo: Trinity College Library)

students seeking to explain Romanesque art. Excellent use of texts has been made to elucidate questions of the function of Romanesque art and to study it in its religious and intellectual context.[82] Nuanced associations with literature and philosophy have been productively explored by Seidel.[83] Indeed, the study of texts fascinates a number of scholars in the field who wish to explore the metaphorical content of Romanesque monumental art. With Marie Chenu, they see the importance of the symbolist mentality in the period and they see in art equivalents to symbols, allegories, and multileveled, veiled senses, which were the rule of the day, which made *integumenta* standard in the texts of twelfth-century scholastics, and which contributed so substantially to the iconography of the Gothic period.[84] The premise which must be conceded, however, is that the unity of Romanesque culture allowed a gifted artist, even an illiterate sculptor (perhaps sometimes not illiterate?), to have access to such ideas, especially when participating in a creative dialectic with his patron. Here it must be remembered that patrons, while probably literate, were bilingual. Jan Ziolkowski has described the cultural diglossia of the situation for medieval authors—often members of the patronage group under discussion—who knew from childhood and communicated via vernacular language, their mother tongue and the living oral language of their time; for religious and academic purposes they also had learned Latin, a half-living, half-dead, literate language. Although the influence of vernacular language on medieval Latin literature has not yet been fully documented, it was constant. Ziolkowski is now demonstrating the impact of the orality of vernacular poetry (such as variation through the repetition of the same thought with different words, and formulaic repetition using similar word patterns) on the style of medieval Latin poetry.[85] He has indicated, further, that medieval writers lived part of their lives in the spoken mother tongue with which they formulated many of their thoughts, switching or even combining "codes" as needed, and that the mother tongue was neither forgotten nor despised. Thus both patrons and artists in our period were intimately familiar with an orality native to their own semiliterate culture. Surely that primary orality might surface in sculpture as it does in other arts.

Can learned texts then help us decipher enigmatic images in cloisters and resolve the dilemma of cloister programming? Skeptics consider it insufficient to point out associations between text and sculpture, and they often believe sculptors incapable of sophisticated, interpretive expansion and expression of even basic iconography. On the other hand, the study of orality and literacy has vaulted ahead recently with the impetus given by scholars such as Walter Ong and Brian Stock.[86] Among art historians, Michael Camille has done provocative and highly acclaimed work on manuscripts, which is suggestive for some of the problems posed by sculpture, especially when accompanied by inscriptions. In his "Seeing and Reading" study of 1985 he brilliantly demonstrated the twelfth-century expectation that images should convey speech and oral experience.[87] The force of such orality is evident in the forms of Romanesque manuscript illumination such as the initial he cites

in the Cambridge manuscript (Fig. 13), where the process of learning is shown in oral rather than written terms. This initial reminds us that oral learning is primary learning, as Ong has emphasized. The bear of the initial is being taught his A-B-C's and learns them by repeating them back to his master.[88] The figure above is ruminating (*ruminatio*) on the meaning of the letters, and what they signify in the accompanying text, by metaphorically "chewing" on them, as he literally chews on the tendril of the A.

As the cloister was the locale where the *lectio,* or reading, commonly took place, it was there that the words were read aloud or whispered—in what I call the "oral silence" of the cloister—where the words were mouthed, twirled about on the tongue, tasted, chewed over, and digested in a process of ruminating and meditating (*meditatio*) on their meaning. Through the vehicle of reading aloud, words should be masticated to release the "full flavor" of their meaning and their "spiritual nurture," as described by Jean Leclercq, who notes the use of the vocabulary of eating in twelfth-century references and records report of the resultant buzz in the cloister as the words' depths were sounded.[89] Camille underscores the distinction that this illuminated initial makes graphic, between learning by rote, or memorization through repetition of sound, which the dumb beast performs here, as primary orality, and the learning of the *litteratus,* who learns *in ore cordis,* as the texts often say.[90] In his *lectio* the *litteratus* meditates on the deeper meaning of the word via its sound. He chews the word over in the manner of the figure who munches the leaf here. Such a mental procedure, so contrary to our own where we consider moving the lips during reading to be a sign of dull wit, is a procedure which produces "verbal echoes"[91] and results in a rich array of allusions and associations, not all of them strictly logical and relevant to the primary meaning of the word. This mental habit, associational rather than sequential (aggregative, in Walter Ong's sense), may well have resulted in exceptional tolerance for its artistic analogue in the sculpture of the cloister, the monsters of the imposts of Moissac and La Daurade, say, being "visual echoes" to ruminations of the *lectio divina,* counterparts to the fabulous marginalia or even the fanciful initials of manuscripts.

Inscriptions and gestures abound in both sculpture and manuscript illumination because of the importance of the spoken rather than the written word of this predominantly oral society and as artists aimed to "evoke the sound of the voice."[92] The author of the *Pictor* says "the stones cry out," as indeed they often seem to do.[93] This phenomenon may help explain the declamatory character of much Romanesque art and why many of its images seem rather "noisy." It may also explain why cloisters seem recalcitrant in yielding to us the keys to their varied thematic designs. My final suggestion, then, is that this line of reasoning and method of research holds promise for future work on the Romanesque cloister. Traditional stylistic, archaeological, antiquarian, and contextual studies will surely continue, and that is essential, but we may also look for invigoration from new approaches to our problems, particularly those which explore the function of the work of art through investigation of contemporary texts relevant to it, and those which give due consideration to the importance of orality in the thinking of the period which so beguiles us.

ACKNOWLEDGMENTS

I wish to express appreciation to William D. Wixom, Chairman of the Department of Medieval Art and The Cloisters, and Elizabeth C. Parker, of the International Center of Medieval Art, for their kind invitations to contribute to the symposium and the publication of its papers in celebration of the Fiftieth Anniversary of The Cloisters. My warm thanks are also due Walter Cahn, who graciously read the typescript and made a number of suggestions, from which the paper has greatly benefited. I am also grateful to many others who shared with me their perceptions regarding the state of our field. None of these, however, should share responsibility, which is mine alone, for any shortcomings in the paper presented here.

NOTES

1. International Center of Medieval Art, *Newsletter,* ed. Jane Rosenthal (1985/1), p. 1 ("Romanesque—34; Gothic—12; Late Medieval/Italian Renaissance—12 . . .").

2. Dorothy F. Glass, *Italian Romanesque Sculpture, an annotated bibliography* (Boston, 1983); Thomas W. Lyman, with Daniel Smartt, *French Romanesque Sculpture, an annotated bibliography* (Boston, 1987); see also Deborah Kahn, "La Sculpture romane en Angleterre: état des questions," *Bulletin monumental* 146 (1988), pp. 307–40.

3. Herbert L. Kessler, "On the State of Medieval Art History," *Art Bulletin* 70 (1988), pp. 166–87, discusses recent research and includes reference to some studies dealing with Romanesque sculpture (p. 177 n. 140). Particularly important recent books include: Jean-Claude Bonne, *L'Art roman de face et de profil, le tympan de Conques* (Paris, 1985); Jean Cabanot, *Les Débuts de la sculpture romane dans le sud-ouest de la France* (Paris, 1987); Éliane Vergnolle, *Saint-Benoît-sur-Loire et la sculpture du XIe siècle* (Paris, 1985).

4. J. L. Schrader, "George Gray Barnard: The Cloisters and The Abbaye," *MMAB* 37/1 (1979), pp. 3–52; Harold E. Dickson, "The Origin of 'The Cloisters,'" *The Art Quarterly* 38 (1965), pp. 253–74; Walter Cahn and Linda Seidel, *Romanesque Sculpture in American Collections, I, New England Museums,* Publications of the International Center of Medieval Art 1 (New York, 1979), pp. 1–16. See also the paper, "Five Key Persons in the Founding of The Cloisters," presented by William H. Forsyth at the symposium and included in this volume. For the interest of Paul Sachs and Arthur Kingsley Porter, see idem, "The Avignon Capital," *Fogg Art Museum Notes,* ed. Margaret Gilman (Cambridge, 1923), pp. 3–15; Cahn and Seidel, *Romanesque Sculpture,* pp. 8–10, 120ff., esp. p. 161.

5. Jacques Bousquet, "Problèmes d'origines des cloîtres romans. Histoire et stylistique. De l'époque carolingienne à Aurillac, Conques et Moissac," *Les Cahiers de Saint-Michel de Cuxa* 7 (1976), pp. 7–34, esp. pp. 3–13; Wayne Dynes, "Introduction," *The Cloister Symposium, 1972,* ed. Wayne Dynes, *Gesta* 12 (1973), p. v; Paul Meyvaert, "The Medieval Monastic Claustrum," ibid., pp. 53–59.

6. Meyvaert, "Medieval Monastic Claustrum," pp. 57, 59 n. 49; Jean Leclercq, "Le Cloître est-il une prison?" *Revue d'ascétique et de mystique* 47 (1971), pp. 407–20; Gregorio Penco, "Monasterium-Carcer," *Studia Monastica* 8 (1966), pp. 133–43.

7. Giles Constable, "Monachisme et pèlerinage au Moyen Âge," *Revue historique* 256 (1977), pp. 3–27; regarding Bernard of Clairvaux's injunction to the monk to seek not the earthly but the heavenly Jerusalem and to make pilgrimage "with [his] feelings" rather than "with [his] feet": idem, "Opposition to Pilgrimage in the Middle Ages," *Mélanges G. Fransen, I. Studia Gratiana* 19 (1976), pp. 125–46; idem, "The Study of Monastic History Today," *Essays on the Reconstruction of Medieval History,* ed. V. Mudroch and G. S. Crouse (Montreal, 1974), p. 32 (repr. idem, *Religious Life and Thought* [London, 1979], papers I, III–IV). Jean Leclercq, "Monachisme et pérégrination du XIe au XIIe siècle," *Studia monastica* 3 (1961), pp. 33–52, esp. p. 48. Meyvaert, "Medieval Monastic Claustrum." For Bernard's references to monastic life as a pilgrimage, Migne, *PL,* vol. 183, cols. 179B, 183D, 186A. Ilene H. Forsyth, "The '*Vita Apostolica*' and Romanesque Sculpture: Some Preliminary Observations," *Essays in Honor of Whitney Snow Stoddard,* ed. Jerrilynn D. Dodds and Elizabeth C. Parker, *Gesta* 25/1 (1986), pp. 75–82.

8. Narrative in medieval art has been of recent interest: *Pictorial Narrative in Antiquity and the Middle Ages,* Studies in the History of Art 16 (Center for Advanced Study in the Visual Arts, Symposium Series IV), ed. H. Kessler and M. S. Simpson (Washington, D.C., 1985), publishing the proceedings of the symposium of 1984 held at Johns Hopkins University (with papers by Irene Winter, Elizabeth Myers, Andrew Stewart, Herbert Kessler, William Tronzo, Yoshiaki Shimizu, Marianna Shreve Simpson, Hans Belting, and Anne Hedeman, but with no papers devoted to Romanesque narrative); "Visual Narratives: Methods of Story-Telling in the History of Art," symposium held at the University of Notre Dame, 1985 (papers by Richard Brilliant, Henry Maguire, Samuel Edgerton, Craig Owens, and Karal Marling, but again with no papers on Romanesque narrative); "Story and Image in Medieval Art," symposium presented by the Robert Branner Forum for Medieval Art (Columbia University, 1989) (papers by Richard Brilliant, Brian Stock, Herbert Kessler, Mary Shepard, Robert Hanning, and papers dealing with Romanesque narratives by Marcia Kupfer and Paul Binski). See also Kathryn Horste, "The Capitals of the Second Workshop from the Romanesque Cloister of La Daurade, Toulouse" (Ph.D. diss., University of Michigan, 1978); idem, "The Passion Series from La Daurade and Problems of Narrative Composition in the Cloister Capital," *Gesta* 21/1 (1982), pp. 31–62; Kathleen Nolan, "Narrative in the Capital Frieze of Notre-Dame at Étampes," *Art Bulletin* 71 (1989), pp. 166–84; Otto Pächt, *The Rise of Pictorial Narrative in Twelfth Century England* (Oxford, 1962); and Meyer Schapiro, "The Romanesque Sculpture of Moissac," *Art Bulletin* 13 (1931), pp. 283–308, 504–11, and *passim* (repr. *Romanesque Art* [New York, 1977], pp. 156–72). Stimulating studies of narrative have recently centered on stained glass: Jean-Paul Deremble and Colette Manhes, *Les Vitraux légendaires de Chartres* (Paris, 1988); Wolfgang Kemp, *Sermo corporeus. Die Erzählung der mittelalterlichen Glasfenster* (Munich, 1987). In related fields, see also Richard Brilliant, *Visual Narratives* (Ithaca, 1984); Henry Maguire, "The Art of Comparing in Byzantium," *Art Bulletin* 70 (1988), pp. 88–103.

9. Émile Mâle, *L'Art religieux du XIIe siècle en France* (Paris, 1922), ed. H. Bober, trans. M. Marthiel Mathews, *Religious Art in France: The Twelfth Century* (Princeton, 1978), pp. 187–245, 364–76, 377–419; Ernest Rupin, *L'Abbaye et les cloîtres de Moissac* (Paris, 1897; repr. *Les Monédières*, 1981).

10. Léon Pressouyre, "St. Bernard to St. Francis: Monastic Ideals and Iconographic Programs in the Cloister," *Gesta* 12 (1973), pp. 71–92, esp. p. 87 n. 52. For the ritual of the washing of the feet, see: T. Schaefer, *Fusswaschung im monastischen Brauchtum und in der lateinischen Liturgie,* Texte und Arbeiten, 1.47 (Beuren, in Hohenzollern, 1956); H. Giess, *Die Darstellung der Fusswaschung Christi in den Kunstwerken des 4–12 Jahrhunderts* (Rome, 1961). Regarding processions and the rite of *Ecclesiastica Officia* in England, see Peter Fergusson, "The Twelfth-Century Refectories at Rievaulx and Byland Abbeys," *Cistercian Art and Architecture in the British Isles,* ed. C. Norton and D. Park (Cambridge, 1986), p. 170.

11. "*Paradisus Claustralis.* What is a Cloister?," pub. in *The Cloister Symposium, 1972,* with relevant papers by Alfred Frazer ("Modes of European Courtyard Design Before the Medieval Cloister"), Walter Horn ("On the Origins of the Medieval Cloister"), Paul Meyvaert ("Medieval Monastic Claustrum"), Wayne Dynes ("The Medieval Cloister as Portico of Solomon"), Léon Pressouyre ("St. Bernard to St. Francis"), and Jane Hayward ("Glazed Cloisters and Their Development in the Houses of the Cistercian Order"). The symposium, "Le Cloître roman dans le Midi de la France et en Catalogne, 1975," ed. Pierre Ponsich, in *Les Cahiers de Saint-Michel de Cuxa* 7 (1976), with papers by Jacques Bousquet ("Problèmes"), Thomas Lyman ("Portails, portiques, paradis. Rapports iconologiques avec les cloîtres méridionaux"), Robert Saint-Jean ("Le Cloître supérieur de Saint-Guilhem-le-Désert. Essai de restitution"), Marcel Durliat ("Le Cloître historié dans la France méridionale à l'époque romane"), Pierre Ponsich ("Chronologie et typologie des cloîtres romans roussillonnais"), Mario Mirabella Roberti ("L'Atrium paléo-chrétien, ancêtre des cloîtres"), Mireille Mentré ("L'Apocalypse

dans les cloîtres romans du Midi"), Xavier Barral i Altet ("Fontaines et vasques romanes provenant de cloîtres méridionaux: problèmes de typologie et d'attribution"), and Jacques Lacoste ("La Galerie nord du cloître de Saint-Trophime d'Arles").

12. Eugène Viollet-le-Duc, "cloître," *Dictionnaire raisonné de l'architecture française du XIe au XVIe siècle,* 10 vols. (Paris, 1854–68), vol. 3, pp. 410–39. Other studies include: Wolfgang Braunfels, *Monasteries of Western Europe* (Princeton, 1972); Robert de Lasteyrie, *L'Architecture religieuse en France à l'époque romane,* 2d ed. (Paris, 1929), pp. 353–57; Albert Lenoir, *Architecture monastique,* 2 vols. (Paris, 1852–56); Léon Pressouyre, "Cloîtres," *Encyclopaedia Universalis* 4 (1968), pp. 629–33; Raymond Rey, *Les Cloîtres historiés du Midi dans l'art roman, Mémoires de la Société Archéologique du Midi de la France* 23 (1955), pp. 7–124; idem, *L'Art des cloîtres romans* (Toulouse, 1955); Hans-Adalbert von Stockhausen, "Die romanischen Kreuzgänge der Provence, I. Die Architektur, II. Die Plastik," *Marburger Jahrbuch für Kunstwissenschaft,* vol. 7 (1933), pp. 135–90; vols. 8–9 (1936), pp. 89–172. For attractive illustrations, see Jacqueline Carron-Touchard, *Cloîtres romans de France* (La Pierre-qui-Vire, 1983).

A list of Romanesque cloisters in France would include: Aix-en-Provence, Saint-Sauveur; Angers, Saint-Aubin; Arles, Saint-Trophime; Avignon, Notre-Dame-des-Doms; Avignon, Saint-Ruf; Beaulieu, Saint-Pierre; La Bruyère; Carpentras, Saint-Siffrein; Cavaillon, Cathedral; La Celle; Châlons-sur-Marne; Charlier, Saint-Fortunatus; Cluny, Saint-Pierre et Saint-Paul; Conques, Sainte-Foy; Coulombs, Notre-Dame; Cuxa, Saint-Michel; Elne, Cathedral; Fontenay; Fréjus; Ganagobie; Lavaudieu; Lérins; Lombez; Mauriac, Saint-Pierre; Moissac, Saint-Pierre; Montmajour, Notre-Dame; La Motte Galaure; Nîmes, Cathedral; Obasine; Le Puy, Cathedral; Romans, Saint-Bernard; Saint-Avit-Sénieur; Saint-Bertrand-de-Comminges, Cathedral; Saint-Denis; Saint-Donat-en-Herbasse; Saint-Gaudens; Saint-Gilles; Saint-Guilhem-le-Désert; Saint-Lizier; Saint-Martin-du-Canigou; Saint-Michel-de-Frigolet; Saint-Paul-du-Mausolée; Saint-Pons-de-Thomières; Salles; Savigny, Saint-Martin; Sénanque; Serrabone; Silvacane; Ternay; Le Thoronet; Toulouse, La Daurade; Toulouse, Saint-Étienne; Toulouse, Saint-Sernin; Tournus, Saint-Philibert; La Trappe d'Aiguebelle; Vaison, Cathedral; Valence, Saint-Félix; Valence, Saint-Ruf; Vézelay, La Madeleine; Vienne, Saint-André-le-Bas; Vienne, Saint-Pierre.

13. Marcel Durliat, review of Jacques Bousquet, *La Sculpture à Conques aux XIe et XIIe siècles* (Lille, 1973), in *Bulletin monumental* 132 (1974), p. 173; Willibald Sauerländer, "Das 7. Colloquium der Société française d'archéologie: Sainte-Foy in Conques," *Kunstchronik* 26 (1973), pp. 225–30; Helga Möbius, "Französische Bauplastik um 1100. Form und Funktion im geschichtlichen Prozess," *Skulptur des Mittelalters. Funktion und Gestalt* (Weimar, 1987), pp. 44–80, esp. pp. 62–64.

14. Charles Little, with David Simon and Leslie Bussis, "Romanesque Sculpture in North American Collections. XXV. The Metropolitan Museum of Art. Part V. Southwestern France," *Gesta* 26/1 (1987), p. 73; Bousquet, "Problèmes," pp. 28–33; idem, *Sculpture à Conques,* pp. 353–72, pls. 472–543.

15. Möbius, "Französische Bauplastik," pp. 62–64.

16. Éliane Vergnolle, "Chronologie et méthode d'analyse: Doctrines sur les débuts de la sculpture romane en France," *Les Cahiers de Saint-Michel de Cuxa* 9 (1978), pp. 141–62, esp. p. 142.

17. Charles Little, "From Cluny to Moutiers-Saint-Jean: The Origin of a Limestone Fragment of an Angel at The Cloisters," *Current Studies on Cluny,* ed. Walter Cahn, William W. Clark, and Ilene H. Forsyth, *Gesta* 27 (1988), pp. 23–29; Neil Stratford, "A Cluny Capital in Hartford (Connecticut)," ibid., pp. 9–21. For the complicated example of Cuxa, involving study of dissemination of some of the sculptures, see David L. Simon, "Romanesque Sculpture in North American Collections. XXIV. The Metropolitan Museum of Art. Part IV. Pyrenees," *Gesta* 25/2 (1986), pp. 245–76 (see pp. 254–55, and pp. 264–67 for the earlier literature, particularly the studies of Marcel Durliat and Pierre Ponsich); see also Marcel Durliat, "La tribune de Saint-Michel-de-Cuxa," *Bulletin monumental* 146 (1988), pp. 48–49; and Thomas Lyman, "Les Origines énigmatiques du cloître de Saint-Michel de Cuixà," *Études roussillonnaises offertes à Pierre Ponsich,* Mélanges d'archéologie, d'histoire et d'histoire de l'art du Roussillon et de la Cerdagne (Perpignan, 1987), pp. 255–59. Neutron-activation analysis and other technical procedures have been useful for art historians: Lore Holmes, Charles Little, and Edward Sayre, "Elemental Characterization of Medieval Limestone Sculpture from Parisian and Burgundian Sources," *Journal of Field Archaeology* 13 (1986), pp. 419–38; Jean M. French, Edward Sayre, and L. van Zelst, "Nine Medieval French Limestone Reliefs: The Search for Provenance," *Proceedings of the Fifth Seminar on the Application of Science in the Examination of Works of Art, September 1982* (Boston, 1987); Annie Blanc and Claude Lorenz, "Les Approvisionnements en matériaux calcaires d'édifices du premier millénaire en Limousin," *Travaux d'archéologie limousine* 6 (1985), pp. 7–16.

18. For examples of contextual studies that consider the cloistered life in relation to societal developments: *Il Monachesimo nell'alto Medioevo e la formazione della civiltà occidentale, Settimane di Studio del Centro italiano di Studi sull'alto Medioevo,* IV (Spoleto, 1957); *La vita commune del clero nei secoli XI e XII, Atti della Settimana di Studio, Mendola,* 1959, 2 vols. (Milan, 1962); Christopher Brooke, "Reflections on the Monastic Cloister," *Romanesque and Gothic. Essays for George Zarnecki* (Woodbridge, 1987), pp. 19–25; *The Medieval Monastery,* ed. Andrew MacLeish, Medieval Studies at Minnesota, no. 2 (St. Cloud, Minn., 1988). On *mentalité* of the period: Georges Duby and Guy Lardreau, *Dialogues* (Paris, 1980), pp. 9, 15–17, 59–60; Möbius, "Französische Bauplastik," pp. 74–78. For comments on changes of approach in the archaeology of monasticism, see Sheila Bonde and Clark Maines, "The Archaeology of Monasticism," *Speculum. A Journal of Medieval Studies* 63 (1988), pp. 796–97. Regarding recent work on orality and literacy, see notes 85–92 below.

19. The Cluny sculptures are currently under study by Neil Stratford and David Walsh (see note 40 below); Lydwine Saulnier and Neil Stratford, *La Sculpture oubliée de Vézelay* (Geneva, 1984); Saint-Jean, "Le Cloître."

20. Jean-Claude Fau, "Le Bassin roman de serpentine du cloître de Conques," *Actes du Congrès d'Études de Rodez, 1974* (Rodez, 1975), pp. 319–32; Walter Cahn, "Romanesque Sculpture in American Collections. XI. The Philadelphia Museum of Art," *Gesta* 13/1 (1974), pp. 48–49; Barral i Altet, "Fontaines"; Jean Adhémar, "La Fontaine de Saint-Denis," *Revue archéologique,* 6th ser., 7 (1936), pp. 224–32.

21. A. Fontaine, *Pontigny abbaye cistercienne* (Paris, 1928), p. 141; Terryl Kinder, "Architecture of the Cistercian Abbey of Pontigny: The Twelfth-Century Church" (Ph.D. diss., Indiana University, 1982); Viollet-le-Duc, "lavabo," *Dictionnaire;*

Heinrich Grüger, "Cistercian Fountain Houses in Central Europe," *Cistercian Art and Architecture* II, ed. M. Lillich, Cistercian Studies Series 69 (Kalamazoo, 1984), pp. 201–22; Meredith P. Lillich, "Cleanliness with Godliness: A Discussion of Medieval Monastic Plumbing," *Mélanges à la mémoire du père Anselme Dimier,* ed. B. Chauvin (Arbois, 1982), pp. 123–49. With regard to possible symbolic meaning, often affecting the whole of the cloister, see: Barral i Altet, "Fontaines"; Cahn, "Philadelphia Museum"; Dynes, "Medieval Cloister"; M. T. Gousset, "Iconographie de la Jérusalem céleste dans l'art médiévale occidentale du IXe à la fin du XIIe siècle" (Ph.D. diss. [3e], Paris IV, 1978); Lyman, "Portails, portiques, paradis"; Meyvaert, "Medieval Monastic Claustrum," pp. 57–58. Trenchant remarks on the cloister as paradise are also written by: Jean Leclercq, "Le Cloître est-il un paradis?," *Le Message des moines à notre temps* (Paris, 1958), pp. 141–59; Giles Constable (with incisive comment about the rhetorical use of such metaphors by twelfth-century authors and reformers), "Renewal and Reform in Religious Life: Concepts and Realities," *Renaissance and Renewal in the Twelfth Century,* ed. Robert Benson and Giles Constable with Carol Lanham (Cambridge, Mass., 1982), pp. 37–67, esp. pp. 48–51.

22. Bonde and Maines, "Archaeology of Monasticism," p. 803, regarding the work of Bernadette Barrière and Joseph Falco.

23. Fergusson, "Twelfth-Century Refectories," pp. 160–80; idem, *The Architecture of Solitude* (Princeton, 1984); idem, "The Refectory at Easby Abbey: Form and Iconography," *Art Bulletin* 71/3 (1989), pp. 334–51; Roger Stalley, *The Cistercian Monasteries of Ireland* (London, 1987), p. 169.

24. Cahn and Seidel, *Romanesque Sculpture,* pp. 43–44; cf. Bonnie Young, *A Walk Through the Cloisters* (New York, 1979), pp. 42–45; Pressouyre, "St. Bernard to St. Francis," p. 88 n. 67; François Deshoulières, "Marcilhac," *Congrès archéologique de France* 100 (1937), pp. 77–81; Jeanne Missonier, "Mauriac," *Bulletin monumental* 146 (1988), pp. 38–40; Dominique Poulain, "Découverte de vestiges du XIIe siècle dans l'ancienne abbaye de Saint-Michel-en-Thiérache," *Bulletin monumental* 145 (1987), p. 107.

25. Bonde and Maines, "Archaeology," p. 803 nn. 16–17; see also: L. Chomton, *Histoire de l'église Saint-Bénigne de Dijon* (Dijon, 1900), pp. 133–34; Jean Marilier, "Abbaye Saint-Bénigne," *Mémoires de la Commission des Antiquités de la Côte-d'or* 26 (1963–69), pp. 106–7; Bruno Albers, ed., *Consuetudines monasticae, I, Consuetudines Farfensis* (Stuttgart/Vienna, 1900), p. 137; Bernard Beck, "Les Salles capitulaires des abbayes de Normandie: éléments originaux de l'architecture monastique médiévale," *L'Information d'histoire de l'art* 18 (1973), pp. 204–15. Recent monographic studies include: Christian Gilbert, "L'Abbaye Saint-Michel de Bois-Aubry," *Bulletin archéologique du Comité des Travaux historiques et scientifiques,* n.s. 19A (1987), pp. 7–68; Fang-Chen Wu, "Les Arcades du cloître de l'abbaye Saint-Aubin d'Angers (1128–1151)," *Histoire de l'art* 3 (1988), pp. 37–46 (see also Sheila R. Connolly, "The Cloister Sculpture of Saint-Aubin in Angers" [Ph.D. diss., Harvard University, 1979]). For the La Daurade, Toulouse chapter house, see note 29 below. Neil Stratford, who has reviewed our knowledge of a group of early examples in his work on the Worcester chapter house, has indicated what could be done with this subject ("Notes on the Norman Chapterhouse at Worcester," *Medieval Art and Architecture at Worcester Cathedral,* British Archaeological Association Conference Transactions for the year 1975 [London, 1978], pp. 51–70), as has Stephen Gardner for later centralized examples ("The Role

of Central Planning in English Romanesque Chapter House Design of the Twelfth Century" [Ph.D. diss., Princeton University, 1976]).

26. Pressouyre, "St. Bernard to St. Francis," p. 75 nn. 43–44; see also Dynes, "Medieval Cloister," pp. 61–63. For the Cluny Customaries, see: [Farfa, considered to represent Cluny] Albers, *Consuetudines Farfensis,* pp. 137–39; [Bernard] *Ordo Cluniacensis* in Herrgott, ed., *Vetus Disciplina Monastica* (Paris, 1726), pp. 133–364; [Ulrich] *Consuetudines,* in L. d'Achery, *Spicilegium* (Paris, 1728), I, p. 668, and *PL,* vol. 149, cols. 643–778. These works are being restudied and published in a number of volumes under the direction of Dom Kassius Hallinger in the *Corpus Consuetudinum Monasticarum* series. For the Fleury *Consuetudines,* see Bruno Albers, ed., *Consuetudines Monasticae, V. Consuetudines Monasterium Germaniae, necnon S. Vitonis Virdunensis et Floriacensis Abbatiae, monumenta saeculi decimi continens* (Monte Cassino, 1912). Kenneth J. Conant, *Cluny, les églises et la maison du chef d'ordre* (Mâcon, 1968), pp. 42ff.; Joan Evans, *The Romanesque Architecture of the Order of Cluny* (Cambridge, 1938), pp. 137, 141–43; Stratford, *Worcester Cathedral,* nn. 21, 28, 34. Note also the work *Usus Monachorum,* Jeremiah O'Sullivan and Anne Mannion, ed. and trans., forthcoming, a reference I owe to Elizabeth Parker.

27. Pressouyre, "St. Bernard to St. Francis."

28. Ibid. Rupin discusses monastic discipline in relation to reliefs of St. Benedict, *L'Abbaye,* pp. 183–86. See also *Monasticism and the Arts,* ed. Timothy Verdon (Syracuse, 1984).

29. Linda Seidel, "Romanesque Sculpture from the Cathedral of Saint-Étienne, Toulouse" (Ph.D. diss., Harvard University, 1964), published in the Garland series, *Romanesque Sculpture from the Saint-Étienne Cathedral,* Outstanding Dissertations in the Fine Arts (New York, 1977); idem, "A Romantic Forgery: The Romanesque 'Portal' of Saint-Étienne in Toulouse," *Art Bulletin* 50 (1968), pp. 33–44; review by Léon Pressouyre, *Bulletin monumental* 127 (1969), pp. 241–42; for illustrations, Paul Mesplé, *Toulouse, Musée des Augustins, Les sculptures romanes,* Inventaires des collections publiques françaises, 5 (Paris, 1961), nos. 1–27.

See also Seidel's later study of the La Daurade chapter house portal, "The Facade of the Chapter House at La Daurade, Toulouse," *Art Bulletin* 55 (1973), pp. 328–33; reviewed by Marcel Durliat, "Le portail de la salle capitulaire de La Daurade à Toulouse," *Bulletin monumental* 132 (1974), pp. 201–11; Kathryn Horste, "An Addition to the Documentation on the Facade of the Chapter House of La Daurade in Toulouse," *Art Bulletin* 59 (1977), pp. 618–21.

30. Seidel, *Romanesque Sculpture from Saint-Étienne,* pp. 66–67; idem, "A Romantic Forgery," p. 37, fig. 15; Kathryn Horste has recently reviewed the matter: "A New Plan of the Cloister and Rampart of Saint-Étienne, Toulouse," *Journal of the Society of Architectural Historians* 45 (1986), pp. 5–19. My own view is that the apostles, along with the other, lost figures, described consistently in the literary sources as having once graced the cloister (Seidel, *Romanesque Sculpture from Saint-Étienne,* pp. 15–18; Horste, "A New Plan," p. 11), were possibly intended for the cloister piers.

31. Seidel, "A Romantic Forgery," p. 36. The vault paintings of the Worcester and Brauweiler chapter houses rendered typologies of Old and New Testament subjects but they are both rather distant and somewhat later in date. Walter Cahn's symposium paper on San Pedro de Arlanza in Spain, included in this volume, addresses this question in relation to the funerary

function of the Arlanza chapter house and cites the particularly relevant paper by Creighton Gilbert (see note 78 below).

Conventual furnishings, such as tombs and attendant burial insignia, sometimes located in the privileged areas of cloister walkways and chapter houses, and commemorative reliefs, displayed in such areas, are still very little studied. An exception is the discussion by Marcel Durliat and Daniel Cazes of the recently rediscovered relief representing Abbot Gregory of Cuxa ("Découverte de l'effigie de l'abbé Grégoire créateur du cloître de Saint-Michel de Cuxa," *Bulletin monumental* 145 [1987], pp. 7–14 and Marcel Durliat, "Chronique," *Bulletin monumental* 146 [1988], p. 48). My thanks to Walter Cahn for kindly reminding me of this study. See also the review of work on monastic burial by Bonde and Maines, "Archaeology," pp. 806–8.

32. I differ here with Dr. R. Capelle Kline, who considers the early La Daurade group to predate the Moissac cloister ("The Decorated Imposts of the Cloister at Moissac" [Ph.D. diss., University of California, Los Angeles, 1977], pp. 151–52, 199–200). Marie Lafargue, *Les Chapiteaux du cloître de Notre-Dame la Daurade* (Paris, 1940), pp. 23–45, had considered the group "pre-Moissac" and had assigned a very early date of ca. 1067–80, but her view was not generally accepted (see the review by William Forsyth, *The American Journal of Archaeology* 49 [1945], pp. 391–93, who argued for a post-Moissac date). A like stand for a post-1100 date has been taken by Horste, "Capitals," pp. 38, 337–39, 347–48; idem, "Passion Series from La Daurade," pp. 31–34; idem, "A New Plan," p. 15. This later date is also preferred by Marcel Durliat, "La date des plus anciens chapiteaux de la Daurade à Toulouse," *Estudios dedicados a Durán y Sanpere: Cuadernos de arqueología e historia de la ciudad de Barcelona* (Barcelona, 1967), pp. 195–202.

33. Related problems of the narrative methods used in the La Daurade cloister have now been taken up by Kathryn Horste, who studies "the way in which the narrative composition affects the observer's comprehension of the story" ("Capitals"; "Passion Series"), and by Linda Seidel (see note 48 below). I would differ with the premise of both authors that the presentation of such stories must have followed a chronological scheme. Nonlinear arrangements seem to me more likely in most of the cloisters under review.

The Moissac inscriptions require a full, interdisciplinary study (see note 88 below). Leah Rutchick has begun exploration of this topic in her doctoral research on Moissac at the University of Chicago, reported on at Kalamazoo in 1987 and at the College Art Association meetings in New York, 1990. Katherine Watson has reviewed the implications of the Kufic inscription on an impost of the Moissac cloister (mentioning Argaud's attempt to decipher it as an invocation of Allah, to be whispered by some Muslim sects during a pause in their morning prayer), "The Kufic Inscription in the Romanesque Cloister of Moissac in Quercy: Links with Le Puy, Toledo and Catalan Woodworkers," *Arte Medievale* ser. 2, 3 (1989), pp. 12–13. Cf. the work of Calvin B. Kendall, who analyzes the leonine hexameters of the Conques tympanum, also rich with inscriptions: "The Voice in the Stone: the Verse Inscriptions of Ste.-Foy of Conques and the Date of the Tympanum," *Hermeneutics and Medieval Culture*, ed. Patrick J. Gallacher and Helen Damico (Albany, 1989), pp. 163–82.

34. Pressouyre, "St. Bernard to St. Francis." Kathryn Horste associated the impact of the Gregorian Reform on Toulouse with the capitals of the La Daurade cloister in a paper presented at Kalamazoo in 1980, "A Sculptural Program in the Benedictine Cloister, the Passion Series from La Daurade"; see her later publication "The Passion Series," and her forthcoming book,

Cluniac Art and Spirituality in Toulouse: The Romanesque Cloister of La Daurade. See also: I. H. Forsyth, "*Vita Apostolica*" (based on a paper presented in 1983 at the Harvard University Arthur Kingsley Porter Centenary Symposium, "Abstraction and Rationality in Romanesque Art"); Linda Seidel, an unpublished paper, "Sculpture in Toulouse: Some Other Questions," presented at the Medieval Art Forum, "Arthur Kingsley Porter and the Pilgrimage Roads," Barnard College, Columbia University, 1983, and a recent paper, "Medieval Cloister Carving and Monastic Mentalité," in *The Medieval Monastery*, ed. MacLeish, pp. 1–16. Regarding Benedictine iconography: Pamela Z. Blum, "The Saint Benedict Cycle on the Capitals of the Crypt at Saint-Denis," *Essays in Honor of Harry Bober*, ed. Elizabeth C. Parker, *Gesta* 20/1 (1981), pp. 73–87.

35. Hagiography has been a fruitful field for recent writers of dissertations, such as: Barbara Abou-el-Haj, "The First Illustrated Life of St. Amand: Valenciennes, B.M., MS 502" (Ph.D. diss., University of California, Los Angeles, 1975); Magdalena Carrasco, "Some Illustrations of the Life of St. Aubin (Albinus) of Angers (Paris, Bibl. Nat., MS N.A.L. 1390) and Related Works" (Ph.D. diss., Yale University, 1980); and Cynthia Hahn, "Narrative and Liturgy in the Earliest Illustrated Lives of the Saints" (Ph.D. diss., Johns Hopkins University, 1982); all, however, are concerned with manuscripts. An excellent related work is Magdalena Carrasco, "Spirituality in Context: The Romanesque Illustrated Life of St. Radegund of Poitiers" (Poitiers, Bibl. Mun. MS 250), *Art Bulletin* 72 (1990), pp. 414–35.

36. Mentré, "L'Apocalypse dans les cloîtres"; idem, "Images bibliques autour de l'An Mil," *Les Cahiers de Saint-Michel de Cuxa* 19 (1988), pp. 123–28; Peter Klein, "Le Tympan de Beaulieu: Jugement dernier ou seconde Parousie?" *Les Cahiers de Saint-Michel de Cuxa* 19 (1988), pp. 129–38; see also Lyman, "Portails, portiques, paradis." Peter Klein is preparing a forthcoming study on the subject.

37. For Schapiro, "Romanesque Sculpture of Moissac," see note 8 above. Recent dissertations devoted to Moissac (not all on the cloister) include: Kline, "Decorated Imposts"; Susan Raglan Dixon, "The Power of the Gate: The Sculptured Portal of St. Pierre, Moissac" (Ph.D. diss., University of Wisconsin, 1987); Eleanor Scheifele, "Path to Salvation: The Iconography of the South Portal of Saint-Pierre de Moissac" (Ph.D. diss., Washington University, Saint Louis, 1985).

38. Saulnier and Stratford, *Vézelay*, cat. no. 293, see also nos. 285–86, 287, 289, 291, 344; review by Ilene H. Forsyth, *Speculum. A Journal of Medieval Studies* 61 (1986), p. 459.

39. Saulnier and Stratford, *Vézelay*, pls. 138–40. Harry Titus kindly gave information that this arcade originally formed part of the episcopal palace at Auxerre.

40. Marcel Aubert, *L'Architecture cistercienne en France*, 2d ed. (Paris, 1947), pp. 33, 140 n. 1; Joan Evans, *Monastic Life at Cluny* (Oxford, 1931), p. 37; Charles Oursel, *L'Art romane de Bourgogne* (Dijon, 1928), pp. 177–79; but see Jean Leclercq's caveat, "Introduction," *The Works of Bernard of Clairvaux: Treatises I*, Cistercian Fathers Series 1 (Spencer, Mass., 1970), p. 25.

Neil Stratford, who, with the assistance of David Walsh, is preparing a full study on the sculptural remains of Cluny, presented an exhibition of photographs of carvings from the Cluny cloister, along with his scholarly notes on them, at the International Center of Medieval Art Symposium on Cluny held in Kalamazoo, 1986, and also questioned this traditional view,

21

as in Saulnier and Stratford, *Vézelay,* p. 171 n. 47. Conrad Rudolph has recently reviewed the matter (see note 41 below).

41. Bernard of Clairvaux's sensitive observations of such art have often been discussed, most eloquently by Meyer Schapiro, "The Aesthetic Attitude in Romanesque Sculpture," *Art and Thought, Issued in Honour of Dr. Amanda K. Coomeraswamy* (London, 1947), pp. 130–50 (*Romanesque Art,* pp. 1–27); Leclercq, *The Works of Bernard,* intro; Conrad Rudolph, "The Things of Greater Importance: Bernard of Clairvaux's *Apologia* and the Controversy over Monastic Art" (Ph.D. diss., University of California, Los Angeles, 1985); idem, "Bernard of Clairvaux's *Apologia* as a Description of Cluny, and the Controversy over Monastic Art," *Gesta* 27 (1988), pp. 125–32; and now Conrad Rudolph, *The "Things of Greater Importance": Bernard of Clairvaux's Apologia and the Medieval Attitude toward Art* (Philadelphia, 1990).

42. Relevant studies include: [Arles] Stockhausen, "Die romanischen Kreuzgänge," vol. 7, pp. 136–45; vols. 8–9, pp. 89–97; Richard Hamann, *Die Abteikirche von St. Gilles und ihre künstlerische Nachfolge* (Berlin, 1955), pp. 190–98; Whitney W. Stoddard, *The Facade of Saint-Gilles-du-Gard* (Middletown, Conn., 1973), pp. 191–271; Lacoste, "Galerie nord"; Jacques Thirion, "Saint-Trophime d'Arles," *Congrès archéologique de France* 134 (1976), pp. 402–42; Marilyn A. Schneider, "The Sculptures of the North Gallery of the Cloister of Saint-Trophime at Arles" (Ph.D. diss., Columbia University, 1983); [Avignon, Notre-Dame-des-Doms] Stockhausen, "Die romanischen Kreuzgänge," pp. 162–64; vols. 8–9, pp. 124–34; Jacques Thirion, "Le décor sculpté du cloître de la cathédrale d'Avignon," *Fondation Piot, Monuments et mémoires publiés par l'Académie des Inscriptions de Belles-Lettres* 61 (1977), pp. 87–164; Cahn and Seidel, *Romanesque Sculpture,* pp. 160–62; Little, Simon, and Bussis, "Romanesque Sculpture," pp. 74–75; [Châlons-sur-Marne] Léon Pressouyre, "Sculptures du premier art gothique à Notre-Dame-en-Vaux de Châlons-sur-Marne," *Bulletin monumental* 120 (1962), pp. 359–66; idem, "Fouilles du cloître de Notre-Dame-en-Vaux de Châlons-sur-Marne," *Bulletin de la Société Nationale des Antiquaires de France* (1964), pp. 23–38; idem, "Le Cloître de Notre-Dame-en-Vaux à Châlons-sur-Marne," *Congrès archéologique de France* 135 (1977), pp. 298–306; Sylvia Pressouyre, *Images d'un cloître disparu* (Paris, 1976); [Saint-Pons-de-Thomières] Linda Seidel, "Romanesque Capitals from the Vicinity of Narbonne," *Gesta* 11/1 (1972), pp. 34–45; Cahn and Seidel, *Romanesque Sculpture,* pp. 154–55; Walter Cahn, "Romanesque Sculpture in American Collections XIV. The South," *Gesta* 14/2 (1975), pp. 63–65; Leslie Bussis, in Little, "Romanesque Sculpture," pp. 67–68; [Savigny] Denise Cateland-Devos, "Sculptures de l'abbaye de Savigny-en-Lyonnais du haut Moyen Age au XVe siècle," *Bulletin archéologique du Comité des Travaux historiques et scientifiques,* n.s. 7 (1971), pp. 151–200; I. H. Forsyth, "Vita Apostolica," pp. 77–78 nn. 14, 19; idem, "The Samson Monolith," *The Brummer Collection of Medieval Art* (Durham, N.C., 1991); [Tournus] Raymond Oursel, "La Sculpture romane de Tournus," *Société des Amis des Arts et des Sciences* 78 (1979), pp. 3–40.

43. Jacques Gardelles, "La Sculpture figurative du cloître Saint-Avit-Sénieur," *Bulletin monumental* 143 (1985), pp. 11–24.

44. [Aix] Jacques Thirion, "Le Cloître de Saint-Sauveur d'Aix," *Congrès archéologique de France* 143 (1985), pp. 65–90; [Saint-Guilhem] Saint-Jean, "Le Cloître"; Stoddard, *Saint-Gilles,* pp. 304–24.

45. [Vienne] Victor Lassalle, "L'Église et le cloître de Saint-André-le-Bas," *Congrès archéologique de France* 130 (1972), pp. 486–507; Jean Vallery-Radot, "La Résurrection du cloître de Saint-André-le-Bas," *Bulletin monumental* 101 (1942), pp. 41–56; also at Saint-Guilhem, see Saint-Jean, "Le Cloître."

46. I. H. Forsyth, "Samson Monolith."

47. One such Savigny shaft passed from the Brummer Collection to the Duke University Museum of Art. In this case shaft and capital change in size from side to side and the shaft is enlivened by heads of apes parenthetically projecting from its lateral surfaces. Such whimsy also marks other Savigny capital-columns, as one in Lyons, where capital and column zones interpenetrate one another; I. H. Forsyth, "Samson Monolith."

48. Though not as often as suggested by Linda Seidel, "Installation as Inspiration: The Passion Cycle from La Daurade," *Gesta* 25/1 (1986), pp. 83–92. Viollet-le-Duc, "cloître," *Dictionnaire,* notes that piers are interspersed at intervals among files of columns to strengthen their support function; twin columns might be surmounted by a single block from which twin capitals and even imposts have been carved, also as a strengthening strategy.

49. Horste, "A New Plan," pp. 7–16; see also the review by Marcel Durliat, *Bulletin monumental* 146 (1988), pp. 136–37; and the documents published recently by Quitterie Cazes, "Le Cloître Saint-Étienne de Toulouse sous la Révolution et le Premier Empire," *Mémoires de la Société archéologique du Midi de la France* 49 (1989), pp. 191–206. The Delor lithograph, published by J.-M. Cayla and C. Paul [*Toulouse monumentale et pittoresque,* Toulouse, n.d.—about 1840], appears to have been fancifully based on earlier written descriptions (Horste, pp. 12–14) rather than on direct observation or, as Seidel suggests, on an old drawing (Seidel, *Romanesque Sculpture from Saint-Étienne,* fig. 15, pp. 23–24, 40 nn. 70–71). Regarding the location of the apostles, see note 30 above. For the capitals, Seidel, ibid., pp. 115–23, 143–46; Mesplé, *Toulouse,* nos. 28–41.

50. There was also possibly a five-part cluster at Saint-Étienne; Horste, "A New Plan," pp. 10, 15.

51. The dimensions of the Coulombs colonnettes suggest that they originally served as supports in the cloister; Marcel Aubert and Michèle Beaulieu, *Musée national du Louvre, Description raisonnée des sculptures du moyen âge, de la renaissance et des temps modernes, I, Moyen Age* (Paris, 1950), nos. 71–72; Robert Branner, "A Romanesque Capital from Coulombs," *The Nelson Gallery and Atkins Museum Bulletin* 2/3 (1960), pp. 1–6, esp. p. 3; Marilyn Stokstad, "Romanesque Sculpture in American Collections. XV. Kansas City, Missouri, and Lawrence, Kansas," *Gesta* 16/1 (1977), p. 49. For Châlons, see note 42 above.

52. Horste, "A New Plan," p. 15.

53. [Aix], Thirion, "Le Cloître"; [Saint-Bertrand-de-Comminges] de Lasteyrie, *L'architecture,* pp. 353–54; [Châlons] Léon Pressouyre, "La Colonne dite 'aux trois chevaliers' de Châlons-sur-Marne," *Bulletin de la Société Nationale des Antiquaires de France* (1963), p. 76; idem, *Un Apôtre de Châlons-sur-Marne* (Bern, 1970), p. 20; see also note 42 above. Perhaps also at Avignon (Thirion, "Le Cloître"), in addition to examples of figures addorsed to piers from Arles (see note 42 above), Montmajour (Walter Cahn, "Romanesque Sculpture in American

Collections, I. Hartford," *Gesta* 6 [1967], pp. 47–48; Cahn and Seidel, *Romanesque Sculpture,* pp. 18–20; Stockhausen, "Die romanischen Kreuzgänge," vol. 7, pp. 145–55; vols. 8–9, pp. 97–107; de Lasteyrie, *L'architecture,* pp. 353, 356); Savigny (see note 42 above; Cahn, Hartford), and others.

54. Vera K. Ostoia, "A Statue from Saint-Denis," *MMAB* 13 (1955), pp. 298–304; Dom Bernard de Montfaucon, *Les Monumens de la monarchie françoise qui comprennent l'histoire de France* (Paris, 1729–39), I, pp. 57–58, pl. X; Pamela Z. Blum, "Method and Techniques of Restoration: The Met King and the Pitcairn Queen," unpublished paper presented at the Kalamazoo conference in 1982; Sumner McKnight Crosby and Pamela Z. Blum, *The Royal Abbey of Saint-Denis* (New Haven, 1987), pp. 195–96; Charles T. Little with Sumner McKnight Crosby, Jane Hayward, and William D. Wixom, *The Royal Abbey of Saint-Denis in the Time of Abbot Suger (1122–1151),* exhib. cat., The Metropolitan Museum of Art (New York, 1981), no. 4; Pierre Quarré, "La Sculpture des anciens portails de Saint-Bénigne de Dijon," *Gazette des Beaux-Arts,* 6th ser., 50 (1957), pp. 177–95; Willibald Sauerländer, *Gothic Sculpture in France 1140–1270* (New York, 1972), ill. 4, pp. 381–82; William D. Wixom, *Treasures from Medieval France,* exhib. cat., Cleveland Museum of Art (Cleveland, 1967), no. III.15; Léon Pressouyre, "Did Suger Build the Cloister at Saint-Denis?" *Abbot Suger and Saint-Denis,* ed. Paula Lieber Gerson (New York, 1986), pp. 236–38.

55. Pressouyre, "Did Suger Build the Cloister," pp. 229–44. For the head of a figure from the facade recently acquired by the Cluny Museum, see Fabienne Joubert, in "Actualité," *Bulletin monumental* 146 (1988), p. 359 and idem, "Recent Acquisitions, Musée de Cluny, Paris," *Gesta* 28 (1989), p. 107.

56. Pressouyre, "Did Suger Build the Cloister," nos. 7, 12, 13, 15. For an interesting, new relative, see Deborah Kahn, "A Recently Discovered Early Gothic Capital in the Bronx," *Gesta* 26/1 (1987), pp. 59–60.

57. See Eugene Kleinbauer's history of the Center, above, and François Bucher's remarks, "SEMPER RESURGET: Analecta of the International Center of Medieval Art," *Gesta* 25/1 (1986), pp. 167–70. Shortly after Schapiro's call, work began on the Romanesque Archive at the University of Michigan under my direction.

58. See *Gesta* indices for the relevant issues. Those installments studying New England *lapidaires* were republished in hardcover format by Cahn and Seidel, *Romanesque Sculpture in American Collections.* The volume also has an excellent historiographic introduction.

59. Its devoted editors have been instrumental in bringing recent research to the fore; they include: François Bucher, Wayne Dynes, Walter Cahn, Linda Seidel, Eugene Kleinbauer, Elizabeth C. Parker, William W. Clark, and now Lucy F. Sandler.

60. "*Paradisus Claustralis.* What is a Cloister?" in *The Cloister Symposium, 1972,* ed. Wayne Dynes, *Gesta* 12 (1973); "Current Studies on Cluny," at the XXIst International Congress on Medieval Studies, Kalamazoo, 1986: *Current Studies on Cluny,* ed. Walter Cahn, William Clark, Ilene Forsyth, *Gesta* 27 (1988); "Suger and Saint-Denis Symposium," at Columbia University and The Cloisters, 1981: *Abbot Suger and Saint-Denis,* ed. Gerson.

61. Among the most important might be: "L'Art roman," Barcelona, 1961; "Les Trésors des églises de France," Paris, 1965; "Treasures from Medieval France," Cleveland, 1967; "Selected Works from the Brummer Collection of Duke University," Durham, N.C., 1967; "L'Europe Gothique," Paris, 1968; "Medieval Art in Private Collections," New York, 1969; "The Renaissance of the Twelfth Century," Providence, R.I., 1969; "The Year 1200," New York, 1970; "Rhein und Maas," Cologne, 1972; "The Royal Abbey of Saint-Denis," New York, 1981; "Radiance and Reflection. Medieval Art from the Raymond Pitcairn Collection," New York, 1982; "English Romanesque Art," London, 1984; "Ornamenta Ecclesiae," Cologne, 1985. See Eugene Kleinbauer's introductory remarks above for sponsorship of some of these by the International Center of Medieval Art.

62. Ilene H. Forsyth, *Throne of Wisdom. Wood Sculptures of the Madonna in Romanesque France* (Princeton, 1972), nos. 1–3; H. Wilm, *Die gotische Holzfigur* (Leipzig, 1923), pp. 47–50.

63. Edson Armi, *Masons and Sculptors in Romanesque Burgundy. The New Aesthetic of Cluny III* (University Park, 1983). See also the recent paper by C. R. Dodwell, "The Meaning of 'Sculptor' in the Romanesque Period," *Romanesque and Gothic. Essays for George Zarnecki* (Woodbridge, 1987), pp. 49–61; idem, "Artists and Craftsmen in Anglo-Saxon England," *Anglo-Saxon Art: A New Perspective* (Ithaca, 1982), pp. 44–83.

64. Virginia Egbert, *The Medieval Artist at Work* (Princeton, 1967); Richard Hamann-Maclean, "Kunstlerlaunen im Mittelalter," *Skulptur des Mittelalters. Funktion und Gestalt,* ed. Friedrich Möbius and Ernst Schubert (Weimar, 1987), pp. 385–452, esp. pp. 430–35.

65. Günther Binding, "Der romanische Baubetrieb," in *Rhein und Maas: Kunst und Kultur 800–1400,* exhib. cat., Kunsthalle (Cologne, 1972), pp. 93–95. *Ornamenta ecclesiae: Kunst und Künstler der Romanik,* exhib. cat., Schnütgen Museum (Cologne, 1985), 1. "Fabrica," B1–B129, pp. 117–384, esp. B18–B23, B54, B56, pp. 185–86, 257–60; see also Günther Binding, "Baumeister und Handwerker im Baubetrieb," ibid., pp. 171–83; Peter Cornelius Claussen, "Künstlerinschriften," ibid., pp. 263–76; Peter Springer, "Modelle und Muster, Vorlage und Kopie, Serien," ibid., pp. 301–14. See also Günther Binding, ed., *Romanischer Baubetrieb in zeitgenössischen Darstellungen,* 2. Veröffentlichung der Abteilung Architektur des Kunsthistorischen Instituts der Universitäts Köln (Cologne, 1972).

66. "Artistes, artisans et production artistique au moyen-âge, Colloque international," Centre Nationale de la Recherche Scientifique, Université de Rennes II–Haute-Bretagne, 1983: *Artistes, artisans et production artistique au moyen-âge,* 3 vols., ed. Xavier Barral i Altet (Paris, 1986–90). Particularly relevant papers include: Jean-Claude Bonne, "Organisation architectonique et composition plastique des tympans romans: les modèles de Conques et d'Autun," *Artistes, artisans,* vol. 2, pp. 185–202; Nicole Thierry, "Illustration de la construction d'une église. Les sculptures de Korogo (Géorgie)," ibid., pp. 321–29; and Xavier Barral i Altet, "Organisation du travail et production en série: les marques de montage du cloître de Subiaco près de Rome," *Artistes, artisans,* vol. 3, pp. 93–99; Thomas Lyman, "Format and Style: The Adaptation of Cartoons to Reused Marble at Saint-Sernin," ibid., pp. 223–33; Neil Stratford, "Romanesque Sculpture in Burgundy. Reflections on its Geography, on Patronage, on the Status of Sculpture and on the Working Methods of Sculptors," ibid., pp. 235–63; Alain Erlande-Brandenburg, "Observations sur la technique de la sculpture," ibid, pp. 265–67.

67. Beatriz Mariño, "Artistic Self-Portraiture in Medieval Spain," unpublished paper, Kalamazoo, 1988; for illustration, see: Miguel Angel García Guinea, *El Arte Románico en Palencia* (Palencia, 1961), pl. 188.

68. Michael Camille gave this explanation following Ms. Mariño's presentation. We eagerly await Ms. Mariño's publication of her material. See also her study on the making of coins: "Testimonios iconográficos de la acuñación de moneda en la Edad Media, La portada de Santiago de Carrión de los Condes," *Artistes, artisans,* vol. 1, pp. 499–513.

69. Walter Cahn, "The Artist as Outlaw and *Apparatchik:* Freedom and Constraint in the Interpretation of Medieval Art," *The Renaissance of the Twelfth Century,* ed. Stephen K. Scher (Providence, 1969), pp. 10–14.

70. Kessler, "State of Medieval Art History," pp. 182, 186; cf. Linda Seidel, "Images of the Crusades in Western Art," *The Meeting of Two Worlds: Cultural Exchange between East and West during the Period of the Crusades,* ed. Vladimir Goss and Christine Verzár Bornstein (Kalamazoo, 1986), p. 380. See also the recent discussion on the state of medieval art history by Lucy Freeman Sandler and Herbert Kessler, *Art Bulletin* 71 (1989), pp. 506–7.

71. Stephen G. Nichols, "The Visual Image as Textual Unconscious," paper at College Art Association Annual Meeting, Houston, 1988, Abstracts, p. 53; idem, *Romanesque Signs: Early Medieval Narrative and Iconography* (New Haven, 1983), *passim.*

72. Thomas Lyman, "Theory and Practice: A Critical Look at the Theoretical Basis of Medieval Art," College Art Association Annual Meeting, Houston, 1988, Abstracts, p. 52; Linda Seidel, chair, panel on "Art and its Audience," Medieval Academy of America, Philadelphia, 1988, with papers by William W. Clark, Joan Diamond, and Robert Nelson; idem, panel on "Art and the Medieval Audience: Participation and Performance," Chicago, 1989.

73. Much of this presumption is based on Gregory's statements regarding the didactic usefulness of art; see the excellent study of Gregory by Herbert Kessler, "Pictorial Narrative and Church Mission in Sixth-Century Gaul," in *Pictorial Narrative in Antiquity and the Middle Ages,* pp. 75–91, and an unpublished paper by Brian Stock, "Augustine and Gregory: Image and Narrative," Columbia University, 1989. For Gregory, see Caecilia Davis-Weyer, *Early Medieval Art 300–1150,* Sources and Documents in the History of Art Series, ed. H. W. Janson (Englewood Cliffs, 1971), pp. 47–49; cf. Paulinus of Nola, ibid., pp. 17–23. Recent studies on Gregory's precepts include: Herbert Kessler, "Reading Ancient and Medieval Art," *Word & Image* 5 (1989), p. 1; Lawrence Duggan, "Was art really the 'Book of the Illiterate?'" *Word & Image* 5 (1989), pp. 227–51; Celia Chazelle, "Pictures, books and the illiterate: Pope Gregory I's letter to Serenus of Marseilles," *Word & Image* 6 (1990), pp. 138–53; Herbert Kessler, "Diction in the Bibles of the Illiterate," *World Art: Themes of Unity in Diversity,* Acts of the XXVI International Congress of the History of Art, ed. I. Lavin (Washington, D.C., 1989), vol. 2, pp. 297–308. Regarding patrons ("those who supervise such matters," according to the anonymous *Pictor in Carmine*), see M. R. James, "*Pictor in Carmine,*" *Archaeologia* 94 (1951), esp. p. 142; also see Creighton Gilbert, "A Statement of the Aesthetic Attitude around 1230," *Hebrew University Studies in Literature and the Arts* 13 (1985), pp. 125–52, esp. pp. 133–35.

74. One recent example, among many: Peter Diemer, "What does *Prudentia* Advise? On the Subject of the Cluny Choir Capitals," *Gesta* 27 (1988), pp. 149–73.

75. Meyer Schapiro, *The Sculpture of Moissac* (New York, 1984), figs. 120, 127, p. 115.

76. Linda Seidel, "Salome and the Canons," *Women's Studies* 11 (1984), pp. 29–65; Horste, "Passion Series," p. 41; I. H. Forsyth, "Vita Apostolica," pp. 77–78, fig. 3; idem, "Samson Monolith."

77. James, "*Pictor,*" pp. 141–66; for St. Bernard, see note 41 above.

78. Gilbert, "Statement," pp. 125–52, discusses Lucas of Tuy's comments on the paintings and carvings which the bishop considered to be generally permissible in churches. Lucas names those to be used for doctrinal purposes, those for imitation, and those for ornamental beauty only; he puts animals, birds, and serpents in this last, "ornamental only," category. For Honorius of Autun, Sicard of Cremona, and others, see Gerhart B. Ladner, "Der Bilderstreit und die Kunstlehren der byzantinischen und abendländischen Theologie," *Zeitschrift für Kirchengeschichte,* ser. 3, 50 (1931), pp. 1–23; Lyman, "Portails, portiques, paradis."

79. Creighton E. Gilbert, "Last Suppers and their Refectories," *The Pursuit of Holiness in Late Medieval and Renaissance Religion,* Papers from the University of Michigan Conference, ed. Charles Trinkaus and Heiko A. Oberman (Leiden, 1974), pp. 380–81; Vasari, *Lives* (Everyman ed., London, 1927), vol. 2, p. 346.

80. Michael Camille, "Seeing and Reading: Some Implications of Medieval Literacy and Illiteracy," *Art History* 8 (1985), pp. 26–49, esp. p. 37; Gilbert, "Statement," *passim;* Stratford, "A Cluny Capital," p. 16.

81. Pressouyre, "St. Bernard to St. Francis," p. 84 n. 107; James, "*Pictor.*"

82. Relevance to liturgical matters has been effectively probed by Elizabeth Parker in her recent work, with Charles T. Little, on The Cloisters Cross to be published by The Metropolitan Museum of Art in 1992, in which she convincingly assesses the metaphoric meaning of the images and related texts. The writings of Walter Cahn, Yves Christe, Carol Heitz, Peter Klein, Elizabeth Parker McLachlan, Léon Pressouyre, Éliane Vergnolle, and Karl Werckmeister, along with a number of others, have also been exemplary. Some recent, younger scholars have also been successful in following Schapiro's prescription. Marcia Kupfer is one; in her work on Vicq in relation to Herveus of Déols and Hugh of Saint-Victor ("Spiritual Passage and Pictorial Strategy in the Romanesque Frescoes at Vicq," *Art Bulletin* 68 [1986], pp. 35–53), she gives a sharper sense of the intellectual and liturgical context of these paintings; see the follow-up to this by Cynthia Hahn, "Purification, sacred action and the vision of God: viewing medieval narratives," *Word & Image* 5 (1989), pp. 71–84. Stephen Lamia is another; his study of the holed tomb documents Western emulation of the Holy Sepulcher in Jerusalem ("*Sepulcrum Domini:* The Iconography of the Holed Tomb of Christ in Romanesque and Gothic Art" (Ph.D. diss., University of Toronto, 1982).

83. Seidel, "Salome"; idem, *Songs of Glory: The Romanesque Facades of Aquitaine* (Chicago, 1981).

84. Marie-Dominique Chenu, *Nature, Man, and Society in the*

Twelfth Century, ed. and trans. Jerome Taylor and Lester K. Little (Chicago, 1968), esp. chap. 3. "The Symbolist Mentality," pp. 99–145; Pressouyre, "St. Bernard to St. Francis"; and lately Georgia Nugent (*Allegory and Poetics: The Structure and Imagery of Prudentius' 'Psychomachia,'* Studien zur klassischen Philologie, 14 [Frankfurt am Main, 1985]). Being also of this view, I believe paraenetical literature of the period to be particularly helpful: "The Ganymede Capital at Vézelay," *Essays in Honor of Sumner McKnight Crosby,* ed. Pamela Z. Blum, *Gesta* 15 (1976), pp. 241–46; idem, "The Ass of Balaam in Burgundian Romanesque Sculpture," *Essays in Honor of Harry Bober,* ed. Elizabeth C. Parker, *Gesta* 20 (1981), pp. 59–65.

85. Jan Ziolkowski, "Orality and Literacy in the Production of Medieval Latin Poetry," paper presented at the 24th International Congress on Medieval Studies, Kalamazoo, 1989; forthcoming as "Cultural Diglossia and the Nature of Medieval Latin Literature," in *Harvard English Studies* 16 (1991), ed. Joseph Harris (my thanks to Professor Ziolkowski for allowing me to consult the revised version of his paper in typescript); Ziolkowski, *Alan of Lille's Grammar of Sex,* Speculum Anniversary Monographs 10 (Cambridge, Mass., 1985), *passim.*

86. Walter Ong, *Orality and Literacy* (New York, 1982); Brian Stock, *Implications of Literacy* (Princeton, 1983). See also Franz H. Bäuml, "Varieties and Consequences of Medieval Literacy and Illiteracy," *Speculum* 55 (1980), pp. 237–65; D. H. Green, "Orality and Reading: The State of Research in Medieval Studies," *Speculum* 65 (1990), pp. 267–80. Relevant conferences include: "Literacy and Orality: Word, Text, and Image in Medieval and Renaissance Culture," Barnard College, 1988; "Oral Tradition in the Middle Ages," State University of New York, Binghamton, 1988.

87. Camille, "Seeing and Reading." See also his unpublished paper for the Barnard conference, 1988, "Talking Pictures: The Dynamics of Orality and Literacy in Medieval Art."

88. See the relevant play with the letters of the alphabet, based on the A-B-C's and the prayer of Psalm 53 (54), of the inscription on the impost of a capital in the Moissac cloister; Rupin, *Moissac,* no. 25 (called the "Teaching of the Alphabet Capital" by Willibald Sauerländer, in his review of M. F. Hearn, *Romanesque Sculpture. The Revival of Monumental Stone Sculpture in the Eleventh and Twelfth Centuries* [Ithaca, 1981], in *Art Bulletin* 66 [1984], p. 521). The prayer of Psalm 53 also appears, in fuller form, in the inscription on the impost of the Lazarus and Dives capital (Rupin, *Moissac,* no. 31). Both suggest the usefulness of such inscriptions as teaching and memory aids.

89. Jean Leclercq, *The Love of Learning and the Desire for God. A Study of Monastic Culture* (rev. ed., New York, 1974), pp. 89–90; Camille, "Seeing and Reading," p. 29; Meyvaert, "Medieval Monastic Claustrum," p. 54. See also the discussion of the murmur during meditation, in the service of memory, by Frances A. Yates, *The Art of Memory* (Chicago, 1966), esp. pp. 51–52.

90. Leclercq, *Love of Learning,* p. 90.

91. Ibid.

92. Camille, "Seeing and Reading," p. 28. Often the inscriptions were intended for reading *en masse* as a community experience; ibid., p. 33; Rupin, *Moissac,* p. 49 (this would also be true of the psalm-prayer of capital no. 25). There may be a clue in this to the use of meter, particularly hexameters, in inscriptions; Kendall, "Voice in the Stone."

93. James, "*Pictor,*" p. 142.

Gothic Art Reconsidered: New Aspects and Open Questions

Willibald Sauerländer

The Cloisters opened its collection in 1938, one year before European medieval art would be packed away for the six long years of World War II and research on Gothic art and architecture would come practically to a standstill. But 1938 was also the year that one of the most sensitive and most intelligent books which has ever been written on medieval art was published: Henri Focillon's *Art d'occident*.[1] Focillon's mind had something of the lucidity and the lightness of a Paul Valéry. With an admirably elegant pen he could praise in subtle sketches "l'harmonie géométrique" of the Rayonnant style in French architecture, the "humanisme" of the Gothic sculpture at Chartres and Reims but also "la physiognomie théâtrale" of the art of the late Middle Ages in Germany. It would be easy to trace the origin of Focillon's ideas on Gothic art along the French tradition that reaches back to Eugène Viollet-le-Duc and Émile Mâle.[2] It might be less easy to demonstrate how Focillon broke with these traditional ideas by introducing his Bergsonian notion of a "vie des formes."[3]

Be that as it may, any glance into Focillon's fascinating book of 1938 teaches the reader of 1988 how far we have come away from Focillon's world, from his ideas, and above all from his values. For Focillon the development of Gothic art from Saint-Denis and Chartres to Grünewald was the visual expression of the "vie des formes," which bloomed as an autonomous force, budding with the "premier art gothique," maturing in the "âge classique," and finally fading with the extravagances of "le baroque gothique."[4] Such ideas about the birth, the maturity, and the final dissolution of a style have a biological bias which, to put it mildly, has long since gone out of fashion.[5] Soon after 1938 scholarly interest in Gothic art turned in directions which Focillon could probably not have even imagined. In 1944 Erwin Panofsky

published—ironically enough in a posthumous Festschrift for Focillon—his seminal article "Note on a Controversial Passage in Suger's *De consecratione ecclesiae Sancti Dionysii*," where for the first time he connected the light of Gothic stained-glass windows with medieval Neoplatonism.[6] The impact of this article on the interpretation of Gothic architecture and stained glass can scarcely be overrated. For several decades of art history, Neoplatonism replaced the rib as the generative force of Gothic architecture. Not engineering but philosophy now seemed to be the inspiring force— the secret—behind the Gothic cathedral.[7] Only quite recently has this approach been seriously questioned.[8] I shall come back to these problems shortly.

It was not long before another great phenomenon of Gothic art, "la physiognomie théâtrale" of Northern painting in the fifteenth century, was also wrapped in a mystifying envelope of symbolism. It was again the great Erwin Panofsky who—in his admirable book *Early Netherlandish Painting*, which was published in 1953—rescued the Master of Flémalle and the brothers van Eyck from the blame of vulgar realism and naturalism by introducing the tricky notion of "disguised symbolism."[9] The buildings, flowers, and fruits represented with such stunning illusionism on the panels of Jan van Eyck were now interpreted as "spiritualia sub metaphoris corporalium."[10] Panofsky's suggestion has been frightfully successful: one has only to remember all the symbolic explanations of the mousetrap in the Mérode Altarpiece.[11] Again, it is only in the last few years that the concept of "disguised symbolism" has been subject to critical reflection from a younger generation of art historians.[12]

Thus, soon after 1938 the interpretation of Gothic art underwent a fundamental change that led it far away from Focillon's "vie des formes." But this was an intellectual and scholarly development that took place thirty to forty years ago, in the aftermath of the turmoil of World War II, which may at least explain in part the yearning for spiritualization expressing itself in these symbolizing explanations of Gothic churches and images. Some years ago Henk van Os voiced similar thoughts in looking back on another significant book of those postwar years: Millard Meiss's pathbreaking pages in *Painting in Florence and Siena after the Black Death*.[13] In the changed intellectual climate of the 1960s, the approach to Gothic art underwent a rapid

change and was, one might say, despiritualized. "Devotional Images and Imaginative Devotions: Notes on the Place of Art in Late Medieval Piety" was the title of an article that Sixten Ringbom published in the *Gazette des Beaux-Arts* in 1969.[14] Four years earlier the same author had presented his seminal book, *Icon to Narrative: The Rise of the Dramatic Close-up in Fifteenth-Century Devotional Painting*.[15] The first section of Ringbom's book deals with the "empathy of the beholder." The author affirms that in late-medieval private pious imagery "a certain psychological state of mind is regarded as the primary goal for the beholder of the image."[16] This is not the place to discuss the details of Ringbom's interpretation of the function of art during the waning of the Middle Ages. What concerns us at the moment is only the shift of interest indicated by Ringbom's book. The Gothic image is no longer regarded as a spiritual and cultural symbol of nearly timeless significance as it had been in Panofsky's *Early Netherlandish Painting*. It is now seen as a calculated message to the pious beholder, an object of religious consumption which functioned under very specific historical and social conditions.

When Ringbom wrote *Icon to Narrative*, he could not have known the work of Pierre Bourdieu, who in the same years was addressing the problem of the sociology of symbolic forms.[17] But there is no doubt that a new awareness of the complicated relations between different kinds of images and different classes or groups of people—illiterates, pilgrims, heretics, the clergy, the nobility, and women—has shaped some of the most stimulating publications on Gothic art since the 1960s. This seems particularly true of some recent books and articles on Northern art in the fifteenth century. James Marrow's *Passion Iconography in Northern European Art of the Late Middle Ages*, published in 1979, confronts us with a complex analysis of the expansion of narrative imagery as "an adjustment of spirituality to the tastes and the character of a progressively less sophisticated and less educated audience."[18] The old problem of Late Gothic realism is seen as part of a change in devotional practice and the result of the rise of a new audience. The images—it is argued—address the pious beholder with the same strategy as the contemporary devotional or literary texts. Such an approach is nowadays no longer limited to the late Middle Ages. Michael Camille has adapted it in a very stimulating

way to English manuscripts of the fourteenth century. In his article "The Language of Images in Medieval England, 1200–1400," he cites a sentence from the Middle English prose dialogue between Dives and the Pauper: "How shulde I rede in the boke of peynture and of ymagerie?" and he reminds the art historian that "Reading this 'boke of ymagerie' depends on our understanding of the society of readers who used it."[19] Wolfgang Kemp tried a similar approach in an effort to understand the narrative structure of Gothic stained-glass windows in the cathedrals of Chartres and Bourges around 1220 in his book, *Sermo corporeus,* which appeared in 1987.[20] He compared the discontinuous sequence of the narrative on such windows as those of the Prodigal Son in Bourges and Chartres to contemporary plays such as the *Courtois d'Arras* or *Le Jeu de Saint Nicolas.*

But let me conclude these general introductory remarks. It was necessary to begin this essay with a reminder that Gothic art no longer means the same thing to us in 1988 as it did fifty years ago when The Cloisters opened. It is no longer regarded as a pure form in the sense of Focillon, nor as a mere spiritual symbol in the sense of Panofsky. Rather, it is now seen as part of a semiotic context, of a system of communication comprising the patron, the artist, and the audience, and so the most stimulating recent research more often operates around the objects rather than dealing directly, physically, with the artifacts themselves. Needless to say, even in this new situation traditional connoisseurship, the inventory of the monuments (which must always be enlarged, perfected, and, above all, corrected and revised) remains the indispensable basis of any serious art-historical scholarship. I have not the least sympathy for a scholarly "modernism" which declares that the days of connoisseurship are simply gone. But let me come, finally, to my real homework for this essay.

Before the symposium, William Wixom wrote me a letter asking me to do the following: "It is important to address the topic broadly; considering the span of Gothic art from the era of Saint-Denis to Tilman Riemenschneider, as well as treating artistic production throughout Europe. To that end all mediums should come into play as they relate to our ideas, including architecture, painting, sculpture and metalwork—ecclesiastical as well as secular." I confess that after having read these lines I was certainly flattered, but also stunned, and more

than slightly frightened. It is true that one sometimes hears these days the complaint that studies of medieval and of Gothic art no longer play the same central role in our field as they did—let us say—thirty years ago. But this nostalgic complaint is right only in a sense of relative proportion. During the last three decades, other fields, from Renaissance to Modern, have seen an enormous expansion of research and publication. So the proportion of medieval studies to the total output of art-historical publications seems minor when compared to that which came immediately after World War II. In absolute terms, however, the number of books and papers on Gothic art and architecture published in the last ten to fifteen years is probably greater than ever before in the history of our discipline. To mention only a few examples: in the 1980s alone, two big, comprehensive books on Gothic architecture in France appeared, as well as numerous studies on single buildings, such as the cathedrals at Auxerre, Beauvais, Chartres, Laon, Noyon, Paris, Reims, Sens, and Toul, and the abbey churches of Saint-Denis, Saint-Germer, and Braine.[21] An inventory of "Les Monuments de la France gothique" is on its way, and the first volume, *Les églises de la vallée de l'Oise et du Beauvaisis* by Maryse Bideault and Claudine Lautier, appeared in 1987.[22] A similar situation is true for Gothic sculpture. In 1970, I published a book on Gothic sculpture in France from 1140 to 1270, trying to get hold of all publications which had appeared up to that date.[23] Since then at least two to three hundred new titles have been presented on the material I dealt with in that book, including two copious volumes on the sculptures of the facade of the cathedral at Reims by Peter Kurmann.[24] The cloister of Notre-Dame-en-Vaux has been admirably reconstructed by Léon Pressouyre.[25] The numerous fragments of the original sculpture of Notre-Dame in Paris that were discovered in 1977 have enriched our idea about Parisian art in the thirteenth century in a most unexpected way.[26] The progress made in the study of Gothic stained glass is even greater. Louis Grodecki has summarized his unrivaled knowledge of this material in two comprehensive volumes.[27] But it was above all the monumental achievement of the *Corpus Vitrearum Medii Aevi* that put our knowledge of this material on an entirely new and solid basis. In the 1980s alone, we have had volumes on the stained glass of the cathedrals and churches of Santa María del Mar in Barcelona,

and of Canterbury, Erfurt, Lincoln, Milan, Regensburg, Strasbourg, and York.[28] In the same years volumes dealing with the windows in Swabia appeared, as well as a listing of the stained glass in several regions of France, from Picardy to the Alps, and checklists of material held in American collections.[29] Wall-painting fares less well, but Austria has set a model by publishing the first volume of a corpus which presents *Die mittelalterlichen Wandmalereien in Wien und Niederösterreich.*[30] A similar enterprise is planned for West Germany and one hopes that other countries will follow. But let me now turn to manuscripts.

The publication *A Survey of Manuscripts Illuminated in the British Isles,* which Jonathan Alexander has undertaken, now comprises four Gothic volumes by Nigel Morgan and Lucy Freeman Sandler, which give a concise summary of the state of research in a field with a particularly rich scholarly tradition.[31] Again these surveys were accompanied by monographic studies, such as Lucy Sandler's monographs on the Peterborough Psalter and the Psalter of Robert de Lisle, Peter Klein's stimulating *Endzeiterwartung und Ritterideologie,* which presents a fresh look at the much-debated English Apocalypses, Suzanne Lewis's weighty volume *The Art of Matthew Paris in the Chronica Majora,* not to mention W. Brunsdon Yapp's book *Birds in Medieval Manuscripts,* a charming and very useful study by an outsider.[32] Turning to France, one knows that the study of French illuminated manuscripts from the time of the duke of Berry had been considerably advanced in the late 1960s and early 1970s by the work of Millard Meiss.[33] This effort has been continued and expanded into the earlier fourteenth century by the sensitive and careful studies of François Avril.[34] A survey of French illuminated manuscripts, modeled after the English series edited by Jonathan Alexander, is in preparation. Eberhard König studied fifteenth-century illumination in Nantes and Angers, concentrating in a somewhat old-fashioned way on problems of stylistic attribution.[35] Sandra Hindman's book, *Christine de Pizan's "Epistre d'Othéa": Painting and Politics at the Court of Charles VI,* published in 1986, represents, on the other hand, a metastylistic approach which seems to come close to the kind of mental and socioanthropological history which flowers in Paris today around the École des Hautes Études.[36] Interest in the illustration of secular manuscripts—the interrelation between their content, their text, and their imagery—seems to be growing.

To come to a last example: one might expect that a field such as late-medieval sculpture in central Europe, which had once been so passionately overstudied with unpleasant nationalistic undertones by the German segment of our profession, would have been put to rest in recent years. On the contrary, the output remains astonishing. A long series of outstanding exhibition catalogues contains an enormous bulk of material and sometimes revolutionary ideas: "Herbst des Mittelalters," Cologne, 1970; "Spätgotik am Oberrhein," Karlsruhe, 1970; "Rhein und Maas," Cologne, 1972; "Kunst um 1400 am Mittelrhein. Ein Teil der Wirklichkeit," Frankfurt, 1976; "Die Parler und der Schöne Stil 1350–1400. Europäische Kunst unter den Luxemburgern," Cologne, 1978; "Nürnberg 1300–1550. Kunst der Gotik und Renaissance," New York and Nuremberg, 1986—a truly impressive list. Monographs continue to appear. Roland Recht has just published a book on Nikolaus Gerhaert von Leyden and the sculpture at Strasbourg from 1460 to 1525.[37] Beside these conventional publications stands, finally, Michael Baxandall's book, *The Limewood Sculptors of Renaissance Germany,* an exotic outsider full of unexpected suggestions which seem not yet to have been intellectually digested by the traditional inhabitants of the Late Gothic woods.[38]

But enough of statistics! I could go on for a long while with such enumerations of recently published titles on Gothic art and architecture. As we have seen, the pace of publications has not slowed down in the last decade. On the contrary: no single individual can read—and still less analytically understand—what so many others write, discover, and think. This is the difficulty that any report on the state of research in any field faces. Herbert Kessler, in his recent article, "On the State of Medieval Art History," in the *Art Bulletin,* has been trapped in this unavoidable dilemma.[39] It is a thoughtful and even sensitive text, but the title awakens false expectations. It is an interesting discussion of certain trends in the present study of medieval art, not a balanced report on the state of research as a whole, and I do not think it could have been anything else. Even in dealing with Gothic architecture and art alone, I too must of necessity be selective, arbitrary, and subjective. I suspect that

William Wixom was well aware of these inherent limitations and restrictions when he asked me to deal with "all mediums" as they "relate to our ideas." So in the second part of this essay I shall deal with only a few selected problems and open questions.

I begin with Gothic architecture. Two comprehensive books on Gothic architecture of the classic period in France were published within a period of two years, by Jean Bony in 1983 and Dieter Kimpel and Robert Suckale in 1985. This was an astonishing coincidence. Bony's book, which grew out of the Matthews Lectures (given in New York in 1961), proceeds largely on Focillonian paths and deals with spaciousness, surface, volumes, and grids. Its strength lies in the sensitivity of his formal analysis, in his careful and subtle observation of trends and variations in the vast laboratory of French Gothic cathedrals. For Bony, the form of Gothic architecture is autonomous; it exists outside—or beyond—the trivial horizon of political, ecclesiastical, and economic history, and—astonishingly enough—is largely independent even of technical problems of construction.[40] Function—the practical use of these buildings—is not discussed. This puzzling one-sidedness allows for the rare aesthetic refinement and beauty of Bony's descriptions of the formal structure of walls, shells, and sheds.

Kimpel and Suckale, writing their book in the 1980s and being much younger scholars than Bony, have chosen a fundamentally different approach. They try to demonstrate how the rise of Gothic architecture was—or may have been—embedded in the specific political, economic, and social conditions developing in Capetian France from the reign of Louis VI to the days of St. Louis. The architecture of the cathedral at Amiens, for instance, is for Kimpel and Suckale bound to a rather unique constellation— an alliance between bishop, chapter, and town during a period of economic growth and "industrial" progress. The rationalization and standardization of masonry techniques and labor organization, which they believe can be observed in the nave of Amiens, is for them an analogy for the modernization and acceleration of the textile production in the same time and in the same region. In a certain sense, this is a return to the laicized ideas cherished by Viollet-le-Duc and others, a return perhaps overdue after much spiritualizing mystification of the Gothic cathedral in the 1950s.[41]

But to turn to another aspect of Kimpel and Suckale's book: architectural language. For them, architectural vocabulary is not autonomous, not the result of an "interior" evolution of architectural history, but rather the product of conscious choices. With their book, semiotics has reached the study of Gothic architecture, even if the authors never refer expressly to semiotic theories.[42] The sober forms of the cathedrals at Chartres and Soissons are said to correspond to the cool administrative climate of the reign of Philip Augustus. A certain architectural vocabulary may have been chosen by the patron of a specific building in order to signal his affiliation with a religious order, a church province, or even a dynastic connection. The zigzag ornament in the choir at Saint-Quiriace at Provins is said to be a tribute paid by the counts of Champagne to the duke of Normandy and to the king of England. The idioms of twelfth-century architecture in the Île-de-France, Champagne, and the North, are read as a sort of visual-political language.

Perhaps the greatest merit of this approach lies less in what it achieves than in what it postulates: a new historical reading of Gothic buildings. If this is the goal of future studies on Gothic architecture, most of the research is yet to be done. We would then need monographs on buildings that contain more information than just a chronological reading of moldings and joints. This would mean, first of all, a new exploitation of the written sources. Jean-Pierre Ravaux for Reims, Stephen Murray for Beauvais, and Jan van der Meulen for Chartres have shown how incomplete the art historian's knowledge of the written documents often is and how sloppily these documents have sometimes been interpreted.[43] In England, Howard Montagu Colvin's masterful publications, *The History of the King's Works* and *The Building Accounts of King Henry III*, have set a model for the study of sources connected with buildings.[44] The conclusions to be drawn from such a mass of contemporary information are essential for our understanding of the practical, financial side of medieval and Gothic building activity.[45] Studies in this field remain rare. Robert Branner was one who early on tried to study the financing of the first campaigns in the construction of the new cathedral at Reims after 1210.[46] Philippe Braunstein and others have begun to study the importance of mines and quarries for building in medieval France.[47] These different investigations have to be combined with a still more careful

examination of the monuments themselves, still lacking in many, if not most, cases. John James has made a great number of important observations at Chartres by looking more closely at the building than anyone before him.[48] It was only a pity that he used these observations to invent a number of "ghost architects" instead of mapping a historical reconstruction of the building process.

Another aspect of the study of Gothic churches, which has been neglected for a long time, is function and liturgy. Yet neither the plan nor even the elevation of many medieval ecclesiastical buildings can be historically understood without reading the liturgical texts, especially the Ordinaries. A beginning has now been made with such studies as those by Peter Draper on Durham, Ely, and Winchester and that of Renate Kroos on Bamberg and Cologne.[49] A different approach which seems promising is the exploitation of statistical studies that examine a great number of buildings and monuments, including all the minor ones, found in one region. The approach of John James in his article "Investigation into the Uneven Distribution of Early Gothic Churches in the Paris Basin 1140–1240," published in 1984, may still be immature, but he has at least shown what kind of insights into building booms, building recessions, geographical distribution of monuments, and the exploitation of local quarries can be gleaned from such statistical studies.[50]

To conclude these remarks on architectural history, I am aware that this new interest in sources, labor, financing, materials, and function leads—and has already led— to a devisualization of architectural history. But I think in the long run there will be no great danger. We have to admit that the time is past when art historians can honestly believe in their ability to gain essential insights simply by gazing at medieval churches. We need these complementary studies in order to understand historically what we observe visually. It is important not to lose Bony as we integrate other interests and new perspectives into our study of Gothic architecture.

Now a glance at recent research on Gothic light and windows. In an article which has become a classic, "Le vitrail et architecture au XIIe et au XIIIe siècles," Louis Grodecki described how stained-glass windows, which showed deep colors—red and blue—in the early thirteenth century, became increasingly clear and bright after 1250.[51] He found the reason for this change in the growing refinement

and linear design of Rayonnant architecture, which could achieve its effect only in a clearly lighted interior. I think that Grodecki's description of this change still withstands any possible criticism. The explanation that he proposed for this change, however, was evidently a "Focillonian" one, belonging to the realm of the "vie des formes," and it no longer seems satisfactory to present scholarship.

In 1982 John Gage published a provoking article called "Gothic Glass: Two Aspects of a Dionysian Aesthetic."[52] Concerning the bright and clear windows of the second half of the thirteenth century, Gage proposed an understanding of them not only as an aesthetic answer to a more linear architectural design but also as the visual reflection of a new definition of light and brightness in thirteenth-century philosophy from Thomas de Cantimpré to Albert the Great.[53] More sophisticated still, and more exciting, is Gage's argument concerning the deeper color and lesser brightness of the earlier windows from the twelfth and thirteenth centuries. He argued, as opposed to Panofsky and his followers, that the double aspect of Pseudo-Dionysian philosophy, attributing to God the character of light and clearness, was only on an exterior level: in a more profound and hidden sense, the divine mystery of darkness is reflected in the deep color and especially in the sapphire blue of the windows in the chapels of Suger's choir at Saint-Denis. It is not for me to decide now if Gage's shrewd proposal is totally justified or not. Of interest here is only the fact that in Gage's article the simplistic—and idealistic—equation of Gothic light with Neoplatonic light, generally accepted since Panofsky, was seriously questioned for the first time.

But Gage's essay was only a beginning. In 1987 Peter Kidson published a paper called "Panofsky, Suger and Saint-Denis," which questioned the Neoplatonic interpretation of Gothic architecture in a much more radical way. Kidson states with biting irony: "Light has become for modern art-historians what the rib was for Viollet-le-Duc."[54] Kidson insisted—and it seems that he insisted rightly—that there is not a single passage in Suger's "De administratione" and "De consecratione" that can be directly traced to the writings of Pseudo-Dionysius or John the Scot. Implicitly Kidson contests the influence of light symbolism on the architecture of Saint-Denis altogether and asks instead for a much more pragmatic, craftsmanlike approach to the

problems of the construction of Suger's choir. Certainly the issue is a complex one, and Kidson's article, perhaps somewhat simplistic in its argumentation, will probably not be the last word on this subject. But our English colleague has initiated a "desymbolization" of Gothic light and Gothic architecture and has opened a path toward the "sunset" of its Neoplatonic interpretation, which was—at least I think so—long overdue.[55]

I must cite three further sentences from Kidson's text: "Far from being a Platonist, Suger discloses himself as a proto-Jesuit. He would have no difficulty in understanding the techniques of seducing souls for God through beauty, and would have thoroughly approved. His Saint-Denis was a first step along the road which led to Quattro Fontane and Vierzehnheiligen."[56] Here, then, the persuasive, the theatrical—one hesitates to say the propagandistic—features of Gothic architecture are stressed.[57] In the light of all these recent contributions, one might speak of a general tendency toward "despiritualization," which certainly has its dangers—triviality being one of them—but which has become fatally unavoidable after the long phase of mystification of Gothic architecture and Gothic light. This brings me to another and last field of interest: the discovery of the Gothic stained-glass window as a narrative medium.

In 1987 Wolfgang Kemp published his already-mentioned book, *Sermo corporeus. Die Erzählung der mittelalterlichen Glasfenster.* Reviving an approach and a method which had been developed at the beginning of our century by August Schmarsow and his school, Kemp analyzes the structure of a small number of early-thirteenth-century stained-glass windows from Chartres and Bourges.[58] The topic seems to be in the air, because in 1988 two French authors presented a book, *Les vitraux légendaires de Chartres. Des récits en images,* which argues—perhaps in a more general and more superficial way—along the same lines.[59] One of their chapters is called "Écriture et géométrie," a title which also sums up the main argument of Kemp's book: the armatures of the stained-glass window with their interwoven geometrical figures offer a very peculiar framework for the composition and the redaction of a narrative cycle. Kemp shows how certain windows around 1220—his main examples are the windows of the Prodigal Son at Chartres and Bourges and the window of St. Lubin at Chartres—have a particularly complex and rich interrelationship between the framework of the armatures and the distribution of the narrative with surprising inversions, extensions, and heightenings. This, according to Kemp, corresponds to the last phase of oral—nonwritten—literature around 1220, to the "jeux" and the "fabliaux." The stained-glass window is no longer seen as an emanation of Neoplatonic light but as a piece of entertainment, a storyteller and a visual sermon addressed to a public which does not dream but looks and reads. And this brings me to the next nest of problems I have singled out for this essay: the new interest in the interrelation between the medieval image and the medieval public.

If I am right, one might say that literary history over the last twenty years has shown as much interest in the reader as in the text.[60] In this same period, art history—and especially art history devoted to the late-medieval image—has discovered the beholder. For Panofsky—and I think also for Otto Pächt—the iconography or the form of images from the fourteenth and the fifteenth centuries had been autonomous, "clean" problems, which could be solved face to face with the work of art on the museum's wall, with the manuscript in a library, or with a good reproduction in the art historian's study. For about fifteen years, however, the most stimulating studies in this field have been occupied with the relation between certain classes, types, and styles of images and various kinds of beholders and groups of beholders. The best of these studies have demonstrated that this new interest in the beholder does not reflect a mere theoretical or sociological curiosity that leaves the concrete art object alone or uses it simply as a piece of illustration, as so many books by historians do these days.[61] On the contrary, the content and the style—the rhetoric of the late-medieval image—were conditioned and shaped by its function and by the expectations of the public it addressed.

To give a few examples: Michael Camille has argued, in a series of interesting papers which appeared between 1985 and 1989, that the different languages "spoken" by images in English illuminated manuscripts from the thirteenth and fourteenth centuries reflect the taste and the social status of those who commissioned them.[62] The extremely

refined Amesbury Psalter, which was made for a nun in the richest nunnery in England, is different from the Cuerden Psalter, which was ordered by an unknown lay couple evidently demanding a more obvious, more extended, and less discreet illustration for their prayer book. This example may reveal, as Camille says, "what the 'quasi-literate' reader saw and read as opposed to the monastic literate."[63] But such differences of language also occur in one and the same manuscript. The full-page illuminations of the Oscott Psalter use a solemn and monumental style, while marginal drawings of the same prayer book, which depict not apostles or the life of Christ but proverbs and fables instead, speak in a much more down-to-earth, "lewd" language. This difference of character between main and marginal images in Gothic manuscripts, between the "serious" illustrations and the "drôleries," has always been noticed, but Camille proposes to compare such gradations to the different levels of language used and spoken in thirteenth-century England: Latin, French, and, at the lowest and most accessible level, English. Such an argument permits a new evaluation of manuscripts such as the Holkham Bible, from about 1330, or the Luttrell Psalter, which in the earlier literature were often merely regarded as "lacking in exquisite quality" or as "cheap and coarse."[64] Naturally, it would be naive to regard the images in such manuscripts as a sort of folk art. The Luttrell Psalter was, after all, commissioned by a member of the nobility.[65] As to the "misericords" and the "drôleries" or the peasants working in the margins of the Luttrell Psalter, Camille insists "their function is not so much to expose the social conditions of the masses but to keep them in place, or rather displaced, at the edges of the Latin world. . . . Degrees of naturalism correspond to degrees in the social order in English Gothic art as much as they do in subsequent centuries."[66] The study of English Gothic manuscripts has been intense and fruitful from the days of M. R. James to the recent excellent surveys of Nigel Morgan and Lucy Sandler. Camille has perhaps added little to this long effort to localize and date manuscripts, singling out styles, and pinning down stylistic affiliations, but he has opened a new perspective by asking what this diversity of stylistic language meant in relation to different readers, beholders, patrons, and publics. "Transformations in style are not homologous or internally

motivated. In the case of medieval manuscripts they are often a function of the artists and the readers, of the genre and the language of the text to be illustrated."[67]

To turn to another example: in 1981, Hans Belting published a book entitled *Das Bild und sein Publikum im Mittelalter*.[68] Belting studied the form and the function of those devotional images of the Passion which were mainly created in Italy during the thirteenth and early fourteenth centuries, one of which in 1927 had been the object of Erwin Panofsky's famous paper, "Imago Pietatis."[69] Belting, originally a student of Byzantine art, is interested in the question of what happened to the Eastern icon when it was imitated in the West and transformed in order to address a new kind of public piety, when it was adapted to a different, a Western, understanding and function of the devotional image. He shows that this transplantation initiated a process of activation and specialization. In the West the devotional image integrates narrative details: it can— at least in part—become a painted history. And this transplantation from East to West changed not only the function and the iconography but also the form, the style, the rhetoric of the appeal of the "Imago Pietatis." Whereas the earlier literature on the Western devotional image—Panofsky and before him, Wilhelm Pinder—had insisted that the *Andachtsbild* was a sort of private cult-object, withdrawn from public use, Belting reminds us that, on the contrary, the transformation of the Eastern icon into the Italian devotional image was addressed to—and conditioned by the expectations of—all sorts of characteristically Western audiences: municipalities, corporations, and fraternities as they came into existence in the century of St. Francis and around the order which bore his name. Without taking into consideration these new groups of beholders and their specific expectations, the change from the icon to the devotional image, and particularly the narrative devotional image, cannot be explained.[70] There is no medieval art history without the public.

To turn to the next example: James Marrow's already-cited *Passion Iconography in Northern European Art of the Late Middle Ages and Early Renaissance* bears the telling subtitle: *A Study of the Transformation of Sacred Metaphor into Descriptive Narrative*. In his book, Marrow has

successfully questioned the two traditional interpretations of late-medieval, especially of early Netherlandish and German, imagery: the idea of their hidden symbolism in the sense of Panofsky and the older idea of their face-value realism. Contrary to the idea of "disguised symbolism," Marrow shows how the descriptive, narrative side of the representations is more and more developed and becomes nearly an end in itself. But—and this is perhaps still more important—contrary to the idea of the "mere realism" of late-medieval representations, Marrow demonstrates how these realistic images grew out of the theological exegesis of biblical texts and how they resound with metaphorical undertones which may or may not have been understood by contemporary pious beholders. Marrow has built up his argument by using medieval contemplative texts from Anselm of Canterbury to Bernard of Clairvaux, Bonaventure, Ludolph of Saxony, the German mystics, and the "Devotio Moderna." He does not, however, see the images as simply dependent upon such writings. He shows that contemplative texts on Christ's Passion and the very detailed, often extremely painful visual representations of the Passion in the Netherlands and in Germany both, in the same way, invite the pious reader or the pious beholder to become absorbed in the Lord's suffering. The rhetoric of the text and the appeal of the image are, so to speak, identical. And Marrow is certainly right when he insists that this intense desire to describe in ever greater detail and in ever more affective terms the suffering of the Lord also shaped the form, the style, and the language of late-medieval Northern painting.

Since World War II, there has been—at least in Germany—an understandable reluctance to continue the study of late-medieval German painting. The eleven rather tedious volumes of Alfred Stange on *Deutsche Malerei der Gotik,* which were started in 1934 but appeared mostly in the 1950s, were a mental holdover from the years before 1945.[71] To a younger generation which had been faced with so much cruelty in their own time these crude and often cruel paintings were repulsive. By explaining the function of these paintings in the context of late-medieval piety, by reconstructing their role in the process of visual meditation, Marrow opens a new, "detached" perspective for the study of this material. He no longer provides an endless chain of attributions to hundreds of masters with all sorts of pedantic nicknames as his predecessors in this field had done for a long time. He also does not indulge in parochial discussions about the borderlines between the different regional schools of the "Altdeutsche Malerei," which had been another hobbyhorse of the specialists in late-medieval German art. He initiates instead a discussion of the function of these images and tries to understand their original message to a beholder. This approach seems to be in the air: Robert Suckale's provoking study on the "Arma Christi" in 1977 and Frank Büttner's *Imitatio Pietatis. Motive der christlichen Ikonographie als Modelle zur Verähnlichung,* published in 1983, are two German contributions that move in the same direction.[72]

My final example concerns the study of late-medieval sculpture in central Europe. This is a field where research and connoisseurship have remained extremely lively and very active. In 1966 Pelican published Theodor Müller's classic *Sculpture in the Netherlands, Germany, France, and Spain: 1400 to 1500.*[73] Müller's book was a tough survey, entirely concentrated on such traditional questions as chronology, localization, and eventually attribution. In the years since 1966 many of these problems have perhaps not fundamentally changed, but they have been further explored and some interesting discoveries have been made. For instance, the dominating role of Prague for the crystallization of the International Style in the southeast of the Holy Roman Empire has become much clearer; the role of Salzburg, on the other hand, now seems less important than Müller thought.[74] The situation at Strasbourg around 1460 looks more complex than it did twenty years ago. Netherlandish influence may have been felt there even before the arrival of Nikolaus Gerhaert von Leyden in 1463.[75] The sensational discovery of the 1462 date on the shrine of the altar in Nördlingen has put into question all traditional ideas about the career and activity of the greatest Northern sculptor since Claus Sluter, Nikolaus Gerhaert. If the figures from the Nördlingen altar are attributed to Nikolaus Gerhaert, that means that his revolutionary style was developed even before he arrived at Strasbourg in 1463; if the figures of Nördlingen are attributed to another artist, Nikolaus loses at least part of his unique and groundbreaking position in the history of fifteenth-century German sculpture. The debate on this problem is still open and there may well

never be a general agreement on the attribution or nonattribution of the Nördlingen pieces.[76] The situation in Ulm also looks different since we learned that Jörg Syrlin was only the joiner of the famous choir stalls, while the sculptures must be attributed to Michel Erhart.[77] But I am digressing, because only the structural changes in our ideas on Gothic art, not the details of day-to-day research, as important as they may be, should interest us here.

Concerning the field of late-medieval sculpture, therefore, I would insist on two new methods of approach: the one being purely empirical, the other intellectual. It seems to me that the only substantial progress in our factual, material knowledge of objects in this field has come from a new form of collaboration between art historians and restorers. The restorations of the altars in Nördlingen and in Schwabach, the Riemenschneider altar in Münnerstadt, and the triumphal cross of Bernt Notke in the cathedral at Lübeck, have taught us that nowadays mere stylistic analysis, the naive look with the art historian's eye, must be controlled, corrected, and deepened in the cool light of the results gained from technical examination.[78] I remember an unforgettably odd moment at a symposium in Lübeck when the technicians had amply demonstrated that the wooden nucleus of the figures from Notke's triumphal cross had been "embellished" by all sorts of coverings—not only a kind of *carta pesta* but even nails and ropes—and the art historians, totally unimpressed, continued to distinguish hands by faithfully examining those elementary wooden blocks. Only the restorers can supply the basic data on material, technique, and—particularly important in this field—polychromy.[79] The art historian does not have to abdicate to the restorer, but he must make the restorer's technical data part of his own critical analysis, especially in a field where hardly a single object has survived in its fully original state.

The new intellectual approach was articulated brilliantly in a book written by a notorious outsider to the field of late-medieval German wood sculpture. Michael Baxandall's volume, *The Limewood Sculptors of Renaissance Germany*, has aroused much general interest, but characteristically has not provoked a single review—so far as I know—by a specialist in the field. Baxandall added nothing to our conventional and traditional stock of knowledge of late-medieval German sculpture, of

course, nor did he pretend to do so. But the book opened new perspectives, two of which seem particularly challenging to me. First of all, Baxandall tried to demonstrate that the style or the "mark" of the greatest limewood sculptors—he singled out Michel Erhart of Ulm, Tilman Riemenschneider of Würzburg, Veit Stoss of Nuremberg, Hans Leinberger of Landshut—grew out of, and as a reaction against, the very tense and narrow economic structure of the German cities with their strict borderlines between the different guilds. This situation stimulated the invention of manufacturing processes in an effort to overcome such limitations; another consequence of this tense structure was a strong pressure to compete. The individual forms of the leading limewood sculptors are regarded by Baxandall as aesthetic trademarks which guaranteed and stabilized their success in a competitive market.

Baxandall emphasizes the fact that the production of art—in this case the production of the huge altarpieces for the churches of late-medieval Germany—was part of a very specific economic structure and craft organization. While this may seem to be a mere repetition of well-known art-historical knowledge,[80] Baxandall insists that the economic situation affected directly the highly sophisticated, twisted, and even showy style of the individual sculptors. In modern terms one could almost speak of a design competition between the different altar firms—the words are mine not Baxandall's. Such an explanation is, needless to say, a far and even blasphemous cry from the traditional, more or less expressionistic interpretation of the same altars, which had often mysteriously referred to the soul or the soil of Franconia, Swabia, or Westphalia as the secret source of the drama of Late Gothic folds and gestures.[81] The only specialist who seems to have responded to this kind of approach was the late Jörg Rasmussen and he did so, characteristically enough, in a lecture on Veit Stoss, because it is certainly with Stoss that Baxandall's perspective works best.[82]

The second point which Baxandall developed, in order to make such an alien, exotic, and even atavistic art as German limewood sculpture palatable to an audience and a readership having British taste, is found in a chapter called "Period Eye." The method applied in this chapter recalls an earlier book by the same author, *Painting and Experience in Fifteenth-Century Italy*.[83] Baxandall connects the

basic patterns of the Late Gothic sculptors—their extremely complicated, entwined, and entangled forms—to the patterns of other social activities and rites in the same milieu: the compositional methods of the "Meistersinger," the highly convoluted calligraphy of the German "modistes" (scribes in the schools), and late-medieval dance and dancing terms. It would not be fair to confuse Baxandall's suggestions with such traditional but much vaguer notions as Heinrich Wölfflin's principles of art history. Baxandall wants to find a common signature, a pattern in different but neighboring activities in the same milieu and at the same moment of time. He sees the style of the limewood sculptors as part of a larger but very specific sociocultural physiognomy.

It would be interesting to compare and contrast the results of Marrow and Baxandall because their books, after all, deal with closely related material. It might then appear as a weakness of Baxandall's book that it pays only very limited attention to the religious and devotional functions of the objects it studies. But both Baxandall and Marrow open insights into late-medieval art that transcend the traditional art-historical questions of style or iconography. Both try to read and to understand late-medieval art in the broader context of religious, economic, and cultural history. Marrow seems to cite J. Huizinga with more approval and praise than did either Max J. Friedländer or Erwin Panofsky. This seems to indicate that the tide of studies on late-medieval art has these days somewhat withdrawn from connoisseurship and iconology and turned toward a more comprehensive understanding of Late Gothic imagery and its manifold functions.

I am at the end of this scattered report, which was—I am well aware—arbitrarily selective. But research on a period of art which reaches from Suger to Grünewald is too widespread and too rich for one single individual to deal with in one essay. The one thing which seems common to all truly productive recent research in Gothic art and architecture is a new broadening of approach, the integration of methods borrowed from other fields, from technology to literary history. There is also a new awareness of the function of the art object, its relation to a public, to an audience. Cathedrals and monasteries seem these days perhaps less lofty and auratic than fifty years ago, but our understanding of them will, it is hoped, become even richer. The Cloisters was conceived as the reconstruction of a medieval ambience—a fantasy about the idea and the shape of a medieval monastery—and not just as an assemblage of artifacts in a museum. I have the impression that recent research on Gothic art is trying to achieve a similar thing—to track the place of buildings, statues, and images in their original context, to reconstruct their concrete meaning for people in a certain moment in history. I hope that the few examples I have tried to describe have given at least a vague impression of these new trends in recent scholarship on the old Gothic monuments.

NOTES

Apart from the addition of a few titles I had overlooked, I have left text and notes unchanged since 1988. A number of interesting books, articles, and catalogues have since appeared and could have been added. Such additions would not, however, have changed the main perspective of this essay.

1. Henri Focillon, *Art d'occident* (Paris, 1938). I use the pocket edition of 1965 (with supplementary notes by Jean Bony), vol. 2, pp. 122, 163ff., 347.

2. Focillon's admirable pages on Gothic architecture retain many of the ideas of Viollet-le-Duc, although the author is very critical of nineteenth-century rationalism and the "laïcité" of the great nineteenth-century architect. Focillon's statement about "la physiognomie théâtrale" of late-medieval art resounds with ideas taken over from Émile Mâle, *L'art religieux de la fin du moyen-âge* (Paris, 1905).

3. René Huyghe writes in *Victor Focillon, Dijon, 1819–1918 et Henri Focillon, Dijon, 1881–1943,* exhib. cat., Musée de Dijon (Dijon, 1955), p. 9, "La vie des formes que Focillon donnait en 1934, expliquait le passé, mais trouvait sa confirmation dans les tentatives du présent."

4. See Focillon, *Art d'occident* (1965), vol. 2, pp. 9, 81, 279.

5. For an example of this evolutionary concept in French art from the beginning of our century, see Gaston Richard, *L'idée d'évolution dans la nature et l'histoire* (Paris, 1903). For a critical evaluation of such theories, see, for instance, Dagobert Frey, *Kunstwissenschaftliche Grundfragen. Prolegomena zu einer Kunstphilosophie* (Vienna, 1946), pp. 69–74.

6. Erwin Panofsky, "Note on a Controversial Passage in Suger's *De consecratione ecclesiae Sancte Dionysii,*" *Gazette des Beaux-Arts,* 6th ser., 36 (1944), pp. 95–114.

7. To cite only a few examples: Hans Sedlmayr, "Die Lichtmystik und die Kathedrale," in *Die Entstehung der Kathedrale* (Zurich, 1950), p. 314; Otto von Simson, *The Gothic Cathedral. Origins of Gothic Architecture and the Medieval Concept of Order* (New York, 1956), pp. 21ff. Von Simson states expressly: "Gothic art would not have come into existence without the Platonic

cosmology cultivated at Chartres" (p. 26); Louis Grodecki, in Marcel Aubert et al., *Le Vitrail français* (Paris, 1958), pp. 39–54, on the "fonctions spirituelles."

8. See John Gage, "Gothic Glass: Two Aspects of a Dionysian Aesthetic," *Art History* 5/1 (1982), pp. 36–58; Martin Büchsel, "Ecclesiae symbolorum cursus completus," *Städel-Jahrbuch* 9 (1983), pp. 69–88; Peter Kidson, "Panofsky, Suger and Saint-Denis," *Journal of the Warburg and Courtauld Institutes* 50 (1987), pp. 1–17; and Paul Crossley, "Medieval Architecture and Meaning: the Limits of Iconography," *Burlington Magazine* 130 (1988), pp. 116–21.

9. Erwin Panofsky, *Early Netherlandish Painting. Its Origin and Character* (Cambridge, Mass., 1953).

10. Ibid., p. 131: "Reality and Symbol in Early Flemish Painting: 'Spiritualia sub metaphoris corporalium.'"

11. See Meyer Schapiro, "*Muscipula Diaboli.* The symbolism of the Mérode Altarpiece," *Art Bulletin* 27 (1945), pp. 182–87; Charles de Tolnay, "L'autel de Mérode du Maître de Flémalle," *Gazette des Beaux-Arts,* 6th ser., 53 (1959), pp. 65–78; William S. Heckscher, "The Annunciation of the Mérode Altarpiece: An Iconographic Study," *Miscellanea Josef Duverger* (Ghent, 1968), vol. 1, pp. 37–65; Charles Minott, "The Theme of the Mérode Altarpiece," *Art Bulletin* 51 (1969), pp. 267–71; Carla Gottlieb, "*Respiciens per fenestras:* The Symbolism of the Mérode Altarpiece," *Oud Holland* 85 (1970), pp. 65–83; Ellen Callmann, "Campin's Maiolica Pitcher," *Art Bulletin* 64 (1982), pp. 629–31; and Cynthia Hahn, "Joseph Will Perfect, Mary Enlighten and Jesus Save Thee: The Holy Family as Marriage Model in the Mérode Triptych," *Art Bulletin* 68 (1986), pp. 54–66.

12. See for instance: Lloyd Benjamin, "Disguised Symbolism Exposed and the History of Early Netherlandish Painting," *Studies in Iconography* 2 (1976), pp. 11–24; Craig Harbison, "Realism and Symbolism in Early Flemish Painting," *Art Bulletin* 66 (1984), pp. 588–602; James H. Marrow, "Symbol and Meaning in Northern European Art of the Later Middle Ages and the Early Renaissance," *Simiolus* 16 (1986), pp. 151–69; and Barbara G. Lane, "Sacred versus profane in early Netherlandish painting," *Simiolus* 18 (1988), pp. 107–15. The arguments in these papers differ widely, but they agree in their critical attitude toward Panofsky's concept of "disguised symbolism." Still valid is the late Otto Pächt's clearsighted review of Panofsky's *Early Netherlandish Painting,* in *Burlington Magazine* 98 (1956), pp. 267–79.

13. Millard Meiss, *Painting in Florence and Siena after the Black Death. The Arts, Religion and Society in the Mid-Fourteenth Century* (Princeton, 1951). See Henk van Os, "The Black Death and Sienese Painting. A problem of interpretation," *Art History* 4 (1981), pp. 237–49.

14. Sixten Ringbom, "Devotional Images and Imaginative Devotions: Notes on the Place of Art in Late Medieval Private Piety," *Gazette des Beaux-Arts,* 6th ser., 73 (1969), pp. 159–70.

15. Idem, *Icon to Narrative: The Rise of the Dramatic Close-up in Fifteenth Century Devotional Painting* (Åbo, 1965).

16. Ibid., p. 12.

17. Pierre Bourdieu, *Un art moyen* (Paris, 1965); idem, *L'amour de l'art* (Paris, 1966); idem, *Zur Soziologie der symbolischen Formen* (Frankfurt am Main, 1970).

18. James H. Marrow, *Passion Iconography in Northern European Art of the Late Middle Ages and Early Renaissance* (Kortrijk, 1979), p. 192.

19. Michael Camille, "The Language of Images in Medieval England, 1200–1400," in *Age of Chivalry: Art in Plantagenet England 1200–1400,* Jonathan Alexander and Paul Binski, eds., exhib. cat., Royal Academy of Arts (London, 1987), p. 33.

20. Wolfgang Kemp, *Sermo corporeus. Die Erzählung der mittelalterlichen Glasfenster* (Munich, 1987).

21. Jean Bony, *French Gothic Architecture of the 12th and 13th Centuries* (Berkeley/Los Angeles/London, 1983); Dieter Kimpel and Robert Suckale, *Die gotische Architektur in Frankreich 1130–1270* (Munich, 1985); Harry B. Titus, *The Architecture of Auxerre Cathedral* (Ann Arbor, 1985); Stephen Murray, "The Choir of the Church of St.-Pierre, Cathedral of Beauvais: A Study of Gothic Architectural Planning and Constructional Chronology in Its Historical Context," *Art Bulletin* 62 (1980), pp. 533–51; John James, *Chartres: Les constructeurs,* 3 vols. (Chartres, 1977–82); Jan van der Meulen and Jürgen Hohmeyer, *Chartres. Biographie einer Kathedrale* (Cologne, 1984); W. W. Clark and R. King, *Laon Cathedral: Architecture,* 2 vols. (London, 1983–87); Thomas E. Polk, *Saint-Denis, Noyon and the Early Gothic Choir* (Frankfurt/Bern, 1982); Caroline Bruzelius, "The Construction of Notre-Dame in Paris," *Art Bulletin* 69 (1987), pp. 540–69; Jean-Pierre Ravaux, "Les campagnes de construction de la cathédrale de Reims au XIIIe siècle," *Bulletin monumental* 137 (1979), pp. 7–66; Jacques Henriet, "La cathédrale Saint-Étienne de Sens: Le parti du premier maître et les campagnes du XIIe siècle," *Bulletin monumental* 140 (1982), pp. 81–174; Alain Villes, *La cathédrale de Toul,* vol. 2, *Histoire et architecture* (Metz, 1983); S. McKnight Crosby, *The Royal Abbey of Saint-Denis from its Beginnings to the Death of Suger, 475–1151,* edited and completed by Pamela Z. Blum (New Haven, 1987); Caroline Bruzelius, *The Thirteenth-Century Church at St-Denis* (New Haven/London, 1985); *Abbot Suger and Saint-Denis. A Symposium,* ed. Paula Gerson (New York, 1986); Jacques Henriet, "Un édifice de la première génération gothique: L'abbatiale de Saint-Germer de Fly," *Bulletin monumental* 143 (1985), pp. 93–142; and Madeline H. Caviness, "Saint-Yved de Braine. The Primary Source for Dating the Gothic Church," *Speculum* 59 (1984), pp. 524–48.

22. *Les monuments de la France gothique,* Collection dirigée par Anne Prache, Maryse Bideault et Claudine Lautier, *Île-de-France gothique,* vol. 1, *Les églises de la vallée de l'Oise et du Beauvaisis* (Paris, 1987).

23. Willibald Sauerländer, *Gotische Skulptur in Frankreich 1140–1270* (Munich, 1970); English ed.: *Gothic Sculpture in France 1140–1270,* trans. J. Sondheimer; photos, Max Hirmer (London, 1972).

24. Peter Kurmann, *La façade de la cathédrale de Reims,* 2 vols. (Lausanne, 1987).

25. Sylvia and Léon Pressouyre, *Le Cloître de Notre-Dame-en-Vaux* (Nancy, 1981); Sylvia Pressouyre, *Images d'un cloître disparu* (Paris, 1976).

26. Alain Erlande-Brandenburg with Dominique Thibaudat, *Les sculptures de Notre-Dame de Paris au Musée de Cluny* (Paris, 1982), where all the fragments are inventoried. A definitive study of this astonishing material has yet to be presented.

27. Louis Grodecki with Catherine Brisac and Claudine Lautier, *Le vitrail roman* (Fribourg, 1977). This volume, despite its

title, deals largely with windows one usually calls "Early Gothic"; Louis Grodecki and Catherine Brisac, *Le vitrail gothique au XIIIe siècle* (Fribourg, 1984). The first three chapters of this volume were completed during Grodecki's lifetime. Brisac wrote the remaining parts on "La seconde moitié du XIIIe siècle en France" and "L'Europe au XIIIe siècle."

28. Joan Ainaud i de Lasarte, Joan Vila-Grau, and M. Assumpta Escudero i Ribot, *Els vitralls medievals de l'Església de Santa Maria del Mar, a Barcelona* (Barcelona, 1985); Madeline Harrison Caviness, *The Windows of Christ Church Cathedral Canterbury* (London, 1981); Erhard Drachenberg, *Die mittelalterliche Glasmalerei im Erfurter Dom*, 2 vols. (Berlin, 1980, 1983); N. J. Morgan, *The Medieval Painted Glass of Lincoln Cathedral* (London, 1983); Caterina Pirina, *Le vetrate del Duomo di Milano: dai Visconti agli Sforza* (Milan/Florence, 1986); Gabriela Fritzsche, *Die mittelalterlichen Glasmalereien im Regensburger Dom* (Berlin, 1987); Victor Beyer, Christiane Wild-Block, and Fridtjof Zschokke, *Les vitraux de la cathédrale de Notre-Dame de Strasbourg* (Paris, 1986); and Thomas French and David O'Connor, *York Minster. A Catalogue of Medieval Stained Glass.* Fascicule I: *The West Windows of the Nave* (Oxford, 1987).

29. Rüdiger Becksmann, *Die mittelalterlichen Glasmalereien in Schwaben von 1350–1530 (ohne Ulm)* (Berlin, 1986). In the series *Recensement des vitraux anciens de la France:* I. *Les vitraux de Paris, de la région parisienne, de la Picardie et du Nord-Pas-de-Calais* (Paris, 1978); II. *Les vitraux du Centre et des Pays de la Loire* (Paris, 1981); III. *Les vitraux de Bourgogne, Franche-Comté et Rhône-Alpes* (Paris, 1986). In the checklist series for the United States: *Stained Glass before 1700 in American Collections: New England and New York State* (Studies in the History of Art 15) (Washington, D.C., 1985); and *Mid-Atlantic and South-Eastern Seaboard States* (Studies in the History of Art 23) (Washington, D.C., 1987); and *Mid-Western and Western States* (Studies in the History of Art 28) (Washington, D.C., 1989).

30. *Corpus der mittelalterlichen Wandmalereien Österreichs.* Vol. I: Elga Lanc, *Die mittelalterlichen Wandmalereien in Wien und Niederösterreich,* with contributions by Ivo Hammer and Eva-Marie Höhle (Vienna, 1983).

31. Nigel J. Morgan, *Early Gothic Manuscripts I: 1190–1250* (Oxford, 1982), *II: 1250–1285* (Oxford, 1988); Lucy F. Sandler, *Gothic Manuscripts 1285–1385.* 2 vols. (Oxford, 1985), from the series *A Survey of Manuscripts Illuminated in the British Isles,* ed. J. J. G. Alexander.

32. Lucy F. Sandler, *The Peterborough Psalter in Brussels and other Fenland Manuscripts* (London, 1984); idem, *The Psalter of Robert de Lisle* (London, 1983); Peter K. Klein, *Endzeiterwartung und Ritterideologie. Die englischen Bilderapokalypsen der Frühgotik und Ms. Douce 180* (Graz, 1983); Suzanne Lewis, *The Art of Matthew Paris in the Chronica Majora* (Berkeley/Los Angeles/London, 1987); and W. Brunsdon Yapp, *Birds in Medieval Manuscripts* (London, 1981).

33. Millard Meiss, *French Painting in the Time of Jean de Berry: The Late Fourteenth Century and the Patronage of the Duke* (London/New York, 1967); idem (with the assistance of Kathleen Morrand and Edith W. Kirsch), *French Painting in the Time of Jean de Berry. The Boucicaut Master* (London/New York, 1968); and idem (with the assistance of Sharon O. D. Smith and Elizabeth H. Beatson), *The Limbourgs and their Contemporaries* (New York, 1974).

34. See, for instance, François Avril, "Trois manuscrits de l'entourage de Jean de Pucelle," *Revue de l'Art* 9 (1970), pp. 37–48; idem, "Un chef-d'oeuvre de l'enluminure sous le règne de Jean le Bon: la Bible moralisée manuscrit français 167 de la Bibliothèque Nationale," in *Fondation Eugène Piot. Monuments et Mémoires* 58 (1971), pp. 91–125; and idem, *Manuscript Paintings at the Court of France (1310–1380)* (New York, 1978).

35. Eberhard König, *Französische Buchmalerei um 1450. Der Jouvenel-Maler, der Maler des Genfer Boccaccio und die Anfänge Jean Fouquets* (Berlin, 1982).

36. Sandra L. Hindman, *Christine de Pizan's "Epistre d'Othéa." Painting and Politics at the Court of Charles VI* (Toronto, 1986).

37. Roland Recht, *Nicolas de Leyde et la sculpture à Strasbourg, 1460–1525* (Strasbourg, 1987).

38. Michael Baxandall, *The Limewood Sculptors of Renaissance Germany* (New Haven/London, 1980).

39. Herbert L. Kessler, "On the State of Medieval Art History," *Art Bulletin* 70 (1988), pp. 166–87.

40. Jean Bony (*French Gothic Architecture*) was evidently still under the spell of another famous "Focillonian" book: Pol Abraham, *Viollet-le-Duc et le rationalisme médiévale* (Paris, 1934), which brilliantly criticized the functionalistic interpretation of Gothic architecture developed by Viollet-le-Duc.

41. See, for such connections, André Mussat, "Les cathédrales dans leurs cités," *Revue de l'Art* 55 (1982), pp. 9–22.

42. See Geoffrey Broadbent, Richard Bunt, and Charles Jencks, eds., *Signs, Symbols and Architecture* (Toronto, 1980). Naturally there is another aspect of Kimpel and Suckale's approach (*Die gotische Architektur*) which clearly stems from a specific German tradition of "Architektur als Bedeutungsträger." See esp. Günter Bandmann, *Mittelalterliche Architektur als Bedeutungsträger* (Berlin, 1951). For a critical assessment of such theories, see Martin Warnke, *Politische Architektur in Europa vom Mittelalter bis heute: Repräsentation und Gemeinschaft* (Cologne, 1984).

43. For Ravaux and Murray, see note 21 above. See also Jan van der Meulen, "Recent Literature on the Chronology of Chartres Cathedral," *Art Bulletin* 49 (1967), pp. 152–72.

44. Howard Montagu Colvin, ed., *The History of the King's Works: The Middle Ages,* 2 vols. (London, 1963); idem, ed., *History of the King's Works,* vol. 3, pt. 1 (London, 1975); idem, *The Building Accounts of King Henry III* (Oxford, 1971).

45. Martin Warnke (*Bau und Überbau. Soziologie der mittelalterlichen Architektur nach den Schriftquellen* [Frankfurt, 1976]) makes an interesting if one-sided effort to analyze the organization of medieval building practice in light of the written sources.

46. Robert Branner, "Historical Aspects of the Reconstruction of Reims Cathedral 1210–1241," *Speculum* 36 (1961), pp. 23–37.

47. Philippe Braunstein and Paul Benoît, eds., *Mines, carrières, metallurgie dans la France médiévale,* Actes du Colloque Paris, 1980 (Paris, 1983).

48. For James, see note 21 above.

49. Peter Draper, "The retrochoir of Winchester Cathedral," *Architectural History* 21 (1978), pp. 1–7; idem, "Bishop Northwold and the Cult of Saint Ethelreda," in *Medieval art and architecture at Ely Cathedral,* Conference Transactions of the British Archaeological Association (1979), pp. 9–27; idem, "The Nine Altars at Durham and Fountains," in *Medieval Art and Architecture at Durham Cathedral,* Conference Transactions of the British Archaeological Association (1980), pp. 74–86. Further research on the architecture and liturgy of the choir of Durham is to be expected from Arnold Klukas; Renate Kroos, "Liturgische Quellen zum Bamberger Dom," in Derhard V. Winterfeld, *Der Dom in Bamberg* (Berlin, 1979), vol. 1, pp. 160–76; idem, "Liturgische Quellen zum Kölner Domchor," *Kölner Domblatt, Jahrbuch des Zentral-Dombau-Vereins* 44–45 (1979/80), pp. 35–202.

50. John James, "An Investigation into the Uneven Distribution of Early Gothic Churches in the Paris Basin 1140–1240," *Art Bulletin* 66 (1984), pp. 15–46.

51. Louis Grodecki, "Le vitrail et architecture au XIIe et au XIIIe siècle," *Gazette des Beaux-Arts,* 6th ser., 36 (1949), pp. 5–24.

52. Gage, "Gothic Glass: Two aspects of a Dionysian Aesthetic," pp. 36–58.

53. See also the interesting paper by Meredith Parsons Lillich, "Monastic Stained Glass: Patronage and Style," in *Monasticism and the Arts,* ed. Timothy Gregory Verdon (Syracuse, 1984), pp. 207–54. The author argues that the bright windows appearing in Paris churches after 1240—and in her opinion also in the new abbey church at Saint-Denis—reflect the new interpretation of Pseudo-Dionysius in thirteenth-century philosophy which differs from John the Scot. I thank Madeline Caviness for having drawn my attention to this article, not known to me when I gave my paper at the 1988 symposium in honor of The Cloisters' Fiftieth Anniversary.

54. Kidson, "Panofsky, Suger," p. 10.

55. As already mentioned, some other recent articles have begun to question the Neoplatonic interpretation of Gothic architecture. See, for instance, Büchsel, "Ecclesiae symbolorum," esp. pp. 73, 74; Crossley, "Medieval Architecture and Meaning," pp. 116–21; Mussat, "Cathédrales," pp. 9–22. Also, Willibald Sauerländer, "Abwegige Gedanken über frühgotische Architektur und 'The Renaissance of the Twelfth Century,'" *Études d'art médiéval offertes à Louis Grodecki* (Paris, 1981), pp. 167–79., esp. p. 169 and n. 13; and idem, "'Première architecture gothique' or 'Renaissance of the Twelfth Century'?" *Changing Perspectives in the Evaluation of Architectural History,* Sewanee Mediaeval Colloquium Occasional Papers 2 (1985), pp. 25ff. Finally, one should not forget probably the earliest critic of this hazy and nostalgic architectural iconography: Martin Gosebruch, review of Hans Sedlmayr, *Die Entstehung der Kathedrale* (Zurich, 1950), and of Günter Bandmann, *Mittelalterliche Architektur als Bedeutungsträger* (Berlin, 1951), which appeared in *Göttingische Gelehrte Anzeigen* 208 (1954), pp. 233ff.

56. Kidson, "Panofsky, Suger," p. 8.

57. See also Willibald Sauerländer, *Le siècle des cathédrales, 1140–1260* (Paris, 1989).

58. August Schmarsow, "Kompositionsgesetz romanischer Glasgemälde in frühgotischen Kirchenfenstern," *Abhandlungen der philologisch-historischen Klasse der Königlich Sächsischen Gesellschaft der Wissenschaften* 33/2 (1916), no. 1, pp. 1–55; idem, "Kompositionsgesetze frühgotischer Glasgemälde," ibid., 36/3 (1919), pp. 1–122; idem, *Kompositionsgesetze in der Kunst des Mittelalters* (Leipzig, 1915); Walther Dahmen, *Gotische Glasfenster: Rhythmus und Strophenbau* (Bonn/Leipzig, 1922).

59. Jean-Paul Deremble and Colette Manhes, *Les vitraux légendaires de Chartres. Des récits en images* (Paris, 1988). I did not know of this book at the time of the 1988 New York symposium.

60. See, for instance, Wolfgang Iser, *Der implizierte Leser* (Munich, 1972); idem, *Der Akt des Lesens. Theorie ästhetischer Wirkung* (Munich, 1976); Susan R. Suleiman and Inge Crosman, eds., *The Reader in the Text* (Princeton, 1980).

61. See, for instance, Philippe Ariès and Georges Duby, *Histoire de la vie privée,* vol. 2: *De l'Europe féodale à la Renaissance* (Paris, 1987); Hartmut Boockmann, *Die Stadt im Späten Mittelalter* (Munich, 1987). In these books, which are very successful, the works of art are completely stripped of their aesthetic and even their semiotic qualities. One has the impression of going back to the nineteenth-century history painting or to novels in the line of Walter Scott.

62. Michael Camille, "Seeing and Reading: Some Visual Implications of Medieval Literacy and Illiteracy," *Art History* 8/1 (1985), pp. 26–49; idem, "The Book of Signs: Writing and Visual Difference in Gothic Manuscript Illumination," *Word & Image* 1/2 (1985), pp. 133–48; idem, "Language of Images," pp. 33–40; idem, "Labouring for the Lord: the ploughman and the social order in the Luttrell Psalter," *Art History* 10 (1987), pp. 423–54; idem, "Visualizing in the Vernacular: a new cycle of early fourteenth-century Bible illustrations," *Burlington Magazine* 130 (1988), pp. 97–106; and idem, review of Lucy Freeman Sandler, *Gothic Manuscripts 1285–1385 (A Survey of Manuscripts Illuminated in the British Isles, V),* in *Art Bulletin* 71/1 (1989), pp. 134–37.

63. Camille, "Language of Images," p. 35.

64. See, for instance, Margaret Josephine Rickert, *Painting in Britain in the Middle Ages* (London, 1954), pp. 149, 150.

65. Geoffroy Luttrell (1276–1345), Lord of Irnham: *Age of Chivalry,* no. 575.

66. Camille, "Language of Images," p. 39.

67. Camille, "Visualizing in the Vernacular," p. 106.

68. Hans Belting, *Das Bild und sein Publikum im Mittelalter. Form und Funktion früher Bildtafeln der Passion* (Berlin, 1981).

69. Erwin Panofsky, "'Imago Pietatis': Ein Beitrag zur Typengeschichte des 'Schmerzensmanns' und der 'Maria Mediatrix,'" *Festschrift für Max J. Friedländer zum 60. Geburtstage* (Leipzig, 1927), pp. 261–308. Also Wilhelm Pinder, "Die dichterische Wurzel der Pietà," *Repertorium für Kunstwissenschaft* 42 (1920), pp. 145–63.

70. Belting is continuing this line of research. See, for instance, Hans Belting, "Die Reaktion der Kunst des 13. Jahrhunderts auf den Import von Reliquien und Ikonen," in *Ornamenta ecclesiae: Kunst und Künstler der Romanik,* ed. Anton Legner, vol. 3 (Cologne, 1985), pp. 173–83; idem, "The New Role of Narrative in Public Painting of the Trecento: historia and

Allegory," in *Pictorial Narrative in Antiquity and the Middle Ages* (Studies in the History of Art 16) (Washington, D.C., 1985), pp. 151–68; idem, "Wandmalerei und Literatur im Zeitalter Dantes," in *Epochenschwelle und Epochenbewusstsein,* ed. Reinhart Herzog and Reinhart Koselleck (Poetik und Hermeneutik, 12) (Munich, 1987), pp. 53ff.

71. Alfred Stange, *Deutsche Malerei der Gotik,* 11 vols. (Berlin/Munich, 1934–61).

72. Robert Suckale, "*Arma Christi:* Überlegungen zur Zeichenhaftigkeit mittelalterlicher Andachtsbilder," *Städel-Jahrbuch* 6 (1977), pp. 177–208; F. O. Büttner, *Imitatio Pietatis. Motive der christlichen Ikonographie als Modelle zur Verähnlichung* (Berlin, 1983).

73. Theodor Müller, *Sculpture in the Netherlands, Germany, France, and Spain: 1400 to 1500* (Baltimore, 1966). Another comprehensive book on this material is M. J. Liebmann, *Die deutsche Plastik 1350–1550* (Leipzig, 1982).

74. This situation has become very clear in the light of the magnificent exhibition, "Die Parler und der Schöne Stil 1350–1450," Cologne, 1978. There now seems to be agreement that such capital pieces of the International Style as the "Fair Virgin" in Altenmarkt in the Pongau from 1393 or the Pietà from Seeon in the Bavarian National Museum, Munich, probably come from Prague and not from Salzburg. For Altenmarkt, see Manfred Koller and Giovanna Zehetmaier in the catalogue, *Die Parler und der Schöne Stil,* vol. 1, pp. 408–9. For the Pietà from Seeon, see Alfred Schädler, "Masterpieces of Medieval Sculpture," *Apollo* 92/2 (1970), pp. 434–43.

75. See Eva Zimmermann, *Spätgotik am Oberrhein. Meisterwerke der Plastik und des Kunstgewerbes 1450–1530* (Karlsruhe, 1970), pp. 73, 77–84.

76. Recht, *Nicolas de Leyde,* p. 185. The author has listed thirty-four proposals for the attribution of the Virgin of Danolsheim and the Nördlingen altar between 1890 (Adolf Goldschmidt) and 1985 (Eva Zimmermann). This list is meant to be taken quite seriously. One wonders, however, if one could invent a more ironic denunciation of the "comedy of errors" of connoisseurship.

77. Anja Broschek, *Michel Erhart* (Berlin, 1973); Walter Deutsch, "Der ehemalige Hochaltar und das Chorgestühl: Zur Syrlin- und zur Bildhauerfrage," in *600 Jahre Ulmer Münster: Festschrift,* ed. Hans Eugen Specker and Reinhard Wortmann (Stuttgart, 1977), pp. 242ff.

78. See Manfred Koller, "Hauptwerke spätgotischer Skulptur und ihre aktuelle Restaurierung als Anlass wissenschaftlicher Kolloquien," *Maltechnik-Restauro* 84/2 (1978), pp. 81–95; for Nördlingen: Johannes Taubert, "Friedrich Herlins Nördlinger Hochaltar von 1462, Fundbericht," *Kunstchronik* 25/3 (1972), pp. 57–61; for Schwabach: Günter Bauer, ed., *Der Hochaltar der Schwabacher Stadtkirche,* with contributions by Christian Baur et al. (Schwabach, 1983); for Münnerstadt: Hartmut Krohm and Eike Oellermann, "Der ehemalige Münnerstädter Magdalenenaltar von Tilman Riemenschneider und seine Geschichte: Forschungsergebisse zur monochromen Oberflächengestalt," *Zeitschrift des Deutschen Vereins für Kunstwissenschaft* 34, 1/4 (1980), pp. 16–99; and for Lübeck: Eike Oellermann, "Bernt Notkes Werk, dessen Geschichte und Restaurierung," *Triumphkreuz im Dom zu Lübeck* (Wiesbaden, 1977), pp. 55–96.

79. See the excellent article by Thomas Brachert and Friedrich Kobler, "Fassung von Bildwerken," *Reallexikon zur Deutschen Kunstgeschichte,* vol. 7 (Munich, 1974), cols. 743–826.

80. See the old but still very useful book by Hans Huth, *Künstler und Werkstatt der Spätgotik* (Augsburg, 1923; 2d, enlarged ed., Darmstadt, 1967).

81. See, for instance, August Grisebach, *Die Kunst der deutschen Stämme und Landschaften* (Vienna, 1946); Paul Pieper, *Kunstgeographie. Versuch einer Grundlegung* (Berlin, 1936); and idem, *Das Westfälische in Malerei und Plastik* (Münster, 1964).

82. Jörg Rasmussen, "'Far stupire il mondo': Zur Verbreitung der Kunst des Veit Stoss," in *Veit Stoss: Die Vorträge des Nürnberger Symposions* (Munich, 1985), pp. 107ff. It is also characteristic that after this splendid talk Rasmussen was asked by a very serious colleague if he had the intention to turn to journalism.

83. Michael Baxandall, *Painting and Experience in Fifteenth-Century Italy. A primer in the social history of pictorial style* (Oxford, 1972).

The Cloisters or the Passion for the Middle Ages

Hubert Landais

The Cloisters is fifty years old now—or, to be more precise, it opened its doors to the public fifty years ago. I discovered it for the first time almost exactly thirty-five years ago, when, thanks to Francis Henry Taylor, then the director, and his friend Georges Salles, my first director, I received a research grant to spend three months in the United States. I remember going to The Cloisters at the very beginning of my stay, and I have often been back since, at least once each time I am in New York.

At the time, I was aware of the often virulent criticism of The Cloisters being expressed on the other side of the Atlantic, especially in France. I was a young medievalist and I almost went so far as to share in those criticisms. My professors were exacting, rigorous men, whose scholarship and competence I admired. Their criticisms were scathing and were focused on two main points: the composition of the collection and the way it was presented. What a scandal indeed for these French archaeologists to watch these cloisters taken stone by stone and reconstructed on the banks of the Hudson. Even the name—"The Cloisters Museum"—was a provocation for them. The cloisters reconstructed—Saint-Guilhem, Bonnefont, Trie, and Cuxa—all came from France, while the chapter house was from Pontaut, an arcade was from Froville, an arch from Narbonne, a fountain from Saint-Genis-des-Fontaines, and so on and so on.

The plan of the museum itself was inspired by a Cistercian abbey, and it is no accident that a number of guidebooks chose to demonstrate this to the public by including the plan of the French abbey of Royaumont. The same guidebooks contained a map that showed more than thirty-five locations in France from which objects or architectural elements in the collection originally came.[1]

The bitterness of the critics was even stronger in stressing the negligence, or the powerlessness, or both, of French authorities who neither would nor could protect these incomparable architectural ensembles, the destruction and dismemberment of which dated sometimes to the wars of religion, occasionally to the French Revolution, and sometimes, sadly enough, to much more recent periods.

In France, the growing interest on the part of individual regions in their patrimony was henceforth to be the strongest factor in their protection and preservation. There is no doubt that the creation of The Cloisters served as a warning for both European medievalists and public authorities and was the occasion for an important raising of consciousness.

The installation itself at The Cloisters, though seductive, was criticized for its use of modern elements to simulate the medieval, which the purists deemed excessive.

All this will easily explain why, upon my arrival as a graduate fellow in the Medieval Department at The Metropolitan Museum of Art, I was not spontaneously welcomed. Francis Taylor told me so, with his easy smile, and placed me in the "Renaissance and Medieval Department," where John Goldschmidt Phillips kindly received me. To complicate matters further, a controversy had arisen two years before between my then boss, Pierre Verlet, and James Rorimer on the occasion of the exhibition of French tapestries, the first important French exhibition in the United States after World War II.[2] The argument centered on the Unicorn tapestries: the Lady with the Unicorn at the Cluny Museum and the Hunt of the Unicorn at The Cloisters. Rorimer pointed out the evident restoration of the Parisian tapestries at the beginning of this century; Verlet responded by citing the La Rochefoucauld inventory of 1728, which specified that "They were in need of repairs," and by raising the question of their possible ownership by Anne of Brittany. Such bickerings were not easily forgiven!

It was only after several weeks that I had my first personal contact with the formidable chief curator of the Medieval Department and The Cloisters. I shall never forget the dinner to which I was invited at his home, where Mrs. Rorimer received me with her characteristic kindness. My esteem and my friendship for the Rorimers was born that day. From then on all doors were open to me.

How can one speak of The Cloisters without speaking of Rorimer, who was its soul and its driving force. I have called this essay "The Cloisters, or the Passion for the Middle Ages"—this passion was certainly his, a man who, underneath a sometimes brusque manner, hid a sensitivity, exacting standards, and a depth of knowledge that one finds in all aspects of the Museum.

First, though, let me correct a mistaken belief common in France. It was not Rorimer who first had the preposterous-sounding idea of bringing dispersed cloisters together in New York and then making a museum. George Grey Barnard had opened his collection to the public beginning in 1914: it already included the cloisters of Cuxa, Saint-Guilhem, Bonnefont, and Trie; and a cloisters museum belonging to the Metropolitan was in existence from 1926.

At this juncture, one man played a considerable role; he was John D. Rockefeller, Jr., who provided The Metropolitan Museum of Art with 600,000 dollars for the purchase of the Barnard collection in 1925 and then gave a large part of his own collection, and offered the land that was to become Fort Tryon Park to the city of New York. He recognized the importance of these assembled collections and the interest that there would be in presenting them in a modern, attractive way.

Who first had the idea for the present design? I do not know. What part was played by the architect, Charles Collens, what part by Joseph Breck, "master of the works" up to his death in 1933, or by Rorimer, who was involved in the operation from the beginning? What is clear is that from 1933 to 1938, thus during the entire period of construction, Rorimer was responsible. In the preface to the first edition of the guidebook, Herbert E. Winlock emphasized the collaboration of Collens and Rorimer: ". . . and to these two more than to anyone else the present form of The Cloisters is due."[3] William Forsyth will also discuss the origins of the museum, which are poorly known.

Now that The Cloisters has become a classic museum of its kind, it is difficult to imagine how novel it seemed at the time; nevertheless let us, now, with the benefit of a little hindsight, analyze the elements that made it so new.

If we consider the evolution of museums during this century, it can be said that The Cloisters was one of the first "site museums"—that is, one of the

first museums where discrete architectural elements were transplanted to a predetermined site and then grafted onto a new building complex that would evoke the original location from which the exhibited works came. This idea had been adopted in very different realms, especially for museums of folk art and popular culture. It has been most successful in Northern European countries, which have always been in the vanguard in this area. At The Cloisters, the adaptation of the architectural ensemble to the new site was closely studied. After all, it was not easy to conjure up a Romanesque site in the lush landscape of the Hudson River and the George Washington Bridge. The proportions were problematic, but the success is evident for all to see.

A "site" museum, but it was also to be an "ambience" museum—the underlying idea is obvious—to enable the American public to become familiar with the monastic architecture of the Middle Ages. One of the hazards that such "ambience" museums have not always been able to avoid is the artificiality of their interior decoration. A certain amount of artifice is of course unavoidable, but it is only acceptable if it is neither seen nor felt.

⊛ The best solution to the problem, and the one adopted at The Cloisters, is to let the objects themselves create the desired ambience, to let them serve as accompaniments to the architecture. If the purists and museum enthusiasts feel uncomfortable here, it is their concern. To them, the object, rightly deemed unique, must be isolated, presented for itself alone, and appreciated outside any other context. The choice taken at The Cloisters was carried to its logical conclusion. The great "Romanesque Hall," for example, has no fewer than three monumental doorways—from Moutiers-Saint-Jean, Reugny, and Poitou.⊛

This careful re-creation of ambience likewise required architectural ensembles that were not in ruins and whose missing elements could be either replaced or restored. Thus arose the campaign of restoration that was, as I have noted, sometimes criticized. In fact, everything was carefully and meticulously planned—even the modern stone foundations were drawn according to the most reliable of models. Probably never before was the evocation of the past so effective—to the point that this great artificial monastery, artfully arranged on several levels, seemed merely to be awaiting its inhabitants who, this time, would not be monks but rather a public eager to discover the roots of its culture.

All the elements contributed to the illusion— the Romanesque-style bell tower with its impressive dimensions, the four cloisters, the two chapels (there were to be three ultimately), the sculpture, the capitals, the stained glass, the fountains. Moreover there was a sense of chronological evolution; while Romanesque was certainly dominant, Gothic also had its rightful place.

This site museum, this "ambience museum," did not, at least at the beginning, attempt to encompass the entire western Middle Ages. Indeed, the very nature of the original collection may seem surprising. The overwhelming majority of works came from France or northern Spain, such that the map in the first two guidebooks, to which I already alluded, showed only those two countries. It was only in the third-edition guides that the map would be expanded to include Germany, Austria, and Italy, testifying to the expansion of the collection. The first section of the introduction to the first and second editions was entitled "The Middle Ages in France and Spain," a title that later disappeared.[4]

Another peculiarity that was not considered the least bit shocking was the mixture of religious and secular objects. Strict "ethics" would no doubt have required that religious objects be used exclusively to furnish the rooms adjoining the cloisters themselves—but how could anyone resist the charm of the Unicorn Tapestries, one of the most prestigious of Rockefeller's gifts. No one dreamed of taking offense at the proximity of the courtly and religious Middle Ages. Imperceptibly, the objects themselves began to modify the original goal of the museum, such that it came near to being a museum of the art of the Middle Ages in the truest sense of the word.

To my mind, these were the innovations. Now we must push the analysis further and look not for the models—there were none—but for other institutions that might have inspired the designers of The Cloisters. Three museums already in existence or under construction at the time seem to me to have exercised a decisive influence; it is probably no coincidence that one is in Spain and the other two are in France.

The Museu d'Art de Catalunya in Barcelona had as its objective the preservation of very important frescoes, which were replaced by copies in the

churches themselves. This impressive, beautifully arranged ensemble set an example. In Paris, the Musée National des Monuments Français, which replaced the earlier Musée de Sculpture Comparée, beloved by Viollet-le-Duc, underwent a complete renovation during the construction of the new Palais de Chaillot; along with the Musée de l'Homme, it became, thanks to Paul Deschamps, one of the most modern in Europe. Just the opposite of Barcelona, its collections were not original works of art but casts and copies of frescoes meant to facilitate comparison and research. An essentially didactic museum, its arrangement demonstrates the impact of monuments presented in an architectural complex of the highest level.

The second French museum was the Musée de Cluny. The former Parisian residence of the abbots of Cluny had the considerable advantage of being a medieval house, with its mullioned windows, its staircases, its chapel, its Gallo-Roman remains. In this museum, religious and secular objects were exhibited side by side, and its collection of tapestries was impressive—features that we can also see at The Cloisters. Even the administrative structure of the two museums is in some ways similar: The Cloisters is a dependency of the Metropolitan, but no outsider has ever been able to discover for what subtle reasons one object is exhibited at the Metropolitan and another at Fort Tryon Park. The same is true of the Cluny Museum, which, up to 1963, was administered by the Département des Objets d'art of the Louvre. Indeed the two museums experienced, and still experience, occasional difficulties in the choice and division of their collections.

In the United States, where the great medieval collections were already established, is it possible to determine if one or more might have served as a model for The Cloisters? While there is no easy answer, it is possible to suggest a certain line of investigation.

From the time of the inaugural exhibition of the medieval collections at Philadelphia in 1931, a large part of the cloister of Saint-Genis-des-Fontaines was on view, its missing elements being completed "with new roof timbers and tiles."[5] At the center of the reconstructed cloister was a fountain from Saint-Michel-de-Cuxa, while at The Cloisters it was a fountain from Saint-Genis that was set in the middle of the cloister from Cuxa. Other architectural ensembles were also shown in Philadelphia, and they belonged either to the museum itself or to private collectors such as Raymond Pitcairn and George Grey Barnard. Thus the influence of John D. McIlhenny, who had wanted to set up the medieval section at Philadelphia, may have extended beyond the city's boundaries.

Similarly, the Toledo Museum of Art had a cloister beginning in 1933; the museum's guide noted that "Cloisters, as well as cathedrals, were frequently built over a period of several centuries.... To show such a progression, the Toledo Museum of Art has secured colonnades from three times and places. The oldest is from Saint-Michel-de-Cuxa [bought in 1934] ...; the next, from the Abbey of St. Pons near Toulouse [bought in 1931] ...; the third, from the cloister of Pontaut [bought in 1933] ...; the fourth side is constructed of wood...."[6] Elements from the cloisters of Cuxa and Pontaut, then, are at Toledo, while the Pontaut Chapter House is in The Cloisters.

Other American public collections do not seem to have influenced the conception of The Cloisters. The admirable collection, in a very different spirit, of Mildred and Robert Woods Bliss had not yet been given to Harvard—that would happen in 1940. Henry Walters, who died in 1931, left "to the people of Baltimore" an astounding number of medieval works, some of them particularly important. But by chance, his museum preserved the atmosphere of a private collection—and Marvin Ross, its curator, spent years in discovering this, for not all the crates were opened before Walters died.[7] In New York, the Morgan Library, while rich in beautiful objects, did not add to their number, but rather concentrated its activity on manuscripts and books.[8] The Metropolitan itself always remained the spiritual mother of The Cloisters, willingly depositing works there or making it the beneficiary of temporary loans during the reinstallation of its own galleries.

Other museums with medieval works of art included within their more general collections, such as Boston, Washington, and Cleveland, seem to have served more as stimuli than as models for The Cloisters.

Cleveland had special links with the Metropolitan and The Cloisters. It must not be forgotten that the two principal protagonists of The Cloisters—John D. Rockefeller, Jr., and James J. Rorimer—were natives of this city. Had they remained there, it is

likely that the future of the two museums would have been entirely different. In Cleveland, William M. Milliken was undoubtedly one of the greatest museum directors of this country. Curator in 1919 and then director in 1931, he succeeded in acquiring the famous Guelph Treasure, placing Cleveland in the front rank of international museums. It is easy to imagine his displeasure in seeing Rockefeller leave for New York, displeasure that can be seen in a chapter of his small book, *A Time Remembered, A Cleveland Memoir:* "opposite the Wade House stood John D. Rockefeller's home, no longer occupied by him. Rapacious Cuyahoga County tax authorities had driven him to New York by attempting astronomical levies on all his tangible properties."[9] The attraction of New York has endured, even for curators.

Whatever the influences and rivalries may have been, let us underscore again this peculiarity about The Cloisters: this was to be the last great collection of medieval works of art to open to the public. The unfortunate dispersal of the von Hirsch collection destroyed one of the last opportunities; there will probably not be another.

Such was the museum at the time of its opening; such it has remained. Directors and curators, whether Francis Taylor, James J. Rorimer, Thomas Hoving, or Philippe de Montebello; Florens Deuchler, Margaret Freeman, Richard Randall, or William Wixom, all have had but one goal: to build upon and improve what had been started, rounding out the collections and developing services that were first "educational" and then "cultural."

James J. Rorimer never considered his work finished: like any curator, he knew that a museum that does not enrich itself, does not change itself, is a museum that risks losing a great deal of its impact. In 1934, the Rogers Fund afforded him the chance to buy elements of the choir of Notre-Dame-du-Bourg in Langon, while the generosity of Rockefeller procured for him the famous Unicorn Tapestries, as well as the Gothic doorway from Moutiers-Saint-Jean, whose original great statues would be added soon thereafter. The early building plans were modified to include the windows of the Dominican church at Sens and the Froville Arcade was given by George Blumenthal.

Rorimer had not been able to realize one of his fondest dreams, as he wrote in 1948: "When The Cloisters was opened to the public in Fort Tryon Park just ten years ago, a place in the new building was reserved for a future treasury." This later became possible with the acquisition, as always thanks to John D. Rockefeller, Jr., "of a selection made from the thousands of objects Joe Brummer . . . acquired. . . . They came via the Hermitage in Russia, great private collections in Paris, and the little fellow around the corner in Brooklyn."[10] The acquisition, in fact, was most important and the "sacristy," as it was called, could finally be installed. In addition to the Brummer collection, it included some works that The Cloisters owned but that it had not yet been able to exhibit, as well as others from the Metropolitan. Thus the ensemble was complete, and like some monasteries, and most great cathedrals—Rorimer evoked Saint-Denis, Cologne, Reims, Sens—The Cloisters had its Treasury (which has recently been reinstalled).

It is difficult to imagine what could have been added as a complement to all this, except a garden piously devoted to plants of the Middle Ages, the very ones that appear in manuscripts and *millefleurs* tapestries. This too was done.

Time does not allow me to review thoroughly the Museum's acquisitions over the last five decades, and *The Metropolitan Museum of Art Bulletin* has regularly published a list. Let it suffice, then, to underscore that these always fit easily within the prescribed framework of the collections. First of all, tapestries, of which the Nine Heroes are the indisputable masterpiece, bring us back to France, to Martinvast, near Cherbourg; then sculpture—the Strasbourg Virgin purchased in 1948, or the architectural elements given by the Hearst Foundation.

The objects destined for the Treasury hold a privileged place. The Chalice of Antioch, hailed as "probably the earliest known surviving Christian chalice," was immediately placed in the center of the gallery after its purchase.[11] One need hardly recall the great event of the acquisition of the Bury St. Edmunds Cross.

Up to now we have not spoken about paintings. Those from the Middle Ages are not numerous, hence the importance of the acquisition in 1950 of the Flemish altarpiece to which Ted Rousseau hoped one day to add "another living element to complete this already remarkable collection."[12] The addition, which was in fact much more than that, came in 1958, when the Mérode Altarpiece could be shown to the public for the first time.

Museums are not libraries, and there was no

book to be seen at The Cloisters until the acquisition in 1956 of two fine works: The Hours of Jeanne d'Évreux and the *Belles Heures* of Jean, duke of Berry. Both came from a well-known French collection, and the Bibliothèque Nationale very much regretted losing them.

To begin to understand how difficult it is to collect objects of this kind, what Francis Taylor called "the art of collecting," it is necessary to reread his book, *The Taste of Angels,* as well as *The Chase, the Capture,* a collection of essays published under the direction of Tom Hoving, and *Merchants of Art* by Germain Seligman, the celebrated dealer, unfortunately now deceased.[13] Seligman's table of contents alone mentions nearly all the dealers or collectors who, from 1880 to 1960, were actively acquiring objects that are now to be found in the great museums, especially the Metropolitan and The Cloisters. It would be interesting to undertake further studies of the history of collections, which are all too often neglected or kept hidden for various reasons, as they are an important key to knowledge.

After what I have said about The Cloisters and its evolution, you will understand how surprised I was not to find The Cloisters in Kenneth Hudson's recent book, *Museums of Influence,* which identifies thirty-seven museums in Europe and the United States that have, during the past two hundred years, pioneered fundamental changes in museum thinking and practice.[14] Not only does The Cloisters seem to me to have introduced a certain number of changes, which I have tried to define, but has also kept its place in the general evolution of museums, about which I wish to add a final word.

It seems to me that one of the notable evolutions that museums have undergone in the last decades is the determining role that they have played and continue to play, along with universities, in the perception of objects and thus of history itself. The time is past when curators were considered the poor relations of research. The great strides toward professionalism have borne fruit. Of course, museums have always had eminent specialists on their staffs, and their influence has allowed their institutions to escape from their isolation and be able to assert themselves—to the point that they have become one of the great laboratories of history.

To stay within the realm of the Middle Ages, this movement seems to me to have been initiated in prewar Germany, where the students or rivals of Wilhelm von Bode were in charge of the most important collections: Erich Meyer in Hamburg, Fritz Volbach in Mainz, and Theodor Müller in Munich. Somewhat later Herman Schnitzler was in charge at Cologne, and Erich Steingräber in Munich. Von Hirsch formed his own private collection after becoming a banker, but he, too, as a young man had been trained as a medieval specialist in the same school. It is hardly necessary to mention the influence in this country of Georg and Hanns Swarzenski, Adolph Goldschmidt, and Kurt Weitzmann.

The same development can be seen throughout Europe. Focusing on the example of France, which I know best, the role played by the university is no longer at issue. Henri Focillon, who taught in the United States, stands at the beginning of a true renaissance. His students, like Charles Sterling, sometimes went to museums, or would be close to them, like Louis Grodecki. Likewise at the university, the work of Marc Bloch, Fernand Braudel, and Georges Duby would profoundly alter our view of the Middle Ages. Their teaching spread within the university system, but equally to the École Pratique des Hautes Études, where J. J. Marquet de Vasselot was trained, and to the École des Hautes Études en Sciences Sociales, directed by Jacques Le Goff.

The École des Chartes, often in conjunction with the École du Louvre, has, in its turn, trained a large number of curators, from Marcel Aubert to Paul Deschamps, from Pierre Pradel to Pierre Verlet, Marc Thibout, and Francis Salet. Happily the tradition has been perpetuated. Before World War I, only one *Chartiste,* and far from the least, numbered among the curators of the Louvre: Émile Molinier.

A parallel evolution can easily be seen in American museums, and it would be interesting to have a list of graduates of Yale, Princeton, Harvard, and the other great American universities who benefited from the teaching of Paul Sachs, Millard Meiss, Meyer Schapiro, and many others, and became responsible for medieval collections.

Neither the Metropolitan nor The Cloisters, which always maintained a symbiotic relationship with the Medieval Department, was immune to these changes, as the examples of James J. Rorimer, William Forsyth, Thomas Hoving, Vera K. Ostoia, and Carmen Gómez-Moreno testify, not to mention those now in charge.

Two particular museum activities have substantially contributed to their credibility: exhibitions and catalogues. Many negative things have been said about exhibitions; yet the importance of successful exhibitions in advancing our knowledge of art cannot be denied. In this brief essay, it is not possible to draw up a complete list. Still, I thought it would be interesting to assemble a list of more than fifty outstanding exhibitions that have taken place over the course of the last forty years:

— "French Tapestries," Paris/London/Amsterdam/Brussels/New York, 1946–48.
— "Early Christian and Byzantine Art," Baltimore, 1947.
— "Trésors des musées de Vienne," Paris, 1947.
— "Trésors du Moyen Âge Allemand," Brussels/Amsterdam, 1949.
— "Ars sacra: Kunst des frühen mittelalters," Munich, 1950.
— "Art Mosan et arts anciens du pays de Liège," Liège, 1951.
— "Le grand siècle des ducs de Bourgogne," Dijon, 1951.
— "Franconia Sacra," Würzburg, 1952.
— "Trésors d'art du moyen âge en Italie," Paris, 1952.
— "Vitraux de France du XIe au XVIe siècle," Paris, 1953.
— "Les Manuscrits à peinture en France du VIIe au XIIe siècle," Paris, 1954.
— "Les Manuscrits à peinture en France du XIIIe au XVIe siècle," Paris, 1955.
— "Werdendes Abendland an Rhein und Ruhr," Essen, 1956.
— "Chefs-d'oeuvre romans des musées de province," Paris, 1957–58.
— "Grosse Kunst des Mittelalters aus Privatbesitz," Cologne, 1960.
— "Saint Louis à la Sainte Chapelle," Paris, 1960.
— "L'Art roman," Barcelona/Santiago de Compostela, 1961.
— "Cathédrales," Paris, 1962.
— "Europäische Kunst um 1400," Vienna, 1962.
— "Medieval Manuscript Illumination from the Private Collection of George Wildenstein in Paris," New York, 1962–63.

— "Byzantine Art: An European Art," Athens, 1964.
— "Romanische Kunst in Österreich," Krems, 1964.
— "Karl der Grosse, Werk und Wirkung," Aachen, 1965.
— "Les Trésors des églises de France," Paris, 1965.
— "Treasures from Medieval France," Cleveland, 1966–67.
— "La Librairie de Charles V," Paris, 1968.
— "L'Europe Gothique," Paris, 1968.
— "Medieval Art from Private Collections," New York, 1968–69.
— "The Middle Ages: Treasures from The Cloisters and The Metropolitan Museum of Art," Los Angeles/Chicago, 1970.
— "The Year 1200," New York, 1970.
— "Art and the Courts," Ottawa, 1972.
— "Rhein und Maas: Kunst und Kultur 800–1400," Cologne/Brussels, 1972.
— "French Art in the Middle Ages," Quebec/Montreal, 1972–73.
— "Venezia e Bisanzio," Venice, 1974.
— "Tesori d'arte sacra di Roma e del Lazio dal Medioevo all'Ottocento," Rome, 1975.
— "Byzantine Art," Moscow, 1977.
— "Die Zeit der Staufer," Stuttgart, 1977.
— "Treasures of Early Irish Art," New York, 1977.
— "Age of Spirituality: Early Christian Byzantine Art, Third to Seventh Century," New York, 1977–78.
— "Die Parler und der schöne Stil 1350–1400," Cologne, 1978.
— "Kaiser Karl IV," Nuremberg/Cologne, 1978–79.
— "The Vikings," London, 1980.
— "Wittelsbach und Bayern," Munich, 1980.
— "The Wild Man: Medieval Myth and Symbolism," New York, 1980–81.
— "Medieval Enamels," London, 1981.
— "The Royal Abbey of Saint-Denis in the Time of Abbot Suger (1122–1151)," New York, 1981.
— "Les Fastes du Gothique: le siècle de Charles V," Paris, 1981–82.
— "Radiance and Reflection: Medieval Art from the Raymond Pitcairn Collection," New York, 1982.
— "English Romanesque Art 1066–1200," London, 1984.
— "The Treasury of San Marco, Venice," Paris/New York, 1984.
— "Gothic and Renaissance Art in Nuremberg 1300–1550," New York/Nuremberg, 1986.
— "Age of Chivalry," London, 1987–88.

These are only the principal examples; there were many others. Their catalogues remain and have become definitive references in the field.

Catalogues of museums' permanent collections have not, alas, developed at the same pace, but the materials now exist to allow them to be continuously updated. Both the Metropolitan and The Cloisters have played an important role in this international activity, as we have seen, maintaining a prominent place in this great network of museums all sharing the same passion for the Middle Ages.

I wish to close by emphasizing the importance of these activities and of international relations. Since 1945, these relations have never stopped growing and strengthening. Gradually cooperation has replaced competition, even if there is considerable progress still to be made. While not always so successful as one might have hoped, international organizations have still played an important role. The International Council of Museums was founded in 1946: its first president, Chauncey J. Hamlin, was American; the second, Georges Salles, was French. Its membership today includes nearly 120 countries. Personal friendships have done the rest; and so, finally, I wish to note the quality of those that I have had with the last four directors of The Metropolitan Museum of Art and The Cloisters and their colleagues, who have honored me with their friendship.

ACKNOWLEDGMENTS

For their assistance in the preparation for publication of this talk, I wish to thank Barbara Drake Boehm for her translation from the French and Allison Merrill for her help with the notes.

NOTES

1. James J. Rorimer, *The Cloisters: The Building and the Collection of Mediaeval Art in Fort Tryon Park* (New York, 1938), p. xxvii (plan of Royaumont), and p. xix (provenance map); ibid., 1951 ed., p. xxix (plan of Royaumont) and p. xix (provenance map); and ibid., 1963 ed., p. 5 (plan of Royaumont) and inside cover (provenance map).

2. There was an exhibition of French tapestries organized under the auspices of the Louvre and shown in Paris during the summer of 1946 (a book by Francis Salet, *La tapisserie française, du moyen-âge à nos jours* [Paris, 1946], was published on the occasion and served as catalogue). Portions of the exhibition were thereafter shown in Amsterdam, Brussels, and London, and opened at the Metropolitan Museum on Nov. 21, 1947. Roland L. Redmond, "The Exhibition of French Tapestries," *MMAB* 6, no. 3 (Nov. 1947), p. 81.

3. Herbert E. Winlock, pref. to James J. Rorimer, *The Cloisters: The Building and the Collection of Mediaeval Art in Fort Tryon Park* (New York, 1938), p. vi.

4. See note 1 above.

5. Pennsylvania Museum of Art [now Philadelphia Museum of Art], *The Display Collections: European and American Art* (Philadelphia, 1931), p. 13.

6. The Toledo Museum of Art, *Guide* (Toledo, n.d.), p. 11.

7. Walters Art Gallery, Baltimore, *Handbook of the Collection* (Baltimore, 1936), p. 6.

8. Frederick B. Adams, Jr., *An Introduction to the Pierpont Morgan Library* (New York, 1964), pp. 6, 16–18.

9. William Mathewson Milliken, *A Time Remembered, A Cleveland Memoir,* Western Reserve Historical Society Publication, no. 132 (1974), p. 27.

10. James J. Rorimer, "A Treasury at The Cloisters," *MMAB* 6, no. 9 (May 1948), p. 237.

11. The Antioch Chalice (50.4) is now on exhibition at The Metropolitan Museum of Art, where it is exhibited with other Early Christian silver objects from Syria.

12. Theodore Rousseau, Jr., "A Flemish Altarpiece from Spain," *MMAB* 9 (June 1951), p. 283.

13. Francis Henry Taylor, *The Taste of Angels: A History of Art Collecting from Rameses to Napoleon* (Boston, 1948), p. x; Thomas Hoving, *The Chase, the Capture: Collecting at the Metropolitan* (New York, 1975); and Germain Seligman, *Merchants of Art, 1880–1960: Eighty Years of Professional Collecting* (New York, 1961).

14. Kenneth Hudson, *Museums of Influence* (Cambridge, 1987).

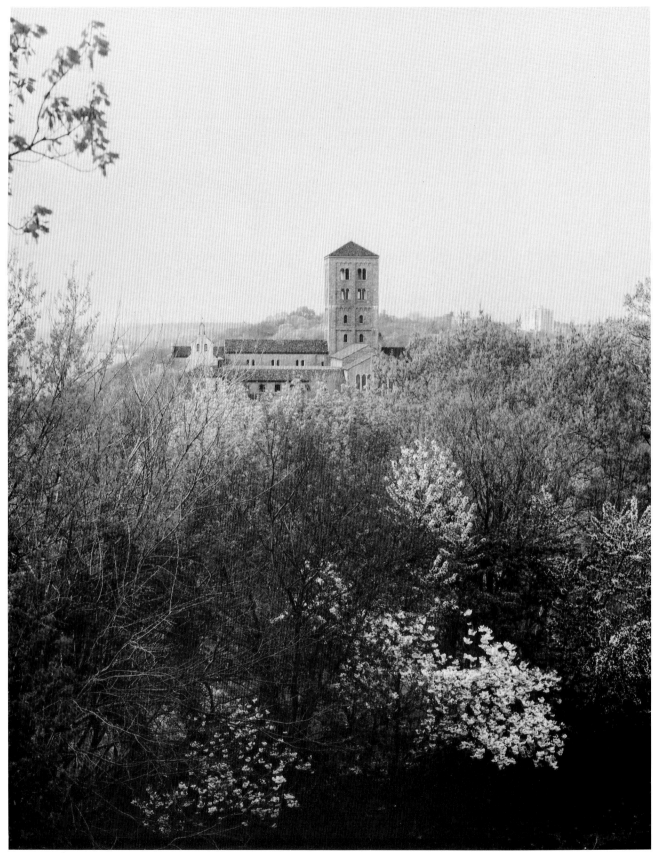

Fig. 1. The Cloisters, Fort Tryon Park (photo: Museum)

Five Crucial People in the Building of The Cloisters

William H. Forsyth

The Cloisters is the only museum in America devoted exclusively to medieval art (Fig. 1). This essay deals with its origin and development through the activities of five men who may be considered its founding fathers. Two are still well remembered: John D. Rockefeller, Jr., and James J. Rorimer (Figs. 2, 3). The others have been largely forgotten: George Grey Barnard, Joseph Breck, and Charles Collens (Figs. 4–6).[1]

The story begins with George Grey Barnard, an imposing, almost heroic, figure despite his size—short, like Napoleon—with a sculptor's hands and an orator's voice (Fig. 4). A man of strong convictions, a creative and romantic sculptor,[2] he helped rouse America to the value of medieval art. He was the first to conceive of a cloisters museum.[3] This would not have been appropriate for Europe, but for those Americans who knew almost nothing of medieval art, the exhibition of medieval works of art in a quasi-medieval setting was enormously powerful. Going abroad to execute a commission of sculpture for the Pennsylvania state capitol at Harrisburg, Barnard was in France when he ran out of money. With a family to support, he began to collect and deal in works of art, partly perhaps from inclination, but certainly from necessity. Sculptor that he was, he appreciated medieval sculpture. He acquired it wherever he could and sold it to whomever he could. Roaming the French countryside, he was also able to amass a sizable and impressive collection for himself, which he had the gumption and the tenacity to get out of France just in time, before both World War I and the new export laws closed the door.[4]

In December 1914, he opened his collection on Fort Washington Avenue to the public for the benefit of French war orphans, and he called it the Cloisters, later to be known as the Barnard Cloisters (Fig. 7).[5] Everyone flocked to see it.

Fig. 2. John D. Rockefeller, Jr., 1874-1960 (photo: Museum)

fragments of cloisters scattered about, and in an outside garden Barnard had erected two sides of a cloister arcade from the monastery of Saint-Michel-de-Cuxa.

John D. Rockefeller, Jr., must have been among the visitors who felt the spell of the place (Fig. 2). Mr. Rockefeller, whose modesty equaled his eminence and whose eminence was worthy of his wealth, was a man of vision and discretion. On May 28, 1925, he offered to buy the collection for the Metropolitan Museum, an offer eagerly accepted by the Trustees, and through the Museum by Barnard.[6] From the beginning Rockefeller evidently regarded it as only temporarily housed on the small property that was soon to be crowded by apartment buildings. In September of the same year, he consulted the architect William Wells Bosworth about transporting the collection to another site. Raymond Fosdick, in his well-informed biography, puts it this way: "In the background of Rockefeller's mind was the idea of a more suitable site for the cloisters on the rocky, woody point just north of the Billings estate which he had bought some years before" (Fig. 9).[7]

Here was an artist's vision of the Middle Ages, not a modern archaeological reconstruction. For all its shortcomings—and there were a number—the Barnard Cloisters opened a door to a romantic vision of the past that nothing else could have done so effectively in America in that period. Here was an Arthurian legend come to life, "mystic, wonderful." Within a rather small brick building, dimly lit and incense-filled, presided over by monk-robed guardians and enlivened by the music of a medieval chant playing in the background, was another world—today quaint and outmoded, but then wonder-filled (Fig. 8). The whole exhibit recalled a medieval church, with arcaded side aisles supporting arcaded balconies, all composed of parts of medieval cloisters, and with an apselike eastern end. The emphasis was on height. One virtue of height is the higher you go, the less you see. And some of the objects on top that look so glamorous—almost like a miracle play—weren't so awfully good when you got them down. There were other

Fig. 3. James J. Rorimer, 1905-1966 (photo: Museum)

Fig. 4. George Grey Barnard, 1863-1938 (photo: courtesy NYT Pictures)

Fig. 5. Joseph Breck, 1885-1933 (photo: Museum Archives)

Cornelius Kingsley Garrison Billings was a strikingly flamboyant character, very much a contrast to the retiring Rockefeller. His fantastic style of living may be imagined by a memorable party he staged in 1903 at Louis Sherry's. He had the roof garden transformed with green turf, trees, plants, and singing birds. His guests were mounted on horseback and while mounted sipped champagne through rubber tubes. Waiters dressed as red-coated grooms served them a full-course dinner on special tables anchored to the animals' flanks.[8]

Rockefeller was deeply concerned about the Hudson Valley and the Palisades, which he had explored on horseback as a young man. He had ridden over this wooded land in northern Manhattan as well. He quietly began to acquire other land on all sides of the Cornelius Billings estate, which he

had purchased in 1917. Rockefeller had the vision of making this entire site a public park, and in June 1930 he offered to give it to New York City for a park to be called Fort Tryon after the fort captured by the British during the American Revolution. Four acres of the highest land were to be reserved for a "monument" to be known as The Cloisters. Although it took five years for the city fathers to accept this offer, it did not take the Museum's Trustees that long, needless to say, to accept such a spectacular gift.[9]

There were a number of ideas about what sort of a building should be erected.[10] From traveling abroad, Rockefeller's early dream was of a castlelike fortification inspired by Sir Walter Scott's *Kenilworth,* which he loved. The suggestion of this Kenilworth idea is implied in an early sketch for the proposed building, where the middle tower originally was like a castle keep (Fig. 10). And this inspiration still remains in the rampart wall, the portcullis, and the entry gate of the present building (Fig. 11). It was Rockefeller's idea that this was to be the monument on the top of this land that was to be seen from

Fig. 6. Charles Collens, 1873-1956 (photo: Collens family)

Fig. 7. Exterior view of the Barnard Cloisters on Fort Washington Avenue (photo: Museum)

the Hudson. Another idea, the fantasy of a modern structure like a glass cube with exhibits displayed like specimens as in a museum of science, fortunately died quickly. The third idea, of a central courtyard with four large halls extending out from it and with Barnard's Cloisters on the periphery, has partly survived in the present plan. In the final plan, the center became a large portion of the cloister from Saint-Michel-de-Cuxa,[11] surrounded by medieval halls containing Romanesque and Gothic art. Three other cloisters are placed outside this central core: the capitals and columns of the monastery of Saint-Guilhem-le-Désert to the north,[12] and carved elements from the cloisters from Bonnefont-en-Comminges and Trie-en-Bigorre to the west and southeast.[13] An open-air corridor on the eastern side

of the building incorporates cusped arches from the wall of a small cloisters at the Benedictine priory of Froville.[14]

The Museum curator responsible for helping to work this plan out was Joseph Breck (Fig. 5). Of the original five, he was the bridge between the Barnard Cloisters and the museum we now know as The Cloisters. Assistant Director of The Metropolitan Museum of Art and Curator of Decorative Arts in charge of its vast collections of Western European art, Breck was a deeply committed and experienced museum man, a talented scholar who knew how to present his ideas in clear visual form.[15] He had the very difficult job of putting order into the rather haphazard, if picturesque, arrangements of the newly acquired Barnard Cloisters without

Fig. 8. Interior view of the Barnard Cloisters (photo: Museum)

Fig. 9. Lithograph showing future site of The Cloisters, 1856 (courtesy of Charles T. Little)

destroying its charm. This he did, although not without arousing the ire of Barnard, who lived next door to his own beloved cloisters, which he regarded as his personal creation, not to be touched. Breck even took a particular interest in installing an herb garden, more authentic than Barnard's own miscellaneous plantings.[16] After some years as Director of the Barnard Cloisters, Breck was put in charge of the planning for the new one, and he worked hard at this project for the last three years of his life.

In support of his plan for a systematic and orderly display of the evolution of Romanesque into Gothic, Breck submitted many ideas and sketches. To avoid unclear interpretations and blendings of style, he sought to copy medieval precedents closely. His knowledge and his sharp historical point of view were a healthy check on the romantic exuberance that had dominated the Barnard Cloisters, and still dominated to a certain extent the new museum. Unfortunately Breck aroused antagonism as idea after idea for "improvements" kept pouring from him. At last a resolution was passed by the long-suffering Building Committee of the Board of Trustees forbidding any further changes unless absolutely necessary, a resolution sent to Rockefeller which Breck was constrained to sign.[17] It is sad to note that soon afterward Breck died in Switzerland of a heart attack, the result—one fears—of so much stress. His obituary clearly acknowledged his great contributions to the formation of the museum.[18] It is certainly right to emphasize that The Cloisters, in the form in which it was finally constructed, followed in large part the plan approved in January 1933, seven months before Breck's death. Later changes, important as they were, were essentially refinements and simplifications of the 1933 plan.[19]

Charles Collens, the next on our list of crucial people, was a gentleman from every point of view (Fig. 6). He was the distinguished architect chosen by Rockefeller and the Trustees to design The Cloisters.[20] Collens, experienced in the use of the Gothic style, and a wise man to boot, was fortunately flexible and modest enough to listen to the opinions of others and to follow them as far as he thought expedient. Collens was also familiar with Rockefeller's thinking because he was then finishing the building of Riverside Church. He deserves great credit for giving us in The Cloisters a building that is both impressive and harmonious, blending the Romanesque and the Gothic without the fuzziness

Fig. 10. Otto Eggers. Early sketch for The Cloisters reflecting influence of Kenilworth Castle, 1928 (photo: Museum)

Breck had so feared. His overall scheme of massing the galleries around the Cuxa Cloister under a great central tower, modeled after one still standing at that monastery, was surprisingly successful.[21] It was his skill in solving the complexities of the project, human as well as architectural, that made the whole plan workable. Collens was shrewd enough to keep the idea of the English castle on the exterior that Rockefeller had wanted for the Hudson view, but its interior design was a compromise between the architect's original conception and Breck's more severely correct sequences from Romanesque to Gothic.

Luckily for the Museum, James Rorimer, who since 1927 had already worked both with and for Breck on The Cloisters, was appointed to succeed him as its Curator (Fig. 3).[22] Rorimer was the man of the hour: sharp-eyed, brilliant, and alert, a master strategist. He substituted for Breck's stubborn tactics more subtle ones that were more effective in carrying out the needed changes, simplifying many of the details, and replacing much of the modern Gothic architectural elements with original ones.

As soon as Rockefeller's gift for the new Cloisters was announced in the press, he was flooded with offers of purchase—good, bad, and indifferent. Gradually, as he came to trust Rorimer's good eye and good judgment, Rockefeller turned these offers over to him to deal with as he thought best. How well Rorimer satisfied the donor is revealed in the words of praise Rockefeller showered on him at the opening ceremony on May 10, 1938.[23] When he made his later gift of ten million dollars in 1952 "for the enrichment of The Cloisters," Rockefeller had every reason to believe that Rorimer would be there to see that it was well administered.[24] Rorimer's efforts also clearly satisfied the Trustees, who elected him Director of The Cloisters in 1949 and Director of The Metropolitan Museum of Art in 1955.[25] And how well he satisfied the general public is proved by the phenomenal attendance figures since The Cloisters opened.

Rorimer told me that he never asked Rockefeller for a cent. He studied his man as intently as an actor does his part. He waited until Rockefeller came to him, and even then he always consulted him on

Fig. 11. Joseph Breck. Pencil sketch of Cloisters
exterior with inset of Carcassone, June 26, 1933
(photo: Museum)

every important phase of each negotiation and
purchase. Both men enjoyed the negotiating process
immensely and both knew the value of the dollar.
Early on, for instance, Rockefeller gave a small sum
to pay for a minor purchase of some original Gothic
window tracery from Normandy. Rorimer saved
several hundred dollars by bargaining with the seller,
and returned the balance to Rockefeller in a
registered check with his thanks. Rorimer was not
only adept at seeing the possibility of obtaining more
reasonable prices whenever he could but he would
also reduce the effective cost of the architectural
exhibits by subtracting the expense of the modern
architecture which they replaced. The stakes grew
higher and higher. At many breakfast conferences
Rockefeller demonstrated his increasing confidence
by turning over to Rorimer more money and more
authority. Purchases were spectacular: the Langon

Chapel, the Pontaut Chapter House, the Boppard
stained-glass windows, a host of doorways, and many
other great additions.[26] The apse of the Fuentidueña
Chapel, perhaps the greatest of the architectural
additions, came long after The Cloisters was built.
After negotiations with the Spanish government,
which went on for years, Rorimer—adroit, patient,
and wise—finally arranged for its installation in 1957
on the basis of a "long-term loan."[27]

During the Great Depression of the 1930s, when
many architects, sculptors, and painters were on
emergency relief, Rorimer seized on the idea of using
them to make a study model of the interior of the
proposed museum (Fig. 12), with sculpture and
frescoes to scale and the light coming through the
windows the way it would if it were built.[28] When
he showed it to Rockefeller, who looked at it intently
and asked: "Is this the way The Cloisters is going
to look?," Rorimer replied: "No, Mr. Rockefeller, it
is not the way it is going to look. It is merely the
way it could look if you wanted it to." Rorimer always
maintained that Rockefeller's reaction to his reply
kindled his enthusiasm for continuing the work. To
do so at that time must have taken a good deal
of courage in the face of almost certain criticism:
that so wealthy a man should spend so much money
in such a way when so many were suffering. But
Rockefeller was thinking of the public good in the
years to come.

Then there were his nonarchitectural gifts,
virtually as important, which included the Unicorn
Tapestries.[29] Rockefeller had noticed on the plans
a room marked "Tapestries." He asked Rorimer just
what he had in mind. Rorimer replied, "Oh,
something like the Unicorn Tapestries." Rockefeller
winced and quickly changed the subject, since he
greatly treasured those tapestries, then hanging in
his New York home. But later he told Rorimer to
include them among his gifts. That was indeed a
real sacrifice on his part. Once, when in France after
I had become Rorimer's assistant (Fig. 13), I had
the joy and excitement of discovering two missing
and crucial sections of the capture scene in the
Unicorn Tapestries; this was when I ventured to call
on the comte de la Rochefoucauld. His father had
once owned the whole set and had kept back these
two sections as curtains for his bed!

The story of how the other great set of tapestries,
called the Nine Heroes, was acquired is also worth
telling.[30] The antiquarian and art dealer Joseph

Fig. 12. Study model of The Cloisters (photo: Museum)

Fig. 13. William H. Forsyth in 1938, the year of The Cloisters' opening (photo: Museum)

Brummer had seen a photo of a vase offered for sale. Behind the vase he spotted the tapestries, dim and out of focus. Intrigued, he visited the Norman château, ostensibly to buy the vase, but casually asking that the tapestry curtains be included in the purchase price. An easy maneuver for Brummer, but far from easy for us in turn to buy them from him. He knew very well that they were the rarest set available in the world! Because the tapestries had been cut up for draperies into more than ninety pieces, it took the Curator, Peg Freeman, and her associates months of patient fitting together, a real picture puzzle, before, under Rorimer's supervision, she was able to hang them in their own gallery.

In summation, one can say that The Cloisters would never have been built without the vision and the funds that Rockefeller supplied; that it could hardly have been conceived without the pioneer zeal of Barnard; that it would not have been so well planned without the painful and sometimes stubborn insistence of Breck on historical accuracy; nor so well built without the architectural expertise of Collens—and of his chief contractor, Marc Eidlitz, who got a lot of stonemasons, some of them from Europe, to cut stones the right way for a medieval

59

site;[31] nor, above all, without the eye for enriching and simplifying, and the adroit maneuvering of Rorimer. Never was there a better blend of talents, despite much tension and stress along the way, and at times—as I well remember—near despair. How fortunate we all are that these singular talents, to be remembered with gratitude, along with many others, were able to combine so magnificently to give countless Americans a living experience of medieval Europe.

ACKNOWLEDGMENTS

I am indebted to all the staff from the Metropolitan Museum who helped gather the material to assist in the preparation of this paper, in particular William D. Wixom, Chairman of the Department of Medieval Art and The Cloisters, Mary B. Shepard, Charles T. Little, Lauren Jackson-Beck, Mary Rebecca Leuchak, Jeanie James, and Barbara File.

NOTES

1. Contributions of later benefactors and curators are not within the scope of this essay, but would necessarily be part of the as-yet-unwritten full history of The Cloisters. Some of the others who should be remembered include Cloisters Curators Margaret Freeman (employee, 1928–65) and Anne de Bonneville ("Bonnie") Young (1946–81). The Metropolitan Museum Directors during the construction period were Edward Robinson (1910–31), and Herbert E. Winlock (1932–39). The relevant Presidents of the Museum were Robert W. de Forest (1913–31); William Sloane Coffin (1931–33); George Blumenthal (1934–41), who was President at the opening of The Cloisters in 1938; and William Church Osborn (1941–47).

2. For more detailed accounts of Barnard, see Harold E. Dickson, "The Origin of 'The Cloisters,'" Art Quarterly 28 (1965), pp. 253–71; Mahonri Sharp Young, "George Grey Barnard and The Cloisters," Apollo 106 (Nov. 1977), pp. 332–39; J. L. Schrader, "George Grey Barnard: The Cloisters and the Abbaye," MMAB 36 (1979), pp. 1–52. Barnard's best-known sculpture is probably The Two Natures of Man (96.11), now exhibited in The Engelhard Court in the Metropolitan Museum's American Wing.

3. Isabella Stewart Gardner's Fenway Court in Boston, opened in 1902, had already evoked fifteenth-century Venice with the installation of her collection in galleries surrounding an inner courtyard with arcaded balconies suggesting cloisters. See George L. Stout, Treasures from the Isabella Stewart Gardner Museum (New York, 1929), pp. 22, 31. Later, in the 1920s and 1930s, the exhibition design of other American art museums included cloisterlike reconstructions using medieval architectural elements: in 1928 the Philadelphia Museum of Art installed a cloister believed to be from the abbey at Saint-Genis-des-Fontaines, see: Francis Henry Taylor, "Two great works of

Romanesque Art," The Pennsylvania Museum Bulletin 24, no. 123 (1928), pp. 3–11; The Fifty-Third Annual Report: Pennsylvania Museum of Art (1929), p. 17; Pennsylvania Museum of Art, The Display Collections of European and American Art (Philadelphia, 1931), pp. 10–13; Philadelphia Museum of Art, Treasures of the Philadelphia Museum of Art (Philadelphia, 1973), p. 32; Edna Diskant, "Le cloître de Saint-Genis-des-Fontaines à Philadelphie," Les Cahiers de Saint-Michel de Cuxa 20 (1989), pp. 225–34. In 1933 the Toledo Museum installed a cloister composed of disparate architectural elements, including capitals from the abbeys of Saint-Pons-de-Thomière (mid-twelfth century and early thirteenth century), Saint-Michel-de-Cuxa (late twelfth century), and Notre-Dame-de-Pontaut (late fourteenth century). See Toledo Museum News 64 (1933), n.p.; "Medieval Art at Toledo: a selection," Apollo 86 (1967), p. 438; R. Weinberger, "The Cloister," Toledo Museum News 21 (1979), pp. 53–72. Similarly, in 1930, the Cleveland Museum of Art installed fourteen capitals from the narthex of the Collégiale de Saint-Melaine-de-Preuilly-sur-Claise (reinstalled in 1978) in a manner suggesting their original architectural context. See William M. Milliken, "Report of the Department of Decorative Arts," Fifteenth Annual Report of the Cleveland Museum of Art (1930), pp. 30–31; idem, "Romanesque Capitals," Bulletin of the Cleveland Museum of Art 17 (Apr. 1930), pp. 57, 59–63, 69, 72; William D. Wixom, "The Romanesque Sculpture in American Collections. XVIII. The Cleveland Museum of Art," Gesta 18 (1979), pp. 40–41. For a general discussion of medieval installations in American museums, see Germain Bazin, The Museum Age (New York, 1967), chap. 11: "The New World," pp. 241–62, esp. p. 256.

4. Robert A. M. Stern, Gregory Gilmartin, and Thomas Mellons, New York 1930: Architecture and Urbanism between the Two World Wars (New York, 1987), p. 771 n. 31.

5. Schrader, "George Grey Barnard," pp. 1–10.

6. See Joseph Breck, "The Cloisters," MMAB 20 (July 1925), pp. 166–77; Winifred E. Howe, A History of The Metropolitan Museum of Art, vol. 2: 1905–1941 (New York, 1946), p. 212; Schrader, "George Grey Barnard," p. 36. The official press release of June 1925 announcing the decision of the board was made by Robert W. de Forest, then President of the Museum's Board of Trustees [Museum Archives]. The news reached the public in the New York Herald Tribune (June 6, 1925), the New York Telegram (June 15, 1925), and the New York Sun (June 15, 1925).

7. See Raymond D. Fosdick, John D. Rockefeller, Jr.: A Portrait (New York, 1956), pp. 337–38. See John E. Harr and Peter J. Johnson, The Rockefeller Century (New York, 1988), p. 221, who suggest Rockefeller only developed the idea of moving the collection in the late 1920s. A catalogue of the Billings estate, Fort Tryon Hall: The Residence of C. K. G. Billings, esq., described by Barr Ferree, was printed privately by the owner in 1911 [The Cloisters Library].

8. For a full account of the evening, see Albert Stevens Crockett, Peacocks on Parade (New York, 1931), p. 231.

9. For June 7, 1930, the Times banner headline on the first page ran: **ROCKEFELLER OFFERS CITY 56 ACRE $13,000,000 PARK TO INCLUDE ART MUSEUM.** Rockefeller's offer was finally accepted by New York City in 1935.

10. Among those Rockefeller consulted were Dr. William R. Valentiner, a former curator of the Metropolitan Museum from

1908 to 1917 and director of the Detroit Institute of Arts from 1924 to 1945. Valentiner encouraged Rockefeller to find an architect who could create "an original piece of modern architecture . . . suggesting the idea of a medieval building. The building should, however, have no imitation Gothic and Romanesque chapels, no Romanesque portals or Gothic windows and buttresses." Rather, Valentiner's ideal museum would "suggest the general impression of a former style . . . and, at the same time, create something new." See Margaret Sterne, *The Passionate Eye: The Life of William Valentiner* (Detroit, 1980), pp. 237–38. For a fuller discussion of the Valentiner-Rockefeller correspondence, see ibid., pp. 234–40. See also Mary Rebecca Leuchak, " 'The Old World for the New': Developing the Design for The Cloisters," *MMJ* 23 (1988), pp. 257–77, esp. pp. 262, 263.

11. The sculpture from the abbey at Cuxa was arranged at The Cloisters to "approximate rather than to replicate" the original. See David L. Simon, "Romanesque Sculpture in North American Collections. XXIV. The Metropolitan Museum of Art," *Gesta* 25/2 (1986), pp. 245–58.

12. For the sculpture from Saint-Guilhem-le-Désert, see Robert Saint-Jean, "Le cloître supérieur de Saint-Guilhem le Désert," *Les Cahiers de Saint-Michel de Cuxa* 7 (June 1976), pp. 45–60.

13. The two arcades of the Bonnefont Cloister are composed of architectural elements from the Comminges region of France, southwest of Toulouse; most are thought to have come from the Cistercian abbey of Bonnefont-en-Comminges, but others may have come from nearby religious foundations. See Élie de Comminges, "Y a-t-il des chapiteaux du cloître de Bonnefont au Metropolitan Museum of Art de New York?" *Revue de Comminges* 93 (1980), pp. 1–23. Similarly, the three parapeted arcades of the Trie Cloister incorporate late-fifteenth-century marble capitals, bases, and shafts from the Carmelite convent at Trie-en-Bigorre, from the monastery at Larreule, and possibly from the abbey of Saint-Sever-de-Rustan, all neighboring foundations in the Bigorre region of southwestern France. See notes, January 1907, George Grey Barnard files in archives of the Philadelphia Museum of Art; James J. Rorimer, "Recent Gifts in the Department of Medieval Art," *MMAB* 31 (Oct. 1936), pp. 202–3.

14. For a more detailed description and illustrations of the seven different museum plans proposed in the early stages, see Leuchak, "The Old World for the New," pp. 263–66.

15. See *MMAB* 27 (Feb. 1932), p. 32.

16. See Joseph Breck, *The Cloisters: a brief guide* (New York, 1931); and Dickson, "The Origin of 'The Cloisters,' " pp. 253–74.

17. Notes to the Building Committee meeting, May 26, 1933 [The Cloisters Archives].

18. For Breck's obituaries see: *MMAB* 28 (Aug. 1933), p. 147; idem (Nov. 1933), p. 182; *The New York Times* (Aug. 3, 1933), p. 17. William Sloane Coffin, President of the Museum at the time of Breck's death, recalled The Cloisters as among the "standing [testimonies] to [Breck's] taste and knowledge in installation and arrangement. A skilled draftsman, knowing much of architecture and fully acquainted with the requirements and desires of the Museum, Mr. Breck was largely responsible for the plans for [The Cloisters] and [its] arrangement."

19. Preserved in The Cloisters Archives are plans for the electrical wiring of the proposed museum dated Jan. 1, 1933. They show virtually the same design of the museum as it was finally built. See Leuchak, " 'The Old World for the New,' " p. 257.

20. Ibid., pp. 259–61; Collens's obituary in *The New York Times* (Sept. 18, 1956), p. 50; and a five-page typescript autobiography, property of the Collens family.

21. See James J. Rorimer, *The Cloisters: The Building and the Collection of Medieval Art in Fort Tryon Park* (New York, 1951), p. xxxi.

22. For background on Rorimer, see *MMAB* 25 (Summer 1966), pp. 37–56.

23. Rockefeller's praise in his speech at the opening, *Addresses on the Occasion of the Opening of the Branch Building of The Cloisters* (New York, 1938), p. 25, was repeated in an even more glowing letter to Rorimer of June 3, 1938 [The Cloisters Archives]: "Once more I want you to know to what a very considerable extent I feel you are responsible for what The Cloisters are. . . . I hope you feel as deep satisfaction as I feel genuine pride in the result which has been accomplished by the painstaking, tireless and highly skilled service you rendered in the development, construction and arrangement of The Cloisters. I cannot speak too highly of your part in this so wholly satisfactory result. Again my congratulations."

24. "Recent Gift by John D. Rockefeller, Jr.," *MMAB* 11 (Summer 1952), p. 10; and Harr and Johnson, *The Rockefeller Century*, p. 519.

25. See *MMAB* 9 (Summer 1950), p. 5; and idem 14 (Oct. 1955), pp. 37–38.

26. Many important acquisitions added to the architectural fabric of The Cloisters were made possible through the generosity of Mr. Rockefeller: the chapter house from the abbey of Notre-Dame-de-Pontaut (35.50; 35.51); stained glass from the church at Boppard-am-Rhein (37.52.1–6); the Gothic doorway from the abbey of Moutiers-Saint-Jean (32.147; 40.51.1,2). The elements from the choir of the church of Notre-Dame-du-Bourg at Langon (34.115.1–269) were purchased with income from the Rogers Fund. George Blumenthal, then President of the Metropolitan Museum, also donated significant architectural elements to be incorporated into The Cloisters' galleries. These included four large windows from the refectory of the Dominican convent at Sens (35.35.1–4), an arcade from the fifteenth-century cloister of the Benedictine priory of Froville (35.35.5–13), and a number of Romanesque and Gothic stone portals, wooden doors as well as ten corbels from Notre-Dame-de-Grande-Sauve (34.21.1–8; 35.35.15–16), which were used to support the ribs of the vaulted walkway in the Saint-Guilhem Cloister. See James J. Rorimer, "New Acquisitions for The Cloisters," *MMAB* 33 (June 1938), pp. 3–19.

27. In 1935 Rockefeller first brought the apse from the church of San Martín at Fuentidueña, north of Madrid, to Rorimer's attention. Negotiations with the Spanish government and ecclesiastical authorities over the next twenty-five years resulted in an exchange loan of the architectural element in return for the loan of a series of frescoes from San Baudelio de Berlanga to the Prado Museum, Madrid. For a discussion of the history, style, and rebuilding of the apse as an integral part of The Cloisters, see the articles by James J. Rorimer, Carmen Gómez-Moreno, and Margaret B. Freeman in *MMAB* 19 (June 1961),

pp. 265–96; and James J. Rorimer, *Medieval Monuments at The Cloisters as they were and as they are* (New York, 1972), pp. 38–44.

28. The study model was made by the Museum's Department of Medieval Art with the cooperation of the Architects' Emergency Committee (later Emergency Relief Bureau) and in consultation with Charles Collens: *The Metropolitan Museum of Art Sixty-Sixth Annual Report of The Trustees 1935* (New York, 1936), p. 29 [Archives].

29. For the Unicorn Tapestries (38.80.1–6; 38.51.1,2), see Geneviève Souchal, *Masterpieces of Tapestry from the fourteenth to the sixteenth century,* exhib. cat. (New York, 1973), pp. 69–79; and Margaret B. Freeman, *The Unicorn Tapestries* (New York, 1976). For other gifts and acquisitions made possible by John D. Rockefeller, Jr., see Rorimer, "New Acquisitions for The Cloisters," pp. 6–19.

30. For the Nine Heroes Tapestries (32.130.3a,b; 47.101.1–5; 47.152; 49.123), see Souchal, *Masterpieces of Tapestry,* pp. 34–38; and James J. Rorimer and Margaret B. Freeman, "The Nine Heroes Tapestries at The Cloisters," *MMAB* 7/9 (May 1949), pp. 243–60.

31. The stonework was cut in irregular blocks in accordance with medieval usage, whether millstone and Connecticut granite for the exterior or Doria and Indiana limestone for the interior. The red roof tiles were manufactured in California, where they were specially fired in variegated colors to avoid a modern look. The courtyard was paved with Belgian blocks taken from New York City streets. Rorimer, *The Cloisters,* pp. xxxii–xxxiii.

Four Langobardic Marble Reliefs Recently Acquired by The Cloisters

Beat Brenk

I n 1986, The Cloisters Collection acquired four arcuated marble lintels of nearly identical size (Figs. 1–22).[1] Quite a number of questions arise in connection with these reliefs. To which period and to which country can they be attributed? What was their initial function? Did they originally belong together? If so, what artistic concept was involved? What about their provenance and their effect on other works of art?

Research on the early medieval relief sculpture of Italy has thus far failed to provide a complete corpus formulating objective criteria for evaluation of, as well as long-term goals for the investigation of this subject. There are, however, two fundamental publications by Rudolph Kautzsch, which appeared in the *Römisches Jahrbuch für Kunstgeschichte* in 1939 and 1941,[2] and the *Corpus della scultura altomedievale,* which has now published its twelfth volume.[3] Added to this, we have numerous articles dealing with particular objects, but all in all research has not advanced further than the publication of a smattering of individual pieces with suggestions as to dating and location. We know next to nothing about workshops, art centers, means of production, and *Kunstlandschaften,* that is, areas of patronage of artists and arts during a given period of time. In the few pages allotted for this essay, it is not possible to eliminate these deficiencies, especially since the objects in question present many puzzles, some of them probably insoluble. I would like, instead, to focus on a particular problem: the concept behind the design of so-called Langobardic relief sculpture. The four lintels at The Cloisters offer surprising new insights into this question.

Fig. 1. Peacock lintel, front view. The Metropolitan Museum of Art, The Cloisters Collection, 1986 (1986.144.1) (photo: Museum)

Fig. 2. Peacock lintel, back

64

Fig. 3. Peacock lintel, right side

Fig. 4. Peacock lintel, left side

Fig. 5. Peacock lintel, from below

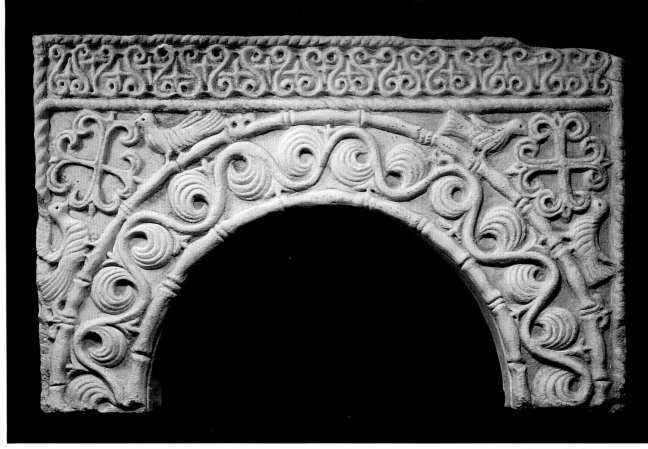

Fig. 6. Dove lintel, front view. The Metropolitan Museum of Art, The Cloisters Collection, 1986 (1986.144.2) (photo: Museum)

Fig. 7. Dove lintel, back

Fig. 8. Dove lintel, right side

Fig. 9. Dove lintel, left side

Fig. 10. Dove lintel, from below

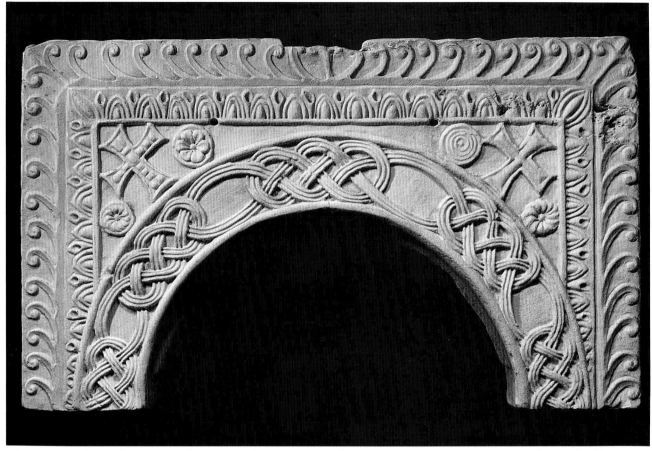

Fig. 11. Cross lintel, front view. The Metropolitan Museum of Art, The Cloisters Collection, 1986 (1986.144.3) (photo: Museum)

Fig. 12. Cross lintel, back

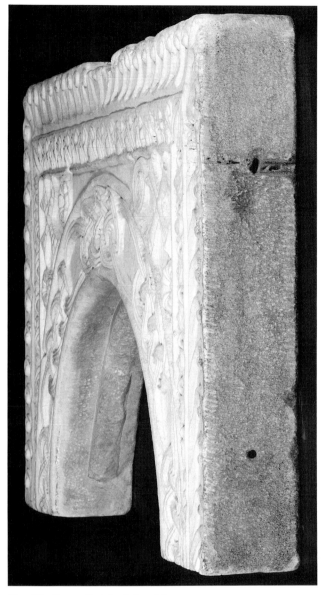

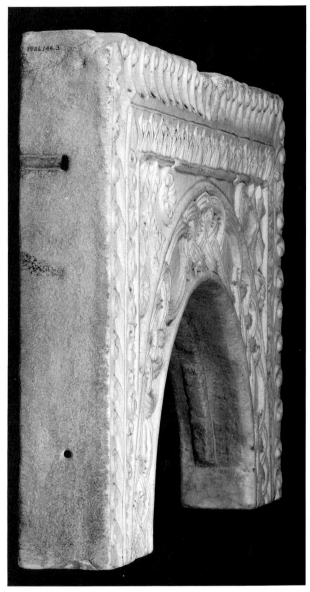

Fig. 13. Cross lintel, right side

Fig. 14. Cross lintel, left side

Fig. 15. Cross lintel, from above

Fig. 16. Cross lintel, from below

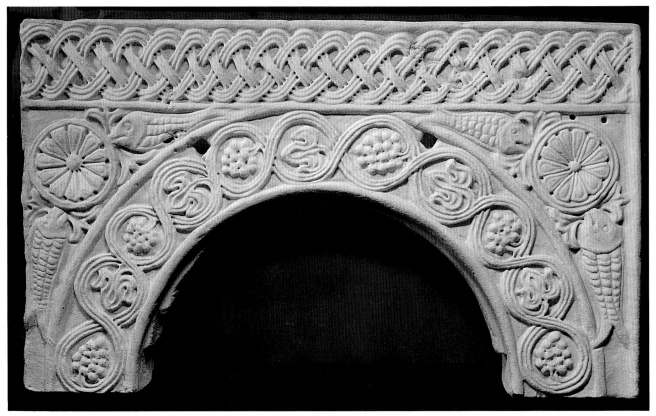

Fig. 17. Fish lintel, front view. The Metropolitan Museum of Art, The Cloisters Collection, 1986 (1986.144.4) (photo: Museum)

Fig. 18. Fish lintel, back

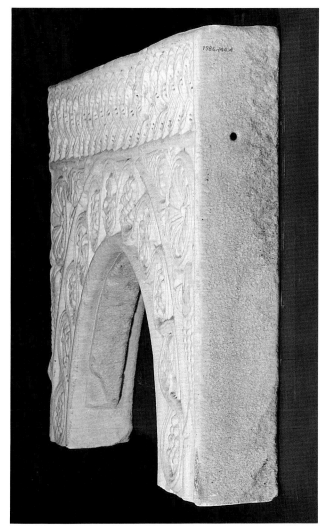

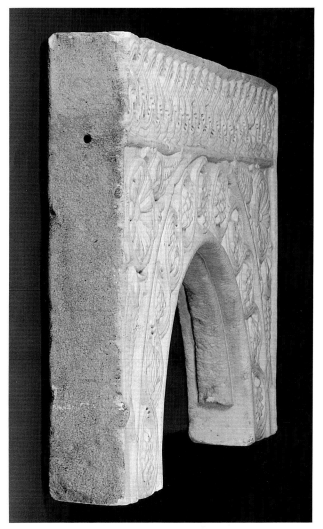

Fig. 19. Fish lintel, right side

Fig. 20. Fish lintel, left side

Fig. 21. Fish lintel, from above

Fig. 22. Fish lintel, from below

Fig. 23. Arched lintel, fragment. Sirmione, Castello
(photo: author)

CHARACTERISTICS OF A COMMON WORKSHOP

The four lintels are made of marble and their measurements are almost identical: the respective heights are 59.6, 60.9, 59.8, and 59.8 cm, and the respective widths are 105.9, 100.2, 104.1, and 104.1 cm. The arch spans measure 61.5, 61.8, 63, and 64 cm. The narrow side of the peacock piece has a smooth surface (Figs. 3, 4). Its width of 105.9 cm is thus the original measurement. The cross lintel shows that the carving along the narrow sides was smoothed at a later date: it measures only 104.1 cm in width (Figs. 13, 14). The edge of the fish lintel, having been cut off along its left side, measures only 101 cm in width (Fig. 17). The conformity of the measurements leads to the conclusion that these four lintels were originally parts of the same object.

A unique feature common to all four lintels is the flat, fillet-shaped outline that marks the frame and the arch on the back of each relief (Figs. 2, 7, 12, 18). These elements on the back do not tally with the finished work on the front. The simple relief decoration of the arches on the back extends nearly to the width of the four slabs, although in the execution of the front the artist made the frame of the arches somewhat narrower in order to adorn the right and left sides with a vertical ornament. The craftsmanship of these outlined arches is quite consistent on all four slabs, which suggests a common workshop. Only on the cross lintel does the outlined arch differ from the other three inasmuch as the top of the arch is exactly as high as the lintel itself (Fig. 12). Moreover, whereas all

the holes on the three other pieces are equidistant, the cross lintel has more holes and in different positions. I shall address this problem later in connection with the reconstruction of the four pieces.

The back of each lintel has been roughened by short chisel strokes in order to apply a layer of stucco, a different, independent step from the making of the outline. The treatment of the back parts must not necessarily be interpreted as a preliminary study or sketch rather than as an intended decoration. The stucco layer may have been decorated with paintings, because the back parts of the lintels were probably intended to be visible.

Finally, the pillow-shaped projections, about 3 cm high in the soffits of the arches of three of the lintels, also support a common provenance (Figs. 3–5, 13, 14, 16, 18–20). They are absent on the dove piece, however, and in any case their purpose is unclear. Perhaps they were meant to be shaped into some kind of relief at a later date. Then again, they may have served to protect the soffits against damage during transport. Only one other example where wholly identical elements can be found is on the jambs of an arched lintel in the Castello at Sirmione (Fig. 23).

With respect to the front of the reliefs, the most significant technical characteristic of the four lintels is their drilling technique—a technique unusual for so-called Langobardic reliefs. A braided ribbon decorates the borders of the upper ends of the peacock and fish lintels (Figs. 1, 17). On the fish lintel, it has three strands: two drill holes are placed between two strands where they are intersected by the third. The braided ribbon of the peacock lintel has only two strands and hence only one drill hole at the intersections. Since the shape of the drill holes in both braided bands is exactly the same—at a slanted angle to the surface—it once again suggests the technique of a common workshop.

Three-stranded braids with drill holes at a slanted angle appear again as arch ornaments on the peacock, cross, and fish lintels (Figs. 1, 11, 17). Each time the undercuttings are marked by drill holes. Up to now I have managed to locate only one single slab, preserved in the Castello Sforzesco, Milan (Fig. 24),[4] where the undercuttings on a four-stranded ribbon braid have been drilled in the same manner as those on The Cloisters lintels. This plaque originates from Santa Maria d'Aurona, Milan, and

Fig. 24. Fragment from Santa Maria d'Aurona. Milan, Castello Sforzesco (photo: author)

has not yet been exactly dated. Silvana Casartelli Novelli has assigned it to the eighth century,[5] but the sculptures of Santa Maria d'Aurona require further study and publication in their entirety before a specific date can be confirmed.

As a further indication that The Cloisters lintels are the products of a common workshop, both the undercuttings of the braided ribbons and the rosettes on the cross and fish lintels have been drilled. Furthermore, the darts displayed in the egg-and-dart ornamental design on the peacock and cross lintels reveal a highly individual style (Figs. 1, 11). While the shape of the eggs is quite flat, the artist made the darts more gobletlike, with the

opening of the goblet appearing slanted. This again constitutes a distinctive workshop characteristic which suggests that the peacock and the cross pieces are the work of the same artist. Taking all these arguments together, it follows that our four lintels originate from the same workshop and belong to the same monument.

THE CONCEPT OF THE DESIGN

All four slabs are equally adorned by an ornament meandering horizontally along the upper edge (Figs. 1, 6, 11, 17). On each, the arcade is bordered by a broad ornamental design, and the spandrels

Fig. 25. Ciborium of Eleucadius. Ravenna, Sant'Apollinare in Classe (photo: Bildarchiv Foto Marburg)

above the arcades are each embellished with heraldic motifs. However, these are the only elements of composition common to all four lintels. Upon closer examination, we find that numerous details are executed quite differently. Of the four lintels, the peacock piece alone displays a vertically arranged egg-and-dart ornament on the outer borders of the design to the left and right (Fig. 1). Rather than smoothly polished astragals subdividing the separate areas, the dove lintel has stringlike twisted astragals as border elements above and below the horizontal ornament and on the right and left edges (Fig. 6). Only on the dove lintel is the arched ornament framed by a beaded astragal; the others have smooth astragals. Two of the four horizontally arranged ornaments are braided ribbons, one of them three-stranded; the other, two-stranded. Since the drilling technique is the same in both cases, the display

of three- and two-stranded braids side by side must have been the specific artistic intention of the designer. Furthermore, four completely different ornamental designs have been selected for the decoration of the arches: a wave tendril, a medallion tendril, a braided ribbon with spaces, and two braided ribbons running parallel. Variety is the leitmotif of the spandrel designs as well: a gem-cross flanked by two rosettes, an anchor-cross flanked by two doves, a rosette flanked by two fish, and finally two heraldic peacocks.

By far the most amazing composition is demonstrated on the cross lintel (Fig. 11). It differs from the others in that the downward extension of its upper horizontal ornament composed of an egg-and-dart motif is intersected by the arch at the lower corners. And the fact that the back of this slab displays an outlined arch, which is very different from the

74

Fig. 26. Arched lintel. Grado, Santa Maria delle Grazie (photo: author)

other three, is another feature that cannot be easily explained (Fig. 12). These variances suggest the possibility that the cross lintel was intended to be a centerpiece, and point to the reconstruction of the four lintels as a ciborium.

A work of art that reveals different techniques, shapes, or designs often incites the investigative inclination of the art historian. It is generally assumed that irregularities cannot be part of a single, original artistic concept and that different techniques appearing on one and the same work of art betray, without a doubt, the hands of different artists. Thus, the art historian becomes a self-styled advocate of a harmony which is a law unto itself and known only to him. During the course of my deliberations on workshop characteristics, I have reached the conclusion that the four Cloisters lintels were conceived and executed simultaneously in the same workshop. The individual motifs are not exactly alike, suggesting that the artist attempted to offer variety wherever possible. In other words, there seems to have been a concern for the widest possible variation, or *varietas*. This is not just fun and games (as one might think). I would like to proffer the following thought: anyone doubting the workshop relationship of the four lintels has to arrive at the unlikely conclusion that these four pieces, despite their same size and technique, belong to four different monuments and even to four different periods.

By the concept of the design of The Cloisters lintels, the artist was subjected to a quasi-uniform composition. On only one of the four lintels did he adopt an alternate framing system, but in the application of ornamental and figural motifs he was more free to exercise variety. Is it possible to detect such a concept operating in any other relief

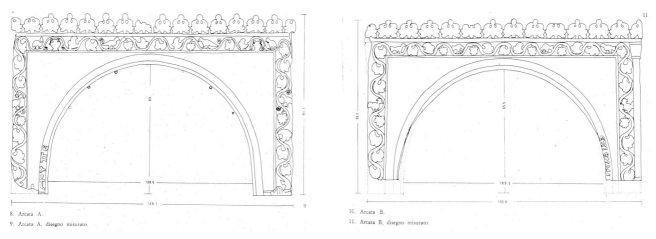

8. Arcata A.

9. Arcata A, disegno misurato.

10. Arcata B.

11. Arcata B, disegno misurato.

Fig. 27. Arched lintels from Portogruaro, drawings (after Bonfioli, *Tre arcate marmoree protobizantine,* figs. 9, 11)

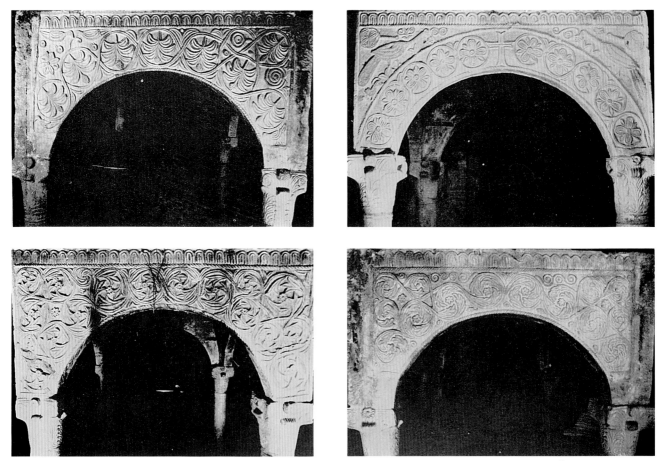

Fig. 28. Ciborium, four views. Perugia, San Prospero (photo: from L'Orange, *La scultura,* ills. 331-34)

ensemble of the early Middle Ages? An answer to this question brings us to the more general problem of conformity versus *varietas* in this period.

It is an astonishing fact that the Eleucadius ciborium from the ninth century, today in Sant'

Apollinare in Classe, Ravenna (Fig. 25),[6] displays on its four front sides a mode of composition similar to the lintels at The Cloisters. Each of the braided ribbons along the arches is different and so are the spandrel motifs: vines with grapes, two peacocks

76

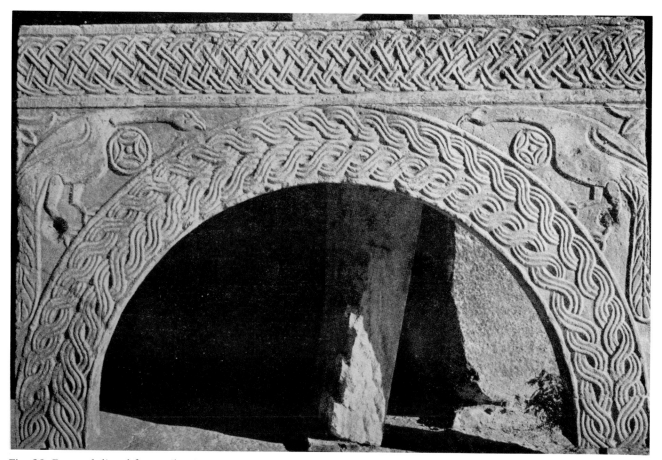

Fig. 29. Peacock lintel from ciborium. San Giorgio in Valpolicella (photo: from Arslan, *La pittura e la scultura,* pl. 3)

drinking from a goblet, ribbon knots, and crosses flanked by doves. And the upper horizontal ornament varies from slab to slab. On two slabs (not visible in Fig. 25), the vertical side strips and the upper horizontal strip are decorated with a uniform U-shaped ornament, intersected by the ornamented arch. Here we are confronted with the same principle of composition that is seen on the cross lintel at The Cloisters, where the egg and dart is also intersected by the ornamented arch (Fig. 11). Since the four Cloisters pieces and the Eleucadius ciborium display no further common workshop characteristics and vary considerably in their measurements, I assume that we are dealing here with a design concept for ciborium sides which made its way independent of the workshops. Although not so pronounced as in the cross lintel, an intersection of the vertical ornaments by an ornamented arch is also to be found in a ciborium in Santa Maria

delle Grazie, Grado, dating from the ninth century (Fig. 26).[7]

This particular type of framing of a ciborium arch with horizontal and vertical border elements has been documented since early Byzantine times. Because the art of early Byzantine relief sculpture remained intact in Italy's large art centers, we may assume that it constitutes one of the main sources for the artists of so-called Langobardic relief sculpture of the eighth to the tenth century. The sixth-century ciborium in Portogruaro should be especially borne in mind in this context (Fig. 27).[8] Its border invariably displays the same design: the tendril extends along three sides of the rectangle as a regular ornament. This decorative scheme was also used by the sculptor of The Cloisters cross lintel borders, but he deliberately chose to allow the vertical borders to be intersected by the arch. The diversity in the overall design of The Cloisters pieces has to be interpreted

77

as a positive sign: their creator aimed at *varietas*. In the compositional as well as in the figural area *varietas* is favored over uniformity.

Varietas as an artistic concept is further evident in the ciborium of San Prospero, Perugia (Fig. 28).[9] Its three sides are crowned by an egg-and-dart ornament along the upper edge, but the remaining space is hidden under a maze of tendrils, different on each piece. It is only on the fourth side (upper right in Fig. 28), crowned by a similar horizontal band, that the arch shows a medallion tendril ornament culminating in a cross, framed by an astragal border that does not appear on the other three slabs. A peacock and a roundel occupy the spandrels, as in The Cloisters lintel (Fig. 1).

At this point one must ask: when does this concept of *varietas* first appear in relief sculpture of the early Middle Ages? While this question cannot be answered in depth within the confines of this essay, it seems of such basic importance that at least two steps in the development of this new aesthetic deserve to be mentioned. Since serious art-historical research on this subject is lacking, it is important to recognize that in the Middle Ages an aesthetic doctrine based upon representational art was not known. The medieval aesthetic consists of a number of merely coincidental statements, contrasting fundamentally with the principles of the antique aesthetic, which oriented itself equally toward nature and representational art.[10] In antique aesthetics the meaning of *unitas* is of overriding importance. Augustine, for example, refers to "omnis porro pulchritudinis forma unitas sit" in his eighteenth letter,[11] his explanation expanded in chapter 30 of *De vera religione*.[12] Terms such as *convenientia, aequalitas,* and *unitas* are linked to *similitudo*. Symmetry, equality and unity are predestined by nature; its laws are accepted by the artist and reproduced according to his ability. Some of these basic terms crop up in architectural theory, for example, in Vitruvius (I, 2): "Architecture consists of Order, which in Greek is called *taxis,* and of Arrangement, which the Greeks name *diathesis,* and of Proportion and Symmetry and Decor and Distribution, which in Greek is called *oeconomia*."[13] By order, *dispositio,* Vitruvius means the harmonious assembly of components. "Symmetry also is the appropriate harmony arising out of the details of

the work itself; the correspondence of each given detail among the separate details to the form of the design as a whole."[14]

By the seventh century, this highly differentiated terminology disappears from the literature and thus from human conception. A prime example is Isidore of Seville, who, when he writes in his *Libri etymologiarum* (Book 19, 9) about ships, buildings, and garments, clings solely to the basic terms of *dispositio, constructio,* and *venustas.* His definition of beauty is quite interesting: "*Venustas* implies the accessories added to the bare building for decoration's sake: paneled ceilings adorned with gold, precious marble incrustations, and wall painting."[15] Thus, *venustas* is not part of the building but added to it as a decoration. The contrast of this use of terminology to that of Vitruvius could not be more striking. With Isidore, *venustas* does not stand for symmetry, eurythmia, and consensus of individual components but, instead, for opulent decoration. In the ninth century, Rabanus Maurus incorporated this definition into his *De Universo* (XXI, 2–4) without citing the source. He makes no mention of *varietas,* but by referring to *venustas,* the *varietas* of decoration is implied.[16]

Not before the height of the Middle Ages is *varietas* frequently proposed as the only available aesthetic option. In Theophilus's work, all antique terminology is absent and he begins his *Schedula diversarum artium* by pointing out the importance of studying and mixing of colors and by saying that above all painting has to be an adornment.[17] He avoids the mention of a design or a drawing and starts with the color. In his prologue, he praises the quality of his own work by alluding to various countries and their techniques: "You will find here whatever kinds of the different pigments Byzantium possesses and their mixtures . . . whatever decoration Italy applies to a variety of vessels . . . whatever France loves in the costly variegation of windows."[18] Surely Theophilus concerns himself here with the variety of techniques and not with *varietas* as an aesthetic option. Nevertheless, the listing of so many different countries and techniques is recommended as exemplary and worthy of imitation. *Varietas* of technique is valued much higher than composition, symmetry, and consensus, three terms ignored by Theophilus.

We are confronted with this mentality in inscrip-

tions as well, and I cite two prominent examples from the twelfth century. The apse inscription of the cathedral in Cefalú, 1148, reads:

Rogerius Rex egregius plenus pietatis.
Hoc statuit templum motus zelo Deitatis.
Hoc opibus ditat variis varioque decore.[19]

While this inscription's only claim to aesthetic qualification is *varietas, opibus variis,* and *vario decore,* we still have to take it seriously, *varietas* being the aesthetic goal. A second inscription is found in the twelfth-century cloister of Sant Orso, Aosta: "Marmoribus variis hec est distincta decenter fabrica nec minus est disposita convenienter."[20] It merits our attention because it relates positive aesthetic qualifications—*decenter, convenienter*—to material facts—*marmoribus variis*—with the inclusion of *varietas* as well. It is a valid objection that different kinds of marble were already used in Roman times and that we are dealing here with a topos. Indeed, the cloister of Sant Orso is not adorned with different types of marble but only with different types of stone, and not all that noticeable. Nevertheless, the author of Sant Orso's inscription must have thought it important enough to describe the beauty of this cloister with the topos "*marmoribus variis.*"

The dogma of variety and beauty of various techniques, materials, compositions, shapes, and colors has never been formulated *expressis verbis,* but Isidore was the first to manage—without the antique terms and concepts—to demonstrate a relationship between the idea of beauty and different techniques. It would be naive to assume that Isidore had influenced the course of art or the aesthetic of the Middle Ages, but his interpretation is in itself a document to a changed situation in the areas of aesthetic theory in representational art and architecture. Even skeptics have to admit that little attention has been given to the aesthetic concept of *varietas* in the Middle Ages. For The Cloisters lintels, variety was not a by-product but was intended from the beginning.

In its strictest sense the concept can be traced back to only those works that have remained at their original sites. To cite just one example in order not to take us away from the focus of this study: the four pedestals under the corner pillars in the Zeno chapel in Rome.[21] All four display various types of

decoration on each of their two visible sides. One pedestal, however, differs noticeably in its compositional concept from the other three, which exhibit a largely congruous composition in spite of differently executed details. It is obvious that the artist had *varietas* in mind.

THE PROBLEM OF LOCALIZATION

All the problems that have arisen thus far in connection with the four Cloisters lintels were comparatively easy to resolve. Nevertheless, the problem of the localization of The Cloisters lintels is a real one. For each of these lintels there is a parallel, if not a replica, in San Giorgio in Valpolicella, differing only inasmuch as the lintels at The Cloisters are marble and those in Valpolicella are limestone.[22] What does this mean? In Valpolicella, north of Verona, seven ciborium slabs of varying sizes have been preserved. In 1923, four of these, together with four mini-columns, two of which display inscriptions from the reign of King Leoprand (712–736), were integrated into a ciborium now erected on the altar. These eighth-century pillars were assumed to have belonged to the ciborium originally in San Giorgio, which Edoardo Arslan demonstrates had been destroyed in 1412.[23] Two of the four mini-columns carry engraved inscriptions. One reads: "hanc civorius sub tempore domno nostro Lioprando rege," and the other: "Ursus magesto com discepolis suis Invintino et Invano edificavet hanc ciborium. Vergondus et Teodoalfo scari."

The reconstruction of this ciborium does not satisfy Italian scholars. To quote L. Barbi: "[The reconstruction] is in fact not certain and not even the best."[24] Granted that it must have been tempting to reconstruct columns bearing a ciborium inscription together with ciborium sides into a piece of church furniture, but, by the same token, it cannot have been easy to make a selection from the seven remaining lintels. In other words, San Giorgio's ciborium in Valpolicella today is nothing more than a pastiche from 1923. We do not even know whether or not those small, dated pillars belong with the slabs; for the seven pieces of different sizes now preserved in San Giorgio, the possibilities for reconstruction are numerous.

A starting point for comparison between The

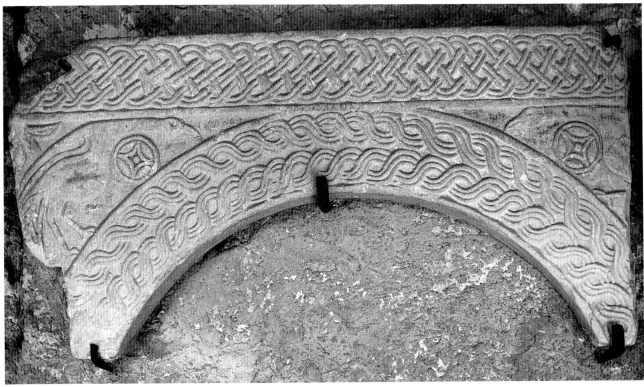

Fig. 30. Arched lintel fragment from cloister. San Giorgio in Valpolicella (photo: author)

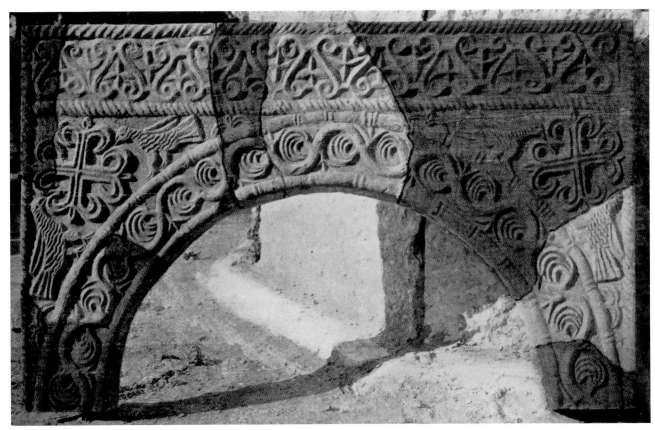

Fig. 31. Dove lintel from ciborium. San Giorgio in Valpolicella (photo: from Arslan, *La pittura e la scultura*, pl. 5)

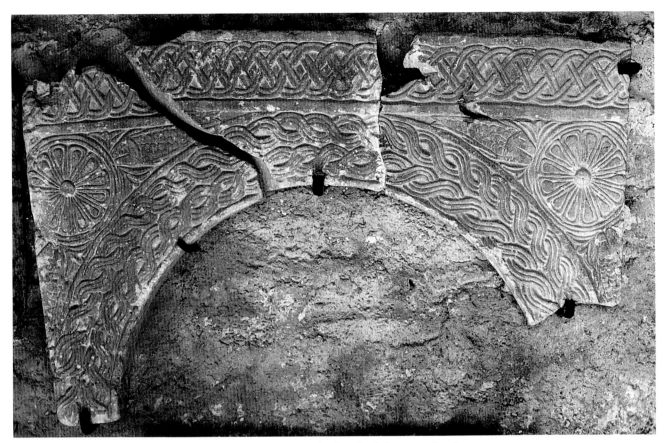

Fig. 32. Lintel fragment from cloister. San Giorgio in Valpolicella (photo: author)

Cloisters lintels and their counterparts in San Giorgio is the peacock piece, still the original width of 106 cm (Fig. 1). Its fragmented counterpart in the cloister of San Giorgio originally measured 130 cm (Fig. 29).[25] Its design matches The Cloisters one, but not its material, size, or technique, as can be seen in the medallion under the peacock's neck, as well as in the two- and three-stranded tendrils. The drill holes are absent in San Giorgio. Cavazzocca Mazzanti published it in 1908 in the local paper, *Madonna Verona,* after he had discovered the peacock lintel of the cloister in San Giorgio in the apse of the eleventh-century church.[26] He also mentioned another peacock piece, which he described as a "perfetta copia di quella esistente nell abside" (Fig. 30).[27] It is this "copy" or replica that was integrated into the ciborium reconstructed in 1923. However, the peacock lintel on the north side of the ciborium measures only 121 cm. What concerns us here is the fact that in San Giorgio in Valpolicella, two replicas of The Cloisters piece exist,

each of them differing in size, The Cloisters lintel being the smallest.

The dove lintel with anchor-cross in The Cloisters is matched by a larger one in San Giorgio, which is 127.5 cm in width (Figs. 6, 31). This one was also integrated into the ciborium in 1923 and was also published for the first time in the *Madonna Verona* in 1908. Only its left side has been preserved, as most of the right side has been restored in a modern fashion. The fragments in San Giorgio reveal the same combination of motifs as their counterpart at The Cloisters—astragal, ribbon frieze, anchor-cross flanked by two doves—thus permitting the conclusion that both pieces were fashioned after the same design.

The fish lintel at The Cloisters is again matched by two larger replicas (Figs. 17, 32), both measuring 127 cm in width, one integrated into the ciborium and the other, consisting of three fragments, left in the cloister of San Giorgio. The most important point of comparison is the difference in the border

81

ornament of the arches: in San Giorgio two parallel braided ribbons, in The Cloisters a medallion tendril depicting grapes and leaves, the only motif that does not appear at San Giorgio. It cannot be said that the lintels in San Giorgio are copies of those at The Cloisters, or vice versa; there are not only differences in the variety of motifs but also in the workmanship. The carving of The Cloisters fish, for example, is more animated than those in San Giorgio. The fish piece in the San Giorgio cloister surfaced in the literature for the first time in 1889, when Raffaele Cattaneo showed only the right-hand fragment;[28] in 1908, Cavazzocca Mazzanti published only the left half. Arslan believed the fish slab integrated into the ciborium to be a modern copy.[29]

Finally, we have no counterpart in San Giorgio for the lintel at The Cloisters depicting crosses flanked by rosettes, but as if to make up for its absence, there is documentary evidence dating to 1889 of the existence of a fragment revealing a nearly identical design at the cloister of San Giorgio (Fig. 33).[30] Particularly close is the combination of braided ribbon and intervals along the circular arch and the egg-and-dart ornament. The vertical section of the egg-and-dart ornament in San Giorgio, however, is not intersected by the arch, as it is on The Cloisters cross lintel (Fig. 11). Originally, the fragment with crosses and rosettes from San Giorgio's cloister was a piece 141.5 cm wide, the reason for its not being integrated into the ciborium. Two slabs of 127.5 and 127 cm in width were used instead, as well as two smaller ones measuring 118 and 121 cm each. San Giorgio may have had several ciboria of varying sizes, but it is unthinkable that two altar ciboria had been erected in San Giorgio. Therefore, we must look further for an explanation of the original context. Perhaps the slab with a side length of 141.5 cm was part of a ciborium above the baptismal font; the ciborium of Cividale might support this theory. On the other hand, the considerable number of pieces of varying size, but modeled after one and the same design, could also point to the presence of a once-active workshop of early medieval church furniture at San Giorgio in Valpolicella.

While faced with the fact that all four marble lintels in The Cloisters are nearly but not completely matched by stone replicas in San Giorgio in Valpolicella, we have no proof for the assumption that The Cloisters lintels were manufactured for San Giorgio, but it could have been possible. Certainly the four Cloisters lintels originated in northeastern Italy, probably in the Veronese region. Most likely the expensive marble lintels were intended for an important church in a town. Our analysis demonstrates that the stone replicas of the marble pieces, executed in a less meticulous manner, cannot be attributed to the same workshop. The design was repeated, but this repetition is not totally identical. Possibly the marble lintels functioned as a model on whose historical origins we can only speculate. Or, to put it another way, the artists of the lintels at The Cloisters may have had access to a model book which included the designs of the pieces at San Giorgio in Valpolicella.

RECONSTRUCTION AND DATING

Not knowing whether or not additional slabs belong with the four lintels at The Cloisters, any attempt at a reconstruction is necessarily limited. Along the upper border of the dove and peacock lintels, matching dowel holes with a subsequent rectangular drilling channel have been preserved; they probably once housed a support system of either wood or iron. Therefore, I assume these lintels faced each other. Round dowel holes without drilling channels are to be found on the two other lintels. The most obvious reconstruction thus presents us with a four-sided square ciborium, the parts arranged edge to edge with either little columns or pillars placed in the corners. This reconstruction is confirmed by the dowel holes on the backs (Figs. 2, 7, 12, 18). Three of the lintels are equipped with five dowel holes each, distanced equally along the arcade and probably having served to anchor wooden or iron bars. The dowel holes on the back seem to have been a secondary precaution, though our imagination would be severely stretched were we to believe that the not-exactly-beautiful support structure on the inside of the ciborium constituted part of the original concept. The dowel holes, however, imply that two lintels always faced each other; this confirms that at a certain time our ciborium was square.

The narrow upper edge of the peacock lintel displays the engraved letters *A*, *G*, and *B*—probably the work of an engraver who still needed practice, because these letters are not connected and are positioned left and right of the three dowel holes arranged in a V-shape (Fig. 34). Moreover, they shy away from the bordering decor—the right bar of

Fig. 33. Lintel fragment from cloister. San Giorgio in Valpolicella (photo: author)

Fig. 34. Peacock lintel, from above. The Metropolitan Museum of Art, The Cloisters Collection, 1986 (1986.144.1) (photo: Museum)

the *A* just touching, taking care not to intersect. It therefore seems that these three letters were engraved immediately after the lintels were completed. Nevertheless, it is difficult to pinpoint their paleography exactly. Nicolette Gray lists only one inscription from 772–95 that corresponds to the *A*,[31] but one single corresponding shape does not

carry much weight. We do better, however, when comparing examples for the *B*, as we have at our disposal eight dated inscriptions from the eighth century,[32] but only one of these particular *B*'s is from the tenth century.[33] For the *G*, as well, numerous comparable examples exist from the eighth century,[34] but in the ninth century this letter shape

appears only in isolated cases.[35] This meager circumstantial evidence points to the eighth century as the period when these letters were carved.

As for the style of the sculpture, it is not quite yet possible to differentiate with absolute certainty between monuments of the eighth, ninth, and tenth centuries. Certainly we can accumulate numerous corresponding examples for individual motifs and for combinations of motifs, but that alone does not permit a final dating. We are dealing here with ornamented motifs enjoying an extended longevity. Compared with stylistic identification, the paleographic one carries more weight, and from this we may assume the origin of these lintels to be in the eighth rather than in the ninth century. In conclusion, their importance rests upon their outstanding sculptural quality, upon their surprising compositional accordance with lintels in San Giorgio in Valpolicella, and in the concept of variety on which their design is based.[36]

NOTES

1. This essay is not a full publication of the four lintels in The Cloisters. It is an abstract of a short lecture, and the author wishes to stress that a complete and thorough investigation will follow at a later date. See also Timothy Husband, "Four Arcuated Lintels," in *Recent Acquisitions: A Selection 1986–1987, The Metropolitan Museum of Art* (New York, 1987), p. 117.

2. Rudolph Kautzsch, "Die römische Schmuckkunst in Stein vom 6. bis zum 10. Jahrhundert," *Römisches Jahrbuch für Kunstgeschichte* 3 (1939), pp. 3–73; and idem, "Die langobardische Schmuckkunst in Oberitalien," *Römisches Jahrbuch für Kunstgeschichte* 5 (1941), pp. 3–48.

3. *Corpus della scultura altomedievale. Centro italiano di studi sull'alto medioevo*, vols. 1–12 (Spoleto, 1959–85).

4. *I Longobardi e la Lombardia;* saggi: Milano, Palazzo Reale (1978), pl. XXVII, fig. 28.

5. Silvana Casartelli Novelli, "Nota sulla scultura," in *I Longobardi e la Lombardia*, pp. 75–84.

6. Patrizia Angiolini Martinelli, "Altari, amboni, cibori, cornici, plutei con figure di animali e con intrecci, transenne e frammenti vari," in *Corpus della scultura paleocristiana, bizantina ed altomedioevale di Ravenna* (Rome, 1968), vol. 1, n. 34.

7. Paolo Lino Zovatto, *Grado: Antichi monumenti* (Bologna, 1971), fig. 128.

8. Maria Bonfioli, "Tre arcate marmoree protobizantine a Lison di Portogruaro," *Ricuperi bizantini in Italia* 1 (Rome, 1979).

9. Hans Peter L'Orange, *La scultura in stucco e in pietra del Tempietto di Cividale* (*Acta ad archaeologiam et artium historiam pertinentia* 7/3) (Rome, 1979), figs. 331–34.

10. Lionello Venturi, *Storia della critica d'arte* (Florence, 1948); Edgar de Bruyne, *Études d'Esthétique Médiévale*, 3 vols. (Bruges, 1946); idem, *L'Esthétique du Moyen Âge* (Louvain, 1951–55); Rosario Assunto, *Die Theorie des Schönen im Mittelalter* (Cologne, 1963), with bibliography; Luigi Grassi, *Teoria e storia della critica d'arte* (Rome, 1970); Umberto Eco, *Art and Beauty in the Middle Ages,* trans. Hugh Bredin (New Haven, 1986), with bibliography; and Wladyslaw Tatarkiewicz, *Geschichte der Aesthetik,* ed. H. R. Schweitzer, 3 vols. (Basel, 1979, 1980, 1988).

11. Augustine, Letter XVIII: *Corpus Scriptorum Ecclesiasticorum Latinorum,* vol. 34, ed. Alois Goldbacher (Vienna, 1895), p. 45.

12. Idem, *De vera religione: Corpus Scriptorum,* ed. G. M. Green (Vienna, 1961), vol. 77, chap. 151, p. 39: "Sed cum in omnibus artibus convenientia placeat, qua una salva et pulchra sunt omnia, ipsa vero convenientia aequalitatem unitatemque appetat vel similitudine parium partium vel gradatione disparium, quis est qui summam aequalitatem vel similitudinem in corporibus inveniat adeatque dicere. . . ."

13. *Vitruvii de architectura libri decem,* 1, 2, ed. Curt Fensterbusch (Darmstadt, 1964), p. 36: "Architectura autem constat ex ordinatione, quae graece dicitur [τάξις], et ex dispositione, hanc autem graeci [διάθεσις] vocitant, et eurythmia et symmetria et decore et distributione, quae graece [οἰκονομία] dicitur," *Vitruvius on Architecture,* trans. Frank Granger (London/ Cambridge, Mass., 1962), p. 25.

14. *Vitruvii de architectura,* I, 4, p. 38: "Item symmetria est ex ipsius operis membris conveniens consensus ex partibusque separatis ad universae figurae speciem rotae partis responsus" (trans. Granger, p. 27). Although the aesthetic of *varietas* has, to my knowledge, never gained a solid theoretical foundation, it was nevertheless practiced at least since the third century A.D., at first in floor mosaics, and from the fourth century on in architecture as well. In the time of Constantine, architectural orders were mixed for the first time. In the course of the Middle Ages, all artistic expression reflected the aesthetic of *varietas,* albeit in very dissimilar ways. The problem has up to now never been dealt with. Most art historians judge medieval art unconsciously according to antique standards such as symmetry, regularity, and unity. Augustine still defended this typical Greco-Roman aesthetic in a time when *varietas* was already widespread. For the modern critic the difficulty is that we are not dealing with a theory expounded in writing. So much the more, it is the monuments that testify to this entirely novel, and far too little investigated aesthetic viewpoint.

15. Isidore of Seville, *Libri etymologiarum,* XXI, 9, *PL,* vol. 82, col. 675: "de venustate. Huc usque partes constructionis, sequitur de venustate aedificiorum. Venustas est aliquid illud ornamenti, et decoris causa aedificiis additur, ut tectorum auro distincta laquearia, et pretiosi marmoris crustae, et colorum picturae."

16. *Rabani Mauri de universo Libri XXII. PL,* vol. 3, col. 559: XXI.2 "de dispositione. Aedificiorum partes sunt tres: dispositio, constructio, venustas"; ibid., cols. 562–63: XXI.4 "de venustate. Huc usque partes constructionis. Sequitur de venustate aedificiorum. Venustas est, quidquid illud ornamenti et decoris causa aedificiis additur, ut tectorum aura distincta laquaearia, et pretiosi marmoris crustae et colorum picturae."

17. Theophilus presbyter, *Schedula diversarum artium,* ed. Albert Ilg (*Quellenschriften für Kunstgeschichte und Kunsttechnik des Mittelalters und der Renaissance,* vol. 8), 2d ed.

(Osnabrück, 1970), p. 3: "Post ad mixturas commitat mens tua curas. . . . Ut sit adornatum quod pinxeris."

18. Ibid., pp. 9–11; *Theophilus: On Divers Arts,* trans. John G. Hawthorne and Cyril Stanley Smith (New York, 1979), p. 13.

19. Otto Demus, *Mosaics of Norman Sicily* (London, 1949), p. 6.

20. Arthur Kingsley Porter, *Lombard Architecture* (New Haven, 1916), vol. 2, p. 62. Similar inscriptions and texts are published by Julius von Schlosser, *Schriftquellen zur Geschichte der karolingischen Kunst,* 2d ed. (Hildesheim, 1974), p. 30: *vario ornatu,* p. 32: *variis ornatibus,* p. 48: *vario venustavit decore,* for example.

21. Letizia Pani Ermini, *La diocesi di Roma* (Corpus della scultura altomedievale VII) (Spoleto, 1974), vol. 1, pls. XLII–XLV.

22. *San Giorgio in Valpolicella a cura di Pier Paolo Brugnoli* (Verona, 1975), pp. 113–20; Andrea Castagnetti, *La Valpolicella dall'alto medioevo all'eta communale* (Verona, 1984), pp. 57–62; Fulvio Zuliani, *La scultura a Verona nel periodo longobardo. Verona in eta gotica e longobarda* (Atti) (1982); and Paolo Lino Zovatto, *Scultura: Verona e il suo territorio* (Verona, 1964), pp. 515–21.

23. Edoardo Arslan, *La pittura e la scultura veronese dal sec. VIII al sec XIII* (Milan, 1943), pp. 1–25.

24. L. Barbi, "La chiesa, il ciborio, il chiostro," in *San Giorgio in Valpolicella,* p. 113: "essa tuttavia non e affatto secura e nemmeno la migliore."

25. Castagnetti, *La Valpolicella,* p. 61.

26. Vittorio Cavazzocca Mazzanti, "Un nuovo archivolto del ciborio di S. Giorgio di Valpolicella," *Madonna Verona* 2/4 (1908), pp. 145–49.

27. Ibid., p. 147.

28. Raffaele Cattaneo, *L'architettura in Italia dal secolo VI al mille circa* (Venice, 1889), pp. 79–83, fig. 29; Kautzsch, "Die langobardische Schmuckkunst," pp. 38, 42, fig. 48.

29. Arslan, *La pittura e la scultura veronese,* p. 2 n. 11.

30. Castagnetti, *La Valpolicella,* p. 61.

31. Nicolette Gray, "The Paleography of Latin Inscriptions in the Eighth, Ninth and Tenth Centuries in Italy," *Papers of the British School at Rome* 16 (1948), pp. 38–167 n. 14.

32. Ibid., nos. 5, 9, 11–12, 15, 55.

33. Ibid., no. 159.

34. Ibid., nos. 38–40, 42, 44, 46.

35. Ibid., nos. 83, 123.

36. I should like to express my gratitude to Mrs. Anneliese Weil for the translation of my German text into English.

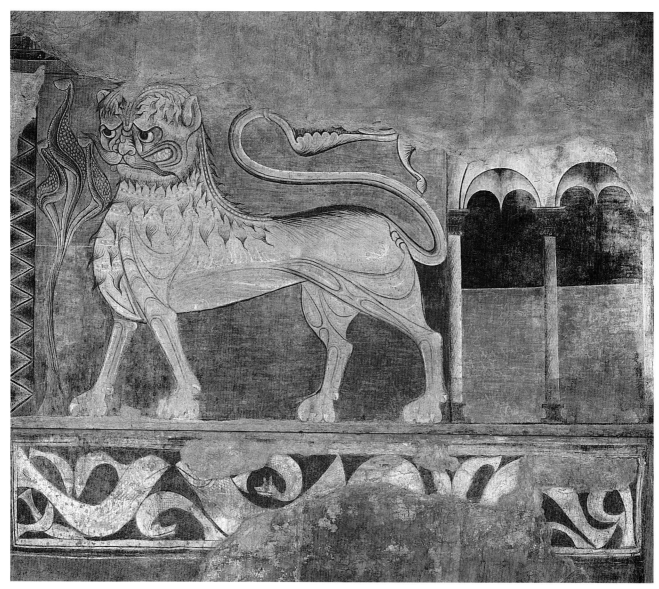

Fig. 1. Lion fresco, San Pedro de Arlanza. The Metropolitan Museum of Art, The Cloisters Collection, 1931 (31.38.1a,b) (photo: Museum)

The Frescoes of San Pedro de Arlanza

Walter Cahn

The frescoes of San Pedro de Arlanza were acquired for The Cloisters in 1938, as part of an important group of works purchased on the occasion of the opening of the museum in May of that year. An article from the pen of the prominent art critic Alfred Frankfurter, published in *Art News* to salute the event, included an illustration of the striking lion in its unrestored state; and James Rorimer briefly discussed the paintings in *The Bulletin of the Metropolitan Museum of Art* concerned with the same occasion.[1] Since then, the Arlanza frescoes have scarcely been ignored, being mentioned at least in passing in general surveys of Romanesque wall painting and in most studies of Spanish medieval art. A very comprehensive and judicious presentation of the frescoes is found in Joan Sureda's recent book *La pintura románica en España,* published in 1985, where the basic facts are assembled.[2] That author's speculations parallel my own thoughts about the monument on a number of points. Still, nearly everything about these paintings remains mysterious, or as scholars with a professional pride at stake prefer to say, problematic.

The Cloisters Arlanza frescoes consist of two sections now mounted on a canvas backing, the first with the familiar lion (Col. pl. 1 and Fig. 1), the second featuring an equally large dragon (Fig. 2). Both creatures are depicted in profile, although what hints there may be of heraldic detachment are contradicted by their lively characterization and their placement in implicit landscape settings, indicated in the case of the dragon by a pair of vaguely exotic trees. The lion, on the other hand, whose head is notable for its curiously anthropomorphic quality, is juxtaposed with an architectural structure resembling a tomb or altar canopy. The disposition of these images on the wall also deserves to be noted. Framed by variously patterned borders, now only partially preserved, they occupied roughly the upper three-fifths

Fig. 2. Dragon fresco, San Pedro de Arlanza. The Metropolitan Museum of Art, The Cloisters Collection, 1931 (31.38.2a,b) (photo: Museum)

of the space available to the artist, that is to say the area normally devoted in medieval wall painting to the unfolding of narrative or iconic representation, religious or secular. Below, there is a narrow, predellalike strip filled with small-scaled and fanciful imagery, a seascape with fish under the lion, and a sequence of motifs drawn from fable or the *mirabilia* under the dragon: a pair of confronted bird sirens, a donkey with a lyre entertaining a rabbit and a goat, and two figures apparently warming themselves or otherwise involved with two boulderlike objects. Below these compositions, there is a blank dado zone of approximately equal width.

The Benedictine monastery of San Pedro de Arlanza is located some fifty kilometers southeast of Burgos, in a picturesque site along the road that follows the Arlanza River, between Covarrubias to the west and the hamlet of Hortigüela to the east. The early history of the community is rather obscure, but the cartulary places its foundation in the year

912.[3] The reputed founders were Fernán González, a petty border warlord whose family stronghold was located in the nearby mountains of Lara, and his second wife, Sancha, a daughter of the king of Navarre. Fernán's career, partly history and partly myth, follows a pattern observable elsewhere in tenth-century Europe, a time marked by the dislocation of traditional centers of power and the constitution of new territorial entities. Fernán's lands were situated within the kingdom of León and he fought on the side of King Ramiro II at the famous battle of Simancas against the troops of Caliph Abd el-Rahman in 939. But he was very much his own man, and taking advantage of his relatively powerful position in a border area remote from the Leonese-Asturian heartland, he readily switched allegiances and eventually rebelled against Ramiro, for which he was for a time imprisoned in León. In a document dated 937, and sporadically thereafter, he began to use the novel title Count of Castile,[4] claiming for himself jurisdiction over the territory lodged between the cities of León in the west and Pamplona in the east, with newly founded Burgos at the center

of his domain. The subsequent counts and later kings of León and Castile recognized him as the founder of the dynasty, and he appears in the imposing sixteenth-century gate of Burgos, the Arco de Santa María, to the right of the emperor Charles V, while another hero and semimythical founding father, the Cid, is seen in the corresponding position at the left.

Fernán González died in 970 and was buried at Arlanza along with his Navarrese spouse, and, some authors claim, his parents as well.[5] His descendants, who became hereditary counts of Castile, did not follow this example but chose to be buried in other monasteries of the region: García Fernández (970–95) at San Pedro de Cardeña, and Sancho García (995–1017) at San Salvador de Oña, which he had founded. King Fernando I (1035–65) favored Arlanza with benefactions and seems for a time to have considered being interred there, although he eventually chose to establish his pantheon at León. It was during his reign, apparently, that Abbot García obtained for Arlanza the bodies of three martyrs of Avila, Sts. Vincent, Sabina, and Christeta, who

Fig. 3. San Pedro de Arlanza, view of the monastery ruins (photo: author)

thereafter figure with the apostles Peter and Paul as patrons of the community.[6] In the course of Cluny's expansion into northern Spain, the monastery seems to have come under its jurisdiction.[7] If the sixteenth-century chronicler Fray Antonio de Yepes is to be believed, there were one hundred and fifty monks at Arlanza around this time, and one hundred and eighty toward the end of the twelfth century.[8]

The existing buildings of the monastery, which now lie in ruins, belong to three distinct periods (Fig. 3). The church proper, of which only the triple apse, part of the perimeter walls to the west, and the tower flanking the northern side of the choir still stand, is thought—on the basis of an inscription recorded in the last century—to have been begun in 1081, though it would seem to have been completed a good deal later.[9] The vaults were redone in an opulent Late Gothic style toward the end of the fifteenth century. The claustral buildings that lie to the south are postmedieval and were for the most part constructed in the seventeenth and eighteenth centuries. An inscription with the date 1617 once visible on the west cloister wing probably commemorates the bulk of this work.[10] In the aftermath of the Napoleonic Wars, the monastery was secularized and the buildings eventually fell into private hands. The Romanesque portal of the church was transferred to the Museo Arqueológico Nacional in Madrid, and an elaborate (though perhaps composite) tomb in the cloister to the upper galleries of the Burgos Cathedral cloister.[11] The process of physical decay of the ruins on the site has continued nearly to the present day, although a restoration of the claustral buildings is now in progress.

Fig. 4. Ostrich fresco, San Pedro de Arlanza. Cambridge, Mass., Fogg Art Museum, Harvard University (photo: Visual Collections, the Fine Arts Library, Harvard University)

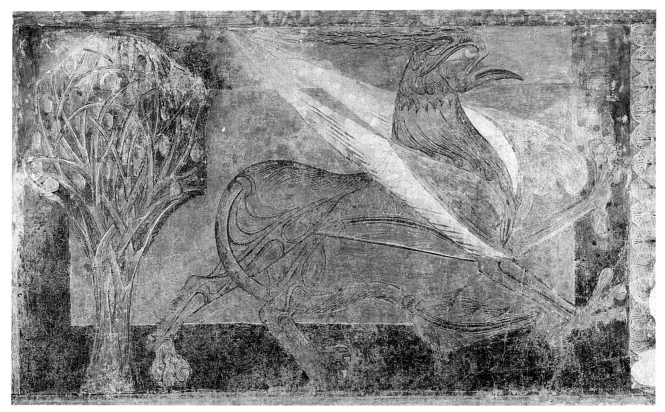

Fig. 5. Griffin fresco. Barcelona, Museu d'Art de Catalunya (photo: Museu d'Art de Catalunya)

The structure from which The Cloisters frescoes come is the towerlike building located along the southern side of the choir, at the northern extremity of the eastern arm of the cloister (Fig. 3). It is usually described as the chapter house, which, given the location, may well be accurate, even though the building goes unmentioned in the Arlanza documents. But this is a question to be considered in further detail below. The transformation of this sector of the monastic complex in the Baroque period affected this building as well. A monumental staircase coursing along three sides of the structure was installed at the time at ground level,[12] and the upper space was converted into a large and open *salone* covered with a plaster domed vault and a triple-arched opening onto the cloister along its western side. The Romanesque frescoes were themselves covered with plaster after being prepared for this operation by systematic pocking with the chisel. In 1894 there was a serious fire that caused the dome to collapse and, among other damage, some of the plaster to fall from the walls, bringing parts of

the paintings to light. Their discovery was publicly announced in 1912,[13] but in the meantime, the interior of the structure seems to have remained exposed to the elements, a situation that persisted until the installation of a new tiled roof during the current restoration.

The paintings, however, were removed from the walls in the late 1920s and offered for sale by the owners of the property. Beyond the fragments in The Cloisters, a large bird resembling an ostrich went to the Fogg Art Museum at Harvard University (Fig. 4); and a striding griffin with a fruit-laden tree (Fig. 5), along with a number of other fragments, went to the Museu d'Art de Catalunya in Barcelona. Still other elements comprising sections of decorative borders and ornaments filling the spandrels of the windows are said to be in Spanish private hands.[14] The removal and dispersal of these paintings, whatever might be said in defense of these actions, have robbed us of the chance to experience and assess them as a coherent whole and within their original setting. But their arrangement and a

Fig. 6. Cloister walk and chapter house. Arlanza (photo: author)

already mentioned. The room within is a square space whose sides measure approximately ten meters, or a bit over thirty feet (Fig. 8). The inner face of the back or eastern wall that faces the viewer incorporates two comparatively shallow blind arches, which read like an echo of the openings on the opposite side of the room—one of them more or less intact, the one on the left partially destroyed by the rising path of the Baroque staircase (Fig. 9). The northern and southern walls, on the other hand, each have a pair of deeper niches, which it is reasonable to assume must once have sheltered tombs (Fig. 10). The now-empty spaces of these burials are visible at the base of the wall. In the brief discussion devoted to Arlanza in the first volume of his history of Spanish painting, published in 1930, Chandler Post mentions a painting of the Pantocrator flanked by personifications of the sun and moon and symbols of the Evangelists in one of these niches, but does not say which.[16] The existence of this painting is also recorded in Walter Cook and José Gudiol Ricart's *Ars Hispaniae* volume of 1950, but whereas Post considered it to be part of the original decorative scheme, Cook and Gudiol Ricart regarded it as an addition, made around 1300.[17] The painting is no longer visible, although whether it has been removed or lost through erosion is not known to me. Kingsley Porter's photograph of it shows the Lord seated on a throne supported by a pair of eagles (Fig. 11). The paint surface is largely eroded, thus revealing the sketchy underdrawing beneath. The head gives the impression of having been summarily repaired, and the foliate and floral ornament around the rim of the composition attests in unmistakable fashion to a late or postmedieval intervention.

By what means the upper story was reached before the Baroque remodeling is also uncertain and would have to be clarified by a more searching archaeological investigation of the structure. But the existence of a walled-up door near the western end of the north wall on the upper level indicates that this room was entered at this point (Fig. 19), perhaps by way of a spiral staircase on the exterior of the building. It is in this space that the paintings in The Cloisters and those connected with them were found (Fig. 12). The Cloisters dragon and its ornamental "predella" occupied the south wall (Figs. 2, 13, 14), together with the Barcelona griffin and a corresponding strip of diminutive cavorting animals. The

partial, though reasonably reliable, impression of their appearance in situ can be gained with the help of photographs taken by Arthur Kingsley Porter and the author and dealer Arthur Byne of Madrid. Photographs taken for José Gudiol show the fresco fragments after their removal, and Gudiol's reconstruction drawings indicate the disposition of the paintings on their respective walls.[15]

The building with which we are concerned is accessible from the eastern arm of the cloister by means of two round-arched openings, one of them quite well preserved, the other bisected by a seventeenth-century doorway (Figs. 6, 7), but easy to reconstruct. The view into the interior is partly blocked by the triangular mass of masonry representing the base of the Baroque staircase that I have

paintings were separated by an arched recess originally pierced by twin round-headed windows. The eastern wall housed The Cloisters lion and its poorly preserved pendant, a second lion with a turreted building or facade, now also found in Barcelona, that constituted the counterpart of the domed structure in the New York painting (Figs. 1, 15, 16).[18] Between the two beasts, in the middle of the wall, there was a recessed space with a segmented arch, though the double window within it is placed much lower down than that on the south wall, and whether this opening belongs to the medieval construction is uncertain.

On the north wall was positioned the Harvard ostrich, facing another creature, which, save for a fragmentary crest or hump included among the extant Arlanza fragments, seems now to be lost (Figs. 4, 17, 18). There was between them only a single window, handsomely framed by a molding and colonnettes bearing ornamental capitals, and no accompanying architecture or vegetation, as in the other paintings, because space had to be provided for the already-mentioned door near the left end of the wall (Fig. 19).

The decorative scheme of the west wall is not known, since it was entirely lost when the Baroque triple-arched loggia was carved out of this side of the structure. The best guess is that this space harbored yet another pair of animals, each again combined with a narrow strip of ornamental *zodia*. The room was in all likelihood covered with a wooden roof.

A history of Arlanza compiled in 1563 by Juan de Pereda, a local author, credits the building of the tower on the north side of the church to one of the monks, named Ximéno, and the decoration to a painter, Gudesteo, who is said to have covered the walls within the church with scenes of the Passion, the chapter house with unspecified subjects drawn from the Bible, and the "passageways" (*ámbitos*), whose location is not otherwise specified, with purely decorative motifs.[19] According to Pereda, Ximéno carried out his work on the still-standing tower, known as the Torre del Tesoro (Fig. 3), in

Fig. 7. Chapter house, entrance. Arlanza (photo: author)

93

ENFEU TOMB

ENFEU TOMB

ENFEU TOMB?
(DESTROYED)

ENFEU TOMB

LOWER STORY

Fig. 8. Chapter house, ground floor layout. Arlanza

1138. But few scholars have been willing to accept such an early date for the frescoes still preserved,[20] whose subject is in any case at variance with the program ascribed to Gudesteo. Both Kuhn and Post, who first undertook to ascertain the date of the paintings on the basis of stylistic criteria, compared them to the illustrations in the Las Huelgas copy of Beatus' Apocalypse Commentary (now in the Pierpont Morgan Library), which was completed in 1220 at a place not too distant from Arlanza.[21] Cook and Demus, scholars writing in the 1950s and 1960s, called attention instead to the connections of the Arlanza paintings with the frescoes of the chapter house at Sigena in Aragon—the "discovery" of Romanesque mural decoration of these years— which are now generally accepted as the work of an English painter active in the last decade of the twelfth century.[22] These connections are germane to the issue of dating, but they cannot be pressed too far. Beyond general similarities, Arlanza and Sigena do share some additional common ground

Fig. 9. Chapter house, ground floor, east wall. Arlanza (photo: author)

Fig. 10. Chapter house, *enfeu* along the south wall. Arlanza (photo: author)

in their colorful population of hybrid fauna and drolleries, late-Romanesque imports of Spanish art, so far as can be judged, from northern Europe. These fanciful motifs also appear in the copy of Peter Lombard's Commentary on the Pauline Epistles, completed in 1181 for an abbot of Sahagún, which could well be taken for a product of a Parisian or northeastern French atelier, and might be added to the list of the Arlanza frescoes' stylistic relations.[23]

Some scholars, finally, have compared The Cloisters lion with the animal accompanying the portrait of King Alfonso IX of León on horseback in a miniature added to the first volume of the cartulary (Tumbo A) of the cathedral of Santiago de Compostela (Fig. 20). According to recent research, this miniature was executed between the years 1208 and 1212, and perhaps on the occasion of the dedication of the cathedral in April 1211.[24] The ferocious characterization of the lion, with gritted, flashing teeth—"más humana que animal," as Moralejo has written—appears in both images.

In the miniature of the Santiago manuscript, this characterization has a distinctly heraldic connotation, since it is also featured on the lion of Alfonso's shield and on the royal *signum* of official documents.[25]

Is such a heraldic reading applicable to Arlanza as well? This is a question that might also be raised in connection with the motif of the castle to the left of the Harvard ostrich (Figs. 17, 19, 21), and again, though on a smaller scale, in the spandrel of the window on the southern wall (Fig. 13). It is a squarish block, from which three towers rise, one in the middle, and two smaller ones at the ends. The castle in this form is of course the heraldic figure of Castile, used almost obsessively by members of the ruling dynasty, who in the thirteenth century, and after, often made far-flung alliances with princes of the major courts of Europe. It is prominent also at Las Huelgas, among the Hispano-Mauresque stuccos of the former vaults of the cloister, for example (Fig. 22).[26] Bishop Lucas of Tuy's world chronicle informs us that it was King Alfonso VIII

95

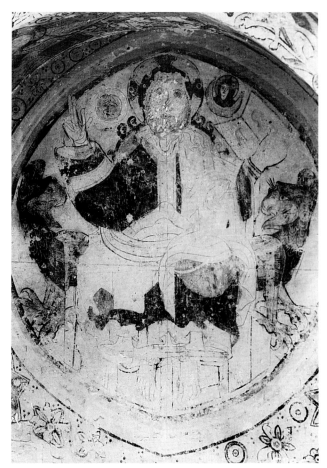

Fig. 11. Pantocrator. Chapter house, Arlanza (photo: A. K. Porter, Visual Collections, the Fine Arts Library, Harvard University)

Fig. 12. Chapter house, layout of the upper story. Arlanza

of Castile (r. 1158–1214), the founder of Las Huelgas, who adopted the castle as the emblem of his kingdom.[27] There are thus credible indications, if not unimpeachable proof, that the frescoes that concern us were executed in the first or second decade of the thirteenth century. Certain archaizing features of their style, like the ornamental linear patterning of the body of The Cloisters lion, which recall Romanesque of an older and more abstract phase, would, at any rate, make it difficult to envisage a date much further forward in time.

Some thoughts on the meaning of the ensemble that has been briefly described are now in order. It was clearly no ordinary chapter house, although what might count as ordinary or exceptional in the conception and decoration of such buildings is not easy to say. The chapter houses of Romanesque times in which an ambitious painted decoration is preserved—Worcester, Brauweiler (near Cologne), come to mind, along with Sigena—have a primarily biblical imagery and thus nothing in common with Arlanza.[28] The principal purpose of the *capitulum* in monastic houses was the conduct of meetings affecting the life of the community and the administration of corporal punishment for offenses committed by individual monks. But abbots and founders of a monastery were also sometimes buried in its chapter house, a practice that is well documented from the eleventh century onward, but has older roots.[29] Such burials were normally carried out under the pavement of the structure and therefore did not leave a mark on the architecture. The building at Arlanza is exceptional in this respect, since tombs were provided for at the outset and incorporated into the fabric of the structure. It would be good to know who were the persons buried in the monument at Arlanza, but this is a subject on which the sources are entirely silent. In theory, Fernán González and his family might merit some consideration, as the drift of my remarks may have already suggested. We do not know where in the monastery the count's tomb was actually located. Prudencio de Sandoval, a seventeenth-century author, states that Fernán was buried "at the foot of the church" (presumably in front of the west portal) "following the custom of the time," but that the body was moved into the interior of the vessel toward the end of the fifteenth century and placed within a marble sarcophagus resting on lions behind the altar of the choir.[30] In 1843, the princely remains were translated

96

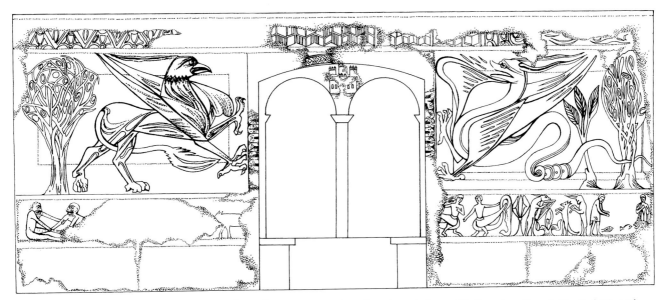

Fig. 13. Chapter house, upper story, south wall, reconstruction drawing. Arlanza (J. Sureda, after J. Gudiol Ricart)

into the choir of the Colegiata, in nearby Covarrubias, where they are found today: Count Fernán's body in a rather plain limestone gabled chest, Sancha's in a splendid Roman fourth-century marble sarcophagus with a Romanesque lid (Fig. 23).[31]

While it is uncertain just when Sancha's sarcophagus reached Arlanza, Sandoval's statement deserves to be taken seriously, since the custom to which he alludes is well documented. Sandoval refers to the fact that though early medieval princes and other magnates were moved to patronize churches and to seek benefit from the intercessory prayers of the clerical servants of their foundations, they could not, as laymen, be buried within the church proper. Thus, to cite but a few cases, King Fernando I established his Panteón de los Reyes in the atrium of the former church of San Juan Bautista, renamed San Isidoro, at León.[32] The counts of Toulouse lie in a niche adjoining the south transept doorway of Saint-Sernin at Toulouse (a niche constructed by Viollet-le-Duc in the nineteenth century, but on the site of an older chapel), and the counts of Burgundy, who chose Cîteaux as their resting place, were interred in a chapel under the porch of the abbey church.[33] There is some evidence that attitudes on the question of lay burials in churches were shifting in a more permissive direction in the period when the Arlanza frescoes were painted. But the sparse information that we

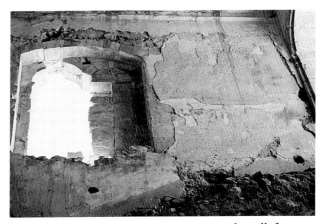

Fig. 14. Chapter house, upper story, south wall, former site of The Cloisters dragon fresco, condition in 1988. Arlanza (photo: author)

possess on the tombs in the monastery suggests that the customary hierarchy prevailed there: the church was reserved for holy bodies or saintly clerics, while the few lay burials of which there is some record are found in the cloister.[34] That the lower story of the chapter house might have been designed to house Fernán's mortal remains and those of his kin may thus be admissible in principle, although it is not demonstrable in fact.

The entirely zoological or zoomorphic decor of the upper story, on the other hand, declares its

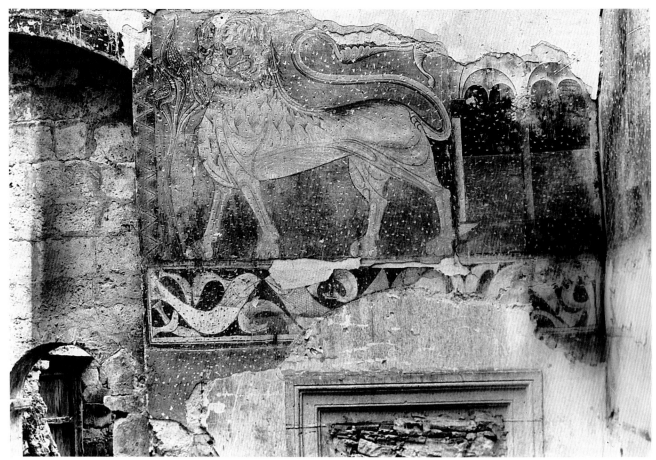

Fig. 15. Chapter house, upper story, east wall with The Cloisters lion fresco (with blocked-up Baroque window below). Arlanza (photo: A. K. Porter, Visual Collections, the Fine Arts Library, Harvard University)

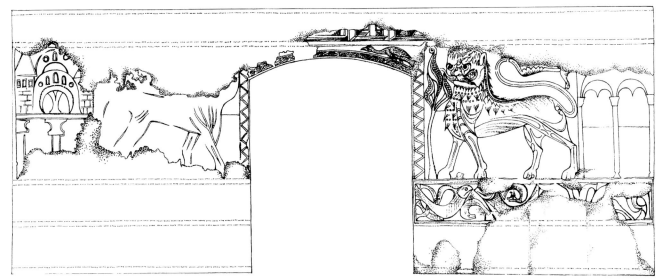

Fig. 16. Chapter house, upper story, east wall, reconstruction drawing. Arlanza (J. Sureda, after J. Gudiol Ricart)

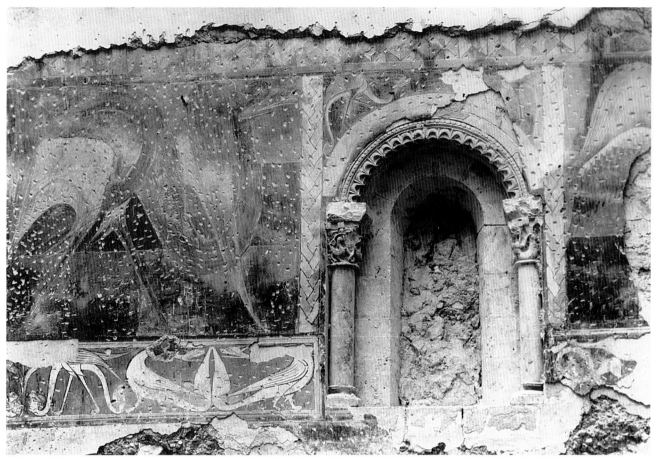

Fig. 17. Chapter house, upper story, north wall with Harvard ostrich fresco. Arlanza (photo: A. K. Porter, Visual Collections, the Fine Arts Library, Harvard University)

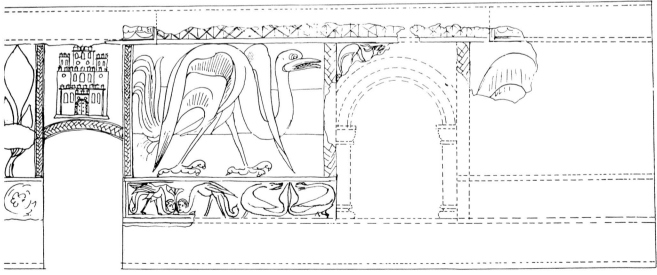

Fig. 18. Chapter house, upper story, north wall, reconstruction drawing. Arlanza (J. Gudiol Ricart, with modification by W. Cahn)

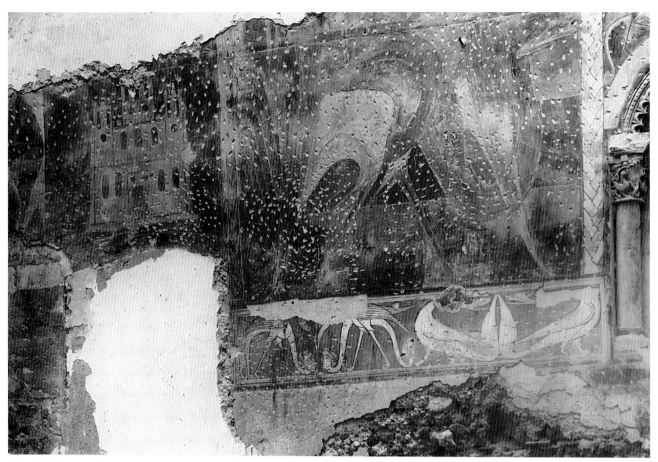

Fig. 19. Chapter house, upper story, north wall, former entrance. Arlanza (photo: A. K. Porter, Visual Collections, the Fine Arts Library, Harvard University)

allegiance to the lay or princely side in a less ambiguous fashion. It is of course possible on the basis of medieval animal symbolism to construct a moral interpretation of the paintings, and one cannot exclude altogether the idea that they may have communicated a religious message to some medieval spectators.[35] The lion, the dragon, and perhaps the fish-filled predella composition under the first-mentioned creature are subjects that carry a large symbolic freight, as medievalists well know.[36] Exotic animals and fantastic subjects are also part of the vocabulary of church decoration, but whether a moralizing or didactic intention should be attributed to their creators remains most uncertain. We also know that doubts were expressed by contemporaries that images of animals and composite creatures could be reliable instruments of moral instruction, and it is noteworthy that Lucas of Tuy, in a text to which Creighton Gilbert has recently drawn attention, justifies the painting of animals on church

walls solely on the grounds that these images of "birds, serpents and other things" give pleasure to the eye.[37] It is tempting in this context to mention a somewhat earlier ensemble of wall paintings in Castile, the frescoes of the church of San Baudelio at Berlanga, where this exotic imagery, though it occupies a subordinate position in relation to a cycle of New Testament scenes above it, is given remarkable prominence.[38] This aspect of the work, perhaps best understood in the light of the bishop of Tuy's strictures, makes the imagery of the later paintings at Arlanza seem a shade less exceptional.

Yet neither religious symbolism nor the interpretive stance habitually opposed to it, simple aesthetic delight, seems an appropriate frame of reference for an understanding of the Arlanza frescoes. They are best comprehended, in my view, as an evocation of palace decoration. Their substance is epic rather than descriptive, the symbolic expression of an aristocratic ethos concerned with the

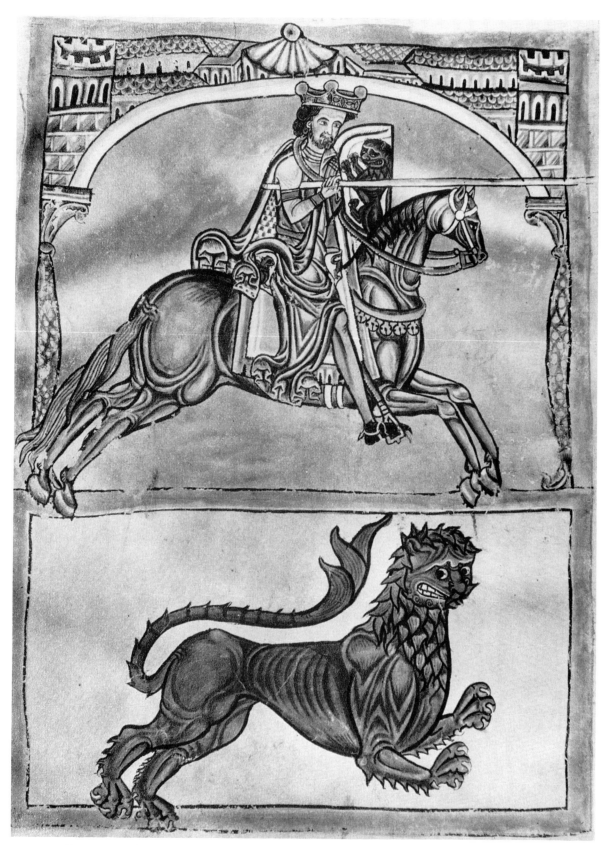

Fig. 20. Alfonso IX on horseback. Santiago de Compostela, Cathedral Library, Tumbo A, fol. 62v (from *Ars Hispaniae,* XVIII, p. 57)

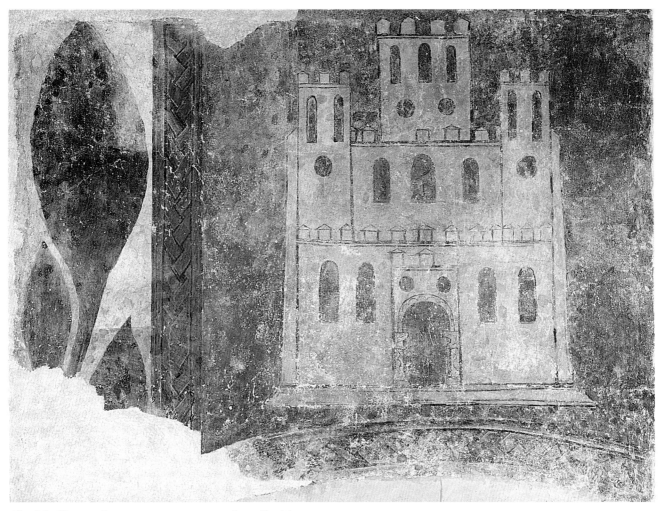

Fig. 21. Chapter house, upper story, north wall with castle, Arlanza. Barcelona, Museu d'Art de Catalunya (photo: Museu d'Art de Catalunya)

exaltation of untamed might, heroic deeds, and the opulent display of fabled rarities. On the other hand, their essentially static and plotless character also sets them against the biblical or hagiographically based narratives that were the normative province of church art. It is difficult from the surviving materials and documentary sources to recover a consistent and continuous tradition of this secular, palatial decoration for the early Middle Ages.[39] None may have existed. We are distantly reminded at Arlanza of the shieldlike reliefs decorating the upper hall and the exterior of the palace of the Asturian monarchs at Naranco, overlooking Oviedo,[40] or of the halls of princely residences hung with precious woven and embroidered hangings that are men-

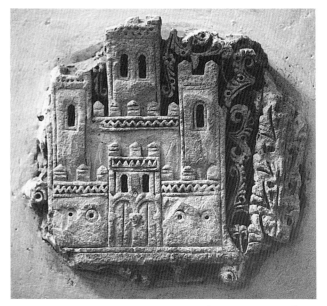

Fig. 22. Stucco fragment from the cloister. Las Huelgas (photo: author)

102

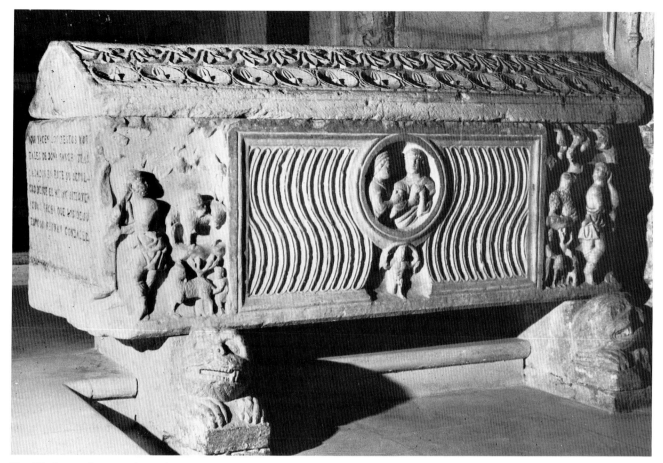

Fig. 23. Sarcophagus of Sancha. Covarrubias, Colegiata (photo: author)

tioned in contemporary chronicles and chivalric literature.[41] Such prized textiles, for the most part of Islamic origin, not infrequently found their way into the possession of monasteries of northern Spain, Arlanza included,[42] and the frescoes share this *arts somptuaires* orientation. Animals placed heraldically in landscape settings occur in Islamic art, and it is well to be mindful of the renewed contacts between the Latin kingdoms in the north and Muslim cultures of southern Spain during the period of reconquest, when cities like Toledo came under Christian rule. But neither the style nor the pictorial grammar of this tradition is very markedly reflected in the frescoes.[43]

The monument that can claim the closest resemblance to the Arlanza paintings, itself a *unicum* in the domain of aulic art, is the so-called Stanza di Ruggiero in the Norman palace at Palermo, whose mosaics are now generally associated with the reign of William II, spanning the years 1154 to 1166 (Figs. 24, 25).[44] The walls of this room feature wild animals and birds heraldically positioned in spaces that are delineated by exotic trees, and the vault has medallions with lions and griffins surrounding a triumphant eagle. The landscape plays a greater role at Palermo than in the Spanish work, and other differences hardly need detailed enumeration. But the two spaces are united in their similar emphasis on fabulous beasts and exotic vegetation, as well as in their curious combination of careful attention to the definition of plant and species with a highly formal presentation, axialized and flattened, making the imagery seem as if frozen in time. This comparison, to be sure, begs a number of questions. The background and sources of the Sicilian mosaics remain to be explicated,[45] and the formal coincidences that have been noted remain for the moment without a palpable historical context.

103

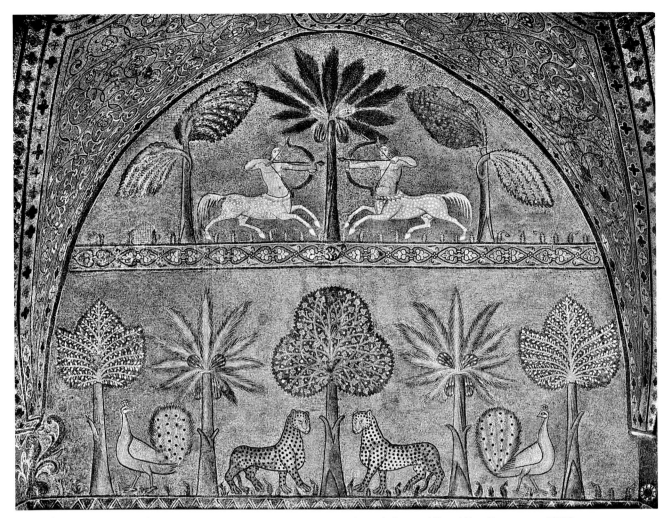

Fig. 24. Wall mosaic. Palermo, Stanza di Ruggiero, Norman palace (photo: Alinari/Art Resource, N.Y.)

At the time when the Arlanza frescoes were painted, the situation of the monastery was somewhat paradoxical. Under Alfonso VIII and his immediate successors the kingdom of Castile became a power to be reckoned with, overshadowing its neighbor and rival León, to which it had formerly been subordinate. The need for the establishment of a dynastic history grounded in the noble and warlike deeds of an illustrious ancestor must have made itself felt. Yet although Alfonso himself was generous in his donations to the monastery,[46] the significance of Arlanza in social and political terms was no longer what it had been at an earlier time. The old Benedictine monasteries of the region had now to vie for influence with the growing cities and their bishops, as well as with the more dynamic new monastic and military orders. Alfonso himself opted for the Cistercians when he established his pantheon at Las Huelgas in 1187.[47] In these circumstances, the palatial decoration of the upper room of the chapter house at Arlanza has something of the air of a nostalgic fantasy, perhaps designed to press the claims of the house against its rival, closely connected with the court at Burgos. Was the room designed with any particular practical purpose in mind? My supposition is that the kings of Castile might have used it for ceremonial purposes on visits to Arlanza connected with the memorial cult of their ancestor. But no information concerning such visits has as yet come to light.

However this may be, Arlanza's claims in the manufacture of a dynastic legend were supported

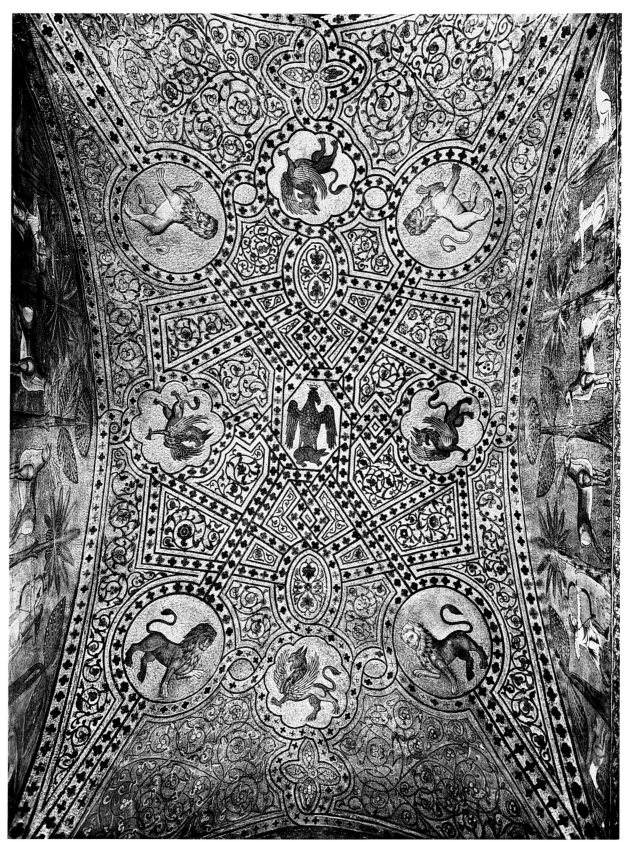

Fig. 25. Vault mosaic. Palermo, Stanza di Ruggiero, Norman palace (photo: Alinari/Art Resource, N.Y.)

on the literary side by a work whose relevance for an understanding of the frescoes is difficult to overlook. The work in question is the *Poema de Fernán González,* a composition of some seven hundred verses (in the incomplete state in which it has come down) in the Castilian vernacular, thought to have been written around the middle of the thirteenth century by a monk of Arlanza, and in fact the only known literary production attributable to the monastery in the medieval period.[48] The *Poema* presents an idealized account of the old battler's career as seen through clerical eyes, magnifying the role of Arlanza and of the divine assistance procured for him by the prayers of the monks. His fate, Arlanza's, and Castile's are seen to be intertwined in it. In the larger historical picture of his time, he is a familiar hero, another Cid, and a not-too-distant cousin of Westminster's St. Edward or Aachen's Charlemagne.

APPENDIX
Inventory of Fresco Fragments from Arlanza

I. *South Wall*
1. Dragon and frieze with fantastic subjects. The Cloisters (31.38.2)

2. Griffin. Barcelona, Museu d'Art de Catalunya, No. 40142.

3. Pair of monkeys from the border of the griffin fresco. Barcelona, Museu d'Art de Catalunya, No. 40143.

4. Section of a floral border from the griffin fresco. Whereabouts unknown (Gudiol photo, Fogg Art Museum)

5. Spandrel of double window with castle. Whereabouts unknown (Gudiol photo, Fogg Art Museum)

II. *East Wall*
1. Lion and fish border. The Cloisters (31.38.1)

2. Lion fragment with architecture, pendant of the above. Barcelona, Museu d'Art de Catalunya

3. Section of a meander border and right spandrel area with bird and foliate border of segmented arch. Barcelona, Museu d'Art de Catalunya, No. 40145

III. *North Wall*
1. Ostrich. Fogg Art Museum, Harvard University, Inv. No. 1938.124

2. Castle and tree. Barcelona, Museu d'Art de Catalunya, No. 40144

3. Section of a pleated border and bird-dragon, left spandrel of window. Barcelona, Museu d'Art de Catalunya, No. 40146

4. Fragment of geometric border and "hump" of a fantastic creature, right side of the north wall. Whereabouts unknown (Gudiol photo, Fogg Art Museum)

5. Frieze section with confronted birds, and human-headed storks, formerly under ostrich fresco at Harvard. Whereabouts unknown (Gudiol photo, Fogg Art Museum)

NOTES

1. Alfred Frankfurter, "The Opening of the Cloisters," *Art News* 7 (May 1938), pp. 9-14, 21; James J. Rorimer, "New Acquisitions for the Cloisters," *MMAB* 33 (1938), p. 8. I am grateful for advice and assistance received in the preparation of this paper from Paul Binski, Claude Cahn, Carme Ferré, Charles Little, Paul Meyvaert, Serafín Moralejo, and Debra Pincus.

2. Joan Sureda, *La pintura románica en España* (Madrid, 1985), pp. 22, 164, 390-94, no. 39. A comprehensive bibliography is appended to Sureda's description and analysis, of which the following are the most important titles: Charles L. Kuhn, "Notes on Some Spanish Frescoes," *Art Studies* 6 (1928), pp. 128-30; Chandler R. Post, *A History of Spanish Painting* (Cambridge, Mass., 1930), pp. 18-94; Walter W. S. Cook and José Gudiol Ricart, *Pintura e imaginería románicas* (Ars Hispaniae 6) (Madrid, 1950), pp. 127, 173-74; Juan Antonio Gaya Nuño, *La pintura románica en Castilla* (Madrid, 1954), pp. 21-23; Otto Demus, *Romanesque Mural Painting* (New York, 1970), p. 487; James J. Rorimer, *Medieval Monuments at the Cloisters, as They Were and as They Are* (New York, 1972), pp. 48-49.

3. Luciano Serrano, *Cartulario de San Pedro de Arlanza* (Madrid, 1925), pp. 5-10, no. 2. The authenticity of this document is disputed. Early authors were led to place the foundation of Arlanza in Visigothic times, but this idea is now discounted. For the history of the monastery, see Antonio de Yepes, *Crónica general de la Orden de San Benito* (Yrache, 1609), vol. 1, pp. 375-81 (repr. in the series *Biblioteca de autores españoles,* ed. Justo Pérez de Urbel [Madrid, 1959], vol. 1, pp. 121-33). Prudencio de Sandoval, *Historias de Idacio, que escribió poco antes de que España se perdiese* . . . (Pamplona, 1615), pp. 308-23, 336-67; Henrique Flórez, *España sagrada* (Madrid, 1772), vol. 27, cols. 81-154; Luciano Huidobro, "El monasterio de San Pedro de Arlanza y su primer compendio historial, inédito," *Boletín de la Comisión Provincial de Monumentos Históricos de Burgos,* vol. 1, no. 7 (1924), pp. 199-207, and vol. 2, no. 20 (1926), pp. 211-14; A. Lambert, "Arlanza," *Dictionnaire d'histoire et de géographie ecclésiastique* 4 (1930), pp. 224-31; Luciano Serrano, *El obispado de Burgos y Castilla primitiva* (Madrid, 1935), vol. 2, pp. 252-58; Justo Pérez de Urbel, *Historia del Condado de Castilla* (Madrid, 1935), vol. 1, pp. 358-61; T. Moral, "Revisión crítica de los estudios sobre

los monasterios Burgaleses," *Annuari de estudios medievales* 5 (1968), p. 577; Fray Valentín de la Cruz, *Patria y altares. Las donaciones religiosas del Conde Fernán González* (Burgos, 1970), pp. 46–53; M. del Carmen de León-Sotelo Casado, "Formación y primitiva expansión del dominio monástico de San Pedro de Arlanza, Siglo X," *En la España medieval. Estudios dedicados al Profesor D. Julio González González* (Madrid, 1980), vol. 1, pp. 223–35.

4. Serrano, *Cartulario*, pp. 43–45, no. 15. On Fernán's career, see Ramón Menéndez Pidal, "Fernán González, su juventud y su genealogía," *Boletín de la Real Academia de la Historia* 134 (1954), pp. 1–30; Justo Pérez de Urbel, "Fernán González: su juventud y su linaje," *Homenaje a Johannes Vincke* (Madrid, 1962–63), vol. 1, pp. 47–72; idem and Ricardo del Arco y Garay, *Historia de España,* ed. Ramón Menéndez Pidal (Madrid, 1964), vol. 6, pp. 220–21; René Cotrait, *Histoire et poésie. Le comte Fernán González. Genèse de la légende* (Grenoble, 1977); Manuel Marquez-Sterling, *Fernán González, First Count of Castile: The Man and the Legend,* University of Mississippi Romance Monographs, no. 40 (Valencia, 1980).

5. Fernán's burial at Arlanza is recorded in the chronicle of Rodrigo Jiménez de Rada, archbishop of Toledo from 1210 to 1247: "Monasterium Sancti Petri in ripe Aslantiae aedificavit, et multis possessionibus illud dotavit. Morte propria defunctus, in eodem monasterio est sepultus" (Rodericus Ximenius de Rada, *Opera*) (Madrid, 1793; repr. in the series *Textos Medievales* [Valencia, 1968], vol. 22, p. 99). "Ea tempestate [*sic*] vir strenuus Fernando Gundisalvi comes Castellae moritur, qui in acquisitione et tuitione et dilatatione patriae utiliter, strenueque, et fideliter laborabat, et in monasterio Sancti Petri de Aslantia quod ipse construxerat, sepelitur" (ibid., p. 105). The information that Fernán's parents were also buried at Arlanza is given in Flórez, *España sagrada,* vol. 27, col. 99.

6. On Fernando's desire to be buried in Arlanza, see the chronicle of Jímenez de Rada (note 5 above), p. 127. On the question of the three martyrs of Avila, see *Acta SS,* Oct. XII, pp. 193–204.

7. Arlanza's affiliation with Cluny is mentioned by Julio González, *El reino de Castilla en la Época de Alfonso VIII* (Madrid, 1960), vol. 1, pp. 500–501, but the study of Peter Segl, *Königtum und Klosterreform in Spanien. Untersuchungen über die Cluniacenserkloster in Kastilien-Leon vom Beginn des 11. bis zur Mitte des 12. Jahrhunderts* (Kallmünz, 1974), does not characterize it in that way.

8. Yepes, *Crónica,* vol. 1, pp. 127, 130. These figures may well be exaggerated. In the time of Flórez, during the eighteenth century (*España sagrada,* vol. 27, col. 101), there were only twenty-four monks left, "the times having changed."

9. On the Romanesque architecture at Arlanza, whose study has thus far concerned only the church, see Vicente Lampérez y Romea, *Historia de la Arquitectura Cristiana Española en la Edad Media* (Madrid/Barcelona, 1930), vol. 2, pp. 43–46. Walter M. Whitehill, *Spanish Romanesque Architecture of the Eleventh Century* (London, 1941; repr. Oxford, 1968), pp. 194, 202–5; José Pérez Carmona, *Absides románicos en la Provincia de Burgos,* Publicaciones del Seminario Metropolitano de Burgos, Ser. C. (Burgos, 1956), vol. 3, pp. 31, 46–47; idem, *Arquitectura y escultura románicas en la Provincia de Burgos* (Burgos, 1960), pp. 115–16; Juan Antonio Gaya Nuño, *La arquitectura española en sus monumentos desaparecidos* (Madrid, 1961), pp. 134–36.

10. Rodrigo Amador de los Ríos, "Burgos," in *España, sus monumentos y artes* (Barcelona, 1888), p. 91 n. 1 and p. 891.

11. The portal, shown still in situ, is illustrated in Serrano, *Obispado de Burgos,* vol. 2, pl. 5. The portal and the tomb (called "of the Mudarra") are also depicted in Rodrigo Amador de los Ríos, *Las ruinas del monasterio de San Pedro de Arlanza en la Provincia de Burgos* (Madrid, 1906), and the tomb further in Téofilo López Mata, *La catedral de Burgos* (Burgos, 1950), p. 331. The state of the monastery and its ruins in the nineteenth century is recorded in R. Monge, "El monasterio de San Pedro de Arlanza," *Seminario Pintoresco Español* (1847), p. 235 (not available to me); Isidoro Gil, "Monasterio de San Pedro de Arlanza," *La Ilustración Española y Americana* (July 30, 1887), p. 12; Amador de los Ríos, "Burgos"; Eloy García de Quevedo y Concellón, "El monasterio de San Pedro de Arlanza," *Boletín de la Sociedad Española de Excursiones* 2 (1894–95), pp. 56–59; idem, *Excursión per la Provincia de Burgos* (Madrid, 1899).

12. According to a note in the Registrar's file at the Fogg Art Museum, the interior remodeling and staircase were carried out around 1773. I have not been able to discover the source of this information.

13. J. Chapée, "Arlanza, découverte de peintures," *Revue de l'art chrétien* 62 (1912), pp. 380–81.

14. See the appendix for the list of extant fragments.

15. The Porter photos are in the library of the Fogg Art Museum (see Figs. 11, 15, 17, 19), along with a set of Gudiol's photographs of the remounted frescoes. A photo of the interior of the chapter house, credited to Arthur Byne and bearing the number 4580, is in the Conway Library of the Courtauld Institute, London. Gudiol's reconstruction drawings are housed in the Casa Amattler, Barcelona (see Figs. 13, 16, 18).

16. Post, *History of Spanish Painting,* p. 190. Edgar W. Anthony, *Romanesque Frescoes* (Princeton, 1951), pp. 180–81, locates the fresco "under a niche at the base of the east wall," but the niches are found only along the north and south walls.

17. Cook and Gudiol Ricart, *Pintura e imaginería románicas,* p. 174.

18. Sureda, *Pintura románica,* p. 269, states that this fragment is in The Cloisters, but in answer to my query he has indicated that it is in the collection of the Museu d'Art de Catalunya.

19. The text has unfortunately remained unpublished; it is known only through the summary and selective quotations provided by Luciano Huidobro, who discovered it (see note 3 above).

20. An exception is José Camón Aznar, *Pintura medieval española* (*Summa Artis,* vol. 22) (Madrid, 1961), p. 118, who upholds (mistakenly, I believe) the date 1138 furnished by Pereda's chronicle.

21. See note 2 above. For the bibliography on Pierpont Morgan Library, M. 429, see the exhib. cat. *Los Beatos* (Madrid, 1986), p. 117, no. 20, to which should be added David Raizman, "The Later Morgan Beatus (M. 429) and Late Romanesque Illumination in Spain" (Ph.D. diss., University of Pittsburgh, 1980). An anonymous reviewer of my paper has pointed out to me that the manuscript has also been connected with Toledo, based on the vendor's purchase of it from the convent of San Clemente in that city (Edgar S. Buchanan, *The Catholic Epistles and Apocalypse from the Codex Laudianus . . . ,* Sacred Latin Texts, no. 4 [London, 1916], p. 4). One of the painters of the Las Huelgas Beatus is also thought to have painted frescoes in the

church of El Cristo de la Luz in Toledo (David Raizman, "A Rediscovered Illuminated Manuscript of St. Ildefonsus's *De Virginitate Beatae Mariae* in the Biblioteca Nacional in Madrid," *Gesta* 26/1 [1987], p. 42).

22. Cook and Gudiol Ricart, *Pintura e imaginería románicas,* pp. 127, 173; Demus, *Romanesque Mural Painting,* pp. 119, 487. For Sigena, see Otto Pächt, "A Cycle of English Frescoes in Spain," *Burlington Magazine* 103 (1961), pp. 166-75, and Walter Oakeshott, *Sigena. Romanesque Paintings in Spain and the Winchester Bible Artists* (London, 1972). On the history and architecture, see J. Gardelles, "Le prieuré de Sigena aux XIIe et XIIIe siècles; étude architecturale," *Bulletin monumental* 133 (1975), pp. 15-28.

23. Now Pierpont Morgan Library, M. 939. Eric G. Millar, *The Library of Alfred Chester Beatty, A Descriptive Catalogue of the Western Manuscripts* (Oxford, 1927-30), pp. 1-4, and Christopher F. R. de Hamel, *Glossed Books of the Bible and the Origins of the Paris Booktrade* (Woodbridge/Dover, 1984), pp. 22, 59, 60. The impact of northern European manuscript illumination of the later twelfth century is also apparent in books from the library of Las Huelgas (G. Sonsoles Herrero, *Codices miniados en el Real Monasterio de Las Huelgas* [Madrid, 1988]).

24. Serafín Moralejo Álvarez, "La miniatura en los Tumbos A y B," in Manuel C. Díaz y Díaz, Ferdinando López Alsina and Serafín Moralejo Álvarez, *Los Tumbos de Compostela* (Madrid, 1985), pp. 57-58.

25. Moralejo Álvarez, ibid.

26. Leopoldo Torres Balbás ("Las yeserías descubiertas recientemente en Las Huelgas de Burgos," *Al-Andalus* 8 [1943], pp. 209-54) dates the cloister and its stuccos in the period 1230 to 1260. On the architecture of the *Claustrillas* at Las Huelgas, see also Pérez Carmona, *Arquitectura Cristiana,* pp. 300-301; Élie Lambert, *L'art gothique en Espagne aux XIIe et XIIIe siècles* (Paris, 1931), p. 53; and Julio González, "Un arquitecto de las Huelgas de Burgos," *Revista de archivos, bibliotecas y museos* 53 (1947), pp. 47-50.

27. "Iste rex Adefonsus primo castellum armis suis depinxit, quamvis antiqui reges patres ipsius leonem depingere consueverunt, eo quod leo interpretatur rex vel rex omnium bestiarum." The edition available to me, a Castilian version of the author's *Chronicon mundi,* quotes the Latin original cited above where the manuscript with the Romance text is faulty (*Crónica de España,* ed. Julio Puyol y Alonso [Madrid, 1926], p. 410). A castle with three turrets appears on a seal of Alfonso VIII datable ca. 1181: see Teofilo F. Ruiz, "Images of Power in the Seals of the Castilian Monarchy: 1135-1469," *Estudios en Homenaje a Don Claudio Sánchez Albornoz en sus 90 años* (Buenos Aires, 1986), vol. 4, pp. 455-63, with reference to Araceli Guglieri Navarro, *Catálogo de Sellos de la sección de sigilografía del Archivo Histórico Nacional* (Valencia, 1974), vol. 1, pp. 16-17, no. 18.

28. A summary, though suggestive treatment of the decoration of chapter houses is found in Léon Pressouyre, "St. Bernard to St. Francis: Monastic Ideals and Iconographic Programs of the Cloister," *Gesta* 12 (1973), pp. 78-81. On Worcester, whose decorative scheme is known through *tituli* preserved in a manuscript of the Chapter Library, see Neil Stratford, "Notes on the Norman Chapterhouse at Worcester," *Medieval Art and Architecture at Worcester,* British Archaeological Association Conference Transactions for the year 1975 (London, 1978), pp. 51-70. On Brauweiler, see Demus, *Romanesque Mural Painting,* pp. 607-8.

29. Stratford, "Notes on the Norman Chapterhouse at Worcester," p. 54. Marcel Aubert and Geneviève A., marquise de Maillé, *L'architecture cistercienne en France* (Paris, 1947), vol. 1, pp. 331-35. In Marie de France's *Yonec,* there is reference to the burial of a knight in the chapter house of a monastery: "El chapitre vindrent avant/Une tumbe troverent grant" (Karl Warnke, *Die Lais der Marie de France,* Bibliotheca Normannica 3 [Halle, 1900], p. 143, vs. 503ff.). This passage was called to my attention by Professor Robert Hanning.

30. Prudencio de Sandoval, *Fundaciones de los monasterios del glorioso Padre San Benito . . .* (Madrid, 1601), pp. 334-35: ". . . en orden de sepultura a la puerta de la iglesia como entonces se usava." Yepes, *Crónica,* vol. 1, p. 121: "Mando pusiesen su sepulcro, no en la iglesia, sino en los pies de ella." Concerning the transfer of the bodies in the Capilla Mayor within the church, Yepes writes that they were placed "in una tumbas de piedra con mucha decencia," while Flórez (*España sagrada,* vol. 27, col. 152) states that "y [Fernando and Sancha] yace en la Capilla Mayor en arca de marmol sobre leones. . . ."

31. The sarcophagi are catalogued in Antonio García y Bellido, *Esculturas romanas de España y Portugal* (Madrid, 1949), pp. 278-80, and Giuseppe Bovini, *Sarcofagi paleocristiani della Spagna* (Vatican City, 1954), pp. 29-32, and are also discussed by Serafín Moralejo Álvarez, "La reutilización e influencia de los sarcófagos antiguos en la España medieval," *Colloquio sul Reimpiego dei Sarcofagi Romani nel Medioevo* (Pisa, Sept. 5-12, 1982), in *Marburger Winckelmann-Program,* 1983 (Marburg, 1984, pp. 189-90), idem, "Artes figurativas y artes literarias en la España medieval: Románico, Romance y Roman," *Boletín de la Asosiación Europea de Profesores de Español* 17 (1985), pp. 68-70. Moralejo suggests that the monks of Arlanza might have taken the portrait of the Roman couple in the *clipeus* of Sancha's sarcophagus for portraits of Fernán and Sancha. Why the sarcophagus identified since the nineteenth century as Sancha's should be so much more sumptuous than that of her husband is unclear, although Moralejo stresses the important role given to her in the *Poema de Fernán González* (see note 48 below) in the liberation of her husband from prison. I have not been able to discover a reliable account of the discovery of the sarcophagus. Serrano, *Obispado de Burgos,* vol. 1, p. 36, perhaps more plausibly calls it "Sepulcro de Fernán González" and claims that it was found at the beginning of the seventeenth century in a farmhouse at Lara, but gives no evidence for this view.

32. John Williams, "San Isidoro in León: Evidence for a New History," *Art Bulletin* 55 (1973), pp. 170-84.

33. Marcel Durliat, *Saint-Sernin de Toulouse* (Toulouse, 1986), pp. 77-79. Aubert and de Maillé, *Architecture cistercienne,* vol. 1, p. 335.

34. On the location of the various tombs at Arlanza, see Amador de los Ríos, "Burgos," pp. 892ff.

35. A symbolic interpretation of the paintings is offered by Sureda, *Pintura románica,* p. 392, in terms of an opposition between the animals represented on the walls along the east-west axis of the room, said in view of The Cloisters lion to be "animales cristológicos," and those in the axis north-south, which are understood to be invested with a diabolical meaning. Xenia Muratova has connected the animals at Arlanza with the illustrations of the English bestiaries, though she is concerned primarily with possible antecedents and lines of transmission on which the pictorial cycles of the English manuscripts depend. See her articles "I manoscritti miniati del Bestiario medievale:

origine, formazione e sviluppo dei cicli di illustrazioni. I Bestiari miniati in Inghilterra nei secoli XII–XIV," *Settimane di Studio del Centro Italiano di Studi sull'Alto Medioevo* 31 (1985), pp. 1336–37, and "Bestiaries: An Aspect of Medieval Patronage," *Art and Patronage in the English Romanesque,* ed. Sarah Macready and Frederick H. Thompson, Society of Antiquaries, Occasional Papers, vol. 8 (London, 1986), p. 134.

36. On the possible iconographic reading of fish-filled seascapes, see André Grabar, "La Mer Céleste dans l'iconographie carolingienne et romane," *Bulletin de la Société Nationale des Antiquaires de France* (1957), pp. 98–100; B. Andberg, "Le paysage marin dans la crypte de la cathédrale d'Anagni," *Acta ad archaeologiam et artium pertinentia,* vol. 2 (1965), pp. 195–201, and Elisabeth Chatel, "Les scènes marines des fresques de Saint-Chef. Essai d'interpretation," *Synthronon,* Bibliothèque des Cahiers archéologiques, vol. 2 (Paris, 1968), pp. 177–87.

37. Creighton Gilbert, "A Statement of the Aesthetic Attitude Around 1200," *Hebrew University Studies in Literature and the Arts* 13, no. 2 (1985), pp. 125–52. The passage in question, which appears in *De altera vita,* is given in full on pp. 150–52.

38. For Berlanga, see Demus, *Romanesque Mural Painting,* pp. 481–82, and Sureda, *Pintura románica,* pp. 319–27. Gilbert, "Statement," holds that the views of Lucas of Tuy may be applicable to these frescoes.

39. The decoration of the *camera regis* of the thirteenth-century palace at Westminster included among other subjects "panellis continentibus species et figuras leonum, avium et aliarum bestiarum" (Ernest W. Tristram, *English Medieval Wall Painting: The Thirteenth Century* [Oxford, 1950], p. 574, and Paul Binski, *The Painted Chamber at Westminster,* Society of Antiquaries, Occasional Papers, n.s., vol. 9 [London, 1986], p. 16). For palace decoration of the early Middle Ages, see the primarily architectural study of Karl M. Swoboda, *Römische und romanische Paläste* (Vienna, 1918); André and Oleg Grabar, "L'essor des arts inspirés par les cours princières à la fin du premier millénaire: princes musulmans et princes chrétiens," *Settimane di Studio del Centro Italiano di Studi sull'Alto Medioevo* 12 (1965), repr. in André Grabar, *L'art de la fin de l'Antiquité et du moyen âge* (Paris, 1968), vol. 1, pp. 121–44; idem, "Le rayonnement de l'art sassanide dans le monde chrétien," *La Persia nel Medioevo,* Atti del Convegno Internazionale (Rome, 1970), ill. in André Grabar, *L'art du moyen âge en Occident: Influences byzantines et orientales* (London, 1980), pp. 679–707; Oleg Grabar, *The Formation of Islamic Art* (New Haven/London, 1973), pp. 141–78; Andrew Martindale, in "Painting for Pleasure. Some Lost Fifteenth-Century Secular Decorations of Northern Italy," *The Vanishing Past: Studies of Medieval Art, Liturgy and Metrology Presented to Christopher Hohler,* ed. Alan Borg and Andrew Martindale, BAR International Series, vol. 3

(Oxford, 1981), pp. 109–31, presents much material concerning a better-documented, later period.

40. Helmut Schlunk, "La decoración de los monumentos ramirenses," *Boletín del Instituto de Estudios Asturianos* 5 (1948), pp. 55–94; Jean Hubert, "Le décor du palais de Naranco," *Symposium sobre cultura asturiana de la alta edad media* (Oviedo, 1967), pp. 151–60; and Jacques Fontaine, *L'art préroman hispanique,* Coll. Zodiaque 38 (La Pierre-qui-Vire, 1973), vol. 1, pp. 316–21.

41. For some literary references concerning such works from Spanish sources, see Ramón Menéndez Pidal, *La España del Cid* (Buenos Aires/Mexico City, 1943), pp. 417–18.

42. An Islamic textile with decorative medallions from Arlanza, preserved in the Colegiata at Covarrubias, is mentioned by Évariste Lévi-Provençal, *España musulmana* (*Historia de España,* vol. 5 [Madrid, 1965]), p. 785.

43. Borrowings from Islamic art in the frescoes are detected by André Grabar, whose opinion, however, delivered *en passant,* remains unsubstantiated (André Grabar and Carl Nordenfalk, *Romanesque Painting* [Lausanne, 1958], p. 71). For heraldically positioned animals in landscapes in Islamic art, see, for example, the illustrations of the Arabic Bestiary in London, British Library, MS Or. 2784 (Hugo Buchthal, "Early Islamic Miniatures from Baghdad," in *Art of the Mediterranean World, A.D. 100 to 1400* [Washington, D.C., 1983], pp. 18–31 and esp. figs. 99–100), brought to my attention by an anonymous reviewer of this paper.

44. Adolf Goldschmidt, "Die normannischen Konigspaläste in Palermo," *Zeitschrift für Bauwesen* 48 (1898), pp. 541–90; Otto Demus, *The Mosaics of Norman Sicily* (London, 1949), pp. 180–83; and André Grabar, "L'art profane en Russie pré-Mongole et le 'Dit d'Igor,'" *Art de la fin de l'antiquité et du moyen âge,* vol. 1, pp. 308–12.

45. Eva Börsch-Supan, *Garten, Landschafts- und Paradiesmotive im Innenraum* (Berlin, s.d.), pp. 196–97, relates them to a tradition of "paradisiac" interiors with illusionistic landscapes.

46. González, *Reino de Castilla,* vol. 1, pp. 500–501.

47. See the comments of Cotrait, *Histoire et poésie,* pp. 22–23, and González, *Reino de Castilla,* vol. 1, pp. 526ff. On Las Huelgas, see Manuel Gómez-Moreno, *El Panteón Real de Las Huelgas* (Madrid, 1946).

48. The work has been edited by Charles Carroll Marden, *El Poema de Fernán González* (Baltimore, 1904), and several times since then. It is exhaustively discussed by Cotrait, *Histoire et poésie,* to which may be added David G. Pattison, *From Legend to Chronicle. The Treatment of Epic Material in Alphonsine Historiography,* Medium Aevum Monographs, n.s., vol. 13 (Oxford, 1983), pp. 23–42, and Louis Chalon, *L'histoire et l'épopée castillane du moyen âge,* Nouvelle bibliothèque du moyen âge 5 (Paris, 1976), pp. 389–475.

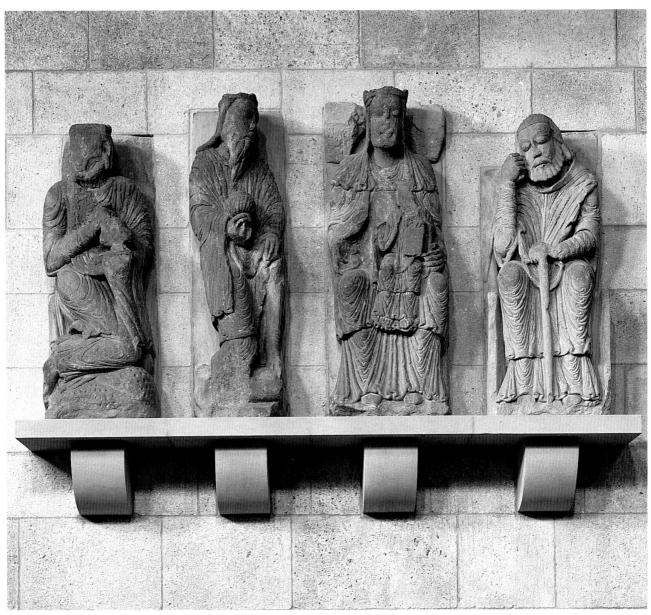

Fig. 1. Epiphany, relief, Cerezo de Riotirón (Burgos), third quarter of the twelfth century. The Metropolitan Museum of Art, The Cloisters Collection, 1930 (30.77.6-9) (photo: Museum)

The Epiphany Relief from Cerezo de Riotirón

Elizabeth Valdez del Alamo

One of the finest examples of large-scale Spanish Romanesque sculpture outside of Spain is a group of figures representing the Adoration of the Magi (Fig. 1), reinstalled at The Cloisters in 1985.[1] The Epiphany relief from Cerezo de Riotirón (in the province of Burgos) is the work of an artist who participated in the decoration of many of the most important surviving monuments of the region. In addition, it is carved in the distinctive manner of northeastern Castile, a crossroad for artistic movements in Christian Spain (Fig. 2).[2] The Epiphany from Cerezo de Riotirón can serve, therefore, as a focus for a study of this twelfth-century style. The relief also presents an archaeological problem: its intended placement on the church of Nuestra Señora de la Llana is unknown and the surviving evidence is ambiguous. An examination of Romanesque portal decoration in north-central Spain, particularly in Burgos, can provide the arena for selecting the most likely positions on a church facade for these figures.

The group is composed of four figural slabs; by their postures, the figures indicate how they should be arranged. The largest depicts a frontal, enthroned Virgin with the Christ Child seated in her lap, holding a book and raising one hand (now broken) in what probably was a gesture of blessing. She is crowned, and, even though the Child's head has been lost, its silhouette, visible against the Virgin's chest, indicates that he too was crowned. To the right, a seated Joseph sleeps, his head resting on one hand and inclined toward Mary and the Child. His other hand rests on a staff. Only two Magi appear in the group in its present state. The first kneels to the left of the Virgin while presenting his gift to the Child; the second, also on his knees, turns his head back as if to converse with the third, missing, Magus. By his very absence, the missing Magus is a reminder of the archaeological problems presented

Fig. 2. Map. Cerezo de Riotirón and related monuments

us by these figures and of the need to verify, as far as possible, the intended setting for the Epiphany relief.

Situated at the peak of the hill, surveying the territory on all sides, the church of Nuestra Señora de la Llana (Our Lady of the Plain) crowns the town of Cerezo de Riotirón.[3] Photographs published by Arthur Kingsley Porter (Fig. 3) and José Pérez Carmona show the Epiphany group installed over a blind arch west of the south portal of the church.[4] Unfortunately, the original architectural setting of the Epiphany relief cannot be determined from the surviving evidence. The church of Nuestra Señora

de la Llana was in ruins before 1924, and the many ruptures visible in the fabric of the building and around the reliefs themselves make it difficult to assert that the figures were in the place for which they were planned.[5] The lack of positive proof of the sculpture's original disposition has raised the question as to whether these figures formed a tympanum, as the curve formed by their heads suggests, or a relief installed elsewhere, as its position on the south portal of the church suggests.

Our only information concerning what might have been the figures' original disposition comes from photographs and descriptions of the 1920s and

from the remains of the church today (Fig. 4). In 1924, Narciso Sentenach described the ruined building and mentioned the south portal, its archivolts, and lateral reliefs of beautiful figures in Romanesque style. He identifies one of these lateral reliefs as the Adoration of the Magi, but says nothing of the subject matter of the others.[6] The south portal, with Elders of the Apocalypse, animals, and foliage in the archivolts, may be seen today in the Paseo de la Isla, a park in the city of Burgos (Fig. 5). The portal shows no sign of ever having contained a tympanum, and measurements demonstrate that the opening is too small for a group the size of the Epiphany.[7] Whatever else might have been at the church of Nuestra Señora de la Llana must have disappeared or perhaps was in very poor condition when Arthur Kingsley Porter was there to photograph the building, sometime before 1928, because no

other large figures were published by him. Porter's photographs of the Epiphany and portal do provide us with additional bits of information about the building and the sculpture (Fig. 3).[8] The south facade, where the portal and the reliefs were installed, appears to have been at least partially enclosed in a Gothic porch, as indicated by the capital and springing of arches at the lower right of the Epiphany group, and at the upper left of the portal. Perhaps the third king was lost when an opening was made in the wall, for the beveled strip under the figures in Porter's photograph continues past the second king and is cut off by a frame.[9] In the old photographs one can also see that stone slabs were placed under two of the figures—Joseph, at the right, and the Magus to the far left—to raise their heads to the same level as that of the other figures.

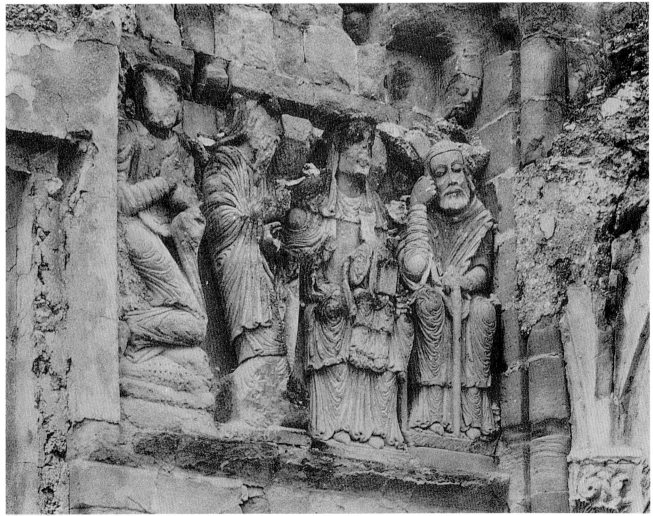

Fig. 3. Epiphany, relief, south portal during the 1920s. Cerezo de Riotirón (photo: from A. K. Porter, *Spanish Romanesque Sculpture*, vol. 2, pl. 112)

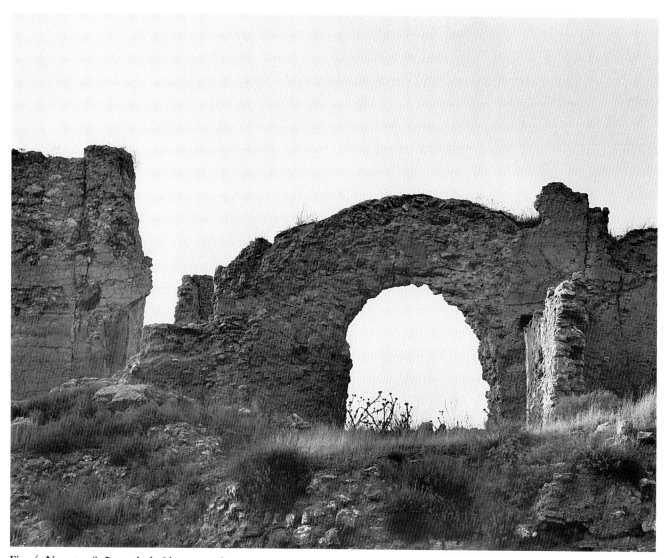

Fig. 4. Nuestra Señora de la Llana, south nave exterior, portal opening today. Cerezo de Riotirón (photo: author)

The argument for the relief's having been a tympanum is appealing because of its simplicity: when all the figures are placed at the same level, as they are now, their heads produce a curve that suggests they were intended for, or modeled on, a tympanum.[10] The image would have been completed by a third king at the left, and probably the kings' guiding star somewhere near the Virgin and Child. Such a tympanum would not have been symmetrical, but this kind of asymmetry was acceptable in tympanum compositions of the region; for example, in the Epiphany at Ahedo de Butrón (Fig. 11), the central axis falls between Mary and the first king, creating an irregular yet visually balanced composition.[11]

Part of the difficulty in ascertaining whether the relief formed a tympanum derives from the condition of each of the sculptures. The fact that the hatch marks on the upper edges of some of the Cerezo reliefs are distinct from the marks on the lower edges indicates that some of the slabs have been cut down to produce their present shape (Figs. 6–10).[12] For example, a comparison between the right and left sides of the Virgin's slab (Figs. 6, 7) demonstrates that the right side was reduced at the upper and lower right edges, and, according to Timothy Husband, there is evidence to suggest that a section of the relief over her head was cut away. The slab with the king kneeling immediately to Mary's left clearly shows the effects of weathering and trimming

114

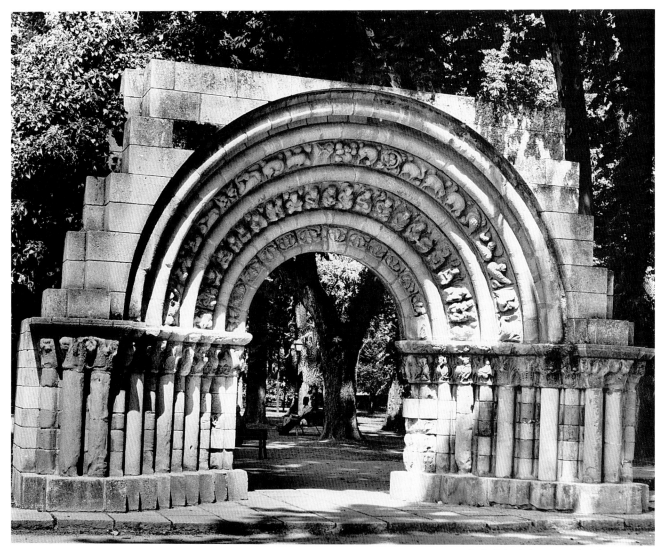

Fig. 5. Nuestra Señora de la Llana, south portal, Cerezo de Riotirón. Burgos, Paseo de la Isla (photo: author)

on its right (Fig. 8): the edge is roughly hewn and patched; the king's right hand and knee are damaged, as are his right foot, the cushion, and the ledge on which they rest. A section of his left knee was also chipped off (Fig. 1), while the upper and lower limits of the relief, in addition to the area just to the left of the king's head, have also been altered. Perhaps the most weathered figure is the second king (Fig. 9), whose face has lost all detail, as has the gift in his hands. His slab has been cut away over his left shoulder and along the left edge, following the general outline of his figure. The figure of Joseph has suffered the least damage (Fig. 10). Although his nose and the hand over his cane are worn, and his shoes broken, his is the only face that still shows

the delicately outlined pupils and brow all the figures once must have had. As with the second king, a right-angled section was cut away to the left of his head.

The amount of cutting above and behind the figures could explain why the curve formed by their heads produces a segmented arch, rather than the full half-circle or slightly pointed arch this tympanum should have had.[13] The full height of a tympanum with the Cerezo Epiphany might have accommodated a canopy, or baldachin, over the Virgin and Child, suggested by the rough blocks on either side of Mary's head (Figs. 6, 7). Structurally, the Cerezo blocks resemble those on either side of the heads of two figures placed high on the facade

115

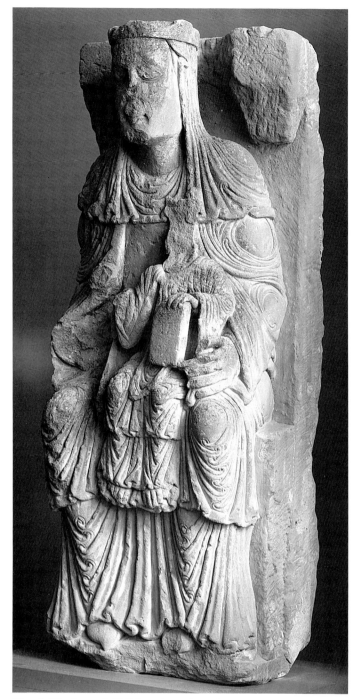

Fig. 6. Virgin and Child, right side, relief, Cerezo de Riotirón. The Metropolitan Museum of Art, The Cloisters Collection, 1930 (30.77.8) (photo: Museum)

Fig. 7. Virgin and Child, left side, relief, Cerezo de Riotirón (photo: Museum)

of Santo Domingo in Soria (Fig. 29); the blocks serve to interlock the relief and the facade while forming the base for a baldachin over the figure.[14] A canopy is depicted in the Epiphany of the Sorian capital frieze, and, in another Epiphany in the archivolts, the figures appear under an arcade (Fig. 33). The guiding star, no longer with the Cerezo figures, appears here on the impost between the Virgin and Child, and the first king. Such a tympanum at Cerezo would also have included not only a third king to

Fig. 8. First kneeling king, right side, relief, Cerezo de Riotirón. The Metropolitan Museum of Art, The Cloisters Collection, 1930 (30.77.7) (photo: Museum)

Fig. 9. Second kneeling king, relief, Cerezo de Riotirón. The Metropolitan Museum of Art, The Cloisters Collection, 1930 (30.77.6) (photo: Museum)

the left but also possibly an additional figure, such as the prophet which appears to Joseph's right in the Epiphany at San Martín de Mura in Catalonia.[15] At Mura, censing angels fill the space on either side of the Virgin's head.

How four to six straight-sided slabs might have sustained themselves over an opening raises the question of the original shape of this relief. Typically, Spanish tympana of the period did not have lintels. Because the hatch marks on the upper edges of some

Fig. 10. Joseph, relief, Cerezo de Riotirón. The Metropolitan Museum of Art, The Cloisters Collection, 1930 (30.77.9) (photo: Museum)

have been monolithic, as are many tympana in the Iberian Peninsula, but such examples tend to be smaller than the Cerezo Epiphany.[17] Most likely the sides of the Cerezo slabs were intended to be straight with interlocking segments. Many Spanish tympana are constructed of pieces with straight sides that lock together by means of projecting and receding parts, for example, the Puerta de las Platerías at Santiago de Compostela and the Puerta del Perdón at San Isidoro of León.[18] The straight-sided slabs of the Cerezo figures as we know them, however, cannot in themselves indicate whether the Epiphany was meant to be a tympanum or a lateral relief. The best evidence for the tympanum theory continues to be that the figures' heads form a curve.

If the Epiphany was a tympanum, the most likely alternate location for it at Nuestra Señora de la Llana would have been a portal on the west facade, where there was another entrance to the church, or on a porch enclosing the south portal.[19] The surviving west facade and south porch are Gothic, probably fourteenth century, and it is possible that the Epiphany was moved to the south nave exterior when the church was reconstructed at that time.[20] The pattern of wear on the figures, worse at the left than at the right, seems to correspond to the wind patterns experienced by the south facade; the portal now in Burgos displays a similar pattern (Fig. 5). Since the weathering seems consistent on the Epiphany relief, it must have been on the south portal of Nuestra Señora de la Llana a very long time. Another possibility that might be considered is that, once the figures for the tympanum were carved, there was a change in plan requiring their placement on the south facade as a lateral relief.

The longtime placement of the Epiphany beside the south entrance to the church raises the further question as to whether the figural group was originally rectangular and intended to be installed on the south portal from the beginning. A review of comparable local portal types suggests that it is possible that the Epiphany was intended to be set into a wall next to the south portal in a manner similar to its former installation at Nuestra Señora de la Llana, but the evidence is complex and at times contradictory. Most characteristic of Burgos are doorways with or without a tympanum, ornamental archivolts that alternate with torus moldings, flanking a capital frieze with columns, like the Cerezo portal in the Paseo de la Isla (Fig. 5), or the portals of

of the slabs are different from those on the lower edges, the possibility exists that some slabs may have been wedge-shaped. But, except for the hatch marks, it is difficult to gather evidence to support such an idea.[16] Another possibility is that the tympanum may

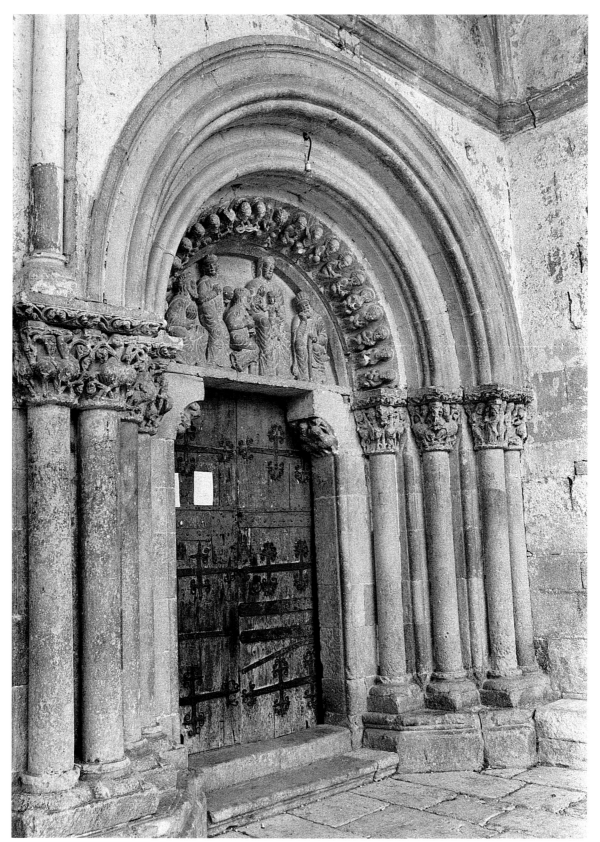

Fig. 11. South portal, Ahedo de Butrón (Burgos), third quarter of the twelfth century (photo: author)

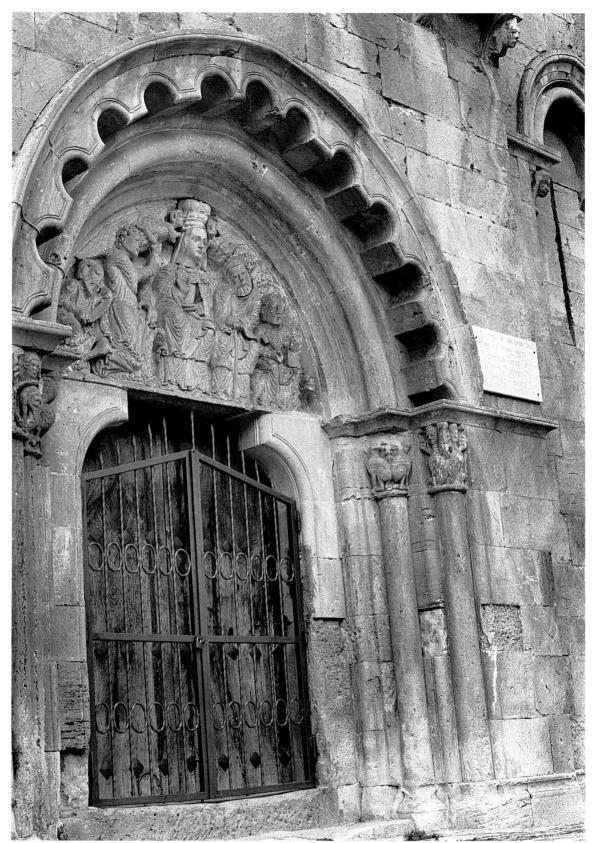

Fig. 12. South portal, Gredilla de Sedano (Burgos), third quarter of the twelfth century (photo: author)

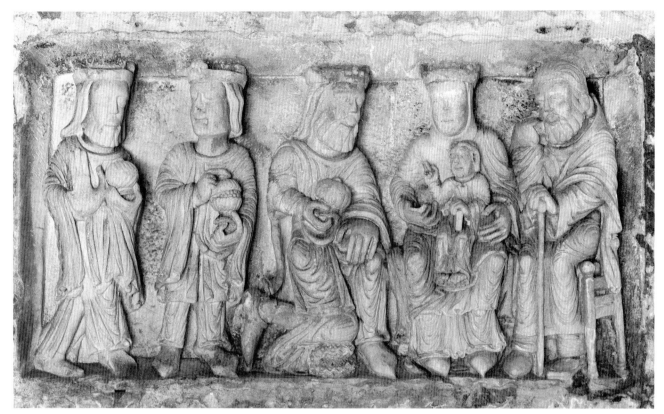
Fig. 13. Epiphany, relief, interior wall facing south portal, Butrera (Burgos), late thirteenth century (photo: author)

the churches in Gredilla de Sedano (Fig. 12) and Ahedo de Butrón (Fig. 11). There are many significant exceptions to this convention, and they include the use of figural reliefs in different places around the facade. If in comparing these figural reliefs with the Cerezo Epiphany one keeps in mind factors such as scale, function, and compositional type, one is forced to conclude that, while within the range of possibilities, this is the more problematic solution for the relief at The Cloisters.

The comparisons with other monuments may conveniently begin with an Epiphany similar to the Cerezo example, found in the church at Butrera (Fig. 13).[21] It is composed of six figures: at the left, three Magi adore the Child held on his mother's lap, while Joseph dreams at the right. The relief is set at eye level into a wall forming an entryway just inside the church door, so it is the first thing the visitor sees as he enters. An examination of the mortar around the relief's frame suggests, however, that the Butrera sculpture may not be in its original setting. Although its original location may be unknown, it seems clear that this sculpture was not intended to

be a tympanum but was instead applied to the wall of the church, perhaps as a lateral relief. The Butrera Epiphany was composed as an isocephalic group on a single slab of stone; the figures are even distorted in scale in order to conform to the predetermined rectangular form of this relief. A comparison between the reliefs of Butrera and Cerezo demonstrates that local sculptors—possibly the same group, as discussed below—did find the Epiphany to be an appropriate subject for a large relief that was not a tympanum.

Another possible placement of the Cerezo figures may have been on the exterior of the portico, like the Annunciation relief of the church at Villasayas (Soria) (Fig. 14), but it too is problematic.[22] Like the Cerezo Epiphany, with which it is contemporary, the relief is composed of large figures, whose heads suggest the curve of a tympanum, but which are carved on straight-sided slabs. The figures rest on a ledge and are presently set above the arched entrance to the portico. The difficulty in accepting this model is that, like the Cerezo and Butrera Epiphanies, the wall into which this Annunciation

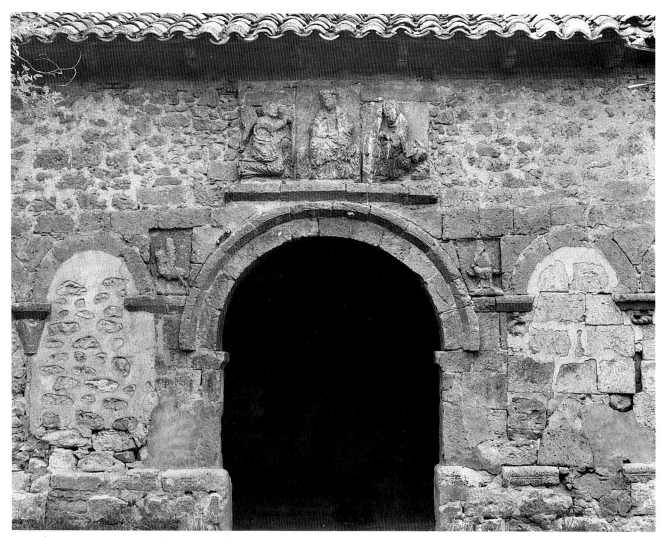

Fig. 14. Annunciation, relief, Villasayas (Soria), third quarter of the twelfth century, portico exterior (photo: author)

is set has been subjected to alterations and repairs that cast doubt upon the authenticity of this portal composition.[23]

Large-scale historiated reliefs beside or above the portal occur outside of Burgos: for example, at San Miguel of Estella (Navarre) (Fig. 15), where lateral reliefs flank the portal, and at Santa María la Real of Sangüesa (Navarre), and at Santa María of Ripoll (Catalonia), where rows of figures and historiated reliefs cover the entire portal.[24] Cerezo de Riotirón was located on the frontier between Castile and Navarre; hence, possible models for portal decoration at Cerezo need not be limited to Castile. The lateral reliefs of San Miguel are both large in scale and historiated, like the Cerezo Epiphany, and at least one of the scenes depicted—the angel Michael

standing between Abraham and a devil—contains figures whose heads form an arch which, out of context and cut down like the Cerezo figures, could suggest a tympanum.[25] This brings us full circle, in a sense, because we cannot completely dismiss the possibility that the installation of the Epiphany to the left of the Cerezo portal may in fact reflect the original conception of the sculptors.

When the relief was acquired by The Cloisters, James J. Rorimer wished to reflect the "original" setting of the group, an idea shared by Joseph Breck, so he installed the figures similarly (Fig. 16), placing them in a deep rectangular niche over a blind arch and above a doorway, not next to one as in Cerezo.[26] That installation made manifest the difficulty of deciding whether the Epiphany relief from Cerezo

122

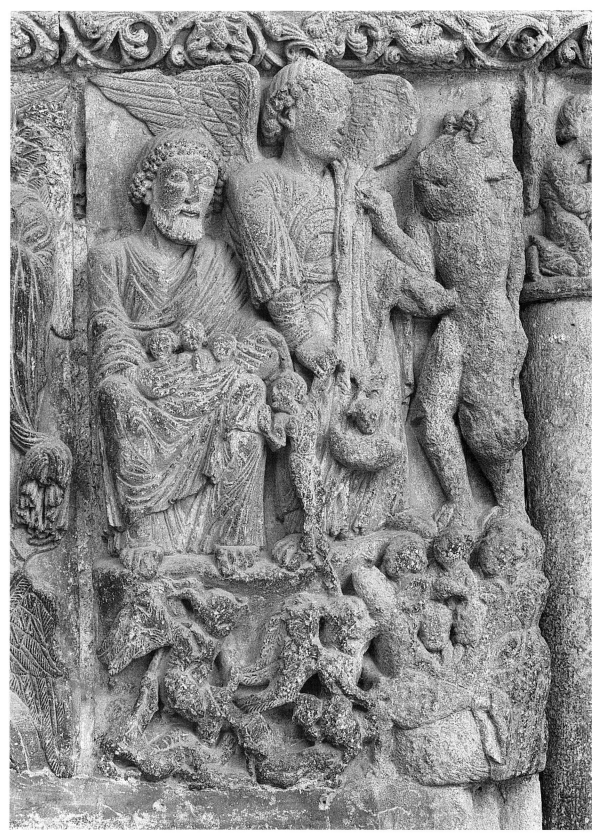

Fig. 15. Abraham, Michael, and a Devil, relief, north portal, San Miguel in Estella (Navarre), last quarter of the twelfth century (photo: author)

de Riotirón was a tympanum or another type of portal sculpture. The aim of the 1985 installation (Fig. 17), according to Timothy Husband, was to take a neutral stance on the tympanum/lateral relief issue, while at the same time to highlight the forceful three-dimensionality of the figures.[27] Despite the intention to be neutral, however, the resulting placement high on the gallery wall, with the figures separated, might imply a point of view to those expecting the type of "archaeological" installation typical of the Museum in the past.[28] In a memo discussing plans for the 1985 installation Husband stated, "There are many examples of high relief sculpture of ca. 1200 all over Burgos set into walls, usually above the height of the portal, as though an extension of the tympanum. This is essentially the way we are treating the figures."[29]

One Burgalese portal type in which figural reliefs are placed above the portal may be found at Pineda de la Sierra and at Moradillo de Sedano (Fig. 18), where the figures are placed over the imposts of the outermost capitals in the capital frieze.[30] These examples, however, are distinct from the Cerezo Epiphany, because the figures, although thematically related, do not form historiated groups. The same can be said of the *Apostolados* (apostle friezes) on the upper facades of many twelfth-century churches, such as Santa María la Real in Sangüesa (Navarre), or Santiago in Carrión de los Condes (Palencia) (Fig. 19).[31] The present installation of the Cerezo Epiphany at The Cloisters most closely resembles an *Apostolado* in the height and spacing of the figures, but separating the figures as individuals does not seem to be an appropriate model for a historiated group. Thus, whether intended or not, this neutral or, perhaps, ambiguous stance generates even further speculation on the archaeological questions: was the Epiphany a tympanum, and, if not, where was it meant to be placed, high on the facade or as a lateral relief pendant to the south portal of the church of Nuestra Señora de la Llana?

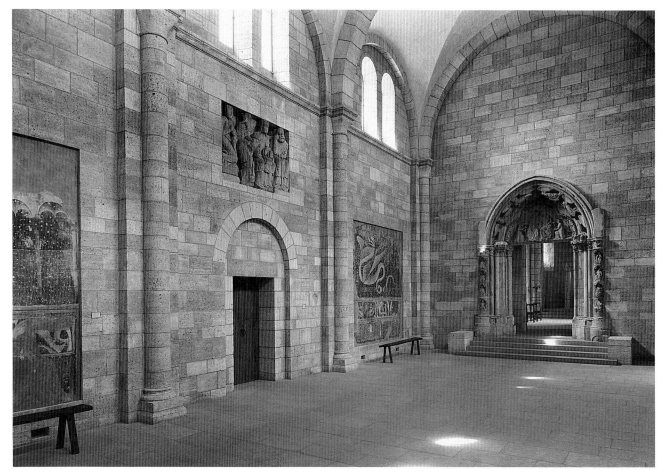

Fig. 16. Epiphany, relief, Cerezo de Riotirón, original installation at The Cloisters (photo: Museum)

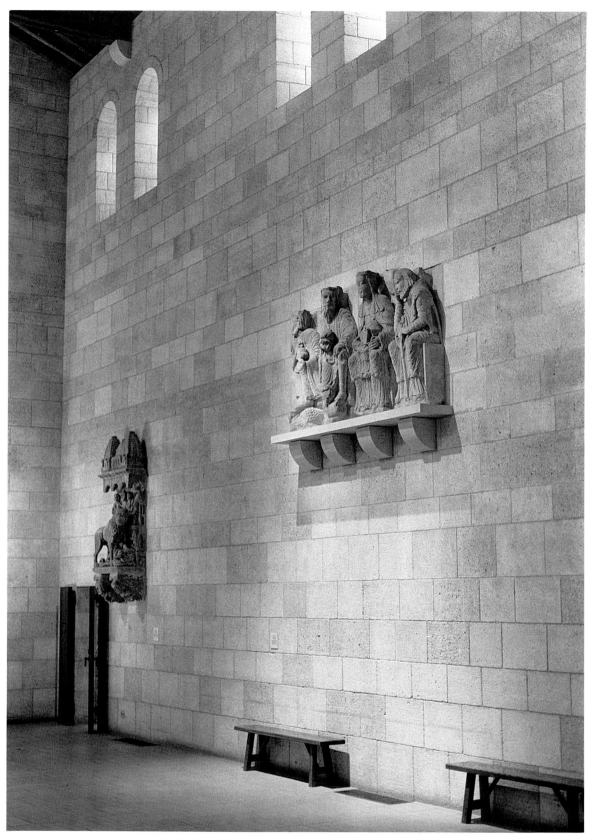

Fig. 17. Epiphany, relief, Cerezo de Riotirón, present installation at The Cloisters (photo: author)

125

Fig. 18. South portal, Moradillo de Sedano (Burgos), ca. 1188 (photo: author)

126

Fig. 19. *Apostolado*, west facade, Santiago in Carrión de los Condes (Palencia), ca. 1170-75 (photo: author)

While the problems concerning the intended use of the Cerezo Epiphany have long been recognized, only recently was the provenance of the relief questioned. David Simon, in his catalogue entry for the Epiphany, raised the possibility that the sculpture might have been intended for another church altogether.[32] Although a common provenance cannot be absolutely proven, Arthur Kingsley Porter's photographs tend to confirm that the Epiphany was indeed carved for Nuestra Señora de la Llana, and not for a different building. In his photograph, just over Joseph's head, is a corbel (Fig. 3) comparable to the heads in the Epiphany, especially those of Joseph and the kneeling kings (Figs. 1, 8-10). The same distinctive facial features, a long face with a long, protuberant upper lip and flowing beard, appear among the Elders in the archivolts (Fig. 20), on a king's head in the capital frieze, and on the first kneeling king at The Cloisters (Fig. 8). Therefore, the very slight recarving visible on this king's lower lip did not radically alter his appearance. Many of

the archivolt figures—the Elders of the Apocalypse and an angel—and the mythological creatures on the capital frieze (Fig. 21) also closely resemble the other relief figures with their blocklike bodies, rectangular heads, and large, protruding eyes.[33] The draperies manifest the same playfulness with pattern, and sometimes rise over the body in ropelike folds, sometimes flatten themselves against the body plane. The comparisons with the corbel and archivolts suggest that the provenance for the Epiphany relief, the church of Nuestra Señora de la Llana, is quite secure. The monumental Virgin of the Epiphany relief also suggests that the church could have been dedicated to Our Lady of the Plain from the twelfth century on, if not before.

The sculptor of the Epiphany and the capitals, archivolts, and corbels of the portal is a distinct artistic personality and may be designated the Master of Cerezo de Riotirón.[34] Despite the lack of documentation for Nuestra Señora de la Llana, there is sufficient evidence concerning the style and

Fig. 20. Elders of the Apocalypse, archivolts, south portal from Cerezo de Riotirón. Burgos, Paseo de la Isla (photo: author)

Fig. 21. Fantastic beasts in foliage, capital frieze, right, south portal from Cerezo de Riotirón. Burgos, Paseo de la Isla (photo: author)

Fig. 22. Annunciation-Coronation, south portal, Gredilla de Sedano (Burgos), third quarter of the twelfth century (photo: author)

subject matter at related sites to suggest a likely period and area for his activity. The heavy, ropelike draperies of the Cerezo Epiphany group are typical of the figural sculpture of La Bureba, the region of northeast Burgos. A survey of the monuments most closely related to the Cerezo style suggests that this is the radius within which this master worked and that he was fully aware of contemporary artistic developments.

Of the comparisons made between Cerezo and other monuments, one of the best is to the portal of the parish church in Gredilla de Sedano (Figs. 12, 22).[35] Here, there is a tympanum depicting an Annunciation-Coronation, in which Mary, enthroned at the center, is crowned by two angels and flanked by Gabriel and Isaiah to the left and Joseph and Peter to the right. With the exception of the restored crown and head of the Virgin, the Gredilla figures have very similar features and display the same type of surface pattern and plasticity as are found at Cerezo. Gredilla is somewhat less refined than

Cerezo; the edges are in general, sharper. A comparison of the two figures of Joseph (Figs. 10, 22), in the same pose, demonstrates the striking similarity of the facial type, with large, bulging eyes, clearly defined eyebrows, a pyramidal nose, and full lips emphasized by his beard. At Gredilla, however, Joseph's hair and beard terminate in ornamental snail-shell curls, a device not used at Cerezo, and the folds of his robe terminate in flamelike tips instead of the interlocking hook-folds so predominant at Cerezo. The type of drapery characteristic of Cerezo—in which the cloth clings to the limbs like wet drapery, then develops a series of swirling, interlocking folds at the joints—can be best seen at Gredilla in the figure of Isaiah to the left. Other details in the Gredilla tympanum are reminiscent of the Cerezo figures. The square head, full cheeks, and bowed lips of Gabriel are comparable to the face of the Cerezo Virgin; the same crisscross embroidery is found on the sleeves and hems of both the Gredilla Virgin and the Cerezo Joseph; the

Fig. 23. The Infancy of Christ, Elders of the Apocalypse, archivolts, south portal, Moradillo de Sedano (Burgos), ca. 1188 (photo: author)

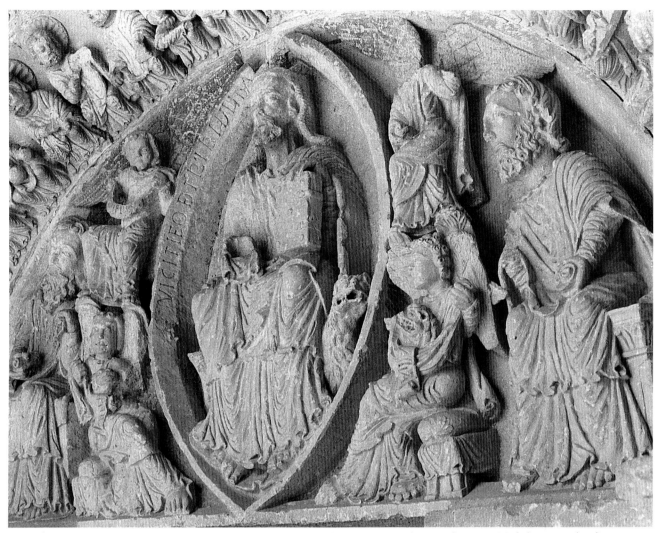

Fig. 24. Christ in Majesty, tympanum, south portal, Moradillo de Sedano (Burgos), ca. 1188 (photo: author)

same fly-away hems with C-shaped frills and the large, doughlike hands with exaggeratedly long fingers appear at both sites—in both large and small scale. In addition, the treatment of the wings of the angels of Gredilla is comparable to that of the wings of the harpies and birds of the Cerezo portal, now in Burgos (Figs. 12, 21, 35).

Nearby Moradillo de Sedano (Figs. 18, 23, 24), like Gredilla, is usually cited as a place where the Cerezo Master worked. Although James J. Rorimer, José Pérez Carmona, and others recognized the relationship, it has never been examined in detail.[36] The Master of Cerezo de Riotirón did carve some figures in the archivolts at Moradillo (Figs. 18, 23)— such as the Annunciation, Visitation, and Flight into Egypt. In these archivolts, we can see the same sturdy

bodies, large, rectangular heads, protruding eyes, and full, clearly delineated lips, even though the Moradillo figures are slightly more slender. The large figures installed over the imposts on either end of the capital frieze (Fig. 18) are very close in technique to the Cerezo Magi (Figs. 8, 9). They display the same fondness for linear effects—flattened pleats producing swirling patterns over the body—and have a dramatic presence that survives the damage to their faces.

A distinction should be drawn between the Cerezo Master and another artist who may be designated the Master of the Moradillo Tympanum. Along with the tympanum (Fig. 24), he carved some of the Elders in the archivolts (Fig. 23) and the Last Supper for the capital frieze. When the Moradillo

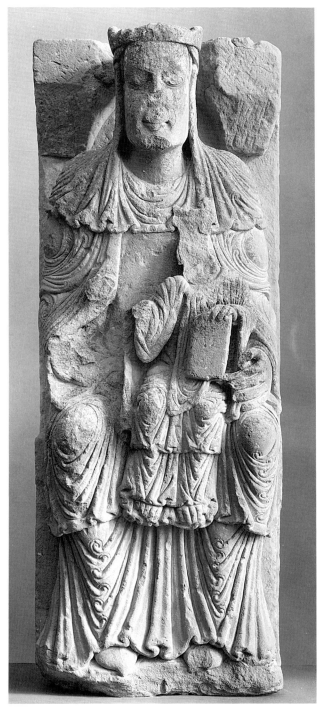

Fig. 25. Virgin and Child, epiphany relief, Cerezo de Riotirón, third quarter of the twelfth century. The Metropolitan Museum of Art, The Cloisters Collection, 1930 (30.77.8) (photo: Museum)

Elders are compared with those of the Cerezo portal (Fig. 20), it becomes clear that the Cerezo Elders are more solid in conception, with exaggeratedly large heads in proportion to their bodies and with deep furrows articulating the ropelike folds of their drapery; the Moradillo Elders, on the other hand, are much more slender, with smaller heads, longer necks, and their robes fall in long, flat pleats with fly-away hems. They occasionally cross their legs, twist more as they turn toward their neighbors, and convey a greater sense of movement than do the Cerezo Elders. The same can be said when comparing the large figures in the Moradillo tympanum with those of the Cerezo Epiphany. While the Cerezo figures are each carefully aligned to a central axis, the Moradillo tympanum figures lean or twist in place. They, in turn, contrast to the lateral figural reliefs (Fig. 17), probably by the Master of Cerezo de Riotirón, which are forceful in their verticality. Even the treatment of the hair by these two masters differs. The Cerezo bearded Magus and Joseph have large, clearly defined locks of hair and beards that end in a relatively straight line (Figs. 18, 10). The Moradillo prophets and Christ have wavy hair that twists into decorative ringlets or snail-shell curls (Fig. 24). If one compares the Cerezo Virgin and Child (Fig. 25) with the Moradillo Christ (Fig. 24), one can see that the Cerezo Mary is relatively boxy and still. Despite the activity of the patterns formed by her drapery, the folds themselves respect the rectangular silhouette of her figure. The Moradillo Christ, on the other hand, is lighter by virtue of his more slender proportions and is not bound by a strictly geometric silhouette. His drapery, while still stylized, is not governed as much by pattern as by a desire to convey movement, particularly at the hem, where the folds fly up and away from his legs; the interlocking hook-folds so characteristic of the Cerezo figures are less pronounced when they are found at Moradillo, for example, along the legs of the prophets and of Christ. The Master of the Moradillo Tympanum, therefore, is distinct from the Master of Cerezo de Riotirón, and the latter appears to have learned from the former. Some of the differences between the figures at Cerezo and those at Gredilla de Sedano (Fig. 22) might be understood as adaptations of elements in the Moradillo tympanum, for example, the substitution of flamelike folds for the hooklike folds.

Another sculptural fragment in northeastern

Burgos may have been carved by the Master of Cerezo de Riotirón: a statue of the Virgin in the church of Butrera (Fig. 26), where the Epiphany relief (Fig. 16) discussed earlier is also found.[37] To judge from the Virgin's gesture of acceptance, the statue probably was part of a figural group which depicted the Annunciation, as at Gredilla de Sedano (Fig. 22). The softer, more fluid drapery of the Butrera Virgin looks very much like that of certain archivolt figures at Moradillo—for example, the Visitation (Fig. 23) or the Flight into Egypt—which are attributable to the Master of Cerezo de Riotirón. The Epiphany relief at Butrera also seems to reflect the experience of Moradillo, for the long-necked kings are reminiscent of many figures by the Master of the Moradillo Tympanum (Figs. 13, 24). When the Virgins from Cerezo, Gredilla, and Butrera are placed side by side, they share enough features—the structure of the faces and hands, and the general conception of the figure—that they may demonstrate different stages in the career of the Cerezo sculptor.

Another sculpture that has been placed into this stylistic group is the Virgin and Child from Aradón (Fig. 27), a fragment of a relief now found in the parish church of Alcanadre in La Rioja, on the border with Burgos (Fig. 2), and part of the medieval kingdom of Castile.[38] The curve of the stone behind the Virgin's head clearly suggests that this relief formed part of a tympanum.[39] The remnants of a shoe to the lower left must have belonged to a kneeling figure and indicate that the tympanum depicted another Adoration of the Magi. This group was made for the hermitage of Santa María in Aradón, just outside Alcanadre.[40] Unfortunately, this Epiphany tympanum suffered a fate similar to that of the Epiphany from Cerezo de Riotirón: because the church was rebuilt over the course of time, the sculpture was first moved from its original location, and then eventually removed from the site altogether.

In the only previously published photographs, this Virgin and Child look very much like the Cerezo Virgin and Child and have been attributed to the Master of Cerezo de Riotirón.[41] But there are enough significant differences between the two reliefs to make one wonder whether this figure is truly by him (Figs. 25, 27). The face, shoulders, and general proportions of the Aradón Virgin are, in fact, more slender than the Virgins from Cerezo, Gredilla (Fig. 22), and Butrera (Fig. 26), all of whom maintain a blocklike massivity that binds them to the stone.

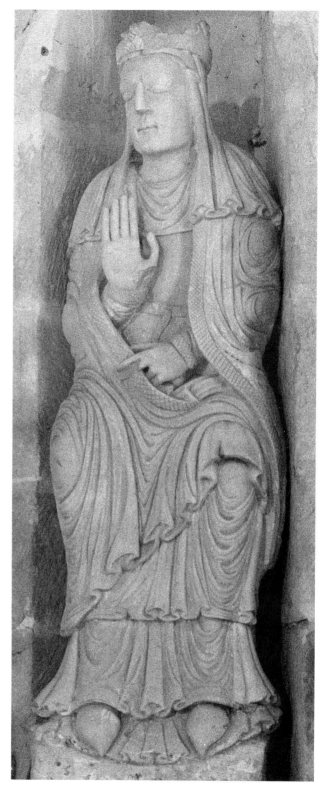

Fig. 26. Virgin, relief, Butrera (Burgos), late twelfth century (photo: author)

133

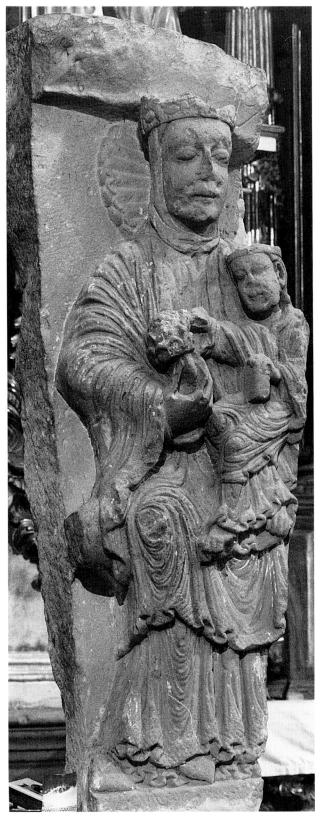

Fig. 27. Virgin and Child, tympanum fragment, from Santa María de Aradón (La Rioja), last quarter of the twelfth century. Alcanadre, parish church (photo: author)

When the Cerezo and Aradón Virgins are viewed obliquely (Figs. 6, 27), it is easy to observe the difference between the oblong head and square jaw of the Cerezo Mary and the broad brow, high cheekbones, and pointed chin of the Aradón Mary. Relatively speaking, the Aradón Virgin and Child seem freer, partly because of their slighter proportions, but also because of the way this artist disrupts the solidity of the surface with a variety of broken diagonal lines. This is a different manner from that of the Cerezo Master, who tends to use long, continuous horizontals or verticals to divide the surfaces of his reliefs into large areas that are then articulated by multiple interlocking folds. The Aradón sculptor uses a similar technique, but subdivides his surface even further by often changing the direction of his lines, thus creating a more active surface. The two Infants further characterize the differences between the Cerezo and Aradón reliefs: the Cerezo Child is as majestic as his mother, facing the viewer frontally, with one hand displaying a book, and raising the other in a gesture of benediction; the Aradón Child is seated in profile, legs crossed, and almost seems to forget the book he is holding in one hand, because, with the other, he is reaching for the blossom Mary holds. Therefore, although the Aradón Virgin and Child are clearly related to the group of sculptures from north Burgos, they are not so easily attributable to the Master of Cerezo de Riotirón himself.

Both the Aradón Virgin and the Master of the Moradillo Tympanum point to an important source for the north Burgos group: the royal city of Soria.[42] The Aradón Virgin, in the curve of her mouth and facial structure, is reminiscent of the more schematic Virgin in the tympanum of Santo Domingo de Soria, dated to the 1170s (Fig. 28).[43] Moreover, the tendency to terminate folds with a teardrop shape, or hook, can be seen in the Soria Virgin's robe. The pose of the Infant Christ of Aradón (Fig. 27) is strikingly similar to the angels who carry the evangelists' symbols in the lower registers of the tympana at both Moradillo (Fig. 24) and Santo Domingo of Soria (Fig. 29). The Child of Aradón is seated in his mother's lap, with his inner leg crossed behind the outer, as are the Moradillo and Soria angels, and the Child's robes pull across his thigh with such tension that teardrop-shaped folds run from his knee to his hip, like theirs. It is the ropelike drapery folds with interlocking hooks, the

delight in patterned surfaces, and the manner of using joints and limbs as a springboard for these patterns that link the Soria tympanum stylistically not only with Moradillo de Sedano and the related style of the frontier site of Aradón (La Rioja) but also with Gredilla de Sedano, Cerezo de Riotirón, and Butrera. These resemblances support the suggestion by Simon that the sculptor of Cerezo de Riotirón may have known the portal of Santo Domingo in Soria very well, and drew on it as he developed his own style, but other sources came into play as well.[44]

It has been maintained in the literature that the deep pleats with interlocking folds found throughout northeast Burgos and in Soria may ultimately derive from the luxuriant drapery in the reliefs of the second cloister campaign at Silos (Fig. 30), and José Pérez Carmona suggested that the Cerezo artist was trained there.[45] However, as with Soria, there are enough differences between Cerezo and Silos to assume that he probably was not a student of the Silos atelier, even though he seems to have been familiar with the monastery's sculpture. When Pérez Carmona made his suggestion, he was thinking of the Silos cloister, but the tympanum of the north portal, which Pérez Carmona never saw, also contributed to the Cerezo style.[46] As at Cerezo, the decoration of the figure with wet drapery and luxuriant swirling folds can be seen in the standing figure of Mary in the Presentation of the Silos tympanum (Fig. 31), and, to a lesser extent, in the ruined figures of the Adoration of the Magi at the left. These folds can be compared with the drapery of Joseph and the Virgin from Cerezo (Figs. 10, 25). On the other hand, the tall, stately figures of the Silos tympanum and the lively, twisted figures in the cloister do not resemble the massive rectangular figures of the Cerezo Epiphany. Some elements characteristic of Cerezo, such as the interlocking hook-folds, are not found in Silos at all, whereas they are found in the tympanum of Santo Domingo in Soria (Fig. 28). It seems, therefore, that it would be more accurate to say that both Silos and Soria contributed to the development of the Master of Cerezo de Riotirón. His style is a logical outgrowth of his presence at the frontier of Burgos.

The blending of Burgalese with Sorian art is not surprising considering their geographic proximity and political and ecclesiastical ties. However, not just the city of Soria but the other major artistic

Fig. 28. Virgin, tympanum, Santo Domingo de Soria (Soria), last quarter of the twelfth century (photo: author)

Fig. 29. West portal, Santo Domingo de Soria (Soria), third quarter of the twelfth century (photo: author)

center in the province participated in the develop-
ment of this style: the cathedral of El Burgo de Osma.
Osma was the seat of the bishopric that included
Soria, and was, with the royal city, one of the most
important sources for the style and iconography of
Sorian sculpture during this period. The cathedral
of Osma also maintained a fraternity with the
influential Burgalese monastery located on the
frontier between the two bishoprics, Santo Domingo
de Silos.[47] In fact, the Osma chapter house, probably
built during the second third of the twelfth century,
took the Christological subjects that appeared
separately at Silos and unified them—with some
iconographic variants—into a narrative cycle in its
capitals (Fig. 32).[48] From Osma, Christological scenes

as a cycle spread throughout the bishopric in the
form of small-scale architectural sculpture, such as
the archivolts of Santo Domingo in Soria (Fig. 33).

Compositional features of the Cerezo sculptures
also suggest Osma as the conduit for certain motifs
from Silos to Soria. For example, the odd kneeling
pose of the first king (Fig. 8) repeats the twisted-
knee pose of the angel Gabriel in the Annunciation
relief at Silos (Fig. 30), a pose also to be found
in the Infancy capital at Osma (Fig. 32). Rather than
being restorer's work, as was once suggested, the
Cerezo king's leg is authentic; the surface reveals
no obvious signs of recarving, even though the
drapery over the king's knee has been broken off.
Sometimes misread as baring his leg, the king is

136

Fig. 30. Angel Gabriel of the Annunciation, relief, southwest pier, finished ca. 1170. Cloister of Santo Domingo de Silos (Burgos) (photo: author)

Fig. 31. The Infancy of Christ, tympanum, north portico interior, last third of the twelfth century, Santo Domingo de Silos (Burgos). Silos, Monastic Museum (photo: author)

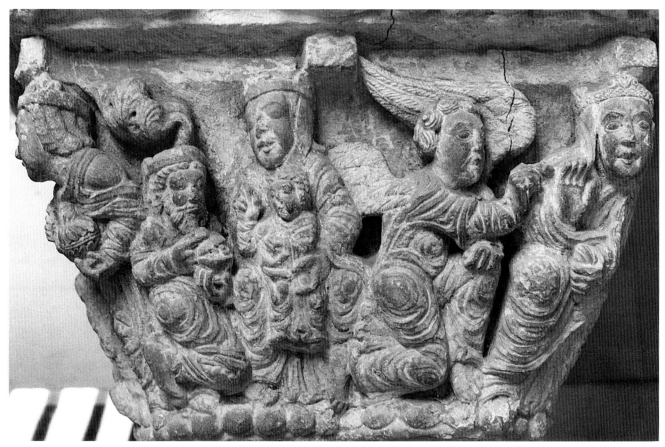

Fig. 32. Epiphany, Annunciation, capital, chapter house, second half of the twelfth century. Cathedral of El Burgo de Osma (Soria) (photo: author)

Fig. 33. Epiphany, archivolts, west portal, third quarter of the twelfth century. Santo Domingo de Soria (Soria) (photo: author)

actually clad in fitted trousers, indicated by the ornamental hem at his ankle.[49] This detail ties the Cerezo king to Soria, for the same convention appears twice at Santo Domingo in Soria, in the capital frieze and the archivolts (Fig. 33), and the Cerezo Master uses it again at Butrera in Burgos (Fig. 13). In fact, the large-scale composition of the Cerezo Epiphany appears to reflect a model based on the small-scale Epiphanies of Osma and Soria rather than that of Silos. The Adoration of the Magi in the Silos tympanum (Fig. 31) is distinct from the Epiphanies at Osma (Fig. 32), Soria (Fig. 33), and Cerezo (Fig. 1). At Silos, the Magi appear to the right of Mary and are grouped together; two kneel with both knees

to the ground while the third stands behind them. In the Osma, Soria, and Cerezo examples, the Magi appear to the left and are spread out. Their postures may vary, but the kneeling kings have only one knee on the ground.

The chapter house at the cathedral of Osma, from which the iconographic repertory of Silos spread, may have been the locus for the formation of the Silos-influenced style used by the Master of Cerezo de Riotirón. What was treated in a relatively naturalistic yet ornamental manner at Silos was stylized, coalesced into harder forms by other sculptors, such as those at Osma. The Silos-derived style at Osma (Fig. 32) presents us with the more

139

Fig. 34. Bestiary, archivolts, chapter house, second half of the twelfth century. Cathedral of El Burgo de Osma (Soria) (photo: author)

rigid, albeit animated, forms that are the basis of the Cerezo style, and are strikingly similar to both the portal and the Epiphany from Cerezo de Riotirón. A comparison between the figural styles of the three sites is revealing. Chunky figures with large heads, like those of Cerezo, appear in the capitals of the cathedral's chapter house, whereas the Silensian figures tend to have large, delicately formed heads on slender bodies—a very different conception of the human figure. The voluminous, crumpled drapery found in the Silos cloister reliefs is transformed at Osma into a series of parallel, geometric shapes centered over limbs and joints, as at Cerezo. If one compares the Virgin and the Elders of Cerezo (Figs. 1, 20) with the two representations of Mary in the

Infancy capital of Osma (Fig. 32), one finds the same facial type with full cheeks and bowed lips. In the delightful bestiary on the archivolts of Osma, there are short, snub-nosed, hunchbacked animals with either highly textured ornamental fur and feathers or extremely smooth coats, and they have very precise anatomical detail that also suggests a close relationship to Cerezo (Figs. 34, 35). The resemblances between the two sites are such that one might wonder whether the Cerezo Master in fact was trained at Osma, where the essential characteristics of his art first appear together at one place, and perhaps even whether he carved some of the sculpture there.

The Cerezo sculptures, as we have seen, are the work of an artist who must have been highly

140

Fig. 35. Sow, dragons, archivolts, south portal from Cerezo de Riotirón. Burgos, Paseo de la Isla (photo: author)

appreciated in his own time—as his participation in so many major monuments of the last third of the twelfth century in Burgos indicates. In the course of identifying the oeuvre of this sculptor, it may even be possible to trace phases of his career: originating perhaps in Osma, working on his own at Cerezo and at Gredilla de Sedano, working with another artist at Moradillo de Sedano, then going on to Butrera.[50] His capacity for integrating new elements into his style can be seen in the modifications visible in his work at each site. Despite the unfortunate loss of the church of Nuestra Señora de la Llana and its numerous small-scale reliefs, such as corbels that must also have been produced by this master, at least The Cloisters Epiphany from Cerezo de Riotirón and its companion piece, the Burgos portal, have survived, and they represent the full flowering of this sculptor in his maturity.

NOTES

This article grew out of research for my dissertation on the cloister of Santo Domingo de Silos. The opportunity to examine the Cerezo reliefs before they were reinstalled and to visit many related sites was supported by fellowships from The Metropolitan Museum of Art and the Kress Foundation. The research, additional fieldwork, and writing of the article itself were made possible by a postdoctoral fellowship from the Getty Grant Program.

1. They were acquired from the dealer Joseph Brummer of New York City in 1930. The most recent publication about these sculptures (30.77.6–9) is by David Simon, "Romanesque Art in American Collections. XXI. The Metropolitan Museum of Art. Part I: Spain," *Gesta* 23/2 (1984), pp. 158–59. The group, exhibited at The Cloisters since its acquisition, was removed from display at the time of "The Year 1200" exhibition in 1970, with the intention of including it in the show. According to a note in The Cloisters files, it was then determined that the stone was too fragile to move, so the pieces remained in storage for fifteen years.

2. Located on the Roman road that became the pilgrims' route to Santiago de Compostela, the town of Cerezo was built on a hill that rises over the Tirón River and dominates the surrounding fertile plain. For the history of Cerezo de Riotirón, see Marino Pérez Avellaneda, *Cerezo de Riotirón (Autrigón, romano y medieval)* (Cerezo de Riotirón, 1983); Fray Valentín de la Cruz, *Burgos. Guía completa de las tierras del Cid* (Burgos, 1984), pp. 229–30; Julio González, *El reino de Castilla en la época de Alfonso VIII*, 3 vols. (Madrid, 1960), vol. 1, p. 765 n. 12; ibid., p. 789 n. 14; vol. 3, pp. 773–74, no. 1032.

There is disagreement as to whether the pilgrims' road always passed through Cerezo; it was diverted, ca. 1000, to nearby Belorado (a dependency of Cerezo), on the route described by the Pilgrims Guide in the *Codex Calixtinus*. A scallop shell, pierced in order to be worn by a pilgrim, was found in the ruins of the apse of Nuestra Señora de la Llana. Pérez Avellaneda, *Cerezo*, pp. 133–37; Teófilo López Mata, "La ruta jacobea a través de la provincia de Burgos," *Boletín de la Institución Fernán González* 44/164 (1965), pp. 528–59.

3. There is some confusion, perhaps originating with Arthur Kingsley Porter, concerning the name of the church, which sometimes appears as Nuestra Señora de la Llama (Our Lady of the Flame) in The Cloisters publications and files. In Spanish publications it is always called Nuestra Señora de la Llana— a logical title, considering that the building overlooks a plain. See Arthur Kingsley Porter, *Spanish Romanesque Sculpture*, 2 vols. (Florence, 1928), vol. 2, p. 28, pls. 111, 112; James J. Rorimer, *The Cloisters*, 3d ed. (New York, 1963), pp. 23–25; and José Pérez Carmona, *Arquitectura y escultura románicas en la provincia de Burgos*, 3d ed. (Burgos, 1975; orig. pub. 1959), pp. 200–202.

Unfortunately, Nuestra Señora de la Llana is not mentioned in any documents, although other churches of Cerezo are, including a Cluniac monastery: San Pelayo; San Jorge; San Martín; and Sancto Cipriano. The sites of these churches are not documented, and it is possible that one of them was latter rededicated to the Virgin and became Nuestra Señora de la Llana. González, *Alfonso VIII,* vol. 2, pp. 365–68, no. 221; see esp. p. 368. Pérez Avellaneda, *Cerezo,* believes that San Pelayo might have been at the limits of the town, pp. 81–82; other churches are cited on pp. 103–6, 112, 121, 169.

4. Porter, *Spanish Romanesque Sculpture,* vol. 2, pl. 112; also published in James J. Rorimer, *Medieval Monuments at The Cloisters as They Were and as They Are,* rev. ed. by Katherine Serrell Rorimer (New York, 1972; orig. pub. 1941), p. 50; Pérez Carmona, *Burgos,* fig. 161.

5. The earliest description I could find is by Narciso Sentenach, "La Bureba," *Boletín de la Sociedad Española de Excursiones* 33 (1925), pp. 36–46, 122–30.

6. ". . . pero sólo conserva de su primitiva construcción portada con archivoltas iconísticas y relieves laterales de hermosas figuras estilo románico, representando uno de ellos la adoración de los Reyes Magos, con valentísimas figuras, y algo de su ábside correctísimo," Sentenach, "La Bureba," p. 129.

Perhaps he did not identify the other subjects because he was using the term "relieves" merely to indicate that the figures appeared on more than one piece of stone, and that we have all the large figures he saw. Gaya Nuño uses the term this way in his description of the Villasayas Annunciation (see Fig. 14), Juan Gaya Nuño, *El románico en la provincia de Soria* (Madrid, 1946), pp. 199–200. On the other hand, Sentenach specifies that "one" of the reliefs represented an Epiphany, suggesting that something more may have been there.

7. The opening measures 220 cm, while the reliefs' widths (without a third Magus) total 191 cm. The tallest figures measure 137.8 cm, while the radius of the portal arch is only 109 cm. The measurements of the figures (recorded in The Cloisters files by M. Frinta, Sept. 29, 1958) are as follows: 30.77.6: H. 126 cm, W. 47 cm, D. 38 cm; 30.77.7: H. 137.5 cm, W. 43 cm, D. 45 cm; 30.77.8: H. 137.8 cm, W. 55 cm, D. 46 cm; and 30.77.9: H. 127.6 cm, W. 46 cm, D. 51 cm. There are minor variations from the measurements published in inches by Simon, "Spain," p. 158.

8. Porter, *Spanish Romanesque Sculpture,* vol. 2, pls. 111, 112.

9. The rectangular frame visible to the left of the group (Fig. 3), may have been part of the opening near the former location of the reliefs, visible at the site today (Fig. 4).

10. Pérez Carmona, *Burgos,* p. 202; Gary Radke, Summer Fellow at The Cloisters, unpublished notes, 1976, p. 2; Simon, "Spain," p. 158, and his letter dated Apr. 15, 1985, in The Cloisters files.

11. Other tympana which may resemble the original arrangement of the Cerezo Epiphany are at San Juan del Mercado in Benavente (Zamora), San Martín in Mura (Barcelona), and Santa María in Uncastillo (Zaragoza), in Porter, *Spanish Romanesque Sculpture,* vol. 2, pls. 135, 137, 154. It should be pointed out, however, that the Magi in these three examples are all standing, unlike the Cerezo relief.

12. According to Timothy Husband, the slabs were cut down in modern times, "and there is evidence that most, if not all, of the slabs were altered in earlier times."

13. Compare with the arches formed by the tympana of Ahedo de Butrón (Fig. 11), Gredilla de Sedano (Fig. 12), and Moradillo de Sedano (Fig. 18), all in Burgos.

14. The two figures under the cornice have been identified as King Alfonso VIII of Castile and his wife, Leonor of Aquitaine (Georgiana Goddard King, "The Problem of the Duero," *Art Studies* 3 [1925], p. 4). However, this cannot be the case, since the figure at the left is nimbed and carries an open scroll. He is probably a prophet: Blas Taracena and José Tudela, *Guía de Soria y su provincia,* 4th ed. (Madrid, 1973), p. 122. To the right might have been either the Virgin or another prophet. These figures may have been copied in the portal of Pineda de la Sierra (Burgos); see note 30 below.

15. For an illustration of this tympanum, see Porter, *Spanish Romanesque Sculpture,* vol. 2, pl. 137; the Epiphany tympanum at San Juan del Mercado in Benavente (Zamora) also appears to have lost a figure, pl. 135.

16. At Santo Domingo de Silos (Burgos, Fig. 31), the tympanum is composed of wedge-shaped pieces, but the pictorial composition is very different from the relief from Cerezo. The Silos tympanum is exceptional among Spanish tympana of the twelfth century because of its scale. Its height, 144 cm, is close to that of the Cerezo Virgin and Child, 137.8 cm, which means that the Cerezo Epiphany, if it was a tympanum, was at least as large as the Silos tympanum. For Silos, see Joaquín Yarza Luaces, "Nuevos hallazgos románicos en el monasterio de Silos," *Goya* 96 (1970), pp. 342–45. At Gredilla de Sedano (Burgos, Figs. 12, 22), a diagonal cut can be observed between Joseph and Peter at the right, but it is possible that this is a break or a repair. At Aradón (La Rioja, Fig. 27) a Virgin and Child from a tympanum now appears on a wedge-shaped slab, but this too may not be original, since, at the lower left of the wedge, a fragment of a king's shoe may be seen, and it is unlikely that the sculptor would have divided a figure in this manner.

17. See, for example, the tympana at Santo Domingo in Soria (Fig. 29), Agüero, Jaca, and Huesca. For illustrations, see Pedro de Palol and Max Hirmer, *Early Medieval Art in Spain,* trans. Alisa Jaffa (London, 1967), pl. 100; and Porter, *Spanish Romanesque Sculpture,* pl. 92B.

18. De Palol and Hirmer, *Early Medieval Art,* pls. 86, 110.

19. Gallery porches enclosing the main entrance to the church sometimes had large reliefs or tympana on their exteriors, for example, Villasayas (Soria, Fig. 14, a problematic example discussed below) and the nonextant north porch of Silos, in Gaya Nuño, *Soria,* pp. 199–200, fig. 203; for the description of the Silos porch, see P. Nebreda, "Registro de Archivos," fols. 73–75 (lost), published in Marius Férotin, *L'histoire de l'abbaye de Silos* (Paris, 1897), p. 349.

20. The west facade of Nuestra Señora de la Llana rises from a precipice and therefore is a more difficult approach than the south facade, which must have been the more frequently used entrance. In the living rock at the base of the west facade is a cavelike space which may have been used as a hermitage.

21. Pérez Carmona, *Burgos,* p. 204; Radke, notes in The Cloisters files, p. 2.

22. Gaya Nuño, *Soria,* pp. 199–200.

23. Villasayas is badly in need of an archaeological study; its structure might be authentic. The personages represented in the Annunciation are, left to right, Gabriel, Mary, and Joseph,

as in the Annunciation of Gredilla de Sedano (Fig. 12). For the iconography of the Annunciation, see Justo Pérez de Urbel, *El Claustro de Silos*, 3d ed. (Burgos, 1975; orig. pub. 1930), pp. 146–49; Francisco Iñiguez Almech, "Sobre tallas románicas del siglo XII," *Príncipe de Viana* 29/112-113 (1968), pp. 181–235; and Elizabeth Valdez del Alamo, "*Nova et Vetera* in Santo Domingo de Silos: the Second Cloister Campaign" (Ph.D. diss., Columbia University, 1986), pp. 152–75.

24. For full views of Sangüesa and Ripoll, see de Palol and Hirmer, *Early Medieval Art,* pls. 135, 232.

25. It should be pointed out that the angel's wings in fact fill in some of the space created by the variation of head height. However, it is clear that some details, such as the Magi's guiding star have been lost in the Cerezo reliefs due to trimming the slabs, and these lost details might have given us a different impression of the shape of the relief. The height of the lateral reliefs at San Miguel of Estella is 135 cm; Luis-María de Lojendio, *Navarre romane,* La nuit des temps 26 (1967), p. 325. The Cerezo Virgin is 137.8 cm high.

26. "... A photograph of the Cerezo group in its original setting, in a niche above an arch west of the south portal of the church, shows the composition exactly as it appears here." Rorimer, *Cloisters,* p. 23, and a letter by Joseph Breck, dated Apr. 25, 1930. The possibility that the group may have once occupied a tympanum is expressed in the revised edition of Rorimer, *Medieval Monuments* (1972), p. 50.

For the tradition of reconstructing the original ambience of works of art in The Cloisters Collection, see J. L. Schrader, "George Grey Barnard: The Cloisters and the Abbaye," *MMAB* 37 (1979); Mary Rebecca Leuchak, "'The Old World for the New': Developing the Design for The Cloisters," *MMJ* 23 (1988), pp. 257-77; William D. Wixom, "Medieval Sculpture at The Cloisters," *MMAB* 46/3 (Winter, 1988/89), pp. 1-64, esp. pp. 5-6, 10; and articles by William Forsyth and Hubert Landais in this volume. For a critique of the tradition of re-creating the historical and archaeological context of medieval works of art in museums, see Stephen Bann, "The Poetics of the Museum: Lenoir and Du Sommerard," *The Clothing of Clio* (Cambridge, 1984), esp. pp. 77-78. My thanks to J. J. G. Alexander and Aimee H. Conlin for calling my attention to this essay.

27. I would like to thank Timothy Husband for taking the time to discuss with me the condition of the figures and their installation. According to Husband, the emphasis of the discussions concerning the new installation centered on the Museum display, not on the archaeological context of the sculpture. For purposes of display, the scale of the figures and of the large wall required placing the figures high on the wall (3.23 m), where they create a balanced composition within the gallery (one in which a series of reliefs progressively rises up from left to right). The bases of the Epiphany figures line up with the windowsills in the Fuentidueña apse installed at the north end of the hall. A 20.5-cm space was left between the figures to allow the viewer to see the extensive carving on the sides. In the course of discussions concerning the new installation, David Simon advised that the sculpture should be set with the figures abutting each other and lower on the wall, because he believed that the reliefs were intended for a tympanum (Simon, memo in The Cloisters files, Apr. 15, 1985). However, because the figures have been cut down, they probably should not be set tangent to each other, as Husband pointed out. The height of the installation was also an issue when the pieces were first purchased; Breck hoped to install the figures "in a shallow niche

in the wall, or possibly above a door (if it did not bring the sculptures too high)," letter in The Cloisters files, Apr. 25, 1930.

In addition to the questions of height and spacing, the issue of whether to place the figures over a series of corbels or over a sill was discussed. The Museum decided to employ a sill set over corbels perpendicular to the wall, necessary to support the weight of the massive figures if they were to project outward. As installed, these supporting corbels repeat others above and the figured corbels from Zamora at the left of the hall. Simon counseled against the use of corbels on the basis that they would be "distracting and misleading." Corbels were also used to support the tympanum installed in the monastic museum of Silos, but because that sculpture is set low, the corbels are below eye level and do not enter the line of vision when one looks at the sculpture.

28. The conflict inherent in the re-creation of the context of a medieval work of art and contemporary priorities of museum display is made clear by the discussions that took place at the time of the new installation of the Cerezo reliefs (see note 27 above). One problem, in the case of these reliefs, is not so much the installation as that the Museum visitor is provided with no means of distinguishing between those pieces that are installed "archaeologically" and those that are not—something that might be clarified on the label. In fact, many of the objects installed in the same hall are not displayed "archaeologically," but are set into the wall in such a manner as to make them accessible to the visitor. There is much to be said in favor of such an exhibition.

My own preference would have been to install the Cerezo Epiphany figures lower on the wall and closer together, for several reasons both personal and archaeological. Possibly the most important is the feeling of intimacy a museum visitor can achieve with works of art installed close to eye level, as many are at The Cloisters. In addition, this closeness is typical of many Spanish portals where capital friezes, doorway corbels, and lateral reliefs are within reach of the viewer. Because the reliefs form a cohesive group, their relationship to each other would be more clearly stated if they were set closer together, even allowing for some separation between them because of their having been cut down.

29. Memo dated Feb. 25, 1985, in The Cloisters files. Although examples are not named in this memo, the list of related monuments and study photographs in the file for Cerezo include Moradillo de Sedano (Burgos, Fig. 18), Pineda de la Sierra (Burgos), Santo Domingo of Soria (Soria, Fig. 29), Santiago de Compostela (Galicia), Sangüesa (Navarre), and Santiago in Carrión de los Condes (Palencia, Fig. 19).

30. For Pineda de la Sierra, see Luis-María de Lojendio and Abundio Rodríguez, *Castille romane* 2. La nuit des temps 24 (1966), pl. 58; Pérez Carmona, *Burgos,* fig. 192.

Yet another possibility was suggested by Carolyn Howard Hyman, who, in reviewing portal types, suggested that the Cerezo Epiphany might have rested above the south portal "as a frieze," like the one at Santa María in Carrión de los Condes (Palencia). However, there are significant differences in scale, for these reliefs are not much larger than ca. 50 cm, approximately one-third the height of the Cerezo Virgin and Child (137.8 cm). Therefore, the Cerezo Epiphany was probably not part of one of these historiated friezes set high above the portal. See Hyman, "A Spanish Romanesque Adoration Group from Cerezo de Riotirón in The Cloisters Collection, New York" (Spring 1976), p. 2; in The Cloisters files.

31. At Sangüesa the spandrels on either side of the tympanum are filled with numerous small-scale plaques, some figural and others historiated, but their scale sets them apart from the large reliefs of Estella and Ripoll.

32. Simon, "Spain," p. 159. The question is not one of artistic attribution but rather of whether the same artists could have produced sculpture for more than one structure in the same locale. The only other structure near Nuestra Señora de la Llana is another church, slightly downhill. Unlike Nuestra Señora de la Llana, this church appears more unified in its fabric, which is Late Gothic. The structure of Nuestra Señora, on the other hand, incorporates the work of at least three stylistically and chronologically different campaigns; after the Romanesque campaign, much of the building appears to have been reconstructed in Gothic style with further Neoclassical alterations. It seems more likely that the relief, if it was moved, was moved from another part of the same building.

33. Pérez Carmona, Burgos, pp. 200–202.

34. Ibid., p. 201. The sculpture of both the Epiphany and the portal are sufficiently unified, stylistically, to suggest only one sculptor; it is possible, however, that he worked with an assistant.

35. Luciano Huidobro y Serna, "Moradillo de Sedano," Boletín de la Comisión Provincial de Monumentos Históricos y Artísticos de Burgos 3 (1930–33), pp. 199–204, 217–23, 257–63, 294–98; Rorimer, Cloisters, p. 25; José Gudiol Ricart and Juan Antonio Gaya Nuño, Arquitectura y escultura románicas, Ars Hispaniae 5 (Madrid, 1948), p. 256; Pérez Carmona, Burgos, p. 201; and Simon, "Spain," p. 159.

36. Pérez Carmona, Burgos, pp. 90, 193–202; Rorimer, Cloisters, p. 25; Huidobro, "Moradillo," pp. 257–58; and Gudiol Ricart and Gaya Nuño, Arquitectura románicas, p. 256.

37. Pérez Carmona, Burgos, p. 204; and Simon, "Spain," p. 159.

38. José G. Moya, "Una escultura románica inédita en Alcanadre," Archivo Español de Arte 42/166 (1969), pp. 205–7.

39. The survival of all of these fragments depicting Mary is an indication of the profound veneration of the Virgin in Spain and the affection held, even to this day, for these reliefs.

40. The hermitage was constructed by the Navarro-Aragonese Commandery of the Knights Templar after the donation of the site to them had been approved by King Alfonso VII of Castile and his son Sancho III in 1155. Moya, "Alcanadre," p. 206 n. 6, gives this date as 1156, citing José María Lacarra, Documentos para el estudio de la Reconquista y Repoblación del valle del Ebro, 3d ser. (Saragossa, 1952), nos. 378–79; and Juan Antonio Llorente, Noticias históricas de las tres provincias Vascongadas (Madrid, 1808), vol. 5, nos. 126, 132, 193. However, the document published first by Llorente, then González, gives the date as ERA 1193 (A.D. 1155): Llorente, Provincias Vascongadas, vol. 4, pp. 158–59, no. 130; cited by González, Alfonso VIII, vol. 2, pp. 41–43, no. 21. See González, vol. 1, pp. 311, 778, for additional documentation on Alcanadre.

41. See the two photographs in Moya, "Alcanadre," pl. I, following p. 206. See also: Radke, notes in The Cloisters files, p. 1; and Simon, "Spain," p. 159. Hyman also made this comparison, although she does not attribute the sculptures to the same artist, "A Spanish Romanesque Adoration Group," pp. 13–16.
 The issue of the interpenetration of Aragonese, Navarrese, and Burgalese styles, raised by Moya and pursued by Hyman and Radke in relation to the Aradón and Cerezo sculptures, is beyond the scope of this essay. In my opinion, the distinctive style of the Aragonese cloister of San Juan de la Peña is completely distinct from that of Aradón and Cerezo de Riotirón. They grow out of different traditions. On the other hand, Agüero (Aragón) does form part of a group with San Juan de la Peña, and the tympanum of Ahedo de Butrón (Burgos, Fig. 11) reflects contact with Agüero. The source for these problematic comparisons is Lacoste, who proposed that the Master of San Juan de la Peña was trained in Soria and influenced by the second Silos style, but the differences in style and questions of chronology make such a suggestion unconvincing. Jacques Lacoste, "Le Maître de San Juan de la Peña," Les cahiers de Saint-Michel de Cuxa (1979), pp. 175–89. For other opinions on the subject of this artist, see René Crozet, "Recherches sur la sculpture romane en Navarre et en Aragon. Sur les traces d'un sculpteur," Cahiers de Civilisation Médiévale 11 (1968), pp. 41–57; and José María de Azcárate, "Sincretismo de la escultura románica navarra," Príncipe de Viana 142–43 (1976), pp. 131–50.

42. A detailed description of the stylistic, iconographic, and architectural relationship between Santo Domingo of Soria and the parish church of Moradillo de Sedano is beyond the scope of this paper; refer to J. Martínez Santa-Ollala, "La iglesia románica de Moradillo de Sedano," Archivo Español de Arte 6/18 (1930), pp. 267–75; Huidobro, "Moradillo," pp. 258–59; Gudiol Ricart and Gaya Nuño, Arquitectura románicas, p. 256; Pérez Carmona, Burgos, p. 194; Éliane Vergnolle, "Le tympan de Moradillo de Sedano: autour du Maître de L'Annonciation-Couronnement de Silos," Actas del XXIII Congreso de Historia de Arte (Granada, 1973), vol. 1, pp. 546, 548.

43. The church is generally assumed to have been built after the marriage, in 1170, of Alfonso VIII: Vicente Lampérez y Romea, "Santo Tomé de Soria," Boletín de la Sociedad Española de Excursiones 9 (1901), pp. 87–88; Gaya Nuño, Soria, pp. 129–30, 142–43.

44. Simon posits that "Santo Domingo in Soria was the locus for our artist's training," "Spain," p. 159.

45. Pérez Carmona, Burgos, pp. 193, 223; Gaya Nuño, Soria, pp. 17–19; Simon, "Spain," p. 159.

46. The Silos tympanum was excavated from the foundations of the eighteenth-century church in 1964. Yarza Luaces, "Nuevos hallazgos," pp. 342–45.

47. For a discussion of the relationship between Silos and Osma and its artistic repercussions, see Elizabeth Valdez del Alamo, "Relaciones artísticas entre Silos y Santiago de Compostela," Acts of the symposium "O Pórtico da Gloria e a Arte do seu Tempo," Santiago de Compostela, 3–8 outubro de 1988 (Santiago de Compostela, in press).

48. Ibid., for a discussion of the date. A different opinion is expressed by Joaquín Yarza Luaces, "Nuevas esculturas románicas en la Catedral de Burgo de Osma," Boletín del Seminario de Arte y Arqueología, Universidad de Valladolid 34–35 (1969), pp. 217–29.
 This artist is also closely related to some of the sculpture found in the cloister of San Pedro in Soria, a possession of the cathedral of Osma since 1148. For San Pedro in Soria and its artistic relationship with Silos, see Ann S. Zielinski, "The Cloister of San Pedro in Soria," Ph.D. diss., Syracuse University, 1971 (Ann Arbor, 1975), pp. 62, 320; idem, "Silos y San Pedro de Huesca: estudiados de nuevo," Archivo Español de Arte 54/213 (1979), pp. 1–28.

49. Rorimer sought to explain the king with a distorted leg as a historical figure who had a deformed foot: James J. Rorimer, *The Cloisters* (New York, 1938), p. 4. Simon suggested that this may have been a restoration: Simon, "Spain," p. 159. But compare the present condition of the leg with Pérez Carmona's photograph, *Burgos,* fig. 161.

The same costume of fitted trousers with embroidery at the ankles appears in Early Christian and Byzantine Epiphanies, for example, in a Byzantine gold medallion known as "La Dama de Turuñuelo" in Mérida, or in a fourth-century sarcophagus in the sacristy of Santo Domingo el Real, Toledo: see Jacques Fontaine, *L'art préroman hispanique,* La nuit des temps 38 (1973), p. 240, fig. 84; and Porter, *Spanish Romanesque Sculpture,* vol. 1, pl. 2a.

50. The close relationship between these sculptures supports the view that the date, 1188, of Moradillo must be close to that of Cerezo de Riotirón. The date is inscribed on an impost high on the exterior of the southwest nave of the church of Moradillo de Sedano, and is a key to the chronology of sculpture in the region. See Pérez Carmona, *Burgos,* p. 224; Georges Gaillard, "Sculptures espagnoles de la seconde moitié du douzième siècle," *Acts of the XXth International Congress of the History of Art* I. Studies in Western Art (Princeton, 1963), pp. 142–49; and Valdez del Alamo, "Relaciones."

Pérez Carmona, *Burgos,* pp. 200–202, interprets the greater variety of pose and more "baroque" drapery of Cerezo as an indication that these sculptures may be later than Gredilla and Moradillo. My own observation has been just to the contrary: that in Burgos a fondness for texture and elaborate effects gives way to a more reduced, often severe style toward the end of the twelfth century. Compare the lower and upper cloisters of Silos, for example, and, beyond Burgos, the lower with the upper region of the Pórtico de la Gloria of Santiago de Compostela. For Santiago, see Marilyn Stokstad, "Forma y Formula: reconsideración del Pórtico de la Gloria," and Michael Ward, "El Pórtico de la Gloria y la conclusión de la Catedral de Santiago," in the acts of the Santiago de Compostela symposium, cited above. Huidobro, "Moradillo," p. 257, also expresses the opinion that Cerezo is earlier than Moradillo.

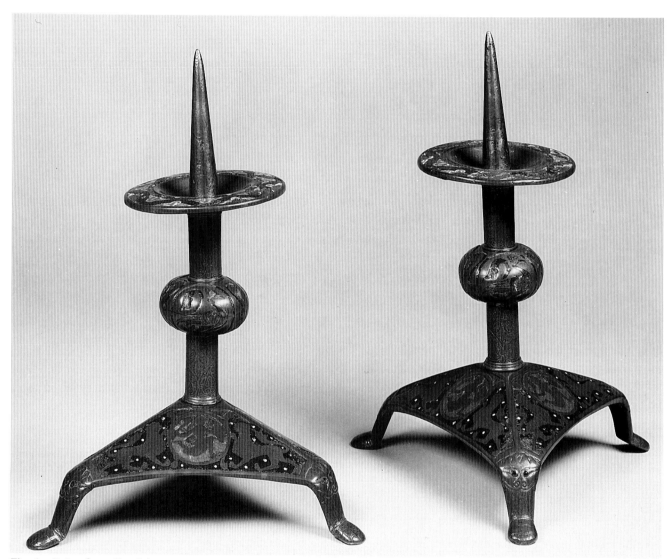

Fig. 1a. Pair of candlesticks, ca. 1180, *champlevé* enamel on copper-gilt, H. 23.7 cm. The Metropolitan Museum of Art, The Cloisters Collection, 1947 (47.101.37,38) (photo: Museum)

A Pair of Limoges Candlesticks in The Cloisters Collection

Barbara Drake Boehm

Following the death of Joseph Brummer in 1947, James Rorimer negotiated The Metropolitan Museum of Art's purchase of more than 250 objects from the dealer's holdings[1] before the bulk of the collection was sold at Parke-Bernet in New York.[2] The precious objects that became the core of the treasury of The Cloisters were an important part of this acquisition.[3] A pair of enameled candlesticks attributed to Limoges and destined for that treasury (Col. pl. 2 and Figs. 1a–g) have received little attention since their acquisition by the Museum, though they were frequently exhibited and published in the nineteenth century.[4] Marked by exceptionally fine engraving and enameling, The Cloisters candlesticks combine decorative motifs—traditionally associated with enamels attributed to a workshop active at Silos in northern Spain around 1180—with other elements linked exclusively to the French city of Limoges. The pair are part of a small group of related candlesticks that can be dated to the late twelfth century, when the use of paired candlesticks on the altar became the norm throughout Europe and when, coincidentally, Limoges emerged as the preeminent center for the production of enameled altar furnishings. Indeed, the collection history of The Cloisters candlesticks can now be sufficiently reconstructed to suggest that they were exported to England in the Middle Ages. The candlesticks are clearly the product of a workshop that both met this international demand and merited the fine reputation that Limoges work enjoyed for the better part of two centuries.

Each candlestick stands on a truncated pyramidal base. Decorating each face of the pyramid is a striding warrior inscribed in a green enameled circle and flanked by lions set against a deep blue ground punctuated with white enamel dots. At each lower corner of the triangles is a short, squat foot in the form of an animal's paw

Fig. 1b. Candlestick, detail: foot

Fig. 1c. Candlestick, detail: knop

issuing from a lion mask (Fig. 1b). The thin shaft of each stick, composed of two cylinders on either side of a central knop, is engraved with a scrollwork pattern known as *vermiculé* for its wormlike appearance. The spherical knop bears three roundels containing fantastic birds of blue, red, and green and interspersed foliate hooks (Fig. 1c). The drip pans poised below each of the modern copper prickets have a narrow inner ring of dark blue, decorated at regular intervals with white circles with a centered red dot (Fig. 1d). The wider outer ring adopts the form of a seven-petaled dark blue flower, with a yellow and green trefoil at the center of each petal. Filling the spaces between the petals are blue and white splayed trefoils set in counterpoint to the yellow and green ones.

The two candlesticks differ slightly in dimension and in details of their decoration. The decoration of the first candlestick, designated as 47.101.38 (Fig. 1a, left), has, moreover, some internal variation.

The back foot of one of the warriors points out behind him (Fig. 1e); on the other two roundels, it points straight down (Fig. 1f), as it does on each of the three roundels of 47.101.37 (Fig. 1a, right). Similarly, the orientation of the leaves of the knop varies on the candlestick illustrated at the left, but not on the one illustrated at right. The enameling of the leaves is turquoise on the left, but green on the right. These variations reflect a capacity for artistic experimentation. Despite these small variations, however, the pair displays a remarkably balanced decoration. In both, base and knop have a lively, animated design. On the base, the figures are reserved against a colored ground; on the knop, the system is reversed, with the enamel used to define the birds and the background reserved. All the enamel is opaque. Shades of blue dominate the palette. Green is used for the warriors' roundels and as an accent on the floral decoration, along with yellow. Red is used to accentuate the color of the

birds and also used extensively to fill the engraved lines of the warriors and lions as a means of enhancing the lively, virtuoso drawing.

There is considerable loss to the gilding in all areas, giving the reserved areas a warm brown patina. There are losses to the enameling, especially to the knop of the one to the left and to the drip pan of the one to the right (Fig. 1a). The inlaid blue glass eyes are partially preserved on three of the six lion masks of the feet. The smoothing effect of wear has resulted in loss of definition to the engraved decoration, especially the richly patterned lines of the lions' bodies (Fig. 1g). The present prickets of solid brass were added in this century,[5] but approximate the form seen on other contemporary examples. All the elements are threaded on a pin, with a tapped end inserted from the bottom. While apparently modern, this system of threading is consistent with the construction of other medieval candlesticks of about the same size.[6] Such mechanical joining probably ensured greater strength in the face of heavy usage than would have been afforded along relatively weaker solder joins.[7]

The decorative elements seen on the candlesticks are hallmarks of enameling that characterize a number of works beginning in the mid-twelfth century, but these works cannot be presumed to share a common place of manufacture. Fifty years of scholarly debate have still not satisfactorily explained the evolution of enamel workshops in northern Spain and in the Limousin, nor succeeded in determining where certain shared stylistic or decorative motifs were initiated.[8] What is clear is that during the second half of the twelfth century, there are several such motifs used on monuments destined for churches in northern Spain and equally on works of art destined for Limousin churches. The scrolling *vermiculé* that decorates the shafts of the candlesticks on either side of the knop, for example, is used extensively on the sarcophagus, or *Urna,* of Santo Domingo de Silos, decorated with enamel and *émail brun* and generally considered to have been produced in either Silos or Burgos in the 1170s.[9] It is equally a feature, however, of the chasse with scenes of the life of St. Martial (Fig. 2), patron of Limoges, or those with the life of St. Valerie, one now in Leningrad and another in London (Fig. 3), whose distinctively well-developed, local iconography indicates that they were produced in the Limousin in the last decades of the twelfth century.[10]

Fig. 1d. Candlestick, detail: drip pan

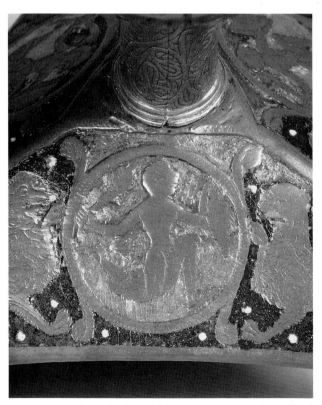

Fig. 1e. Candlestick, detail: base, with warrior inscribed in circle

Fig. 1f. Candlestick, detail: base, with warrior inscribed in circle

Fig. 1g. Candlestick, detail: base, with lion

The birds inscribed in circles on the knop of the candlesticks are bound to the same tradition as those addorsed on the rectangular plaques of the framing bands of the *Urna* of Silos,[11] but equally to the pair set in a roundel on the casket in Bellac, whose history suggests a Limousin origin.[12]

The many motifs shared among early enamels in France and Spain have been recognized as a function of the fluid monastic and political exchanges between Aquitaine and northern Spain in the twelfth century, a rapport that similarly continues to complicate efforts to define the sculpture workshops active on the pilgrimage roads.[13] The problems are exacerbated in the case of precious objects, for not only the artist but also the object could travel from place to place. The exchange of both monastic and political personnel is well documented. Pierre d'Andouque, a monk at Conques, was bishop of Pamplona from 1083 to 1115; his contemporary, Ponce, a monk at Conques, was bishop of Roda de Isábena (Aragon) from 1097 to 1104.[14] The elder daughter of Eleanor of Aquitaine and Henry II—themselves patrons of ecclesiastical establishments in the Limousin, especially the abbey of Grandmont—married Alfonso VIII the Noble, king of Castille (r. 1158–1214), and she and her husband became the principal patrons of the monastery of Silos.[15]

In the absence of additional documentation, the localization of many early enameled works cannot be resolved. The Cloisters candlesticks, however, have an additional decorative motif that binds them firmly to Limoges work: the "snowflake" pattern of the blue ground on the base. White enamel dots on a rich field of blue first appear on the clothing of figures in narrative chasses that are unquestionably Limousin, such as the Leningrad and British Museum's reliquaries of St. Valerie,[16] as well as on other important caskets, such as the one with secular scenes in the British Museum (Fig. 4).[17] In each case, the polka-dot pattern suggests opulent fabric associated with aristocratic dress.[18]

A second decorative element of The Cloisters candlesticks that seems to characterize Limoges work but not that linked to Spain is the use of red enamel to fill the engraved lines of the reserved figures. Used to articulate the features and clothing of the warriors and the fur and sinew of the lions, the enameling provides color, depth, and richness. It is used to similar effect on such early Limoges work

as the chasse of St. Valerie in Leningrad and the chasse of St. Stephen at Gimel, and on the plaques from the altar of Grandmont in the Cluny Museum.[19] On the candlesticks, then, the stylized birds and *vermiculé* patterning, which could be used to argue for a workshop either in Silos or Limoges, are joined on an object whose other decorative details are associated exclusively with Limoges work of about 1180.

The earliest surviving Limoges candlesticks and the earliest inventory references to them date to the period when paired altar candlesticks became part of the standard decoration of altars in the churches of Western Europe. Medieval references to paired candlesticks begin as early as the tenth century, but these were not placed on the altar itself.[20] From the eleventh century, candlesticks appear on pictorial representations of altars; the practice is also reflected in surviving examples.[21] The first liturgical references to the use of candlesticks on altars, however, date from the late twelfth century, contemporary with the earliest Limousin examples and including The Cloisters pair. Pope Innocent III (r. 1198–1216), in *De sacra altaris mysterio,* specifically refers to paired candlesticks at the corners of the altar.[22] Nevertheless,

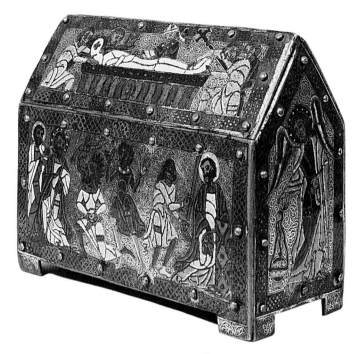

Fig. 2. Chasse of St. Martial, ca. 1165-75, *champlevé* enamel on copper-gilt, H. 12.2 cm; W. 16.4 cm. Paris, Musée du Louvre (photo: courtesy of the Musées nationaux)

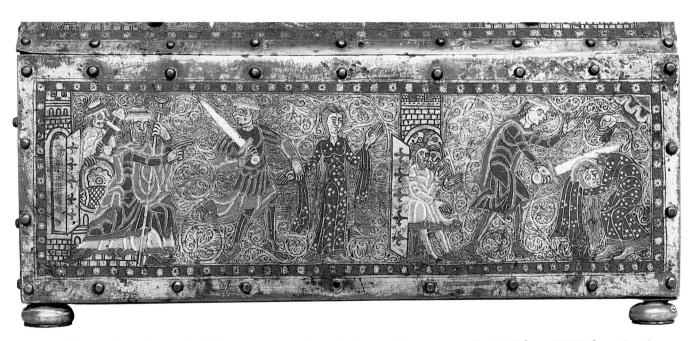

Fig. 3. Chasse of St. Valerie, detail: front, ca. 1170, *champlevé* enamel on copper-gilt, H. 15.4 cm; W. 28.6 cm. London, British Museum (photo: British Museum)

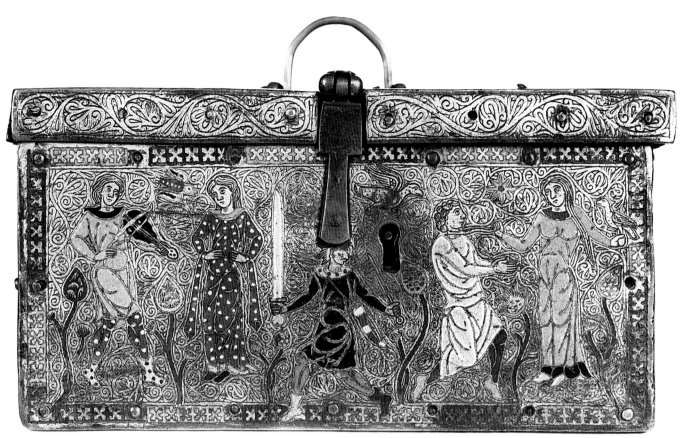

Fig. 4. Chasse with secular scenes, ca. 1180, *champlevé* enamel on copper-gilt, H. 9.1 cm; W. 21.2 cm. London, British Museum (photo: British Museum)

Fig. 5. Chasse of St. Calminus, detail: building the monastery of Saint-Chaffre, ca. 1181-1200. *Champlevé* enamel on copper-gilt. Mozac, church treasury (photo: from Rupin, *L'Oeuvre de Limoges*)

Fig. 6. Chasse of St. Calminus, detail: Peter, Abbot of Mozac, at the altar, ca. 1181-1200, *champlevé* enamel on copper-gilt. Mozac, church treasury (photo: from Rupin, *L'Oeuvre de Limoges*)

in the same period it was still the practice at the monastery of Cîteaux to place candles only near the altar, at either side.[23]

On the Limousin chasse of St. Calminus, which can be dated within a generation of The Cloisters pair, candlesticks appear on altars both singly and in pairs. The single candlestick on the altar in the scene of the building of the monastery of Saint-Chaffre (Fig. 5) appears proportionately taller than The Cloisters candlesticks and is used at the altar in conjunction with a hanging oil lamp. The paired candlesticks in the scene of Abbot Peter of Mozac officiating at the altar, from the same chasse (Fig. 6), are equally large, suggestive of the pair from Sankt Gangolf, Bamberg.[24] Other pairs seen on Limoges chasses have the same height relative to other liturgical objects as do The Cloisters candlesticks. Without exception, they stand on three-footed bases, though the legs are taller relative to the overall candlestick. The greater number of surviving paired candlesticks of the thirteenth century of about 15 to 20 cm in height surely reflects their general use on altars by that time. By the reign of St. Louis, there were always at least two candlesticks on the altar at the Sainte-Chapelle.[25]

The earliest candlestick associated with Limoges is a large, engraved copper-gilt example attributed to the second quarter of the twelfth century in Modena (Figs. 7a,b). Originally from the abbey of Frassinoro in Emilia, it bears the inscription CONSTANTINUS FABER DE LEMOEI CIVITATIS ME FECIT on the tulip-shaped drip pan.[26] Over a meter and a half in height, with three spherical knops along its shaft, it stands on a tripod base and was clearly meant for use at the side of the altar, perhaps in Holy Saturday rites.[27] Both by its size and its form, the Modena stick is an anomaly among surviving candlesticks made in or attributed to Limoges.

More common are paired candlesticks of more modest size, destined, like The Cloisters examples, for use on the altar. Those that can be dated to the twelfth century assume two basic forms: those with hemispherical bases raised on three legs and those, like The Cloisters candlesticks, with pyramidal bases. Only a half-dozen single candlesticks or pairs with hemispherical bases survive, among them a pair found at Bethlehem, the basis of Marie-Madeleine Gauthier's attribution of several of the group to "a Limousin enameler for the Holy Land," about 1150.[28] With their elaborate crownlike drip pans and their

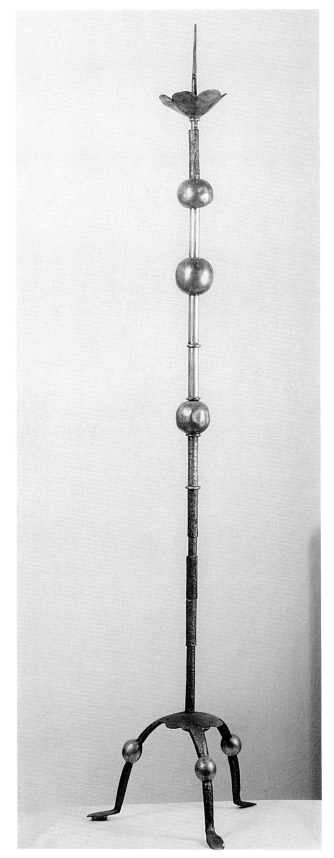

Fig. 7a. Candlestick, ca. 1125–50, copper-gilt, H. 1.64 m. Modena, Museo Civico (photo: Museo Civico)

153

Fig. 7b. Candlestick, detail: uppermost knop with symbol of St. Luke

rather simple turned shafts, the group is distinct from The Cloisters pair. Yet common to them are the lion-mask and -paw decoration of the feet and, more important, the appearance of fantastic birds inscribed in roundels on the knop and base. The birds on the knop of a single candlestick in Munich (Fig. 8)[29] assume a form very similar to those on The Cloisters pair, although the decorative motifs filling the space between the roundels are far simpler.

Another important group is the handful of surviving examples of candlesticks that stand on pyramidal bases. Ranging in height from 18 to 40 cm, they have multiple knops decorating their shafts.[30] The single candlestick in the Metropolitan retains a simplified crownlike drip pan (Fig. 9),[31] whereas the others assume the flatter, disk-shaped pan that becomes the standard for the later twelfth and the thirteenth century. Each face on the base has figures set in inverted lunettes. Here, for the first time, are figures battling fantastic beasts, the use of *vermiculé* collars on the shafts, and in the case of a pair in Sigmaringen,[32] birds in roundels on the knops.

The pair at The Cloisters are representative of an equally small group of candlesticks about 18 cm in height, with *vermiculé* or engraved patterned shafts, birds in roundels on their knops, and warriors framed in roundels on each face of their pyramidal

bases. The closest comparison to The Cloisters candlesticks is a second single candlestick in the Bayerisches Nationalmuseum, Munich (Figs. 10a–c).[33] The decorative scheme of this candlestick matches that of The Cloisters pair motif for motif and must be considered, therefore, a product of the same workshop, but not the same hand. A warrior inscribed in a roundel and flanked by lions is centered on each face of a pyramidal base. Each of the three feet of the candlestick is in the form of a lion mask and paw. Paired cylinders with a simple palmette

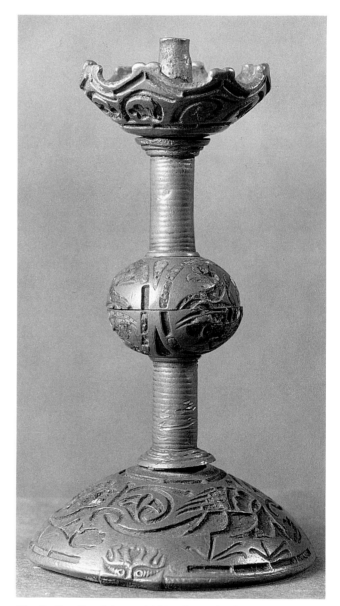

Fig. 8. Candlestick, ca. 1160, *champlevé* enamel on copper-gilt, H. 13.5 cm. Munich, Bayerisches Nationalmuseum (photo: Bayerisches Nationalmuseum)

design are set on either side of the knop decorated with enameled fantastic birds in roundels, interspersed with foliate hooks. The palette range of the enamels is identical, except for the use of white on the knop of the candlestick in Munich. Additionally, the field behind one of each of the paired lions is green with yellow dots, the other blue with white snowflakes, like The Cloisters examples. The stance of the warriors on the Munich candlestick is slightly different: their feet are planted squarely on the ground and their swords poised upright, unlike the swinging clubs wielded by The Cloisters warriors. It is predominantly this aspect that gives the warriors of the Munich candlestick a stockier appearance than their counterparts on The Cloisters examples (Figs. 10b and 1e,f). The Cloisters warriors are posed so that they seem to move within the confines of their inscribing circle. In the rendering of their features, too, The Cloisters candlesticks betray a more delicate artistic hand.

A single candlestick in the Glencairn Museum, Bryn Athyn, Pennsylvania (Figs. 11a–c), can likewise be assigned to the same workshop as The Cloisters candlesticks and the same hand as the Munich example just cited.[34] This is seen in the similar engraving of the warriors, extending to such details as the shield with the scroll-like boss at the center and the sense of the warrior's hand disappearing into the shield. The decoration of the collars of the shaft on both the Munich and Bryn Athyn examples produces a visual effect similar to *vermiculé,* but it is achieved by cutting more deeply into the copper, as would be done in preparing the metal for *champlevé* enameling. Compared to The Cloisters candlesticks, the drip pans in Munich and Bryn Athyn display a simpler pattern of three colored enamels contained within a continuous chevron. Neither of the single candlesticks has the inlaid glass eyes seen on the lion feet at The Cloisters. The knop of the Bryn Athyn candlestick has lost nearly all its enamel. Nevertheless, traces of each of the colors found on the Munich knop appear at Bryn Athyn: green on one tail and on one foliate hook, red in one bird's crest, turquoise in one bird's head, and light blue in one foliate hook.

The most distinctive feature of the Glencairn candlestick is the form of the birds (Fig. 11c). As on the Munich candlestick, the leg of the bird is raised. At Glencairn, however, this feature is coupled with the arching of the neck and the tucking in of

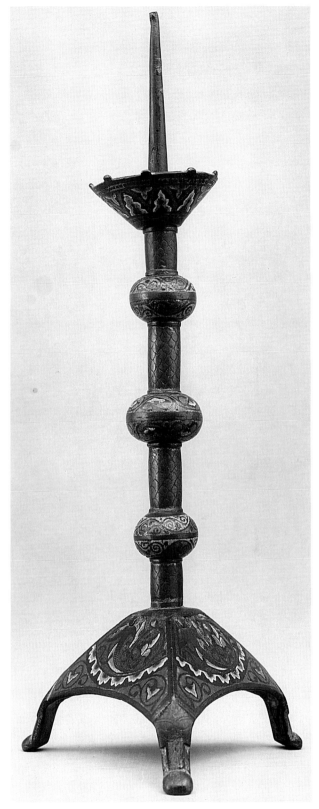

Fig. 9. Candlestick, ca. 1180, *champlevé* enamel on copper-gilt, H. 40 cm. The Metropolitan Museum of Art, Gift of J. Pierpont Morgan, 1917 (17.190.345) (photo: Museum)

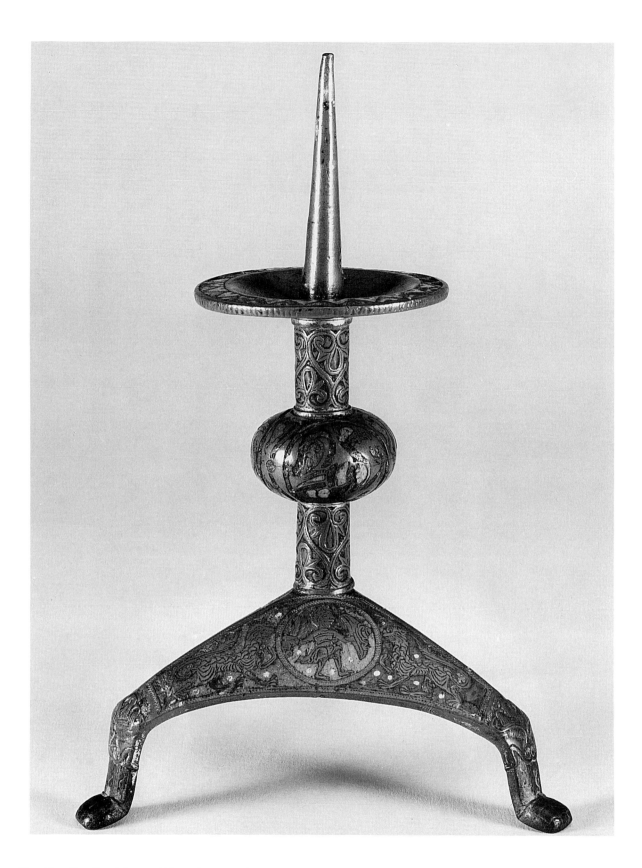

Fig. 10a. Candlestick, ca. 1180, *champlevé* enamel on copper-gilt, H. 20.2 cm. Munich, Bayerisches Nationalmuseum (photo: Bayerisches Nationalmuseum)

156

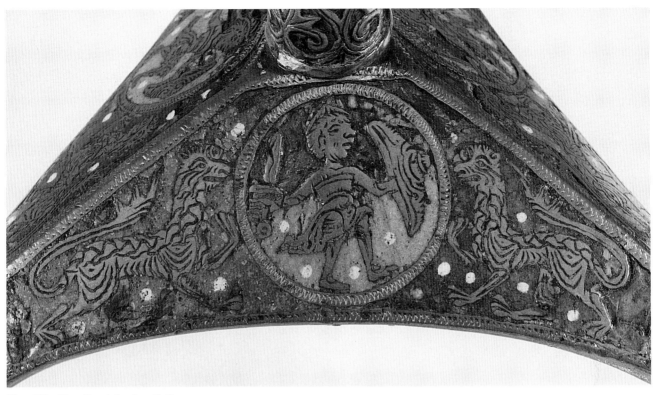

Fig. 10b. Candlestick, detail: foot

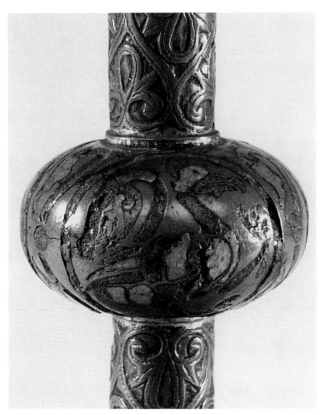

Fib. 10c. Candlestick, detail: knop

the head, such that the claws of the foot nearly touch the bird's lowered head. This dramatic sense of strutting stands in sharp contrast to the relatively tame birds of The Cloisters candlesticks.

The birds that decorate the knops of the candlesticks at The Cloisters are of exceptional quality; though small in scale, they are skillfully designed and vibrant in palette. They are particularly close to a group of four roundels, perhaps from a casket, formerly in the Lambert collection, Paris, and then in that of Mme Féron-Stoclet and Jacques Stoclet. Three of the group are now on loan to The Cleveland Museum of Art.[35] Most remarkable is the affinity between The Cloisters birds and one of the roundels in Cleveland (Fig. 12) and another roundel in the Kunstgewerbemuseum, Cologne.[36] The form of the body and the articulation of the feet, wings, and head are extremely similar. Only the tail differs on the Paris and Cologne roundels, displaying a more elaborate trefoil flourish at the end. Because of their similarity to the decorative vocabulary of the Silos *Urna,* the roundels have traditionally been attributed to Spain. Since The Cloisters candlesticks show this motif to have been in use in Limoges work, a Limousin origin cannot be excluded for the roundels.

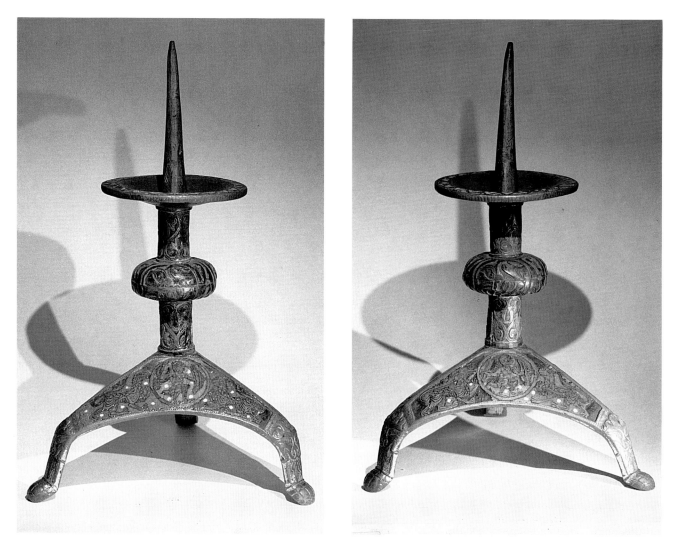

Figs. 11a,b. Candlestick, ca. 1180, *champlevé* enamel on copper-gilt, H. 19.8 cm. Bryn Athyn, Pennsylvania, Glencairn Museum, Academy of New Church (photo: Charles T. Little)

Fig. 11c. Candlestick, detail: base

By tracing the collection history of The Cloisters candlesticks, it is possible to suggest that they were exported to England from the Limousin in the Middle Ages. Preserved in the county records office at Bristol is a letter of 1834 from the London dealer Horatio Rodd to George Weare Braikenridge, a Bristol merchant and collector of medieval and Renaissance works of art.[37] In it, Rodd describes and illustrates The Cloisters candlesticks (Fig. 13).[38] The detail of one side of the pyramidal base, labeled no. 1, showing a warrior in a roundel framed by lions, and a detail of the knop, labeled no. 2, showing a fantastic bird, allow the identification of the candlesticks as those acquired by The Cloisters from the Brummer collection, despite the cylindrical candleholder seen in the drawing, a postmedieval

alteration recognized as such by Rodd.[39] Rodd had purchased the candlesticks at the Lee Priory sale, August 11–15, 1834.[40] The sale of the contents of the house followed the death of Thomas Brydges, the third-generation owner of Lee Priory in Kent, who had inherited it from his great-uncle, the younger Thomas Barrett, in 1803.[41] The younger Thomas Barrett had had Lee Priory remodeled in the Gothic style, beginning in 1783 (Fig. 14).[42] The Kent estate housed a remarkable collection of works of art, a number of which he had in turn inherited from his father, the elder Thomas Barrett, in 1757.[43]

The tastes of the Barrett family fall squarely within the English antiquarian tradition best exemplified by Horace Walpole, who was an avid collector of medieval objects appropriate to furnish his neo-Gothic residence. He considered Strawberry Hill "a suitable place for pilgrimage" and the "last monastery in England,"[44] and noted that he had purchased some reliquaries from the sale of the antiquarian Lord Bateman's collection for Strawberry Hill.[45] Walpole himself had purchased some of the objects sold at auction following the death of the elder Thomas Barrett in 1757. Among these was a Limoges reliquary of Thomas Becket documented in the collection of John Batteley (1647–1708), archdeacon of Canterbury. At the least, this establishes that the elder Barrett had a taste for medieval enamels and suggests that The Cloisters candlesticks might have had a common Kentish provenance.[46] The younger Barrett, inheritor of his father's fortunes at age thirteen, was clearly influenced by Walpole. Walpole seems to have nurtured Barrett as an antiquarian, occasionally recommending a visit to Barrett's estate in Kent to his circle of friends.[47] Correspondence establishes that Walpole advised the younger Barrett to buy a work by the Flemish painter Jan Gossaert, called Mabuse, for his collection and then offered his opinion as to where it should hang.[48] The design of the "closet"—perhaps the "Star Room"—and the library of Lee Priory were indebted to the architecture of Strawberry Hill, as Walpole himself had noted.[49] The younger Barrett might well have followed Walpole's example for the furnishing of his home as he had for its architecture, perhaps purchasing The Cloisters candlesticks for Lee Priory's library, which Walpole described as having "all the air of an abbot's study excepting that it discovers more taste," or for another of its gothicizing rooms.[50]

Fig. 12. Roundel, ca. 1180, *champlevé* enamel on copper-gilt. The Cleveland Museum of Art (photo: from *Adolphe Stoclet Collection*, p. 170)

Whether they were acquired by the elder Thomas Barrett before 1757 or by the younger thereafter, the candlesticks more than likely have a medieval English provenance. Before the French Revolution in 1789, which brought in its wake not only the destruction but also the dispersal of ecclesiastical property, altar candlesticks from French churches would not commonly have been in commerce. The elder Thomas Barrett, his taste for enamel documented by his ownership of the Becket reliquary, had died more than three decades before that date. Barrett the younger spent several years on the Continent, but was back in England as a Member of Parliament for Dover by 1773. Renovations of Lee Priory began in 1783. A little more than a decade separates the French Revolution of 1789 and the younger Barrett's death at age fifty-nine. The candlesticks might have been purchased in this period. Yet, the younger Barrett's acquisitions were partly shaped by Walpole, and Walpole's extensive correspondence clearly demonstrates that he often purchased objects—both secular and ecclesiastical—from English collections.[51] *Champlevé* enamels on base copper metal, moreover, were exactly the kind of ecclesiastical objects to have escaped destruction during the Protestant and Puritan reformations in England. Candlesticks were particularly adaptable for domestic use. Thus preserved, they would have been available to eager antiquarians.[52]

Fig. 13. Letter from Horatio Rodd to George Weare Braikenridge, 1834. Bristol Records Office, B.R.O. 14182 HB/C/40 (photo: Sheena Stoddard)

Apart from the single inscribed stick at Modena, no surviving Limousin candlestick bears any inscription concerning its maker, patron, or destination. Nevertheless, the history of the related candlestick in the Bayerisches Nationalmuseum, Munich, most closely related to The Cloisters pair, suggests that it, too, was an early exported Limoges work. The stick was purchased directly in 1913 from the parish church of Au am Inn, located some fifty kilometers southeast of Munich.[53] The parish was created in 1803 following the secularization of the monastery at Au, itself an Augustinian foundation originally endowed by the Graf von Megling in 1120.[54] It is possible that it came there in the twelfth century.

Like other Limousin altar furnishings, enameled candlesticks appear often in medieval inventories, usually in pairs or multiples of two. The chronicles of Saint-Martial, the premier monastic foundation in Limoges, records a pair of candlesticks in 1207.[55] In Germany, the monastery of Sankt Gangolf, Bamberg, possessed a large pair of late-twelfth-century candlesticks with pyramidal bases and confronted lions flanking applied bosses, now lost.[56] The pair in Sigmaringen come from the former priory of Kettenacker, founded in 1109 as a Benedictine dependency of Zwiefalten.[57] The fourteenth-century Avignon inventories of Pope Innocent VI (r. 1352–62), a native of the diocese of Limoges, include numerous Limoges candlesticks, cited with one exception in multiples of two: one pair was clearly part of the outfitting for a chapel, offered by a Limousin priest along with vestments, a chalice, paten, and cross,[58] as was one of two pairs of enameled candlesticks recorded at St. Andrew's Cathedral, Rochester (Kent), in the mid-twelfth century, which have been cited by Marie-Madeleine Gauthier as perhaps Limousin in origin.[59] St. Paul's, London, included one pair from Limoges in a thirteenth-century inventory.[60] The history of the pair at Bristol suggests they, too, may well have been in England since the Middle Ages.[61]

160

The possibility that some of the candlesticks may have originally been used in a secular context need not be excluded. However, the large numbers surviving in churches, or that can be traced to churches, and the common inclusion of candlesticks of Limoges work in church inventories must be seen as evidence that many of these candlesticks were destined for church use. The decoration of The Cloisters candlesticks and others from the same workshop is not linked to a particular church, but is equally suitable to any. It is not clear whether the figurative scenes on the late-twelfth-century candlesticks had specific symbolic associations.[62] Seen in the context of the innumerable scenes of men battling animals on such diverse Romanesque objects, both secular and ecclesiastical, as sculpture, manuscripts, and textiles, any suggestions to the contrary must be tentative.[63] Scenes of men combating animals are ubiquitous images on twelfth-century candlesticks, regardless of their place of manufacture, scale, or decoration.

Certainly, though, candlesticks designed for church use, and lighting within the church, were subject to multiple layers of interpretation in the Middle Ages. Candlelight was symbolic of divine light; the candlesticks were identified with Christ; by extension of the metaphor, the candle, wick, and flame together were associated with the Trinity.[64] For Durandus in the thirteenth century, the lighted candles at either side of the altar cross symbolized the joy of Jews and Gentiles at the birth of Christ.[65] Only rarely, however, are such elaborate metaphors elucidated on the objects themselves, like the figured bronze candlestick given by Abbot Peter to the abbey of St. Peter at Gloucester between 1107 and 1113. The body of the candlestick is alive with figures of men wrestling beasts; its inscribed ring relates the scenes to the struggle of light against darkness

Fig. 14. Lee Priory, published by William Angus, September 1, 1796 (photo: Museum)

161

and virtue against vice: "This flood of light, this work of virtue, bright with holy doctrine instructs us, so that Man shall not be benighted in vice."[66]

Like other altar equipment from Limoges, enameled candlesticks such as those at The Cloisters must have been appealing to ecclesiastical clients on a number of levels. Fashioned from sheets of copper, they were sturdy enough to withstand regular and sustained use; yet, engraved and gilded, they shone like precious metal. The enamel afforded a variety and richness of color that rivaled that of gems. Placed on their prickets were the beeswax tapers that were in themselves a valuable commodity.[67] The illumination from those candles would have played over the surfaces that were alternately engraved, gilt, and colored. At close hand, the imagery would have been easily read by the officiating priest. The figures themselves, their engraved lines enhanced by red enamel, must have fairly leaped from their richly colored ground. With such rich imagery and fine workmanship, it is easy to understand the international taste for *opus lemovicense,* of which The Cloisters candlesticks are accomplished, rare, and early exponents.

NOTES

1. "Three-Way Split," *Time* (Sept. 24, 1947), p. 53; "Ancient Splendor for the Metropolitan," *Art News* (Oct. 1947), pp. 19, 58–59, where the number was given as over 150.

2. *The Notable Art Collection belonging to the Estate of the Late Joseph Brummer,* pts. 1–3, Parke-Bernet Galleries, New York (Apr. 20–23, May 11–14, June 8–9, 1949).

3. James J. Rorimer, "A Treasury at The Cloisters," *MMAB* 6, 9 (1948), pp. 237–60. The Cloisters candlesticks are mentioned, but another pair in Limoges style from the Spitzer collection is illustrated on p. 246.

4. H. 23.7 cm; 16 cm to top of upper *vermiculé* collar; distance between each foot 17.5 cm (18.5 cm for 47.101.38, at left of Fig. 1). The candlesticks were included and published in the following exhibitions: (1) John B. Waring, ed., *Art Treasures of the United Kingdom* from the Art Treasures Exhibition, Manchester (London, 1858), "Vitreous Art" by Augustus M. Franks, p. 26, with engraving of one side of a base of one of the candlesticks; (2) John C. Robinson, ed., *Catalogue of the Special Exhibition of Works of Art of the Mediaeval, Renaissance, and more recent periods, on loan at the South Kensington Museum,* June 1862 (London, rev. ed., 1863), nos. 1109 and 1110, pp. 82–83; (3) John H. Pollen, ed., *Catalogue of the Special Loan Exhibition of Enamels on Metal held at the South Kensington Museum in 1874* (London, 1875), no. 875/877; (4) 1878 Temporary Museum, Bristol; published in *Transactions*

of the Bristol and Gloucestershire Archaeological Society 3 (1878/79), pp. 36–38; and (5) John S. Gardner, *Burlington Fine Arts Club, Catalogue of a Collection of European Enamels from the Earliest date to the End of the XVII. Century* (London, 1897), cat. 20/21, pl. VII (one of the pair). They were listed by Ernest Rupin, *L'Oeuvre de Limoges* (Paris, 1890), p. 525.

The lack of attention to them since entering the Museum's collection may stem partly from the fact that their accession numbers (47.101.37,38) follow in sequence the numbers of the pair from the Spitzer collection that date to the nineteenth century (47.101.35,36). The two pairs have a single documentation file and the collection history of the Spitzer pair was incorrectly repeated on the Brummer inventory cards for the pair discussed here. Thus the collection and exhibition history before Brummer's purchase of them from Mrs. Otto Kahn in 1936 was unknown. I am indebted to my colleague Mary B. Shepard for bringing this pair to my attention after she saw drawings of them while doing research on the Braikenridge collection (see notes 30 and 31 below). I would like to express my thanks to her, as well as to Sheena Stoddard, whose study on Braikenridge has been of enormous help in reconstructing the history of the candlesticks and upon whose help I frequently relied in the preparation of this article (see note 38 below). My thanks are also due to Marie-Madeleine Gauthier and Geneviève François for permission to consult the dossiers on related candlesticks in the *Corpus des émaux méridionaux* in Paris; to Elisabeth Delahaye, Conservateur, Musée du Louvre; Marian Campbell, Assistant Keeper, Victoria and Albert Museum; and to Elizabeth Parker and William D. Wixom for their thoughtful reading of this paper. Wherever possible, references given in the body of the paper are to the publication of works in the first volume of the *Corpus,* where all earlier literature is cited.

5. See note 39 below.

6. This is true of the candlesticks in Munich and Bryn Athyn, Pennsylvania, discussed below. For additional examples, see Marie-Madeleine Gauthier, *Émaux méridionaux, Catalogue international de l'oeuvre de Limoges, L'Époque romane* (Paris, 1987), vol. 1, nos. 70–73, 187–88, 290–91.

7. I am grateful to Pete Dandridge, Associate Conservator, Objects Conservation, for the technical observations concerning The Cloisters candlesticks.

8. The literature on this subject is substantial. The classic definition of the works identified as Limousin is given by Rupin (*L'Oeuvre de Limoges*), who also benefited from studies of individual works or groups of objects published largely in local French historical journals in the second half of the nineteenth century. The questioning of these attributions was initiated by Walter L. Hildburgh, *Medieval Spanish Enamels* (London, 1936). As the title suggests, he proposed that most of the early works attributed to Limoges were in fact Spanish and that the later enamels of Limoges simply followed their good example. This thesis was then argued in reviews of the book and letters to the editor by Walter W. S. Cook, Marvin Chauncey Ross, and Frederick Stohlman. See the discussion and bibliography in Marie-Madeleine Gauthier, "Les Émaux Champlevés 'limousins' et 'l'oeuvre de Limoges': Quelques problèmes posés par l'émaillerie champlevée sur cuivre en Europe méridionale, du XIIe au XIVe siècle," *Cahiers de la céramique et des arts de feu* 8 (1957), pp. 146–66.

9. Gauthier, *Émaux méridionaux,* no. 78, with earlier literature. On *vermiculé* decoration in particular, see J.-J. Marquet de

Vasselot, "Les Émaux limousins à fond vermiculé (XIIe et XIIIe siècles)," *Revue archéologique* 2 (1905), pp. 15–30, 231–45, 418–31 (published independently in 1906); and Marie-Madeleine Gauthier, "Les Décors vermiculés dans les émaux champlevés limousins et méridionaux: Aperçus sur l'origine et la diffusion de ce motif au XIIe siècle," *Cahiers de civilisation médiévale* 1 (1958), no. 3, pp. 349–69.

10. On the chasse of St. Martial in the Louvre (OA 8101), see Gauthier, *Émaux méridionaux,* no. 175; on the chasses of St. Valerie, see Marie-Madeleine Gauthier, "La Légende de Sainte Valérie et les émaux champlevés de Limoges," *Bulletin de la société archéologique et historique du Limousin* 86 (1956), pp. 35–80. I am grateful to Neil Stratford of the British Museum for kindly providing the photograph of the St. Valerie chasse.

11. Gauthier, *Émaux méridionaux,* figs. 207–08, 232–36.

12. Ibid., no. 57, fig. 149.

13. See most recently Serafín Moralejo, "Modelo copia y originalidad, en el marco de las relaciones artísticas hispano-francesas (siglos XI–XIII)," *Actas del V° congreso español de historia del arte* (Barcelona, 1984), pp. 89–112. I am grateful to Charles Little for this reference.

14. Gauthier, *Émaux méridionaux,* no. 49, pp. 63–64.

15. Ibid., no. 81.

16. Hermitage, inv. I 175 and Waddesdon Bequest, no. 19. Gauthier, *Émaux méridionaux,* nos. 91, 94.

17. Inv. no. MLA 59, 1–10, 1; Gauthier, *Émaux méridionaux,* no. 174. I am grateful to Neil Stratford for this photograph as well.

18. The motif is perpetuated on the martyrdom of Stephen on the chasse from the church of Malval (Creuse), for the heavenly angels, and for Saul and Stephen. The use of this motif for heavenly figures, for whom the richest fabrics are always reserved, can also be seen on caskets at Auxerre, Lyons, and Regensburg. See Gauthier, *Émaux méridionaux,* nos. 178, 226, 232, 237.

19. For the Gimel chasse, see ibid., no. 90. For the Cluny plaques, see ibid., nos. 247a,b. On other works deep blue enamel is used. Both seem to have been employed on objects with *vermiculé* fields, presumably to give greater emphasis to the figures and to distinguish them from the patterned ground. Red or blue enamel engraved lines are also found on works from the Mosan Valley and England, such as the group of Mosan square plaques, four of which are in The Metropolitan Museum of Art, and the Balfour and Morgan ciboria; for discussion and illustrations in color, see William H. Forsyth, "Around Godefroid de Claire," *MMAB,* n.s., 24 (1966), pp. 304–15, and *English Romanesque Art, 1066–1200,* exhib. cat., Hayward Gallery (London, 1984), nos. 278, 279.

20. Xavier Barbier de Montault, "L'Appareil de lumière de la cathédrale de Tours," *Congrès archéologique de France, XLIXe session: séances générales tenues à Avignon en 1882* (Paris, 1883), p. 396. The history of candlestick usage in the church was the subject of several important studies by nineteenth-century antiquarians and churchmen. See also Abbé Jules Corblet, "Les Chandeliers d'église au moyen-âge," *Revue de l'art chrétien* (1859), pp. 17–57; Charles Rohault de Fleury, "Chandeliers," *La Messe: Études archéologiques sur ses monuments* (Paris, 1888), vol. 6; Henri-René d'Allemagne, *Histoire du Luminaire depuis l'époque romaine jusqu'au XIXe siècle* (Paris, 1891), with discussion of Limousin examples on p. 118; for photos without text, see Gabriel Henriot, *Encyclopédie du luminaire: Appareils de toutes les époques et de tous les styles; choix d'objets de formes et décors apparentés depuis l'Antiquité jusqu'à 1870,* 2 vols. (Paris, 1933), though it does not include any enameled candlesticks. An important discussion also appears in Joseph Braun, *Das christliche Altargerät* (Munich, 1940), pp. 492–526.

21. Rohault de Fleury, "Chandeliers," p. 43; Braun, *Altargerät,* pp. 493–94.

22. Braun, *Altargerät,* p. 494.

23. Rohault de Fleury, "Chandeliers," p. 48.

24. See note 56 below.

25. Rohault de Fleury, "Chandeliers," p. 50.

26. Gauthier, *Émaux méridionaux,* no. 52. Gauthier's attribution to the second quarter of the twelfth century, refuting earlier attributions to the thirteenth made by Italian scholars, is argued primarily on orthographic evidence. The date seems reasonable on stylistic grounds, for it would place the candlestick within a generation of the Conques coffret of Abbot Boniface (Gauthier, ibid., no. 36), to which the Evangelist symbols and animals tightly inscribed within the roundels can be loosely compared.

27. I am grateful to Elizabeth Parker for bringing this to my attention. See O. B. Hardison, Jr., *Christian Rite and Christian Drama in the Middle Ages* (Baltimore, 1965; repr. 1969), pp. 146–49.

28. Gauthier, *Émaux méridionaux,* no. 70, "Courant aquitano-hispanique, émailleur limousin pour la Terre-Sainte." The dating is based on the resemblance, and apparent stylistic debt, of the birds in roundels to the work of the atelier of Abbot Boniface at Conques. The decoration of the candlesticks with fantastic birds places them squarely in the midst of the Spain/Limoges argument. The pair was excavated in 1863 near the Church of the Nativity, Bethlehem, along with another single candlestick, ibid., no. 125. Their discovery in the Holy Land raises the question of whether they were made specifically for export to the Holy Land, as Gauthier proposes, or simply were sent there, part of the larger phenomenon of export of Limoges work throughout medieval Christendom. Other related candlesticks are nos. 70bis–73, though 70 and 71 are not linked to the Holy Land by Gauthier. By contrast, no. 73 is given the same attribution as the Bethlehem pair and yet has no collection history to confirm the link.

29. Bayerisches Nationalmuseum, MA 236: see Gauthier, *Émaux méridionaux,* no. 70bis.

30. Gauthier, *Émaux méridionaux,* nos. 184, 185–88, 191. The pair in Amsterdam (no. 191) with three knops on each shaft has birds in roundels similar in form to The Cloisters pair on the largest, bottom knop. It was not possible for the author to examine the Amsterdam candlesticks. Mme Gauthier considers them to be a neo-medieval interpretation of Limoges work. It is apparent that the bottom roundel of one of the pair has been inverted. Thus at the least, the elements have been rethreaded. Yet they were acquired by Samuel Meyrick perhaps in Aachen before 1831, perhaps before 1823. See Clive Wainwright, *The Romantic Interior* (New Haven, 1989), pp. 255–56, ill. no. 224. Wainwright believes that the low price for genuine examples at the time would not encourage forgery, but he does not consider them from a stylistic or technical point of view.

31. Formerly in the Hoentschel collection; Gauthier, *Émaux méridionaux,* no. 185.

32. Fürstlich Hohenzollernsche Sammlungen und Hofbibliothek, Schloss, Inv. 7435A, B; and Gauthier, *Émaux méridionaux,* nos. 184A, B.

33. Inv. no. 13/1457. H. 20.2 cm. I had the opportunity to examine the Limoges enamels at the Bayerisches Nationalmuseum, Munich, thanks to a John J. McCloy Fellowship in Art in Jan. 1988. I am grateful to Dr. Lorenz Seelig, Konservator of that collection, for his generosity in providing archival information concerning the candlestick and for providing new photographs.

34. Inv. no. 05.EN.120. H. 19.8 cm. The candlestick was purchased by Raymond Pitcairn from Demotte, New York, on May 3, 1929. According to the dealer, it had been in the Chappee collection, Le Mans, and the Plandiura collection, Barcelona. I am grateful to Stephen Morley, Director, the Glencairn Museum, for permission to study the candlestick and to Charles T. Little for bringing it to my attention and for photographing it.

35. Gauthier, *Émaux méridionaux,* no. 89. The three illustrated in color in *Adolphe Stoclet Collection (Part 1): Selection of the works belonging to Madame Féron-Stoclet* (Brussels, 1956), p. 170, are those in Cleveland. I wish to thank William D. Wixom for alerting me to their present whereabouts and Renate Eikelmann for generously providing the essential information.

36. Inv. Nr. H 1013c1, Gauthier, *Émaux méridionaux,* no. 87. A third roundel preserved in the Ashmolean Museum, Oxford, inv. 2395/1887 (ibid., no. 85), also belongs to the same group. It was in a Canterbury collection in the nineteenth century.

37. The best-known work in Braikenridge's collection was the Malmesbury ciborium, purchased by J. Pierpont Morgan at the sale of the Braikenridge collection by his heir, W. Jerdone Braikenridge, Esq., by Christie, Manson and Woods, Feb. 27, 1908, lot 50. For the press attention given the collection at the time of its sale, see Sheena Stoddard, *Mr. Braikenridge's Brislington* (Bristol, 1981), pp. 24–25. The candlesticks sold for £450; the ciborium for £6,000.

38. The letter was included by Sheena Stoddard, "George Weare Braikenridge (1775–1856): A Bristol Antiquarian and his Collections" (M. Litt. thesis, University of Bristol, 1984), pp. 261–62, no. 61, and ill. in fig. 60.

39. The present prickets were added sometime between 1908, when the candlesticks were sold as lot 51 of the Braikenridge collection, and before or soon after 1936, when they were purchased by the Brummer Gallery from Mrs. Otto H. Kahn, New York. The Brummer Gallery inventory card's photograph, N3798A,B first stamped in 1936, shows the present prickets, but the date of the negative is not known.

40. The dates of the sale are noted by Michael Holmes, *The Country House Described: An Index to the Country Houses of Great Britain and Ireland* (London, 1986), p. 106. The candlesticks were then offered to Braikenridge by Horatio Rodd "in conjunction with Mr. Swaby." On the activities of these dealers, see Stoddard, "Braikenridge," pp. 109–13. Rodd recognized that the prickets had been replaced and noted the relationship of the candlesticks to the pair in the Meyrick collection, now in Amsterdam, as a means of encouraging Braikenridge to buy them. See note 30 above.

41. Hugh Honour, "A House of the Gothic Revival," *Country Life* 111 (May 30, 1952), p. 1665.

42. Ibid.

43. Ibid.

44. Letter to the Reverend William Cole, May 4, 1774, W. S. Lewis, ed., *The Yale Edition of Horace Walpole's Correspondence,* 42 vols. (New Haven/London, 1937–80), vol. 1, pp. 324–26.

45. Ibid.

46. I owe this suggestion to Marian Campbell, who published the reliquary, now in the Burrell collection. See Jonathan Alexander and Paul Binski, eds., *Age of Chivalry: Art in Plantagenet England 1200–1400,* exhib. cat., Royal Academy of Arts (London, 1987–88), no. 87.

47. Walpole wrote to the Reverend William Mason on Aug. 31, 1780, describing the setting of both the house and books: Lewis, *Walpole's Correspondence,* vol. 29, p. 78. On July 25, 1790, he wrote to Miss Hannah More: "I have since been beyond Canterbury . . . to visit my friend Mr Barrett and his lovely house, which I recommend you to see the next time you go to Kent: it is the quintessence of Gothic taste exquisitely executed" (ibid., vol. 31, p. 342).

Walpole's role apparently extended to advice on the remodeling of Lee Priory, as is suggested in a 1785 letter to George Hardinge: "I have seen over and over again Mr Barrett's plans and approve them exceedingly. The Gothic parts are classic, you must consider the whole as Gothic modernized in parts, not as what it is,—the reverse" (ibid., vol. 35, p. 635). Writing to Miss Mary Berry on Aug. 27, 1789, Walpole said: "I had promised Mr Barrett to make a visit to my Gothic child, his house, on Sunday" (ibid., vol. 11, p. 59).

48. A letter to Thomas Barrett, May 14, 1792, inquires whether the painting had arrived safely (ibid., vol. 42, p. 362). A letter to Mary Berry, Oct. 17, 1794, laments that Barrett would not oblige the architect, Wyatt, to hang the picture over the chimney in the library (ibid., vol. 11, p. 98).

49. The references appear in three separate letters to Mary Berry: "You will see a child of Strawberry prettier than the parent, and so executed and so finished! There is a delicious closet too, so flattering to me! and a prior's library so antique . . ." (Sept. 27, 1794, ibid., vol. 12, p. 111). "*My* closet is as perfect as the library . . ." (Oct. 17, 1794, ibid., vol. 12, p. 137), and, more generally, "I think if Strawberry were not its parent, it would be jealous" (July 23, 1790, ibid., vol. 11, p. 98).

50. Letter to Mary Berry, Oct. 17, 1794 (ibid., vol. 12, p. 137). The comparison of Lee Priory to an abbot's or monk's residence is pervasive in this letter and others. See also letter to Mary Berry, Sept. 27, 1794 (ibid., vol. 12, p. 111, and n. 31 for another possible description sometimes attributed to Walpole), and a letter to Hannah More, July 25, 1790 (ibid., vol. 31, p. 342). The catalogue for the sale of the contents of Lee Priory in 1834 includes "a pair of antique candlesticks" on p. 23 as lot no. 462, in the Drawing Room. I am indebted to Marian Campbell, Department of Metalwork, Victoria and Albert Museum, for this reference. See also note 40 above.

51. Letters survive showing that Walpole bought painted portrait enamels from French dealers, but none mentions other kinds of enamels. These are indexed by Mrs. Paget Toynbee, ed., *The Letters of Horace Walpole, Fourth Earl of Oxford* (London, 1905), vol. 16, p. 340.

52. See Simone Caudron, "Connoisseurs of *champlevé* Limoges enamels in eighteenth-century England," *Collectors and Collections* (The British Museum Yearbook, 2) (London, 1977), pp. 9–23 and, in French, "Émaux champlevés de Limoges et amateurs britanniques du XVIIIe siècle," *Bulletin de la société archéologique et historique du Limousin* 103 (1976), pp. 137–68.

53. This information is preserved in the files of the Bayerisches Nationalmuseum, Munich.

54. *Reclams Kunstführer Deutschland, Band I: Bayern* (Stuttgart, 1974), pp. 80–81.

55. "*Duo candelabra d'esmaus empta sunt iiij lb*," cited in Henri Duplès-Agier, ed., *Chroniques de Saint-Martial de Limoges* (Paris, 1874), p. 73. The text is cited in more recent literature by Hubert Landais, "Contribution à l'étude des origines de l'émaillerie limousine," *Monuments et Mémoires, Fondation Eugène Piot* 60 (1976), p. 130, in suggesting the importance of the Order of Grandmont in the patronage and distribution of Limoges enamels, as opposed to the role of Saint-Martial, whose inventory consists primarily of gold and silver objects.

56. Munich, Bayerisches Nationalmuseum, MA242; purchased directly from St. Gangolf, 1864–65.

57. See note 32 above.

58. Hermann Hoberg, *Die Inventare des päpstlichen Schatzes in Avignon, 1314–1376* (Vatican City, 1944), pp. 132, 191, 341, 346, 348, 426.

59. Gauthier, *Émaux méridionaux,* nos. 96a,b.

60. "*Item duo candelabra de cuprea de opera lemovicensi,*" cited in Otto Lehmann-Brockhaus, *Lateinische Schriftquellen zur Kunst in England, Wales und Schottland, vom Jahre 901 bis zum Jahre 1307* (Munich, 1956), vol. 2, p. 185, no. 2892.

61. Gauthier, *Émaux méridionaux,* no. 186; and *Age of Chivalry,* no. 126.

62. Such symbolism has generally been considered to be nonexistent. See Braun, *Altargerät,* p. 524.

63. In other Limoges work, such scenes are found only on boxes decorated with applied enamel roundels, generally assumed to have been secular in use. This has been deduced from their elongated form, their secular or heraldic decoration, and the provenance of some examples. Nevertheless, it is evident that similar chests were also intended for church use, the casket of Boniface from Conques being the best-known example. The black box with applied enamels recorded at St. Paul's, London, in 1295 was probably the same type. See Gauthier, *Émaux méridionaux,* no. 97. See also Rupin, *Limoges,* pp. 436–41. Geneviève François is currently preparing a thesis on these coffrets: "La décoration profane des coffrets et cassettes émaillés de l'oeuvre de Limoges au XII siècle," Paris IV, Sorbonne.

64. Rohault de Fleury, "Chandeliers," p. 46.

65. William Durandus, *The Symbolism of Churches and Church Ornaments,* ed. John Mason Neale and Benjamin Webb (London, 1906), p. 54.

66. +LVCIS ON(VS) VIRTVTIS OPVS DOCTRINA REFVLGENS PREDICAT VT VICIO NON TENEBRETVER HOMO. See the discussion by Neil Stratford, *English Romanesque Art,* no. 247, p. 249.

67. For extensive citations of the gift of wax or money to pay for candles in medieval churches and particularly before the shrines of saints, see Barbier de Montault, "L'Appareil," pp. 418–19, 524–25.

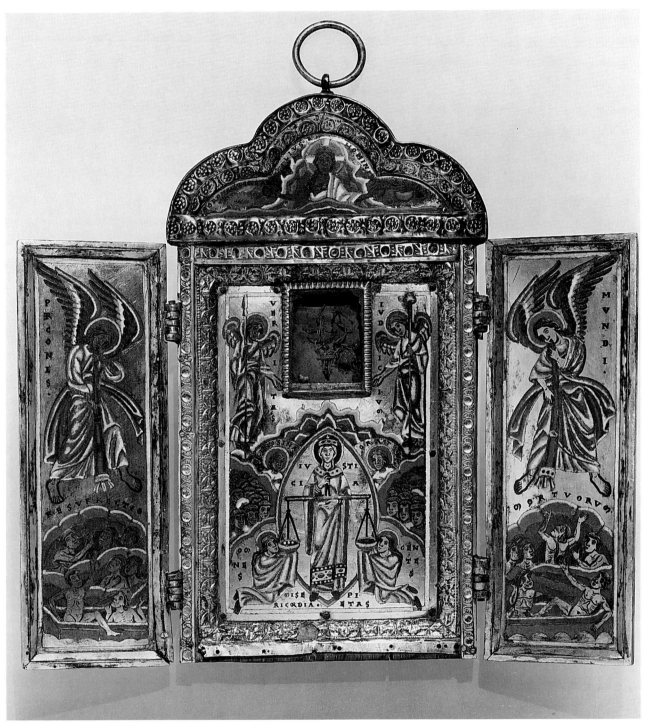

Fig. 1. Guennol Triptych, ca. 1160, copper gilt, *champlevé* enamel, and *émail brun,* 29 x 32 cm. The Metropolitan Museum of Art, Anonymous Loan (L.1979.143) (photo: Museum)

The Guennol Triptych and the Twelfth-Century Revival of Jurisprudence

William S. Monroe

The Guennol Triptych is one of an intriguing group of reliquaries of the True Cross produced in the Meuse Valley in the latter half of the twelfth century (Figs. 1, 2). Sometimes attributed to the school or even to the person of Godefroid of Huy, and dated to the 1160s or early 1170s,[1] it has much in common with these other triptychs (Figs. 3–5), especially in their iconography. But this particular piece stands out for its emphasis on one element. Although the figure of *Iustitia,* Justice, appears in other Mosan reliquaries, the Guennol Triptych is unique in making her the central figure.[2] A reason for this emphasis on the allegorical figure of Justice is proposed here, by placing the work in the context of the legal history of the period, in what was termed by Charles Homer Haskins "The Revival of Jurisprudence."[3]

Harry Bober has analyzed the iconography of this work on two levels: historical and allegorical.[4] The historical is represented by the scriptural Second Coming of Christ, as depicted in the lunette and the outer panels. The allegorical mode is shown on the central panel, which Bober calls "a one-sided exposition of redemption through Virtue. . . ."[5] With the doors of the reliquary closed, the only visible image is in the lunette above the doors, showing the Son of Man (*Filius Hominis*) with outstretched arms displaying his wounds and pointing to instruments of the Passion: the Crown of Thorns (*Corona Spinea*) and the cup of vinegar (*Vas Aceti*). This image, and its placement at the top of the reliquary, resembles one in the series (Fig. 3), although missing entirely from the other two (Figs. 4, 5). The open wings present, in marked variation from the related triptychs, the heralds of the world (*Praecones Mundi*) sounding the trumpets to announce the Resurrection of the Dead (*Resurrectio Mortuorum*).[6]

The central panel contains the framed, rectangular compartment that held the

Fig. 2. Guennol Triptych, detail (photo: Museum)

pupil, meant to explain many of the mysteries of the Faith.[9] At one point the Disciple asks, "How will the Lord come to Judgment?" To which the Master replies: "Just as an emperor enters a city. The crown and other signs are carried before him, by which his coming is known. Thus Christ, in the same form in which he ascended, comes with all the orders of angels to the Judgment; angels bearing the cross go before him; with both horn and voice they will rouse the dead to assembly. . . ."[10]

This description closely matches the depiction on the Guennol Triptych of the Son of Man coming to judgment. He is accompanied by signs of the Passion, including the Cross, which is carried by angels in the form of virtues, while horn-bearing angels on the wings "rouse the dead to assembly." Philippe Verdier has pointed to Psalm 96(97):1–2 as a source for some of the imagery:

> The Lord has reigned, may the earth rejoice;
> May the many islands be glad!
> Clouds and mist are all around him;
> Justice and judgment are the rod of his throne.[11]

relic of the True Cross. This compartment appears in the upper half of the panel and is flanked and carried by two winged figures labeled Truth (*Veritas*) and Judgment (*Iudicium*), who also hold instruments of the Passion: the lance and the sponge. The lower half of the panel is dominated by the female figure, labeled Justice (*Iustitia*), holding a balance. She is crowned and royally attired. Like all the other personifications, she bears a nimbus but, unlike them, she stands in a mandorla. At her shoulders, left and right, are Almsgiving (*Eleemosyna*) and Prayer (*Oratio*). To her right and left are crowds of people, some of whom are also haloed, who are labeled All Nations (*Omnes Gentes*). At her knees, kneeling and each supporting a pan of the balance, are Mercy (*Misericordia*) and Piety (*Pietas*). Three small weights in each of the pans signify that the balance is just.[7] The ensemble (with the lunette and the outer panels) is certainly an allusion to the Second Coming and Last Judgment.[8]

The choice of this theme for a reliquary of the True Cross is appropriate, for the Cross was one of the signs expected to precede Christ as he returns for judgment. In the earliest years of the twelfth century, Honorius Augustodunensis wrote his *Elucidarium,* a dialogue between a master and his

A later verse (96[97]:6) reads: "The Heavens announce his justice, and all peoples behold his glory." These verses may very well be one source for the appearance of *Iustitia* and *Iudicium* (and *Omnes Gentes*), but they do not explain the presence of the other personifications, nor their relationships to one another.

While the Last Judgment theme provides the setting for the idea expounded on this triptych, the personifications are drawn from the tradition of allegorizing the moral virtues.[12] Common to all triptychs in this group is the pairing of the figures *Iudicium* and *Veritas* bearing the relic (Figs. 1, 3–5). Three of the pieces also show *Misericordia* (Figs. 1, 3–4); only the Guennol Triptych shows *Iustitia* (Fig. 1). In it, these virtues are incorporated into the fullest and most complex arrangement. A figure holding a scale is, of course, also a prominent part of Last Judgment depictions.[13] In Western versions made in the twelfth century, however, the archangel Michael, rather than *Iustitia,* is the weigher of souls in most such representations.[14]

The *Iustitia* of the Guennol Triptych has also been interpreted as having the complementary meaning of *Ecclesia.* This interpretation is based on a quotation attributed to Bernard of Clairvaux, "The

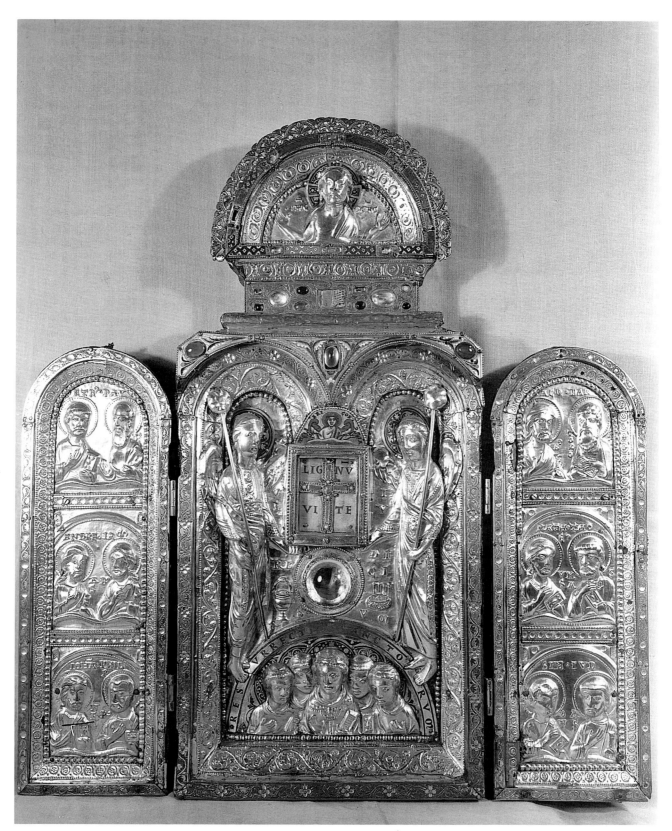

Fig. 3. True Cross reliquary, ca. 1150, 55 x 52 cm. Liège, Trésor de l'Église Sainte-Croix (photo: Copyright A.C.L., Bruxelles)

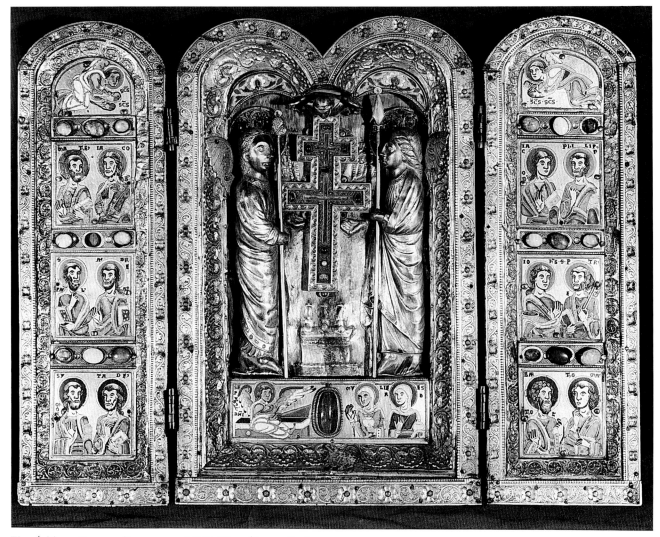

Fig. 4. True Cross reliquary, ca. 1150, 33 x 43 cm. Paris, Musée du Petit Palais, Collection Dutuit ("Grand reliquaire") (photo: Giraudon/Art Resource, N.Y.)

Cross was made the balance of the body of Christ, which is the Church," and on the likeness of this *Iustitia* to the *Ecclesia* of the contemporary portable altar of Stavelot.[15] What may be another explanation for the prominence of this figure of Justice has barely been explored.[16] For Justice is also a legal concept, and the period in which this reliquary was made was a pivotal time in the history of law. As F. W. Maitland once wrote, "Of all the centuries, the twelfth is the most legal. In no other age, since the classical days of Roman law, has so large a part of the sum total of intellectual endeavor been devoted to jurisprudence."[17] One aspect of this "revival of jurisprudence" was a multifaceted discussion, by

philosophers and theologians as well as civil and canon lawyers, of the nature of justice. The following review of a portion of these sources chronologically does not imply a steady evolution of the concept of justice. Instead, there were several concepts struggling for general acceptance. It is in the context of this discussion, rather than in reference to any one source, that we need to interpret the *Iustitia* of the Guennol Triptych.

During the period in which this triptych was made, the idea of justice was being discussed throughout western Europe, and being defined and redefined. The eleventh-century reforming movement had sent churchmen and laity to the archives and libraries in search of material to justify their respective causes. In the course of this research, someone seems to have discovered, after mid-century, the *Digest* of Justinian. This was a collection of passages and glosses from juristic commentaries on Roman law, and had been virtually unknown in the West since its compilation in the sixth century.[18] The discovery of this major source for Roman jurisprudence spurred the study of Roman law, and even church law, in Italy and the rest of Europe in the following century.[19] The *Digest* gives us what is to be the classic definition of justice in the twelfth century, that of the third-century jurist Ulpian: "Justice is a steady and enduring will to render unto everyone his right. The basic principles of right are: to live honorably, not to harm any other person, to render to each his own. Practical wisdom in matters of right is an awareness of God's and men's affairs, knowledge of justice and injustice."[20] A passage ascribed to him in the very beginning of the *Digest* describes *ius*, in the sense of law or right, as derived from *iustitia*.[21] Justice, in this context, is thus a moral concept of fairness from which all law is derived.

Theologians of the late eleventh and early twelfth centuries had another concept of justice, that of retributive justice, equated with punishment or even vengeance.[22] As a characteristic of God, this appears to be in direct conflict with his quality of mercy. Anselm of Canterbury felt the need to reconcile these aspects of the Deity. In his *Prologion* (1077–78), he wonders "what justice is there in giving eternal life to one who deserves eternal death?" This seems to be against "the very nature of justice." Yet, it is God's mercy that permits this, for "though it is hard to understand how thy mercy is consistent with thy justice, yet we must believe that what flows forth from thy goodness—itself nothing without justice—is in no way opposed to justice, but agrees perfectly with justice." He concludes, "Thou art merciful simply because thou art just."[23]

Ivo of Chartres, bishop and canonist, expressed a similar concept of justice as punishment in the prologue to his *Panormia,* a very influential collection of canon law compiled in the closing years of the eleventh century.[24] This prologue is important for its theme that law must be subject to relaxation and *mutatio* to suit circumstance and cannot be applied strictly to all cases.[25] A contemporary of both Anselm and Ivo was Alger of Liège, secretary to Bishop Otbert of that city. About the year 1105, Alger wrote a treatise on both theology and canon law, *De misericordia et iustitia.* This is the first compilation of canon law to do more than simply assemble the texts in a systematic way,[26] for Alger added a commentary upon the texts, and the ensemble was meant to show the superiority of mercy over justice. But here, as with Ivo, justice is identified chiefly with punishment. His statement, "that in discipline it is better to hold to mercy than to severity," is supported by a quotation from Ambrose, "Moderation must temper justice."[27]

Gratian's *Decretum,* compiled about 1140, was the culmination of the approach suggested by Ivo of Chartres and attempted by Alger. Called the *Concordia discordantium canonum,* it was the application of the scholastic method to a systematically arranged body of canon law texts, with commentary meant to reconcile their differences.[28] It quickly became the foundation for the standard textbook of medieval canon law. Gratian begins his collection with a discussion of the nature of law, which dwells greatly upon the law of nature. He uses the term *ius naturae* where other writers often use *iustitia.*[29] He thus parallels the *Digest* with a Christian version of Ulpian's definition of justice: "The law of nature is that contained in the Law and the Gospel, by which each is ordered to do to another what he would wish done to him, and is forbidden to do to another what he would not wish done to him."[30] Gratian draws the distinction between natural law (or justice), which is God's, and human laws—*mores* and *leges*—citing Isidore of Seville: "Fas lex divina est; ius lex humana."[31] In a later commentary on the *Decretum,* the *Summa Coloniensis,* after the

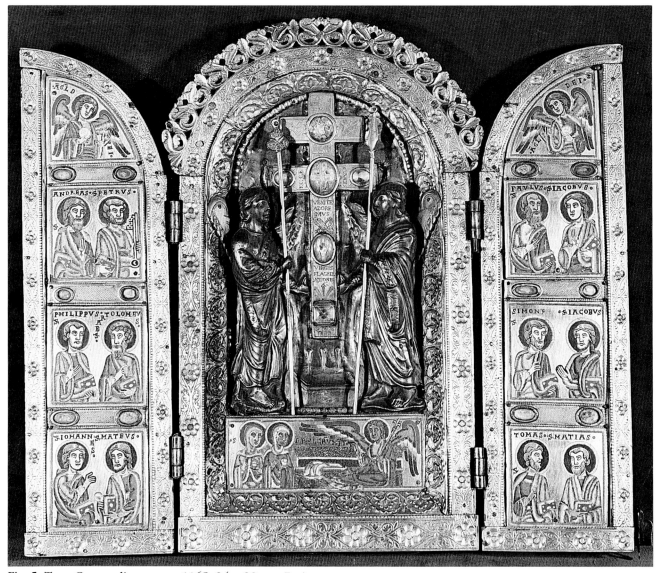

Fig. 5. True Cross reliquary, ca. 1165, 34 x 39 cm. Paris, Musée du Petit Palais, Collection Dutuit ("Petit reliquaire") (photo: Giraudon/Art Resource, N.Y.)

rubric "How law differs from justice," the commentator declares: "It differs from justice in that the author of law is man, the author of justice is God."[32]

The preceding passages demonstrate different ways of conceiving justice. To civil lawyers, justice is a social concept which characterizes a relationship (or transaction) between two persons. To the canon lawyers and theologians, it is identified with judgment and punishment, and is an attribute of God. While they emphasize the need for mercy over justice, this is only for men; God will be merciful and just at once.[33] It would appear that none of these works serves as a direct source for the Guennol

Triptych, but perhaps a search for textual sources is not the best way to explain the work. Rather, we should see the triptych as one more text in the discussion and thus to read it in the context of the others. While each of these texts, including the Guennol Triptych, draws on earlier sources for its elements, it is the combining of these elements into a new statement that is most important. Which conception of justice is portrayed in this triptych?

One might begin by looking at the relation of *Iustitia* to the other virtues portrayed, especially that of Mercy to Justice, which is important to those Mosan triptychs that show *Misericordia*. Taking them chronologically as Verdier dates them,[34] the two earlier are those in the church at Sainte-Croix in Liège and the larger triptych in the Dutuit Collection of the Petit Palais, Paris (Figs. 3, 4). These show, above the relic, *Misericordia* flanked by *Veritas* and *Iudicium*. Verdier connects this arrangement with a passage from Tobit (3:2): "All your ways are mercy, truth and judgment." The figure of Mercy in these works is in the same pose as the *Filius Hominis* in the lunette of the Liège and Guennol triptychs, and is obviously meant to stand for him (Figs. 1, 3). Drawing again on the *Elucidarium* of Honorius Augustodunensis, we find the student asking, "Since Christ is Mercy itself . . . who comes to call not the just, but the sinners, why is he not merciful to them?" The answer is that Christ is also Justice itself.[35] On the Guennol Triptych, Justice becomes the main figure, with Mercy and Piety kneeling at either side (Fig. 2). Here, *Iustitia*, *Veritas*, and *Iudicium* are divine attributes, while *Misericordia* (no longer winged) and *Pietas* are human virtues.

This equal placement of Mercy and Piety may draw upon Peter Lombard's *Sentences*, written between 1155 and 1158, which includes a short discussion of the cardinal virtues. Peter Lombard takes his definition of justice from the *De Trinitate* of St. Augustine: "Justice lies in aiding the wretched."[36] But he adds, again following Augustine, that Justice lies also in submission to God, or Piety.[37] Peter Lombard, in fact, again joins Mercy and Piety to Justice later in the *Sentences*, this time quoting Cassiodorus on Psalm 51: ". . . speaking about mercy and piety of God: 'These two things,' he said, 'are always connected to the judgment of God.'"[38] He later asks, "But, how did Cassiodorus say that the justice of God and piety, that is mercy, are 'two things' which are always joined to the judgment of God?

For indeed, the justice of God and mercy are not two things, but one thing. . . ."[39] Thus, Mercy and Piety are the same in that they are both qualities of justice. This interpretation fits well with the placement of *Eleemosyna* above *Misericordia* and *Oratio* above *Pietas*, for almsgiving and prayer are virtues that reflect the attitudes, respectively, of mercy and piety.

These discussions of justice did not take place in a vacuum. Alger of Liège's *De misericordia et iustitia* was certainly a response to the investiture struggle.[40] While that particular battle was to end with the Concordat of Worms in 1122, the more general conflict was to intensify in the second half of the twelfth century. The *Summa Coloniensis* comes from the same province and, dated as it is around 1169, perhaps even the same decade in which the Guennol Triptych was made, from a region particularly affected by the struggles between emperor and pope in the eleventh and twelfth centuries. During this period, as in the conflict of the previous century, both sides tried to show that their cause was that of justice.[41] But justice, here, was more than the idea of fairness or of retribution portrayed in the legal and theological sources discussed here. It also implied the authority to render judgment. While the emperor claimed that authority in temporal affairs, the pope could argue that justice is God's, and, as God's representative on earth, it falls to him.

A major actor in this twelfth-century conflict was Henri de Léez, bishop of Liège (1145–64), and an adviser to the emperor Frederick Barbarossa. When the antipope, Victor IV, died in 1164, Henri de Léez was recommended to fill the position. Although he declined, it was he who consecrated the new antipope (Pascal III) at Lucca that same year.[42] Gilles of Orval, the thirteenth-century chronicler, portrayed Henri as both a great art patron and lover of justice. Prominent among the many works of art given by Henri to the episcopal church at Liège was a "book of Gratian."[43] Since the Guennol Triptych is believed to have belonged to the archbishops of Liège,[44] it would be tempting to put forth Henri de Léez as the patron, but more research into both the politics and the patronage of the bishops of this period is necessary for a better sense of who might have commissioned this reliquary and for what purpose.[45]

When viewed in the context of the arguments over different conceptions of the nature of justice,

the message carried by the Guennol Triptych becomes clear. Justice, here, is firmly tied to the Last Judgment and to God. It is *Iustitia Dei,* identified with Christ and with his Cross, and meant for "All Nations."[46] Created in the twelfth century, when the legal foundations of the secular state were being laid,[47] the Guennol Triptych reminds men of their proper roles, shown here by *Misericordia* with *Eleemosyna,* and by *Pietas* with *Oratio.* It is both a depiction of the world to come and a model for the world that is.

ACKNOWLEDGMENTS

I would like to thank Rebecca Leuchak for invaluable art-historical advice in the course of writing this paper. Robert Somerville read several drafts and made many helpful suggestions concerning the legal aspects. I would also like to thank the editor of this volume and the unknown readers whose many questions and suggestions helped to shape this into a much more coherent and meaningful contribution than it was originally.

NOTES

1. For a summary of scholarship on the work, with bibliography, see Harry Bober, "Mosan Reliquary Triptych," in *The Guennol Collection,* ed. Ida Ely Rubin (New York, 1975), pp. 151–64. The series of Mosan reliquaries was studied by A. Frolow in *Les Reliquaires de la Vraie Croix* (Paris, 1965), a companion to his earlier *La Relique de la Vraie Croix: recherches sur le développement d'un culte* (Paris, 1961), and also by Philippe Verdier, "Les staurothèques mosanes et leur iconographie du Jugement Dernier," *Cahiers de civilisation médiévale* 16 (1973), pp. 97–121, 199–213. Because of its style and similarity to other Mosan reliquaries, the Guennol Triptych has been dated to somewhere between 1160 and 1175. Scholars have suggested that it was made in Liège or Stavelot or Maastricht. Not an art historian, the author does not attempt to answer such questions. For the purpose of this discussion, 1160–75 is an acceptable date, as is the assumption that the work was created somewhere in the diocese of Liège, which would include all three of the localities mentioned. As for the attribution to Godefroid of Huy or his school, see Peter Lasko, *Ars Sacra: 800–1200* (Harmondsworth, 1972), p. 186.

2. See Verdier, "Staurothèques," for comparisons and illustrations. There are four triptychs directly related in terms of their iconography. Listed here, along with the numbers

assigned to them in Frolow, *Relique:* 393a. Liège, Église Sainte-Croix (Fig. 3); 393c. Paris, Petit Palais, Coll. Dutuit, "Grand reliquaire" (Fig. 4); 393d. Paris, Petit Palais, Coll. Dutuit, "Petit reliquaire" (Fig. 5); 394. New York, The Cloisters, "Guennol Triptych" (Fig. 1).

3. Charles Homer Haskins, *The Renaissance of the Twelfth Century* (Cambridge, Mass., 1927). This is the title of chap. 7 (pp. 193–223). See also Stephan Kuttner, "The Revival of Jurisprudence," in *Renaissance and Renewal in the Twelfth Century,* ed. Robert L. Benson and Giles Constable (Cambridge, Mass., 1982), pp. 299–323. The title was used earlier by Paul Vinogradoff in his *Roman Law in Mediaeval Europe* (London, 1909), chap. 2.

4. Bober, "Mosan Reliquary," pp. 156–60.

5. Ibid., p. 157.

6. The other triptychs all show the apostles on the wings. The seated apostles form another Last Judgment motif, since they are to sit with Christ to judge the twelve tribes of Israel (Matthew 19:28).

7. See Job 31:6, "Let me be weighed in a just balance, and let God know my integrity." Bober ("Mosan Reliquary," p. 159) pointed out that there are three weights in each pan. Those on the right, being darker, are difficult to see.

8. For a succinct treatment of the theme in medieval art, see Samuel G. F. Brandon, *The Judgement of the Dead: An Historical and Comparative Study of the Idea of a Post-mortem Judgement in the Major Religions* (London, 1967), pp. 118–31. See also Émile Mâle, *Religious Art in France: The Twelfth Century,* ed. Harry Bober, trans. Marthiel Mathews (Princeton, 1978), pp. 406–19.

9. Émile Mâle has pointed out the importance of this work as a source for medieval iconography, *Religious Art,* p. 408.

10. Honorius Augustodunensis, *Elucidarium,* bk. III, chap. 51, in Yves Lefèvre, *L'Elucidarium et les lucidaires* (Paris, 1954), p. 457:

> D. Qualiter veniet Dominus ad judicium?
> M. Sicut imperator ingressus civitatem. Corona et alia insignia praeferuntur, per quae adventus ejus cognoscitur. Ita Christus in ea forma qua ascendit cum omnibus ordinibus angelorum ad judicium veniens; angeli crucem ferentes praeeunt; mortuos et tuba et voce in occursum ejus excitant; omnia elementa turbabuntur, tempestate ignis et frigoris mixtim undique furente. . . .

11. Verdier, "Staurothèques, " p. 115 n. 108. Psalm 96(97): 1–2:

> Dominus regnavit exutet terra laetuntur insulae multae nubes et caligo in circuitu eius iustitia et iudicium correctio sedis eius

Psalm 96(97):6:

> adnuntiaverunt caeli iustitiam eius et viderunt omnes populi gloriam eius.

12. On this theme in general, see Adolf Katzenellenbogen, *Allegories of the Virtues and Vices in Medieval Art: From Early Christian Times to the Thirteenth Century* (London, 1939; repr., New York, 1964), and the 1972 doctoral thesis (University of Nottingham) by Jennifer O'Reilly, *Studies in the Iconography*

of the Virtues and Vices in the Middle Ages (New York, 1988). For a fuller treatment, see Rosamund Tuve, *Allegorical Imagery: Some Medieval Books and Their Posterity* (Princeton, 1966), pp. 57–143. O'Reilly, *Studies,* summarizes Tuve and provides some further information (see esp. pp. 83–162). For the theme in Mosan art, see Joseph de Borchgrave d'Altena, "Des figures de vertus dans l'art mosan au XIIe siècle," *Bulletin des Musées royaux d'art et d'histoire* 5 (1933), pp. 14–19, and, more recently, Nigel Morgan, "The Iconography of Twelfth-century Mosan Enamels," in *Rhein und Maas, Kunst und Kultur 800–1400* (Cologne, 1972–73), vol. 2, pp. 263–75. For the treatment of justice specifically, see Georg Frommhold, *Die Idee der Gerechtigkeit in der bildenden Kunst* (Greifswald, 1925). The author was unable to see Lodovico Zdekauer's *L'Idea della Giustizia e la sua immagine nelle arti figurative* (Macerata, 1909).

13. See Brandon, *Judgement of the Dead,* pp. 23–29.

14. Ibid., pp. 119–26. See also *Lexikon der christlichen Ikonographie,* 8 vols. (Rome/Freiburg, 1968–76), vol. 4, p. 515; and Louis Réau, *Iconographie de l'art chrétien* (Paris, 1957), vol. 2, pt. 2, p. 742.

15. "Crux facta est statera corporis Christi, quod est Ecclesia," from *Feria secunda Paschatis sermo,* chap. 12, in *PL,* vol. 184, col. 972. Migne reproduced this text from the Mabillon ed., which placed this sermon among "Opera supposititia et aliena." The interpretation is that of Yvonne Hachenbroch, "A Triptych in the Style of Godefroid de Clair," *The Connoisseur* 134 (1954), p. 187, and accepted by Bober, "Mosan Reliquary," p. 158 and n. 5.

16. Ernst Kantorowicz is the only scholar, to this author's knowledge, to make the connection between this triptych and legal affairs, and that was only in a footnote. See his *The King's Two Bodies: A Study in Medieval Political Theology* (Princeton, 1957), p. 112 n. 73, where he says, "The iconographic problem is involved, and I may discuss it in another connection," which apparently he never did.

17. Frederick Pollock and Frederic William Maitland, *The History of English Law,* 2d ed. (Cambridge, 1898; repr., 1968), vol. 1, p. 111. The literature on the idea of justice is enormous, although very little of it treats the subject historically. Even discussions of the concept in medieval philosophy generally jump directly from Augustine to Aquinas, thereby skipping our period altogether. The best book on the subject, most helpful for its bibliography for the Middle Ages, is Giorgio Del Vecchio, *Justice: An Historical and Philosophical Essay* (Edinburgh, 1952). For a recent survey of the legal history of this period, see Harold J. Berman, *Law and Revolution: The Formation of the Western Legal Tradition* (Cambridge, Mass., 1983).

18. This is the dominant view of the origin of the revival of Roman law, proposed by Paul Fournier, "Un tournant de l'histoire du droit, 1060–1140," *Nouvelle Revue historique de droit français et étranger* 41 (1917), pp. 129–80.

19. Although some practices of Roman law had survived to varying degrees in the countries of the West, there had been no study of jurisprudence, that is, the scientific or philosophical study of the law. Del Vecchio (*Justice,* pp. 24–27, 54–56) regards the Middle Ages as an aberration in the development of what he calls "the proper or 'juridical' concept of justice" (p. 77), which had existed in Roman law.

20. Ulpian, *Digest,* 1,1,10: "Iustitia est constans et perpetua uoluntas ius suum cuique tribuendi. Iuris praecepta sunt haec: honeste uiuere, alterum non laedere, suum cuique tribuere. Iuris prudentia est diuinarum atque humanarum rerum notitia, iusti atque iniusti scientia." The text and translation are from *The Digest of Justinian,* ed. Theodor Mommsen and Paul Kreuger, English trans. and ed. Alan Watson, 4 vols. (Philadelphia, 1985), vol. 1, p. 2. Justinian's *Institutes* also opens with a discussion of justice and law, containing some of these same texts (unattributed). A basic textbook on Roman law, the *Institutes* seems to have been used in Italy through the early Middle Ages, but it never inspired the kind of discussion as did the *Digest,* which carried the authority of the Roman jurists.

21. *Digest,* 1,1,1 (vol. 1, p.1): "unde nomen iuris descendat. est autem a iustitia apellatum." Further, according to Celsus (another ancient jurist), "ius est ars boni et aequi" (ibid.). *Ius* is difficult to translate, as there is no exact English equivalent. It usually means "law," but in the general sense; whereas *lex* is "a law." The distinction between *ius* and *lex* is similar to that between the French *droit* and *loi.*

22. For further treatment of this concept, see Geoffrey Koziol, "The Monastic Idea of Justice in the Eleventh Century," in *The Medieval Monastery,* ed. Andrew McLeish (St. Cloud, Minn., 1988), pp. 70–76. For justice as vengeance, see esp. p. 71.

23. Anselm of Canterbury, *Prologion,* chap. 9, in *A Scholastic Miscellany,* ed. and trans. Eugene R. Fairweather (Philadelphia, 1956), pp. 78–79: "Aut quae iustitia set merenti mortem aeternam dare vitam sempiternam? . . . Etenim licet bonis bona et malis mala ex bonitate retribuas, ratio tamen iustitiae hoc postulare videtur. . . . Nam etsi difficile sit intelligere, quomodo misericordia tua non absit a tua iustitia, necessarium tamen est credere, quia nulla est sine iustitia, immo vere concordat iustitiae. . . . Vere ergo ideo misericors es, quia iustis." Latin text from F. Schmitt, ed., *Opera omnia,* 6 vols. (Edinburgh, 1946–61), vol. 1, pp. 106–8; Michael Corbin, ed., *L'oeuvre d'Anselme de Cantorbéry* (Paris, 1986), vol. 1, pp. 254–58.

24. See Paul Fournier and Gabriel Le Bras, *Histoire des collections canoniques en occident,* 2 vols. (Paris, 1932; repr., Aalen, 1972), vol. 2, pp. 55–114. On Ivo himself, see Rolf Sprandel, *Ivo von Chartres und seine Stellung in der Kirchengeschichte* (Stuttgart, 1962). Ivo's Prologue and two of his collections, the *Decretum* and the *Panormia,* are in *PL,* vol. 161.

25. The Prologue (*PL,* vol. 161, cols. 47–60) is placed with the *Decretum,* but probably belongs to the *Panormia.* See Fournier and Le Bras, *Histoire des collections canoniques,* vol. 2, pp. 106–8. Part of it is translated by Fairweather in *Scholastic Miscellany,* pp. 238–42. Ivo does not write specifically of justice, but rather of judgment (*iudicium*), but the sentiment is the same. He wants his reader to note in his collection, "quid secundum rigorem, quid secundum moderationem, quid secundum iudicium, quid secundum misericordiam dicatur . . ." (col. 47). On application of the law: "Multa quoque principes Ecclesiarum pro tenore canonum districtius judicant, multa pro temporum necessitate tolerant, multa pro personarum utilitate, vel strage populorum vitanda dispensant" (cols. 51–52).

26. Text in Robert Kretzschmar, *Alger von Lüttichs Traktat "De misericordia et iustitia": ein kanonistischer Konkordanzversuch aus der Zeit des Investiturstreits* (Sigmaringen, 1985). See also Fournier and Le Bras, *Histoire des collections canoniques,* vol. 2, pp. 340–44.

27. Alger of Liège, *De misericordia et iustitia,* bk. II, chap. 3 (p. 248): The chapter heading reads, "Quod in disciplina magis est misericordia tenenda quam severitas." The quotation follows: "Unde Ambrosius in libro primo de penitentia adversus Novatianum [bk. I, chaps. 1, 2]: Debet iustitiam temperare moderatio."

28. On Gratian's work, see Stephan Kuttner, *Harmony from Dissonance: An Interpretation of Medieval Canon Law* (Latrobe, Pa., 1960), and Gabriel Le Bras et al., *L'Age classique, 1140–1378: sources et théorie du droit* (Paris, 1965), pp. 49–129. The standard edition is *Decretum magistri Gratiani,* ed. Emil Friedberg (Leipzig, 1879; repr., Graz, 1955), as vol. 1 of the *Corpus iuris canonici.*

29. Contemporary manuscript illuminations of the *Decretum* show that twelfth-century readers interpreted Gratian's *ius naturae* as *iustitia.* See Anthony Melnikas, *The Corpus of the Miniatures in the Manuscripts of the Decretum Gratiani,* 3 vols. (Rome, 1975), vol. 3, p. 1205, and figs. 4, 5 in Appendix I. Two manuscripts which Melnikas calls "late twelfth century" depict Justice within the first initial. One (Saint Omer, Bibliothèque municipale, MS 454, fol. 1) shows a female figure holding an elaborate staff topped by a balance. With the bottom of the staff she is piercing the dragon on which she stands. The similarity here to the iconography of St. Michael is noteworthy. The other Justice (Munich, Bayerische Staatsbibliotek, MS Clm. 4505, fol. 1v) holds a scroll which reads "Justitia est constans," referring, of course, to the *Digest* (see note 20 above).

30. *Decretum* D.1. "Ius naturae est, quod in lege et euangelio continetur, quo quisque iubetur alii facere, quod sibi uult fieri, et prohibetur alii inferre, quod sibi nolit fiere."

31. Ibid., D.1, c.1. The citation is from Isidore's *Etymologies,* bk. V, chap. 2. It is virtually impossible to translate into English, since all three nouns translate only as "law." *Fas* is literally "God's word," *ius* is "right" or law in a general sense, and *lex* is positive law (see note 21 above).

32. *Summa "Elegantius in iure diuino" seu Coloniensis,* ed. Gérard Fransen and Stephan Kuttner (New York, 1969), vol. 1, p. 1. "Differt a iustitia eo quod auctor iuris homo, auctor iustitie Deus."

33. Another conception is that of the moral philosophers, represented by Alain of Lille, *De Virtutibus et de Vitiis et de Donis Spiritus Sancti,* ed. Odin Lottin, in "Le Traité d'Alain de Lille sur les vertus, les vices et les dons du Saint-Esprit," *Mediaeval Studies* 12 (1950), pp. 20–56. Alain, writing about 1160, attempts to combine Roman moral philosophy with Christian. Leaning heavily on Cicero, he makes justice a human virtue, rather than a divine attribute: "Iustitia est uirtus ius suum cuique tribuens, communi utilitate seruata" (ibid., p. 30). Piety, severity, vengeance, and mercy are only types or divisions of justice (ibid.).

34. Verdier, "Staurothèques," pp. 105–19. Verdier gives little reason for dating the works in this way. This schema is used only for convenience here.

35. Honorius Augustodunensis, *Elucidarium,* bk. II, chap. 65 (p. 430):
　　D. Cum Christus sit ipsa misericordia . . . qui venit vocare non justos, sed peccatores, cur non est misertus eorum?
　　M. . . . Et cum ipse sit ipsa iustitia. . . .

36. "Iustitia est in subveniendo miseris." Peter Lombard, *Sententiae in IV libris distinctae,* 3d ed. (Grottaferata, 1971–81), bk. III, dist. 33, chap. 1 (vol. 2, p. 188). See also Augustine, *De Trinitate,* ed. W. J. Mountain (Turnhout, 1968), bk. 14, chap. 9 (p. 439); and Stephan Kuttner, "A Forgotten Definition of Justice," *Studia Gratiana* 20 (1976), pp. 75–109 (p. 94 for Peter Lombard).

37. "naturae divinae, quae creauit omnes caeterasque instituit naturas . . . cui regenti subditum esse, iustitiae est." Peter Lombard, *Sententiae,* bk. III, dist. 33, chap. 3 (vol. 2, p. 189).

38. Ibid., bk. IV, dist. 46, chap. 1 (vol. 2, p. 530): ". . . loquens de misericordia et pietate Dei: 'Hae duae, inquit, res iudicio Dei semper adiunctae sunt.'"

39. Ibid., chap. 3 (vol. 2, pp. 532–33): "Sed quomodum iustitiam Dei et pietatem, id est misericordiam, supra Cassiodorus 'duas res esse' dixit, quae semper adiunctae sunt Dei iudicio? Iustitia enim Dei misericordia non duae res sunt, sed una res. . . ."

40. Fournier and Le Bras, *Histoire des collections,* vol. 2, pp. 340–41. For a recent synthesis on the investiture conflict with a good bibliography, see Uta Renate Blumenthal, *The Investiture Controversy: Church and Monarchy from the Ninth to the Twelfth Century* (Philadelphia, 1988).

41. It is instructive to look at the use of the word *iustitia* in imperial *arengae,* which increases markedly during the eleventh and twelfth centuries, only to fall off again after Frederick Barbarossa. See Friedrich Hausmann and Alfred Gawlik, *Arengenverzeichnis zu den Konigs- und Kaiserurkunden von den Merowingern bis Heinrich VI* (Munich, 1987).

42. Édouard de Moreau, *Histoire de l'Église en Belgique,* 5 vols. (Brussels, 1946–52), vol. 3, pp. 59–63.

43. Gilles of Orval, *Gesta episcoporum Leodiensis,* bk. 3, chap. 30, ed. J. Heller, in *Mon. Germ. Hist., Scriptores* (Hannover, 1880), vol. 25, p. 105. "Dedit etiam ecclesie duas dalmaticas cum subtili, immo et sex pallia bona et tapete magnum et librum Gratianum. . . ." Gilles uses the word "justice" numerous times in his description of the episcopacy of Henri de Léez, and hardly anywhere else in his narrative, which is often lifted directly from contemporary sources for each bishop; see ibid., bk. 3, chaps. 30–33, pp. 103–7.

44. Bober, "Mosan Reliquary," p. 162.

45. The possiblities, given the accepted dating, are: Henri II de Léez (1145–64); Alexander II (1166–67); Raoul of Zähringen (1167–91). Jean-Louis Kupper has written much about the politics of the episcopacy of Liège in his recent books, but does not deal with art patronage. See his *Raoul de Zähringen, évêque de Liège 1167–1191: Contribution à l'histoire de la politique impériale sur la Meuse moyenne* (Brussels, 1974), and *Liège et l'Église impériale XIe–XIIe siècles* (Paris, 1981). Raoul was also an art patron, as we know from Gilles of Orval and other sources; see Émile Schoolmeesters, "Les Regesta de Raoul de Zähringen, prince-évêque de Liège, 1167–1191," *Bulletin de la Société d'art et d'histoire du diocèse de Liège* 1 (1881), p. 156 (no. 19), which indicates that Raoul probably commissioned the present reliquary of St. Domitian at Huy. The author was not able to see the second edition of Schoolmeesters's work, *Les Actes de Radulphe de Zähringen, prince-évêque de Liège, 1167–1191* (Liège, 1911).

46. That *Iustitia* is not only haloed but also appears in a mandorla is an attribute of her divine nature. See "Mandorla," in *Lexikon der christlichen Ikonographie* (1971), vol. 3, cols. 147–49. The image called to mind is Augustine's denial of the possibility of an earthly commonwealth: "For there is no true justice except in that republic whose founder and ruler is Christ," *De civitate Dei,* Bernard Dombart and Alphonse Kelb, eds. (Turnhout, 1955), bk. 2, chap. 21, p. 55.

47. Especially through the creation of a new caste of civil servants educated in law. See Joseph R. Strayer, *The Medieval Origins of the Modern State* (Princeton, 1970), pp. 23–33.

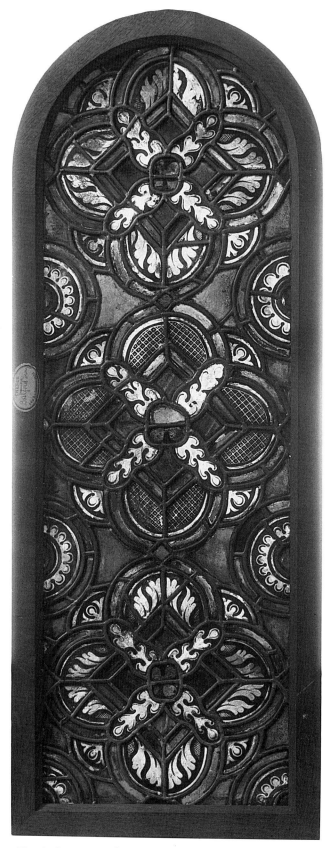

Fig. 1. Ornamental stained-glass panel from the Abbey
Church of Saint-Remi, Reims, ca. 1170-80 (type R.O.5).
The Metropolitan Museum of Art, Gift of George D.
Pratt, 1926 (26.218.1) (photo: Museum)

The Twelfth-Century Ornamental Windows of Saint-Remi in Reims

Madeline H. Caviness

A spectacular panel of ornamental stained glass, now installed in The Cloisters,[1] was among the many works that entered the collections of the Medieval Department of The Metropolitan Museum of Art as part of the bequest of George D. Pratt of Glen Cove, New York, in 1926 (Col. pl. 3 and Fig. 1).[2] It came with no record of immediate provenance, nor of origin, and was thus without a history.[3] Like many such Museum objects, it had not only been detached from its original monumental setting but also from a remote cultural context. By 1926 it had become a part of American twentieth-century culture, and its only known provenance was that of Pratt, a prolific collector of medievalia, perhaps best known for his interest in arms and armor. Its reception might be further elaborated in the context of nonrepresentational art, or in relation to the battle over the use of architectural ornament that was joined in the first quarter of this century.[4]

Thanks, however, to the perceptions of Cloisters Curator Jane Hayward, the original site of this piece has been rediscovered.[5] She noted that a drawing of comparable design reproduced in a line engraving in Merson's general history of stained glass, published in 1895, is labeled Saint-Remi of Reims.[6] But for some additional foliage in the engraving, its ornamental composition is a fair match for that of the small section in New York (Fig. 2). A colored print of the same window design had been published in the early 1840s by the pères Cahier and Martin; the predominant yellow helps to identify the Pratt piece, or at least to give it such a close analogue that the same provenance cannot be doubted (Fig. 3).[7] Another design included in the same plate by Cahier and Martin is still recognizable in Saint-Remi, and comparison with the original glass indicates the liberties taken in the graphic reproduction with detail, as also with color balance (Figs. 4, 5).

Fig. 2. Ornament recorded in the Abbey Church of Saint-Remi, Reims, nineteenth century (type R.O.5) (after Merson, *Les vitraux,* fig. 46)

Fig. 3. Ornament recorded in Saint-Remi, ca. 1840 (type R.O.5) (after Cahier and Martin, *Monographie de la cathédrale de Bourges,* Mosaïques F 6)

In our historical purview, this small section of a window immediately regains its original twelfth-century monumental setting, even though the whole piece is scarcely more than a meter high and less than half a meter wide, or about a quarter the size of an opening in the Gothic retrochoir (Figs. 6–9). Despite severe damage in World War I, the great Benedictine Abbey Church of Saint-Remi still stands.[8] Burial place of many saintly archbishops of Reims, and some of the Frankish kings, the eleventh-century church was consecrated by a pope (the nave is largely of that period). The church gained prestige in the twelfth century when the custom was established of anointing the French kings at their coronation in the cathedral at Reims with the holy chrism that had been kept at the shrine of the patron saint in

Saint-Remi since the fifth century, when it had been believed to have been delivered by a dove from heaven.[9] By mid-century its choir fittings rivaled those of Abbot Suger's Saint-Denis.[10] By the end of the twelfth century the great mystical humanist, Abbot Peter of Celle, had again transformed the choir (which occupied the crossing and the first four bays of the nave) by replacing the small apse that housed St. Remigius's shrine with a new extended chevet that has three tiers of large windows (Figs. 9, 11). It is possibly to the lower chapel windows, but more probably to the tribune of the retrochoir, that the brilliant ornamental panel now in The Cloisters belonged.

The only glass that is clearly in situ in the tribune at Saint-Remi is a Crucifixion window in the axial

Fig. 4. Retrochoir tribune, ornament now in window St II a. Reims, Abbey Church of Saint-Remi (type R.O.1) (photo: COPYRIGHT 1991 ARS, N.Y./SPADEM)

Fig. 5. Ornament recorded in Saint-Remi, ca. 1840 (type R.O.1) (after Cahier and Martin, *Monographie*, Mosaïques F 5)

light. It is flanked by four windows containing fragments of other authentic ornamental designs. These were supplemented in the 1950s, with great sensitivity, by Charles Marq in order to complete the series; nineteenth-century complements were either destroyed in World War I or eliminated in this restoration. Early remnants of ornament in the tribune show the same stickwork in the grounds as the New York piece—a bold crosshatch with pinpoints of light in the centers—and comparable fleshy leaves (Figs. 4, 12, 13, 16). Yet the Museum panel alone is almost perfectly preserved, those on the site having suffered paint-loss and corrosion. In all, four original designs are preserved on the site.[11] One is based on the quatrefoil, and also has some of the same distinctive green that is seen in the

New York panel, but the differences establish the latter as the fifth design type (Figs. 1, 12). Yet another design was recorded in the nineteenth century and published by Cahier and Martin, but all physical trace of this type seems to have disappeared (Fig. 17).[12]

In fact the drawings made for that publication about 1840 mark the beginning of an intense interest in Gothic ornament; glass was highly appreciated as decoration, after a long period of neglect, and designers were eager for patterns.[13] The same motivation probably lay behind the very accurate drawings of foliate capitals made by the architect Auguste Reimbeau (Fig. 19); these examples are still preserved in the wall arcades of the lower chapels at Saint-Remi.[14] The rich variety of leaf forms in these capitals is comparable to that of the ornamental glass.

Fig. 6. St. Remigius and another archbishop in a window of the retrochoir tribune of Saint-Remi. Rothier photo taken before 1896 (photo: author)

conducted by the abbé Aubert, without government authorization, and letters are on file from Boeswillwald to Viollet-le-Duc threatening suit.[18] By 1884 a private owner was openly loaning panels of Saint-Remi glass to the Exposition Universelle in Paris.[19] The combination of neglect by its legitimate custodians and appreciation by others had resulted in a market.[20]

A little more archaeological detail is needed to help us envisage the original arrangement of the glass before we can understand how it functioned spiritually in the monks' choir and its radiating chapels. In the present arrangement, standing and seated figures of at least four different iconographic series are framed by ornamental glass and distributed in the lights flanking the axial Crucifixion in the tribune. Some are modern confections, made after World War II to balance old assemblages. The general composition has a parallel in the late-thirteenth-century glazing of the abbey of Saint-Père in Chartres (Fig. 20), and in several monuments, such as the cathedrals of Reims and Auxerre in between, so that Meredith Lillich once speculated that the type might have originated in Saint-Remi (Figs. 6, 7).[21] A few standing figures of kings are from a genealogy of Christ based on the gospels of Matthew and Luke. Two female saints are larger than these ancestors; one, labeled Agnes, is paired across the tribune of the retrochoir with Martha, who originally processed in the same direction but who has been turned inside out to face the first; both hold scrolls with the opening of the *Ave Maria,* an anthem appropriate to address the Virgin rather than Christ crucified. Such figures were recorded both in the west end of the nave and here in the tribune in notes made about 1820.[22] Since the nineteenth-century arrangement, photographed before 1896 by the rémois photographer Rothier, clearly shows that the figure was then on a modern arched ground cut into ornament, I assume it had been inserted from elsewhere either during the abbé Aubert's restorations in the 1870s or earlier.[23]

The Rothier photograph of another window in the tribune shows ornament comparable to the Museum's piece, but from the photograph I would judge it to be a copy (Fig. 6). The figures framed in it had been used as stopgaps in the clerestory, where they were still visible in 1840, but had originated in the smaller openings of the eleventh-century building. The upper one is the patron of

Another extremely competent watercolorist—not the same as the one who worked for Cahier and Martin—recorded ornamental designs in the Saint-Remi glass (Fig. 14). These drawings, probably by a Frenchman judging from the handwriting, were done sometime before 1860, at which time they became part of the Buckler bequest to the British Library.[15] At about the same time Viollet-le-Duc commented on the graphic strength of panels with cross-hatching and foliage that he saw in a storage area in Saint-Remi.[16]

Being an abbey church rather than a cathedral, Saint-Remi was not classified as a historical monument until 1842. Not long after, it was reported with some alarm that the galleries were open to casual visitors and they could help themselves to original stained-glass panels that were lying around in stacks.[17] A radical reordering of the glass was being

Fig. 7. Interior of the tribune of the retrochoir, north side, before 1916. Reims, Abbey Church of Saint-Remi (photo: COPYRIGHT 1991 ARS, N.Y./SPADEM)

Fig. 8. Interior of the tribune of the retrochoir, after 1916. Reims, Abbey Church of Saint-Remi (photo: COPYRIGHT 1991 ARS, N.Y./SPADEM)

the church, St. Remigius, and I suppose Peter of Celle had wished to preserve this cult image when he enlarged the chevet—though I doubt it is older than 1150–60. There is no reason to associate the original ornamental panels with these figures, nor to date them as early. Another early photograph, however, seems to show patinated glass of a uniform geometric design resembling the Museum's piece, in the westernmost opening of the choir tribune on the south side (Fig. 11). And some pieces of this design may have been in the Lady Chapel, that is, at lower level, as late as 1940. A photograph of the Lady Chapel taken after World War I damage was attached to restoration proposals in 1941, when repairs to the east end were only just beginning (Fig. 10). That not all the figural glass and fragments of ornament were evacuated in World War I is

indicated in another archival photograph (Fig. 8). Had the Museum's panel remained in the building in 1916 during the German bombardments that led to the capitulation of Reims, however, it is doubtful it would have survived in such good condition. I believe it is more likely that the Museum's panel left the site in the course of the wholesale dismantling of the glass in the nineteenth century.

Ornament is not easy to date when it is detached from its monumental context. Conservatively, the Saint-Remi ornamental panels could be put in at the very end of the twelfth century—by comparison for instance with the outer lobes of the reliquary of St. Sixtus that is in the cathedral treasury which has similar wreath forms (Figs. 12, 21).[24] Many of the panels are leaded to very narrow borders in the same "pastel" colors—green, yellow, purple, and

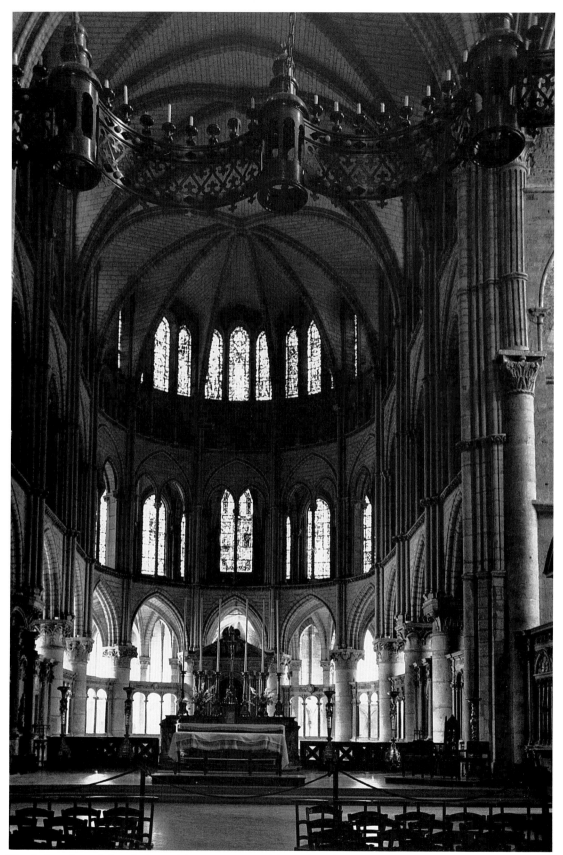

Fig. 9. Interior of the choir to the east. Reims, Abbey Church of Saint-Remi (photo: author)

Fig. 10. Exterior of the Lady Chapel before 1941.
Reims, Abbey Church of Saint-Remi. Paris, Ministère de
la Culture et de la Communication, Bibliothèque de la
Direction de l'Architecture, 823, dossier 7, proposal of
Juliard, 1940 (photo: author)

Fig. 11. Exterior of the south side of the retrochoir before 1916. Reims, Abbey Church of Saint-Remi
(photo: Roger-Viollet)

Fig. 12. Ornament now in the retrochoir tribune, window Nt II a (type R.O.2). Reims, Abbey Church of Saint-Remi (photo: COPYRIGHT 1991 ARS, N.Y./ SPADEM)

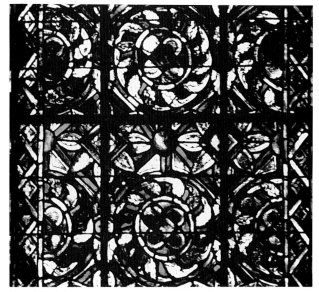

Fig. 13. Ornament now in the retrochoir tribune, window St III a (type R.O.3). Reims, Abbey Church of Saint-Remi (photo: COPYRIGHT 1991 ARS, N.Y./ SPADEM)

white rather than the saturated red-blue palette that is better known in French glass, at least by 1200 (Figs. 13, 14). Several have parallels in late-twelfth-century glass from Troyes and in Strasbourg Cathedral, and in Rhenish metalwork and rémois manuscripts of the same date.[25] In fact an exhaustive study of the forty-five border designs preserved from Saint-Remi has identified an early-looking group of about six that are uniformly narrow and geometric, and these might be grouped with the ornamental glass, dating them about 1170 to 1180.[26] The date is an appropriate one for the glazing of the tribune.

Significantly earlier are the famous ornamental griffin windows of Saint-Denis, which probably formed part of the original program of the choir, completed for the consecration of 1144 (Fig. 22).[27] These offer similar color combinations and dense painting to the Saint-Remi ornament, yet the complex syncopated rhythm of the Saint-Remi designs, which are organized into a series of geometric fields—squares, circles, or lozenges—forming a counterpoint to the grid armature, differentiate themselves from the simple square repeat of Saint-Denis. Furthermore, none of the six designs known at Saint-Remi includes animal motifs; the foliate motifs are as pure as those of all but one of the Gothic capitals of the chevet (Fig. 19), as if frivolous subjects were rigorously excluded from the ornament of the new retrochoir and chapels that were laid out by Peter of Celle about 1165. Yet, like the ornamental windows of Saint-Denis that were used as a rich setting for a dense program of imagery, these too may be a response to the extreme austerity of contemporary Cistercian programs.[28]

Was this type of sumptuous yet aniconic decoration specific to its monastic context? It has parallels, as Kline has demonstrated, in the slightly later Benedictine Abbey of Orbais, near Reims (Figs. 15, 18).[29] Unfortunately the panels of the Saint-Remi type, though a good fit in the straight bays of the choir clerestory at Orbais, may have originated elsewhere in the building, which makes it hard to date them conclusively. Other examples in Orbais tend to be less richly colored; in fact they run through the whole gamut of even less colorful grisaille designs.[30] In situ in the north transept at Orbais are a superb group of painted grisaille windows, with thin colored fillets defining elongated shapes with complex boundaries, and predominantly greenish-white painted glasses giving a chill effect. There are

186

Fig. 14. Watercolor of ornament seen in Saint-Remi before 1860 (type R.O.3). London, British Library, Add. MS 37, 138, Buckler bequest no. 38 (photo: By permission of The British Library)

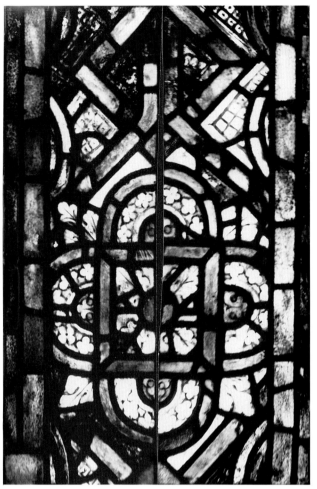

Fig. 16. Ornament now in the retrochoir tribune, window St II c (type R.O.4). Reims, Abbey Church of Saint-Remi (photo: COPYRIGHT 1991 ARS, N.Y./ SPADEM)

Fig. 15. Ornament now in choir clerestory, window N III b. Orbais, Benedictine Abbey Church (photo: COPYRIGHT 1991 ARS, N.Y./SPADEM)

Fig. 17. Watercolor of ornament seen in Saint-Remi ca. 1840, now lost (type R.O.6). Paris, Musée des Arts Décoratifs, Dessins originaux, Vases-Vitraux (album n.p.) (photo: Musée des Arts Décoratifs)

187

Fig. 18. Ornament now in choir clerestory, window
S III b. Orbais, Benedictine Abbey Church (photo:
COPYRIGHT 1991 ARS, N.Y./SPADEM)

also whole unpainted colorless windows, with elegant blank-glazed patterns of Cistercian origin. Indeed the overall effect of true grisaille ornament, as readily seen in the transept of Orbais, is much lighter than the impression that can be gained from the single light in the tribune of Saint-Remi that is entirely filled with colored ornamental glass, composed around old fragments. Yet it is likely that the Orbais choir originally contained a similar combination of figural and ornamental windows as the chevet of Saint-Remi.

Other than at Orbais, the impact of the Saint-Remi ornamental windows seems to have been very limited, whether in Benedictine or cathedral churches; by the second quarter of the thirteenth century painted grisailles with colored fillets were the norm. Yet the reappearance of the same general type in the churches of the new preaching orders in the Rhineland (and in Cistercian buildings farther afield) may be a conscious revival of a form that filled the contemplative needs of the Benedictines in Saint-Remi. Thus the true legacy of the Saint-Remi type is in the so-called carpet designs used to fill the soaring late-thirteenth-century lancets of Rhenish and Austrian churches—such as the Cistercian abbey church of Heiligenkreuz (Fig. 23),[31] or the church of the Dominicans in Strasbourg. The affinity was noticed in the nineteenth-century studies of

ornament.[32] In Heiligenkreuz, the color is needed to carry through the vast space, and almost homogeneous saturation is achieved even when colored figures are framed in the ornament.

The effect may have been similar in Saint-Remi, where I envisage the brilliant Crucifixion window set like a cluster of colored gemstones among purely ornamental lights that enhance the solemnity of the central image. It is also possible that the ground-floor chevet chapels were treated in the same way. Thus, the areas dedicated to the monastic liturgy would be differentiated from others, in a choir that had been highly decorated in two campaigns over a half-century. As well as giving light for the altars positioned in front of them, these "abstract" windows would have provided a contemplative ambience, without referential imagery that would direct the content of thought. The predominant geometric motifs belong in the repertory of forms commonly associated with diagrams and images of divine order: they include the perfect forms of circle and square, as well as composite quatrefoils and lozenges, that recur in diagrams of the microcosm and macrocosm.[33] Recalling such configurations to a monastic audience, they would invite cognitive as opposed to intuitive or emotive meditations.

A very unusual aspect of the Museum panel is the use of yellow as a ground color, in contrast to the normative blue or red ground used in stained glass (Col. pl. 3). Other designs in the series share this predilection for gold and silver, along with green and purple. These chromatic hierarchies may be associated with Peter of Celle's two exegetical treatises on the furnishings in the Tabernacle of Moses as described in Exodus, where he lays emphasis on the tangible aspects of these precious metals and also on their mystical and moral significance. Gold and silver head the list of offerings to be made by the Israelites for the making of the tabernacle, followed by brass, blue, purple, and "others," and he defines gold as the clarity of true wisdom, silver as the lucidity of sacred eloquence, brass is confession leading to salvation, blue is celestial dwelling, and purple the corporeal Passion.[34] In general, precious stones are spiritual works.[35] The crown of gold around the ark is the glory of the resurrection and ascension of Christ, and the rings on its corners are the four principal virtues emanating from wisdom, which is gold.[36] The mercy seat of purest gold is the Redeemer, who

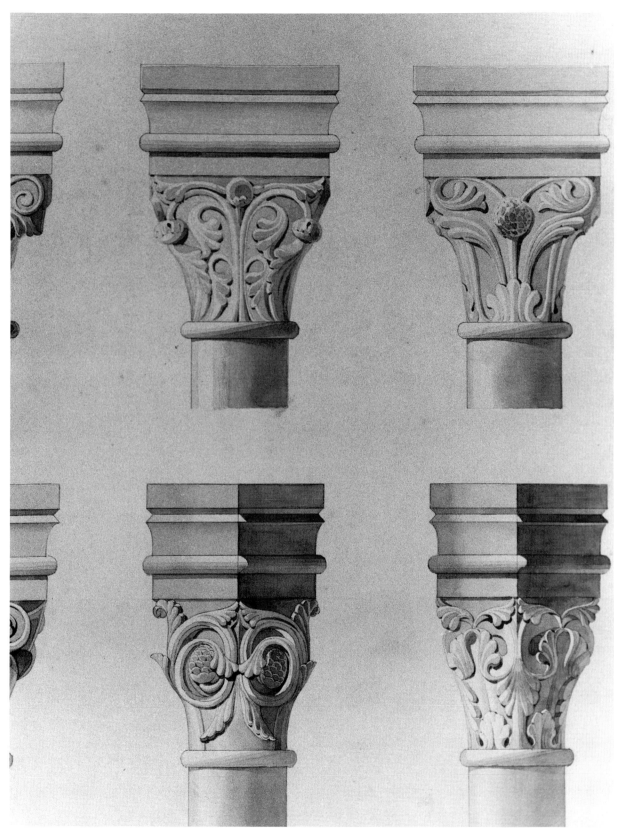

Fig. 19. Lithograph by Auguste Reimbeau, before 1868, of capitals in the lower wall arcades of the chevet of Reims, Abbey Church of Saint-Remi. Bibliothèque Municipale, Estampes E a, detail (photo: author)

Fig. 20. Window on the choir (Bay 12), photomontage, second half of the thirteenth century. Chartres, Benedictine Abbey Church of Saint-Père (photo: COPYRIGHT 1991 ARS, N.Y./SPADEM)

Fig. 21. Detail of the Reliquary of St. Sixtus, early thirteenth century. Reims Cathedral Treasury, Palais du Tau (photo: author)

forgave our sins through grace and who was conceived by the Holy Spirit and born of an immaculate Virgin.[37] Both texts and windows provided powerful answers to St. Bernard's scathing rhetorical question: "What doeth this gold in the sanctuary?"[38]

The coloring of the New York panel, and of others on the site, harmonizes extraordinarily well with the figures in the clerestory windows above, several of which have a great deal of yellow, green, and white. The Saint-Remi retrochoir program established a hierarchy of color saturation. The heavenly zone of the upper story was filled with a series of archbishops of Reims, and above them patriarchs and apostles, culminating in the axial light with the Virgin and Christ Child against a blue ground strewn with stars; these figural windows are relatively dark in color that is brilliant in the sense of brightly colored. Below them only the Crucifixion received this brilliant treatment.[39] To the distant viewers below, the lateral windows provided a warm light, and if they stood on axis, the corpus of Christ was masked behind the slender column of the tribune arcade, rendering the entire zone virtually aniconic (Fig. 9). This was the light that Peter of Celle chose to illuminate the new monks' choir, the school of the cloisters where the novices were to spend their hours "neither in the flesh nor yet in spirit," as he phrased it.[40]

Seen down the length of the nave, the most visible levels of the new chevet formed a double-tiered wheel of light, its upper zone inhabited by celestial beings, its middle zone radiating light around the great gilded candlewheel that Abbot Odo

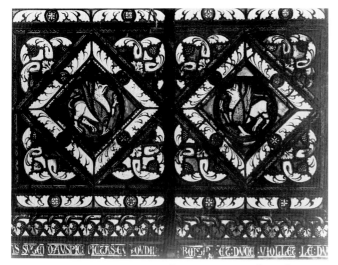

Fig. 22. Ornament, nineteenth-century copy based on the griffin windows of 1141-44. Saint-Denis, Benedictine Abbey Church (from Grodecki, *Les Vitraux de Saint-Denis,* pl. xv)

had hung in the liturgical choir before 1151 (a copy appears in Fig. 9). Peter of Celle thereby enhanced and dignified the rich display of his predecessor, despite the severe censure of such things by St. Bernard and by the reformist Benedictine abbots in the region of Reims earlier in the century.[41] Representations that might have seemed frivolous or meaningless are avoided, but the Benedictine way tended to prefer sobriety rather than austerity, and colorful brilliance rather than absolute clarity, in the furnishings of God's house.

NOTES

1. This material is expanded from that presented in Madeline H. Caviness, *Sumptuous Arts at the Royal Abbeys in Reims and Braine ornatus elegantiae et varietate stupendae* (Princeton, 1990). Information concerning Saint-Remi that is not referenced here may be found in that publication.

2. 94 x 31.7 cm (without modern edges); Naomi Kline, *The Stained Glass of the Abbey Church at Orbais* (Ann Arbor, 1983), pl. 128; Jane Hayward in "Stained Glass before 1700 in American Collections, New England and New York" (Corpus Vitrearum, USA, Checklist I), *Studies in the History of Art* 15 (1985), p. 94 (with other bibliog.); Caviness, *Sumptuous Arts,* Cat. D, R.o.5.

3. For the Pratt collection, see Hayward, "Stained Glass before 1700," pp. 16, 19 n. 15.

4. A taste for the geometric nonfigural art was validated by Cubism and other abstract modes. On the other hand, the controversial

Fig. 23. Heiligenkreuz, Cistercian Stiftskirche choir, carpet window, ca. 1295 (photo: Bundesdenkmalamt, Vienna)

elimination of decoration from Bauhaus architecture occasioned a vogue for equally austere Cistercian buildings: M. H. Caviness, "Erweiterung des 'Kunst'-begriffs: Die Rezeption mittelalterlicher Werke im Kontext nachimpressionistischer Strömungen," *Oesterreichische Zeitschrift für Kunst und Denkmalpflege* 40 (1986), pp. 212–13, figs. 241, 242, expanded in idem, "Broadening the Definitions of 'Art': The Reception of Medieval Works in the Context of Post-Impressionist Movements," in *Hermeneutics and Medieval Culture,* ed. Patrick Gallacher and Helen Damico (Albany, 1989), pp. 267–70, figs. 7, 8. Pratt's liking for ornament was more likely conservative, based in the Crafts Revival and validated by reactionary decorators like Stanford White, whose impact in the twentieth century is only just being acknowledged: Monroe Hewlett, "Stanford White, Decorator," *Good Furniture* 9 (Sept. 1917), pp. 160–79, and M. H. Caviness and Jane Hayward in "Stained Glass before 1700 in American Collections, Mid-Western and Western States" (Corpus Vitrearum USA, Checklist 3), *Studies in the History of Art* 28 (1989), pp. 14–15.

5. Jane Hayward, "Stained Glass Windows," *MMAB* 30 (Dec. 1971–Jan. 1972), n.p.

6. Olivier Merson, *Les vitraux* (Paris, 1895), fig. 46.

7. Charles Cahier and Arthur Martin, *Monographie de la cathédrale de Bourges* (Paris, 1841–44), Mosaïques F 6.

8. The only complete history of the building is that by Anne Prache, *Saint-Remi de Reims: L'oeuvre de Pierre de Celle et sa place dans l'architecture gothique* (Bibliothèque de la Société d'Archéologie, 8) (Geneva, 1978). A synopsis is in Caviness, *Sumptuous Arts,* chap. 1.

9. The growth of this legend is examined by Francis Oppenheimer, *The Legend of the St. Ampoule* (London, 1953).

10. The entire "decoration" of the church and its relationship to Saint-Denis are dealt with in Caviness, *Sumptuous Arts,* chaps. 1, 2.

11. Ibid., Cat. D, R.o.1–R.o.4.

12. Ibid., Cat. D, R.o.6.

13. It has been overlooked until recently that several of the original watercolors that served for the plates in Cahier and Martin are preserved in Paris, Musée des Arts Décoratifs, "9 Feuilles originaux de la Monographie de la cathédrale de Bourges par Cahier et Martin relevé probablement du R. P. Martin, don de M. Maciet," Dessins originaux [XIXe siècle] 123: Vases-Vitraux (album, n.p.).

14. Reims, Bibliothèque Municipale, MS 2100: "Études sur l'église Saint-Remi de Reims, texte et Dessins par Auguste Reimbeau, architecte à Reims, décédé en 1865," II, f.1; and Estampes, Ea 4.

15. C. A. Buckler, "Vitraux—small drawings, England and France," London, British Library, Add. MS 37, 138.

16. Eugène E. Viollet-le-Duc, "Vitrail," in *Dictionnaire raisonné de l'architecture française du XIe au XVIe siècle* (repr., Paris, 1970), vol. 9, p. 448.

17. Paris, Ministère de la Culture et de la Communication, Bibliothèque de la Direction de l'Architecture, Dossier 821bis, 28 mars 1877. I have not been able to find a source for the statement by Jacques Simon, "Restauration des Vitraux de Saint-Remi de Reims," *Les Monuments Historiques de la France,* n.s. 5 (1959), p. 15 n. 1, that the abbé Bulteau had reported that

fragments of glass were scattered on the floor of the tribunes and that M. Bulteau-Jupin, a rémois sculptor, had collected some.

18. Correspondence of 1877, Paris, Ministère de la Culture et de la Communication, Bibliothèque de la Direction de l'Architecture, Dossier 821bis.

19. Lucien Magne, *Vitraux anciens... catalogue* (Union Centrale des Arts Décoratifs, Section des Monuments Historiques) (Paris, 1884), p. 30, no. 46.

20. By 1900 it was common knowledge that glass had been alienated from Saint-Remi: Henri Jadart, "Le Vitrail de Puiseux et autre anciens vitraux des Églises du Département des Ardennes," *Revue historique ardennaise* 7 (1900), p. 318 n. 3: "Les peintres verriers fabriquent avec les mille débris qu'ils enlèvent de tous côtés des vitres en mosaïque d'un très riche effet. Nous en avons vu chez MM. Bulteau et Haussaire à Reims, qui ont été vendues au loin et très cher." See also Paris, Ministère de la Culture et de la Communication, Bibliothèque de la Direction de l'Architecture, Dossier 821bis, letter dated Sept. 24, 1900, complaining to the minister that a glass painter had acquired some panels; a second reference gives the glass painter's name as Bonbonneau, perhaps mockingly. There is no sign of a response.

21. Meredith P. Lillich, "The Band Window: A Theory of Origin and Development," *Gesta* 9 (1970), p. 28.

22. Reims, Bibliothèque Municipale, MS 1837: Povillon-Piérard, "Description historique de l'église Saint-Remi de Rheims," 1824–28, edited as Appendix 2 in Caviness, *Sumptuous Arts.*

23. Ibid., pl. 93. I am extremely grateful to Benoît Marq for allowing me to study the unique set of prints by Rothier in his atelier and for allowing me to have copies made.

24. Musée des Arts Décoratifs, *Les Trésors des Églises de France,* exhib. cat. (Paris, 1965), p. 66, no. 133, pl. 96.

25. Many examples illustrated in Caviness, *Sumptuous Arts,* Cat. D.

26. Ibid., Cat. D, R.b.1–4,6, and perhaps 7, 8. Another (R.b.5), of richer design, has tiny jewel-like cut pieces, and uses a reddish purple with a light streaky orange-red—a very unusual palette. This appears to me to be one of the very earliest, perhaps coeval with the small figure of St. Remigius (Fig. 6) that I date about 1150–65.

27. Louis Grodecki, *Les Vitraux de Saint-Denis: Étude sur le Vitrail au XIIe siècle,* Corpus Vitrearum Medii Aevi, France Études I (Paris, 1976), pp. 122–26, pl. xv, figs. 183–92.

28. For the best overview of the early Cistercian tradition, see Helen Jackson Zakin, *French Cistercian Grisaille Glass* (New York/London, 1979).

29. Kline, *Orbais,* pp. 48–52, 252–56, pls. 38–40, 121–26.

30. Ibid., chap. 1, usefully made a distinction between ornamental colored, ornamental painted grisaille, and blank-glazed glass.

31. Eva Frodl-Kraft, *Die Mittelalterlichen Glasgemälde in Niederösterreich* 1: *Albrechtsberg bis Klosterneuburg,* Corpus Vitrearum Medii Aevi, Austria II/I (Vienna, 1972), pp. 127–28, pls. 394, 433–73.

32. As at least implied in the sequence of plates in Cahier and Martin, *Bourges,* Mosaïques F–H.

33. Madeline H. Caviness, "Images of Divine Order and the Third Mode of Seeing," *Gesta* 22 (1983), pp. 99–120; see esp. figs. 9–13, 19–21, 27.

34. "Petri Cellensis Abbatis, Mosaici Tabernaculi Mystica et Moralis Expositio," ed. *PL,* vol. 202, col. 1050, cf. Exod. 25:3–4. Similar references occur in his more spiritual treatise, "De Tabernaculo Moysi," ed. Jean Le Clercq, *La Spiritualité de Pierre de Celle (1115–1183)* (Paris, 1946), e.g., pp. 164–66.

35. "Lapides pretiosi opera sunt spiritualia," ibid., p. 163.

36. *PL,* vol. 202, cols. 1056–57.

37. Ibid., vol. 202, col. 1062 (Exod. 25:17).

38. "St. Bernard to William of St. Thierry," ed. and trans. Caecilia Davis-Weyer, *Early Medieval Art 300–1150* (MART repr., Toronto, 1986), p. 169; as the editor points out, he is quoting Persius Flaccus, an A.D. first-century Stoic poet.

39. A hierarchy of saturation, with a predominance of blue in the "anagogical" and other figural windows at Saint-Denis, has been linked with the concept of divine darkness, known through available translations of Pseudo-Denis the Areopagite. See Meredith P. Lillich, "Monastic Stained Glass: Patronage and Style," in *Monasticism and the Arts,* ed. Timothy Verdon (Syracuse, 1984), pp. 222–36.

40. Gérard de Martel, *Pierre de Celle. L'École du Cloître. Introduction, texte critique, traduction et notes* (Paris, 1977), chap. xii, p. 192: "Novitius . . . in confinio rationis et sensualitatis positus, iam quidem non est in carne, sed necdum in spiritu."

41. The Benedictine reform movement was led by William of Saint-Thierry in Reims, to whom Bernard addressed his famous outburst against certain kinds of images, ca. 1125; in 1131 William and other abbots attended a council at Reims, but Abbot Odo of Saint-Remi was not among them. See S. Ceglar, "Guillaume de Saint-Thierry et son rôle directeur aux premiers chapitres des abbés bénédictins: Reims 1131 et Soissons 1132," in *Saint-Thierry: Une Abbaye du XIe au XXe siècle,* Actes du colloque international d'histoire monastique (Saint-Thierry, 1979), pp. 320–33; Adriaan H. Bredero, *Cluny et Cîteaux au douzième siècle: L'Histoire d'une controverse monastique* (Amsterdam/Maarssen, 1985), pp. 78–79, 88–89 n. 29.

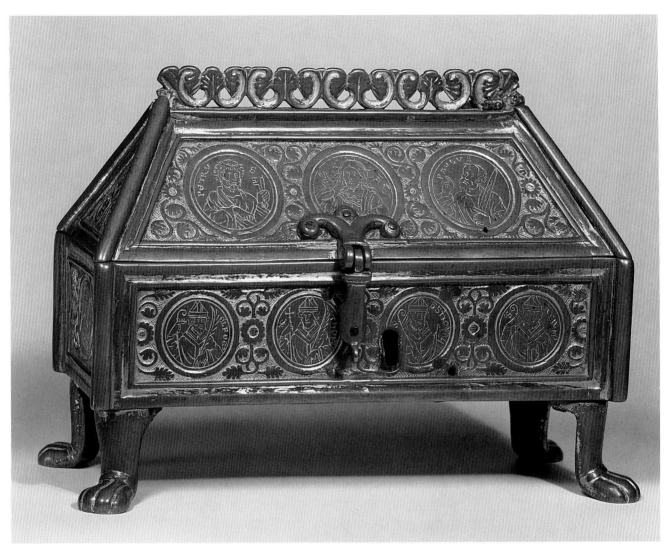

Fig. 1a. View of the front

Figs. 1a-e. Reliquary Chest, England, Canterbury, ca. 1200-1207, copper: shaped, engraved, chased, and gilded; feet cast, 7 x 10 x 4½ in. (17.8 x 25.4 x 11.4 cm). The Metropolitan Museum of Art, The Cloisters Collection, 1980 (1980.417) (photo: Museum)

In quinto scrinio de Cupro, A Copper Reliquary Chest Attributed to Canterbury: Style, Iconography, and Patronage

William D. Wixom

The intention of this essay is three-fold: first, to reexamine a little-studied copper-gilt hip-roof reliquary chest, or chasse, acquired for The Cloisters in New York in 1980 (Col. pl. 4 and Figs. 1a–e);[1] second, to discuss some of the most important stylistic and iconographic arguments connecting this chasse with Christ Church monastery and cathedral in Canterbury; and third and finally, to focus on questions of patronage, function, and chronology in relation to specific monuments and events at Christ Church Canterbury.

The chasse itself, traditional in shape, recalls the sarcophagus hip-roof form of a series of Early Christian, Byzantine, and medieval reliquaries and caskets, such as the Byzantine sixth-century reliquary in the Hermitage (Fig. 2),[2] several seventh- to ninth-century Irish-Scots-Pictish copper-alloy shrines (Fig. 3),[3] the Cleveland Anglo-Saxon boxwood reliquary of the mid-eleventh century (Fig. 4),[4] the oak casket in the Bargello, probably secular and attributed to Canterbury just after 1150 (Fig. 5),[5] and the Metropolitan Museum's silver-gilt and niello Becket reliquary of about 1173 from the Morgan Collection (Fig. 6).[6] Like these works, The Cloisters chasse is self-contained and mostly complete. Only minor additions have been made to some of them, as in the fourteenth-century bronze lock, hinges, knob, and feet with articulated toes on the Bargello oak casket. Likewise, the interior lock was replaced and the keyhole possibly enlarged on The Cloisters chasse, probably in the late-medieval period. On the other hand, there is no reason to doubt the originality of the cast lion-paw feet that are riveted to the base of this work (Fig. 7a). Each of these supports shares the color, evidence of wear, and vestiges of the original fire gilding with the main body of this reliquary, and the relative proportions are consistent with

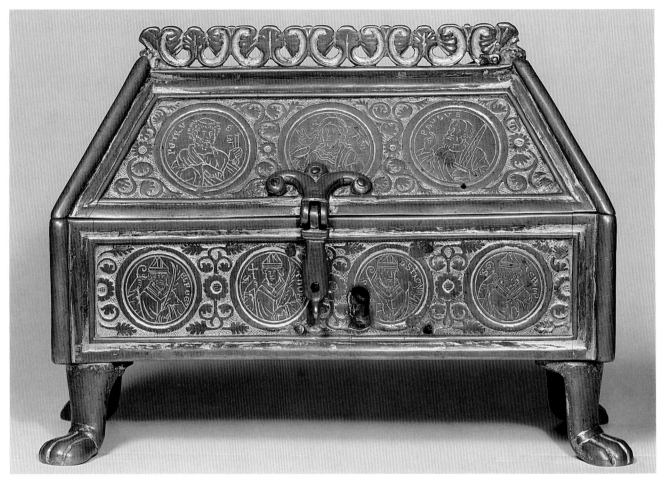

Fig. 1b. Front

those of other works of this type dating from the Late Romanesque and Early Gothic period.[7]

Taken in its entirety, The Cloisters chasse is especially interesting for the combination of its traditional form with a certain sturdiness of construction, consistency of technique, animated decoration, and particular iconography. For instance, from a technical point of view, the embellishment of the various sides and of the openwork crest is achieved through the techniques of shaping, chiseling, engraving, fire-gilding, and burnishing. This decoration is offset visually by separate border and corner moldings, which are riveted to the engraved portions. These riveted moldings are the essential structural elements that help hold the chasse together, as is clear from an examination of the interior and exterior surfaces and edges (Fig. 7b). The planning and execution of the construction and decoration were done with logic and care.

Security is an important aspect of this chasse as well. Bundles of relics may have been tied to the interior rings (Fig. 7b). Rivets near the center of the base plate may indicate either the positions of additional points of attachment or a subdivision of the interior. With sturdy hinges at the back, the chasse was held closed at the front by a hasp suspended tongue-and-groove fashion from a riveted, stylized floral appliqué. The ungilded tongue-and-groove lug at the lower back edge of the chasse, together with a lost chain, undoubtedly secured the chasse to its original location (Fig. 1c). Mechanisms of this type may be seen in twelfth-century reliquary caskets, as in examples in Besançon[8] and in the Lateran.[9] These reliquaries were, then, virtual strongboxes for the protection

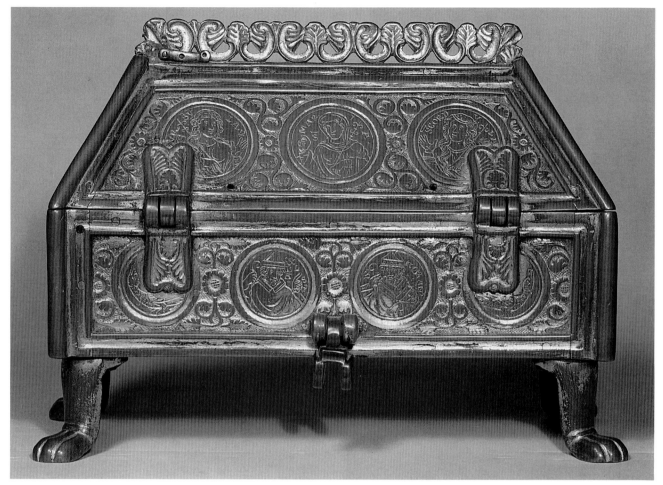

Fig. 1c. Back

of the very precious contents they were intended to contain.

Furthermore, The Cloisters chasse must have been designed with the dim, flickering light of a church interior in mind. In the Middle Ages, when the overall gilding was still intact, the decoration, originally far sharper, would have been discernible by means of the varying refraction of light on the bevels of the incised lines and on the cross-hatched textures of the backgrounds, as seen in several less-worn areas on the medallions on the back, especially near the hinges and security lug (Figs. 1c, 8). Today, with much of the gilding worn from the more exposed surfaces, the designs are mostly read as gilded lines and textured backgrounds against the warm, light-chocolate natural patina of the copper. Other copper-gilt church utensils, roughly contemporary with the chasse, share these features although even

more of their former gilding has eroded away. Two examples are a thirteenth-century paten, now on loan to the Victoria and Albert Museum from the Church of St. Peter in Bredhurst, Kent (Fig. 9),[10] and a small candlestick without any known provenance, now in The Cloisters Collection (Fig. 10). Thus "all was not gold that glittered on and around the altars of medieval churches."[11] Gilt plate in base metal seems to have been part of a long tradition in English churches, and not only in those unable to afford more costly gold or silver-gilt.[12] The Canterbury Cathedral inventory of 1540 relates that the frontals for the altars for Sts. Dunstan and Elphege, on either side of the high altar, were made of copper-gilt, underscoring the use of copper-gilt there.[13]

The engraved busts of holy personages in the sixteen medallions on The Cloisters chasse, each identified by inscription, are of special importance

197

Fig. 1d. End with King Edward the Confessor

Fig. 1e. End with King Edmund

and completeness. Christ, cross-nimbed and flanked in accordance with long tradition by Peter with his keys and Paul with a sword, appears at the center of the front panel of the lid (Figs. 1b, 11a–c), while Mary, with St. Ursula and her companion, St. Cordula, are depicted on the opposite side, each with a scepter (Fig. 1c). Four canonized archbishops of Canterbury appear on the front vertical panel: St. Elphege (martyr and twenty-eighth archbishop, 1005–12), St. Thomas Becket (martyr and thirty-ninth archbishop, 1162–70), St. Dunstan (twenty-fourth archbishop, 960–88), and St. Anselm (thirty-fifth archbishop, 1093–1109 [Figs. 12a–d]). Sts. Elphege and Thomas clutch martyrs' palms. St. Thomas bears a processional cross while the other archbishops hold crosiers. The back panel shows St. Blaise, the bishop of Sebaste in Armenia, martyred in 316 (Fig. 13a). Next to Blaise

is St. Augustine (the first archbishop of Canterbury, 597–605), to whom the monastery of St. Augustine at Canterbury was dedicated (Fig. 13b). Both of these saints hold crosiers. Canonized kings, Edward the Confessor (king of the English, 1042–66) and the martyred Edmund (king of East Anglia, 855–70), are shown on the end panels (Figs. 14a,b). The representation of five archbishops of Canterbury, two saintly British monarchs, and two female martyr virgin saints thought to have come from Britain suggest that this reliquary chasse might have a unique and special connection, not only with England but specifically with Canterbury, the preeminent diocese in Britain. If this relationship with England and Canterbury can be sustained, does this mean that the chasse could have originally contained relics of all, or nearly all, of the sixteen holy personages

represented? Why and when was the chasse made? How was it used?

Two general points concerning the chasse will become clear. First, stylistic comparison with manuscript illustrations, glass painting, and metalwork objects of the twelfth and early thirteenth centuries supports an English attribution and date around the year 1200 or shortly thereafter. Second, specific information and works of art at Canterbury support a more precise attribution to a metal workshop employed in Canterbury for Christ Church monastery. The nervous calligraphic character of the medallion busts and their animated gestures seem to depend on a tradition begun with Anglo-Saxon illustrations (before the Norman Conquest in 1066), which continued in part in post-conquest manuscripts, as in a drawing ascribed to Canterbury in the first quarter of the twelfth century (Fig. 15).[14] The rendering in this drawing of the gestures of the two nimbed ecclesiastics, St. Blaise and St. Augustine, finds echoes in the images of Christ, St. Paul, and St. Blaise on the chasse (Figs. 1b, 11b, 11c, 13a). The bearded head of the king in the drawing may be seen as an ancestor for the head of King Edward on the chasse (Fig. 14a).

The partial abandonment of Early Romanesque formulas for physiognomic types and drapery in favor of Italo-Byzantine–inspired conventions helps to establish a date for the chasse within the transitional period around 1200. This point is supported by a comparison of the busts of Christ, Peter, Paul, and the Virgin on the chasse—however cursive and worn—with the busts and figures in the Great Psalter painted at Christ Church Canterbury, ca. 1180–90 (Figs. 16, 17, 35).[15] Similarly, and despite the differences of technique and scale, Canterbury glass painting of the last quarter of the twelfth century comes to mind, and the Christ on the chasse, with his rounded cap of hair and details of costume, may be compared with the Jonah of about 1180–90 from the southeast transept (Figs. 11b, 18).[16] The models for these figure types, for both the glass and the chasse, could have been original Byzantine illustrated manuscripts or pattern drawings, such as a drawing in a Gospel Book in Princeton (Fig. 19).[17] Motif books by Western artists, such as the examples in Freiburg and Wolfenbüttel, that directly or indirectly reflected Byzantine manuscript illustrations as well as monumental wall paintings in mosaic or fresco, could also have been a source.[18]

Fig. 2. Reliquary Chest, Byzantium, Constantinople, ca. 550-65, silver, 4³/₁₆ x 5¼ x 3⅜ in. (11 x 13.4 x 8.5 cm). Leningrad, State Hermitage Museum (photo: State Hermitage Museum)

Fig. 3. Pendant Reliquary Chest, Ireland, late seventh-early eighth century, copper alloy, lead-tin alloy, gilt, wood, 3⅝ x 4¼ x 1¹¹/₁₆ in. (9.2 x 10.5 x 4.1 cm). Boston, Museum of Fine Arts, Theodora Wilbour Fund in memory of Charlotte Beebe Wilbour (52.1396) (photo: courtesy of Museum of Fine Arts)

Fig. 4. Reliquary Chest, England, Anglo-Saxon, mid-eleventh century, boxwood with glass or jet inlays in the eyes, 3½ x 6 x 2¾ in. (8.9 x 15.2 x 7 cm). The Cleveland Museum of Art, Purchase from the J. H. Wade Fund (53.362) (photo: Cleveland Museum of Art)

The ecclesiastical and royal costumes and gestures of the other busts on The Cloisters chasse also have parallels in English transitional art, both in painting and sculpture, with many examples coming from or preserved at Christ Church Canterbury. One might single out for comparison with the details of the archbishops' vestments two Canterbury manuscript portraits of St. Dunstan: the first ca. 1170 (Fig. 20),[19] and the second ca. 1190–1200 (Fig. 21).[20] Proportions, drapery, and gestures may be compared with those of the framed busts dating from the 1180s in the nave vaults and arch of St. Gabriel's chapel (Figs. 1b,c, 22, 23),[21] with the stone ancestors of Christ and a Christian martyr with a palm of 1180 from the destroyed choir enclosure (Figs. 11c, 13a, 24, 25),[22] and with the Methuselah of 1180–90 in the choir clerestory in which the raised position of the right hand is repeated in the medallion with St. Edmund (Figs. 14b, 26).[23] The crowns with wide decorated bands and projecting knobs in the Jesse Tree of about 1200 in the Corona (Fig. 27) find a partial reflection in the minute crowns of the kings on the chasse.[24] The series of bust medallions that portray biblical and saintly personages on the chasse seem to fall, in terms of surety or sketchiness of linear definition, between such highly finished paintings as the Tree

of Jesse in the Great Canterbury Psalter of about 1180–90 (Fig. 16),[25] and the fairly coarse imagery of the Beatus page in the Little Canterbury Psalter of about 1210–20 (Fig. 28).[26]

Because of the international character of the transitional style and because there are so few assuredly English engraved metalwork objects of this period preserved,[27] one might seek stylistic and technical parallels in German engraved objects that also have Italo-Byzantine elements. Such a comparison might be made with a Lower Saxon, late-twelfth-century portable altar (Fig. 29) that includes, as in The Cloisters chasse, several line-engraved busts of saints, each identified by an inscription and each drawn in a manner that depends partly on Italo-Byzantine sources of the type found in the Princeton Gospel Book (Fig. 19). Yet this comparison underscores both the international and the uniquely English elements of the engravings on the chasse. The sketchiness, the animation, the expressive thick-thin variation of the line in the chasse—features absent in the German work—make the chasse seem all the more English.[28] In this regard, the figurative engravings on the chasse may be seen as precursors of the limpid pen-and-wash drawings by and from the circle of Matthew Paris, a monk of Saint Albans, who was active from 1240 until his death in 1259.[29]

The medallion format as a decorative series on a metalwork casket finds a partial precedent in the late-twelfth-century von Hirsch enameled plaques, which have been generally accepted as English.[30] The medallions in series are also found in the English late-twelfth-century silver-gilt embroidered amice from the tomb of Archbishop Hubert Walter (forty-second archbishop of Canterbury, 1193–1205 [Fig. 30]).[31] However, the medallion frames of both the enamels and of the embroidered textile, like those on the earlier wood casket in Florence (Fig. 5), have occasional organic outgrowths of vine stems, a predominantly Romanesque ornamental feature that is absent in The Cloisters chasse. There, the series of medallions set against cross-hatched backgrounds are interspersed with rinceaux entirely independent of the smooth medallion borders.

These rinceaux are both curvilinear, as on the lid, and vertically or symmetrically aligned, as on the sides; in each instance they are centered on marigolds or rosettes with cross-hatched centers. The leaves take the form of half- or full palmettes. The triangular roof plaques are characterized by symmetrical,

Fig. 5. Casket, England, Canterbury, ca. 1150, oak, 3⅛ x 8¼ x 4⁷⁄₁₆ in. (8 x 21 x 11.3 cm). Florence, Museo Nazionale, Louis Carrand Collection (photo: Gabinetto Fotografico Soprintendenza Beni Artistici e Storici di Firenze)

intertwined branches with full- and half-palmette leaf terminals (Figs. 1d,e). The open-work crest is also notable for its series of full palmettes framed by burnished concave curves ending in half-palmettes. A variation of this scheme in a vertical format can be seen on the hinges at the back (Fig. 1c). While some of these palmettes and half-palmettes on the crest and hinges are badly worn, quite a few still retain their exquisite relief character and gilding.

Can any potential sources at Christ Church Canterbury be discerned for the various aspects of this ornament? Seal bags, made from scraps of Eastern or Spanish textiles dating from the eleventh and twelfth centuries (Figs. 31a,b), may possibly have been an inspiration for the vine tendrils and palmettes found not only on the chasse[32] but also

in some of the decorative details of Christ Church glass painting. The palmettes recur in the borders of the second typological window of the north aisle of about 1178–80 (Fig. 32). The concept of facing half-palmettes centered on a full one finds a variety of additional permutations at Christ Church Canterbury, such as the sculpted choir enclosure fragments (Fig. 33),[33] the stone floor roundel with a lion and dragon dating just before 1220 in the Trinity Chapel (Fig. 34),[34] and some of the glass borders of the same period in the windows of the Trinity Chapel.[35] The balanced reverse curves of the foliated tendrils on the main roof panels of the chasse have variants in early Canterbury manuscript decoration as in the initials of the Great Psalter (Fig. 35). The symmetrical tendrils on the sloping roof ends

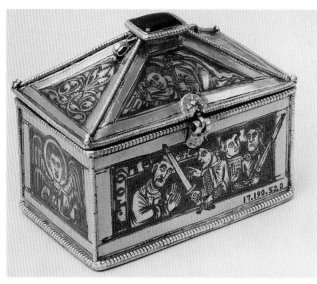

Fig. 6. Reliquary Chest, England, ca. 1173–80, silver, gilt, niello, glass, 2⁵/₃₂ x 2¹¹/₁₆ x 1¾ in. (5.5 x 6.9 x 4.4 cm). The Metropolitan Museum of Art, Gift of J. Pierpont Morgan, 1917 (17.190.520) (photo: Museum)

Fig. 7a. Underside of The Cloisters Reliquary Chest

Fig. 7b. Interior of The Cloisters Reliquary Chest

of the chasse (Figs. 1d,e) can also be partial reflections of examples in the glass, as in the Jesse Window of about 1200 (Fig. 27) and in the spandrels of the Becket Miracle Window of before 1200 (Fig. 44).

The marigolds centered on stems with rinceaux extensions seen on the sides of the chasse may be similarly related to the design of the lattice of silver-gilt thread containing thin crosses centered on small disks that appear on the buskins embroidered in England between 1170 and 1200 and found in the tomb of Hubert Walter (Fig. 36).[36] It is tempting to postulate a Canterbury or East Kent predilection for such stems with rinceaux extensions when one considers the horizontal stem hinges on the door of about 1175–85 to the former Chapel of St. Blaise in Christ Church Canterbury (Fig. 37).[37] Another early and partial model for the chasse may be noted in relation to the use of cross-hatching in the background: Hubert Walter's silver-gilt chalice, assigned by Charles Oman to an English artist working around 1160, sets its more exuberant vine and leaf forms against such a cross-hatched background (Fig. 38).[38] Many borders for the various scenes in the glass at Christ Church have cross-hatched backgrounds (Fig. 40).[39] The marigolds or multi-petaled rosettes on the chasse may refer either to those on Hubert Walter's silver-gilt pall pins (Fig. 39)[40] or to those in the cathedral's glass of 1178–80 (Fig. 40).[41]

The epigraphy of the minute letters on the chasse (Fig. 41)[42] is of particular interest because the capital letter forms, including the curved E, are also found in several earlier works at Canterbury. Hubert Walter's silver-gilt paten, about 1160 (Fig. 38),[43] illustrates similar, partially thickened letter forms, although on a considerably larger scale. Even better comparisons for the square capitals and curved E's are to be found in the choir aisle windows by the Methuselah Master of about 1180 and in the Trinity Chapel ambulatory windows of about 1200–1207 and 1213–20.[44] The decorative flourishes and other eccentricities in the inscriptions on the chasse may be explained partly by the probability that they were not the work of a scribe. More likely they were made by a goldsmith/engraver who copied the names provided by a scribe. It is hard to believe that a scribe would have intended the haphazard crowding of the letters in some of the medallions. A glaring error occurs in the upside-down *omega* in the Christ medallion (Fig. 11b), a feature which

had occurred in other Western or non-Greek works of art.[45] A more obvious mistake for Western eyes occurred in Hubert Walter's amice, in which the evangelist symbols for Luke and Mark were reversed with one inscription given for the other.[46]

Especially important to an attribution to Canterbury is the fact that the saints represented on the chasse are compatible with information gleaned from early chronicles, inventories, and calendars. The eyewitness account of the monk and chronicler Gervase (1141–after 1210),[47] and Robert Willis's reconstruction of the plan of 1174 for Christ Church,[48] tell of the existence and location of altars dedicated to the Virgin Mary, to St. Blaise, to Sts. Dunstan and Elphege, to Sts. Peter and Paul, and to St. Augustine, the first archbishop. The burial places of various other archbishops were also indicated; these included Sts. Dunstan, Elphege, Anselm, as well as Thomas Becket. Only Sts. Ursula, Cordula, and the two canonized kings, depicted on the chasse, were not accounted for on Willis's plan.[49] Gervase stated that some relics were in shrines or tomb-altars near the high altar. In the early twelfth century, the "great beam" above the altar supported "seven chests covered with gold and silver, and filled with the relics of diverse saints," among them a shrine of St. Blaise. Other reliquary chests were set above or behind other altars, again on beams, "where the hooks that sustained them remain."[50] The Cloisters chasse may have been kept shackled to one of the altar beams or surrounding structures.[51] The proliferation of the reliquary chests at Christ Church had a parallel at St. Augustine's monastery nearby, as richly depicted in Elmham's illustration of the high altar with its enframing structure and beam that supports several crosses, reliquaries, and books (Fig. 42).[52]

The fact that Christ Church Canterbury was extremely rich in vestments, jewels, a variety of furnishings, numerous relics, and reliquaries of all kinds is made abundantly clear from the first inventory, dating from 1315, that gives the partial contents of the vestry—some leaves are missing. Also included is a listing of manuscript texts and the locations of numerous relics throughout the building.[53] If the relics in The Cloisters chasse had been restricted to the English saints represented in the medallions, and if this combination had been listed at Christ Church, The Cloisters chasse would be an example of the second of five broad categories proposed by J. Wickham Legg and W. H. St. John

Fig. 8. Detail of the back of The Cloisters Reliquary Chest

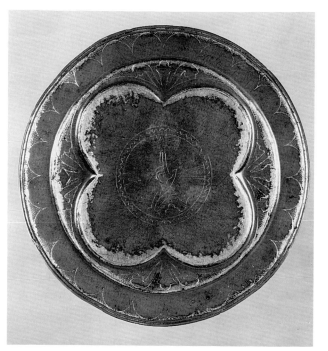

Fig. 9. Paten, England, Canterbury(?), first half of the thirteenth century, copper alloy, gilt, Diam. 4⅞ in. (12.4 cm), Bredhurst (Kent), St. Peter's Church (on loan to the Victoria and Albert Museum) (photo: courtesy of the Trustees of the Victoria and Albert Museum)

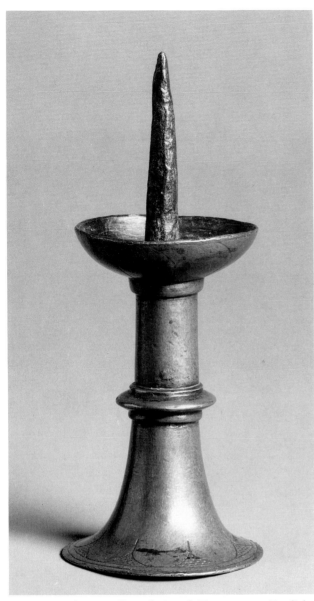

Fig. 10. Pricket candlestick, North European or English, thirteenth century, engraved copper alloy with traces of gilding, 3⅝ in. (9.2 cm). The Metropolitan Museum of Art, Gift of Dr. Louis R. Slattery, 1982 (1982.481) (photo: Museum)

Fig. 11a. Medallion with St. Peter, The Cloisters Reliquary Chest

Hope: "The lesser relics, of saints and archbishops, contained in portable or moveable shrines."[54] The fact that the New York chasse cannot be identified in this inventory does not negate the possibility that it was nevertheless in the church some one hundred years earlier,[55] or that it might have been indicated on one of the missing leaves for the contents of the vestry.[56] Not all of the relics at Christ Church were included in the inventory, possibly because they were under the care of a special keeper, or *custos:* two extremely important relics, the Crown of St. Thomas and the Sword Point, are examples.[57] Other relics and their containers may have been omitted through oversight. Thus the inventory of 1315, extensive as it is, cannot be regarded as definitive.

Nevertheless, the details of this early-fourteenth-century inventory are revealing. The description, combination, and housing of the many relics provide helpful parallels to The Cloisters chasse. For example, there were at that time four small copper reliquary chests (*scrinia*), each with multiple relics of a variety of saints, including relics of Mary, Paul, Anselm, and the faithful virgins.[58] One of these chests held relics of as many as seventeen different saints. The blood and the other relics of Edmund, king and martyr, were enshrined in a hanging reliquary, or *filacterio*, of copper-gilt with crystal mounts.[59] Various relics of Christ[60] and of all of the saints depicted on The Cloisters chasse, except for Ursula and Augustine, are recorded in this inventory. Presumably the focus of the veneration of Augustine was at the now-ruined Canterbury monastery that he founded, which was originally dedicated to Peter and Paul and which was later named for him.[61] Gervase had mentioned an altar dedicated to Augustine that was on the south side of the crypt

Fig. 11b. Medallion with Christ, The Cloisters Reliquary Chest

Fig. 11c. Medallion with St. Paul, The Cloisters Reliquary Chest

at Christ Church and he referred to the patriarch's episcopal throne or chair, "formed out of a single stone," that was set up behind the high altar.[62] The Christ Church inventory does include saints who are also represented on the chasse and who might be considered unusual, such as Cordula and Blaise, the latter having six separate relics. Blaise's relics were brought from Rome in the tenth century by Archbishop Plegmund.[63] Cordula was cited in the inventory as one of the eleven thousand virgins.[64] The cult and the legend of the eleven thousand virgins had gained considerable momentum in Germany and beyond by the end of the twelfth century.[65] Especially important is the fact that relics from several different saints were frequently combined in one reliquary. Even some of Becket's relics were occasionally combined with those of other saints.[66]

Additional documentary background for The Cloisters chasse is provided by the early-thirteenth-century calendar for Christ Church Canterbury.[67] This contains all of the saints' names, except for two of those that appear on the chasse. The exceptions are Ursula and the above-mentioned Cordula, both of whom were probably covered by prayers to the ancient virgins (January 18) and to the Christian virgins and martyrs (July 24). Augustine is mentioned five times in the calendar.[68]

From the discussion so far, one may reaffirm that The Cloisters chasse was most likely made in Canterbury around 1200 or shortly thereafter. One may additionally assume that it was made for use at Christ Church Canterbury. A perennial question is whether the workshops where such an object was made were monastic ones or functioned, in part at least, outside the monastery. Certainly during the twelfth and early thirteenth centuries the scriptoria were within the convent precinct. Yet Dom David Knowles suggested that in the thirteenth century, during the latter years of the reign of King John, who died in 1216, "the large-scale, 'heavy' arts of architectural engineering and sculpture were, as a general rule, in the hands of professional masons. So also, for the most part, were the 'medium' arts of metal and woodwork, and wall and panel painting. Here, however, a number of executants, and those among the most gifted and celebrated, were, or subsequently became, monks."[69] Master Walter (d. 1248), the painter from Colchester, was considered one of the most gifted artists and craftsmen of the time, chiefly because the carved and painted high altar of St. Albans was carried out under his direction. Starting as a lay artist, he became a monk and sacristan at St. Albans. His fame led him to be the choice of the monks of Christ Church Canterbury in designing and setting up the new

Fig. 12a. St. Elphege, The Cloisters Reliquary Chest

Fig. 12b. St. Thomas Becket, The Cloisters Reliquary Chest

Fig. 12c. St. Dunstan, The Cloisters Reliquary Chest

Fig. 12d. St. Anselm, The Cloisters Reliquary Chest

shrine for Thomas Becket in the Trinity Chapel.[70]

There is no clear answer as to whether The Cloisters chasse was produced in a lay workshop in the town or in one within the monastery. Certainly the arts of metalworking were well developed in Canterbury, judging by the number of active mints there in the late twelfth century,[71] by the contemporary production of the iron straps and hinges for doors, and by the far more numerous iron armatures

still existing that were needed for the vast series of glass windows in the east end of the cathedral produced in the period between the rebuilding following the fire of 1174 and the translation of the relics of Thomas Becket in 1220.[72] Also, the richness of the Christ Church inventory of 1315 attests to the availability of the talents of a number of goldsmiths in the provision of the vast amount of furnishings both in precious and base metals. There

Fig. 13a. St. Blaise, The Cloisters Reliquary Chest

Fig. 13b. St. Augustine, The Cloisters Reliquary Chest

Fig. 14a. King Edward the Confessor, The Cloisters Reliquary Chest

Fig. 14b. King Edmund, The Cloisters Reliquary Chest

is some evidence of specific goldsmiths' activity, both in the Christ Church monastery and especially in the town, in the monk or citizen designations for particular goldsmiths recorded in various documents.[73]

In the case of the chasse, we can postulate at least that the patron was probably not an archbishop. The tiny Becket reliquary in the Metropolitan Museum, ordered in the late 1170s by Bishop Reginald of Bath, is made not of copper but of gold.[74] The deluxe and precious tomb contents of Archbishop Walter (Figs. 30, 36, 38), along with his magnificent gifts and bequests of silk and gold vestments, of gold, silver, and crystal altar vessels, and other objects of precious materials,[75] would seem to rule out the commissioning by this archbishop of a reliquary of base metal, even if gilt.

It seems more likely that The Cloisters chasse

Fig. 15. A King Blessed by Two Ecclesiastics, *Benedictional,* England, Christ Church Canterbury, ca. 1100-30, parchment, pen, color. Paris, Bibliothèque Nationale, MS lat. 987, fol. 111r (photo: Bibliothèque Nationale)

Fig. 16. Tree of Jesse, *Psalter* (The Great Canterbury Psalter), England, Christ Church Canterbury, ca. 1180-90, parchment, 18⅞ x 12¾ in. (48 x 32.5 cm). Paris, Bibliothèque Nationale, MS lat. 8846, fol. 4r (photo: Bibliothèque Nationale)

Fig. 17. St. Peter's mother-in-law, restored to health, ministers to Christ, *Psalter* (The Great Canterbury Psalter). Paris, Bibliothèque Nationale, MS lat. 8846, fol. 3r (detail) (photo: Bibliothèque Nationale)

Fig. 18. Johanna (Jonah), England, Christ Church Canterbury, ca. 1180-90, pot metal glass. Canterbury, Cathedral, SW Transept Clerestory, window s. XIV (photo: Royal Commission on the Historical Monuments of England)

Fig. 20. St. Dunstan. *Commentary on the Rule of Saint Benedict* ascribed to Smaragdus, abbot of St. Mihiel (809), England, Christ Church Canterbury, ca. 1170, parchment, 9⅝ x 6¹⁵/₁₆ in. (24.5 x 17.6 cm). London, British Library, MS Royal 10.A.XIII, fol. 2r (photo: By permission of The British Library)

Fig. 19. Bust of Christ and Head of the Virgin, *Four Gospels,* Byzantium, second half of the twelfth century, parchment, 7⁵/₁₆ x 5⅞ in. (18.6 x 15 cm). Princeton University, Firestone Library, MS Garrett 2, Gift of Robert Garrett (photo: Princeton University)

was ordered by the Benedictine monks themselves, already the patrons of the great east end of the cathedral. The overriding concern of the monks of Christ Church was the translation of Thomas Becket's remains from the crypt to a new and prominent focal point at the east end of the cathedral in the center of the Trinity Chapel. In times of peace, intensive efforts must have been made to ready the building for this event. The exile of the monks from 1207 to 1213,[76] the interdict of 1208–14 imposed by Pope Innocent III, the campaign of Louis of France in England in 1216–17, and the absence of Archbishop Langton from 1216 until 1218, were all factors causing delay in the plans for the translation, which finally occurred on July 7, 1220.[77] The great series of frescoes in the Trinity Chapel ambulatory vaults were either

Fig. 21. St. Dunstan(?), *Lives of Saints*, England, Canterbury or Faversham, ca. 1190-1200, parchment, 11⅞ x 8 in. (30.2 x 20.2 cm). Cambridge, Corpus Christi College, MS 161, fol. 1r (photo: Conway Library, Courtauld Institute of Art, London)

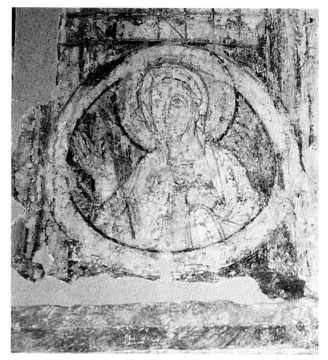

Fig. 22. Nave arch painting (detail), England, Christ Church Canterbury, ca. 1180, St. Gabriel's Chapel. Canterbury, Cathedral, crypt (photo: author)

painted for the occasion or to commemorate it.[78] Unfortunately, we have only mid-nineteenth-century drawings as an imperfect guide to their style and iconography (Fig. 45). The program was the representation of a series of saints—including Peter, Elphege, Thomas (Fig. 45), Dunstan, and Blaise, among others—and revered English kings, some of them canonized. This iconography, only known fragmentarily, recalls the more focused iconography of The Cloisters chasse. It would seem that both were created on the order of the monks themselves: the chasse before 1207 and the frescoes just before 1220. The presence of Edward and Edmund on the chasse may reflect reverence and nostalgia for ancient and saintly kings in a time of conflict with

Fig. 23. Nave vault painting, ancestors of Christ (detail), England, Christ Church Canterbury, ca. 1180, St. Gabriel's Chapel. Canterbury, Cathedral, crypt (photo: author)

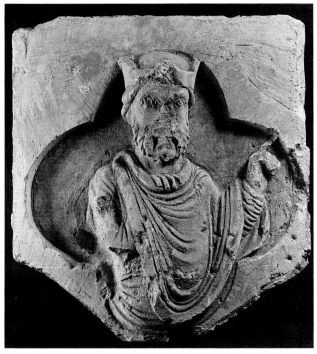

Fig. 24. Quatrefoil with an Old Testament king from a screen, England, Christ Church Canterbury, 1180, stone, 13½ x 12¾ x 5¾ in. (34.3 x 32.4 x 14.6 cm). Canterbury, Royal Museum and Art Gallery (photo: courtesy of the Trustees of the Victoria and Albert Museum)

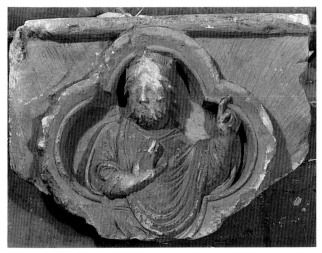

Fig. 25. Quatrefoil with an Old Testament prophet from a screen, England, Christ Church Canterbury, 1180, stone. Canterbury, Cathedral, Dean and Chapter (photo: Malcolm Thurlby)

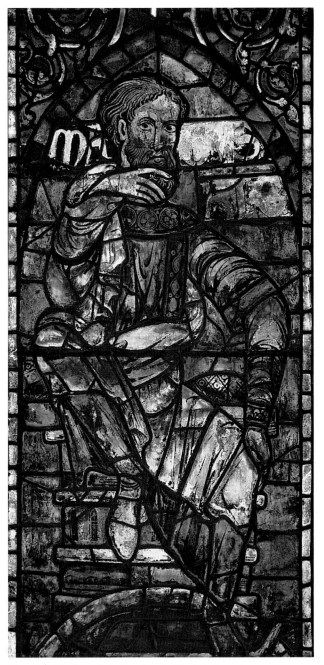

Fig. 26. Methuselah, England, Christ Church Canterbury, ca. 1180-90, pot metal glass. Canterbury, Cathedral, Choir Clerestory, window N. XXI (photo: Royal Commission on the Historical Monuments of England)

King John, while those represented in the frescoes may be a response to a period of reconciliation with the monarchy that came with the ascendancy of Henry III.[79]

The chasse, then, may have been made with multiple purposes in mind: first, as part of a general

211

Fig. 27. Jesse Tree (detail), King Josiah, England, Christ Church Canterbury, ca. 1200, pot metal glass. Canterbury, Cathedral, Corona, window n. III (photo: Royal Commission on the Historical Monuments of England)

Fig. 29. Portable Altar of Thidericus, abbot of St. Godehard, Hildesheim, Germany, Lower Saxony, ca. 1200, copper alloy, gilt, ivory, rock crystal. London, British Museum, 1902, 6-25, 1 (photo: British Museum)

Fig. 28. Beatus Page, *Psalter* (The Little Canterbury Psalter), England, Christ Church Canterbury, ca. 1210-20, parchment, 11½ x 7¾ in. (29.2 x 19.8 cm). Paris, Bibliothèque Nationale, MS lat. 770, fol. 11v (photo: Bibliothèque Nationale)

enrichment of the eastern structures in preparation for the long-postponed translation; second, as part of the procession of the litany of the saints that might have been planned for that and subsequent occasions and that might have been provided for at the end of contemporary psalters with Canterbury usage.[80] A Mass and Office for the commemoration of many of the saints whose relics were venerated in a church with a large collection was widely practiced.[81] In general, then, the chasse was probably commissioned to be part of the orderly veneration of the saints, the bearing of their relics in procession, the censing of these relics upon the altar, and the special prayers, verses, and responses traditional to the litany. While hardly in isolation in this context—there must have been many other relics and

Fig. 30. Amice, detail of border, England, 1170-1200, silk embroidered with silk and silver-gilt thread, 3½ x 22⁵/₁₆ in. (8.9 x 56.7 cm). Canterbury, Cathedral, Dean and Chapter (photo: Conway Library, Courtauld Institute of Art, London)

Figs. 31a,b. Seal Bags. Silk. Northeastern Persia, eleventh century, and Spain, first third of the twelfth century. Canterbury, Cathedral Library, Seal Bags nos. 18 and 15, respectively (from Robinson and Urquhart, *Archaeologia* 84 [1934], pls. LV, LVII)

reliquaries involved—The Cloisters chasse must have been integral to the rich liturgical events and the measured movement of the solemn processions through the eastern end of the cathedral.

Another use of the chasse, not necessarily intentional, may relate to the monks' forced evacuation during the exile between 1207 and 1213. The fact that it must have contained relics of most, if not all, of the represented saints suggests, along with its small size and sturdiness, that it may also have served as a portable reliquary to help celebrate the Christ Church calendar while traveling.[82] The ungilded lug at the lower back and the missing chain

may have been added to the chasse when it was associated with a particular location, a specific altar, or a place in the great almery (relic cupboard)[83] at Christ Church after the monks returned from exile.

A final consideration of the place of The Cloisters chasse within the chronology of monuments and events at Christ Church should take into account the form and probable dates of two other major monuments: the Purbeck marble tomb monument of Hubert Walter (Fig. 43) and the destroyed Thomas Becket shrine originally set up in the center of the now sadly barren Trinity Chapel. The tomb may have been carved in anticipation of

213

Fig. 32. Christ Leading the Gentiles from Pagan Gods, England, Christ Church Canterbury, 1178-80, pot metal glass. Canterbury, Cathedral, North Choir Aisle, n. XV (photo: Royal Commission on the Historical Monuments of England)

Fig. 34. Pavement roundel with a Lion and a Dragon. Border enhanced. Made by craftsmen from Saint Omer(?), 1213-20, stone. Canterbury, Cathedral, Trinity Chapel floor (photo: Royal Commission on the Historical Monuments of England)

Fig. 33. Screen fragment, England, Christ Church Canterbury, 1180, stone. Canterbury, Cathedral, Dean and Chapter (photo: author)

the archbishop's death in 1205. In any case, it probably was in place before the exile of the monks in 1207, as suggested by a comparison to the derivative tomb at Rochester Cathedral of Bishop de Glanville, who died in 1214.[84] The second Becket shrine—the first was the shrine-tomb in the crypt—may have been designed at about the same time as the Walter tomb but was probably not executed until after 1216. The three depictions in the windows of the Trinity Chapel ambulatory may show fairly accurately the form and decoration of the shrine as it sat on its high arcaded base after completion.[85] The clearest of these depictions is at the top of the third window devoted to the miracles of the saint (Fig. 44).[86]

In a major recent study of the vast program of early glass at Christ Church Canterbury, the change in style from Late Romanesque to Gothic has been seen as the central issue.[87] The Cloisters chasse, on a far more modest scale, confronts the same crossroads. In its overall form—with sloping, hip roof and with a simple series of evenly spaced medallions—the chasse seems closer to the Romanesque than to the Trinity Chapel monuments just mentioned. In the Hubert Walter tomb the

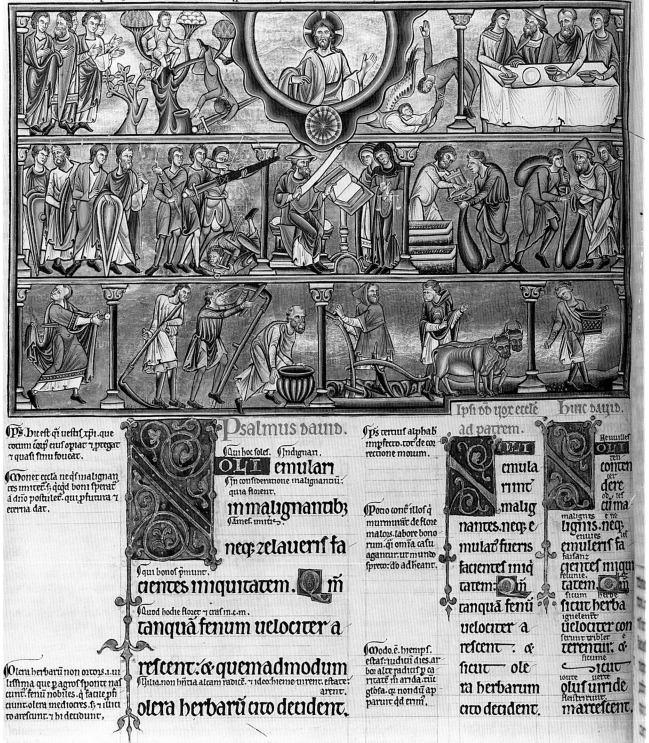

Fig. 35. *Psalter* (The Great Canterbury Psalter). Paris, Bibliothèque Nationale MS lat. 8846, fol. 62v
(photo: Bibliothèque Nationale)

Fig. 36. Buskin, detail of one of a pair, England, 1170–1200, silk, embroidered with silver-gilt thread. Dean and Chapter of Canterbury (photo: author)

Fig. 37. Door to the former Chapel of St. Blaise, England, Canterbury: wood construction, ca.1175–85; horizontal decorated iron straps, ca. 1175–85; C-shaped hinges, late eleventh century. Canterbury, Cathedral (photo: Reproduced by kind permission of the Dean and Chapter of Canterbury)

medallions have been transformed into an interlocking series of circles and lozenges framing quatrefoils with projecting heads that may represent the guardians of the Church (Fig. 43).[88] The medallions in the gold-sheathed Becket shrine become a part of an overall pattern of circles and quatrefoils studded with leaf-work and gems (Fig. 44). In contrast to the more elegant proportions of the tomb and of the shrine, The Cloisters chasse seems to be a logical stylistic antecedent to these larger monuments, just as the choir enclosure bust fragments in their simple quatrefoil frames seem to be reasonable ancestors for the framed heads on the Walter tomb (Figs. 24, 25, 43).

The evolution from the Late Romanesque or transitional style of the chasse to the Early Gothic style of the tomb and shrine is further underscored by the existence of an early-thirteenth-century wood

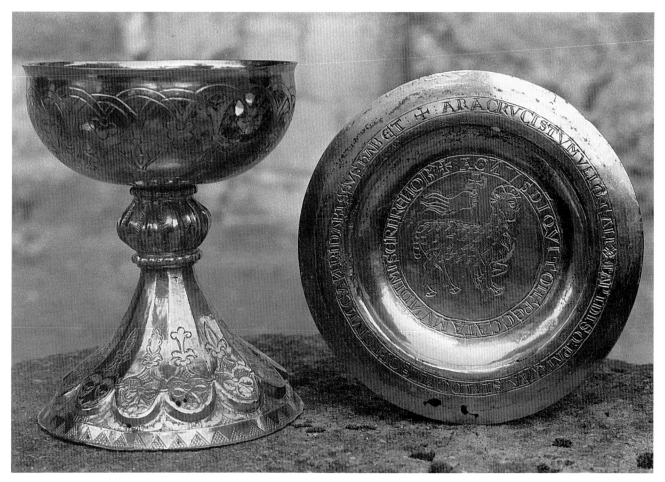

Fig. 38. Chalice and paten, England, ca. 1160, silver, gilt, shaped and engraved. Chalice: 5⅝ x 4⅜ in. (14.2 x 11.1 cm). Paten: Diam. 5½ in. (14 cm). Canterbury, Cathedral (photo: Reproduced by kind permission of the Dean and Chapter of Canterbury)

reredos said to have come from the Christ Church Cathedral but preserved today in the church at Adisham, Kent (Fig. 46).[89] While the monochrome paintings of the Evangelists that take the place of a lost altar are postmedieval, the central openwork frieze of quatrefoils within circles interspersed with leaf-work is an intriguing recombination of some of the elements of the Walter tomb (Fig. 43). The symmetrical, long-stemmed leaves and half-palmettes recall elements in the Great Canterbury Psalter (Fig. 35). The faceted, smoothly curved leaves resemble those of the better-preserved palmettes and half-palmettes on the chasse (Fig. 1c). The foliated, crocket capitals on the reredos, while reflecting the style of some of the small capitals of the choir,[90] may actually represent the type of small capital used in the stone base of the Becket shrine (Fig. 44).

In this rather elegant context, too, The Cloisters chasse seems all the more Late Romanesque or transitional rather than Early Gothic.

As the *only* surviving reliquary that may be attributed to Canterbury, the historical, stylistic, iconographic, and functional importance of The Cloisters chasse should not be underestimated within the larger issues of the artistic patronage of the monks of Christ Church Canterbury, nor should its purely artistic merits. The chasse's fine proportions and rich decoration, however worn, are immediately appealing as close study reveals the marvelously free and nervous line drawings of the various holy personages. These drawings, confined within the firm outlines of the medallions, are combined with the interspersed foliated stems and rosettes and the careful, logical, and sturdy construction, so that the

217

Fig. 40. The Magi Journeying to Jerusalem (detail of border), England, Christ Church Canterbury, 1178-80, pot metal glass. Canterbury, Cathedral, North Choir, n. XV (photo: Royal Commission on the Historical Monuments of England)

Fig. 39. Pair of pall pins, England, late twelfth century, silver, shaped and engraved, 4½ in. (11.3 cm). Dean and Chapter of Canterbury (from Hope, *Vetusta Monumenta* VII, Part I [1893], p.5, fig.1)

chasse may be admired for its extraordinary balance of freedom and control. Indeed, The Cloisters chasse represents a very significant addition to the Metropolitan Museum's small collection of fine and rare English medieval works of art.

ACKNOWLEDGMENTS

Marian Campbell, Assistant Keeper of Metalwork, Victoria and Albert Museum, London, and Barbara Drake Boehm, Associate Curator of Medieval Art, The Metropolitan Museum of Art, for information concerning Samuel James Whawell; Ann Oakley, Archivist, Canterbury Cathedral, for assistance in the Chapter Library and for making available for study the textiles from the tomb of Hubert Walter and the seal bags (Figs. 31, 37, and 32a–c, respectively); Victor de Waal, former Dean of the Chapter, Canterbury Cathedral, for providing access to the fragments from the stone screen, including the pieces illustrated here (Figs. 25, 34), and the silver plate of Hubert Walter (Figs. 39, 40).

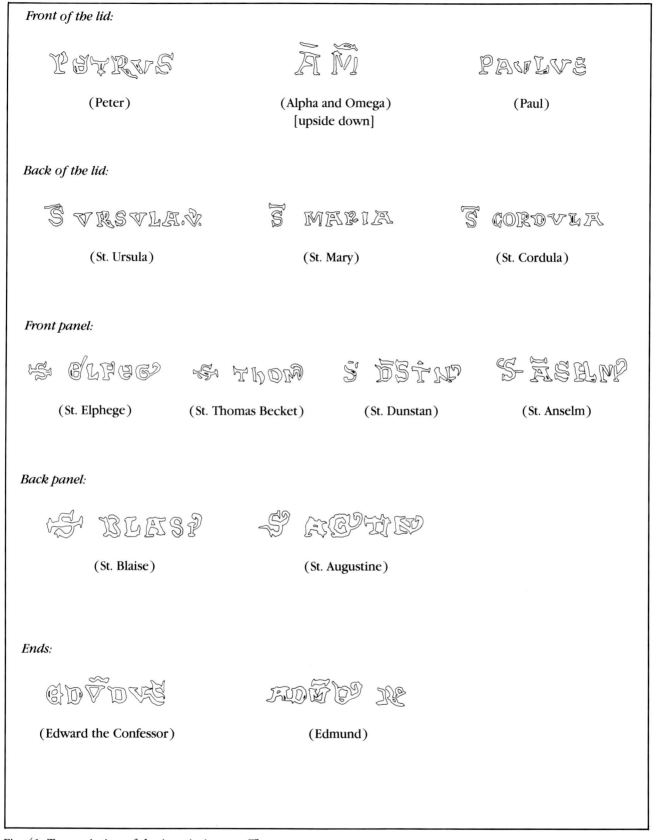

Front of the lid:

(Peter) (Alpha and Omega) (Paul)

[upside down]

Back of the lid:

(St. Ursula) (St. Mary) (St. Cordula)

Front panel:

(St. Elphege) (St. Thomas Becket) (St. Dunstan) (St. Anselm)

Back panel:

(St. Blaise) (St. Augustine)

Ends:

(Edward the Confessor) (Edmund)

Fig. 41. Transcription of the inscriptions on The
Cloisters Reliquary Chest (Catherine Hiller)

219

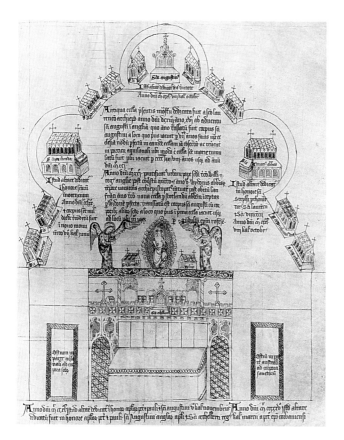

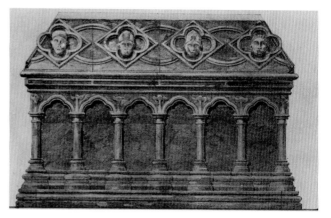

Fig. 42. Reliquaries above the high altar and in the chapels of St. Augustine's monastery, Canterbury, from Elmham's *History of St. Augustine's Canterbury*, early fifteenth century. Cambridge, Trinity Hall, MS 1, detail (photo: by permission of the Masters and Fellows of Trinity Hall, Cambridge)

Fig. 43. Tomb of Archbishop Hubert Walter (d. 1205), stone ("Purbeck marble"). England, Christ Church Canterbury, south ambulatory, ca. 1201-7 (from Crossley, *English Church Monuments* [1921], p. 33)

NOTES

1. The present article expands on the author's talk, "A Reliquary Chasse Attributed to Canterbury ca. 1200," given in "Session 1. Medieval Art in North American Collections I: Metalwork, Sculpture and Other Art Forms," Seventeenth International Congress on Medieval Studies, Kalamazoo, Mich., May 6, 1982. An abbreviated version of this paper was delivered at a symposium, "Patronage of the Arts in England 1066-1200," at the Victoria and Albert Museum, Feb. 26, 1984. A longer version of these talks was presented to the alumni at the Institute of Fine Arts, New York University, May 11, 1984. Ex collections: Samuel James Whawell (b. 1857-d. 1926), Hampstead, England; Robert Haynes, England; [D. Black, London, 1966]; Mr. and Mrs. John Hunt, Drumleck Baily, County Dublin, Ireland. Bibliography: *Catalogue of the Magnificent Collection of Armour, Weapons, and Works of Art, the Property of the late S. J. Whawell, Esq.,* London, Sotheby and Co., May 6, 1927, lot 449, may refer to the chasse despite the errors in the description: "A sixteenth-century, gilt metal casket, of plain shape, engraved with medallions of heads and floral scrollwork, 3¾ in. long" (not ill.); *Catalogue of English and Continental Furniture, Rugs and Carpets and Works of Art,* London, Sotheby and Co., June 3, 1966, lot 57 (described as "in Rhenish style" and accompanied by a letter in script from Sir Guy Laking, Lancaster House, St. James SW, to Mr. Whawell, dated June 17 [no year is indicated]: "In reply to your letter of the sixteenth— In my opinion the

Copper Gilt Chasse is mid thirteenth century and I would say of Rhenish origin. It is a very desireable object. Very truly yours, Guy Francis Laking"); Konrad Hoffmann, *The Year 1200: A Centennial Exhibition at The Metropolitan Museum of Art*, exhib. cat. (New York, 1970), vol. 1, pp. 80–81, no. 88, attributed to England around 1200: "From the casket's emphasis on episcopal and royal tradition, as well as the special role of St. Thomas, an origin in Canterbury may be deduced" (not ill.); Peter A. Newton, "Some New Material for the Study of the Iconography of St. Thomas Becket," in *Thomas Becket Actes du Colloque International de Sédières* (Beauchesne, 1973), p. 263, where the inscriptions are transcribed for the first time, with the following comment: "It is a curious piece, difficult to place in terms of style. The rather eccentric forms fo [*sic*] abbreviation used in the inscriptions merit a more detailed investigation" (not ill.); William D. Wixom in *Notable Acquisitions 1980–1981*, New York, The Metropolitan Museum of Art (1981), pp. 23–24 (col. pl.); Günther Shiedlavsky, *Kühlkugel und Wärmapfel* (Munich/Berlin, 1984), p. 50; Margaret E. Frazer, "Medieval Church Treasuries," *MMAB* 43/3 (1985–86), pp. 50, 52, 53, fig. 60 (col. pl.).

2. Kurt Weitzmann, ed., *Age of Spirituality, Late Antique and Early Christian Art, Third to Seventh Century*, exhib. cat., The Metropolitan Museum of Art (New York, 1979), no. 572 (ill.): Reliquary with medallion busts of Christ, Sts. Peter and Paul, and the Virgin with angels, Leningrad, State Hermitage Museum, x249; Marie-Madeleine Gauthier, *Les routes de la foi, reliques et reliquaires de Jérusalem à Compostelle* (Fribourg, 1983), p. 13, no. 2 (ill.).

3. Martin Blindheim, "A House-shaped Irish-Scots Reliquary in Bologna and Its Place Among the Other Reliquaries," *Acta Archaeologica* [Copenhagen] 55 (1984; repr. 1986), pp. 1–53, pl. 1, figs. 5, 6, 12, 22–52; Hanns Swarzenski and Nancy Netzer, *Catalogue of Medieval Objects, Enamels and Glass* (Boston, 1986), pp. 32–33, no. 1 (ill.); Susan Youngs and R. Michael Spearman, in *"The Work of Angels," Masterpieces of Celtic Metalwork, 6th–9th centuries A.D.*, exhib. cat., British Museum, National Museum of Ireland, and National Museums of Scotland (London, 1989), pp. 134–40, nos. 128, 132.

4. Philip Nelson, "An Ancient Boxwood Casket," *Archaeologia* 86 (1936), pp. 91–100, pls. XX (figs. 1, 2) and XXI (figs. 1, 3): England, Winchester (?), ca. 1020; Hanns Swarzenski, *Monuments of Romanesque Art* (Chicago, 1953), pl. 66, fig. 151: "Anglo-Saxon, early XI century"; *Handbook, The Cleveland Museum of Art* (Cleveland, 1978), p. 50: England, Anglo-Saxon, ca. 960–80, acc. no. 53.362 (ill.); Leslie Webster, in *The Golden Age of Anglo-Saxon Art 966–1066*, exhib. cat., British Museum (London, 1984), pp. 125–26, no. 129 (ill.): "Anglo-Saxon mid 11th century." The subjects on the sides and lid of this casket include scenes of the Nativity, the Baptism of Christ, Christ's Entry into Jerusalem, the Crucifixion, the Ascension of Christ, and Christ in Glory. Two subjects represented on either side of the Nativity are uncertain, although they were tentatively identified by Nelson as the Institution of the Eucharist and Christ's appearance to Mary Magdalen.

5. George Zarnecki, "A Romanesque Casket from Canterbury in Florence," *Studies in Romanesque Sculpture* (London, 1979), chap. XIX, pp. 37–43, pls. 1–6 (repr. from *The Canterbury Cathedral Chronicle* 64 [1969]). Apparently oblivious of Zarnecki's article, the cataloguers of *Die Zeit der Staufer*, exhib. cat. (Stuttgart, 1977), vol. 1, no. 520, vol. 2, abb. 312, called this object "Rheinland, um 1200." Similarly unaware of Zarnecki's

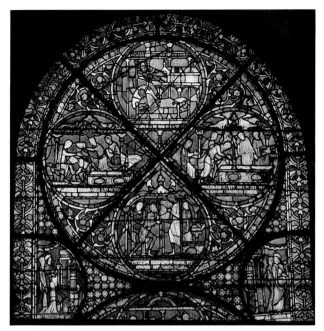

Fig. 44. Thomas Becket Miracle Window (detail), showing the three representations of the low shrine-tomb in the crypt and the second shrine intended for the Trinity Chapel (top), England, Christ Church Canterbury, ca. 1213–15/20, pot metal glass. Canterbury, Cathedral, Trinity Chapel ambulatory, n. III (photo: Royal Commission on the Historical Monuments of England)

attributions, a contributor (M.T.H.) to *Arte del Medio Evo e del Rinascimento, Omaggio ai Carrand, 1889–1989*, exhib. cat. (Florence, 1989), called this work "Arte renena, inizio secolo XIII."

6. Neil Stratford, "Niello in England in the Twelfth Century," *Art and Patronage in the English Romanesque*, Occasional Paper (New Series) VIII, The Society of Antiquaries of London (London, 1986), p. 43, pls. XVIIb, XVIIIa, where a Mosan-German [Rhenish?] artist working in England ca. 1173 is proposed, with earlier bibliography except for the following omission: Charles Oman, *English Church Plate 597–1830* (London, 1957), p. 99 n. 6, pl. 47.

A late example of the sarcophagus executed in the hip-roof form is an English mid-fourteenth-century chrismatory of sheet brass with a crest pierced with quatrefoils and circles preserved at St. Martin's Church, Canterbury. C. F. Routledge, *The Church of St. Martin Canterbury* (London, 1901), pp. 83–85 (ill.); Charles Oman, "English Medieval Base Metal Church Plate," *The Archaeological Journal* 119, The Royal Archaeological Institute (repr., Mar. 1964), p. 204, pl. XXVIA, Chrismatory, brass, length 6 in. (15.2 cm): England, mid-fourteenth century, Canterbury, St. Martin's Church; Colin Platt, *The Parish Churches of Medieval England* (London, 1981), fig. 22 (erroneously located in St. Mary's Church); Marian Campbell in *Age of Chivalry: Art in Plantagenet England 1200–1400*, Jonathan Alexander and Paul Binski, eds., exhib. cat., Royal Academy of Arts (London, 1987), pp. 241–42, no. 123, bibl. (ill.).

Fig. 45. George Austin, Sr. (d. 1848). Thomas Becket, inscribed SCS ThOMAS, after the lost Trinity Chapel vault paintings ca. 1214-20, sketchbook, paper, pencil, and chalk, page size 10¼ x 8¼ in. (26 x 21 cm). Canterbury, Cathedral Library, Add. MS 1, fol. 32v (photo: Verne S. Caviness, Jr.)

Fig. 46. Reredos, said to come from Canterbury Cathedral, England, Canterbury, early thirteenth century, wood, gesso, paint. Adisham (Kent), Church of the Holy Innocents (photo: Royal Commission on the Historical Monuments of England)

7. A detailed condition report and technical study by Pete Dandridge follows this article. While no preserved English examples are known to the author, there are several Mosan, Rhenish, and Lower Saxon lion-paw feet of comparable proportions that support either architectural bases for crosses or reliquaries. Probably the most celebrated is the Reliquary of Henry II, Lower Saxony, ca. 1170, in the Louvre. See *Rhein und Maas, Kunst und Kultur 800–1400*, exhib. cat. (Cologne, 1972), vol. 1, p. 348, no. м3, Reliquary Shrine of St. Simon, Trier, ca. 1220–30 (ill.); *Die Zeit der Staufer*, vol. 1, nos. 575 (Reliquary of Henry II), 680, 686, 688, vol. 2, figs. 380 (col. pl.), 481, 487, 489; for earlier examples, see *Ornamenta Ecclesiae, Kunst und Künstler der Romanik*, exhib. cat. (Cologne, 1985), vol. 1, pp. 454–55, no. C34 (ill.) and 466–67, no. C46 (ill.). Because of the wholesale destruction of church furnishings in England in the sixteenth and seventeenth centuries, it is not surprising that the only Romanesque object to appear in recent exhibitions with feet that even remotely resemble lions' paws

is the base of a candlestick attributed to England, ca. 1130, in the British Museum (78, 11–1, 90), *English Romanesque Art 1066–1200*, exhib. cat., Hayward Gallery (London, 1984), p. 250, no. 249 (ill.).

8. *Les Trésors des églises de France*, exhib. cat. (Paris, 1965), no. 767, pl. 86, "Coffret-reliquaire, cuivre avec reste de dorure, gravé et ciselé," 5⅛ x 8¹/₁₆ x 4½ in. (13 x 20.5 x 10.4 cm), "XIIe siècle," Besançon (Doubs), archevêché.

9. Carlo Cecchelli, "Il Tesoro del Laterano: II. Oreficerie, Argenti: Smalti," *Dedalo* 7 (1926–27), vol. 1, pp. 242–44 (ill.), "Coperchio della cassettina per la tunica di San Giovanni, rame dorato, pietre dure," 6⅞ x 7⅞ x 7½ in. (17.5 x 20 x 19 cm): twelfth century, medallions of the ninth century (?); *Tesori d'arte sacra di Roma e del lazio dal medioevo all'ottocento*, exhib. cat. (Rome, 1975), p. 66, pl. 139, end of the twelfth century. I am indebted to Barbara Drake Boehm for this comparison and bibliography.

10. *Archaeologia Cantiana* 28 (1909), pp. 301–3, ill. opp. p. 301; A. O. James, in *Transactions of the Leicestershire Architectural and Archaeological Society* 10 (1911–12), pp. 231–32; *Illustrated Guide to the Church Congress*, Church Congress Exhibition, 41st Annual Volume (Oxford, 1924), p. 159, no. 244, ill.; Oman, "English Medieval Church Plate," pp. 197–98, pl. XIIIA, "around 1250"; Oman, *English Church Plate*, p. 48. James, *Transactions*, states: ". . . the decoration, even including the circle of the device on the back, is drawn with a free hand, with firmness, and delicacy of line"; "The date of the Bredhurst paten may, perhaps, be placed within the first half of the 13th century."

11. Oman, "English Medieval Church Plate," p. 195.

12. Ibid., pp. 195–99.

13. J. Wickham Legg and W. H. St. John Hope, *Inventories of Christ Church Canterbury with Historical and Topographical Introductions and Illustrative Documents* (Westminster, 1902), pp. 172, 192 ("Item the nether front of the high and the ij side aulters of copper and gilte"). See Nigel Ramsay and Margaret Sparks, *The Image of St. Dunstan* (Canterbury, 1988), pp. 27, 28, 32, 36.

14. C. R. Dodwell, *The Canterbury School of Illumination 1066–1200* (Cambridge, 1954), pp. 21–22, 121, pl. 12c.

15. Nigel Morgan, in *Early Gothic Manuscripts* [I] *1190–1250, A Survey of Manuscripts Illuminated in the British Isles*, ed. J. J. G. Alexander (London, 1982), vol. 4, pp. 47–49, no. 1, ills. nos. 1, 2–7. I am indebted to Professor William Clark for calling my attention to the Jesse miniature, for the busts shown in the medallions that are not entirely frontal.

16. For the dating of this glass, see Madeline H. Caviness, *The Early Stained Glass of Canterbury Cathedral, circa 1175–1220* (Princeton, 1977), chap. IV, especially pp. 49, 58–61. See also idem, *The Windows of Christ Church Cathedral Canterbury* (London, 1981), *Corpus Vitrearum Medii Aevi, Great Britain* II, p. 59, pl. 40, figs. 104, 104a.

17. Slobodan Ćurčić and Archer St. Clair, eds., *Byzantium at Princeton, Byzantine Art and Archeology at Princeton University*, exhib. cat. (Princeton, 1986), pp. 155–56, no. 179, ill. fol. 178. Compare Caviness, *Windows of Christ Church Cathedral*, pp. 106–10, pl. 82, fig. 185, Miracle of Cana scene, for related head types.

18. Kurt Weitzmann, "Zur Byzantinischen Quelle des Wolfen-bütteler Musterbuches," *Festschrift Hans R. Hahnloser* (Basel/

Stuttgart, 1961), pp. 223–50, figs. 1, 3, 5–7, 10, 12, 14, 15, 17, 19; Otto Demus, *Byzantine Art and The West* (New York, 1970), pp. 34–39, figs. 36, 39, 41, 43, 225, 227; William D. Wixom, "The Greatness of the So-called Minor Arts," in *The Year 1200: II, A Background Survey, The Cloisters Studies in Medieval Art*, ed. Florens Deuchler (New York, 1970), vol. 2, pp. 95–96; Caviness, *Early Stained Glass*, pp. 64–65, suggests the possibility of a "motif book" of Byzantine models in Canterbury by the mid-twelfth century. A later yet related English example may be seen in a drawing by or after one by a Brother William, second quarter of the thirteenth century, in London, British Library MS Cotton Nero D. I., Morgan, *Early Gothic Manuscripts* [I], pp. 134–36, no. 87b, ill. 297. See also Kurt Weitzmann, "Eine spätkommenische Verkündigungsikone des Sinai und die zweite Byzantinische Welle des 12. Jahrhunderts," *Festschrift für Herbert von Einem zum 16. Februar 1965* (Berlin, 1965), pp. 299–312, esp. pp. 309–11 and pl. 71.

19. Dodwell, *Canterbury School of Illumination*, p. 122, pl. 68a; C. M. Kauffmann, "Romanesque Manuscripts 1066–1190," in *A Survey of Manuscripts Illuminated in the British Isles*, ed. J. J. G. Alexander (London/Boston, 1975), vol. 3, pp. 115–16, no. 92, ill. 256.

20. Morgan, *Early Gothic Manuscripts* [1], p. 52, ill. 17.

21. E. W. Tristram, *English Medieval Wall Painting: The Twelfth Century* (Oxford, 1944), pp. 19–21, pls. 21b, 22, supplementary pls. 2c, 3a, 3e; K. Flynn, "Romanesque Wall-Paintings in the Cathedral Church of Christ Church Canterbury," *Archaeologia Cantiana* 95 (1979), pp. 186, 191; Deborah Kahn, "The Structural Evidence for the Dating of the St. Gabriel Chapel Wall-paintings at Christ Church Cathedral, Canterbury," *Burlington Magazine* 126, no. 973 (Apr. 1984), p. 225, fig. 67.

22. George Zarnecki, *Later English Romanesque Sculpture, 1140–1210* (London, 1953), pp. 46, 62, fig. 111; idem, "The Faussett Pavilion: The King Canute Relief," *Studies in Romanesque Sculpture* (London, 1979), chap. XI, pp. 1–8, pls. I, II, V, VII (repr. from *Archaeologia Cantiana* 66 [1953], pp. 1–14); *Archive 1, Cathedrals and Monastic Buildings in the British Isles, Part 8, Canterbury, Romanesque Work*, ed. George Zarnecki (London, 1978); *Courtauld Institute Illustration Archives*, ed. Peter Lasko, ills. 1/8/136–141; George Zarnecki, in *English Romanesque Art*, p. 195, no. 164c.

23. Caviness, *Windows of Christ Church Cathedral*, pl. 6, fig. 16.

24. Ibid., pp. 163, 172–74, pl. 106, fig. 233.

25. Hoffmann, *The Year 1200*, vol. 1, pp. 257–59, ill. on p. 258.

26. Madeline H. Caviness, "Conflicts Between *Regnum* and *Sacerdotium* as Reflected in a Canterbury Psalter of ca. 1215," *Art Bulletin* 61/1 (1979), pp. 38, 46, 47, 49, fig. 19; Morgan, *Early Gothic Manuscripts* [I], pp. 83–84, no. 34, ill. 121.

27. See Neil Stratford, "Metalwork," in *English Romanesque Art*, pp. 232–36; Marian Campbell, "Metalwork in England, c. 1200–1400," in *Age of Chivalry*, pp. 162–68.

28. The comparison of the portable altar with the chasse was suggested by Neil Stratford; Hoffmann, *The Year 1200*, vol. 1, pp. 106–8, no. 112 ill.; W. A. Oddy, Susan La Niece, and Neil Stratford, *Romanesque Metalwork, Copper Alloys and their Decoration* (London, 1986), p. 15, pl. 9. See also the front cover for a cartulary from the abbey at Prüm, engraved copper-gilt, Trier, ca. 1200, Trier, Stadtbibliothek, MS 1709: Hans-Werner

Embers, in *Trierer Zeitschrift für Geschichte und Kunst des Trier Landes und seiner Nachbargebiete* 27 (1964), pp. 43–44, pl. 20. This second comparison also stresses the international characteristics of the transitional style while at the same time delineating the dry precision of the Trier manner in contrast to the vivacity of the engravings on the chasse. Embers' early dating of the Trier book cover—to the beginning of the twelfth century—made in relation to the contents of the volume, and probably incorrect considering the transitional character of the style, was maintained in *Rhein und Maas*, pp. 264–65, no. H2 (ill.).

29. Morgan, *Early Gothic Manuscripts* [I], pp. 30–31; Suzanne Lewis, *The Art of Matthew Paris in the Chronica Majora* (Berkeley, 1986); Nigel Morgan and Lucy Freeman Sandler, "Manuscript Illumination of the Thirteenth and Fourteenth Centuries," in *Age of Chivalry*, p. 149.

30. Neil Stratford, in *English Romanesque Art*, pp. 272–73, nos. 289a–c, ill.; Sotheby's, London, sale, July 6, 1989, pp. 22–25, lot 13, col. pl.

31. W. H. St. John Hope, "On the Tomb of an Archbishop Recently Opened in the Cathedral Church of Canterbury," *Vetusta Monumenta* 7, pt. I (1893), pp. 3, 4, pl. IV, fig. 4; Anna M. Muthesius, "The Silks from the Tomb [of Archbishop Walter]," *Medieval Art and Architecture at Canterbury Before 1200*, The British Archaeological Association, Conference Transactions for the Year 1979 V (Leeds, 1982), pp. 81, 84, pl. XXIIIA.

32. I owe this suggestion to the late William Urry, who also provided the following reference for the seal bags: Gertrude Robinson and H. Urquhart, "Seal Bags in the Treasury of the Cathedral of Canterbury," *Archaeologia* 84 (1934), pp. 163–211. See also Alice Hindson, "Canterbury Seal Bag No. 18," *Bulletin de liaison du Centre International des textiles anciens* 30 (1969), pp. 43–56, photographs I and II: Central Asia, N.E. Persia, 9th–11th centuries. This last citation was graciously provided by Leonie von Wilckens.

33. *Archive 1, Cathedrals and Monastic Buildings in the British Isles, Part 8, Canterbury, Romanesque Work*, ill. 1/8/151–54.

34. N. E. Toke, "The Opus Alexandrinum and the Sculptured Stone Roundels in the Retro-Choir of Canterbury Cathedral," *Archaeologia Cantiana* 42 (1930), pp. 206, 213, no. C-4, pl. IV; Elizabeth Eames, "Notes on the Decorated Stone Roundels in the Corona and Trinity Chapel in Canterbury Cathedral," *Medieval Art and Architecture at Canterbury Before 1200*, p. 69, pls. XVB, XVIC; Tim Tatton-Brown, "The Trinity Chapel and Corona Floors," *Canterbury Cathedral Chronicle* 75 (Apr. 1981), pp. 50–56. The published illustrations, as well as the photograph at the National Monuments Record in London (AA 48/7932), are misleading on the ornamental details of these badly worn floor roundels.

35. Caviness, *Windows of Christ Church Cathedral*, pp. 180–85, pls. 115–22: Trinity Chapel Ambulatory n IV, especially the borders of each roundel. See also ibid., pp. 41–42, pl. 27, fig. 69, Trinity Chapel Clerestory n VII, the border immediate to Nathan.

36. Hope, "On the Tomb," p. 6, pl. IV, fig. 3; Muthesius, "Silks from the Tomb," pp. 81, 84, pls. XXIB and XXIC; *English Romanesque Art*, p. 358, no. 493a (one ill.).

37. John Fletcher, "A Door, 800 Years, Not 900 Years Old," *Canterbury Cathedral Chronicle* 74 (May 1980), pp. 45–48, ill. on p. 47. The large C hinges, considered to be much earlier,

were probably reemployed from another door damaged in the fire of 1174.

38. Hope, "On the Tomb," pp. 7–9, fig. 3; C. J. Jackson, *An Illustrated History of English Plate* (London, 1911), vol. 1, p. 95, fig. 128; Charles Oman, "English Medieval Church Plate," *The Archaeological Journal* 96 (1939), pt. 1, Jan. 1940, p. 162: "Twelfth Century, Group II"; idem, *English Church Plate 597–1830*, pp. 40–41: "Group II . . . not much later than the middle of the twelfth century," p. 299, "c. 1160," pl. 2; Neil Stratford, "Notes on the Metalwork from the Tomb [of Archbishop Hubert Walter]," in *Medieval Art and Architecture at Canterbury Before 1220*, pp. 88–90, pls. XXIVA: "by an English goldsmith in the middle years of the twelfth century," XXV A,B; Stratford, in *English Romanesque Art*, pp. 294–95, no. 324d (ill.): "mid 12th century." Neil Stratford kindly supplied the photograph reproduced here (Fig. 38).

39. Caviness, *Windows of Christ Church Cathedral*, pls. 27 (figs. 68, 69), 32 (fig. 82), 61 (fig. 149), 64 (fig. 155), 68 (fig. 161), 71 (fig. 167), 91 (fig. 203), 104 (fig. 229), 112 (fig. 247), 118 (fig. 261), 119 (fig. 261), and 146 (fig. 325).

40. Hope, "On the Tomb," p. 5, fig. 1; Stratford, "Notes on the Metalwork," p. 87, fig. 1D; Stratford, in *English Romanesque Art*, p. 294, nos. 324a,b (not ill.): "English(?), last quarter twelfth century."

41. Caviness, *Windows of Christ Church Cathedral*, pl. 61, fig. 149.

42. See Newton, "Some New Material," p. 263.

43. Hope, "On the Tomb," pp. 8–9, fig. 4; Jackson, *History of English Plate*, p. 96, fig. 129; Oman, "English Medieval Church Plate," p. 168: "Group I. Agnus Dei, ca. 1180," no. 1; idem, *English Church Plate 597–1830*, pp. 51, 55 (identifies the sources of the inscriptions), p. 304 ("1150–1175"), pl. 24a; Stratford, "Notes on the Metalwork from the Tomb," p. 88, pl. XXIVB; idem, in *English Romanesque Art*, pp. 294–95, no. 324e (ill.). The quotation in the inscription is from the Mass and an elegaic couplet from the *De mysterio Missae* by Hildebert of Lavardin, d. 1135, bishop of Le Mans.

44. Caviness, *Windows of Christ Church Cathedral*, pp. 220–23, pl. 162 (table of letter forms).

45. Adelaide Bennett, letter of Aug. 6, 1987, reported on ten examples recorded in the Index of Christian Art, Princeton University. These date mostly from the twelfth through the thirteenth centuries, e.g.: (1) Deposition of Christ, ivory relief, Spanish or English, Herefordshire "School," ca. 1150, London, Victoria and Albert Museum, acc. no. 3-1872; John Beckwith, *Ivory Carvings in Early Medieval England* (London, 1972), pp. 76, 84, 85, 136–37, prev. bibl., ills. 152, 153; Paul Williamson, *Medieval Ivory Carvings* (London, 1982), p. 40, pl. 23; (2) stained-glass windows at Chartres, Le Mans, and Rouen; (3) front cover for a cartulary from Prüm, engraved copper-gilt, Trier, ca. 1200 (see note 28 above).

46. Hope, "On the Tomb," pp. 3–4, pl. IV, fig. 4.

47. William Stubbs, ed., *The Historical Works of Gervase of Canterbury*, 2 vols. (London, 1879–80), Rolls Series 73, vol. 1, pp. 5, 8, 9, 13, 22; Robert Willis, *Architectural History of Canterbury Cathedral* (London, 1845); Charles Cotton, *Of the Burning and Repair of the Church of Canterbury in the Year 1174*, 2d ed. (Cambridge, 1932), pp. 3–4, 12, 15, 16; Francis Woodman, *The Architectural History of Canterbury Cathedral* (London, 1981), pp. 226–28. No relevant sources have been

found under the rubrics of Canterbury, *scrinium, reliquarium,* and *Kleinkunst,* in Otto Lehmann-Brockhaus, *Lateinische Schriftquellen zur Kunst in England, Wales und Schottland vom Jahre 901 bis zum Jahre 1307,* 5 vols. (Munich, 1955).

48. Willis, *Architectural History,* pp. 38 (fig. 3: Plan of Canterbury Cathedral in 1174), 39.

49. According to Nigel Ramsay, letter of Oct. 11, 1989, there was a relic of Edward the Confessor at Canterbury: "Thomas Becket, after presiding at the translation of Edward in 1163, brought back to Canterbury the stone which had covered Edward's original tomb; after Becket's martyrdom (1170) this was set up near Becket's tomb, where it remained until moved by Henry IV." This information is derived from a note inserted in the Continuation of Gervase's chronicle, Stubbs, *Historical Works of Gervase,* vol. 2, p. 285.

50. Ibid., vol. 1, pp. 13–14; Legg and Hope, *Inventories,* pp. 32, 36.

51. William Urry, St. Edmund Hall, Oxford, letter dated Nov. 19, 1980: "I should imagine that your item was kept somewhere in the church, shackled onto something firm (on an altar?)."

52. I am indebted to Deborah Kahn for this comparison. See William Somner, *The Antiquities of Canterbury* (London, 1640), pl. facing p. 46; David Sherlock, *St. Augustine's Abbey: Report on Excavations, 1960–78* (Maidstone, Kent, 1988), pl. I.

53. Legg and Hope, *Inventories,* pp. 9–94.

54. Ibid., p. 34. The other categories noted by Legg and Hope are: "1. The greater relics, of saints and archbishops, canonized at Rome or in popular estimation, which were placed in standing shrines or tombs; . . . 3. The relics of former archbishops and pious lay-folk, buried or placed near altars; 4. Miscellaneous objects enclosed in reliquaries; and 5. The tombs of certain archbishops who were objects of popular veneration or pilgrimage."

55. A point suggested by Urry, letter of Nov. 19, 1980: "The casket must have been in use 100 years before the first inventory of 1321 [*sic*] and all sorts of re-arrangements could have taken place in the interval."

56. Legg and Hope, *Inventories,* p. 21.

57. Ibid., pp. 39, 42. The Sword Point was the broken fragment of Richard le Bret's sword that was used in the murder of St. Thomas Becket. The Altar of the Sword Point, upon which this secondary relic was placed, once stood at the location of St. Thomas's martyrdom in the northwest transept. See also Hartley Withers, *The Cathedral Church of Canterbury* (London, 1901), p. 94, and Woodman, *Architectural History of Canterbury,* pp. 181, 185, 220, fig. 136. This altar has been recently restored with a modern cross in wrought iron that alludes to the Sword Point suspended above.

58. Legg and Hope, *Inventories,* pp. 91–92. These entries lead off with "*In primo scrinio de Cupro continentur, . . . In secundo scrinio de Cupro continentur, . . . In tertio scrinio de Cupro continentur, . . . In quarto scrinio de Cupro continentur. . . .*" These notices and those for notes 59 and 64 below were brought to my attention by Urry, letter of Nov. 19, 1980. "*In quinto scrinio de Cupro,*" the first part of the title of this article, is hypothetical and certainly playful.

According to Bede, the long tradition of relic veneration in England goes back to Pope Gregory when he supplied Augustine in 601 with "everything necessary for the worship and service of the Church, including sacred vessels, altar coverings, church ornaments, vestments for priests and ministers, relics of the holy Apostles and martyrs, and many books"; Bede, *A History of the English Church and People* (Edinburgh, 1955), chap. 29, p. 84.

Reliquaries of a size comparable to that of The Cloisters chasse that still contain numerous relics of a variety of saints are found in continental Europe. Two examples, suggested by Timothy B. Husband, are preserved in Cologne: a reliquary casket of bone plaques over an oak core, Rhenish, 7th–8th century, in St. Ursula's Church, and a lead example, Cologne, second quarter of the 13th century, from the high altar of St. Kunibert's Church. Each of the wrapped relics in these reliquaries is carefully labeled on a strip of parchment. See *Ornamenta Ecclesiae,* vol. 2, pp. 78–83, 346, nos. E110 and D61, respectively.

59. Legg and Hope, *Inventories,* p. 82.

60. Ibid., pp. 37, 38, 81, 82, 87, 90, 92, 94, 360.

61. Arthur P. Stanley, *Historical Memorials of Canterbury* (New York, 1888), p. 50: Augustine was initially interred "by the roadside in ground now occupied by the Kent and Canterbury Hospital." Scott Robertson, "Burial Places of the Archbishops of Canterbury," *Archaeologia Cantiana* 20 (1893), p. 277: "To St. Augustine's Abbey were brought Archbishop Augustine and his 9 immediate successors. . . ."

62. Stubbs, *Historical Works of Gervase,* vol. 1, pp. 9, 13; Willis, *Architectural History,* p. 43; and Woodman, *Architectural History of Canterbury,* pp. 8, 47, 49, 132, 227. The present chair, possibly dating from the time of Stephen Langton (archbishop 1207–29), may be considered a partial replica of the original mentioned by Gervase. See Jonathan Keates and Angelo Hornak, *Canterbury Cathedral* (London, 1980), p. 87 (col. pl.). A drawing of this later chair, also known as the chair of Augustine, is reproduced in Withers, *Cathedral Church,* p. 89. See also C. S. Phillips, "The Archbishop's Three Seats in Canterbury Cathedral," *The Antiquaries Journal* 29 (1949), pp. 26–36; and Anthony Reader-Moore, "The Liturgical Chancel of Canterbury Cathedral," *Canterbury Cathedral Chronicle,* no. 73 (Apr. 1979), p. 26.

63. Legg and Hope, *Inventories,* pp. 29–30.

64. Ibid., p. 84.

65. One must note that the presumed relics of the eleven thousand virgins, deriving from a vast Roman cemetery found in 1106 outside the walls of Cologne, were widely disseminated between 1113 and 1381. By 1187, 9,816 of the virgins had been given names by Abbot Gerlach of Deutz, with the support of the revelations of Elisabeth of Schönau and with the additional anonymous revelations of 1183 and 1187. The widespread traffic in these relics was brought to a halt by Pope Boniface IX in 1381: C. M. Kauffmann, *The Legend of St. Ursula* (London, 1964), pp. 11–12 (I am indebted to Wayne Dynes for this information and reference); see also *Die Hl. Ursula and ihre Elftausend Jungfrauen,* exhib. cat. (Cologne, 1978), and Josepha Weitzmann-Fiedler, *Romanische gravierte Bronzeschalen* (Berlin, 1981), pp. 48–54, nos. 18, 19, pls. 41–47 (for episodes of the Ursula legend engraved on two brass bowls, Rhineland, twelfth century: Baltimore, Walters Art Gallery and Aachen, Suermondt-Ludwig-Museum).

66. Legg and Hope, *Inventories,* p. 83.

67. Francis Wormald, *English Benedictine Kalendars after AD 1100,* Henry Bradshaw Society 77 (London, 1939), vol. 1, pp. 63–79.

68. In 1170, at the time of the murder of Thomas Becket, the squared end of the eastern crypt of Christ Church Cathedral "included two altars, one to St. John (to the north) and the other to St. Augustine (to the south)." William Urry, "Some Notes on the Two Resting Places of St. Thomas Becket at Canterbury," in R. Foreville, ed., *Thomas Becket: Actes du Colloque International de Sédières 19–24,* August 1973 (Beauchesne, 1975), p. 195.

69. Dom David Knowles, *The Religious Orders in England* (Cambridge, 1950), p. 296.

70. In spite of the ambiguous account of Matthew Paris, it has been suggested that Elias of Dereham, canon of Salisbury, helped as an administrator in organizing the project and the ceremonies of translation in 1220. A. Hamilton Thompson, "Master Elias of Dereham and the King's Works," *The Archaeological Journal* 98 for the Year 1941 (1942), pp. 6–7, 20–35; John Harvey, *English Medieval Architects,* 2d ed. (London, 1954), p. 83; Urry, "Some Notes on the Two Resting Places," pp. 200–201.

71. William Urry, *Canterbury under the Angevin Kings* (London, 1967), pp. 113–18. The archbishop of Canterbury and the abbot of St. Augustine, as well as the king, had the privilege of minting coins in Canterbury. Before the centralization of the early thirteenth century, Canterbury had seven "moneyers," whereas London had eight. With the reign of Henry II, the mint at Canterbury was the most prolific in the country. A mint in the town was active until the mid-sixteenth century.

72. Caviness, *Early Stained Glass,* p. 27.

73. In light of the documents mentioning Canterbury goldsmiths, cited by Urry in *Canterbury under the Angevin Kings* (pp. 18, 20, 111, 112–13, 155, 159, 163, 172, 435–36, 500), it seems likely that much of the material mentioned in the inventory was neither imported nor made by foreigners. None of the goldsmiths cited by Urry has a German name.

74. The Metropolitan Museum of Art, Joseph Pulitzer Bequest, 1963 (63.160). Reliquary pendant of Queen Margaret of Sicily, gold, hammered and engraved, 1⅞ x 1³⁄₁₆ in. (4.9 x 3.1 cm): England, 1174–83. Thomas P. F. Hoving, "A Newly Discovered Reliquary of St. Thomas Becket," *Gesta* 4 (Dec. 1965), pp. 28–30, figs. 2, 3: England, 1174–76; Newton, "Some New Material," pp. 260–62; Caviness, *Early Stained Glass,* p. 149 n. 74: "It is doubtful that the piece is of English workmanship; Swarzenski believes it to be south Italian"; and Stratford in *English Romanesque Art,* p. 283, no. 303 (back ill.): "English, as opposed to Sicilian origin . . . late 1170's" or "1174–83."

75. Stubbs, *Historical Works of Gervase,* vol. 2, pp. 413–14; Legg and Hope, *Inventories,* p. 50; C. R. Cheney, *Hubert Walter* (London, 1967), p. 174; Pamela Tudor-Craig, "The Tomb [of Hubert Walter]," *Medieval Art and Architecture at Canterbury, The British Archaeological Association Conference Transactions for the Year 1979* (Leeds, 1982), p. 74. Moreover, the rosettes or marigolds on The Cloisters chasse occur too frequently in the borders of the stained glass of 1170–80 to have any direct connection with Hubert Walter as his personal device: Hope, "On the Tomb," p. 5 n. 3.

76. Caviness, *Early Stained Glass,* p. 25, summarizes the history of continual conflict between the monks and a succession of archbishops, up to and including Hubert Walter, who before his death in 1205 had made peace with the monks. "The peace was again broken, however, by disputes with King John over the election of Stephen Langton to the archiepiscopacy, and in 1207 all the loyal and able-bodied monks left Christ Church to find refuge with their old ally, the Benedictine house of Saint-Bertin at Saint-Omer. They returned only in 1213, with the dispute settled in favor of Langton. During the years of exile, and into 1214, England was under an interdict [imposed by Pope Innocent III in 1208]. Christ Church suffered considerable financial loss in spite of restitutions made after the return." For recent summaries of the enrichment of the eastern end of the cathedral, see ibid., p. 34; Woodman, *Architectural History,* pp. 132–36, 219–21, 259.

77. There are many accounts of these events. Recent references include Caviness, *Early Stained Glass,* pp. 34, 35; Woodman, *Architectural History,* pp. 132–33, 135.

78. Madeline H. Caviness, "A Lost Cycle of Canterbury Paintings of 1220," *The Antiquaries Journal* 54 (1974), pt. 1, pp. 66–74, pls. XIX–XXI; idem, *Early Stained Glass,* pp. 97, 154, fig. 193; Woodman, *Architectural History,* p. 259; Morgan, *Early Gothic Manuscripts* [I], p. 83.

79. Morgan, *Early Gothic Manuscripts* [I], p. 83: "At the beginning of the new reign of Henry III it was significant that [as opposed to the difficult reign of the avaricious King John] the wall paintings on the vaults of the Trinity Chapel at Canterbury represented kings of England affirming belief in just rule." Henry III himself appeared in one of the ambulatory vaults on the north side of the Trinity Chapel. For further representations and genealogical programs of royal saints, see Caviness, "Lost Cycle," pp. 68–71, and Ursula Nilgen, "Amtsgenealogie und Amtsheiligkeit, Königs-Bischofsreihen in der Kunstpropaganda des Hochmittelalters," *Studien zur mittelalterlichen Kunst 800–1250, Festschrift für Florentine Mütterich* (Munich, 1985), pp. 224–31.

80. Victor Leroquais, *Les Psautiers manuscrits latins des bibliothèques publiques de France* (Mâcon, 1940–41), pp. 53 (Paris, Bibl. Nat., MS lat. 770), 141 (Paris, Bibl. Nat., MS lat. nouv. acq. 1670); Caviness, "Conflicts Between *Regnum and Sacerdotium*," p. 57.

81. "After the second Council of Nicaea, in 787, had insisted with special urgency that relics were to be used in the consecration of churches, and that the omission was to be supplied if any church had been consecrated without them, the English Council of Celchyth (probably Chelsea) commanded that relics were to be used, and in default of them the Blessed Eucharist," *The Catholic Encyclopedia* (New York, 1911), vol. 12, p. 737. Certainly by the eighth century, altars included relics as part of their dedication.

In the early thirteenth century the liturgical customs of Sarum (the diocese of Salisbury) found increasing favor in other English dioceses—their cathedrals and churches. A rubric in the Sarum Breviary, *Festum Reliquiarum,* indicates that this feast was celebrated on the Sunday following July 7, the date of the translation of St. Thomas, ibid., p. 738. While possibly not planned, The Cloisters chasse could have also been used later on in this particular celebration.

82. The suggestion that The Cloisters chasse may also have served as a portable reliquary in this way is due to Madeline Caviness.

83. Legg and Hope, *Inventories,* pp. 37, 39, 82.

84. Tudor-Craig, "Tomb [of Hubert Walter]," p. 75. The illustration reproduced here, Fig. 43, is after Fred H. Crossley, *English Church Monuments 1150–1550* (London, 1921), p. 33.

85. Arthur P. Stanley, *Historical Memorials of Canterbury* (Philadelphia, 1889), pp. 265–71, 354–57; Bernard Rackham, *The Ancient Glass of Canterbury Cathedral* (London, 1949), p. 91, pl. opp. p. 13; Urry, "Some Notes on Two Resting Places," pp. 201–6, figs. 2, 3; Nicola Coldstream, "English Decorated Shrine Bases," *Journal of the British Archaeological Association* 129 (1976), pp. 16, 22, 28–30; Caviness, *Early Stained Glass*, pp. 27, 33–34, 140, fig. 164; A. J. Taylor, "Edward I and the Shrine of St. Thomas of Canterbury," *Journal of the British Archaeological Association* 131 (1978), pp. 22–28, for later changes in the shrine; Caviness, *Windows of Christ Church Cathedral*, p. 187.

86. Many of the other scenes show the earlier low shrine-tomb in the crypt.

87. Caviness, *Early Stained Glass*, p. 11.

88. Tudor-Craig, "Tomb [of Hubert Walter]," pp. 76–78.

89. John Newman, *North East and East Kent* (Harmondsworth, 1969; 2d ed. 1976): p. 126, ". . . brought from Canterbury Cathedral. In fact the crocket capitals of the side-posts are copied from capitals of the 1170s, in the cathedral. The only other piece of carving to remain is a row of quatrefoils in circles, with trefoiled leaves in the spandrels, impossible [?] before the middle of the c13. Above this there was gesso and painted decoration, now gone except for the outline of four pointed-trefoil arches. A c19 writer made out the figures of the four Evangelists. The monochrome paintings of the same figures at the bottom are not earlier than the c17." The two gesso fields in the upper blind arcade with repeated circles may be related to the background for the Beatus initial of the Little Canterbury Psalter (Fig. 28).

90. *Archive 1, Cathedrals and Monastic Buildings in the British Isles, Part 9, Canterbury, Early Gothic: Choir and Trinity Chapel*, ed. Lindy Grant (London, 1979), *Courtauld Institute Illustration Archives*, ed. Peter Lasko, ill. 1/9/54, Choir, north side. Vault capitals 3.

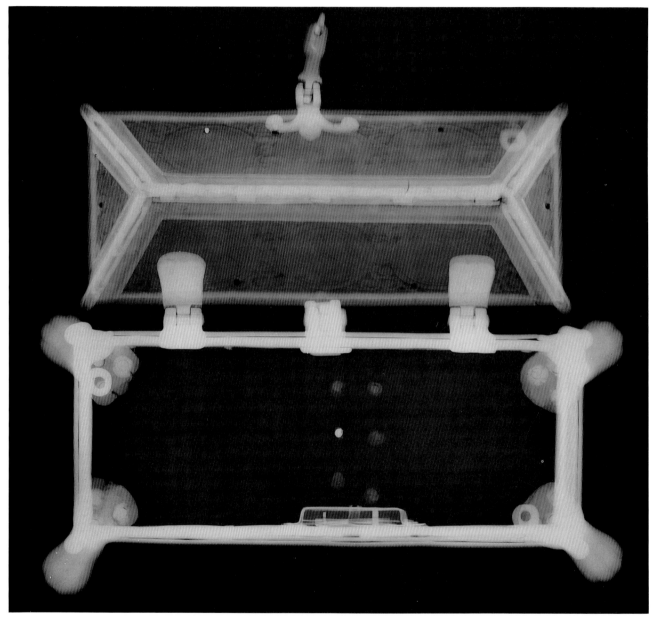

Fig. A. X-ray of The Cloisters Reliquary Chest

The Development of the Canterbury Chest

Pete Dandridge

A t the time of its creation, the visual impact of the Canterbury chest, or chasse, would have come from the brilliance of its gilt-copper surface.[1] Its integrity, however, depends greatly on those elements, both structural and decorative, that lie beneath the surface of the gilding, and on the manner in which they have been joined and carved. The simplicity of the techniques involved belies the skills of the metalsmith, for it is only through a thorough understanding of one's materials that such sureness and simplicity are achieved. Moreover, the beauty of form and technique incorporated in this chasse supports Charles Oman's supposition that English medieval goldsmiths were not limiting their work to the precious metals, but were also crafting objects from copper and its alloys.[2] Certainly, the treatise of the twelfth-century German monk Theophilus draws no distinction between those working in gold and silver, and in copper.[3] Although this treatise is devoted to practices in Germany, it seems reasonable to draw parallels with working methods in England, which had extensive ecclesiastical, political, and commercial connections with Germany at the time.[4]

The fabrication of the chasse was conceived and implemented in a manner that took full advantage of the working properties of the materials used. The hip roof and the oblong base were developed from sheets hammered out from a cast ingot, while the feet were cast individually. Analysis of metal samples from the base of the casket and the feet indicate that an almost pure copper was used.[5] Trace amounts of iron were found both in the feet and in the base; lead and antimony were apparent only in the analysis of the base. While such incidental amounts of lead and antimony do not represent intentional additions, their presence in one set of analyses and not the other does indicate that separate melts of metal were

used for the casting of the feet and of the ingot from which the base was hammered. Theophilus cites the deleterious effects of lead as an alloying element for any metal that was to receive a gilt surface,[6] and the goldsmith responsible for the Canterbury chasse seems to have been aware of the same constraint. By excluding lead, a gilt surface could be achieved that would not be visually disrupted by the diffusion of lead into the gold.[7] A further consideration in the choice of metal composition would be the ease with which it could be hammered, formed, and carved. The absence of any alloying elements with the copper would yield a material that could be worked more readily than a bronze or brass.

The technical expertise inferred from the metal composition of the Canterbury chasse is comparable to the practices of German and Mosan metalworkers of the same period who were hammering, carving, and gilding a copper of similar purity for their *champlevé* enamels, while using different compositions of copper with tin, zinc, and lead as possible alloying elements for those objects that were either to be cast or left ungilt.[8] Analysis of a candlestick in The Cloisters Collection suggests that it, too, falls within that group of objects that were to be hammered and gilt, and thus were developed from an unalloyed copper (Wixom, Fig. 10).[9]

When the hammered sheets reached the desired thickness, they were cut into rectangular shapes from which the roof and base could be developed. For the hip roof, four triangular, pie-shaped slices were removed from the sheet along lines bisecting the corners and meeting at the central axis, or ridge line, of the roof of the chasse. The sheet was then bent to form the hips of the roof. The base was treated in a similar fashion, except that the four sections that were removed were square to allow the sides to be bent upward to form right-angled corners (Fig. B).

The butted edges of the roof and of the base were secured to one another by the addition of corner moldings previously formed from two separate pieces of flat, strip copper: one bent to form an "L" bracket, the other hammered around the angle of the bracket to form a "clasping" molding (Wixom, Fig. 7b). The two were then joined by a series of three rivets along the length of their central axis (Wixom, Fig. 1a). The corner moldings were subsequently attached to the reliquary with rivets

hammered through the exposed flat sections of the bracket and the underlying sheet. The framing of each side of the roof and the base was completed and the edges strengthened by riveting flat strips of copper along those edges not secured by the corner moldings.

The flat sections of the corner moldings and the connecting strips were carved to form a profile with a hollow in the center and a rounded inside edge. Visible along the length of the hollows are both the parallel striations left by the irregularities in the cutting edge of the engraving tool as it was worked across the surface of the metal, and the slight steps or cuts in the metal perpendicular to the edges of the hollows that signal the slight jumps the tool made each time it was struck (Wixom, Fig. 14a).

The openwork crest along the ridge of the roof was cut from a copper blank (Wixom, Figs. 1a–c). The upper half of the strip was carved to create the repeating, pierced foliate pattern with interior details engraved and chased. The bottom half of the blank is not visible except in the x-rays, which indicate that it was thickened on either side by flat strips of copper riveted to the central section of the blank that begin at the base of the carving and extend down to the ridge line of the roof (Fig. A). The tops of these pieces were rounded and turned out slightly to create a transition from the crest to the border moldings (Wixom, Fig. 11a). The bottom of the blank was partially cut away, leaving five tenons that were inserted through holes cut into the ridge of the roof. The bottom of each tenon was cut with a flat chisel into six sections, possibly prior to insertion, to allow for greater expansion when hammered (Wixom, Fig. 7b). The series of holes at the proper left end of the crest represent what appear to be several attempts at riveting on a "U" strap or loop (Wixom, Fig. 1c). When the Museum acquired the chasse, only a section of silver strap remained and, since it was deemed a much later addition, it was removed.

The hip roof and base of the chasse were attached to each other with hinges (Wixom, Fig. 1c). The outline of the straps of the hinges reflects the design of the palmettes engraved within their interiors. Each strap was stepped in cross section, to allow for its positioning over the border moldings, and then attached with three rivets, with the additional support of interior backing plates.

The casket is supported by four simplified lion-

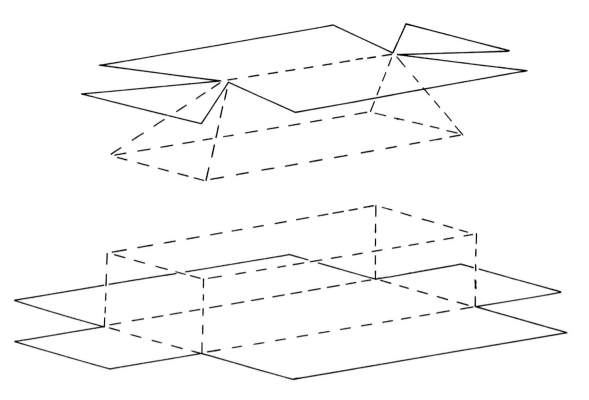

Fig. B. Rendering of the initial fabrication of the roof and base of The Cloisters Reliquary Chest (drawn by Dennis Hawks Degnan)

paw feet. Visual and radiographic examinations indicate that they were cast, with the details engraved and chased afterward (Fig. A). The porosity associated with a cast structure is visible in the x-ray in the horizontal section of each foot which supports the base and through which the feet are riveted to the bottom of the base (Wixom, Fig. 7a).

Once assembled, the chasse's decorative scheme of portrait medallions, animal forms, and foliate patterns was engraved into the copper. Under the microscope, the tapered lead-ins and exits of engraved lines are clearly identifiable, as are the "chips" created by the abrupt endings of the lines. The character of relief has been enhanced by recessing the cross-hatched background. In examining the engraved decoration and the carving of the moldings, it became clear that both were executed only after the casket had been constructed and the roof and base hinged together. Neither the decorative patterns nor the gilding extend under the hinge straps, and the engraved lines can be seen to terminate into the sides of the straps and the moldings (Wixom, Fig. 8). A similar situation exists at the points of intersection between the border moldings and the sides of the hinge straps, where the motion of the carving tool was either halted just at the edge of the strap—leaving a thin ridge of metal—or continued farther into the side of the strap.

The function of the chasse as a reliquary may account for the addition of the three eyelets or rings visible in the interior (Wixom, Fig. 7b). All three were formed from single copper blanks that were cut to create an eyelet with a narrowed shaft extending from it. The rings were attached by inserting their shafts through holes in the sides of the chasse and hammering their ends to form rounded heads. In an attempt to integrate them into the rinceaux pattern, the heads were engraved with a cross-hatched pattern (Wixom, Fig. 14a). Details of the carving and gilding indicate that the eyelets were added to the chasse prior to the engraving of the decorative pattern.

The hinged lug at the bottom back edge of the base and the floral appliqué and hasp on the front of the roof were added after the chasse had been engraved and gilded (Wixom, Figs. 1a–c), since

231

the designs and gilding beneath them are complete and visible under the microscope and in the radiographs. All the elements appear to have been cut from copper blanks and, apart from the bottom lug, appear visually to be of a similar composition to the rest of the chasse. The difference in composition and the lack of gilding on the bottom lug may be due to its association with, and attachment to, a chain that would have affixed the chasse to its support.[10] Like the hinge straps, the riveted appliqué was stepped in cross section to accommodate the depth of the molding, and the lug was supported on the interior by a copper blank pierced in the center to allow for the insertion of the tenon extending from the lug (Wixom, Fig. 7b). The original lock is no longer attached to the base. The copper plugs that fill the holes used for the original lock's attachment are visible (Wixom, Figs. 12b,c), and indicate that the present lock is somewhat larger, but similarly positioned allowing for the continued use of the keyhole.

Two elements of the chasse defy ready explanation as to their original function: a series of six small holes in the roof of the chasse, and the two rows of three rivets each in the bottom of the base (Wixom, Fig. 7a). Of the holes in the roof, all of which are in the same horizontal plane, there are two in the front at the bottom edge of each outer medallion (Wixom, Fig. 1b), two on the back just beyond the borders of the outer medallions (Wixom, Fig. 1c), and one each in the bottom centers of the sides (Wixom, Figs. 1d,e). The interiors of the holes show no trace of gilding; however, a false start, visible under the microscope, to the side of the proper left hole, is gilt, suggesting that the holes were made and then filled prior to the gilding of the chasse. It is possible that the holes supported a network of thin rods or wire that served as a framework for attaching or supporting relics. The six rivets in the bottom of the base, slightly off center, may have served a similar function. Whatever they did secure has since been cut away and the result is the sheared appearance of the rivets on the inside of the base (Wixom, Fig. 7b).

The chasse's present condition reflects its age and function. Where the engraved decorative surface has been protected by elements that project above it, such as hinge straps and moldings, the original surface has been preserved; however, where the casket would have been touched in veneration of the relics, such as the engraved portrait busts, or handled generally, the gilding has been lost and the copper substrate worn down. Ironically, the loss of gilding reveals more clearly the sophistication of the goldsmith's technique. One can begin to discern the separate elements and the methods of joinery originally veiled by the gilded surface.

In reconstructing the methods and materials used in the fabrication of the chasse, the Canterbury chest serves as a document of the workshop practices of an English early-thirteenth-century goldsmith. The master who created the chasse was as aware of the physical properties and characteristics of copper as he would have been of the more noble gold and silver. He appears to have been part of a metalworking tradition active in England as well as on the Continent at this time.

ACKNOWLEDGMENTS

I wish to thank Robert Koestler, Research Scientist, and Mark Wypyski, Research Assistant, Objects Conservation, The Metropolitan Museum of Art, for all the reported analyses, as well as William D. Wixom, Chairman of the Department of Medieval Art and The Cloisters, and Barbara Drake Boehm, Associate Curator of Medieval Art, The Metropolitan Museum of Art, for bibliographic references. I am also grateful to Richard E. Stone, Conservator, Objects Conservation, The Metropolitan Museum of Art, for the generous contribution of his technical expertise.

NOTES

1. Analysis of a sample of gold from the reverse of the proper right rear foot of the Canterbury chasse revealed the presence of mercury, indicating that the gold was applied as an amalgam. This analysis and all further analyses were acquired by Energy Dispersive X-Ray Spectrometer (EDS) analysis of metal samples. Samples were placed on carbon stubs with colloidal graphite conductive paint, and were analyzed with a Kevex Delta IV EDS system combined with an Amray model 1100T scanning electron microscope. Operating conditions were an accelerating voltage of 30 KV. Data was collected for 300 seconds line-time at a magnification of 1,000x (area scanned was approximately 1 x 10^4 square microns).

2. Charles Oman, "English Medieval Base Metal Church Plate," *The Archaeological Journal,* The Royal Archaeological Institute, London (Mar. 1964), p. 195.

3. *Theophilus, On Divers Arts,* John G. Hawthorne and Cyril Stanley Smith, trans. (Chicago, 1963: repr. New York, 1979), pp. 81, 92–93, 130, 132, 139–40, 148–49, 152–54, 157. Theophilus devotes several chapters of his treatise to the working and casting

of copper and its alloys. The references cited are for those instances when he describes techniques specifically stated to be applicable to gold, silver, and copper.

4. See Neil Stratford, "Metalwork," in *English Romanesque Art 1066–1200,* exhib. cat. (London, 1984), pp. 232–36, with earlier bibl.

5. Figures given are averages of results on five samples with the error given as one standard deviation of results. Percent amounts reported for iron, lead, and antimony are very near the minimum detection levels for this instrument under the previously reported conditions.

Weight %	*Cu*	*Fe*	*Pb*	*Sb*
Feet:	99.8	0.2	–	–
Base of chasse:	98.3	0.1	1.3	0.3
Standard deviation:	0.1	0.1	0.1	0.1

6. *Theophilus,* pp. 139, 144.

7. Ibid., pp. 145–46.

8. W. A. Oddy, Susan La Niece, and Neil Stratford, *Romanesque Metalwork, Copper Alloys and Their Decoration* (London, 1986), pp. 10, 13–17.

9. Figures given are averages of results of five analyses conducted in situ on the interior of the foot with the error given as one standard deviation of results. Percent amounts reported for iron, lead, and antimony are very near the minimum detection levels.

Weight %	*Cu*	*Fe*	*Pb*
Candlestick foot:	98.7	0.1	1.1
Standard deviation:	0.3	0.1	0.3

10. See William D. Wixom's discussion of the chasse's function as a reliquary in the preceding article.

Fig. 1. Moses, from Noyon Cathedral, ca. 1170, H. 125 cm. The Metropolitan Museum of Art, Gift of Raymond Pitcairn, 1965 (65.268) (photo: author)

Resurrexit: A Rediscovered Monumental Sculptural Program from Noyon Cathedral

Charles T. Little

The study of French medieval sculpture in the last half of this century has often focused on attempting to understand the context, audience, and meaning of works of art that now grace public and private collections. War, revolution, changes of taste, and neglect have destroyed forever many of the original settings of monumental sculpture. Even a cursory review of now-lost sculptural portals known from eighteenth-century engravings published by Millin, Plancher, Montfaucon, Mabillon, and Morellet dramatically demonstrates the magnitude of the destruction.[1] Entire sculptural ensembles, such as the portal of Saint-Nicolas at Amiens, have vanished without a trace.[2] Consequently our knowledge of the development of Gothic sculpture in some regions is sporadic and, at best, incomplete.

But on the positive side, recent archaeological discoveries, together with the active research in archives and in public and private collections, have significantly transformed our perception of the beginnings of Gothic sculpture in France. The excavations and the exacting study of the cloister at Notre-Dame-en-Vaux at Châlons-sur-Marne and the 1979 finds of the Sainte-Anne portal at Notre-Dame-de-Paris have expanded our understanding not only of these monuments but also of the period.[3] Recognition of the provenance or significance of various *membra disjecta*—such as the bishop's tomb at Gassicourt, the Deposition relief at Coudres, the heads from the facade of Saint-Denis—has greatly contributed to our knowledge of the inception of Gothic art.[4] By the same token, the painstaking process of reunifying long-separated components of figural and decorative series—the magnificent Parisian head and torso in the Cluny Museum, for example—further serves to give us a more complete picture.[5] Finally, the restoration and cleaning of many of the churches and their portals—such as the Porte des Valois at Saint-Denis and the Portail Royal at Chartres—have

Fig. 2. Moses, view of right side

begun to correct our distorted sense of how the sculpture was intended to be seen and appreciated by the medieval audience. The astonishing revelations of the extensive polychromy of the entire Early Gothic portal at Lausanne Cathedral have confirmed what has often been assumed or was only vaguely evident.[6]

Symptomatic of the problems arising from a total loss of context is a group of five life-size statues in limestone (Figs. 1–10, 14–16). Divided among various collections, they share common characteristics that suggest they once formed an integrated ensemble. The two members of this group surviving in the best condition are Old Testament figures exhibited at The Metropolitan Museum of Art—one at The Cloisters and the other in the Medieval Galleries (Figs. 1–6). The others are in the collection of Baron von Thyssen-Bornemisza in Lugano, the Duke University Museum of Art in Durham, North Carolina, and the Dépôt Lapidaire at Noyon Cathedral (Figs. 7–10, 14–16). Until recently the relationship of all five of these statues to one another has not been readily apparent.[7] First of all, over a long period of time, they had been subjected to different environmental conditions that have affected their surfaces. The figure in Lugano has suffered a nearly disastrous reworking of the surface (Fig. 10). In addition, stylistic differences and the separate reputed provenances provided by dealers have obscured their common origin. Indeed it is almost understandable that such a figure as the Moses, which was said by the dealer "to have come from Chartres," was once attributed to the circle of Master Mateo of Santiago de Compostela.[8] These purported or erroneous stylistic relations to works of other provenances have obscured the meaning and significance of the figures as a group.[9]

In 1965 Raymond Pitcairn gave the life-size limestone seated figure of Moses to The Metropolitan Museum of Art and it is now exhibited at The Cloisters (Figs. 1–3).[10] Conceived three-dimensionally but unfinished on the back, the bearded figure, seated on a simple bench, displays the Tablets of the Law in his left hand and gestures in benediction with his right. Evidence of a cusped nimbus remains at the back of the head. Extended exposure has deteriorated the surface of the figure; the calcitic oolitic limestone has gypsum present on the surface, caused by the interaction of the limestone with acid rain, which has considerably darkened its appear-

236

ance. Further evidence of surface erosion appears over the large bore holes on the sides of the figure. The one on the right, located just above the elbow, and the area around it are filled in with cement. They were added after the carving, but an iron ring in the upper back seems to be original and to have once secured the piece in position. The best-preserved passages of the figure still give a sense of the carver's masterly handling of the chisel, especially the goffered sleeve, the long, cascading beard, and the swelling volumes of the drapery that envelop it. Noteworthy in the Moses figure is the play of the drapery over the figure. The weighty fabric of the mantle is expressed in the tightly repeated, prominent folds that swirl and loop in an arrangement of swelling, stretched forms, fanned out on the sides around the knees and culminating in the front in a dominating reverse S-curve that defines the frontal view.

Significantly, the Museum already owned another seated figure that had come to the collection as part of the Michael Dreicer bequest in 1921 (Figs. 4–6).[11] Nearly identical in dimensions, the two figures share a number of technical and stylistic features: their proportions and orientation are similar; both sit strictly frontally upon the same type of sloping bench; they are carved on three sides only and have the same diameter holes drilled on the sides, just below the elbows. This figure also has the vestige of an iron ring on the upper back. Despite these striking technical similarities, however, one might not immediately associate the two sculptures. The Museum's figure survives in far better condition than The Cloisters Moses, even though some of its surfaces have been recut, in particular the elliptical folds of the chest. To compensate for other losses, such as the right foot, parts of the fingers, as well as the nose, eyebrow, and segments of the beard, these areas have been in-filled or restored (probably by a dealer in order to make the figure more desirable).[12]

Unlike the Moses, the Old Testament figure at the Metropolitan Museum lacks an identifying attribute. In his right hand he holds only a scroll that opens across his figure and falls down the left side. It probably had a painted inscription that once carried his name; with his left hand he clutches a section of drapery. An important clue remains, however, in the long veil, called the "schimla," covering his head, clearly identifying him as a high

Fig. 3. Moses, view of left side

237

Fig. 4. "Aaron," from Noyon Cathedral, ca. 1170,
H. 128 cm. The Metropolitan Museum of Art. Bequest
of Michael Dreicer, 1921 (22.60.17) (photo: Museum)

priest, most probably Aaron, patriarch of the Levite priesthood, brother of Moses, and the archetypal Old Testament priest depicted on many Gothic portals offering the Paschal Lamb.[13] Despite the absence of the lamb as his attribute, or the Signum Tau that marked the lintels of the elect at the first Passover, the Metropolitan Museum figure conforms more to images of Aaron in monumental sculpture—the north transept portal of Chartres, the west portal of Senlis, the collegiate church of Saint-Nicolas at Amiens (destroyed)—than to any other Old Testament iconographic type.[14] As such, the figure of Aaron, like Moses, would function as a prefiguration of the redemption offered through the sacrificial death of Christ.

The technique by which plasticity is given to the figure differs somewhat from that which characterizes the seated Moses. Here, a close arrangement of thick drapery folds is defined by sharper incisions and troughs on the surface of the stone and thinner more prismatic ridges. With all sense of animation suppressed in the pose, the sculptor relied on the organization of the drapery to enliven and convey the structure of the figure. The drapery sweeps diagonally across the knees and sides of the figure. The surface is thus animated by the interaction of linear folds. Nevertheless, like the Moses, this figure is conceived as a solid mass compressed and restricted, as it were, by the tight draperies formed of compact linear ridges and curving folds that are calculated to reaffirm the volume of the figure.

A third seated Old Testament figure, today in the collection of Baron von Thyssen-Bornemisza in Lugano, has been associated with the previous two figures (Figs. 7–10).[15] Again it has the same dimensions, the same type of bench, and it also has holes on the sides and an iron ring on the back to hold it in position. Like the "Aaron" figure, he carries an unfurled scroll in one hand, but he clutches his beard with the other in a gesture of either contemplation or "awe in the presence of the divine."[16] His tight-fitting cap conforms to the headgear typically worn by Old Testament prophets. Other Old Testament figures with a similar attribute and gesture are found among the west facade column figures at Saint-Denis, illustrated in Montfaucon, and in the Capucin Bible Tree of Jesse, but in neither case is the figure identified.[17] A strikingly similar head with a hand gripping the beard is now thought

238

Fig. 5. "Aaron," side view of right side

Fig. 6. "Aaron," side view of left side

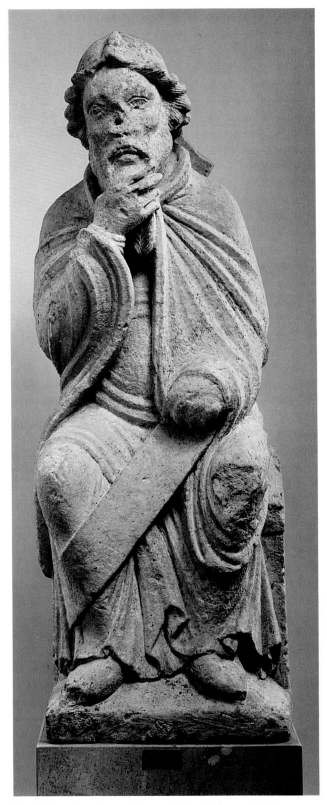

Fig. 7. Prophet, from Noyon Cathedral, ca. 1170,
H. 125 cm. Lugano, Baron von Thyssen-Bornemisza
collection (photo: Leo Hilber; courtesy of Thyssen-
Bornemisza Collection, Lugano, Switzerland)

to belong to a marmoset supporting one of the
column statues of the Porte des Valois at Saint-Denis
(Figs. 10, 11).[18] The Lugano figure has lost much
of the force of its original character because the
surface has been drastically cleaned in an attempt
to bring up the appearance of the limestone.[19]
Nevertheless, a few isolated patches of patination
similar to that on the New York prophets have
survived. Even more than the New York figures, this
prophet is tightly enveloped by a mantle that both
reveals the structure of the figure and creates surface
tensions in a dramatic way. The calm and meditative
pose of the figure again relies on drapery as a vehicle
of expression. In many respects, the sculptor of the
Lugano figure directly adapts elements from the Old
Testament figures of the Tree of Jesse in the voussoirs
of the Coronation Portal at Senlis Cathedral or the
same subject at the collegiate church of Mantes.[20]
Although the physical agitation and three-
dimensional movement of the Senlis figures have
been suppressed, the Lugano sculpture nevertheless
offers an illuminating comparison with the prom-
inent, high cheekbones characteristic of several of
the figures at Senlis, who are also depicted clutching
their beards and holding scrolls that swing across
their laps (Fig. 12). Even the system of tightly
repeated linear ridges curving across the surface
echoes the same sculptural vocabulary of the Senlis
sculptures, but again in a more subdued mode. This
stylistic bond to the Senlis sculptures also extends
to the New York figures, with equally tangible results.
For example, the "Aaron" figure grasps the edge
of his mantle in exactly the same manner as the
Virgin on the Senlis tympanum, and they both
present a certain bulkiness of form with suppressed
facial expressions (Figs. 4, 13). One has the sense
that the metallic qualities often witnessed in the
drapery of the Senlis figures have here become more
truly sculptural and spatial.

A fourth figure can also now be linked to this
group. Coming from the Joseph Brummer collection,
it belongs to the Duke University Museum of Art
(Fig. 14).[21] Even though it is today only a bust, the
figure possesses many characteristics common to the
others. Cut off just above the elbows, the fragment
has the same proportions and, in fact, the same
dimensions as the other figures if measured from
the point of the break. As with the others, there
is a metal ring on the back for securing the piece
in place. The large bore holes in the other figures

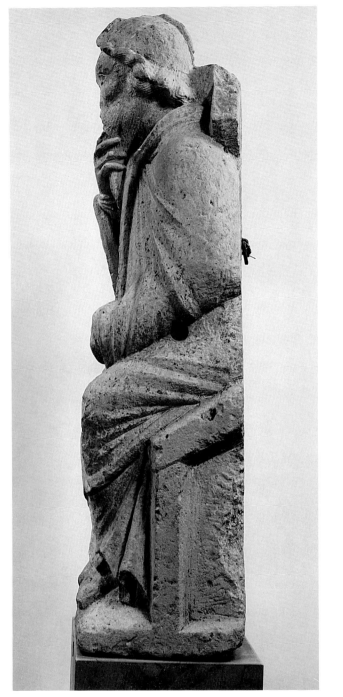

Fig. 8. Prophet, view of right side

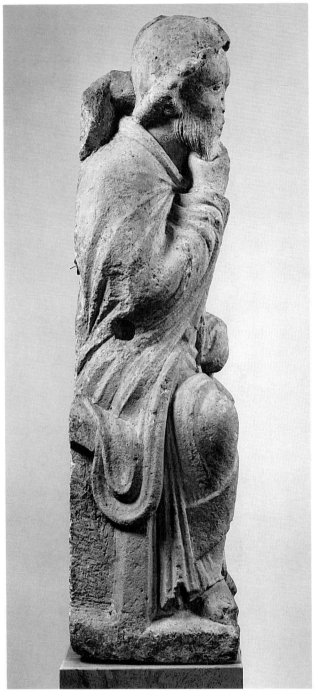

Fig. 9. Prophet, view of left side

occur in exactly the location where this one terminates: perhaps the sculpture was damaged during its removal from its setting or was intentionally reduced to a bust to render it more salable. Like the Lugano prophet, the Duke torso emphasizes a taut yet pliant drapery and linear surface patterns; but even in its fragmentary state, the torso conveys a stronger sense of movement and torsion. Turned sharply to the right and looking downward, the face is severely damaged (the drilled right pupil is not

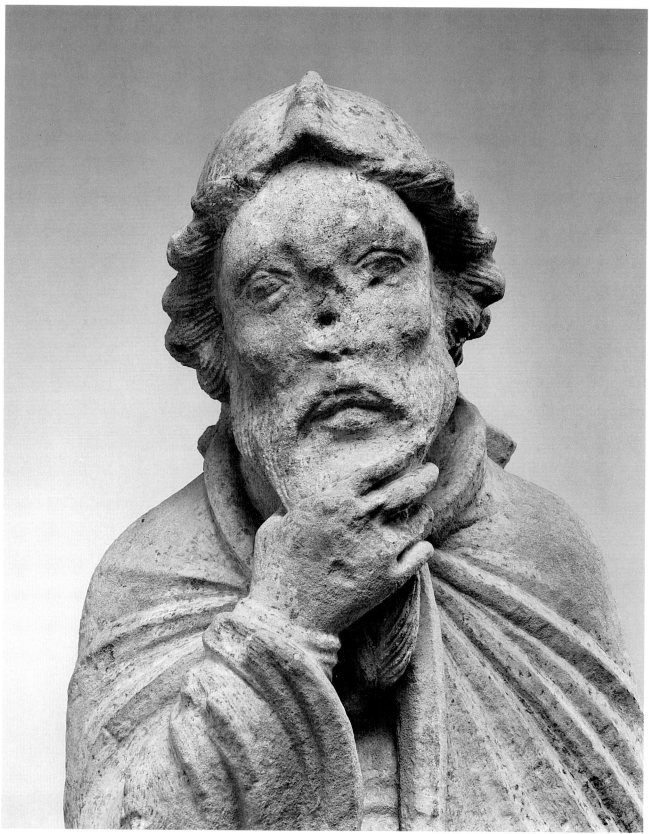

Fig. 10. Prophet, detail

original to the piece). The area behind the neck, where a nimbus might have once been attached, appears to be planed down and now carved with strands of hair. The object on which the figure's gaze is focused is an enigma; it appears to be the upper part of a cross, or tau, possibly with a portion of the banner attached to it. If so, the figure could be identified as John the Baptist, who often holds the disk with the Agnus Dei surmounted by a cross and banner, as seen, for example, on the central doorway of the north transept at Chartres.[22] This seems the only identification that is consistent with an iconographic program encompassing the other seated Old Testament figures, for these sculptures must together form a series of Christophores, the important forerunners of Christ.[23]

The fifth member of this group, the seated Virgin and Child, is critical to establishing the origin, date, meaning, and function of the now-dispersed sculptures as an ensemble (Figs. 15, 16). Positioned until 1918 on the trumeau of the west central portal of the cathedral of Notre-Dame at Noyon, the statue is now in the cloister of the cathedral, which serves as the Dépôt Lapidaire.[24] The sculpture was severely mutilated in the bombardment of the cathedral during World War I, when the heads and hands of both figures were lost, along with upper portions of the Child's torso. Prewar photographs show the Child standing in three-quarter view on the lap of the Virgin, his right hand in benediction and his left grasping his mother's hand (Fig. 16). The photograph indicates that the head of the Virgin, originally crowned, had been cut and reset, possibly not at the original angle. To judge from the measurements of its present damaged state, the figure was originally slightly taller than the prophets. Overall, the dimensions (in cms) of all the figures are nearly identical:

	Moses	"Aaron"	Lugano prophet
H.	125	128	125
W.	40	44	44
D.	34	33.5	32

	Noyon Virgin	"John the Baptist"	torso of "Aaron"
H.	126	48	51
W.	42.5	39	40.5
D.	34	21	21

Fig. 11. Head of a Man, probably from the Porte des Valois, Saint-Denis, ca. 1170, H. 21 cm. Paris, Musée du Louvre (photo: courtesy of the Museés nationaux)

The Virgin shares with the Old Testament figures the same type of slanting bench, bore holes in the area around the elbows (but, as with the Moses figure, now filled with cement), and a drapery system of long, pliant folds combined with a system of fine curvilinear patterns terminating with an undercut flaring hem. Like that of Moses, her drapery possesses a single dominating loop of fabric in the front that drops from her sleeve to the right knee. Here, some elements of fantasy and playfulness of organization replace the logic and consistency characteristic of the drapery of the Moses.

The relationship between the Noyon Virgin and Child and at least one of the Old Testament figures is not a new idea. Shortly after the "Aaron" figure was bequeathed to the Metropolitan Museum in 1921, Johnny Roosval, the Swedish art historian, recognized the Noyon Virgin as influenced by the sculpture of Senlis and considered the New York priest to be clearly related to those works.[25] Now not only the Noyon Virgin and the "Aaron" figure but also, by extension, the other figures represent a small number of works directly influenced by, or contemporary with, the sculpture at Senlis Cathedral.

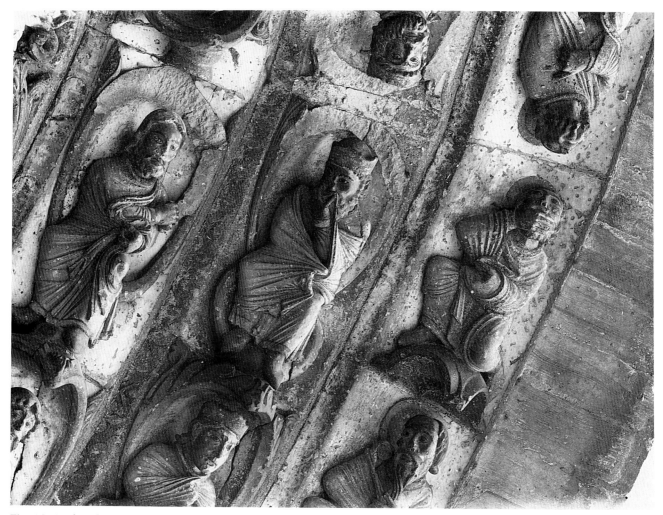

Fig. 12. Archivolt Prophets, from Senlis Cathedral, ca. 1170 (photo: Marburg/Art Resource, N.Y.)

The Noyon Virgin is a free interpretation of the Virgin in the tympanum at Senlis (Fig. 13), but with the handling of the forms heavier, the composition more tranquil, and the drapery marginally less articulated and sensitive. Curvilinear flowing folds dominate, with their pleating in metallic ridges more prominent and decisively linear. Elements of this mannerism in drapery are also evident in several carved wood statues of the Throne of Wisdom type made within the orbit of the Senlis style: for example, the figure now at Jouy-en-Josas (Yvelines), where the Virgin holds the Child in a similar way with a loop of drapery in her left hand (Fig. 17).[26] Here, too, the Child is shown standing in three-quarter view (although supported by two angels) and gesturing in benediction. The physiognomies are also comparable.

If these three Old Testament figures, "John the Baptist," and the Virgin and Child form a cohesive ensemble, how are we to account for the subtle stylistic disparities among them? If separate models—such as the one suggested for the Virgin and Child—were used, they might help to explain the nuances of the formal language among them. Likewise the possibility that different sculptors may have contributed to this enterprise would also help to explain the stylistic differences within the group. Inasmuch as there were three hands working at Saint-Denis in the twelfth century, there are precedents for this workshop practice.[27] Our perceptions of these figures today are conditioned as much by their varying states of preservation—clearly in recent centuries each has had a different environmental history—as by their inherent idiosyncrasies of style. Despite these impediments, it is possible to discern at least two different sculptors at work on the figures. As noted previously, there are similarites between

244

the Lugano prophet, the "Aaron" figure, and the Virgin and Child, which suggest that they are by one hand and that the Moses is by another.

The most striking single feature of the monumental ensemble is the pose. Because all these life-size figures are seated, they constitute an ensemble without precedent in French Gothic sculpture and without a following. Despite this unique situation, the origin of the group can now be established. And because the figures relate stylistically to the Virgin at Noyon, it can be hypothesized that the provenance for the entire group is Noyon Cathedral. The context, function, and significance of this ensemble for Noyon Cathedral are, however, clouded by several factors: the order in 1793 of the assembly in Paris to destroy the sculptural decoration of both the transepts and the west portals of the cathedral at Noyon; the extensive restorations of the cathedral carried out between 1840 and 1910, which altered the decoration of these areas; and finally the enormous damage caused by the bombardment during World War I, which also destroyed the archives of the city.[28] Charles Seymour's statement that "destruction has dealt harshly with the sculpture of the cathedral" understates the magnitude of the losses.[29] These particular sculptures seem to have survived because they were conceived as semi-independent units and were not physically incorporated into the architecture as, say, column figures or voussoirs. The deep bore holes on their sides could well have been made to facilitate their rescue from their original context.

It is occasionally assumed that the statue of the Virgin and Child was originally designed for the place it occupied on the west portal in 1918.[30] The subject of that portal, also destroyed in 1793, was in all probability a Last Judgment and had a trumeau depicting Christ.[31] Moreover, the date of the west front of the cathedral, built about 1205–35, further reduces the possibility that this Virgin was ever designed (or intended) for the facade. Descriptions from the early nineteenth century make no mention of her in that location, thus strongly suggesting that she was put there—as a patron image—only during the restorations.[32] Nevertheless, because of the sheer physical size of this and the other figures and the amount of space they would have occupied, they could have been intended only for the cathedral itself and not for one of the other local churches, all since destroyed, which were much smaller in

Fig. 13. Virgin, from the tympanum of Senlis Cathedral, ca. 1170 (photo: Marburg/Art Resource, N.Y.)

scale. The factor of size raises the critical question as to what spaces in the twelfth-century parts of the cathedral could have accommodated this group. There is a nineteenth-century reference by Moët de la Forte Maison to a "Vierge antique" originally in the south transept of the cathedral.[33] Supposing for the moment that Moët was indeed referring to the Virgin and Child, how might its placement in this location correspond to the first phases of the construction and decoration of the cathedral?

Construction of the Gothic cathedral began sometime after a major fire in 1131 that destroyed the earlier church. The first phase of construction,

Fig. 14. John the Baptist(?), from Noyon Cathedral, ca. 1170, H. 48 cm. The Ernest Brummer Collection, Durham, North Carolina, Duke University Museum of Art (photo: courtesy of Duke University Museum of Art)

which included the choir, presumably had progressed far enough by 1157 to celebrate the translation of the relics of St. Éloi. According to Charles Seymour, there may have been a break before the start, around 1155–60, of the second phase that included the completion of the choir and "apparently the periphery of the south arm of the transept to a height of two feet."[34] At any rate, a second translation of relics in 1167 indicates that the choir and possibly the transepts were then liturgically functioning spaces.[35] Since the entrance to the choir of the Early Gothic church was through the transept portals, these entryways, which Seymour dates about 1160–70,[36] would be expected to have contained extensive decorative sculpture. One of the novel and striking features of Noyon is the design of the transepts, each of which terminates in an apse without a portal on the axis. Instead, the portals are oriented toward the chevet on the east flank of both transepts (Fig. 18). This unusual portal orientation may have been dictated by the placement

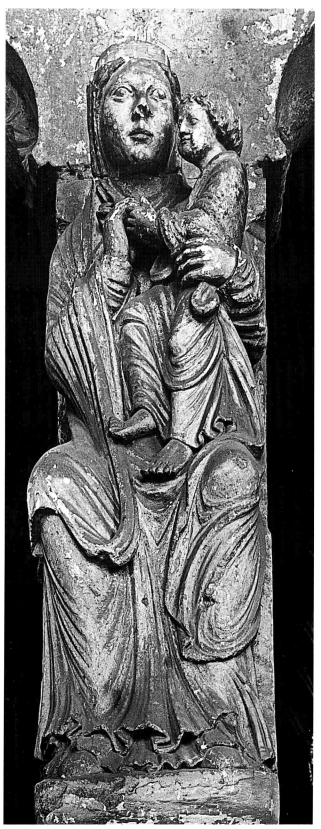

Fig. 15. Virgin and Child, state before 1918, Noyon Cathedral, ca. 1170 (photo: Marburg/Art Resource, N.Y.)

of the bishop's chapel—completed at least by 1183—immediately adjacent to the south transept[37] and by the location of the Salle du Trésor—vaulted around 1170—adjacent to the north transept. Both structures virtually eliminated any possibility of placing the transept portals on the axis of the crossing arms. The Portail Saint-Pierre of the north transept faced the parish church of Saint-Pierre. Except for some superbly carved capitals in the embrasures, the decoration of this portal is completely mutilated (but Lefèvre-Pontalis indicates that the tympanum showed Christ between two angels).[38] The slender colonnettes of the jambs and the overall design of this entryway exclude the possibility of a monumental figure group originating from it.

By the fifteenth century at least, the south transept portal was known as the "Portail des Merciers," possibly a donation of the mercers' guild (Fig. 18).[39] But it is now called the Portail Sainte-Eutrope, after the martyred saint who was the sister of St. Nicaise, bishop of Reims. There are apparently no known descriptions of the decorative program of this portal before its mutilation during the French Revolution. The only visual evidence of it is in a fairly accurate watercolor drawing of the cathedral's chevet executed just before the French Revolution, by Tavernier des Jonquières, which shows the Portail Sainte-Eutrope in the background (Fig. 19).[40] As a result of the extensive nineteenth-century restorations, this Early Gothic portal today retains only vestiges of the original design (Figs. 20, 21).

The portal, usually dated to about 1160–70,[41] is composed of four orders resting on colonnettes surmounted by a gable, a form common to the Île-de-France. Its overall character was so heavily damaged before it was restored around 1850 by Verdier, an architect of the school of Viollet-le-Duc, that hardly a trace of the richness of its program remains. Tavernier's drawing is, therefore, very significant because it shows the portal as having a trumeau, statues on the embrasures, and a tympanum with a five-figured centralized composition whose subject cannot be discerned from the drawing.[42] Even in its mutilated state there are features of the portal that are highly original, if not unorthodox. Unlike other Early Gothic portals, the splays of the doorway were never intended to receive jamb statue columns integrated into the architecture (Fig. 21). Such a disposition requires a different system of colonnettes and architectural bases laid against the plane of the

Fig. 16. Virgin and Child, state after 1918, H. 126 cm. (photo: author)

receding wall and surmounted by capitals and possibly canopies. Instead, the south transept portal at Noyon presents a quite novel solution. The jamb wall above the plinth level contains three massive columns on each side with two smaller intermediate colonnettes. These are surmounted by a continuous acanthus capital frieze, and an abacus that becomes the support for a rectangular platform, now measuring 24 by 156 cm—the platform was originally considerably deeper, but the wall has been built out as part of the restoration. With this arrangement

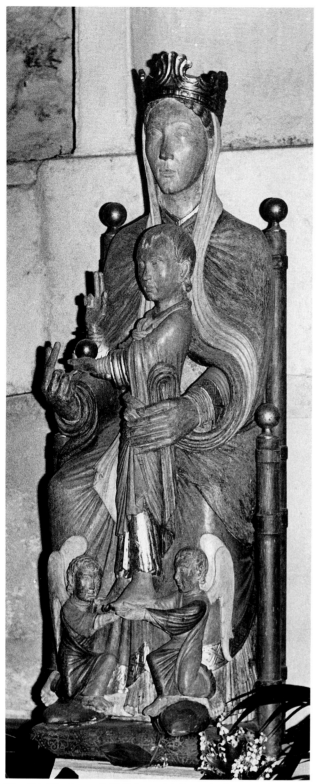

Fig. 17. Virgin and Child, ca. 1170, polychromed wood, H. 140 cm. Jouy-en-Josas (Yvelines) (photo: Ilene Forsyth)

it is impossible to envisage the use of jamb statue columns originally filling the expansive flat wall. It is clear that the portal design once included three architectural canopies for the individual statues on the platform on each side; these projecting elements are now almost totally sheared off near the wall.

The size of the platform, the thickset proportions of the three columns, capitals, and canopies, and the space between these elements only allow for seated figures on either side of the entrance. The New York and Lugano figures could fit exactly in this area and still allow for 12 cm of space between each of them. Logically the only conceivable location for the Virgin and Child would be the trumeau in the center of the group, making the earlier statement of Wilhelm Vöge strike us now as very close to the truth: "Vieleicht hat Sie ursprünglich den Mittelpunkt eines Propheten Portals mit Statuengruppen gebildet."[43] The pose and orientation of the Child on the lap of the Virgin depart from the more rigid frontal poses characteristic of the *Sedes Sapientae*, but are not unlike the more natural poses of the near-contemporary figures from Saint-Martin at Angers (Fig. 27), or the wood figures at Jouy-en-Josas (Fig. 17), or the Virgin and Child at Limay.[44]

Even more unusual than the platform arrangement, however, is the phenomenon of a seated group on a portal. For no other Early Gothic portal, so far as we know, was this method selected of displaying life-size statue figures on a plinth on either side of an entrance. Although the idea of life-size seated figures was not new—it was already an integral feature of the facade at Notre-Dame-la-Grande at Poitiers—the figures are invariably conceived in high relief and usually integrated into arcades on the upper part of the facade. Occasionally this approach is incorporated into Early Gothic facade designs in the Île-de-France: for example, at both Berteaucourt-les-Dames (Somme) and Honnecourt (Nord) such figures are key elements in the organization of the upper facade.[45]

The subject of the tympanum of the south transept portal at Noyon probably would have been the Coronation of the Virgin (or, less likely, the Adoration of the Magi) with three seated Old Testament figures on either doorjamb, each aligned with a column on the plinth below. The identity of the other two missing seated figures on the embrasures is unknown, but the focus of all of them would have been the seated Virgin and Child on

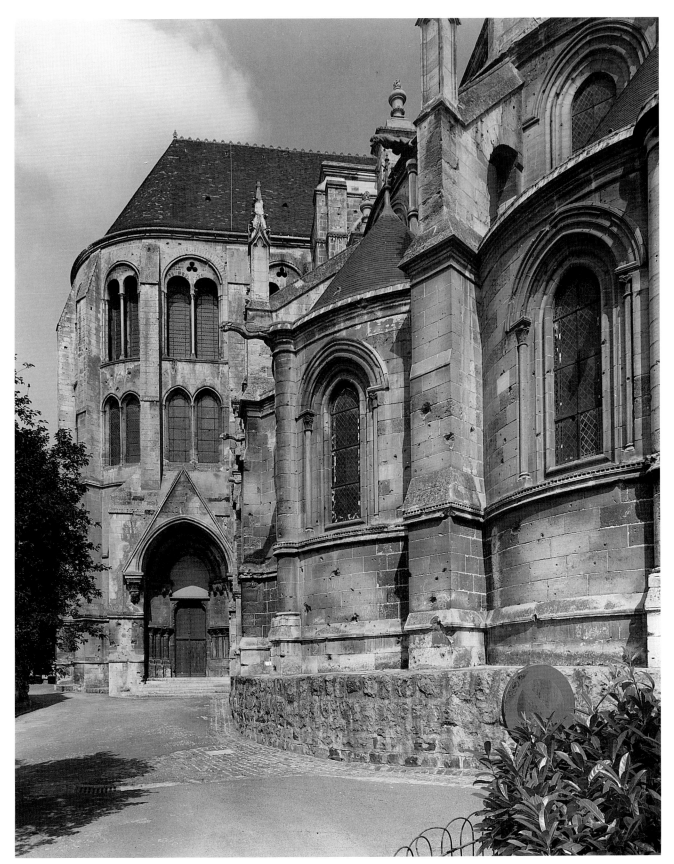

Fig. 18. Choir and south transept, Noyon Cathedral, ca. 1160-80 (photo: Courtauld Institute of Art, London)

Fig. 19. Tavernier de Jonquières, detail of a drawing of the cathedral from the east, just before the French Revolution. Paris, Bibliothèque Nationale, Cabinet des Estampes (photo: Bibliothèque Nationale)

are the vestiges of sculptural decoration still in situ. The corbels on either side of the door that support the lintel each have compact figures, now much defaced, but which give us a glimpse of the original character of the decorative program. The best-preserved corbel, on the right, is of a bearded figure in a crouching posture (Fig. 22). Wrapped in tight draperies, his stereometric body serves to emphasize the full plasticity of the form in a way that is nearly identical to the New York and Lugano figures. This close conceptual and stylistic relationship between the corbels and the seated prophets further advances the hypothesis that the ensemble originated from this portal. The unity of each sculpture within the group and to Noyon itself can also be confirmed, it is hoped, by geological (petrographic and neutron activation) analysis of the limestone employed in these carvings, and the relationship to the quarries that provided stone for the construction and decoration of Noyon Cathedral.[48]

A juxtaposition of a current view of the portal with the drawing of it by Tavernier will immediately reveal critical differences in proportions (Figs. 18–20). It is clear that the restorations of 1840–45 were

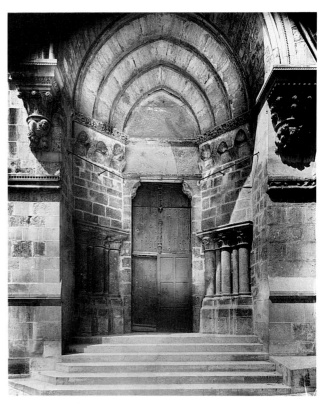

Fig. 20. South transept portal, Noyon Cathedral, ca. 1170 (photo: Marburg/Art Resource, N.Y.)

the trumeau. Such an arrangement bears all the hallmarks of an iconographic program dedicated to the Christofores. Conceptually this thematic arrangement of a Christophores group with the Coronation of the Virgin is not unlike the central portal at Mantes, which, according to both the description of Guilhermy and the engraving published by Millin, had on the trumeau below the Coronation a standing Virgin that was destroyed in the Revolution.[46] Since the tympanum of the north transept at Noyon was dedicated to Christ, it is logical that the south transept tympanum should celebrate the celestial triumph of the Virgin. It is perhaps not by chance that in designing the iconographic program of the west portals of the cathedral, completed about 1235, homage was again paid to these themes in the central and right portal.[47]

The most striking stylistic corroboration of these Early Gothic sculptures having come from this portal

focused on this area of the cathedral because of damage caused by the defacing of the portal in 1793 and other structural problems.[49] The watercolor is more useful for the architecture of the portal than for details of the subjects depicted on it. Because the portal is a small detail within the scene the trumeau does not show any figure, and it is impossible to determine whether the figures on the raised socle are seated. If we can trust the proportions of the portal in the Tavernier drawing, however, the Virgin on the trumeau presided over a less restricted portal opening than is seen now. How can the wide expanse of the doors on either side of the trumeau, as seen in the Tavernier drawing, be reconciled with the present slender opening? From an examination of the fabric of the building, it is certain that when the portal was reset during the restorations, the

Fig. 22. Doorway corbel, south transept, Noyon Cathedral, ca. 1170 (photo: Courtauld Institute of Art, London)

Fig. 21. Right embrasure, south transept portal. Noyon Cathedral (photo: author)

embrasures of the door were moved inward, and that the corbels were reset *after* the trumeau was removed. The entryway was narrowed in order to create additional support for the lintel and tympanum, whose weight would otherwise render them extremely precarious without a trumeau. It is possible artificially to "resurrect" this part of the portal program with these seated figures and to correct its proportions by means of a photomontage (Fig. 23). Conceptually and stylistically, this sculptural ensemble is appropriate to this portal space.

The seated arrangement of figures around an entryway on a raised socle presents an experimental form of portal programming and layout that did not become a model for other Gothic portal designs. Without prototypes for seated trumeau and embrasure figures in the Île-de-France, the concept appears to have been introduced at Noyon. Unlike statue columns—which suggest a fusion of architectural function with linear and vertical emphasis—a group of seated figures negates the idea of a tectonic function as a supporting member of the architecture.

251

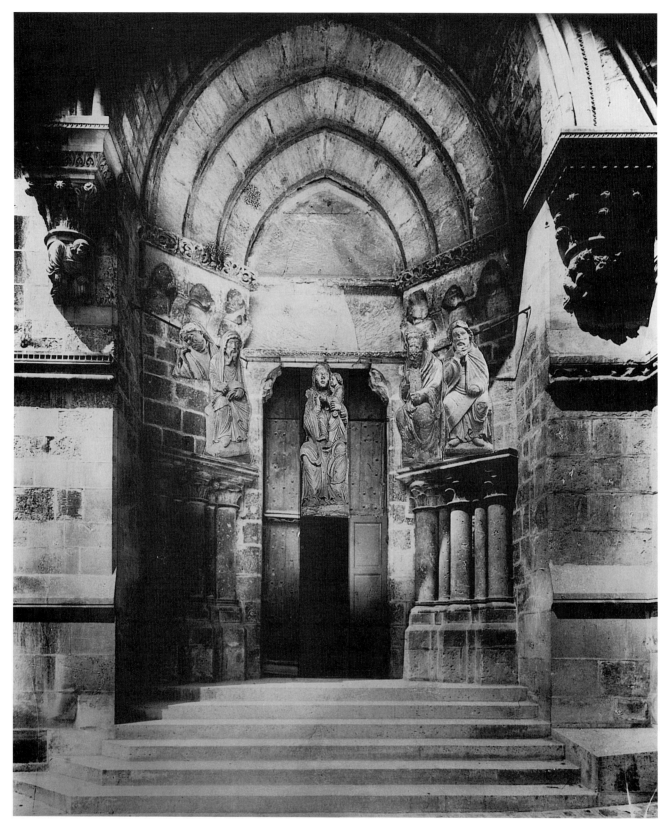

Fig. 23. Hypothetical reconstruction of south transept portal: photomontage (author and Bruce Schwartz)

Fig. 24. Vault boss head, choir, gallery, apse, Noyon Cathedral, ca. 1160s (photo: Marburg/Art Resource, N.Y.)

Fig. 25. Vault boss with Blessing Christ, choir, gallery, ambulatory, Noyon Cathedral, ca. 1160s (photo: Marburg/Art Resource, N.Y.)

In terms of experimentation, Noyon—like nearby Laon Cathedral—elsewhere shows itself to have been at the forefront of Gothic architecture: witness the four-story elevation of the choir and the dazzling effects of light and space produced by the rounded transepts. Moreover, the novel and experimental character of this portal sculpture was adumbrated in the interior decoration, especially in the tribunes of the choir, where "un chantier de premier ordre" was already producing forms that have an amazing verisimilitude.[50] Four of the keystones in the vaults of the choir tribune, plus others on the ground story, have a series of carved human heads. As if springing from life, these astonishing essays in variant physiognomies are the precursors of the expressive grotesques of Reims Cathedral. At least one of the

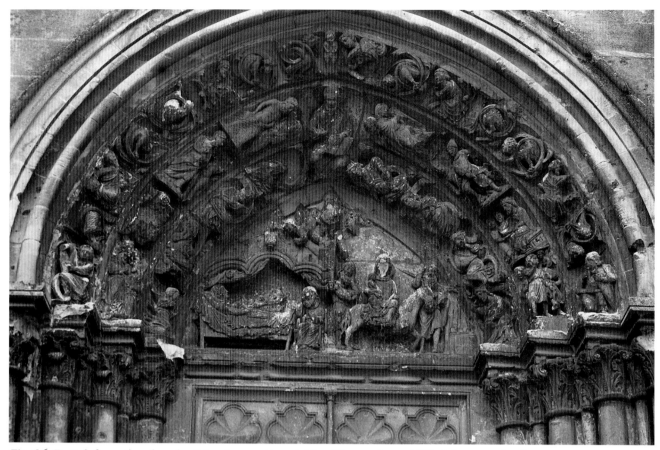

Fig. 26. Portal, from the church of the Assumption, Athies (Somme), ca. 1180 (photo: author)

faces bears a striking resemblance to the prophet in Lugano, with the same emphasis on high cheekbones, sunken eye sockets, and fleshy, down-turned lips (Figs. 10, 24).[51] The heads both on the ground story and in the tribunes are supplemented by more complete figures in the vaulting bosses— a seated blessing Christ with an open book (Fig. 25), a half-length profile figure caught up in a band of drapery, a seated king with a baton, and a Lamb of God.[52] Several of the spandrels of the tribune arcades have reliefs of angels with scrolls which are also evidently the work of the same sculptors. These angels and many other Early Gothic figurative sculptures at Noyon bear some resemblance to the portal sculpture at Senlis, already noted for the Noyon portal group.[53]

These interrelationships raise fundamental questions concerning not only the chronology of the building campaigns at Noyon but also the association of the sculptors with Senlis and Mantes and their influence on later monuments. Since the

masks, bosses, and angel reliefs in both levels at Noyon are probably by the same sculptors, they are integral to the construction of the tribunes and must date to the second campaign, begun by 1155-60 according to Seymour,[54] and possibly completed by 1167, when the remains of St. Godeberte were translated from the abbey of that name to the cathedral,[55] or at the latest by 1185, when the choir was certainly finished, because bell ringers had been appointed.[56] Senlis precedes Noyon for architectural as well as stylistic reasons. The facade sculpture of Senlis has recently been dated to about 1165, based on the form of the capitals and the base profiles and on the chronological and stylistic relationship to other churches in the Paris basin.[57] The left doorway at Mantes is usually dated on stylistic grounds to about 1170 and the central portal toward 1180; the Noyon transept decoration must be nearly contemporary. Although there are similarities in the use of curvilinear and flowing folds, the construction of the folds in the Noyon sculpture has more

prominent ridges that are distinctly rectilinear. This suggests that the Noyon sculptors were familiar with Senlis and Mantes and possibly were trained at these sites.

It is a curious fact that the sculpture of neither Senlis, Mantes, nor Noyon had very much stylistic influence on the formation of the next generation of Gothic sculpture at Laon, Sens, and Chartres. The impact of the Noyon sculptors is felt more in their immediate vicinity. In terms of Early Gothic sculptural decoration, the Oise valley is still very much an open question because of the extensive losses suffered from war and the Revolution. The only surviving contemporary and local work is the small portal of the priory church of Notre-Dame-de-l'Assomption at Athies (Somme), founded in 1178, partly destroyed in World War I and heavily restored, which has a tympanum depicting the Nativity and the Flight into Egypt, surrounded in the voussoirs by Old Testament ancestors of the Virgin (Moses, Aaron, Jacob, and David) and other scenes of the early life of Christ (Fig. 26).[58] This portal, like the Noyon transept portal, again seems to contain unorthodox features, such as the selection of narrative themes for the tympanum. Stylistically Athies presents a comparable orientation, with figures wrapped in linear metallic drapery.

The extent of the influence of the Noyon sculpture is still uncharted. Clear and unmistakable evidence of it exists not in the Île-de-France but farther afield at Saint-Martin in Angers. The former trumeau Virgin from that church (Fig. 27) is surprisingly like the Noyon Virgin in the form of the seated figure with standing Child, especially in his mobile posture, and also in the fluidity of the drapery (Figs. 15, 16).[59] This figure and the four attendant standing saints were made for a portal that was never built, and the statues were subsequently placed under the vaults of the choir. The Angers Virgin seems to have been carved with direct knowledge of the Noyon sculpture. The link between Noyon and Angers is even more demonstrable in the triple-ordered corbels of the crossing piers at Noyon that are nearly replicated in the angel chapel at Saint-Martin toward the end of the twelfth century (Figs. 28, 29). Although none of the Angers sculptures is by the Noyon sculptors themselves, knowledge of them seems unmistakable.[60] The migration of these forms from the Oise valley to Angers presents as much of an enigma as the unique

Fig. 27. Virgin and Child, from the church of Saint-Martin at Angers, ca. 1180s. New Haven, Yale University Art Gallery (photo: courtesy of Yale University Art Gallery, Gift of Maitland F. Griggs)

255

Fig. 28. Corbel, northwest crossing pier, nave, Noyon
Cathedral, ca. 1170-85 (photo: Marburg/Art Resource,
N.Y.)

physical character of the south transept portal at
Noyon itself.

The heterogeneous stylistic character of the
Noyon sculpture and the originality of the design
of the portal seem to have resulted in an artistic
cul-de-sac. The reason for the ultimate failure of this
experiment resides primarily in the contradiction of
the formal values produced by an ensemble of
seated, rather than standing, figures. Despite this
failure, the stylistic links are provocative. The Noyon
sculptures provide one clear indication that the
Senlis style was not an isolated phenomenon. This
partial reconstruction of the program of the south
transept portal at Noyon, furthermore, increases our
understanding of one of the pivotal moments in the
complex history of the formation of Gothic art.

ACKNOWLEDGMENTS

The work of Willibald Sauerländer has greatly
enlarged and profoundly enriched our understand-
ing of Gothic sculpture. At an early stage of this
study—now offered as a tribute to him—I benefited
from his wise and most welcome counsel. My thanks
also to the following for stimulating discussions and
advice on Noyon and its sculptural decoration: John
Cameron, William Clark, John James, Philippe
Plagnieux, Dany Sandron, and Paul Williamson.

NOTES

1. Aubin-Louis Millin, *Antiquités Nationales,* 7 vols. (Paris, 1790–
1802); Dom U. Plancher, *Histoire générale et particulière de
Bourgogne* (Dijon, 1739); Bernard de Montfaucon, *Les
monumens de la monarchie françoise* (Paris, 1729); Jean
Mabillon, *Annales Ordinis S. Benedicti* (Paris, 1703–09); J. de
N. Morellet, S. B. F. Barat, and E. Bussière, *Le Nivernois. Album
historique et pittoresque* (Nevers, 1838–40). See, for example,
those illustrated in Willibald Sauerländer, *Gothic Sculpture in
France 1140–1270* (New York, 1970), figs. 1–4, 8–10, 19, 24,
43, 45.

2. Sauerländer, *Gothic Sculpture,* fig. 53.

3. Sylvia and Léon Pressouyre, *Le Cloître de Notre-Dame-en-
Vaux* (Nancy, 1981); Sylvia Pressouyre, *Le cloître disparu* (Paris,
1970); François Giscard d'Estaing, Michel Fleury, and Alain
Erlande-Brandenburg, *Les rois retrouvés* (Paris, 1977); Alain
Erlande-Brandenburg, *Les sculptures de Notre-Dame de Paris
au musée de Cluny* (Paris, 1982); idem, "Le saint Marcel du
portail Sainte-Anne de Notre-Dame de Paris: sa 'dérestauration,'"
Revue du Louvre 3 (1985), pp. 174–84.

4. Léon Pressouyre, "Le Gisant de Gassicourt (XIIe siècle),"
Monuments et Mémoires Piot 66 (1983), pp. 55–66; Willibald
Sauerländer, "Die Kreuzabnahme in Coudres," *Études d'art
français offertes à Charles Sterling* (Paris, 1975), pp. 23–29;
Diane Brouillette, *Senlis, un moment de la sculpture gothique,*
exhib. cat., in *La sauvegarde de Senlis* 45–46 (1977), no. 47;
Léon Pressouyre, "Une tête de reine du portail central de Saint-
Denis," *Gesta* 15/1–2 (1976), pp. 151–60; Fabienne Joubert,
"La Tête de Moïse du portail sud de la façade occidental de
Saint-Denis," *Monuments et Mémoires Piot* 71 (1990), pp. 83–
96. Alain Erlande-Brandenburg, "Un Gisant Royal du milieu du
XIIe siècle provenant de Saint-Germain-des-Prés," *Bulletin
archéologique* (1981), pp. 33–50.

5. Léon Pressouyre, "Une statue-colonne complétée au musée
de Cluny," *Études d'Art Médiéval offertes à Louis Grodecki* (Paris,
1981), pp. 155–66.

6. See F. Furlan, R. Pancella, and T. A. Hermanès, *Portail peint de la Cathédrale de Lausanne: Analyses pour une restauration* (Lausanne, n.d., ca. 1981); E. Deuber-Pauli and T. A. Hermanès, "Le portail peint de la cathédrale de Lausanne: Histoire, iconographie, sculpture et polychromie," *Nos monuments d'art et d'histoire* 32 (1981/2), pp. 262-74. On the Porte de Valois, which is in the process of being cleaned and restored, see Diane C. Brouillette, "The Early Gothic Sculpture of Senlis Cathedral" (Ph.D. diss., University of California, Berkeley, 1981), pp. 383–425. On the Royal Portal of Chartres, see G. Nicot, "Le Portail Royal restauré," *Notre-Dame de Chartres* (June 1984), pp. 5–15. The study of limestone as an aid to provenance has also proven to be an important new research tool. See Jean M. French, Edward V. Sayre, and Lambertus van Zelst, "Nine Medieval French Limestone Reliefs: The Search for a Provenance," in Pamela A. England and Lambertus van Zelst, eds., *Application of Science in the Examination of Works of Art* (Boston, The Research Laboratory, Museum of Fine Arts, 1985), pp. 132–40; Lore J. Holmes, Charles T. Little, and Edward V. Sayre, "Elemental Characterization of Medieval Limestone Sculpture from Parisian and Burgundian Sources," *Journal of Field Archaeology* 13 (1986), pp. 419–38.

7. See Walter Cahn and Charles Little in *Radiance and Reflection, Medieval Art from the Raymond Pitcairn Collection,* exhib. cat., The Metropolitan Museum of Art (New York, 1982), no. 42; Paul Williamson, *The Thyssen-Bornemisza Collection: Medieval Sculpture and Works of Art* (London, 1987), cat. no. 1.

8. José Manuel Pita Andrade ("Una escultura del estilo de Maestro Mateo," *Cuadernos de estudios Gallegos* 6 [1950–51], pp. 289–436) advanced the unsustained hypothesis that the Moses was created for the choir screen of Santiago de Compostela in the 1160s, a work of the workshop of Master Mateo.

9. The Lugano prophet was said by the dealer to be attributed to the church of Saint-Bénigne, Dijon (Williamson, *Medieval Sculpture*, p. 32 n. 1). Joseph Brummer, who sold the Moses figure (in collaboration with Lucien Demotte) to Raymond Pitcairn, claims it came from a church 13 km from Chartres (information kindly provided by the Reverend Martin Pryke, former Director, Glencairn Museum, Bryn Athyn, Pennsylvania, from letters in the files of Raymond Pitcairn). The "Aaron" figure was also "said to have come from Chartres Cathedral," perhaps, in part, because it was possibly in a private collection in Chartres (Joseph Breck, "Sculpture and Decorative Art," *MMAB* 12 [May 1922], p. 106).

10. Pita Andrade, "Una escultura"; Vera K. Ostoia, *The Middle Ages: Treasures from The Cloisters and The Metropolitan Museum of Art,* exhib. cat., Los Angeles County Museum and The Art Institute of Chicago (1970), no. 47; Cahn and Little in *Radiance and Reflection,* no. 42.

11. Breck, "Sculpture," pp. 106–8.

12. James R. Rorimer, *Ultra-Violet Rays and their Use in the Examination of Works of Art* (New York, 1931), p. 26, fig. 17.

13. Léon Pressouyre, "La 'Mactatio Agni' au portail des cathédrales gothiques et l'exégèse contemporaine," *Bulletin monumental* 132/1 (1974), pp. 49–65.

14. See illustrations in ibid., figs. 1, 3, 4.

15. Williamson, *Medieval Sculpture*, cat. no. 1.

16. H. W. Janson, "The Right Arm of Michelangelo's Moses," *Festschrift Ulrich Middeldorf* (Berlin, 1968), pp. 241–47.

Fig. 29. Corbel, Angel Chapel. Saint-Martin, Angers, ca. 1180s (photo: Marburg/Art Resource, N.Y.)

17. For the drawing of a prophet holding his beard at Saint-Denis, see Montfaucon, *Monumens*, vol. 1, pl. 18, and Sauerländer, *Gothic Sculpture*, fig. 3; for a similar figure in the Tree of Jesse of Paris, Bibl. Nat., MS lat. 8846, fol. 42; H. Omont, *Psautier illustré XIIIe siècle, Paris, Bibliothèque Nationale* (Paris, n.d.), pls. 15, 38.

18. Brouillette, *Senlis, un moment*, no. 36. The fragment came to the Louvre in 1899 from the *chantiers* of Saint-Denis.

19. Williamson, *Medieval Sculpture*, cat. no. 1.

20. Photo Marburg nos. 36647, 36651. In some respects the more metallic quality of the drapery can be better compared to the voussoir figures at Mantes; cf. no. 39846. See also Sauerländer, *Gothic Sculpture*, pls. 44–46.

21. Acq. no. 1966.121. Gift of Ernest Brummer. See Caroline Bruzelius with Jill Meredith, *The Brummer Collection of Medieval Art: The Duke University Museum of Art* (Durham/London, 1991).

22. Sauerländer, *Gothic Sculpture*, pl. 86.

257

23. On the theme of the Christophores, see Willibald Sauerländer, "Sens and York: An Enquiry into the Sculptures from St. Mary's Abbey in the Yorkshire Museum," *Journal of the British Archaeological Association*, 3d Series, 22 (1959), pp. 53–69; Émile Mâle, *Religious Art in France, The Thirteenth Century: A Study of Medieval Iconography and Its Sources*, ed. Harry Bober and trans. Marthiel Mathews (Princeton, 1984), pp. 157–71.

24. Charles Seymour, *Notre-Dame of Noyon in the Twelfth Century: A Study in the Early Development of Gothic Architecture* (New Haven, 1939; rev. ed., New York, 1968), p. 168; Willibald Sauerländer, "Die Marienkrönungsportale von Senlis und Mantes," *Wallraf-Richartz Jahrbuch* 20 (1958), pp. 115–62. Brouillette, *Senlis, un moment*, no. 41.

25. Johnny Roosval, *Romansk Konst* (Stockholm, 1930), p. 148, figs. 116, 121. More recently this relationship with Noyon has been further elaborated with respect to the Moses by Cahn and Little in *Radiance and Reflection*, no. 42, and for the Lugano prophet in the Thyssen-Bornemisza catalogue by Williamson, *Medieval Sculpture*, no. 1.

26. Ilene Forsyth, *The Throne of Wisdom, Wood Sculptures of the Madonna in Romanesque France* (Princeton, 1971), Reg. 103, fig. 183. Also the superb Virgin in the Fogg Art Museum (Harvard University), which has been attributed to Senlis, bears a striking physiognomic relationship to the Noyon Virgin: see ibid., Reg. 102, figs. 178–81.

27. In general, see Whitney Stoddard, *Sculptors of the West Portals of Chartres* (New York/London, 1952, 1986), pp. 4–8, 113–21.

28. A full account of the cathedral and its subsequent history is found in the masterful study by Charles Seymour (*Noyon* [now trans. as *La Cathédrale Notre-Dame de Noyon au XIIe Siècle* (Geneva, 1975)]). For more recent discussions, see the Courtauld Institute Illustration Archives, Archive 3, Medieval Architecture and Sculpture in Europe, pt. 29, *France: Noyon Cathedral*, ed. Lindy Grant (London, 1983); *La Ville de Noyon, Cahiers de l'Inventaire* 10 (Amiens, 1987); Maryse Bideault and Claudine Lautier, *Île-de-France Gothique*, vol. 1: *Les églises de la vallée de l'Oise et du Beauvaisis* (Paris, 1987), pp. 246–71. William Clark and John Cameron are preparing a companion text to the Courtauld Institute Illustration Archive on Noyon Cathedral that will supplement the Seymour monograph.

29. Seymour, *Noyon*, p. 168.

30. Ibid., p. 168.

31. Eugène Lefèvre-Pontalis, "Noyon," *Congrès archéologique* (1905), p. 180 (cf. idem, "Histoire de la cathédrale de Noyon," *Bibliothèque de l'École des Chartes* 61 [1900], p. 289 n. 4; and idem, *Cathédrale de Noyon*, Extrait des Mémoires du Comité Archéologique et Historique de Noyon, 17 [1901], p. 43).

32. Alphonse Dantier (*Description Monumental et Historique de l'Église N.-D. de Noyon* [Noyon, 1845], pp. 68–70) only mentions the Virgin high on the apex of the pediment between the towers, whereas L. A. Moët de la Forte Maison (*Antiquités de Noyon* [Rennes, 1845], pp. 265–66) records only "quatre statues d'évêques ou autres personages" on the lateral doors. Curiously, M. L. Vitet (*Monographie de l'Église Notre-Dame de Noyon* [Paris, 1845]) also omits mention of the statue, but in the accompanying plans and elevations by Daniel Ramée (pl. 3) the figure suddenly appears, although incorrectly drawn. Thus, it is probably the architect Ramée, responsible for the repairs from 1840 to 1846, who completed his work by placing

the statue on the western trumeau. There it stayed until the bombardment of World War I.

33. Moët de la Forte Maison, *Antiquités*, p. 303.

34. Seymour, *Noyon*, p. 56. More recently John James (*The Template-Makers of the Paris Basin* [Leura, 1989], p. 88) contends that there is no evidence of a break between the transept bay and the crossing piers because all coursing is continuous. He dates this construction to the early 1170s.

35. Seymour, *Noyon*, p. 57.

36. Ibid., p. 120.

37. See Thierry Crépin-Leblond, "Les palais épiscopaux au XIIe siècle," *Positions des thèses, École des Chartes* (Paris, 1987); *Ville de Noyon*, pp. 86–87.

38. Lefèvre-Pontalis, "Noyon," p. 182. For illustrations of the north transept, see Grant, ed., *France: Noyon*, ills. 3/11/31–33, and Seymour, *Noyon*, fig. 111.

39. Seymour, *Noyon*, pp. 19–20.

40. Paris, Bibl. Nat., Collection Destailleur, Ve26i, vol. IV, no. 1031.

41. Seymour (*Noyon*, p. 120) dates the portal 1160–70, but in the ground plan (fig. 117) he dates it ca. 1170–85. Still earlier dates (ca. 1155–60) are given for the transept design by Jean Bony (*French Gothic Architecture of the 12th & 13th Centuries* [Berkeley, 1983], p. 482), whereas to John James (*Template-Makers*, p. 89 n. 17) the capitals suggest a date to the mid- or late 1180s.

42. The Tavernier watercolor reveals several discrepancies with the present state of the portal; the massing of the entire portal has been changed as a result of the restorations. A close examination of the structure itself shows that virtually the entire portal and its gable were dismantled along with the adjacent "mur boutant" and the elements then were reassembled using both new and old stone. In the process its proportions and spacing were altered. The bonding of these old and new stones is clearly evident in Fig. 19.

43. Wilhelm Vöge, *Bildhauer des Mittelalters. Gesammelte Studien* (Berlin, 1958), p. 57. It has often been postulated that the Virgin was probably part of a group of the Adoration of the Magi. See Brouillette, *Senlis, un moment*, no. 41.

44. Pamela Z. Blum, "A Madonna and Four Saints from Angers: An Archeological Approach to an Iconographic Problem," *Yale University Art Gallery Bulletin* (Winter 1974), pp. 31–57; Ilene Forsyth, *Throne of Wisdom*, figs. 183, 184.

45. André Lapèyre, *Des Façades occidentales de Saint-Denis et de Chartres aux portails de Laon* (Paris, 1960), figs. 5, 10, 122.

46. Paris, Bibl. Nat., MS nouv. acq. fr. 6104, X, fol. 144v (1842): "La porte centrale était partagée en deux divisions par un pilier qui portait un statue de la Vierge." Cited by Brouillette, "Sculpture of Senlis Cathedral," p. 164 n. 30. The trumeau of the portal at Senlis had the unusual representation of the first bishop, St. Rieul; ibid., p. 148; Millin, *Antiquités Nationales* (Paris, 1791), vol. 2, pl. 19, p. 13.

47. Lefèvre-Pontalis, "Histoire," p. 289 n. 4. See the hypothetical reconstruction of the west portals showing the Last Judgment in the central portal by H. Pigeyre in Philippe Verdier, *Le couronnement de la Vierge. Les origines et les premiers*

développements d'un thème iconographique (Montreal/Paris, 1980), pls. 34a,b. The north portal was dedicated to the saints of the diocese.

48. See especially Annie Blanc, "Les pierres de la cathédrale et de la ville," *La Ville de Noyon,* pp. 59–66. A complete analysis of the limestone used in the sculptural decoration at Noyon was undertaken by the author in the summer of 1989. The results will be incorporated into a larger project, now in progress, on a provenance study of limestone used in French medieval sculpture.

49. See the engraving in Vitet, *Monographie Noyon,* p. 173.

50. Charles Seymour, "Têtes gothiques de la cathédrale de Noyon," *Gazette des Beaux-Arts* (Dec. 1937), pp. 138–44, and idem, *Noyon,* pp. 171–72.

51. See Photo Marburg nos. 37457–459 and Grant, *France: Noyon,* ills. 3/11/60–67.

52. Grant, ibid., ills. 3/11/176–178.

53. Compare, for example, Photo Marburg no. 36–635 and Grant, *France: Noyon,* ill. 3/11/106.

54. Seymour, *Noyon,* p. 55. See also note 32 above.

55. Louis Réau, *Iconographie de l'Art Chrétien,* vol. 3, pt. 2 (Paris, 1958), p. 600; and Seymour, *Noyon,* p. 57.

56. Seymour, *Noyon,* p. 62.

57. John James, "La construction de la façade occidentale de la cathédrale de Senlis," *La Cathédrale Notre-Dame de Senlis au XIIe siècle,* Société d'histoire et d'archéologie de Senlis (Buxerolles, 1987), pp. 110–18.

58. Although virtually unstudied by modern scholars, an engraving exists in M. Gomart, "Portail de l'Église d'Athies," *Bulletin monumental* 32 (1866), pp. 869–76. C. Enlart, P. des Forts, and R. Rodière, *La Picardie historique et monumentale* (Amiens, 1923–31), vol. VI, pp. 139–43. See also *Dictionnaire des Églises de France* (Tours, 1971), VB15. The tympanum scenes are amazingly close in composition, if not in style, to the same subjects found on the twelfth-century reliefs from the church of La Trinité at Fécamp which have recently been redated to 1162. See Sara Jones, "The Twelfth-Century Reliefs from Fécamp: New Evidence for their Dating and Original Purpose," *Journal of the British Archaeological Association* 138 (1985), pp. 79–88; and ill. in *Trésors des Abbayes Normandes* (Rouen/Caen, 1979), no. 259.

59. Blum, "Madonna and Four Saints," pp. 31–57, with older literature.

60. My thanks to William Clark for pointing out the parallels between these two works. See also the comments on the corbels by George Forsyth, *The Church of St. Martin Angers* (Princeton, 1953), pp. 202–3, figs. 92–98.

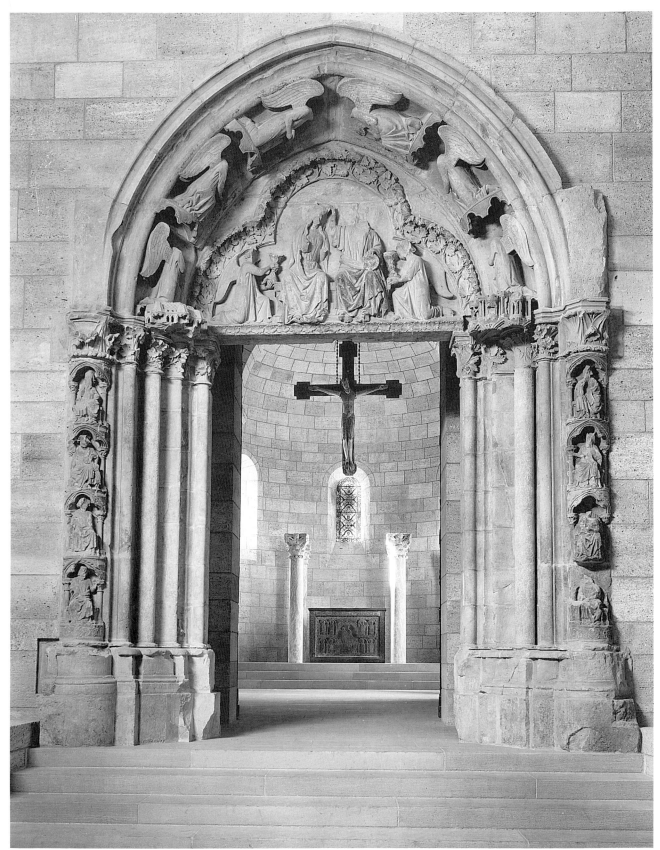

Fig. 1. Door from Moutiers-Saint-Jean in 1938. The Metropolitan Museum of Art, The Cloisters Collection, 1932 (32.147) (photo: Museum)

The Moutiers-Saint-Jean Portal in The Cloisters

Neil Stratford

Moutiers-Saint-Jean is a hill village in the Auxois, some eighty kilometers west of Dijon. Of its medieval abbey, hardly a stone survived above ground after the sale of the buildings in the years following the French Revolution. Several seventeenth- and eighteenth-century monastic offices fared rather better and still serve to remind us of a late flowering of the abbey as an influential center of the religious life after it was reformed by the Benedictine monks of the Congregation of St. Maur in 1635–36. The early contribution of the Maurists to the intellectual revival of interest in the Middle Ages is well known. It therefore comes as a surprise to find that no plan of the monastery as it was before the Revolution has so far been found. Indeed, the historian is faced with an almost total lack of documents relating to the abbey church. Today the site is occupied by a farm, and we do not even know precisely where the church was on the ground, vis-à-vis the surviving classical buildings.[1]

As for the thirteenth-century portal from the church, it was a Rockefeller purchase for The Cloisters in 1932 and was installed by Charles Collens and James Rorimer in the entrance wall of the Langon Chapel. Figure 1 illustrates the door as it was in 1938 at the time of the opening of The Cloisters, Figure 2 as it was after the acquisition in 1940 of the two column-figures of kings. But before turning to the modern history of the door, which is the main topic of this essay, some brief words about the history of the abbey of Moutiers-Saint-Jean, or St. John of Réome as it was called in the Middle Ages.

John of Réome was a hermit who died in the middle of the sixth century, having gathered around him a small group of followers. In the seventh century the abbey was within the sphere of Irish, that is Columbanian monasticism. At some

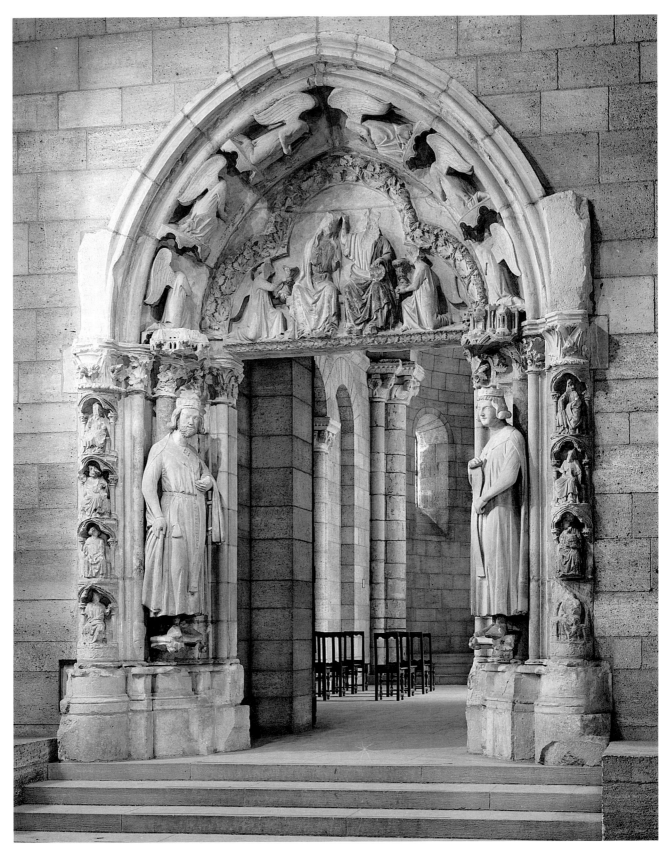

Fig. 2. Door from Moutiers-Saint-Jean, after the addition of the column-figures. The Metropolitan Museum of Art, The Cloisters Collection, 1940 (40.50.1,2) (photo: Museum)

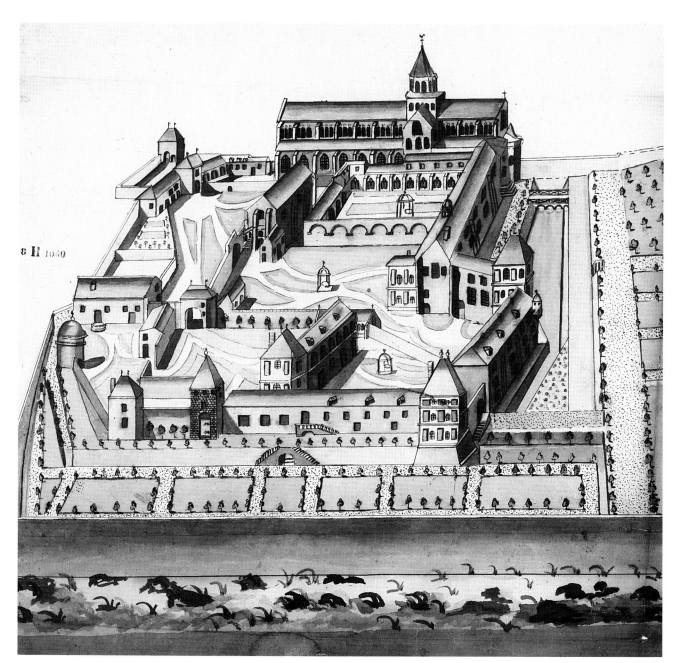

Fig. 3. Watercolor of the abbey of Moutiers-Saint-Jean, ca. 1689. Dijon, Arch. Dép. Côte d'Or (8.H.1030) (photo: Service des Archives)

date in the ninth century, however, the Rule of St. Benedict was adopted.[2] John of Réome's tomb was a reused Early Christian "city-gate" sarcophagus of early-fifth-century date, which was housed before the Revolution in the extreme eastern chapel of the abbey church. The sarcophagus was destroyed during the Revolution but has long been known from an engraving that was published in 1741 by

the great Maurist historian of Burgundy, dom Urbain Plancher.[3] It deserves mention here for two reasons: first, because four fragments of it have now been found in the village, an illustration of the way that new discoveries of sculpture are constantly being made; second, because it introduces us to the historicist climate of the abbey, where the monks could by the twelfth century admire the tomb of

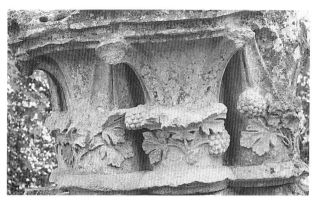

Fig. 4. Pier capitals, mid-thirteenth century. Moutiers-Saint-Jean, Collection Joseph Challan-Belval (photo: author)

Fig. 6. Man's head sprouting foliage, detail of a spandrel carving, mid-thirteenth century. Moutiers-Saint-Jean, Collection Pellicioli (photo: author)

Fig. 5. St. Paul, vault-boss, second half of the thirteenth century. Moutiers-Saint-Jean, Collection Journaux (photo: author)

their founder, housed in a venerable Late Roman sarcophagus, which they no doubt believed to be authentic.

The Carolingian period at Réome was apparently of particular importance: not only does a great illuminated manuscript from the abbey survive, which includes one of the earliest texts of the life of the founder,[4] but also a monk of Réome, Aurelian, wrote in the ninth century one of the earliest surviving treatises on sacred music and the eight tones of plainchant.[5] Of the tenth- and eleventh-century monastery, virtually nothing is known: never Cluniac *sensu stricto*, we can at least assume that Cluny's liturgy, its service-books and customs, was introduced in the years around 1000, when Réome's abbots included Mayeul of Cluny and his disciple, William of Volpiano. It is soon after the year 1000 that the famous chronicler, Raoul Glaber, was a monk of Réome, but of the buildings of these early centuries nothing survives, except one small Carolingian capital.[6]

By the twelfth century, the monks were in possession of an abbey some six hundred years old. And they did not forget it. It is at about this time or a little earlier that charters were forged to establish early benefactions from the Merovingian kings, Clovis and his son Clotaire I.[7] There is nothing unusual about such a claim in ducal Burgundy, but

Fig. 7. Detail of Fig. 1, tympanum, Coronation of the Virgin

Fig. 8. Detail of the voussoirs, three kneeling angels

this fabrication is important, as we shall see, to the iconography of the New York portal.

With the twelfth century came also a rebuilding of the abbey church, whether all or part of it we do not know. Certainly at least the lower parts of the nave and crossing were Romanesque at the time of the Revolution. Over fifty Romanesque sculptures from Moutiers-Saint-Jean have now come to light, of which the most famous are, as every American medievalist knows, the thirteen big capitals in the Fogg Museum. There are however numerous others: in the Louvre, in Dijon, in Williamstown, Mass., and in several local collections in or near the village itself. We may go a little further and say with confidence that the Romanesque church probably dated from between 1120 and 1150, that its elevation was of three stories, with piers and a triforium with fluted pilasters, that is to say it was of the family of buildings associated with Cluny III, and that this filiation is borne out by the style of much of the surviving sculpture (some of the Réome capitals were carved by a sculptor who worked in the western parts of the great church at Cluny).[8] As for the west doors of the nave at Moutiers-Saint-Jean, they were apparently slightly later in date, of the third quarter of the twelfth century, and similar to contemporary sculpture at Dijon. The doors are known from an engraving and a long description,[9] but very few fragments can be plausibly assigned to them: a fragment in the Peyre collection at Moutiers-Saint-Jean, a head at Villiers-Saint-Benoît (Yonne), perhaps a capital in the Glencairn Museum at Bryn Athyn. Again somewhat later in date, Abbot Peter I's tomb, once in the cloister at Moutiers-Saint-Jean, was known only from a watercolor, but recently a fragment of the effigy has been acquired by the Musée Archéologique, Dijon. Peter died in 1179 and his tomb was already Early Gothic, both in style and iconography.[10] He was still abbot in 1177, when the bishop of Langres dedicated the eastern chapel of the abbey church.[11] To sum up, by the end of the twelfth century, a splendid church existed, having a crossing and nave with sculpture related to the western parts of Cluny III, and west doors in the Early Gothic style of the Île-de-France, as we find it at Dijon.

Only one schematic view of the monastery is known: an engraving of this view, dated 1689, has often been published, but illustrated here is one of two watercolors executed to the commission of

Fig. 9. Door at Moutiers-Saint-Jean, after a photograph published in 1899 (photo: author)

the Maurist scholar, dom Michel Germain, from which the 1689 engraving was copied for inclusion in his never-completed *Monasticon Gallicanum* (Fig. 3).[12] The watercolor shows a church with a nave of seven bays, a crossing tower, a choir of three bays, and a round or polygonal eastern chapel. The church was not big ("77 pas" in length, according to an eighteenth-century writer).[13] What is more, we must look at the seventeenth-century view in the knowledge that the monastery had been attacked, pillaged, and severely damaged in the wars of religion, first in 1567 by the Calvinists, then in the 1590s during the Ligue. One result of all this was a series of written accounts of the state of the buildings after the pillages: we know, for instance, that certain of the main vaults collapsed, and we must be correspondingly cautious about interpreting the apparently thirteenth-century openings in the

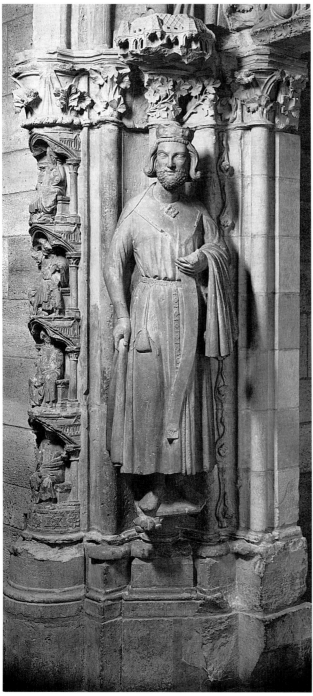

Fig. 10. Left jamb

north walk of the cloister. These written accounts were a prelude to, or, in some cases, a direct result of the resurrection of the monastery in 1635/36. The commendatory abbot at the time was no less a man than Cardinal François de La Rochefoucauld, one of the great figures of the French Counter-Reformation. It was he who introduced Maurist monks to Réome. Thanks to their interest in history, we know the little we do know and possess the few drawings which have survived of the medieval monastery, as well as of the classical buildings still on the site.[14]

The watercolor of about 1689 shows a series of what appear to be thirteenth-century tracery arcades in the north walk of the cloister. This evidence is important. There is no documentary proof, but it is likely that the New York portal opened directly from the south transept into this north walk of the cloister. But the watercolor suggests rather more, namely that the portal was not built in isolation at Réome but was part of an extensive thirteenth-century campaign. This is borne out by the survival of numerous thirteenth-century fragments in the village. Since they are of much the same date and often related to The Cloisters door, I illustrate a monolithic group of foliage capitals from a very large pier, which formerly had detached shafts and was clearly part of a major building, perhaps somewhere in the claustral precinct, such as the refectory or chapter house (Fig. 4), and a disk-shaped vault-boss, one of ten such bosses in the village, perhaps again from the cloister (Fig. 5). There are also three massively carved corbelheads, of much the same date as the New York door, as well as six carved spandrels, of which two are now in Wellesley, Mass., the rest still in local private collections (Fig. 6).[15]

But of course the most important thirteenth-century vestige of Réome is The Cloisters portal (Fig. 2).[16] A Coronation of the Virgin in the tympanum (Fig. 7) is framed within a trefoil of rich naturalistic foliage and accompanied by two candle-bearing angels; there is no lintel, the lower edge of the tympanum being decorated with a further band of foliage (Fig. 8); six angels form a single range of voussoirs within a molded outer arch; a continuous zone of crocket capitals, several enriched with lush, naturalistic leaves, tops the jambs, and part of the central capital on each side projects as a baldacchino, a fantastical creation of turrets and aedicules (Figs. 10, 11); the outermost capitals sur-

268

mount a vertical row of seated figures in niches under trilobe canopies, four on each side, several of whom can be identified as Old and New Testament figures typological of Christ's sacrifice. The bases are of typical thirteenth-century form with a deeply under-cut "waterholding" scotia. On each side a figure of a crowned king is attached by iron clamps to the middle colonnette of the jambs. Ever since the portal is first mentioned in 1567 (and I will quote the 1567 text in a moment), these statues have been identified as Clovis and either his wife, Clotilde, or his son Clotaire I, in fact as the two legendary Merovingian benefactors of the abbey.

We come now to the history of the portal in modern times. A photograph was published in 1899 (Fig. 9),[17] showing the door in ruined condition when it was built into the barn on the north side of the farmyard; the position which the doorway occupied is still clearly visible, as it is filled in with bricks and facing the farmyard. In the 1920s the door was sold by the owner of the farm, Mlle Cambillard, to the local dealer, Peslier, and passed on to Joseph Brummer in 1929, thence to the Metropolitan Museum in 1932. There it was joined in 1940 by the two statues of kings. They had been sold separately in 1909 from a garden at Moutiers-Saint-Jean; they found their way into the Manzi collection in Paris by 1919 and passed via Duveen to New York.

The doorway was not in its original position in the late nineteenth century: no ancient masonry walls were incorporated into the barn. Therefore, at some date in the nineteenth century, the doorway had been removed from the medieval church and reerected as part of the new barn. This fact has an important corollary: the earliest photographs of the doorway (such as Fig. 9) cannot be relied upon as evidence of its original appearance. Since its present setting at The Cloisters makes it difficult to examine the individual blocks of the door in archaeological detail, a preliminary question must be asked: did the elements of the portal fit together originally in the way that James Rorimer has presented them? He was guided essentially by the evidence of these early photographs.

The 1567 document is an account of the state of the abbey following the Huguenot pillage: "Au portail de l'église dans [devant] ledit cloistre nous a apparu que les deux statues des Roys Clovis et Clotilde qui sont eslevés de costé et d'autres dudit

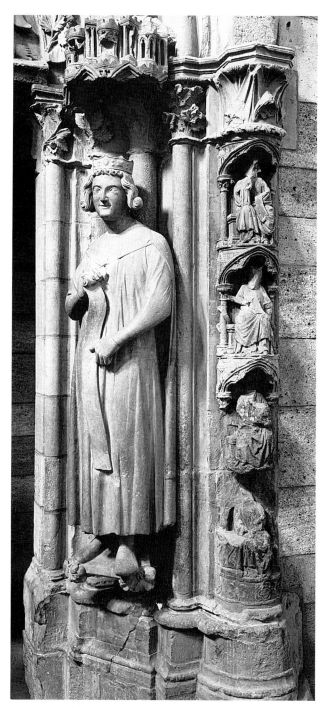

Fig. 11. Right jamb

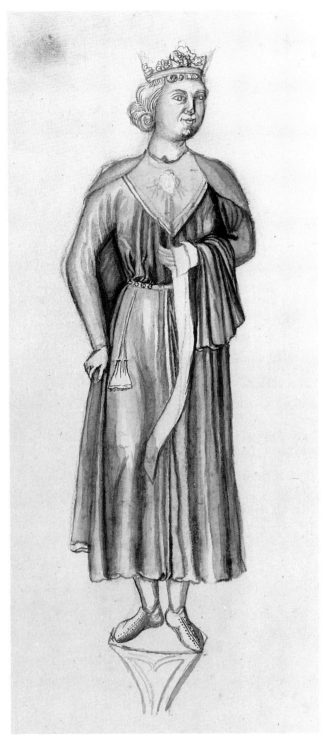

Fig. 12. Dom Pierre Thivel, watercolor showing column-figure of a king at Moutiers-Saint-Jean, 1725. Paris, Bibliothèque Nationale, MS Coll. de Bourgogne 73, fol. 197r (photo: Bibliothèque Nationale)

portail, ont les testes abbattues et plusieurs autres [et pardessus autres] petittes statues d'Images [et Images] qui estoient audit portail rompues. . . ."[18] The severe damage, if not loss of the majority of the heads including the kings' heads, is therefore documented in the sixteenth century. For Clotilde, Clovis's wife, we should read Clotaire, his son: even if the statues were headless at the time, there can be no doubt that the costume of both figures is masculine; the scribe may simply have made a slip of the pen in writing "Clotilde," since he does call the statues "kings."

Recently I discovered drawings of the kings among the Maurist papers in Paris (Figs. 12, 13). They were almost certainly executed by dom Pierre Thivel in August 1725, when he was traveling in the Auxois with dom Urbain Plancher to help with the preparation of his history of Burgundy.[19] By 1725, that is at sometime after 1567 and before 1725, the kings had been restored; their heads are in place in dom Thivel's drawings. The two heads as they are today (Figs. 10, 11) are transposed if we compare them with the drawings of 1725. A first reversal had already taken place by 1900, as can be seen in published photographs of the kings when they were still in a garden in the village (Figs. 14, 15).[20] A re-reversal of the heads was executed by 1919 when they were photographed in the Manzi collection in Paris (Figs. 16, 17).[21] Finally Rorimer was responsible for a re-re-reversal (Figs. 10, 11). After the acquisition of the kings in 1940, he transposed the heads back to their late-nineteenth-century positions, because he did not know the 1725 drawings. Unfortunately the junction between the heads and torsos of the two statues was effected by modern in-fill, so that there is no way of verifying the original joins of the heads. However, their present positions are unlikely to be original, given that when the heads were replaced after 1567, the monks would certainly have known which head belonged to which torso. Rorimer's solution has the two kings gazing away from each other, out at the spectator, as he approaches the door. If the evidence of the Maurist drawings is accepted, the two kings originally looked inward across the doorway, as they do so often on Burgundian portals.

The heads have been restored more than once. Extensive areas of the surface of the faces and necks were in-filled, first for Manzi and then for Duveen; we can follow their condition from 1900 onward

in the published photographs. A schematic drawing in The Cloisters archives shows the areas of restoration on one of the kings (Fig. 18).[22] As to the crowns, they are the work of Joseph Duveen, having survived as they were in 1725 right down to 1919. The 1725 drawings prove that an extensive restoration had already taken place after the 1567 pillage. Probably the Maurists repaired the kings shortly after 1635 when they took over the abbey, for they carried out a major rebuilding program on the abbey church and monastic buildings at that time. From all this, it seems clear that the heads of the kings are not medieval at all, but rather re-creations of the Maurist period, the originals having been so mutilated in 1567 that they were never replaced. After all, none of the other original heads were replaced on the door, and one of them survives in good condition, as we shall see shortly. Stylistic criteria do little to help with a decision on this point, because the heads have been so heavily recut and in-filled. It is however true that they have nothing in common with the heads on comparable medieval portals in the region.[23] Historically too there is every probability that the new Maurist community would have commissioned such a restoration of their Merovingian "founders." As I have already mentioned, the commendatory abbot of Réome at this time was Cardinal François de La Rochefoucauld (Fig. 19).[24] In these very same years around 1627 he was involved in the restoration of King Clovis's own tomb in Paris at Sainte-Geneviève.[25] The heads could also have been carved somewhat later in the seventeenth century, at the time when the great scholar dom Jean Mabillon and others of the Order were proposing a Merovingian date for the royal column-figures of such medieval doorways, and the early archaeology of the French royal dynasties was a current issue of debate: Mabillon himself visited Réome in 1682. Dom Bernard de Montfaucon's entrenched commitment to the early-medieval dating of the royal column-statues belongs to the next generation, about 1700, but on balance the years following 1635 seem the most likely period for the restoration of the two kings.[26] Be that as it may, given these doubts about the medieval date of the heads, it ceases to be realistic to argue about whether the figures represented, from the start, the legendary Merovingian benefactors of the abbey or were the more usual Old Testament precursors of Christ. All that can be said is that in 1567 the two headless

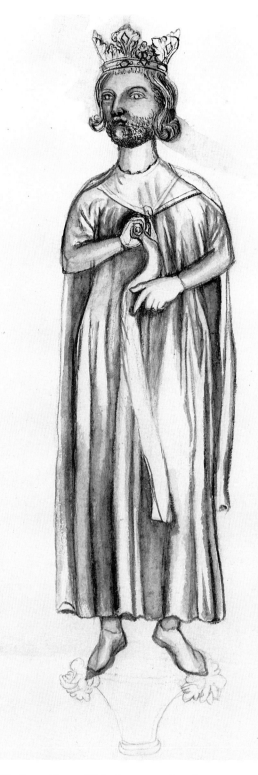

Fig. 13. Dom Pierre Thivel, watercolor showing column-figure of a king at Moutiers-Saint-Jean, 1725. Paris, Bibliothèque Nationale, MS Coll. de Bourgogne 73, fol. 198r (photo: Bibliothèque Nationale)

Fig. 14. Column-figure of a king in a garden at Moutiers-Saint-Jean, after a photograph published in 1900 (photo: author)

Fig. 15. Column-figure of a king in a garden at Moutiers-Saint-Jean, after a photograph published in 1900 (photo: author)

RESTORATIONS

CHIPPED AREAS

Fig. 16. Column-figure of a king from Moutiers-Saint-Jean, after a photograph in the Manzi Catalogue of 1919 (photo: author)

Fig. 17. Column-figure of a king from Moutiers-Saint-Jean, after a photograph in the Manzi Catalogue of 1919 (photo: author)

Fig. 18. Schematic drawing of the restorations to the king of the left jambs. The Metropolitan Museum of Art, The Cloisters Archives

Fig. 19. Cardinal François de La Rochefoucauld, commendatory abbot of Moutiers-Saint-Jean (1631–45), detail of an engraving by Michel Lasne, ca. 1646 (photo: author)

Fig. 21. Old Testament precursor of Christ, niche figure (detail of Fig. 11)

Fig. 20. Fragment of a seated draped figure, mid-thirteenth century. Moutiers-Saint-Jean, Collection Chanu (photo: author)

figures were thought to have been Clovis and his son (or wife).

The Maurist drawings show that formerly the kings stood in one case on a complete crocket capital (Fig. 13), in the other on a console which was decorated with a trefoil pattern (Fig. 12). The crocket capital has an elegant necking-band; it was either to be set on a colonnette or it was an independent capital acting as a corbel. The console with a trefoil pattern is more difficult to "read": was it an architectural element with a support (perhaps even

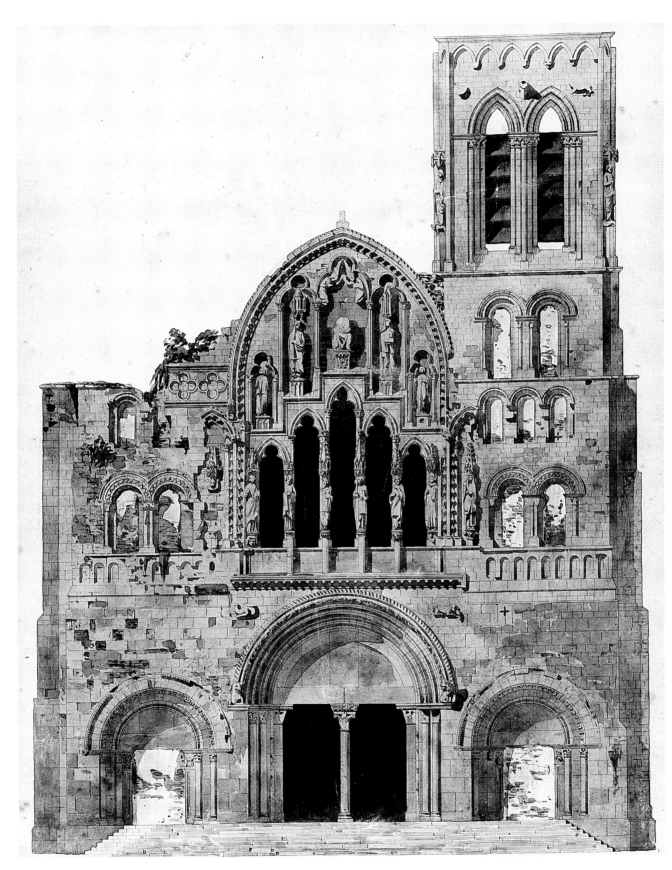

Fig. 22. Eugène Viollet-le-Duc, watercolor showing west facade of La Madeleine, Vézelay, in 1840 (photo: Monuments Historiques, Archives Photographiques)

Fig. 23. Saint-Thibault-en-Auxois, jamb figures of the north transept portal, third quarter of the thirteenth century (photo: author)

Fig. 24. Head of St. Andrew, part of a column-figure, formerly decorating the west window of La Madeleine, Vézelay, ca. 1240-50 (photo: author)

Fig. 25. Head of an angel, from the voussoirs of the portal (H. 12 cm), mid-thirteenth century. Moutiers-Saint-Jean, Collection Peyre (photo: author)

the spandrel of an arcade?), or was it part of a baldacchino? The possible implications of this will be discussed below.

It is impossible to examine fully Rorimer's reconstruction of the door at The Cloisters, given that it is built into the wall, but enough anomalies survive to suggest that when it was removed to the barn wall after the Revolution, the local piety which saved the door did not reemploy all its elements. A few points may be noted: the tympanum has no lintel and sits directly on the jambs, with a curious hiatus beneath the foliage frame of the tympanum at its outer edges (Fig. 8); the lowest angels of the

276

Fig. 26. William D. Wixom replacing the cast of the neck and chin of an angel (Fig. 25) on the shoulders of the angel of the voussoirs (photo: author, Wednesday, October 29, 1988)

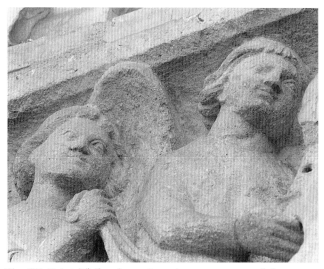

Fig. 27. Saint-Thibault-en-Auxois, tympanum of the north transept portal, detail of two angels, third quarter of the thirteenth century (photo: author)

voussoirs are cut down beneath and can only be accommodated physically within a saucer-shaped depression which has been hollowed out of the tops of the baldacchinos; the baldacchinos themselves have also been cut down on their sides and on their tops and the top part of the tympanum is blank, while the apex of the voussoirs is without a central focal figure (Fig. 7). Finally, a fragment of a seated figure still in the village (Fig. 20) is so close in scale and style to the eight niche figures of the New York jambs (Fig. 21) that one is tempted to ask whether this is not part of a ninth niche figure which was not reincorporated in the portal when it was moved to the barn wall.[27] This all tends to suggest that in the nineteenth-century rebuilding of the door, the decision was taken to omit certain elements and to concertina others.

In their present setting at The Cloisters, the kings (Figs. 10, 11) are almost too tall to fit into the space between baldacchino and base, and this in spite of the fact that they stand on consoles that have clearly been chopped down to make them squatter. As to the colonnettes of the jambs behind the kings, they are new insertions by Rorimer, and the present fixings of the statues with iron clamps are modern. It thus remains impossible to imagine how the kings could ever have been intended for a doorway like this: they are too wide and carved too much in the round to have been set as column-figures against these jambs. The crocket capital of the 1725 drawings suggests a columnar support such as exists, for instance, beneath the window figures of the Vézelay facade (Figs. 13, 22). The trefoil-decorated socle of the other 1725 drawing may also have been something like the plinths of the gable figures at Vézelay (Fig. 12).[28] I cannot help asking whether the kings were not originally set against flat splayed jambs, like the statues at Saint-Thibault-en-Auxois (Fig. 23), without of course the ledge on which the Saint-Thibault figures stand, but rather with consoles or colonnettes beneath and the existing canopies above. In any case, the consoles of the 1725 drawings could not have been accommodated within the present height of the jambs.

The stylistic filiations and the date of the door, whatever its original appearance, are not seriously in doubt. They have been recently studied by Sabine Enders, William Forsyth, and Willibald Sauerländer, and I need not elaborate here on their arguments about the local group of monuments in northern

Burgundy which are connected with the New York door.[29] The stylistic origins of the group lie within the Paris-Reims sculpture of the second quarter of the thirteenth century, but the degree of variation in the way that this common source is interpreted is considerable.[30] For instance, a head at Vézelay is far removed from the metropolitan sources of the style (Fig. 24), but it has its own character and force: the head is given individual character by the fluid but free cutting of the hair and beard, by the definition of the eyes with prominent oval pupils, and by the structure of the head with its bold forehead and eyebrows. What a great gulf separates such a head from those of the two kings (Figs. 10, 11). Such a contrast speaks volumes for a post-medieval dating of the New York heads. As to the date of the northern Burgundian portals, there is architectural evidence that two of the monuments are early: the Semur-en-Auxois north transept door is no later than about 1250, since its lower parts are related to the earlier sculptures of the west doors of Notre-Dame at Dijon (ca. 1230) and the architecture of the eastern parts of the church prohibits a date later than the second quarter of the thirteenth century; the Vézelay gable (Fig. 22) is, again on internal grounds, very likely of about 1240–50.[31] Other monuments of the group could well be later, even into the last quarter of the thirteenth century. Where does the Moutiers-Saint-Jean door belong?

If we exclude the heads of the kings as of later date, there is a single surviving head from the portal (Fig. 25), one of the finest discoveries of sculpture in the village. With the help of a plaster cast of this head provided by the owner, which I brought with me to New York, William Wixom and I were able to establish that it belongs to the second angel of the voussoirs on the left (Fig. 26).[32] This head is close cousin in style to some of the heads at Semur-en-Auxois and Saint-Thibault (Fig. 27). As for the poses, draperies, and costume of the kings, they can be closely compared with the Saint-Thibault jamb figures (Fig. 23). But the beautifully composed kneeling angels of the voussoirs are still close to the Paris sources of the style (Fig. 8). We are in the presence here of a sculptor whose repertoire of figure poses was directly inspired by Parisian or rémois models. With all due deference to the approximate rules which govern chronologies of style, I would date the Réome portal early in the history of the north Burgundian group, between 1250 and 1260.[33]

The title of this essay could have been "the modern story of a Gothic portal." As we celebrate the fiftieth birthday of that unique institution, The Cloisters, the Moutiers-Saint-Jean door points us further back into the antiquarian past to the period of the Maurist historians in France, in fact to the very beginnings of that revival of interest in the Middle Ages which continues lineally through the Gothic Revival to the great historical museums of today.

ACKNOWLEDGMENTS

I have essentially made only minor alterations of syntax to the lecture delivered to the New York symposium in October 1988. My essay is concerned with one particular survival from Moutiers-Saint-Jean, and even then makes no claim to being a full discussion of the portal. For a more detailed account of what is known about Moutiers-Saint-Jean and the surviving sculpture of the Romanesque and Gothic periods from the abbey, see my article "La Sculpture médiévale de Moutiers-Saint-Jean (Saint-Jean-de-Réome)," *Congrès Archéologique de France, 144ème session (1986). Auxois-Châtillonnais* (Paris, 1989), pp. 157–201. I presented the abbey to the Société Française d'Archéologie on the occasion of the first-ever visit of the Congrès to Moutiers-Saint-Jean in September 1986. As the climax of this visit, an exhibition was mounted in the hospital, where many fragments of sculpture from the destroyed abbey were shown together for the first time since the Revolution. A society exists to preserve the local heritage, with the long-term intention of bringing together the many privately owned fragments still in the village. Of the many people who helped to organize the exhibition and encouraged me to search out the surviving sculptures, I would like particularly to thank here François Peyre and his family.

While visiting Moutiers-Saint-Jean and the sad remains of its abbey, I have been constantly aware of the footprints left in the village by Bill Forsyth. His article remains the fundamental study of The Cloisters doorway, and it was his article which first stimulated my interest in this intriguing monument. To him above all my thanks are due.

NOTES

1. The only modern history of the abbey is A. Vittenet, *L'abbaye de Moutier-Saint-Jean (Côte d'Or). Essai historique* (Mâcon, 1938). For the attempts of the local inhabitants to save the abbey church as their parish church in the 1790s and for its final destruction, see pp. 193–210. For a bibliography of the abbey, see Jacques Laurent and Ferdinand Claudon, *Abbayes et prieurés de l'ancienne France*, vol. 12: *Province ecclésiastique de Lyon, 3ème partie. Diocèses de Langres et de Dijon* (Ligugé/Paris, 1941), pp. 262–70. The most important early printed source is the history by the Jesuit, le père Pierre Royer, *Reomaus, seu Historia monasterii S. Ioannis Reomaensis, in tractu Lingonensi . . . ab anno Christi CCCCXXV, a P. Petro Roverio e Societate Jesu* (Paris, apud Sebastianum Cramoisy, 1637). For collections of texts by the Maurists relating to the history of the abbey, see Bibl. Nat., Paris, MS lat. 12676, fols. 282r–299r; MS Coll. de Bourgogne 9, fols. 91r–144r. See also MS français 8239, fols. 180r–184r (notes by Guenyard Ressayre, 1726). This is vol. 24 of the *Receuil d'épitaphes formé par Pierre de Clairambault*. It was for a long period part of MS Coll. de Bourgogne 17. For illustrations of the existing classical buildings, see C. Ansler and P. Gagliardi, "L'abbaye de Moutiers-St-Jean. Trois procédés anciens pour le projet d'une ferme," *Archives d'Architecture Moderne* 25 (1983), pp. 11–24. See also Monique Bugner, *Cadre architectural et vie monastique des Bénédictins de la Congrégation de Saint-Maur* (Nogent-le-Roi, 1984), pp. 6, 31, 37; pls. 139, 162, 170, 180.

2. For the life of John, see *Vita Iohannis*, ed. B. Krusch, in *Mon. Germ. Hist., Script. rer. merov.*, vol. 3 (1896), pp. 502–17. For recent comments on the authenticity of the text of this edition, see J. Marilier, "Les origines de l'abbaye de Moutier-Saint-Jean," *Bulletin de la Société Historique et Archéologique de Langres* 13/4 (1963), pp. 375–79. For the circumstances of the writing of the *Vita*, see I. Wood, "A prelude to Columbanus: the monastic achievement in the Burgundian territories," *Columbanus and Merovingian monasticism*, ed. Howard B. Clarke and Mary Brennan, BAR International Series 113 (1981), pp. 3–5, 13. See also Friedrich Prinz, *Frühes Mönchtum im Frankenreich. Kultur und Gesellschaft in Gallien, den Rheinlanden und Bayern am Beispiel der monastischen Entwicklung (4. bis 8. Jahrhundert)* (Munich/Vienna, 1965), pp. 159, 297. For the Benedictine reform of Réome, see Neithard Bulst, *Untersuchungen zu den Klosterreformen Wilhelms von Dijon (962–1031)*, Pariser Historische Studien (Bonn, 1973), vol. 11, p. 61.

3. Dom Plancher's history was published under the title *Histoire générale et particulière de Bourgogne . . . , par un Religieux Bénédictin de l'Abbaïe de S. Bénigne de Dijon et de la Congrégation de S. Maur*, vol. 1 (Dijon, Antoine de Fay, 1739); vol. 2 (1741); vol. 3 (1748). For the engraving, see vol. 2, after p. 520. Dom Zacharie Merle, who continued dom Plancher's *Histoire* with a fourth volume (Dijon, Louis-Nicolas Frantin, 1781), was a monk of Moutiers-Saint-Jean.

4. Semur-en-Auxois, Bibliothèque Municipale, MS 1. For a description of the MS, see *Catalogue général des manuscrits des bibliothèques publiques de France—Départements, t. VI* (Paris, 1887), pp. 296–98. Two of the pen initials are engraved in Vittenet, *L'abbaye*, p. 1. The MS includes an early copy of the Life of St. John of Réome, written in the middle of the seventh century by no less prestigious a biographer than Jonas of Susa, the author of the *Vita Columbani*. For the text, see note 2 above.

5. *Aureliani Reomensis. Musica Disciplina*, ed. Lawrence Gushee, *Corpus Scriptorum de Musica* 21 (American Institute of Musicology, 1975). Aurelian describes himself as "vernaculus quondam monasterii sancti Iohannis Reomensis, nunc autem abiectus. . . ." He was almost certainly a monk and made his compilation in the 840s; see ibid., pp. 14–16.

6. For this episode of reform and for a discussion of the dates of the successive abbots ca. 1000, see Bulst, *Untersuchungen*, pp. 61–65, 271. There are two new editions of the *Historiae* of Raoul Glaber, one by John France, ed. and trans., for the *Oxford Medieval Texts (The Five Books of the Histories: Rodulfus Glaber* [Oxford/New York, 1989]), the other by Giovanni Orlandi of Milan (in press). See also E. Petit, "Raoul Glaber," *Revue historique*, XVIIème année, 48 (Jan.–Apr. 1892), pp. 283–99, esp. pp. 286–90. Petit dates Raoul's stay at Réome between 1004/5 and 1015, but for a criticism of this chronology, see Bulst, *Untersuchungen*, pp. 63–64.

7. The false charters of endowment of Clovis ("479 AD") and Clotaire I ("539 AD") probably date from the eleventh-twelfth centuries: see Georg H. Pertz, in *Mon. Germ. Hist. Diplomatum imperii*, vol. 1, in-fol. (1872), pp. 113–14, 125–26. For a transcription of the "originals," see Bibl. Nat., MS Coll. de Bourgogne 9, fol. 91r, with a careful rendering of the "signatures" of Clovis and Clotaire.

8. For the Romanesque church and its sculpture, see Stratford, "La Sculpture médiévale de Moutiers-Saint-Jean" (see Acknowledgments). There are various historical lists of the abbots, based in the seventeenth century on a lost obituary of unknown date. According to one of these, under Abbot Bernard II (1109–33): "renovata [est] a fundamentis Basilica" (Bibl. Nat., MS lat. 12676, fol. 285r).

9. Plancher, *Histoire générale*, vol. 1, pp. 516–18.

10. For the watercolor of Abbot Peter's tomb, see Bibl. Nat., MS Coll. de Bourgogne 9, fol. 137r. The fragment of his effigy was acquired in 1982 by the Musée Archéologique, Dijon, from the Chanu collection, Moutiers-Saint-Jean. See Stratford, "Sculpture médiévale," esp. figs. 39, 40, for the watercolor and surviving fragment.

11. For the dedication of the "sacellum majus b. Johannis abbatis" on Dec. 26, 1177, by Gautier de Bourgogne, bishop of Langres, see Bibl. Nat., MS lat. 12676, fol. 285r.

12. Fig. 3 is reproduced by kind permission of Mlle F. Vignier, Directeur des Archives de la Côte d'Or, and is to be found among a set of views of the abbey, the rest being of the eighteenth-century buildings, in *Archives Départementales de la Côte d'Or*, 8.H.1030. It is not signed or dated. However, a virtual replica is: Paris, *Archives de l'Académie des Inscriptions et Belles-Lettres*, 3.H.30. This was sent in 1821 for a later projected *Monasticon Gallicanum*, together with a brief account of the abbey, by Girault, Président de la Commission permanente d'Antiquités de la Côte d'Or. For the 1689 engraving, see *Monasticon Gallicanum . . . , par les soins de M. Peigné-Delacourt*, avec un préface de Léopold Delisle (Paris, 1871), no. 41. Copies of the original engraving: Dijon, Arch. Dép. Côte d'Or, 8.H.1030; Bibl. Nat., Est. Ve 22, no. 43.

13. See Claude Courtépée and Edme Béguillet, *Description générale et particulière du Duché de Bourgogne*, 3d ed. (Paris, 1967), vol. 3, pp. 545–48. The abbé Claude Courtépée wrote his history in the 1770s and 1780s; see the introduction to the 3d ed. by Pierre Gras and Jean Richard (vol. 1, pp. I–XIV).

14. For the "procès-verbal des violences, incendies, vols, sacrilèges etc. commis par les Huguenots dans l'abbaye de Moutier St. Jean le premier octobre 1567," see Bibl. Nat., MS Coll. de Bourgogne 9, fols. 112r–113r, 126r–129v. For the "procès-verbal par la Justice d'Auxois de l'état de l'abbaye de Moutier St. Jean en 1602," ibid., fols. 120r–123v. For the "procès-verbal des ruines de l'abbaye par les Calvinistes et Ligueurs . . . février 1611," ibid., fols. 118–20. For remarks about the state of the monastery in 1636 and 1638, ibid., fols. 108v–110r; Bibl. Nat., MS lat. 12676, fols. 288r–291v. See also Bibl. Nat., MS Coll. de Bourgogne 9, fol. 117v (procès-verbal of 1565, by Anthoyne Fyot, conseiller au Parlement de Dijon). The collapse of the vaults had taken place three years before 1565 and services in 1565 were held in a chapel "hors de danger." For references to François de La Rochefoucauld's rebuilding of the nave vaults, see Bibl. Nat., MS lat. 12676, fols. 283v, 286r. See also fol. 288v: "Il a fait lambrisser toute la grande nef de l'Église"; fol. 287r: "[1650] murus totam ecclesiae partem sinistram tegens, ab iis [les Huguenots] constitutus (monasterium in arcis modum adornarant), dejectus est; et ex eadem parte navis fenestrae lapidibus obturatae, apertae sunt, vitroque munitae." A summary list of the new seventeenth-century building works can be found in Bibl. Nat., MS lat. 12676, fols. 287r–v.

15. For these fragments I am again obliged to refer the reader to my article "La Sculpture médiévale de Moutiers-Saint-Jean." As to the Wellesley spandrels, they are Jewett Art Center (Rogers Fund), Inv. 1949.25–26, formerly [Demotte]; [George Gray Barnard]; [Joseph Brummer]; Brummer sale, 1949, New York, Part III, p. 151 (no. 615 [ill.]). See most recently Dorothy Gillerman, ed., Gothic Sculpture in America. I The New England Museums, Publications of the International Center of Medieval Art 2 (New York/London, 1989), no. 193. For a corbel in Hartford (Conn.), said to come from Moutiers-Saint-Jean and (in my opinion) of doubtful date, see ibid., no. 221.

16. The modern bibliography on the Gothic portal of Moutiers-Saint-Jean is too extensive to be given in full here, but the following references are the most important: Eugène de Lanneau, "L'abbaye de Moutier-St-Jean," Bulletin de la Société des sciences historiques et naturelles de Semur-en-Auxois 6–7 (1871), p. 66; Mémoires de la Commission des Antiquités de la Côte d'Or, vol. 13, pp. cv–cvi (séance du 17 novembre 1897—Henri Chabeuf); pp. cxcvi–cxcviii (séance du 2 avril 1900—Henri Chabeuf); vol. 14, p. xxiv (séance du 15 novembre 1900— Henri Chabeuf); idem, "Porte de l'église abbatiale de Moutier-Saint-Jean (Côte d'Or)," Revue de l'Art Chrétien 42 (1899), pp. 6–10; Catalogue des sculptures . . . principalement du Moyen Age et de la Renaissance composant la collection du feu M. Manzi, Galerie Manzi, 3ème vente (Paris, 15–16 décembre 1919), nos. 100–101; James J. Rorimer, The Cloisters. The Building and the Collection of Medieval Art in Fort Tryon Park (The Metropolitan Museum of Art, New York, 1938), pp. 11–14; idem, "XIII Century Statues of Kings Clovis and Clothar at The Cloisters," MMAB 35/6 (June 1940), pp. 122–26; Willibald Sauerländer, Von Sens bis Strassburg (Berlin, 1966), pp. 121–22; Mémoires de la Commission des Antiquités de la Côte d'Or, vol. 26, 1963–69 (1970), p. 123 (séance du 18 décembre 1968— Pierre Quarré); Pierre Quarré, "Les statues de l'atelier de Rougemont," The Year 1200: A Symposium (The Metropolitan Museum of Art, New York, 1975), pp. 579–89; William H. Forsyth, "A Gothic Doorway from Moutiers-Saint-Jean," MMJ 13, 1979, pp. 33–74; Philippe Verdier, Le couronnement de la Vierge. Les origines et les premiers développements d'un thème iconographique (Montreal/Paris, 1980), pp. 173–76, pls. 31, 32;

Sabine Enders, Die hochgotische Bauskulptur in Burgund, Inaugural-Dissertation . . . Freiburg im Breisgau (Tübingen, 1984), pp. 42–50, 153–58, pls. 19–21; Lydwine Saulnier and Neil Stratford, La sculpture oubliée de Vézelay. Catalogue du Musée Lapidaire, Bibliothèque de la Société Française d'Archéologie 17 (Paris/Geneva, 1984), pp. 41, 118, pl. 96; Dorothy Gillerman, "The Portal of St.-Thibault-en-Auxois: A Problem of Thirteenth-Century Burgundian Patronage and Founder Imagery," Art Bulletin 68 (1986), pp. 567–80.

17. Chabeuf, "Porte de l'église abbatiale," p. 7.

18. The "procès-verbal des violences, incendies, vols, sacrilèges, etc. commis par les Huguenots dans l'abbaye de Moutier St. Jean le premier octobre 1567, tirée sur une autre copie collationée du six février 1696" is found twice in Bibl. Nat., MS Coll. de Bourgogne 9, fols. 112r–113r, 126r–128r. I give variants, where relevant, in brackets for fols. 126r–128r. The procès-verbal is of the visit on Oct. 17, 1567, by Nicolas Oudin, licensier en droit, juge ordinaire des terres et seigneuries de Moutiers-Saint-Jean. This text about the kings was printed by Vittenet, L'abbaye, p. 104; Forsyth, "Gothic Doorway," p. 70. Dom Merle refers to it in Plancher, Histoire générale, vol. 4, p. 569.

19. The letter describing the journey, written by Thivel to dom Bernard de Montfaucon, is printed in dom Ursmer Berlière, "Lettres des Bénédictins de St-Maur," Revue Bénédictine 28 (1911), p. 198. The original is Bibl. Nat., MS français 17712, fols. 252r–253r.

20. Figs. 14 and 15 are rephotographed from Chabeuf, Mémoires 14 (séance du 15 novembre 1900).

21. Figs. 16 and 17 reproduce the photographs from the Manzi catalogue, nos. 100, 101 (see note 16 above).

22. Fig. 18 reproduces a drawing by Rudolph Meyer sent to William Forsyth during correspondence in 1977. For a full discussion of the restorations, see Forsyth, "Gothic Doorway," pp. 72–74.

23. See note 14 above for the rebuilding after 1635. Recently neutron activation analysis of the limestones has established a common pattern for the heads and the rest of the elements of the Réome portal; see Lore L. Holmes, Charles T. Little, Edward V. Sayre, "Elemental Characterization of Medieval Limestone Sculpture from Parisian and Burgundian Sources," Journal of Field Archaeology 13 (1986), pp. 419–38. Unfortunately, the same quarry seems to have been in use at most periods of the abbey's history, including the seventeenth and eighteenth centuries, so that no arguments as to the date of the heads can be based on these analyses. The "carrière d'Anstrude" is situated near the village (Carte de France 1:50,000, Noyers, 2 G 05 Est/52 G 90 Nord).

24. For the signed engraving (Fig. 19) by Michel Lasne, published in 1646, i.e., one year after the cardinal's death, see Bibl. Nat., Estampes, Inventaire du Fonds français. Graveurs du XVIIe siècle (Paris, 1976), vol. 7, no. 377.

25. Alain Erlande-Brandenburg, Le roi est mort. Étude sur les funérailles, les sépultures et les tombeaux des rois de France jusqu'à la fin du XIIIe siècle, Bibliothèque de la Société Française d'Archéologie 7 (Paris/Geneva, 1975), pp. 133–34.

26. See dom Henri Leclerq, Mabillon, 2 vols. (Paris, 1953–57), vol. 1, p. 184, for Mabillon's visit, accompanied by dom Michel Germain, to Réome on Apr. 4, 1682. See also Jacques Vanuxem,

"The Theories of Mabillon and Montfaucon on French Sculpture of the Twelfth Century," *Journal of the Warburg and Courtauld Institutes* 20 (1957), pp. 45–58; idem, *L'abbé Lebeuf et l'étude méthodique des monuments du Moyen Age*, Société des fouilles archéologiques et des monuments historiques de l'Yonne (Auxerre, 1963), pp. 14–17.

27. The fragment in the Chanu collection at Moutiers-Saint-Jean is of a seated figure with part of the throne intact but the upper part of the body lost (Fig. 20). It measures 13 cm in height. The second figure from the bottom, on the right jamb of The Cloisters portal, is missing in the early photographs of the portal (Fig. 9) but is certainly original, having been found in the ground in front of the portal (Forsyth, "Gothic Doorway," p. 72). It measures 31.7 cm in height and is exactly comparable in scale to the less complete Chanu fragment.

28. For convenient illustrations of the Vézelay gable, see Willibald Sauerländer, *Gothic Sculpture in France 1140–1270* (London, 1972), ill. 106; Enders, *Bauskulptur*, figs. 40–51; Saulnier and Stratford, *Vézelay*, figs. 1, 2, 34–41, 43.

29. Sauerländer, *Von Sens bis Strassburg* and *Gothic Sculpture in France*; Forsyth, "Gothic Doorway"; Enders, *Bauskulptur*. See also Gillerman, "The Portal of St.-Thibault-en-Auxois," pp. 567–80.

30. Thanks to new documentary discoveries by Jean-Pierre Ravaux and the extensive publication of the sculptures of the west facade at Reims by Peter Kurmann, the chronology of many of the Reims sculptures has now been revised and they can be seen as a later development from the Parisian monuments. The parallels between Paris and Reims ca. 1235–50 are now established, and the sources of the northern Burgundian group which are visible at Reims could equally well have been Parisian; see Peter Kurmann, *La façade de la cathédrale de Reims* (Paris CNRS/Lausanne, 1987), pp. 284–85, passim.

31. For Semur-en-Auxois, see Anne Prache, "Notre-Dame de Semur-en-Auxois," *Congrès Archéologique de France* 144 (1986), pp. 291–301. See also Christian Freigang and Peter Kurmann, "L'église de l'ancien prieuré de Saint-Thibault-en-Auxois, sa chronologie, ses restaurations, sa place dans l'architecture gothique," in ibid., pp. 271–90, for the complex history of one of the monuments of this group. For the dating of the Vézelay facade, see Saulnier and Stratford, *Vézelay*, pp. 38–42.

32. The photo shows the attachment of a cast of the lower part of the head and neck only.

33. Two documentary references suggest building activity at Moutiers-Saint-Jean in the second half of the thirteenth century. (1) In October 1257 Hugues, vicomte de Tonnerre and seigneur de Quincy-le-Vicomte, bequeathed, among several similar gifts to other churches, 100 *solidi* "operi ecclesiae Sancti Johannis de Reome"; at the time this was probably roughly the wage of a master mason for fifty days. For the will of 1257, see E. Petit, *Histoire des ducs de Bourgogne de la race capétienne* (Paris, 1894), vol. 4, pp. 446–48. For a 1261 contract with the master mason of Saint-Gilles-du-Gard, which included a daily wage of 2 *sols tournois*, see Victor Mortet and Paul Deschamps, eds., *Recueil de textes relatifs à l'histoire de l'architecture . . . en France*, vol. 2, *XIIe–XIIIe siècles* (Paris, 1929), p. 289. (2) Abbot Gaudri (1279–94) was buried "in medio choro sub campanili," that is to say, in front of the high altar beneath the crossing tower. See Bibl. Nat., MS lat. 12676, fol. 285. Gaudri's date of death was given as 1294 on his lost epitaph. A major building campaign in the area of the south transept and cloister, perhaps elsewhere too, probably took place not only under Gaudri but also under his predecessor, Abbot Odo II (1252–79). Gaudri's prominent place of burial in the church is compatible with his substantial role as a builder.

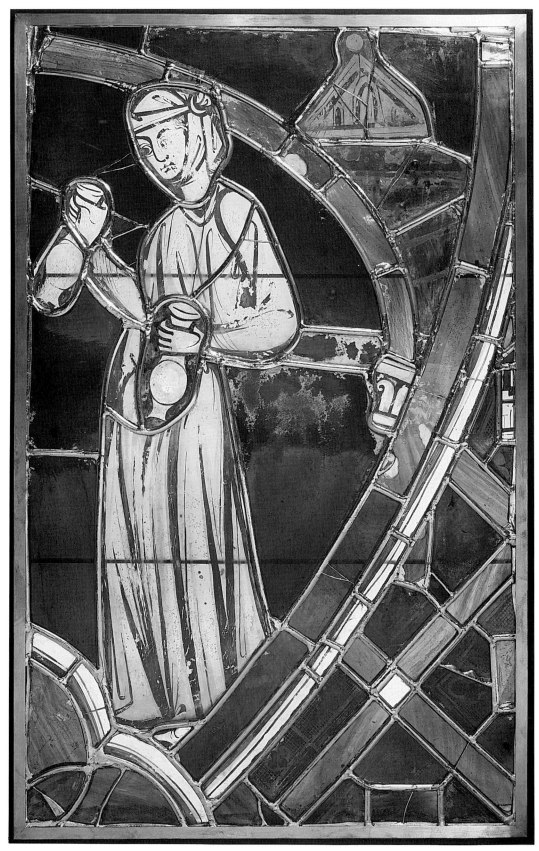

Fig. 1. Scene from the Life of St. Germain of Paris: A servant carrying two flasks. The Metropolitan Museum of Art, The Cloisters Collection, 1973 (1973.262.2) (photo: Museum)

The St. Germain Windows from the Thirteenth-Century Lady Chapel at Saint-Germain-des-Prés

Mary B. Shepard

Two stained-glass panels acquired by The Cloisters in 1973 (Col. pl. 5 and Figs. 1, 2) once formed part of the important stained-glass program from the Lady Chapel of the powerful Benedictine abbey of Saint-Germain-des-Prés in Paris (Fig. 3). Enigmatic in subject matter, these well-preserved panels represent a woman carrying two flasks and a saint appearing to a sleeping monk.[1] Although not from the same narrative episode, The Cloisters panels were originally quadrants in oval medallions, bisected both horizontally and vertically by structural irons which secured the glass panels in the window lancet itself. In the original arrangement, each episode was composed of two horizontal quadrants, allowing the legend to be read from the bottom of the window to its summit. Each oval, comprising two episodes, was joined by a red quatrefoil, trimmed in white with four delicate green leaves bisecting its center.

On the basis of style, the two panels in The Cloisters and other glass at Saint-Denis, the dépôt of the Monuments Historiques at Champs-sur-Marne, the Victoria and Albert Museum, Winchester College, and Christ Church in Manhasset, New York, have been attributed to this series from Saint-Germain-des-Prés, together with four panels preserved there in the ambulatory chapel of Sainte-Geneviève.[2] Altogether twenty extant panels form parts of a coherent narrative group for which, however, attempts to elucidate the meaning of the iconographic program have remained vague and inconsistent. The aim of this essay is to put The Cloisters panels within their original iconographic framework and to establish their subject matter as illustrating the life of one of the abbey's titular saints, Germain of Paris (ca. 496–576), and the wondrous miracles worked by his relics.

The stained glass from the Saint-Germain-des-Prés Lady Chapel was one of

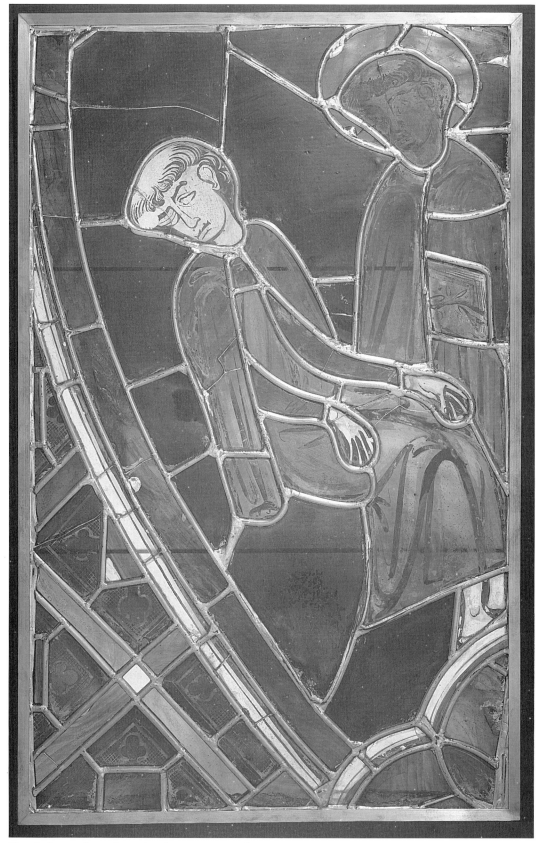

Fig. 2. Scene from the Life of St. Germain of Paris: St. Germain appearing to a monk in a dream. The Metropolitan Museum of Art, The Cloisters Collection, 1973 (1973.262.1) (photo: Museum)

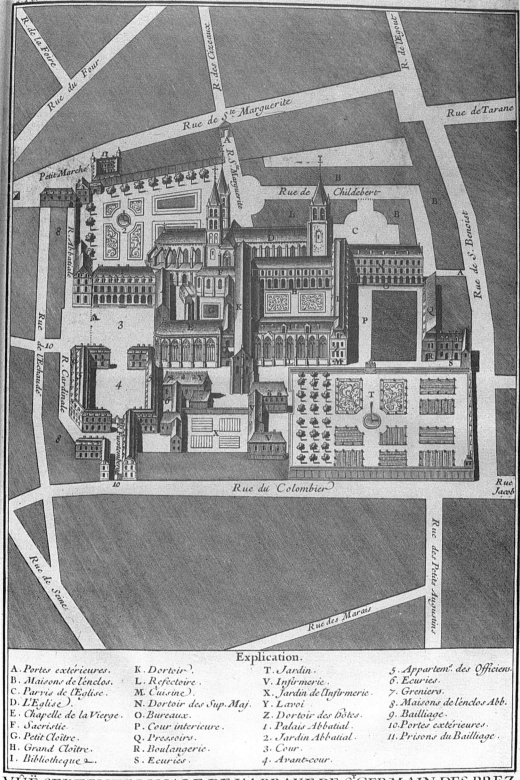

VÛË SEPTENTRIONALE DE L'ABBAYE DE S.ᵗGERMAIN DES PREZ

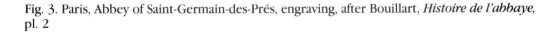

Fig. 3. Paris, Abbey of Saint-Germain-des-Prés, engraving, after Bouillart, *Histoire de l'abbaye,* pl. 2

285

the most notable glazing campaigns of the Gothic period, yet very little is documented about its original appearance. The chapel itself was built under the direction of Pierre de Montreuil as a detached structure on the northeastern grounds of the abbey at nearly the same time that the celebrated Sainte-Chapelle was being constructed by King Louis IX to house the sacred relic of the Crown of Thorns.[3] Unlike the fully saturated colored glazing of the Sainte-Chapelle, the Saint-Germain-des-Prés Lady Chapel was glazed with an innovative combination of colored glass in the seven turning bays and grisaille glass in the flanking straight bays.[4] Following the suppression of ecclesiastical foundations during the French Revolution, the chapel was sold to various Parisian entrepreneurs and was razed by 1802.[5] Yet, the survival of fragments from both the building and its stained-glass program makes it possible to address substantial problems posed by this important lost monument that was extolled by an English writer, just prior to its demolition, as one of "the most perfect exhibitions that can be found anywhere of that 'magic boldness' which all the efforts of the [Gothic] style were directed to attain."[6]

The history of the displaced panels of stained glass from the Saint-Germain-des-Prés Lady Chapel is closely associated with the painter and antiquarian Alexandre Lenoir (1761–1839) and his founding of the Musée des Monuments français, a post-Revolutionary museum devoted to the exhibition of French art.[7] Justifying his many acquisitions as preserving French art from the "destructions de l'ignorance," Lenoir's guiding principle behind the formation of the museum's holdings was the reclamation of works of art from suppressed ecclesiastical sites in Paris and its environs.[8] In 1796, he noted in his journal as having received "huit panneaux de vitraux du XIIIe Siècle" from the curé of Saint-Germain-des-Prés.[9] While Lenoir recorded having acquired only eight panels of stained glass from the curé, it is probable that there were many more panels. Official documents of the exchange refer to the panels as a "suite."[10] Further discrepancies also exist between the number of panels Lenoir listed in an unpublished accounting of glass from Saint-Germain-des-Prés and its description in the museum handbook, indicating that Lenoir had in his possession at least nine "panels" (Lenoir counted two quadrants as constituting one panel) on view in the museum's Salle du XIIIe Siècle.[11] Clearly, while

some glass was installed in the Salle du XIIIe Siècle, additional glass must have been kept in storage. When Lenoir's museum closed in 1816, numerous panels of Saint-Germain-des-Prés glass were either transferred to Saint-Denis or, in 1824, to the parish church of Saint-Germain-des-Prés, or sold abroad.[12]

Alexandre Lenoir's son Albert (1801–91) was the first to publish panels of stained glass from the Saint-Germain-des-Prés Lady Chapel. Drawing upon information gathered by his father, Albert Lenoir included an illustration of three distinct glazing cycles from Saint-Germain-des-Prés (Fig. 4): one, on the right, portraying the story of St. Vincent of Saragossa; eight panels, in the upper center, depicting legends associated with the Virgin Mary; and, at the lower center and on the left, panels from the series in question, illustrating encounters between monks and members of the nobility with their retinues.[13] They show, as do the two panels at The Cloisters, the blue medallion pictorial fields rimmed with red and white fillets and the intricate mosaic ground of red and white lattice, filled with blue canted squares decorated with painted palmette buds and a central red square.

The iconography of this series has been described varyingly as representing historical or moralizing subject matter. Alexandre Lenoir had interpreted the panels on view in the Musée des Monuments français as representing a virtuous paradigm of thirteenth-century monarchical rule: Blanche of Castille ordering the preparation of a beverage, Louis IX giving an audience to a soldier and a bishop, the queen leaving her palace to give daily orders for distributing alms, and the poor receiving the kindness of the queen.[14] Baron de Guilhermy described the panels installed at Saint-Denis and in the chapel of Sainte-Geneviève in the church of Saint-Germain-des-Prés as depicting gestures of compassion and works of charity and mercy.[15]

More recently, Louis Grodecki also saw the panels as representations of historical events. It "is more than likely," he wrote, "that the general theme of the window or windows devoted to this series concerned the translation of relics, the foundation of the monastery of Saint-Germain-des-Prés itself, the translation of the relics of St. Vincent of Spain, and the pious foundations of the kings who took the abbey under their special care, namely, Childebert, Dagobert I and perhaps also Robert the Pious."[16]

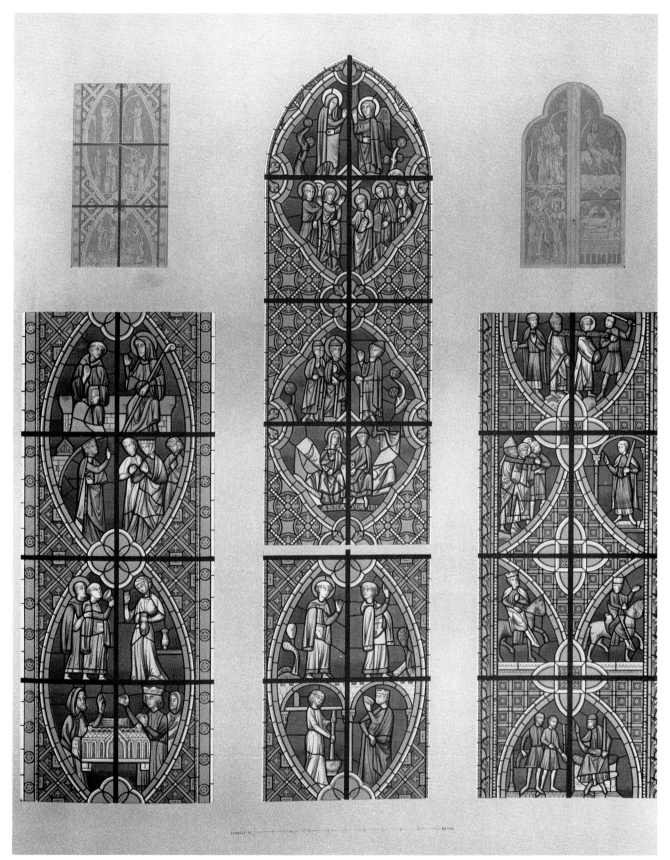

Fig. 4. "Saint-Germain-des-Prés: Vitraux," engraving, after Lenoir, *Statistique monumentale de Paris,* vol. 1, pl. XXXII

287

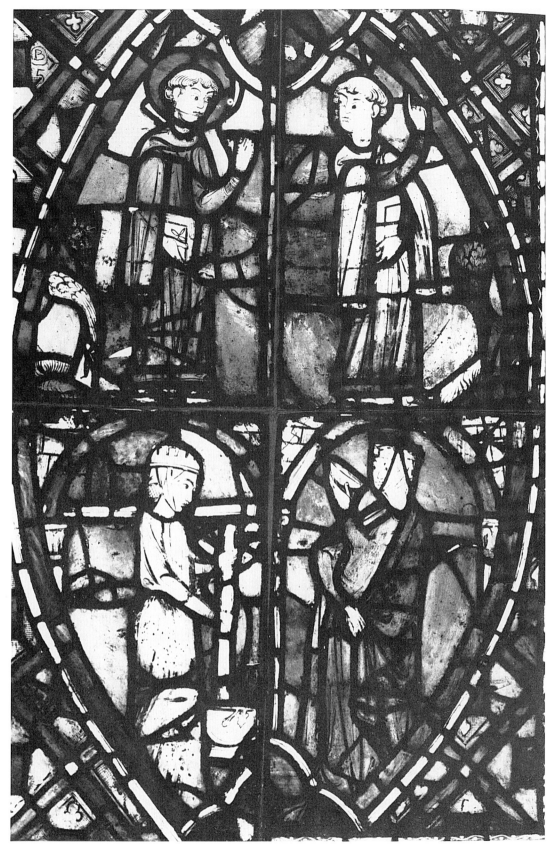

Fig. 5. Two scenes from the Life of St. Germain of Paris: Germain and Stratide leave school, and Germain's mother attempts a miscarriage. Paris, Church of Saint-Germain-des-Prés, chapel of Sainte-Geneviève (photo: COPYRIGHT 1991 ARS, N.Y./SPADEM)

288

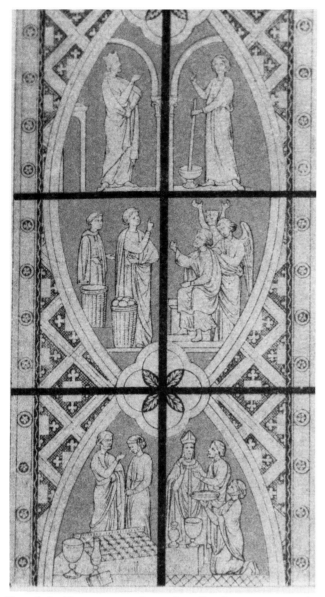

Figs. 6a,b. Three scenes from the Life of St. Germain of Paris: Germain's grandmother orders preparation of a poisoned drink; blessed bread brought to the people of Meudon; and Charity of Saint Germain

Fig. 6a. "Saint-Germain-des-Prés: Vitraux" (detail of Fig. 4)

Fig. 6b. Engraving, after Jean Lubin Vauzelle, "Salle du XIIIe Siècle," detail (from de Roquefort, *Vues pittoresques et perspectives des salles du Musée des monuments français,* pl. IV)

Philippe Verdier looked—quite correctly—to the Merovingian origins of the abbey in elucidating what he interpreted to be a historical series illustrating the charities of Childebert and Ultragoth, Childebert's acquisition of the stole of St. Vincent of Saragossa, and representations of the first monks of the abbey. Like Alexandre Lenoir, Verdier also saw

in some of the panels the illustration of thirteenth-century royal acts: the charities of Blanche of Castille and the deeds at arms of Louis IX.[17] In the first systematic analysis of the glass from Saint-Germain-des-Prés, Grodecki lamented that "the iconographical interest of this glass would certainly be very great if we could identify the subjects more precisely."[18]

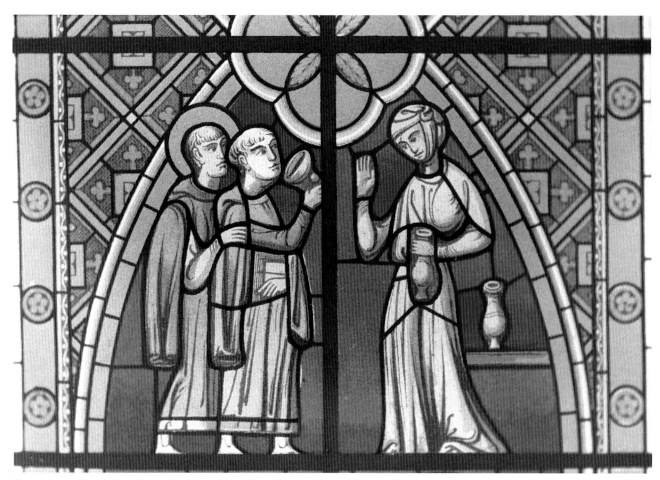

Fig. 7. Scene from the Life of St. Germain of Paris: Poisoning of Stratide (detail of Fig. 4)

Yet, so far, the obvious has been overlooked. The iconography of this series is, in fact, closely tied to works of Christian charity as well as to the abbey's early history, the legend of St. Germain encompassing both. According to his vita, principally recorded by Venantius Fortunatus (ca. 530–ca. 609), Germain was born in Burgundy around 496. He served as abbot of Saint-Symphorien, near Autun, until being appointed bishop of Paris in 555.[19] Germain exerted considerable influence over the Merovingian ruler, Childebert. Having persuaded the worldly Childebert to lead a more Christian life, Germain convinced the king to build a church to receive the relics of the True Cross and of St. Vincent's stole, which Childebert had brought back from a military campaign in Spain.[20] The church, dedicated to Sts. Vincent and Stephen and to the Holy Cross, was consecrated by Germain in 558. An adjacent monastery was erected at the same time.[21] At his

death in 576, at the age of eighty, Germain was buried in the church's oratory of Saint-Symphorien, located in the southwestern corner of the church.[22] The period of Germain's canonization is suggested by the translation of his remains in 754 to behind the altar located in the far eastern end of the choir.[23] It was at this time that the church and monastery became frequently referred to as Saint-Germain-des-Prés.[24]

Few representations of Germain are documented from the ensuing years—between Germain's eighth-century canonization and the expansive depiction of his life and posthumous miracles in the Lady Chapel's thirteenth-century glazing.[25] The cycle's genesis owes much to the chapel's function as a locus for important convocations regarding the administration of the abbey and its dependencies.[26] Sermons read at chapters general held in the Lady Chapel on St. Germain's feast day (May 28) praised

the saint as a model of faith and obedience,[27] a homily reinforced by the depiction of the saint's life and miracles in the glass behind the preaching abbot.[28]

The only known precedent for such a cycle depicting the life of St. Germain is found in a single lancet composed of six registers (ca. 1225) at the eastern end of the parish church at Saint-Germain-lès-Corbeil, south of Paris.[29] The panels at the lancet's top and bottom registers are nineteenth century in date, but the four other panels are original and illustrate significant key episodes in Germain's biography: the presentation of the keys of the city of Paris to Germain, Germain's meeting with King Childebert, Germain's consecration as bishop of Paris, and Germain's death. These important scenes were undoubtedly once also included in the extensive Saint-Germain-des-Prés cycle. However, the brevity of the Saint-Germain-lès-Corbeil cycle precludes its serving as any real guide to the iconography of the glass from Saint-Germain-des-Prés.

Despite the lack of pictorial sources, it is possible to identify the subjects of the two Cloisters panels and other related scenes from this cycle from written accounts of Germain's life. Venantius Fortunatus, poet and bishop of Poitiers, composed the first such chronicle, which remains an especially important means for the identification of the iconography of the Lady Chapel windows devoted to St. Germain. The first window was divided into two sections, the first lancet chronicling the saint's youth and abbacy at Saint-Symphorien, the second illustrating his works as bishop of Paris. The adjoining window, from which only a small number of panels survive, was devoted to the history of Germain's relics and his posthumous miracles.

A substantial number of extant as well as documented panels, whose present whereabouts are unknown, can be identified as depicting two notable incidents of Germain's early life, both of which received considerable attention from Fortunatus. Germain's mother, a woman of noble rank named Eusébie, was—while pregnant with Germain—desperately opposed to giving birth, as she had borne a child only a few months before. Looking for a mode of effecting a miscarriage or stillbirth, she drank a toxic beverage, which was ineffectual. Germain, still healthy in the womb, forgave his mother's improprieties, and his subsequent birth was

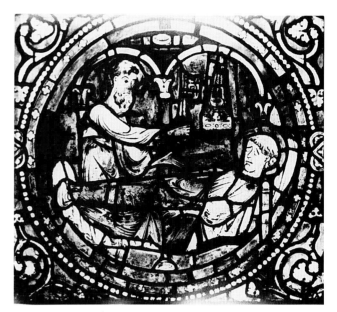

Fig. 8. Scene from the Life of St. Germain of Paris: St. Germain's Dream. Saint-Germain-lès-Corbeil, Church of Saint Vincent, ca. 1225 (photo: COPYRIGHT 1991 ARS, N.Y./SPADEM)

Fig. 9. Scene from the Life of St. Germain of Paris: Childebert receives Germain. London, Victoria and Albert Museum (photo: Royal Commission on the Historical Monuments of England)

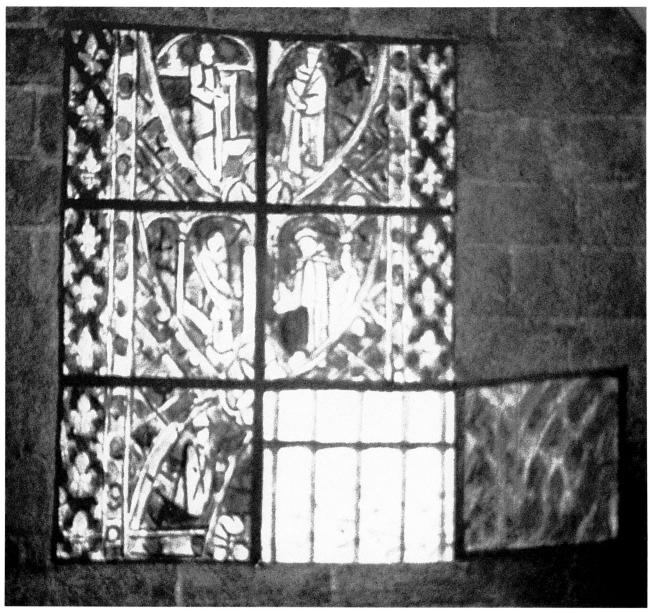

Fig. 10. Julien Léopold Bouilly, "Salle du XIIIe Siècle," watercolor (detail). Paris, Musée Carnavalet (photo: author)

interpreted by the chronicler as a sign of God's eminent esteem.[30] The scene of Eusébie drinking the potion is represented in the bottom two panels now installed at the church of Saint-Germain-des-Prés (Fig. 5). A servant is shown grinding poisonous plants into a liquid as the mother sips the noxious drink from a cup.[31]

The protection of divine providence is demonstrated again in an incident from Germain's adolescence. He was reported to have left his native Autun to attend school in Avallon with his cousin Stratide.[32] The two panels on the window's second register, also at the church of Saint-Germain-des-Prés (Fig. 5), probably illustrate the boys leaving school, an event specifically mentioned by Fortunatus. Germain's grandmother, who lived in Avallon, decided to poison him so that Stratide, her other grandson, could assume Germain's inheritance. The grandmother ordered her servant to prepare a poison, and to serve it to Germain, while offering wine to Stratide.[33] The grandmother ordering the manufacture of the lethal potion is clearly the subject

Fig. 11. Scene from the Life of St. Germain of Paris: Destruction of the pagan idols. Manhasset, New York, Christ Church (photo: author)

of two panels, now lost. They are the top two panels shown in the small monochromatic engraving published by Albert Lenoir, as well as in an engraving after a painting by Jean Lubin Vauzelle showing their installation in the Musée des Monuments français (Figs. 6a,b). Alexandre Lenoir, in his museum handbook, described the panels as illustrating "the queen coming out of her palace, giving orders for her daily distribution of alms."[34] Instead, it more likely represents the episode concerning Germain's grandmother in which she orders her servant to prepare the poison. The "poor ignorant girl," as Fortunatus says, having no idea of the evil intentions of her mistress, unwittingly switched the goblets, giving Stratide the poison, whereupon he fell dead on the spot.[35] It is to this dramatic episode that the first of The Cloisters panels belongs: the servant girl dutifully carries the flasks containing wine and poison (Fig. 1).[36] The tale is continued in two lost

panels known from the colored engraving published by Albert Lenoir (Figs. 4, 7). The servant mistakenly serves the poison to Stratide, while the saintly Germain watches and lends a supporting arm as his cousin takes the fatal drink. The wine intended for Stratide remains on a shelf in the background.[37]

It is regrettable that the scenes portraying Germain's election as bishop of Paris are lost. According to Fortunatus, a venerable old man appeared to Germain in a dream and handed him the keys to the city of Paris.[38] The clergy of the city, recognizing the keys in his possession, unanimously consecrated him to the see made vacant by the recent death of the previous bishop.[39] Although these events are not represented among the surviving panels of Saint-Germain-des-Prés glass, they were certainly the crowning panels of the lancet devoted to events preceding Germain's work as bishop, just as illustrations of St. Germain's dream (Fig. 8) and his

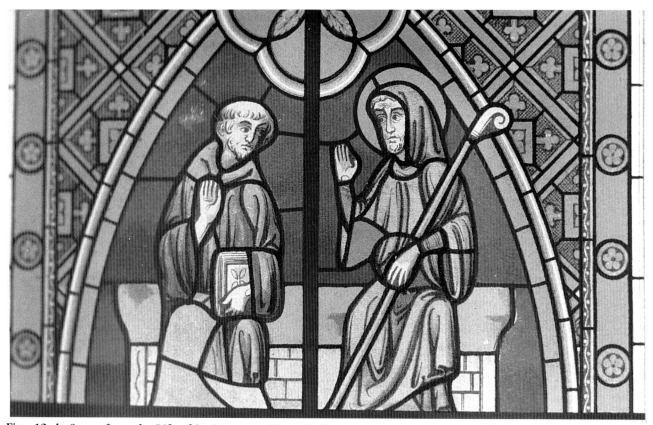

Figs. 12a,b. Scene from the Life of St. Germain of Paris: St. Droctove instructing a monk. Fig. 12a. Detail of Figure 4.

consecration as bishop occupy a major place in the succinct cycle at Saint-Germain-lès-Corbeil.

Germain's impassioned audience with Childebert to argue for the construction of a church to house the relics of St. Vincent's stole and a fragment from the True Cross was illustrated in two panels,[40] one of which is represented in the panel at the Victoria and Albert Museum (Fig. 9), showing an enthroned king receiving a warrior. The lost companion panel illustrating the entreating Germain is recorded in a watercolor of the Salle du XIIIe Siècle by Julien Léopold Bouilly (Fig. 10).[41] In the watercolor, the panel showing Childebert is obscured by its having been pushed to the side for ventilation in the gallery. However, Germain's episcopal miter and crosier shaft are clearly visible in the window's bottom register; the crosier head appears in the upper left corner of the Victoria and Albert panel. This was unquestionably a scene of great importance, as it occupied the lowest register of the right lancet in the window devoted to Germain's life and thus initiated the series devoted

Fig. 12b. Saint-Denis, chapel of Saint-Firmin (photo: COPYRIGHT 1991 ARS, N.Y./SPADEM)

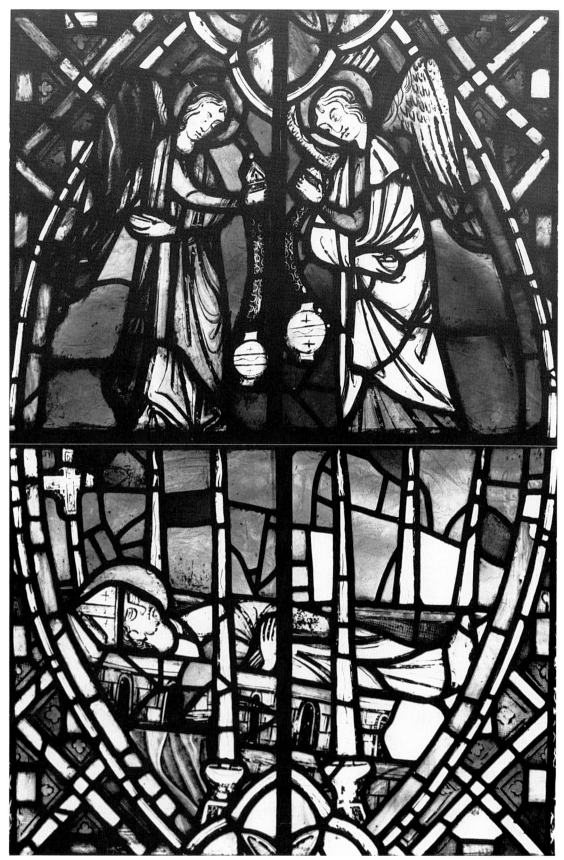

Fig. 13. Scene from the Life of St. Germain of Paris: Death of St. Germain. Winchester, Winchester College (photo: The Warden and Scholars of Winchester College)

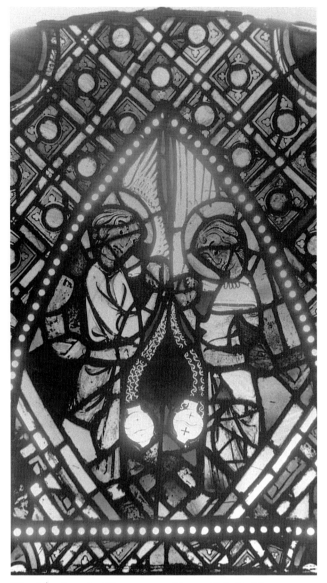

Fig. 14a. Angels. Champs-sur-Marne, Dépôt, Monuments Historiques (photo: COPYRIGHT 1991 ARS, N.Y./ SPADEM)

to Germain's works as bishop of Paris. This placement is confirmed by the survival of the original bottom border in the Victoria and Albert panel as well as in the panel illustrated by Bouilly.

Testimonies to Germain's faith and charity are represented among the other panels dedicated to scenes from Germain's episcopate. The panels in Manhasset illustrate the destruction of pagan idols in Childebert's kingdom (Fig. 11). As bishop, Germain persuaded Childebert to issue an edict to destroy all idols still worshiped by people ignorant of the Christian faith. This order, which in the Manhasset glass appears to be carried out by divine intervention, eradicated paganism in Gaul and strengthened Christianity throughout the land.[42]

Engravings after Albert Lenoir and also by Jean Lubin Vauzelle illustrate two scenes of charitable acts by St. Germain (Figs. 6a,b). While still abbot of Saint-Symphorien, Germain was already renowned for his benevolence to the poor. His boundless charity led the monks under his charge to rebel, as they feared Germain's generosity would leave them without food or basic necessities.[43] These charitable inclinations continued throughout Germain's episcopate, but in his new position Germain was also often able to persuade the nobility to share their wealth with the poor.[44] For example, the lower register glass illustrated in the Lenoir and Vauzelle engravings represents a wealthy couple (indicated by the vessels displayed in the right panel) engaged in discussion. The woman appears reticent, while in the companion panel the vessels are shown being offered to Germain, who is prominently depicted and dressed in his vestments and bishop's miter. Such a story of Christian charity is perfectly in keeping with the events described from Germain's life, but it is difficult to link it with specific stories mentioned by Fortunatus or later chroniclers.

Germain's legend is also filled with numerous curative miracles worked at the behest of the bishop through blessed oil, water, or bread. The middle register of glass shown in both the Lenoir and Vauzelle engravings illustrates such a story (Figs. 6a,b). Two monks with baskets of bread are shown meeting with a seated man, behind whom stands an angel, with an anguished figure in the background. This scene could very well depict the miraculous healing of the inhabitants of Meudon. Decimated by a plague, the townspeople were cured by blessed bread brought by the bishop's envoys.[45]

During the remainder of his life, St. Germain maintained a strong relationship with the abbey of Saint-Vincent, appointing St. Droctove of Autun as its first abbot.[46] Droctove's primary duty was to instruct the monks in leading holy lives according to the rules of St. Symphorien, quite likely the scene illustrated by Albert Lenoir (Figs. 4, 12a). The panel depicting St. Droctove is installed today at Saint-Denis (Fig. 12b).

The panels at Winchester College concluded this series, illustrating Germain laid out on his funeral bier before the saint's burial in the oratory of Saint-

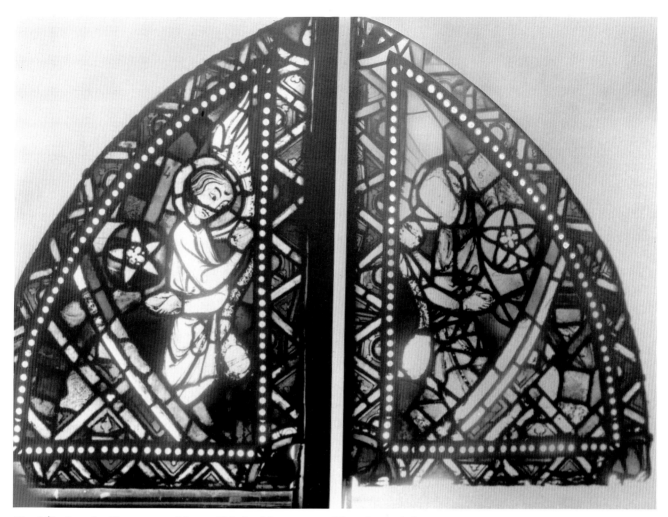

Fig. 14b. Angels. Champs-sur-Marne, Dépôt, Monuments Historiques (photo: COPYRIGHT 1991 ARS, N.Y./SPADEM)

Symphorien (Fig. 13), located in the southwest corner of the church.[47] The censing angels holding incense navettes, depicted directly above the recumbent bishop, make a most appropriate terminus for this funereal scene. They were probably original to this medallion, for as the culmination of the cycle depicting Germain's life and works, they would have been located at the summit of the window. The four angels now at Champs-sur-Marne (Figs. 14a,b) must have been similarly located in the two lancets in the adjoining window devoted to posthumous miracles associated with Germain's relics.

The extremely fragmentary nature of the surviving or recorded glass from this companion window prevents any kind of substantive speculation

as to its narrative or chronological sequence. Stories concerning Germain's relics and miracles effected through their veneration are numerous, and the depiction of these tales could have easily filled the double-lancet window. One of the most significant of these posthumous miracles was represented in two panels illustrated by Albert Lenoir (Fig. 15a), one of which survives at Saint-Denis (Fig. 15b). It concerns the miraculous levitation of the chasse containing Germain's relics at their solemn translation in 754 from the oratory of Saint-Symphorien to their new burial site behind the main altar. Having accompanied his father, Pépin le Bref, to the translation as a young boy, Charlemagne later recounted this wondrous event in detail.[48] At the moment before the relics of Germain were to be

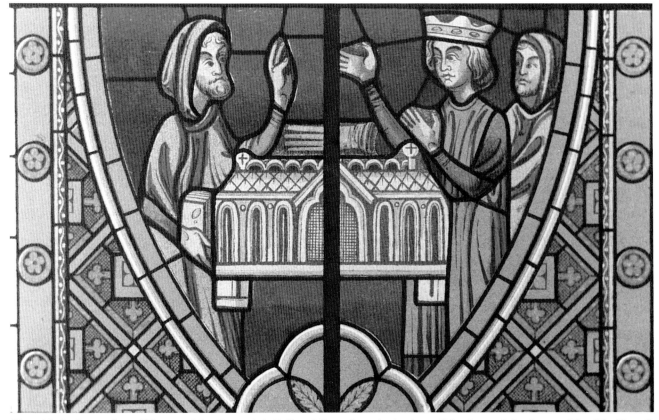

Figs. 15a,b. Scene from History of St. Germain's Relics: Miraculous levitation of St. Germain's chasse. Fig. 15a. Detail of Figure 4.

lowered into their new resting place, the chasse rose into the air from the litter on which it had been placed. The monks of the abbey and the king were both amazed and terrified. Charlemagne reported that the chasse, as it hovered, exuded a sweet, supernatural odor.[49] The levitating chasse, accompanied by two monks and the king with their arms raised in astonishment, is shown quite clearly in Lenoir's engraving.

The second Cloisters panel formed part of a key sequence attesting to the authenticity of Germain's relics, which had been displaced for protection during the Norman incursions (Fig. 2).[50] A mid-ninth-century chronicle relates the events surrounding a subsequent translation of Germain's relics in the wake of the invading Norsemen. The safekeeping of the relics while the monks fled from the abbey was foretold to a monk in a dream two years prior to the incursion; St. Germain was reported to have risen from his coffin and advised the monk that the saint's relics would travel from the monastery

together with the monks and return safely to the abbey.[51] Germain appears in The Cloisters panel with a golden countenance, possibly to suggest his celestial nature. It seems reasonable to suggest that this panel was part of a larger series devoted to Germain's relics during the Norman invasions, constituting a pictorial testimony upon which the identification of the relics rested as well as lending credibility to their authenticity.[52]

The two Cloisters panels and other vestiges provide a fractional but no less compelling insight into the significant cycle devoted to St. Germain in the Lady Chapel glazing program. The detailed glorification of St. Germain's life and posthumous miracles illustrated in the glass created a dual impact. For the individual monk, Germain's portrayal as a model of learned piety and Christian charity offered a life of moral distinction for emulation, providing the occasion for the reaffirmation of monastic vocations. From the collective viewpoint of the monastic congregation, the legend of St. Germain

was inexorably tied to the abbey's distinguished Merovingian origins and subsequent history, and thus the pictorial narrative served both to commemorate and to reinforce the abbey's illustrious status in Paris at the time of Louis IX. Such a cycle dedicated to St. Germain, who, with Childebert, was responsible for the abbey's foundation, would have provided an effective counterpart to the windows illustrating the life of St. Vincent and the history of his relics, in whose name the abbey was originally dedicated and whose tunic and jawbone were prized relics venerated by the abbey's congregation.

Fig. 15b. Saint-Denis, chapel of Saint-Firmin (photo: author)

ACKNOWLEDGMENTS

Research for my work on thirteenth-century stained glass from Saint-Germain-des-Prés has been supported by travel grants from The Metropolitan Museum of Art and Columbia University. Initial work on the St. Germain cycle was presented in the ICMA Sessions of the XXII International Congress on Medieval Studies, Kalamazoo, May 1987. I am indebted to many people for permission to study the extant glass from this cycle: Jane Hayward at The Cloisters; Catherine Brisac of the Ministère de la Culture, Paris; D. Michael Archer at the Victoria and Albert Museum; the Warden and Scholars of Winchester College; and the clergy of Christ Church, Manhasset, New York. I am especially grateful to Allison Merrill for her assistance in the preparation of this article.

NOTES

1. See Jane Hayward, in "Stained Glass before 1700 in American Collections: New England and New York," Corpus Vitrearum Checklist I, *Studies in the History of Art* 15 (1985), pp. 100–101.

2. For those panels at Saint-Denis, see Louis Grodecki, *Les Vitraux de Saint-Denis* (Paris, 1976), p. 43, no. 15; for the dépôt of the Monument Historiques, see ibid., pls. 212, 213; for the Victoria and Albert Museum, see Bernard Rackham, *Victoria and Albert Museum: Guide to the Collections of Stained Glass* (London, 1936), p. 30; and Louis Grodecki and Catherine Brisac, *Gothic Stained Glass 1200–1300* (Ithaca, 1984), p. 254, pl. 85; for Winchester College, see Mary B. Shepard, "French 13th-Century Stained Glass from Saint-Germain-des-Prés at Winchester College," *The Journal of Stained Glass* 18 (1986–87), pp. 115–23; for Manhasset, see Linda Papanicolaou, in "Stained Glass before 1700 in American Collections: New England and New York," p. 86; for the parish church of Saint-German-des-Prés, see Louis Grodecki et al., *Les Vitraux de Paris de la Région Parisienne, de la Picardie et du Nord-Pas-de-Calais*, Recensement des vitraux anciens de la France, Corpus Vitrearum Medii Aevi I (Paris, 1978), pl. III, p. 46 (the iconography of bays 2 and 4 are reversed).

3. Abbey records and transcriptions of inscriptions indicate that construction of the Lady Chapel was begun immediately following the completion of the nearby refectory in 1244 and was concluded by 1255, when an abbatial election took place in the chapel. Dom Jacques Bouillart, *Histoire de l'abbaye royale de Saint-German-des-Prez* (Paris, 1724), pp. 124, 126–27, 129–30.

4. Ibid., p. 126; and Henri Sauval, *Histoire et recherches des antiquités de la ville de Paris* (Paris, 1733), vol. 1, p. 341.

5. E. Lefèvre-Pontalis, "Étude historique et archéologique sur l'Église de Saint-Germain-des-Prés," *Congrès Archéologique de France* (1920), p. 318; Archives de la Seine, DQ 10, Carton 585, dossier 427, chemise 3764; and Louis Réau, *Les monuments détruits de l'art français* (Paris, 1959), vol. 2, p. 18.

6. G. D. Wittington, *An Historical Survey of the Ecclesiastical Antiquities of France* (London, 1811), p. 200.

7. See J. E. Biet and J. P. Brès, *Souvenirs du Musée des monumens français* (Paris, 1812); and Alain Erlande-Brandenburg, "Alexandre Lenoir et le Musée des Monuments Français," *Le "Gothique" Retrouvé avant Viollet-le-Duc*, exhib. cat., Hôtel de Sully (Paris, 1979), pp. 75–84.

8. Alexandre Lenoir, *Description Historique et Chronologique des monumens de sculpture, réunis au musée des monumens français* (Paris, 1800), pp. 2, 4.

9. Louis Courajod, *Alexandre Lenoir: son journal et le musée des monuments français* (Paris, 1878), vol. 1, p. 112; Paris, Bibl. Nat., Estampes, Yb4 671, fol. 250; Jules Guiffrey, *Inventaire Général des Richesses d'Art de la France*, 3 vols. (Paris, 1886), vol. 2, p. 399; and Charles Saunier, "Les réclamations d'objets d'art par la fabrique de Saint-Germain-des-Prés," *Bulletin de la Société Historique du VIe Arrondissement de Paris* 2 (1899), p. 65 n. 1.

10. See Guiffrey, *Inventaire*, vol. 2, pp. 321–22.

11. In the unpublished accounting, Lenoir counted "Des estropiés et des malheureux secourus par la Reine" as a single panel, whereas in the museum handbook it is described as constituting two registers of a window in the gallery: "le tableau . . . est également divisé en trois sujets. . . . Les deux sujets du bas représentent des pauvres qui reçoivent, comme les autres, les bienfaits de la reine." See Paris, Bibl. Nat., Estampes; and Alexandre Lenoir, *Description Historique*, 8th ed. (Paris, 1806), p. 46.

12. For the glass transferred to Saint-Denis, see Guiffrey, *Inventaire*, vol. 3, pp. 289, 298; and Louis Grodecki, *Vitraux de Saint-Denis*, p. 43 n. 15. For Saint-German-des-Prés, see Paris, Arch. Nat., F21 586, dossier No. 2; Georges Huard, "La Salle du XIIIe Siècle du Musée des Monuments Français à l'École des Beaux Arts," *La Revue de l'art ancien et moderne* 47 (1925), p. 118; and Lefèvre-Pontalis, "Étude historique," p. 321. For a succinct discussion of glass sold abroad, see Grodecki, *Vitraux de Saint-Denis*, pp. 45–46.

13. Albert Lenoir, *Statistique monumentale de Paris* (Paris, 1867), vol. I, pl. XXXII.

14. Alexandre Lenoir, *Description Historique*, 1806 ed., p. 46.

15. Ferdinand François de Guilhermy, Paris, Bibl. Nat., MS fr. nouv. acq. 6121, fol. 84; idem, MS fr. nouv. acq. 6122, fol. 117v; and idem, *Itinéraire archéologique de Paris* (Paris, 1855), pp. 138–39.

16. Louis Grodecki, "Stained Glass Windows of St. Germain-des-Prés," *The Connoisseur* 140 (1957–58), p. 36.

17. Philippe Verdier, "The Window of Saint Vincent from the Refectory of the Abbey of Saint-German-des-Prés," *The Journal of The Walters Art Gallery* 25–26 (1962–63), pp. 84, 88–89. Verdier erroneously includes in this series two panels representing two kings on horseback (Metropolitan Museum [24.167]) which stylistically belong to the St. Vincent windows, specifically to the cycle depicting the history of St. Vincent's relics, ibid., p. 84.

18. Grodecki, "Stained Glass Windows," p. 36. See also Grodecki and Brisac, *Gothic Stained Glass*, p. 254.

19. Synopses of Germain's life and miracles are found in the *Acta sanctorum*, May, vol. 6 (Rome, 1866), pp. 764–69; A. A. MacErlean, "Germain," *The Catholic Encyclopedia* (New York, 1909), vol. 6, pp. 473–74; Paul Guérin, *Vies des Saints* (Bar-le-Duc, 1872), vol. 6, pp. 264–74; and Butler, *Lives of the Saints* (New York, 1956), vol. 2, pp. 410–11.

20. Gregory of Tours, *The History of the Franks* (Harmonds-worth, 1983), pp. 186–87; Bouillart, *Histoire*, pp. 1–2; H. Leclercq, "Germain-des-Prés (Saint-)," *Dictionnaire d'Archéologie Chrétienne et de Liturgie* (Paris, 1925), vol. 6, pt. 1, pp. 1102–3.

21. Bouillart, *Histoire*, p. 4.

22. *Acta sanctorum*, p. 779; and Bouillart, *Histoire*, pp. 8–9.

23. Bouillart, *Histoire*, pp. 19–20. Regarding canonization practices prior to their regularization by Rome, see Stephan Beissel, *Die Verehrung der Heiligen und ihrer Reliquien in Deutschland im Mittelalter* (Darmstadt, 1983), pp. 101–17.

24. Leclerq, "Germain-des-Prés," p. 1122.

25. Paris, Bibl. Nat., MS lat. 11615, fol. 2v; and idem, MS lat. 12610, fol. 40v.

26. Bouillart, *Histoire*, p. 153; and Dom A. du Bourge, "La vie monastique dans l'abbaye de Saint-Germain-des-Prés," *Revue des Questions Historiques* 34 (1905), p. 421.

27. Paris, Bibl. Nat., MS lat. 12617. See also Dom Jacques du Breul, *Supplementum Antiquitatum urbis Parisiacae quoad sanctorum Germani a Pratis* (Paris, 1613).

28. There is not sufficient space in this short essay to discuss the relationship between the chapel's conventual use and the iconography of its glazing program. Some of these affinities were presented in a paper given in 1989 at "Story and Image in Medieval Art," a symposium sponsored by the Robert Branner Forum, Columbia University. See also Mary B. Shepard, "The Thirteenth-Century Stained Glass from the Parisian Abbey of Saint-Germain-des-Prés" (Ph.D. diss., Columbia University, 1990), pp. 68–75.

29. L. Vollant, *L'Église de Saint-Germain-lès-Corbeil* (Paris, 1897), pp. 3–4, 31; Grodecki et al., *Vitraux de Paris*, pp. 83–84.

30. Fortunat, *La vie miraculeuse du grand prélat S. Germain*, trans. Jean Jallery (Paris, 1623), p. 2.

31. This scene is also reproduced in Albert Lenoir, *Statistique monumentale*, vol. 1, pl. XXXII.

32. Fortunat, *La vie*, p. 3.

33. Ibid., pp. 3–4.

34. Alexandre Lenoir, *Description Historique*, 1806 ed., p. 46.

35. Fortunat, *La vie*, pp. 3–4.

36. At this panel's purchase in 1973, a piece of fourteenth-century silver-stained grisaille was in place as a stopgap for the servant's left hand and flask. The painting on the fourteenth-century stopgap most likely led to its description as a "spit"; see Grodecki, "Stained Glass Windows," p. 36 n. 14. The present restoration, showing a second flask, is based on the depictions of the servant in the *Statistique* engraving (Fig. 4).

37. Two additional panels illustrated in the third register of Albert Lenoir's engraving, one of which is now at Saint-Denis

(see Grodecki, *Vitraux de Saint-Denis*, p. 235, fig. 216), show a noblewoman confronting a similar couple and their servant. This scene could possibly have been part of this series, depicting a meeting between Germain's grandmother, his parents, and their servant, but there is no confirmation of such an event in any of the writings on Germain's life.

38. Fortunat, *La vie*, pp. 18–19.

39. The abbey of Saint-Germain-des-Prés claimed to possess these very keys until 1556, when they were stolen by thieves who broke into the church at night. Bouillart, *Histoire*, p. 188.

40. Ibid., p. 2; and Fortunat, *La vie*, pp. 28–29.

41. Julien Léopold Bouilly, "Salle du XIIIe Siècle," Paris, Musée Carnavalet. See *Paris Romantique*, exhib. cat., Musée Carnavalet (Paris, 1957), intro. by Jacques Wilhelm, no. 145.

42. L'Abbé Fraichinet, *Notice Biographique sur Saint Germain* (Agen, 1881), p. 123; and L'Abbé Duplessy, *Histoire de Saint Germain* (Paris, 1841), pp. 136–37.

43. Fortunat, *La vie*, pp. 5–6.

44. See Fraichinet, *Notice*, pp. 128–30; and Fortunat, *La vie*, p. 48.

45. Fraichinet, *Notice*, pp. 170–71; and Guérin, *Vies des Saints*, p. 268.

46. Bouillart, *Histoire*, pp. 4–5.

47. Fortunat, *La vie*, p. 92; and *Acta sanctorum*, p. 779.

48. Fortunat, *La vie*, pp. 103–16. See Leclerq, "Germain-des-Prés," p. 1119.

49. Fortunat, *La vie*, pp. 115–16.

50. For the history of Saint-Germain-des-Prés during the Norman invasions, see Bouillart, *Histoire*, pp. 32, 34, 43.

51. "Translation S. Germani Parisiensis, Anno 846," *Analecta Bollandiana* 2 (1883), pp. 76–77. Also see *Acta sanctorum*, pp. 786–96.

52. Such dreams were a common *topos* for establishing the authenticity of relics. See Jonathan Sumption, *Pilgrimage: An Image of Medieval Religion* (London, 1975), pp. 26–27; and Patrick Geary, *Furta Sacra: Thefts of Relics in the Central Middle Ages* (Princeton, 1978), pp. 8, 74.

Fig. 1. Two grisaille glass panels with fleurs-de-lis decoration, French, ca. 1325. (Central lozenges are restored.) The Metropolitan Museum of Art, The Cloisters Collection, 1982 (1982.433.3,4) (photo: Museum)

Two Grisaille Glass Panels from Saint-Denis at The Cloisters

Jane Hayward

Recently installed in the Heroes Tapestry Hall at The Cloisters are two grisaille glass panels (Fig. 1), which were formerly in the Acezat collection.[1] Based on what little is known about this glass, these pieces and others like them have been assumed to be part of "Notre-Dame's Vanished Medieval Glass," as reconstructed by Jean Lafond and Henry Kraus.[2] In addition to The Cloisters panels, which before restoration included borders of grotesques on the outer edges that were removed because they proved to be modern (Figs. 2a,b), there are two more pieces in London at the Victoria and Albert Museum (Figs. 3, 4),[3] one in the Cluny Museum in Paris (Fig. 5),[4] and another, with an original border of grotesques still attached (Fig. 6), now at the dépôt des Monuments Historiques in the château of Champs-sur-Marne.[5] In spite of their attribution to the cathedral of Paris, two of these panels—the one at Champs-sur-Marne and the Cluny piece—were once at Saint-Denis. For this reason, the possibility that all the glass in this group originated in the royal abbey must be considered and weighed against the assigned provenance. A reexamination of the evidence points to the conclusion that not only were these panels made for Saint-Denis but they were also specifically made for the chapel of St. Louis, which was added to the north nave aisle between 1320 and 1324.

The Notre-Dame attribution for the group rests on slender evidence that is almost entirely documentary in nature because, with the exception of the three roses and two isolated panels, none of the medieval glass there has survived. In 1841 Émile Leconte published an album of plates on the cathedral of Paris that included a stained-glass border surrounding a panel of clear leaded glass from a chapel on the north side of the church (Fig. 7). Jean Lafond recognized the border and stated in his study on the stained glass of Notre-Dame: "La curieuse bordure de têtes

grotesques [engraved by Leconte and] reproduite à la planche 61 est du moins conservée en partie à Saint-Denis où elle entoure une belle grisaille décorée de fleurs-de-lys."[6] In his 1966 article on the cathedral's glass, Kraus repeated Lafond's attribution of the piece, now at the dépôt at Champs-sur-Marne, to Notre-Dame, based on the similarity of the border to that published by Leconte.[7] Earlier, Lafond had also recognized the grisailles now in London as part of the series.[8] For this reason all of these panels, including the two at The Cloisters, have been attributed to the cathedral of Notre-Dame in Paris.[9] As even Lafond later admitted, however, the evidence on which this attribution rests is valid only for the grotesque border and not for the grisailles.[10]

What has seemed the ideal location at Notre-Dame for this glass is the chapel on the north side of the choir, the third from the axis, which was dedicated to St. Eutrope and was a donation of Philippe-le-Bel.[11] In the eighteenth century, Pierre Le Vieil had reported that he saw in the window there "le Roi Philippe-le-Bel à genoux, lé derrière lui l'écusson de France semé de fleurs-de-lys sans nombre, . . . & à gauche, Jeanne de Navarre qu'il épousa en 1284, derrière laquelle est l'écusson de Navarre de la même étendue."[12] Le Vieil might seem to have described a band window that would provide the perfect place for the fleurs-de-lis grisailles at Notre-Dame were it not for additional information supplied by the baron de Guilhermy in 1855. He reported seeing remains of the old glass in this chapel and the two that flanked it, which he described as fragments of grisailles and of borders strewn with eaglets and foliage.[13] This description does not conform to the pieces drawn by Leconte. It would be difficult to distinguish any foliage in his border, much less any eaglets. Furthermore, an insurmountable discrepancy is presented by the dimensions of the lancets of the choir chapel windows at Notre-Dame, each about 46 inches (116.8 cm) wide. The grisaille panels are all only about 15 inches (38.1 cm) wide—too narrow, even with two strips of the 3-inch-wide (7.6-cm) grotesque border, to have been accommodated in the cathedral windows even if the panels had been doubled.[14]

The distinctive feature of this group of grisaille panels is the small fleur-de-lis sprouting from the stem of the foliage in every one of the original quarries. So far as is known, this royal symbol is unique to these six panels as it does not appear

in any other grisailles of this period, nor is it known earlier.[15] In most examples of grisailles of this date, each quarry contains a bud of the flower as well as leaflets that can also be seen in the quarries from other sources that have been used to repair the many losses in the group in question. In some cases, the bud has been debased into a spiky burr,[16] but in no case is it a recognizable fleur-de-lis. For this reason, this symbol suggests a special significance for this glass—perhaps a royal donation or a dedication to a royal patron.

In all panels of the series, the quarry pattern, composed of bulged and straight strapwork, has been confused in restoration, so that the flow of tendrils is difficult to read. The main stem runs up one edge and across the bottom of the panel, and each quarry continues the flow of the foliage in an upward diagonal direction. Lateral stems found here are not unknown in grisaille design, but they are rare.[17] A grotesque or a genre figure occupies the central lozenge in each panel.[18] The unusual inclusion of two different patterns of silver-stain ornament decorating the straps that weave over and under each other in a basketwork design suggests an experimental phase and a date early in the fourteenth century. Aside from examples in Lafond's pioneering work on Normandy, however, there are few dated grisaille-glass programs in France to use for comparison; the best is the choir of Saint-Ouen in Rouen, begun in 1318 and finished before 1339, whose glass is generally dated 1325–35.[19] In contrast to the group under discussion that consistently employs the wild rose pattern common to most grisailles of the period, at Saint-Ouen the foliage has been differentiated into recognizable botanical species, suggesting a more advanced stage in the development of ornament.[20] Another indicator of a date earlier than Saint-Ouen is the combination of bulged and straight strapwork in the Saint-Denis group that later tends to be eliminated in favor of rectangular quarries.[21] However, because of the silver stain employed, the date could hardly be earlier than about 1315.[22]

As in the case of Notre-Dame, none of the glass from the thirteenth-century building program or from subsequent medieval additions at Saint-Denis has survived and knowledge of it is all documentary. The abbey church was consecrated in 1281, presumably with its glazing completed.[23] Later structural additions would, therefore, have contained

contemporary windows.[24] The first additions to the thirteenth-century church were the nave chapels, added between the buttresses on the north side (Fig. 8). Construction began on these chapels in 1320 and they were finished and decorated by the summer of 1324.[25] One of these, the third from the west, was dedicated to St. Louis, the second chapel to honor him at Saint-Denis. The window in this chapel, characteristic of the period, is composed of four cusped lancets separated by thin mullions, with a pyramid of three traceried roses above, capped by a pierced gable. Each of the lancets is 34 inches (86.4 cm) wide by about 16 feet 2 inches (4 m 83 cm) high.[26] The grisaille panels under discussion are each 15 inches (38.1 cm) wide by 23½ inches (59.7 cm) long. These measurements would allow for eight panels in the vertical position with a slightly longer piece extending into the trefoil at the top.[27] Two of these panels, side by side, with two 1-inch (2.5-cm) fillets on each outer edge, would exactly fill the width of the lancet.[28]

From the middle of the thirteenth century on, grisaille played an increasingly important role in the decoration of churches. It allowed more light to enter the building, was cheaper than colored glass, and solved the iconographic problem posed by the enormous openings in Rayonnant buildings.[29] In spite of its royal patronage, grisaille was certainly used at Saint-Denis, as Lillich believed.[30] The purpose and physical size of the abbey church were vastly different from the small, private, richly decorated Sainte-Chapelle that Louis IX built in Paris. Saint-Denis served the laity as well as the monks in addition to functioning as the royal necropolis. In fact, a probable reason for a second chapel dedicated to St. Louis in the nave was his popularity as a saint among the people after he was canonized in 1297. The lay congregation could hardly ascend into the ambulatory of the choir, reserved for the monks, to do him honor in his chapel there (Fig. 8).[31] The thirteenth-century rebuilding of the royal abbey was begun just five years after Louis became king and continued throughout his lifetime, being virtually complete by his death in 1270, although it was not consecrated until 1281. That Louis was closely associated with Saint-Denis can be discerned by the carved fleurs-de-lis that are still visible on the south transept portal and that once abounded in the church's decoration.[32] These emblems could only have been a reference to King Louis during his lifetime or to his royal Capetian line, and it can be assumed that the fleurs-de-lis on the glass in the fourteenth-century chapel were a continuation of this practice honoring its patron.

To see Saint-Denis as the provenance for this glass, and yet to understand why there is no specific record of its existence there, it is necessary to review the tragic history of the windows that once filled the abbey church. The fate of the fourteenth-century chapels cannot be separated from the devastation that overtook the thirteenth-century building onto which they had been grafted. The loss of the glass in the Saint-Louis chapel occurred at the same time and was caused by the same circumstances as those that destroyed most of the glass of the nave begun by Abbot Eudes Clément in 1231. It is, therefore, important to follow the fate of the entire building in the Revolutionary period in order to see clearly what happened to the nave chapels.

Saint-Denis had ceased to be an abbey on September 14, 1792, having already been designated a parish church by the Revolutionary government. Its windows remained in place while it served the parish but, by October 14, 1793, the royal tombs at Saint-Denis had been desecrated, the pavement had been torn up in the search for coffins, and of necessity in the wake of such pillage the church had been closed and stripped of its ecclesiastical function. By November 1793 the church had been transformed into a Temple of Reason, a Republican designation that it continued to hold throughout that winter.[33] By 1794, however, a serious threat menaced the basilica: the Republic's pressing need for metals for armaments and war materials. In February of that year the Committee of Public Health designated Franciade, the Republican name for Saint-Denis, as among those churches whose lead roofs were to be removed.[34] La Commission des Armes, Poudres et Exploitation des Mines de la République was charged with executing the decree, but since their need extended to the leading in the stained-glass windows, the matter was referred to the Temporary Commission of the Arts on April 9, 1794.[35] It was not until October of that year, however, that the Arts Commission decreed a postponement for the windows based on the desire to "preserve for the Republic everything useful to the glory of the Arts and Public Instruction."[36] The only activity that then disturbed the peace in the deserted building was that of the gangs of workmen

Figs. 2a,b. The Cloisters grisaille panels with borders still attached (photo: Museum)

dismembering the great tombs to transport them to the storage depot established by Alexandre Lenoir, a member of the Arts Commission, at the former abbey of the Petits-Augustins in Paris.[37] It was also Lenoir who, in October 1794, secured the services of Charles Percier, a young architect, to prepare a drawing of the tomb of Dagobert at Saint-Denis before its removal to the Petits-Augustins.[38] While doing so, Percier made forty drawings of the interior of the building, the earliest set of graphic documents to give even a hint of the appearance of the thirteenth-century windows.[39]

Throughout the period following the destruction of the tombs, suggestions were made as to what to do with the deserted abbey.[40] The sale of the church was narrowly averted on several occasions. From 1794 on, the nave was used to store cereals and grain, but dampness caused the wheat to rot. By 1796, however, there was an attempt to reactivate the church. Pierre Gauthier, former organist at Saint-Denis, is the best source for what happened there during the closing years of the eighteenth century.[41] In his diary he mentions that "in 1796 in the month of September there was still the hope that the church of the Abbey of Saint-Denis would be again a Catholic parish and that the roof had already begun to be re-covered with tiles starting in the nave. But recently these hopes had vanished, since the church is without stained glass and is in a state of dilapidation difficult to repair. The iron bars that stabilize the flying buttresses of the chevet have been taken out and afterward the church will be torn down according to the plan, as far as the galleries. The arcades will stay, in order for the side aisles to form shops when fairs are held."[42] The plan had been the suggestion of the architect Petit Radel, Inspecteur Général des Monuments Publiques.[43] Gauthier's account indicates that between February 1795, when Percier left[44] (at which time the glass was still in the church), and sometime after September 1796 the clerestory windows were taken out of Saint-Denis. On September 6, 1798, Gauthier says that he went up to the organ loft, but the organ was no longer usable on account of dampness, because many of the stained-glass windows had been removed and the vault in this part of the church had been unprotected for a long time.[45] Writing in about 1832, François Debret, architect of the restoration of Saint-Denis, confirms that "the vault

of the great nave was a ruin and only the side aisles were sound enough to serve as a market."[46]

The date for the removal of all the lower windows, including those of the nave and choir chapels, is not certain.[47] In August 1799 Alexandre Lenoir wrote to the Minister of the Interior for permission to remove "thirteenth-century glass" from the lower choir.[48] His request must have been approved by May 29, 1800, when the Sous-préfet de Franciade directed Lenoir to reglaze the bays from which he had taken glass so that robbers could not enter the church.[49] This implies that otherwise the closure of the ground story was intact. It has been assumed that none of the thirteenth-century glass taken by Lenoir has ever been recovered and that no stray pieces that might have remained on the site have survived. It has also been assumed, since there are virtually no descriptions of the windows other than those of Suger's choir, that no glass from the later building campaigns, even if it survived the French Revolution, could be identified. What glass did Lenoir take? Was it, as he maintained, returned to Saint-Denis? Was any debris from the windows left at the abbey? Most important, was there any fourteenth-century glazing left at Saint-Denis? All these are questions that have so far remained un-answered.

Perhaps the most effective way to address these questions is to proceed chronologically, beginning with what is known about the glass of Saint-Denis while still in situ. Dom Jacques Doublet, historian of the abbey in the early seventeenth century, and his successor, Dom Michel Félibien, described the stained glass but only in general terms.[50] In the early eighteenth century Bernard de Montfaucon included the abbey church of Saint-Denis in his monumental work on the French monarchy.[51] In addition to the twelfth-century windows that he illustrated, Montfaucon published a series of eight scenes from the life of Louis IX that were placed in pairs in each of four lancets of the chapel begun in 1299 and dedicated to St. Louis, which was added behind the chapel of St. Romain on the south side of the choir (Fig. 8).[52]

An important eyewitness account is that of the glass painter Pierre Le Vieil, knowledgeable on technique and style, who published a treatise on stained glass in 1774. In describing the brilliantly colored, narrative windows made in the thirteenth century,

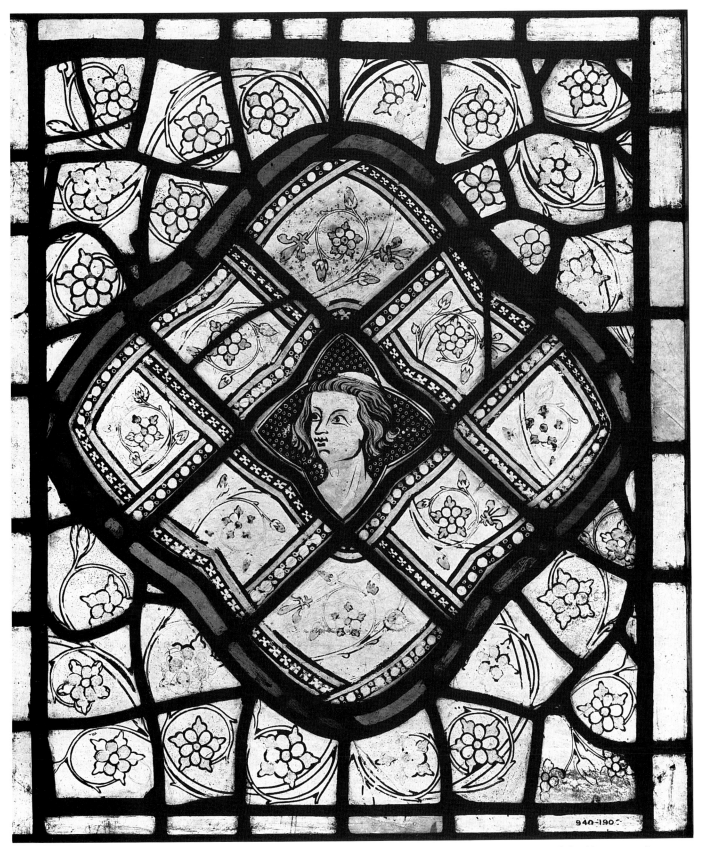

Fig. 3. Grisaille panel with tonsured head. London, Victoria and Albert Museum (photo: courtesy of the Trustees of the Victoria and Albert Museum)

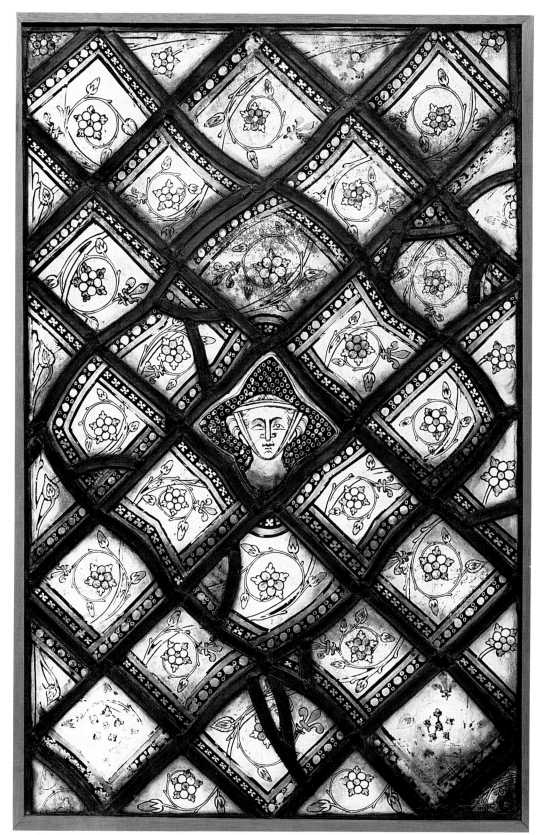

Fig. 4. Grisaille panel with female head. London, Victoria and Albert Museum
(photo: courtesy of the Trustees of the Victoria and Albert Museum)

he stated that most of the glass at Saint-Denis, later than the windows that Abbot Suger had made, was of this type, similar to Notre-Dame and the Sainte-Chapelle in Paris.[53] Charles Percier's album of sketches confirms Le Vieil's statement and is an interesting document, especially for the thirteenth-century clerestory and for the north rose.[54]

Except in very general terms, Alexandre Lenoir has very little to say about which glass he removed from Saint-Denis.[55] During the time that Lenoir first served as guardian of the depot at the Petits-Augustins, he kept a journal in which he recorded objects that were either stored or sorted there.[56] The depot became the Musée des Monuments français on October 21, 1795, at Lenoir's urging, and he became its conservator;[57] the following April, he was made its director. In his published catalogue of the museum, Lenoir stated that his philosophy for the new museum was to display his "monumens" of French sculpture in settings created from material of their period.[58] To that end, he began to utilize the stained glass from many churches that he had acquired in the depot. Lenoir's notes suggest that a great deal of glass from many different periods was installed throughout the museum, leaving very little of the glass recorded in his journal still in storage. It comes as a surprise, therefore, to read in Item No. 799: "The 19th, I cautioned the minister that the administration of the Musée des Arts [Louvre] is about to send him a request suggesting the removal from the Dépôt [Petits-Augustins] of the rest of the stained-glass panels in order to conform, ostensibly, to the plans of the Museum. But where and how will they be placed?"[59] This statement suggests that Lenoir had, in storage at the depot, much more glass than he had recorded. Unfortunately, his day-to-day accounting breaks off on 17 floréal, an VII (May 6, 1799), before the fourteenth-century gallery had been completed and before Lenoir had removed the glass from Saint-Denis to fill its windows.

Proof that Lenoir had not recorded all the glass that he had acquired can be found in descriptions in his catalogue of the thirteenth-century gallery, opened in 1797. There he states that three casements were filled with glass from the abbey of Saint-Germain-des-Prés.[60] These casements, according to all visual records of the room, each contained six panels, a total of eighteen, from Saint-Germain-des-Prés.[61] Lenoir's journal, however, notes that only eight

panels were received from the abbey.[62] Moreover, comparisons with the graphic documents, most of which are admittedly later than 1799, indicate that there was a great deal more glass installed elsewhere in the museum than was ever recorded by Lenoir.[63] In the fifth edition of the catalogue, published in 1799–1800, Lenoir lists glass installed in the museum that does not appear in his journal.[64] Evidently the museum was unfinished at that time, because the fourteenth- and fifteenth-century rooms are listed under one heading in the glass section.[65]

In fact, it was in 1799–1800 that Lenoir began arranging the fourteenth-century gallery,[66] for which he needed glass that was not in storage. By 1800 he was also considering monuments in the various *départements*, or counties, outside Paris. "Now that we at last have a veritable museum of French sculpture," he said, "why not enrich it with the host of monuments scattered in the *départements*?"[67] An early plan for the room was discarded after Lenoir obtained glass from Saint-Denis and the six large Gothic casements from the remains of the treasury of the Sainte-Chapelle, demolished in 1782.[68] In the sixth edition of his catalogue of 1801–2, Lenoir states that the thirteenth-century glass from the nave of Saint-Denis ornaments the fourteenth-century room.[69] Lenoir's own description of the room indicates that he also used twelfth-century panels from the Infancy window of Suger's choir and probably martyrdom scenes from the Sainte-Vaubourg chapel in Normandy.[70] There is no complete record of just what else was in the fourteenth-century gallery. However, descriptions in the literature and in engravings show views of its arrangement that indicate that Lenoir was interested only in pictorial glass for the museum.[71] Any grisailles and ornamental panels that he collected were relegated to storage.

The only firm clue that Lenoir had removed any fourteenth-century glass from Saint-Denis is contained in the account book of Christopher Hampp of Norwich, an agent who dealt directly with Lenoir in 1802–3.[72] Under pieces bought from Lenoir's restorer, Tailleur (April 28, 1802), Hampp includes "St. Louis," and later, in 1803, "Louis touch[g] he Evil [sold to] Mr. Campbell," undoubtedly a depiction of one of the saint's miracles from the glass in the chapel of St. Louis in the choir, created between 1301 and 1303.[73] In all probability, the pieces sold to Hampp were among those kept in

storage at the depot that may have been damaged in transport from Saint-Denis.[74] All the depots holding displaced works that were church property made it a common practice to sell pieces that were considered unsuitable or useless.[75]

By careful political maneuvering Lenoir was able to preserve his museum during the Consulate and the Empire and even to gain favor with Napoleon. But with the return of the monarchy in 1814, his efforts failed. Louis XVIII signed an ordinance on April 24, 1816, ceding the property to the École des Beaux-Arts, and Lenoir was made administrator of monuments at the royal church of Saint-Denis, thus opening a new chapter in the history of its stained glass. During the liquidation of the museum, which took several years, some of the stained glass was returned to various owners.[76] According to Lenoir, all of the glass on exhibition, except what had already been claimed by its owners, was sent to Saint-Denis.[77] He was aware that not all of this glass, including the panels from Saint-Germain-des-Prés, came from Saint-Denis. The exhibited glass, as Lenoir noted on October 23, 1818, "of the fourteenth-century room, most of which came from Saint-Denis, has been dismantled and is in storage," which indicates that it was ready for transport at that time.[78] But the exhibited panels were not, apparently, the only glass returned to the royal abbey. On July 22, 1817, Lenoir noted among the monuments carried to the royal abbey "stained glass originating at Saint-Denis (granary)," suggesting that additional panels from the church in storage at the Petits-Augustins were also returned.[79] This notation is important because it explains where Lenoir probably stored the grisailles that he may have collected from Saint-Denis and other places, as well as those he might have sold.

Louis XVIII's decision to return the church of Saint-Denis to its original function as the royal mausoleum was the main reason for closing the Musée des Monuments français. The architects Jacques-Guillaume Legrand (d. 1807) and Jacques Cellerier (1742–1814), who directed Napoleon's restoration, had seen to its conclusion the work of re-covering the roof, raising the floor level, repaving the church, and glazing the open bays of the clerestory with clear glass.[80] Legrand had blocked the triforium with a shed roof in 1806. In 1812 Cellerier began the construction of a chapel for the parish along the south flank of the nave, and this

would have destroyed any original glass that might have survived because of the shops in the aisles.

François Debret, a pupil of Percier, became the sole architect of Saint-Denis in 1813.[81] He employed some medieval glass in his restoration of the church, apparently panels from Saint-Denis and other sources returned by Lenoir from the Musée des Monuments français. Baron Ferdinand François de Guilhermy, a member of the Arts Commission, kept a watchful eye on the restoration for the newly constituted Service des Monuments Historiques and is the only one to mention the fourteenth-century glass used in Debret's reglazing of the church.[82] The baron not only inspected the building but also inventoried the storage areas. On his various visits to the site, beginning in 1833, Guilhermy made careful records of what he saw and updated the changes that he observed; from these notes a further record of the glass emerges.[83]

Guilhermy was the first to mention the amount of stained-glass debris that had been left at Saint-Denis. As early as 1840, he remarked on "the immense quantity of separated parts of stained-glass windows" that he had found there.[84] Unfortunately, Guilhermy was not precise as to the origin of this glass. Was he referring to the glass from various sources sent back by Lenoir, or did he mean remnants of the original glazing removed from the nave aisles or triforium during the restoration of 1814?[85] Some old glass must have been removed from storage and used in 1841 because Guilhermy mentions that some pieces of thirteenth-century grisaille were tried out as backgrounds for figures in the crypt.[86] Guilhermy first inventoried the glass storage at Saint-Denis in 1842, reviewed it in 1856 and again in 1867. In 1842 he noted "a great quantity of fragments of stained-glass windows of the twelfth and thirteenth century, some taken from Saint-Denis itself. Temporarily placed in the crypt, as a trial, were thirteenth-century grisaille pieces and two roundels of the same epoch, *repeat*, two seated kings, one holding a scepter and the other a viol and a bow."[87] Guilhermy thus suggests that a great deal of thirteenth-century glass had been left and still remained at Saint-Denis.

Eugène Viollet-le-Duc, who succeeded Debret in 1846 as architect of the restoration, seems to have made a further discovery: "Knowing that many stained-glass panels had been transported to the storage rooms at Saint-Denis after the dissolution of the Musée des Petits-Augustins, as soon as we

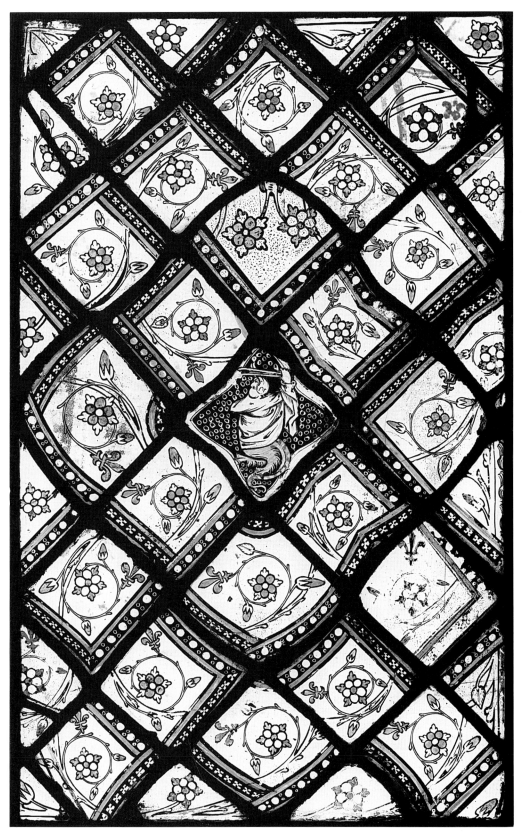

Fig. 5. Grisaille panel with grotesque brandishing a club. Paris, Musée National des Thermes et de l'Hôtel de Cluny (photo: COPYRIGHT 1991 ARS, N.Y./SPADEM)

Fig. 6. Grisaille panel with border of grotesques. Champs-sur-Marne, Dépôt, Monuments Historiques (photo: COPYRIGHT 1991 ARS, N.Y./SPADEM)

had been put in charge of the restoration of the abbey church we asked where this stained glass had been put. We were shown three or four cases containing thousands of pieces of loose glass . . . [of which] there remained scarcely three pieces still joined by leads."[88] Another account probably explains what Viollet-le-Duc had found. In the "Journal des Travaux" kept by Marc Mesnage, architect on the site for Viollet-le-Duc, he reports: "There is in the south tower storage [at Saint-Denis] as much in ingots as in cases, 2028 kilos of lead mixed with tin coming from the debris of the old stained-glass windows."[89] Some of the glass in storage was used for repairs by the Gérente studio, the firm hired by Viollet-le-Duc for the restoration of the windows, as noted in the "Journal des Travaux."[90] Unfortunately this "Journal" does not continue beyond July 1849 and no further removals of glass from storage are mentioned. A great deal more must have been transported to the Gérente studio, however, since Prosper Mérimée, Inspecteur Général des Monuments Historiques, noted in 1848 that nearly two-thirds of the original glass of the Infancy window was then in storage.[91]

These accounts indicate that there were quantities of thirteenth-century glass and leads left at Saint-Denis and that the destruction of the windows was probably interrupted suddenly before the task was finished, perhaps because of the earlier decree of the Arts Commission.[92] It is this debris—together with recognizable subjects and a quantity of grisaille from the thirteenth century in the crypt of Saint-Denis, as mentioned by Guilhermy—plus the panels from various sources returned by Lenoir,[93] that contribute to the enormity of the problems that have confronted scholars in their attempts to identify the original glass from Saint-Denis. Moreover, it is certain that there was much more glass there than was formally recorded by either Lenoir or Guilhermy.

More recently, two discoveries have helped to modify this situation. The first was the identification by Jean Lafond of thirteenth-century grisaille glass from Sainte-Vaubourg in the five windows of the western narthex at Saint-Denis.[94] By means of this glass and other remains still in Normandy, Lafond was able to attribute a considerable amount of the grisailles in storage at Saint-Denis to Sainte-Vaubourg. The second and more important find was the tracings of stained glass made by Just Lisch. Jean Just Gustave Lisch (1828–1910) would become Inspecteur Général des Monuments Historiques in 1878, but in 1850, when he probably made his tracings, he was a young architectural student attempting to incur favor with Viollet-le-Duc.[95] It was customary for the Service des Monuments Historiques to select young architects according to the interest they showed in the buildings of the Middle Ages.[96] These candidates were frequently recommended on the basis of special studies that they undertook for members of the service. Undoubtedly this was the purpose of the Lisch tracings.

The tracings consist of twenty-three drawings on architect's tissue mounted on eighteen folios.[97] That four of these tracings are marked "Troyes cathedral," where Viollet-le-Duc served as consultant to the restoration between 1847 and 1853,[98] helps to confirm both the date and the purpose of the drawings. All the other tracings are marked twice, "St. Denis" and "St. Denis Basilique (vitraux)." These designations indicate that the tracings were made on panels at or from Troyes and Saint-Denis.

In discussing Lisch's drawings of the twelfth-century glass, Grodecki assumed that Lisch had made them in situ at Saint-Denis.[99] However, since the Jesse

Tree border in one drawing appears to have been traced from a trial panel to be used as a model for the restorations rather than from the window, and since there is no evidence that any of the other traced pieces were returned to Saint-Denis, it is more likely that Lisch made all of his drawings at the studio of the glass restorers Henri and Alfred Gérente.[100] In the tracings a convention is employed which seems to have escaped comment thus far. In some of them, including that of the Jesse Tree border, the leading is painted in dense black ink instead of in the hatched lines used elsewhere.[101] It would appear that these black lines, much more regular in thickness and in contour than the hatchings in other drawings by Lisch, were his method of designating new leads and are a further indication that these tracings were made in the studio while repairs were taking place.

Much of the glass traced by Lisch is ornament. One of these panels, marked "St. Denis," has black lines for leading and, in contrast to the other fragmentary pieces, is complete. It is a tracing of the grisaille panel with the grotesque wielding a club (Fig. 9), which is now in the Cluny Museum. Like the other panels in the series, the tracing is 23½ inches (59.7 cm) high but, unlike the others, it has a broad 1-inch (2.5 cm) edge fillet on its left side but not on the right. Lisch thus supplies an additional reason for thinking that these panels were originally paired in the lancets and that each pair was finished with a simple edge fillet rather than an elaborate border.[102] The Lisch tracing also shows parts of a second, narrower outer fillet on its left side at the very edge of the paper. This is the "break" fillet. Although a minor point, the presence of this outer fillet is a further indication

Fig. 7. Border from a panel of Notre-Dame glass, Paris, after Leconte, *Notre-Dame de Paris,* pl. 61 (photo: Bibliothèque Nationale)

Fig. 8. Plan of St. Denis (after Crosby,
The Royal Abbey of Saint-Denis, pl. 1)

1. S. Louis
2. S. Hypolite
3. Notre-Dame
 la Blanche
4. S. Eustache
5. S. Fermin
6. S. Maurice
7. S. Romain
8. S. Louis
9. S. John Baptist
 (Altered 15th c.)
10. S. Michel

that the piece was newly leaded and in the process of restoration. More important, however, is the fact that these two fillets on the outer edges of a pair of grisaille panels would exactly fit the lancet width of the Saint-Louis chapel at Saint-Denis. This arrangement, moreover, could not have fit in the earlier Saint-Louis chapel in the choir, where each lancet is 3½ inches (8.9 cm) wider (total width 95.2 cm)—too wide for edge fillets yet not wide enough for two strips of the 3-inch (7.6-cm) border of grotesques.

A further indication that these panels were designed as pairs can be found in the pattern that adjoins the grotesque on the edge opposite the rising vertical stem. In the center of that side is the design of half of a canted square, which, with its pair, would form a lozenge filled with flowers. This can be seen most clearly both on the pair of panels at The Cloisters and on the Lisch tracing where the design is least disturbed (Figs. 1, 9), but all examples in the group have some vestige of the pattern. With these lozenges as the center motif for the double

panel, the grotesques or genre figures with their painted backgrounds would have formed a double vertical row of accents up the window.[103] It is unlikely that the window in this chapel contained a colored band of scenes like the Saint-Louis chapel in the choir. Colored glass in any of the nave chapels seems improbable because the abbey accounts for the years 1320–24 indicate a total expenditure of 6,000 *livres* for all six chapels as opposed to the 5,500 *livres* spent on the choir chapel to St. Louis alone.[104] It is more likely that one vestige of a decorative

band still survives in the Henry Vaughan collection panel at the Victoria and Albert Museum (Fig. 3). Unlike the other pieces of the series, this panel is shorter, only 18½ inches (47.5 cm) long and it is surrounded by beautiful floral rinceaux in the corners instead of strapwork. Because of the kind of glass and the paint in these corner pieces, so close to that in the central portion of the panel, there is little reason to suspect that this ornament is not original. Rather, this band of grisaille ornament served as an accent, repeating in the lozenge design

the canted central squares in the rest of the window. An additional accent is afforded by the blue fillet that surrounds the central motif. The head, in contrast to the grotesques or genre figures in the other panels, is that of a young, tonsured monk. It is not unlike the band of heads that have been noted as classes of society and that formed a predella in the axial window at Saint-Ouen.[105] The Victoria and Albert head could have been part of a similar band in the Saint-Louis chapel at Saint-Denis that was placed either at the bottom of the window or partway up.

In light of this reconstruction, it is difficult to accept the border on the piece at Champs-sur-Marne as original to the grisaille panel (Fig. 6).[106] It is leaded onto the inside edge that contains half of the floral lozenge that would have linked it to its pendant and must, therefore, have been an addition to the grisaille at some point before its installation in the crypt. However, it is unlikely that this addition, which resembles fourteenth-century borders at the cathedral at Paris, was made by Lenoir. Although he visited the cathedral of Notre-Dame on several occasions to collect the monuments recorded in his journal, Lenoir never mentioned any of its stained glass.[107] It is more likely that Alfred Gérente was responsible for attaching the border to the grisaille. He continued to work on the glass at Saint-Denis until 1858, and he was also employed by Viollet-le-Duc in 1855 to make one of the new windows for the axial chapel at Notre-Dame.[108] While there he could, quite easily, have picked up the glass, added it to the grisaille, and returned this one panel of the group to Saint-Denis. This glass remained in storage there until 1895, when it was set into one of the crypt chapels by Denys Darcy, Viollet-le-Duc's successor.[109] The modern borders on The Cloisters panels repeated the same error of disrupting the design of the pair (Fig. 2). Michel Acezat, a glass painter, was certainly familiar with the glass installed in the crypt at Saint-Denis. It is probably he, recognizing The Cloisters grisaille panels in his possession as part of the same series as the one in the abbey church, who copied its border and added additional characters when he made up similar borders for the glass he owned.

Lisch's tracings bring to light another workshop practice that seems to have been widespread among the glass restorers of that time.[110] Like Lenoir's restorer, Tailleur, before them, the Gérente glaziers seem to have been making up panels from old glass

for sale.[111] Large amounts of loose glass from the Saint-Denis storage were being used for this purpose. However, not before 1962, when Lisch's drawings became known, and 1982, when the Raymond Pitcairn collection was published,[112] could this practice be verified in the Gérente shop, nor could anything definite be known about the windows of the thirteenth-century church at Saint-Denis.

The history of these fleurs-de-lis panels can now be reconstructed. Like the other windows in the nave aisles they must have remained intact while the chapel served as a market; their royal connection not having been noticed by the *sans-culottes* because of the lack of opulent color. All the glass must have been removed, however, by 1814 when Guilhermy reported that the entire church was then newly reglazed in clear glass.[113] Together with other panels from the nave, the fleurs-de-lis glass must have been thrust unceremoniously into storage, where Guilhermy gave it a cursory glance in 1840 before he began his inventory.[114] Unlike the figural glass at Saint-Denis, whose descriptions in the inventory have prompted identification, the grisaille panels were not accorded individual notice by the baron.[115] Following 1847, much of the glass seems to have been successively transferred to the Gérente studio, where Lisch traced it. The fleurs-de-lis panels were certainly gone from Saint-Denis long before 1856, when Guilhermy reviewed and corrected his inventory. Recognizing the profit to be reaped from the sale of old stained glass to the foreign market, Alfred Gérente must have gathered up these loose fragments, ostensibly to use in restoration. Only one transfer was ever recorded in 1847; no records were kept after 1848 for the ten additional years that Alfred Gérente worked at Saint-Denis. Two of the fleurs-de-lis panels were sold directly to England (Figs. 3, 4) while the other four stayed in France. One of these went back to Saint-Denis (Fig. 6), but the other three were passed from hand to hand: one eventually went to the Cluny Museum (Fig. 5); two came to America and thence to The Cloisters (Fig. 1).

Although numerous drawings signed by Alfred Gérente exist for Suger's windows,[116] Lisch's tracings are the only ones that record the later glass at Saint-Denis. At least half of the ten panels of thirteenth- and fourteenth-century ornament drawn by him can, by their dimensions, be attributed to the nave and transept of the abbey church.[117] One fragment has silver-stained ornament of a pattern different from

Fig. 9. Just Lisch. Tracing of grisaille panel now in the Cluny Museum, ca. 1850, ink and pencil, inv. no. 27.179. Archives de la Direction de l'Architecture, Secretariat d'État à la Culture, Paris (photo: COPYRIGHT 1991 ARS, N.Y./SPADEM)

that of the fleurs-de-lis panels and may come from another chapel in the nave, as do two more fragments of silver-stained grisaille that were not drawn by Lisch. These panels were installed in the crypt by Denys Darcy and are now at Champs-sur-Marne.[118] They are both tracery lights and would fit the rosettes of one of the other nave chapels. What is now apparent is that there was a considerable amount of fourteenth-century grisaille in the thirteenth-century church. The whole north aisle, where the chapels were, was a light-filled strip of luminous grisaille that perhaps contributed to the church's seventeenth-century nickname, "the lantern."[119]

The Lisch tracings thus help to identify other glass from the thirteenth-century building and a picture of its glazing begins to emerge. Because they are the exact size of the glass, the tracings provide dimensions that, in turn, can determine possible locations for the panels in the building. Were it not for these remarkable documents, the Saint-Denis provenance for The Cloisters grisailles could never have been suggested.

ACKNOWLEDGMENTS

Many people deserve my thanks for their help in the preparation of this article. I am especially grateful to Elizabeth Parker, a most understanding editor, and, for their astute comments, to Elizabeth A. R. Brown and Mary B. Shepard. I also especially appreciate the cooperation of Meredith Lillich, Terryl Kinder, and Georgianna Ziegler, Special Collections Librarian, Van Pelt Library, University of Pennsylvania, who provided research materials at a moment's notice. Finally, without the patience of Lisa Nolan and Felicity Ratté, former research assistant for the Corpus Vitrearum, this paper could never have been written. Subsequent to writing this paper, the Museum acquired a composite panel (1990.206) containing four grisaille quarries with fleurs-de-lis decoration distinctive to this series. These quarries, in turn, have been used to replace modern restorations in the two Cloisters panels (1982.433.3, 4). Figure 1 illustrates their present appearance.

NOTES

1. *Vente après décès: Ancienne Collection de M. Michel Acezat: Vitraux* [sale cat. Hôtel Drouot, Nov. 24–25] (Paris, 1969), no. 39, pl. IV. Acezat died in 1944 but his daughter, also a glass painter, kept the collection during her own lifetime in very much the same haphazard state in which her father left it. Michel Meyer, a collector of ironwork, purchased the panels along with several other pieces of grisaille at the 1969 sale. They remained almost forgotten in his shop, disdained by would-be purchasers because of the modern borders, until 1982.

2. See articles by Henry Kraus, "Notre Dame's Vanished Medieval Glass," *Gazette des Beaux-Arts* 48 and 49 (Sept. 1966 and Feb. 1967), pp. 131–48; pp. 65–78. In the first article, Kraus mentions two of these panels as "destroyed" (p. 132 and fig. 2), but the second article corrects this error to "packed away" (p. 78); and Jean Lafond, *Les vitraux de Notre-Dame et de la Sainte-Chapelle de Paris* (Corpus Vitrearum Medii Aevi, France I) (Paris, 1959), pp. 13–18 and Annexes II and III, pp. 335–36.

3. The first Victoria and Albert panel, 940.1900 (pub. Bernard Rackham, *A Guide to the Collections of Stained Glass* [London, 1936], pp. 46–47 and pl. 10), was part of the Henry Vaughan bequest acquired in 1900. The second piece, 95.1930, was acquired by that museum in 1930 as a purchase from a country house in England: see "Review of Principal Acquisitions," *The Victoria and Albert Museum* (London, 1930), pp. 81–82.

4. The Cluny Museum's panel, 84 EN S106, was published as a drawing by N. H. J. Westlake, *A History of Design in Painted Glass* II (London/Oxford, 1884), pl. 89, without any source or location other than designating the design as "French." See also Fig. 9.

5. The panel at Champs-sur-Marne, no. MH304 762, was included in "Inventaire Gruber," no. 12a, unnumbered MS in Paris, Archives des Monuments Historiques, an inventory of pieces that were removed from Saint-Denis to the dépôt.

6. Lafond in *Vitraux de Notre-Dame*, p. 16 and pl. p. 17; Émile Leconte, *Notre Dame de Paris* (Paris, 1841–43), pl. 61.

7. Kraus, "Vanished Glass," vol. 48, p. 132 and fig. 2.

8. Jean Lafond in Louise Lefrançois-Pillion, *L'Art du XIVe Siècle en France* (Paris, 1954), p. 209; see also "Acquisitions," *Victoria and Albert Museum*, pp. 81–82.

9. The Acezat sale catalogue, item 39, claimed that the two panels were "d'un modèle analogue" to pieces in the Cluny Museum and in the Victoria and Albert Museum. The Cloisters panels were attributed to "Paris (?)" in "Stained Glass before 1700 in American Collections: New England and New York" (Corpus Vitrearum Medii Aevi, Checklist I), *Studies in the History of Art* 15 (Washington, D.C., 1985), p. 106.

10. Lafond, *Vitraux de Notre-Dame*, Annex I, pp. 335–36. The leading present in the central portion of Leconte's plate, moreover, does not follow the outline of the fleurs-de-lis quarries, nor does the panel appear, based on the border, to be the same size.

11. Marcel Aubert, *Notre-Dame de Paris, sa place dans l'histoire de l'architecture du XIIe au XIVe siècle* (Paris, 1920) p. 146.

12. Pierre Le Vieil, *L'Art de la peinture sur verre et de la vitrerie* (Paris, 1774), p. 29 (note b).

13. Ferdinand François de Guilhermy, *Itinéraire archéologique de Paris* (Paris, 1855), p. 117.

14. This chapel was restored and enlarged to encompass the ones on either side in 1728. Were it not for the baron's unimpeachable eye in recognizing old glass, one might suspect this description to be of the enlarged space. Viollet-le-Duc began restoration of these chapels in 1854 and they were evidently seen in their primitive state by Guilhermy just before. This should lay to rest the question of these grisailles in the cathedral windows.

15. In spite of the works of Jean Lafond (specifically *Les Vitraux de l'église Saint-Ouen de Rouen*, Corpus Vitrearum Medii Aevi, France IV.2, vol. 1 [Paris, 1970]), Lefrançois-Pillion (*L'Art du XIVe Siècle*, pp. 185–237), and Meredith Lillich (specifically *The Stained Glass of Saint-Père de Chartres* [Middletown, Conn., 1978]), non-Cistercian grisaille glass of the fourteenth century remains relatively unstudied. Most examples (see Checklists I, II, and III in *Studies in the History of Art* 15, 23, and 28 [Washington, D.C., 1985, 1987, and 1989]) once detached from the original monument are no longer identifiable.

16. See illustration of grisaille panel, The Cloisters Collection (1982.204.1), in Checklist I (*Studies in the History of Art* 15), p. 106, third piece in the second line of quarries from the bottom.

17. See Jane Hayward and Walter Cahn, *Radiance and Reflection: Medieval Art from the Raymond Pitcairn Collection*, exhib. cat., The Cloisters, Feb. 25–Sept. 15, 1982 (New York, 1982), pp. 227–28.

18. Grotesques as accents in grisaille windows are common in the fourteenth century. On this question and a possible explanation for their presence, see Lafond, *Vitraux de Saint-Ouen*, pp. 41–42.

19. Lafond in Lefrançois-Pillion, *Art du XIVe Siècle*, pp. 185–237; and idem, *Vitraux de Saint-Ouen*, pp. 14–15.

20. Lafond, *Vitraux de Saint-Ouen*, pp. 28–29, identifies six different botanical species in the ornament of Saint-Ouen. See also Jane Hayward, "Stained Glass Window with Grisaille Decoration," *Recent Acquisitions: A Selection 1985–1986*, The Metropolitan Museum of Art (1986), pp. 16–17.

21. Lafond (*Vitraux de Saint-Ouen*, p. 28) catalogued forty-three lancets with straight straps as opposed to only seven with bulged quarries.

22. Still the most comprehensive study of silver stain is Jean Lafond, "Essai historique sur le jaune d'argent," *Pratique de la peinture sur verre* (Rouen, 1943), pp. 56–57, where he states his belief that silver stain was invented in Paris ca. 1310 but that the earliest examples he knows are in Normandy ca. 1315.

23. Caroline A. Bruzelius, *The 13th-Century Church at St-Denis* (New Haven, 1985), pp. 136–37, offers a number of suggestions as to why the consecration of the church that she believes was finished in the 1270s was delayed. This is all the more reason for believing that the windows were finished by the time of the consecration.

24. The famous exception to this rule among the churches furnished with nave chapels in the fourteenth century was at Rouen, where the old "Belles Verrières" were cut down and reused in the chapels. See Jean Lafond in Armand Loisel, *La Cathédrale de Rouen* (Paris, 1936), p. 111; and Michael Cothren, "The Case of Rouen Cathedral: An Art Historical Detective Story," *Vanderbilt Alumnus* 70/1 (1984), p. 22. At Amiens Cathedral, however, in a parallel case new glass was installed. The glazing at Amiens is yet to be studied: see Louis Grodecki and Catherine Brisac, *Le Vitrail Gothique* (Fribourg, 1985), p. 116.

25. Elizabeth A. R. Brown, "The Chapels and Cult of Saint-Louis at Saint-Denis," *Mediaevalia* 10 (1984 [1988]), p. 299 (summary in *Gesta* 17/1 [1978], p. 76).

26. Each of the nave chapel windows varies slightly in size. The first and sixth have lights considerably narrower and the tracery is different in chapel number one. The two chapels that flank that of St. Louis both have lights that are slightly wider than the king's by as much as 2 inches (5.1 cm). The fifth chapel has lancets that are approximately 2 inches (5.1 cm) narrower than that of St. Louis. These differences are not great but they are significant when measuring window panels.

27. These divisions almost exactly match the modern barring in the windows today.

28. Two edge fillets, one as a border strip and the other one as a "break" fillet, are traditional in stained-glass installation. The glass is cemented into the stone frame with putty that, when hardened, has to be chipped away with a chisel when the glass is removed. This process usually fractures the embedded outer fillet, hence the name.

29. By the fourteenth century there was a literate middle class that could follow the Mass in their missals. Lafond has estimated that colored glass cost twice as much as white glass. The development of the band window was a means of including what had been a limited repertoire of hagiographic narrative or single figures in the enormous bays, often more than 30 feet high and 12 feet wide (9.1 x 3.7 m), of Rayonnant buildings. On these questions, see Jean Lafond, "Le Vitrail en Normandie de 1250 à 1300," *Bulletin monumental* 111 (1953), pp. 320–23, and in Lefrançois-Pillion, *Art du XIVe Siècle*, pp. 187–88; and Meredith Lillich, "The Band Window: A Theory of Origin and Development," *Gesta* 9/1 (1970), pp. 26–33.

30. On the question of Louis IX and Blanche of Castille as patrons of Saint-Denis, see Bruzelius, *St-Denis*, pp. 11–13. On the subject of grisaille at Saint-Denis, see Meredith Lillich, "Monastic Stained Glass: Patronage and Style," in Timothy G. Verdon, ed., *Monasticism and the Arts* (Syracuse, N.Y., 1984), p. 227, where she states her belief that "the glazing included some grisaille but that among the clerestories of this renowned ensemble were probably the first band windows."

31. The earlier chapel of St. Louis was located behind the chapel of St. Fermin on the south side of the choir in what is now the sacristy. The dedications of the nave chapels, in addition to St. Louis, included St. Marie Majeure, St. Pantaléon, St. Denis, St. Martin, and St. Laurent, all of whom were especially popular saints. These dedications are given in Dom Michel Félibien, *Histoire de l'abbaye royale de Saint-Denys en France* (Paris, 1706), plan, frontispiece, but see also Brown, "Saint Louis," p. 324 n. 78.

32. See Dom Jacques Doublet, *Histoire de l'abbaye de Saint-Denis en France contenant les antiquités d'icelle, les fondations, prérogatives et privilèges . . .* (Paris, 1625), p. 287; and Félibien, *Histoire de l'abbaye royale*, p. 227, who both speak of the profusion of fleurs-de-lis decoration throughout the church.

33. See Louis Réau, *Les monuments détruits de l'art français*, 2 vols. (Paris, 1959), vol. 1, p. 195.

34. Paul Vitry and Gaston Brière, *L'Église Abbatiale de Saint-Denis et ses Tombeaux* (Paris, 1908), p. 28.

35. See Louis Tuetey, *Procès-verbaux de la Commission temporaire des Arts*, 2 vols. (Paris, 1912; 1917), vol. 1, p. 132.

36. Ibid., vol. 1, p. 437 and n. 1.

37. See Louis Courajod, *Alexandre Lenoir son journal et le Musée des monuments français*, 3 vols. (Paris, 1878–87), vol. 1, pp. 21ff. See also Vitry and Brière, *Église Abbatiale*, pp. 95–98; and Elizabeth A. R. Brown, "The Oxford Collection of the Drawings of Roger de Gaignières and the Royal Tombs of Saint-Denis," *Transactions of the American Philosophical Society* 78, pt. 5 (Philadelphia, 1988).

38. Brown, "Oxford Collection Drawings," p. 575; Georges Huard, "Percier et l'Abbaye de Saint-Denis," *Les monuments historiques de la France* (1936), pp. 139–44, 173–82; and Louis Grodecki, *Les Vitraux de Saint-Denis*, Corpus Vitrearum Medii Aevi, France, Études I (Paris, 1976), pp. 140–41.

39. *Recueil Percier*, unnumbered MS, Bibliothèque Municipale, Compiègne, fols. 42, 43, 47, showing details of the glass, but vague indications are provided on seven more.

40. Vitry and Brière, *Église Abbatiale*, pp. 27–29, gives the most concise account of the period.

41. After the expulsion of the monks in 1792, Gauthier seems to have visited the church, not infrequently, to check on the condition of the organ that was located above the entrance at the west end of the nave. His account probably records the only observation of conditions in that part of the church before the organ was removed in Aug. 1800.

42. Pierre Gauthier, "Recueil d'anecdotes et autres objets relatifs à l'histoire de l'abbaye de Saint-Denis en France," Paris, Bibliothèque Nationale, MS fr. 11681 (1775–1801), p. 129: "en 1796 au mois de septembre on avoit encore l'espérance que l'Église de l'Abbaye de Saint Denis seroit rendu au culte catholique, attendu qu'on avoit déjà commencé à recouvrir en tuiles une partie de la nef. Mais présentement ces espérances sont évanouies, puis que l'Église est sans vitraux, et d'ailleurs elle est dans un délabrement très difficile à réparer. on à [*sic*] retiré les barres de fer qui soutenoient les arcs boutants du chevet, et successivement elle sera abbatue selon le projet jusqu'au galeries et les arcades resteront, ainsi que les bas côtés pour former les boutiques dans le temps des foires." As Grodecki has already observed (*Vitraux de Saint-Denis*, p. 41), Gauthier was exaggerating when he stated that "the church is without stained glass" in this passage. He undoubtedly referred only to the clerestory windows of the nave near the organ. The lower choir glass was untouched at that time, as was, we believe, that of the aisles and chapels.

43. Réau, *Monuments détruits*, vol. 1, p. 307.

44. Tuetey, *Commission des Arts*, vol. 2, pp. 98, 116, 136.

45. Gauthier, "Recueil d'anecdotes," fol. 127: "Le jeudi six septembre 1798, . . . j'eut l'occasion de monter à mon cidevant orgue de l'abbaye pour le faire voir à plusieurs personnes amateurs qui désiroient l'entendre. il n'étoit plus possible à cette époque de s'en servir, vu l'humidité qui à [*sic*] pénétré partout attendu que beaucoup de vitraux étoient déplacés; et la voute ayant été longtemps découverte dans cette partie de l'Église où étoit l'orgue."

46. François Debret, "Notes historiques sur la fondation de l'église royale de Saint-Denis, sa dévastation et sa restauration," 8, DOC. 34 (1832), Archives des Monuments Historiques, p. 5.

47. Based on Gauthier, "Recueil," p. 129: "Dans le courant de septembre 1799 on commença de déplacer les vitraux de l'Église St Denys. . . . Ils étoient du temps de Suger." Grodecki (*Vitraux de Saint-Denis*, p. 41) concluded that this passage seemed to

have referred to the choir windows. The date "1799," however, has been added to the manuscript by an unknown hand at an unknown date.

48. See Lenoir's note, dated Aug. 16, 1799, published by Jules Guiffrey, *Inventaire général des richesses d'art en France. Archives du Musée des Monuments Français*, 3 vols. (Paris, 1883–97), vol. 1, pp. 144–45, and especially Item 13: "Stained glass of casements executed in the thirteenth century of which the major part were engraved and published by Montfaucon." Lenoir was referring to the life of St. Louis panels in Bay sVIII of the choir, since the Crusade and Charlemagne windows, also published by Montfaucon, were from the twelfth century. See Grodecki, *Vitraux de Saint-Denis*, pp. 116–21. For a different interpretation of this glass, see Elizabeth A. R. Brown and Michael W. Cothren, "The Twelfth-Century Crusading Window of the Abbey of Saint-Denis; *praeteritorum union Recordater futirorum est exhibites*," *Journal of the Warburg and Courtauld Institutes* 49 (1986), pp. 1–40. Lenoir's "minor" part probably meant glass in other parts of the monument.

49. Guiffrey, *Archives du Musée*, vol. 2, p. 441.

50. Doublet, *Histoire de l'abbaye de Saint-Denis*, devotes most of his text to the history of the abbey, the tombs, and the treasury. See also Félibien, *Histoire de l'abbaye*, pp. 529–33.

51. Dom Bernard de Montfaucon, *Les Monumens de la monarchie françoise*, 5 vols. (Paris, 1729–33).

52. For more information on the St. Louis chapel, see Brown, "Chapels and Cult of Saint Louis," pp. 280–99.

53. Le Vieil, *Peinture sur Verre*, p. 26.

54. Percier's drawings of thirteenth-century stained glass have been published on several occasions. See Grodecki, *Vitraux de Saint-Denis*, ills. 6, 9; Huard, "Percier," figs. 2, 3; Bruzelius, *St-Denis*, pls. 14, 15; and Lillich, "Monastic Stained Glass," figs. 19b, and 9.14. These drawings, sometimes only rough sketches, seem to indicate large figures, perhaps on grisaille grounds, in the choir clerestory. The north rose in full color may have contained the labors of the months and the zodiac, the transept chapels narratives on colored mosaic grounds.

55. Alexandre Lenoir, *Description historique et chronologique des monumens de sculpture réunis au Musée des Monumens français*, 6th ed. (Paris, 1801–2), p. 373.

56. The journal is published in Courajod, *Lenoir son journal*, vol. 1, pp. 1–210.

57. Ibid., p. 90. Entry in Lenoir's journal for 29 vendémiaire, an IV (Oct. 20, 1795): "je présente au Comité d'instruction publique un projet d'établissement, à Paris, d'un musée historique des monumens français. Je suis introduit au Comité par le citoyen Paganel, représentant du peuple; je fais lecture de mon mémoire et le Comité arrête qu'il y aura à Paris un musée des *monumens français*." Grodecki, *Vitraux*, p. 42 n. 4, gives the exact date of the museum's opening as Apr. 8, 1796. But in fact, according to Lenoir himself, in *Description des monumens*, 6th ed., p. 7, the museum had opened to the public for the first time on Sept. 1, 1795, nearly two months before its status as a museum was official.

58. Lenoir, *Description des monumens*, 5th ed. (Paris, 1799–1800), p. 6.

59. Courajod, *Lenoir son journal*, vol. 1, p. 112: "799–Le 19 (primaire an V) [Dec. 9, 1796] je préviens le ministre que

l'administration du Musée des Arts doit lui adresser une demande tendante à enlever du Dépôt la suite de vitraux qu'il renferme, pour faire suite, soi-disant, aus dessins du Musée. Mais où et comment les placeront-ils?"

60. Dating of the thirteenth-century room is given in Georges Huard, "La salle du XIIIe siècle du musée des monuments français à l'École des Beaux Arts," *Revue de l'Art ancien et moderne* I (1925), pp. 113–26. Lenoir's description of the glass appears in his *Description des monumens*, 5th ed., p. 368.

61. For a listing of the visual documents, see Huard, "Salle du XIIIe siècle," p. 118.

62. Courajod, *Lenoir son journal*, vol. 1, p. 112, item no. 798.

63. The principal graphic sources of the musée are: Jean Baptiste Bonaventure de Roquefort, *Vues pittoresque et perspectives des salles du Musée des Monuments Français*, engraved after designs by M. Vauzelle (Paris, 1816); J.-E. Biet and J.-P. Bres, *Souvenirs du Musée des Monumens français* (Paris, 1821); and Musée du Louvre, Cabinet des Dessins, "Albums Lenoir," 5 vols., R.F. 1870, 5279–84. Lenoir's journal records only an unspecified number of fleurs-de-lis from the Chapel of the Oratory and the Assumption that may even have been used to fill out the panels from Saint-Germain in the thirteenth-century gallery (see Biet and Bres, *Souvenirs du Musée*, pls. 13–15), panels from the Charniers at Saint-Étienne-du-Mont mentioned as "saved" by Lenoir (*Description des monumens*, 5th ed., p. 388), glass from the chapel of the Collège du Picardie (Courajod, *Lenoir son journal*, vol. 1, item no. 946), and an Annunciation from the church of Saint-Leu (ibid., item no. 963).

64. Lenoir, *Description des monumens*, 5th ed., pp. 357–60.

65. Ibid., p. 368.

66. During the year IX (Sept. 1800–Sept. 1801), Lenoir recorded expenses for the fourteenth-century gallery that continued into the next year, see Lenoir, *Description des monumens*, 6th ed., p. 375.

67. Ibid., pp. 15–16. "Puisqu'enfin voilà un véritable Musée de sculpture française, pourquoi ne l'enrichirait-on pas d'une foule de monumens épars dans les départemens?"

68. The illustration of this early plan is in "Musée des Monumens Français," Musée du Louvre, Cabinet des dessins, "Albums Lenoir," vol. 1 (R.F. 1870 5279), fol. 19.

69. Lenoir, *Description des monumens*, 6th ed., p. 365: "Vitraux de Saint-Denis, sous l'abbé Suger, dont une partie orne dans ce Musée de la chapelle sépulcrale d'Héloïse et d'Abélard. Ceux de la nef, qui datent du siècle suivant, décorent le 14e siècle."

70. These scenes are now at Champs-sur-Marne, Archives de Monuments Historiques, "Inventaire Gruber," nos. 16 and 20, MH 304762 and 304763. See also Grodecki, *Vitraux*, figs. 224, 225. For the Templar Chapel of Sainte-Vaubourg at Val-de-la-Haye (Seine-Inférieur), see Lafond, "Vitrail en Normandie," pp. 328–33.

71. See Biet and Bres, *Souvenirs du Musée*, pls. 17, 19, which show remains from the Jesse Tree and griffin windows, and notes 61, 63, 68 above.

72. See Grodecki, *Vitraux*, p. 45, which gives the bibliography on Hampp.

73. Hampp's account book is published by Bernard Rackham, "English Importation of Foreign Stained Glass in the Early

Nineteenth Century," *Journal of the British Society of Master Glass Painters* 2/2 (1927), pp. 87, 89. It is impossible to know to which scene Hampp referred. The only one that could apply is St. Louis feeding the leper. See Montfaucon, *Monumens de la monarchie*, vol. 2, pp. 156–59, and pls. XXII–XXV, and more recently Brown, "Chapels and Cult of Saint Louis," pls. 3–6.

74. Grodecki has discussed the question of the relationship between the early appearance in England of such Saint-Denis fragments as those at Twycross and the transport disaster: Grodecki, *Vitraux*, pp. 66–67, 43. On the disaster itself, see ibid., p. 43.

75. On this question of sales, see Courajod, *Lenoir son journal*, vol. 1, p. lxxiii and esp. pp. lclx, lcclviii.

76. See ibid., vol. 1, p. 186.

77. See Alexandre Lenoir, *Musée des monumens français ou Description historique et chronologique*, 8 vols. (Paris, 1800–21), of which vol. 6 carries the title *Histoire de la peinture sur verre* (Paris, 1803), pp. 61–68.

78. Guiffrey, *Archives du Musée*, vol. 3, p. 298.

79. Ibid., p. 289.

80. Ferdinand François de Guilhermy, "Détails historiques, Saint-Denis, 1840–1872," 2 vols. (Paris, Bibl. Nat., nouv. acq. MSS fr. 6121 and 6122), MS 1621, fol. 9v: "En 1814, l'Église se trouvait récouverte, dallée, exhaussée quant au sol et vitré [in clear glass]."

81. On Debret's restoration of the church, see Paris, Archives Nationales, F²¹ 1451, Laisse "Église St. Denis," Debret, "Église Royale de St. Denis" (dated Paris, Dec. 20, 1832), and Paris, Archives des Monuments Historiques, "Dossier de l'Administration, Saint-Denis, 1836–1851."

82. The most concise account of the formation and history of the Monuments Historiques is that found in M. F. Deshoulières, "Histoire de la Société Française d'Archéologie (1834–1934)," *Congrès Archéologique* 97 (Paris, 1934), vol. 1, pp. 17ff., and vol. 2, pp. 9–84. Guilhermy's comment is found in "Collection Guilhermy, "Détails historiques," MS 6121, fol. 139: "La grande fenêtre centrale, un pêle-mêle de vitraux XIIIe et XIVe siècles." Unfortunately, nothing is known about this glass.

83. Guilhermy, "Détails historiques." For his visits to Saint-Denis, see MS 6121, fols. 14v (1833), 17 (1838), 17v (1839), 18 (1840), 19 (1841). See also Brown, "Drawings of Gaignières," pp. 25–26.

84. Guilhermy, "Détails historiques," MS 6121, fol. 18: "Immense quantité de parties de vitraux dépareillées."

85. The history of the restoration is given in Sumner McK. Crosby, *L'Abbaye royale de Saint-Denis* (Paris, 1953), pp. 71–72.

86. Guilhermy, "Détails historiques," MS 6121, fol. 40 (1841): "Dans les caveaux, essai de vitraux; on y pose provisoirement . . . quelques figures en morceaux de grisailles du 13e siècle."

87. Ibid., MS 6212, fol. 239v (1842): "Fragments XIIe—XIIIe siècles No. 106. Une grande quantité de fragments de vitraux des 12e et 13e siècles; quelques uns tirés de St. Denys même; On a placé, un moment dans le caveaux, comme essai, des morceaux de grisaille, 13e siècle, et deux rondeaux, même époque, *rept.* deux rois assis l'un tenant un sceptre; l'autre, une viole et un archet." Guilhermy's *"rept."* in this case was a clarification. His inventory is added to MS 6121 beginning on fol. 235: "Objets encore en magasin à la fin de 1842."

88. Eugène Viollet-le-Duc, *Dictionnaire raisonné de l'architecture française du XIe au XVIe siècle*, 10 vols. (Paris, 1908; 2d ed. 1925), vol. 9, p. 374: "Sachant que beaucoup de ces vitraux avaient été transportés dans les magasins de Saint-Denis après la dispersion du Musée des Petits-Augustins, nous demandâmes, dès que nous fûmes chargés des restaurations de l'église abbatiale, où étaient deposés ces vitraux. On nous montre trois ou quatre caisses contenant des milliers de morceaux de verre empilés . . . à peine s'il en restait trois morceaux réunis par des plombs. . . ."

89. Archives de la Direction de l'Architecture, Secretariat à la Culture, "Dossiers Saint-Denis, Journal des Travaux de l'église royale de Saint-Denis, par l'architecte Mesnage de janvier, 1847 à 1850" (unpaged and unnumbered): "le 8 mars (1848) pour mémoire . . . il y a au magasin tour sud tant en lingots qu'en caisses, 2028 kilos de plomb mêlé d'étain provenant des débris des vieux vitraux."

90. Ibid., Dec. 17, 1847.

91. See Archives des Monuments Historiques, "Saint-Denis, Dossier de l'Administration, 1841–1876," under Dec. 4, 1847. Only three panels were ever used in the restoration; the rest disappeared.

92. See notes 34–36 above; and Grodecki, *Vitraux*, p. 41.

93. All the glass that has been identified as returned by Lenoir is in the form of panels, although sometimes with missing parts, but none of it has been recorded as loose glass. If Guilhermy's statement regarding the debris left in the Musée des Monuments français is valid, Lenoir gathered up all the panels that had not been claimed by other owners for transport back to Saint-Denis and abandoned what he considered without value or unsalvageable.

94. See Lafond, "Vitrail," pp. 328–33, where he identifies more glass from this site at Hautot-sur-Seine (Seine-Inférieure).

95. Grodecki (*Vitraux*, pp. 55, 85) observed that the prophet Jeremiah, from the Infancy window that Lisch traced, had been seen in storage at Saint-Denis in 1842 by Guilhermy, who noted it missing in 1856. Further, Lisch also traced the border of the Jesse Tree window as restored by Henri Gérente in 1848. For these reasons Grodecki estimated that Lisch made the tracings around 1850, coinciding with the period of his architectural training, which he completed in 1854. See also Hans Wentzel, "Unbekannte mittelalterliche Glasmalereien der Burrell collection zu Glasgow (3. teil)," *Pantheon* 19 (1961), pp. 247–49, who located the Jeremiah panel in Glasgow.

96. Marius Chabaud, "Architectes attachés à la Commission des monuments Historiques et Architectes en chef des monuments Historiques," *Congrès Archéologique* 97, 2 vols. (Paris, 1934), vol. 1, p. 256.

97. Paris, Archives de la Direction de l'Architecture, Secretariat d'État à la Culture, Nos. 27.166–27.183: "Les Calques Lisch." The drawings, made on architect's tracing vellum, are mounted on paper with stitch marks along the right-hand edge. The folios are now contained in an album. The drawings remained in the Lisch family and were given by his grandson Gustave Lisch to the Archives in Nov. 1961; see Grodecki, *Vitraux de Saint-Denis*, p. 55.

98. Viollet-le-Duc was called in at the suggestion of A. N. Didron by the Comité archéologique of Troyes Cathedral, which was dissatisfied with the previous restoration. I thank Dr. Elizabeth Pastan for this information. See her "Restoring the Glass at Troyes Cathedral," *Abstracts and Program Statement*, College Art Association (Houston, 1988), pp. 198–99; and André Marsat, "La décoration intérieure de la Cathédrale de Troyes au XIXe siècle (Simart-Baltard-Viollet-le-Duc)," *Mémoires de la Société Académique de l'Aube* 110 (1979–81), pp. 217–36.

99. See Grodecki, *Vitraux de Saint-Denis*, pp. 55–56.

100. Henri Gérente was hired in 1847 by Viollet-le-Duc to restore the choir windows at Saint-Denis. When he died suddenly, in the beginning of 1849, his place was taken by his brother Alfred. In Henri's restoration of the Jesse Tree Window the lead joints in the edge fillets are in different locations from the tracing, and the leaves of the corner piece have been redesigned. Evidently the tracing came from the only fragment of original glass Henri had to work with, from which he adapted his corner design.

101. See Grodecki, *Vitraux de Saint-Denis*, ills. 64, 92, 147, 163, 196–99. The border in ill. 198, of which preserved examples are unknown, also has this leading convention.

102. In the course of the thirteenth and fourteenth centuries, borders tended to diminish in width and elaboration and in some cases, especially in grisaille windows, to disappear altogether. See, for example, the windows at Saint-Père, Chartres, ca. 1275 (Lillich, *Saint-Père de Chartres*, pp. 23–45); at Saint-Martin-aux-Bois, 1260s (Grodecki and Brisac, *Vitrail Gothique*, p. 157); at Mantes, ca. 1315 (Westlake, *History of Design*, pp. 104–6); and in the Rhineland at Mulhouse, ca. 1320; Strasbourg, ca. 1345; and Niederhaslach, ca. 1370 (Marcel Aubert et al., *Le vitrail français* [Paris, 1958], pp. 160–79). Even at Évreux, ca. 1325 (ibid.), and at Saint-Ouen in Rouen, ca. 1325 (Lafond, *Vitraux de Saint-Ouen*, p. 29), borders were interrupted by the band of scenes.

103. See note 18 above.

104. On the expenses of the chapels, see Brown, "Chapels and Cult of Saint-Louis," pp. 280–82, 299.

105. Lafond, *Vitraux de Saint-Ouen*, pp. 168–69, and pl. 48. See note 3 above.

106. Archives des Monuments Historiques, "Inventaire Gruber," no. 12a, contains a sketch of the grisaille panel detailing restored pieces. The border is marked as original glass.

107. See Kraus, "Vanished Glass," vol. 48, p. 132, who says "there was no Notre-Dame glass among the lancets salvaged by Alexandre Lenoir. . . ."

108. On Alfred Gérente at Saint-Denis, see Grodecki, *Vitraux*, pp. 54–55, and at Notre-Dame, see Paul Frankl, "Unnoticed Fragments of Old Stained Glass in Notre-Dame de Paris," *Art Bulletin* 39 (1957), p. 300.

109. Grodecki, *Vitraux*, p. 57 and n. 15.

110. It appears that glass taken for repairs and not used in a restoration was often considered by the restorers to be their property.

111. See Rackham, "English Importation," pp. 86–94; and Jean Lafond, "The Traffic in Old Stained Glass from Abroad during the 18th and 19th Centuries in England," *Journal of the British Society of Master Glass Painters* 16/1 (1964), pp. 58–67.

112. See Hayward and Cahn, *Radiance and Reflection*, pp. 40–41, 90–94, 195–96.

113. Guilhermy, "Détails historiques," MS 6121, fol. 9v.

114. See note 82 above.

115. On Guilhermy's comments on the grisailles in storage at Saint-Denis, see notes 86 and 87 above. One of the thirteenth-century kings he mentioned from Saint-Denis still exists in window sIV of the choir.

116. Alfred Gérente made cartoon drawings for all the choir windows that he was paid to restore or make anew. For this reason there is a record of all this glass that went through his shop. Because his cartoons of the Crusades and Charlemagne panels in the Pitcairn collection still exist, these pieces were also there, restored according to the cartoons, and then sold from the studio. On this question, see Hayward and Cahn, *Radiance and Reflection*, pp. 40–41, 90–95. See also Brown and Cothren, "Crusading Window," pp. 3–5.

117. Most of this glass appears to have been left at Saint-Denis and may even have been removed or gathered up by Legrand and Cellerier after the Revolution, at the time of Napoleon's restoration of the abbey church. The dimensions and shapes of these tracings are irrefutable in proving that the glass came from the abbey and not from any of the other sites to which Lenoir returned glass.

118. Archives des Monuments Historiques, "Inventaire Gruber," nos. 12b and 12c on p. 15.

119. Both Doublet, *Histoire de l'abbaye*, pp. 265–66, and Dom Germain Millet, *Le Trésor sacré ou inventaire des saintes reliques . . . de l'abbaye royale Saint-Denys en France* (Paris, 1638), pp. 27–29, use this term. And see Lillich, "Monastic Stained Glass," pp. 227–29, 240–41, who quotes them.

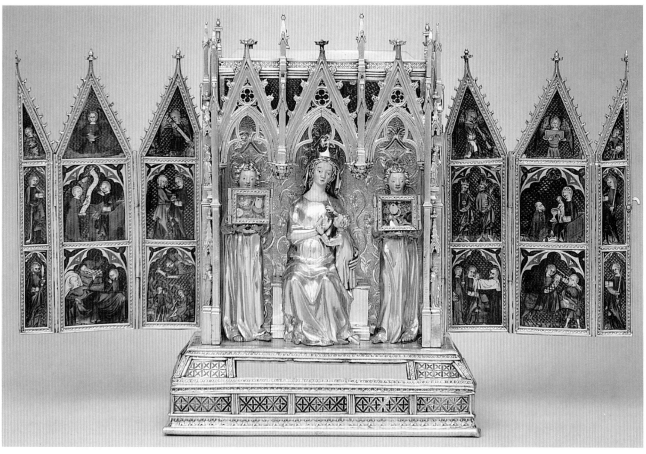

Fig. 1. Reliquary of Elizabeth of Hungary, front view, open, Paris, ca. 1320-40. The Metropolitan Museum of Art, The Cloisters Collection, 1962 (62.96) (photo: Museum)

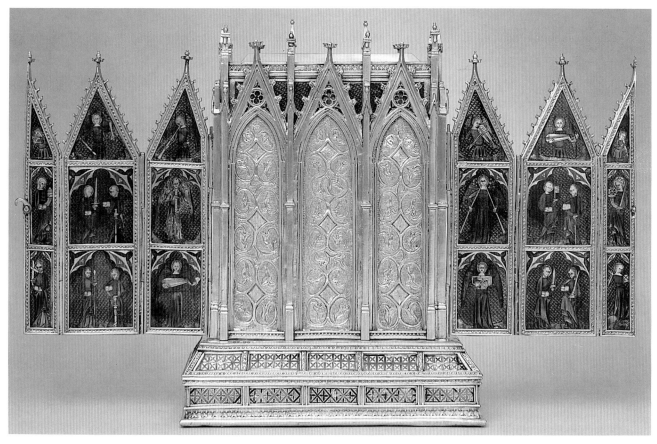

Fig. 2. Reliquary of Elizabeth of Hungary, view of the back

The Reliquary of Elizabeth of Hungary at The Cloisters

Danielle Gaborit-Chopin

The Cloisters Collection was greatly enriched in 1962 by the acquisition of a beautiful silver-gilt and enamel reliquary in the form of a tabernacle or polyptych, known as the Reliquary of Elizabeth of Hungary. The reliquary, which has been published many times,[1] was the object of two fundamental studies in particular: the first by Margaret B. Freeman in 1963,[2] the second by Sandor Mihalik in 1964.[3] As these two articles are largely contradictory in their conclusions as to the condition of the polyptych, its restoration and attribution, it is appropriate to reconsider these questions here.[4]

The reliquary is in the form of a polyptych or tabernacle, with enameled shutters or wings surrounding a central shrine whose form suggests a small chapel or an architectural canopy (Col. pl. 6 and Figs. 1, 2).[5] Under the arcade of this canopy are three statuettes in silver-gilt: the seated Virgin preparing to nurse the infant Christ, and two angels placed on either side of her. Each angel holds a small, square reliquary box; the relics themselves can be seen through a window in each box (Fig. 3). Another reliquary compartment, likewise protected by glass, has been set in the front part of the base of the tabernacle. The pierced upper parts of the architectural canopy are set against a background of translucent blue enamel. Set in the back of this chapel is a metal plaque, which is largely gilt and decorated on the inside and outside with large, repoussé rinceaux decoration, the lance-shaped leaves of which are set against a stippled ground. In the small architectural niches that form the piers of this chapel are four tiny statues of saints: John the Baptist and Stephen on the one hand, and John the Evangelist and Lawrence on the other (Figs. 3, 12).

Attached to the shutters of the tabernacle are plaques of varying dimensions,[6] worked in *basse-taille* and covered on both sides with translucent enamels. The triangles

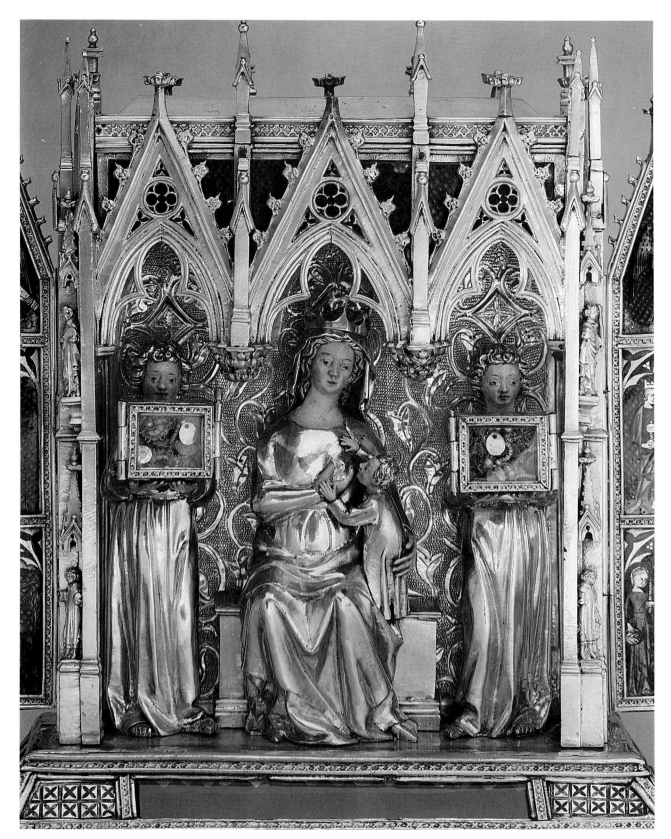

Fig. 3. Reliquary of Elizabeth of Hungary, detail of the central section

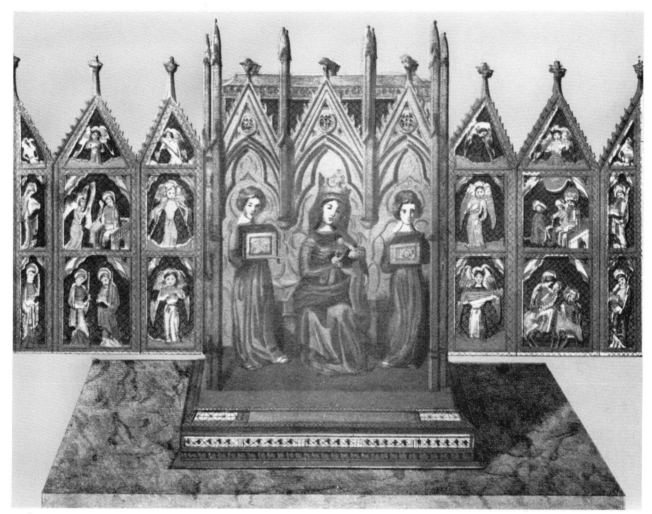

Fig. 4. Reliquary of Elizabeth of Hungary, lithograph of 1847 (according to Sandor Mihalik)

of the upper part contain figures of musical angels seen in three-quarter length. Represented on the inside of the shutters themselves are scenes of the Life of the Virgin and the Infancy of Christ: the Annunciation and Visitation, the Nativity and Annunciation to the Shepherds at the left, the Adoration of the Magi divided between two plaquettes, the Presentation in the Temple and the Flight into Egypt at the right. Corresponding to these scenes on the exterior are four large figures of musical angels,[7] and four pairs of apostles who can be identified, albeit tentatively, given the number of atypical attributes they hold, as the saints Peter and Paul, Philip and James the Great(?), Thaddeus and Simon, Matthew and Thomas(?). Isolated figures of four

female saints—Mary Magdalene, Margaret, Catharine, and an unidentified female martyr—and four male saints—John the Evangelist, Bartholomew, James the Less, and Andrew—occupy the narrower plaques on the exterior edge of the shutters. The iconography of the reliquary is thus very simple: an assemblage of angels, saints, and apostles participate in the Glorification of the Virgin and the Infant Christ.

The history of the tabernacle has been known from the time of its first publication in the nineteenth century and has subsequently been more closely studied by Margaret Freeman and Sandor Mihalik.[8] The Cloisters tabernacle was sold in 1784 as part of the property dispersed after the dissolution of the convent of the Poor Clares of Buda. It is

329

described, in the inventory prepared in 1782 in anticipation of this sale, as a small altar of silver-gilt "with two wings for a domestic chapel, in the center the image of Our Lady the Virgin Mary offering her breast to the Infant Jesus, surrounded by figures of Virgins [that is, angels without wings] on each side, the whole of silver-gilt."[9] Mentioned very succinctly in the inventory of the same convent in 1656,[10] it is described in 1714 as a small silver altar "very deteriorated." The latter inventory of the eighteenth century is also the first to associate the tabernacle with the objects linked to the memory of the "blessed Queen Elizabeth of Hungary."[11] This Queen Elizabeth of Hungary was mistakenly identified by nineteenth-century authors as St. Elizabeth of Hungary,[12] who died in 1231. But the reference could only be to Elizabeth, daughter of the king of Poland, who was married in 1320 to Charles II (Charobert), king of Hungary. It was she who in 1334 founded the convent of the Poor Clares of Buda, where she was subsequently buried in 1380. In its form, its style, and the technique of its translucent enamels on *basse-taille*, the tabernacle is clearly an object of the fourteenth, not of the thirteenth, century.

The most difficult question is the amount of restoration that the reliquary has undergone. Described in 1714 as "very deteriorated," it seems in fact today to be in fine condition. This troubling discrepancy led Sandor Mihalik to try to reconstruct the history of the object following the dissolution of the convent of the Poor Clares of Buda and the sale of its property in 1784, up to the time of its acquisition by The Cloisters in 1962. In doing so,

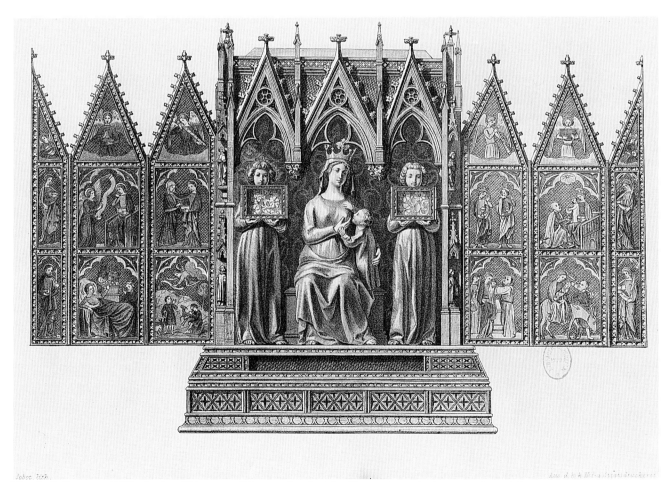

Fig. 5. Reliquary of Elizabeth of Hungary, lithograph of 1867, illustrating Floris Rómer's article

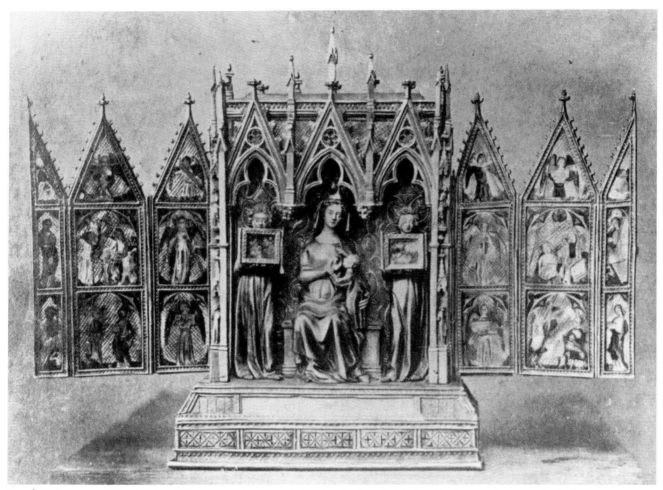

Fig. 6. Reliquary of Elizabeth of Hungary, photograph by the dealer Goldschmidt (according to Mihalik)

he carefully compared the various graphic as well as photographic documents showing the reliquary in the nineteenth century and in the very beginning of the twentieth. Mihalik was thus able to establish that the order of the enamel plaquettes of the shutters of the tabernacle has changed several times, producing successive and contradictory arrangements.[13] These can be summarized as follows:

A. The arrangement shown in a lithograph of 1847, in which the scenes of the Life of the Virgin and the Infancy of Christ were set on the interior and exterior of the shutters, and the two plaques of the Adoration of the Magi separated from each other (Fig. 4).[14]

B. The arrangement shown in the 1867 lithograph that appeared as an illustration to the article by Floris Rómer, in which all the scenes of the Life of the Virgin and the Infancy of Christ were set, as they now are, on the interior of the wings (Fig. 5).[15]

C. The arrangement reflected in the photographs that came from the Goldschmidt firm in Frankfurt am Main (Fig. 6), dated by Mihalik around 1886 and corresponding to arrangement A, as seen in the lithograph of 1847 (Fig. 4).[16]

D. An arrangement of the plaques according to the photographs taken in 1900 in Paris during the Exposition Universelle. This format was a little more logical in the sequence of scenes than that of A and C because, for example, the two plaques of the Adoration

331

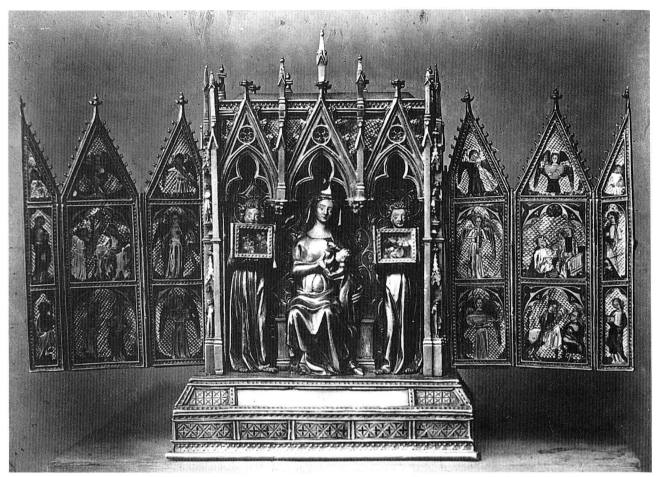

Fig. 7a. Reliquary of Elizabeth of Hungary, open (photograph from the 1867 sale catalogue)

of the Magi were contiguous. This arrangement, however, was distinct from that of B observed in 1867 (Fig. 5).[17]

E. An arrangement shown in a 1931 photograph corresponding to that of 1867 (see B above). This format is easily explained as the result of a decision, taken after the exhibition of 1900, to rearrange the enamel plaques according to the sequence seen in the Rómer 1867 lithograph (Fig. 5). This is the order that is seen today.[18]

Mihalik, recognizing these diverse aspects and the contradictory dates, since A = C, B = E, and D is distinct from both A and B, finally concluded that The Cloisters reliquary had not only been restored but also that one or more copies had been

made and must have been in circulation. Mihalik suggested that these copies could have been made in Vienna in the workshop of the famous forger, Weininger, before 1876.[19] Accepted in recent publications, Mihalik's thesis must, however, be questioned. An important source that has not previously been used must be taken into account: the photographs illustrating the 1867 Paris sale catalogue (Figs. 7a,b), a sale ordered by Charles Mannheim, during the course of which the tabernacle of Elizabeth of Hungary was acquired by a member of the Rothschild family, apparently by Baron Adolphe.[20] In fact, these photographs were printed from the same negatives as those of the German dealer Goldschmidt, which Mihalik had mistakenly dated to 1886. The fact that arrangement B in Rómer's lithograph, likewise dated to 1867—the year of the Paris sale—contradicts these

photographs is not so surprising as it first seems (Figs. 5, 7a). Rómer saw the reliquary in 1864 at the residence of Count Arthur Bàtthyanyi but he could not have seen it again at the time when he was writing his article. Given the careful articulation and detailing of the illustration, it must be a reflection of the form of the tabernacle in 1864, the year of Rómer's visit, at the very latest.[21] Thus the photographs of the sale catalogue of 1867 clearly prove that, counter to what Mihalik suggested, the most important restoration of the reliquary had to have been done before 1867, more likely before 1847, since these photographs correspond closely, except for the central pinnacle, to arrangement A in the earliest lithograph representing the tabernacle (Fig. 4).

Furthermore, a technical peculiarity of the reliquary allows for a rather simple explanation for the different arrangements of the plaques at various points in its history, without necessitating the existence of one or more copies of the tabernacle. As with other translucent enamels of the fourteenth century, such as the Namur triptych or the polyptych in the Pierpont Morgan Library,[22] the silver plaques that bear the figural decoration are enameled on both sides and are simply slipped into their supportive frames in the wings of The Cloisters reliquary. It is easy enough to reverse a certain number of these plaques to obtain arrangement A, B, or C. In this way, the rearrangement effected after the exhibition of 1900, to return to the sequence found in Rómer's lithograph, involved no more than the simple turning of three principal plaques. It was necessary to turn five plaques to go from arrangement A of 1847 to arrangement B of 1867.

Should one conclude that the present condition, which corresponds to that shown by Rómer, is the logical sequence of the plaques as they were originally set into the tabernacle? It seems not. The sequence of the principal scenes, and thus of the paired groups of enameled apostles on the reverse of these same plaques, is logical, but the small plaques on the edges of the wings have been rearranged. The four female saints must have been set on the interior (St. Mary Magdalene and St. Margaret at the left, St. Catharine and the unidentified female martyr at the right), the four male saints on the exterior (with the tabernacle closed, John and Bartholomew at the left, James the Less and Andrew at the right).

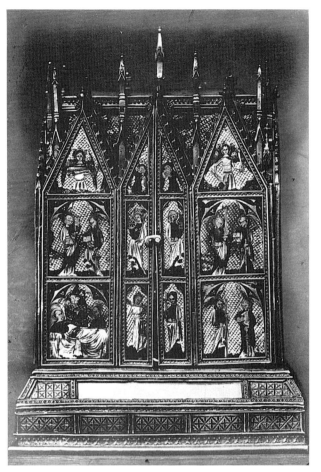

Fig. 7b. Reliquary of Elizabeth of Hungary, closed (photograph from the 1867 sale catalogue)

A careful, nondestructive analysis of the tabernacle of Elizabeth of Hungary was recently carried out in the laboratory of The Metropolitan Museum of Art in an attempt to identify the nature and extent of the restorations. The roof and a large part of the openwork parapets, as well as most of the pinnacles, are modern, and it is likely that the upper parts of the reliquary would have terminated in a more elaborate crowning.[23] The base has likewise been seriously reworked. Furthermore, it lacks the small supporting feet which most likely took the form of animals.[24]

The central statuettes have undergone some changes as well: the angels have lost their wings (at some point, each was also given a halo, for which the mounts can still be seen at the back), and the crown of the Virgin is not the original one.[25] Moreover, the examination of the back of the statuette

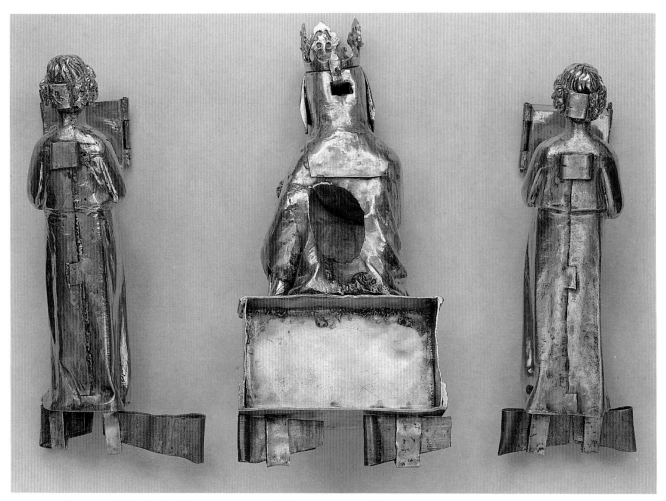

Fig. 8. Reliquary of Elizabeth of Hungary, back of the statuettes of the central section

shows a circular opening that has been cut in a rather brutal fashion into the surface of the metal, the purpose of which has not been ascertained (Fig. 8).[26] The mercury gilding seems old; however, it is heavy to the point of obscuring the engraving of the hair and flooding certain areas, suggesting that it is not the original.[27] The painting of the faces and the hands likewise has a disturbing texture. Laboratory examination has not revealed any modern pigments. While it was the practice in the first half of the fourteenth century to paint the faces and hands of goldsmiths' statuettes,[28] surviving contemporary examples, such as the angels on the Jaucourt reliquary in the Louvre, show a thin film over the surface of the metal.[29] Here, on the contrary, the

paint layer is not only on top of the gilding, which is in itself surprising, but is also so thick that the individual brushstrokes are clearly visible (Figs. 9, 10), making the faces seem heavy and distorted.[30] The clumsiness of the workmanship is certainly indicative of an early restoration.

Many of the enamel plaques have been restored, a fact not surprising in the case of translucent enamels on *basse-taille*. The ground for the enamel is so thin and fragile that it breaks at the slightest jolt; thus, most of the surviving translucent enamels of this period have suffered, even the most celebrated.[31] The restorations here have been done with colored mastic, which can be clearly seen on close examination (Figs. 34, 35). And when one takes

into account the total number of restored plaques, altogether twenty-three or twenty-five, including eight of the principal scenes, it is easier to explain the eighteenth-century description of the reliquary as "very deteriorated." Only one plaque, that of the two Magi (Fig. 21), with a standing angel holding a panpipe on the reverse, does not seem to be of the same workmanship as the others. Its drawing is drier and heavier. The colors of the enamels, especially the greens of the borders and the decoration of the corners, have a rather different aspect from that seen on the other plaques. Nevertheless, these differences are not the result of a change of technique or of the overall style, and may simply represent the hand of a different artist in the same workshop. Furthermore, the angel holding a panpipe is already recognizable in the 1847 lithograph (Fig. 4).[32]

The restorations of The Cloisters tabernacle are thus numerous and undeniable (Margaret Freeman had in fact already identified most of them). It has to be emphasized, however, that they do not detract from the object itself. The photographs of the 1867 sale catalogue show that the restorations described above are earlier than that date and earlier than 1847, except perhaps for the base. This seems to rule out the possibility of a Weininger restoration. The base must have been remade between 1847 and 1867.[33] But an important intervention must have taken place in the seventeenth or eighteenth century, at which time the *paperolles*—the decorative beaded paper ornament—which are very characteristic of nuns' work of this period, were placed in the two reliquaries held by the angels (Fig. 3). The third relic compartment, which was introduced into the base, could have already been made at this date, even though the base itself was remade later. The old but thick gilding and the awkwardly painted faces and hands could likewise date from the seventeenth or eighteenth century.[34]

Fig. 9. Reliquary of Elizabeth of Hungary, detail of the face of an angel

Fig. 10. Reliquary of Jaucourt, detail of the face of an angel, Champagne, ca. 1320-40. Paris, Musée du Louvre (photo: R.M.N., Paris)

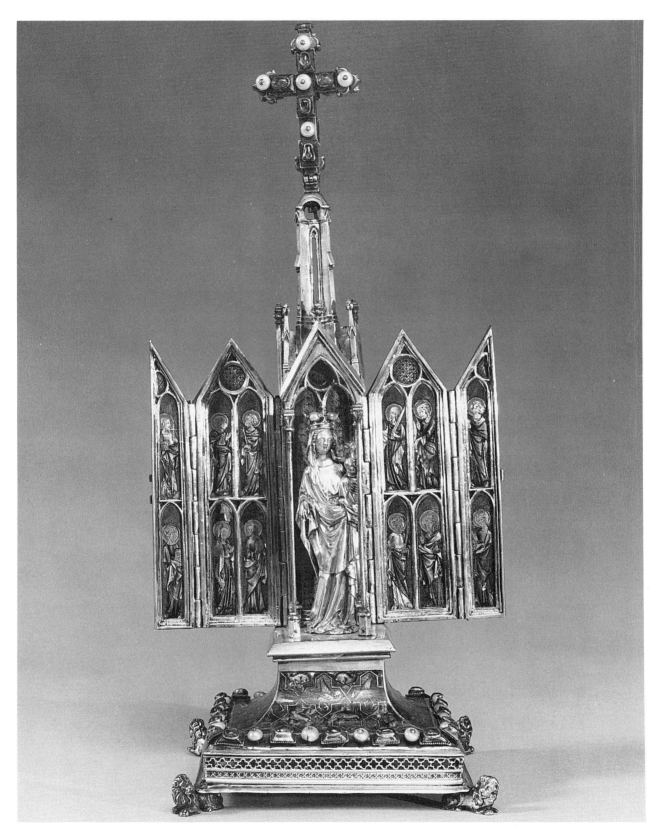

Fig. 11. Enamel tabernacle, Paris, second quarter of the fourteenth century. New York, The Pierpont Morgan Library (photo: The Pierpont Morgan Library, New York)

336

Taking into account these restorations and alterations, the tabernacle of Elizabeth of Hungary is nevertheless uncontestably an object of the four-teenth century. Before the modifications of the base and the upper parts, its form must have been similar to that of a number of ivory tabernacles[35] or of other examples in goldsmithwork, such as the silver and enamel tabernacle of Philip VI at Seville, and the polyptychs in the Poldi Pezzoli Museum, Milan (Fig. 15), or the Pierpont Morgan Library (Fig. 11).[36] These examples show that the upper part of The Cloisters tabernacle must have included a central crowning element in the form of a bell tower that was much more developed than the present modern roof. These same examples of goldsmithwork indicate that the base of The Cloisters reliquary must also have been more complex in its form, enlivened with moldings and projections. It probably stood on feet in the form of small lions, as on the base of the polyptych in the Pierpont Morgan Library, or of the Virgin of Jeanne d'Évreux.[37] Moreover, the style of the statuettes and the type and technique of the enamels have long been recognized as characteristic of the fourteenth century, and a number of contemporary inventories of ecclesiastical treasuries and of French princes, such as Louis d'Anjou, include similar pieces.[38]

However, if there has been general agreement on the dating of the reliquary to the first half—or the middle—of the fourteenth century, there has been no consensus as to the origin of the work. Given to a French workshop by Margaret Freeman, it was considered Hungarian by Mihalik, who attributed it to Petrus Gallicus, an Italian goldsmith who worked at the Hungarian court. Since these articles were published, most attributions have been rather tentative until Johann Michael Fritz, in 1982, having mentioned the previous attributions to France, the Rhineland, and Hungary, noted compar-isons with contemporary Viennese goldsmithwork. Dietmar Lüdke has since assigned it, though with reservations, to Paris.[39]

Although the comparative pieces cited by Mihalik in support of a Hungarian origin are not convincing, his attribution to the goldsmith Peter Gallicus is firmly anchored in historical circumstan-ces.[40] The Sienese goldsmith worked at the court of Naples for the Angevin kings and then in Hungary, where he made the great royal seal of Charobert, the king of Hungary and the husband of Elizabeth.

Thus, having connections to the Tuscan art of translucent enamel on *basse-taille* and, at the same time, through his work in Naples to French art, Gallicus could certainly have been the creator of a reliquary offered by the queen of Hungary to the Poor Clares of Buda. Nevertheless, even though The Cloisters piece was unquestionably in the treasury of the Poor Clares of Buda at the end of the eighteenth century, it must be remembered that it was only in 1714, and not in the earlier inventory of 1656, that the polyptych is associated with the memory of Queen Elizabeth. Moreover, the link Mihalik suggested between The Cloisters polyptych and a reliquary given by the queen to the Poor Clares in 1380 is somewhat uncertain; it is rather difficult to identify The Cloisters polyptych by the "planarium ymaginem Beatae Virginis habens in superiori parte auro et inferiori argento tectum" described in the will of the queen.[41] It has to be especially noted that the polyptych has neither heraldic decoration nor inscriptions and, above all, nothing in its iconographic program to indicate that it was made for Elizabeth of Hungary—the daughter of the king of Poland, Wladislas Lokietek, and the wife of Charobert, who belonged to the Angevins of Naples because he was a grandson of Charles II "the Lame." But among the male and female saints represented on the shutters, there are no patron saints of Hungary, no patron saints of the Angevin princes of Naples, and no patron saints of Elizabeth's own family. St. Margaret of Hungary and St. Stephen of Hungary, for example, might well have been represented, and especially St. Elizabeth of Hungary, since she bore the same first name as the queen. The absence of a representation of St. Louis of Toulouse is even more surprising: the uncle of King Charobert and a Franciscan canonized in 1317, he could not have been omitted from the iconography of an object ordered by the wife of an Angevin prince and destined for a convent of Franciscan nuns. It is clear, then, that The Cloisters polyptych could not have been made especially for Elizabeth of Hungary. If, as it appears, it was given by the queen to the convent of the Poor Clares that she founded, Elizabeth must have either purchased it after it was already made or received it as a gift. Under these circumstances, Sandor Mihalik's thesis in favor of its creation by Petrus Gallicus at the Hungarian court loses much of its strength.

What can be said of the attribution to France?

Fig. 12. Reliquary of Elizabeth of Hungary, detail of the architectural ornament and the statuette of St. John the Evangelist

Fig. 13. Virgin and Child, detail of the base showing the Presentation in the Temple and the Flight into Egypt, given to Saint-Denis by Jeanne d'Évreux in 1339. Paris, Musée du Louvre (Photo: R.M.N., Paris)

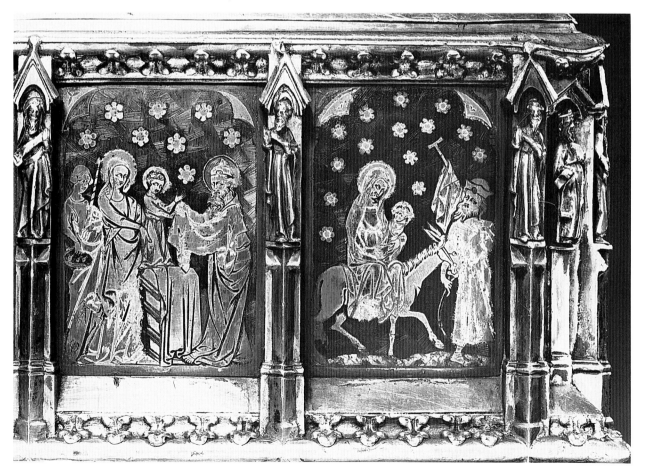

Here the comparison of the architecture is important: the design of the gables enhanced by foliage, the drawing of the pierced rosettes, and the silhouette of the piers in which tiny statues have been placed (Fig. 12) evoke Parisian art of the first half of the fourteenth century. The piers ornamented with statuettes of very high quality set in niches are particularly close to those on the base of the Virgin of Jeanne d'Évreux (Fig. 13), dated 1339 at the latest.[42] Furthermore, a number of Parisian enamel polyptychs are comparable to that of The Cloisters tabernacle: those already cited in Seville, in the Pierpont Morgan Library, in Milan, and in Namur.[43]

But a more careful comparison also reveals subtle differences. The central statuettes of the Virgin and Child and angels on The Cloisters tabernacle bear only general resemblances to Parisian goldsmith figures of this period: the silver-gilt Virgin of Jeanne d'Évreux, and the Virgins at the center of the enamel polyptychs in Seville and the Pierpont Morgan Library (Fig. 11),[44] show an elegance of proportion, a virtuosity in the drawing of drapery and the falling of folds that are not found on The Cloisters statuettes. The Cloisters figures are less supple and have a more

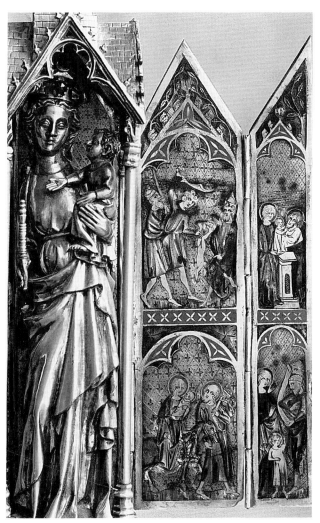

Fig. 15. Enamel polyptych, detail of right wings with the Flight into Egypt, Paris(?), first half of the fourteenth century. Milan, Museo Poldi Pezzoli (photo: Museo Poldi Pezzoli)

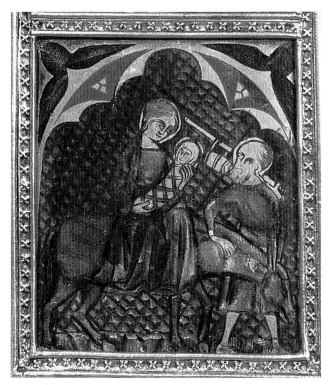

Fig. 14. Reliquary of Elizabeth of Hungary, detail of the Flight into Egypt

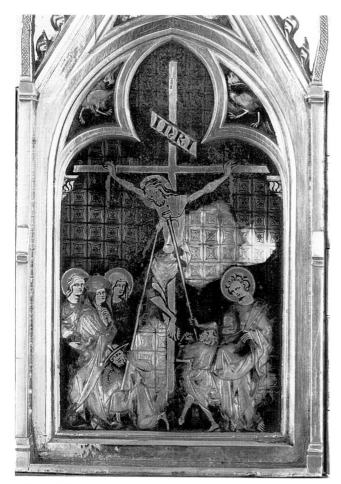

Fig. 16. Enamel triptych, detail of the Crucifixion, Paris, ca. 1320-30. Namur, Musée diocésain (photo: Copyright A.C.L., Bruxelles)

ingenuous appearance, which is, nonetheless, not without charm. The differences are accentuated when one looks at the enamels: if the palette is close, the translucent azurite blue is deeper on the Parisian works already mentioned, where the use of colors is also more refined. Above all, the workmanship of the *basse-taille* is not the same: the enamels of the polyptych of Elizabeth of Hungary show a drier type of drawing, the bodies are more angular, and the drapery work is more schematic. The drawing of the faces is done in a different manner: the eye is set very close to the nose and is entirely surrounded by a dark line, sometimes enlarged toward the temple by the addition of one or more chevrons. The spatial realization of the figures is sometimes rather awkward (Figs. 14, 15). It has been suggested that these characteristics stem from the goldsmith's difficulty in translating the supple lines of contemporary Parisian manuscript illumination, seen especially in the works of Jean

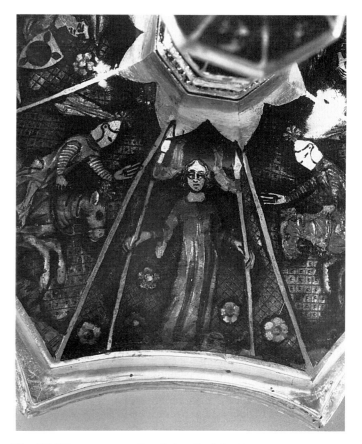

Fig. 17. "Tournament Cup," detail of the base, Avignon, second quarter of the fourteenth century. Milan, Museo Poldi Pezzoli (photo: Museo Poldi Pezzoli)

Fig. 18. Enamel crosier, detail of the shaft, Paris, second quarter of the fourteenth century. Cologne, Cathedral Treasury (photo: author)

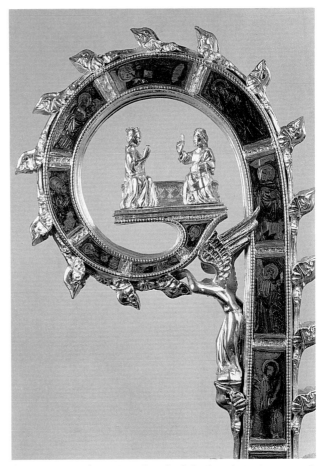

Fig. 19. Enamel crosier, detail of the head, Paris, second quarter of the fourteenth century. Haarlem, Schatkamer van de Kathedrale Basilek (photo: Saint Bavo/ Schatkamer)

Pucelle and his followers, into hard metal.[45] But the enamels of the Namur triptych, for example, clearly show that some Parisian goldsmiths were able to overcome this difficulty (Fig. 16). Thus if the affinities of The Cloisters tabernacle with Parisian art are clear, in particular in its use of architectural forms, the differences in the statuettes and the enamels do not allow the attribution of The Cloisters tabernacle to the workshops that created the polyptychs of Seville, of the Pierpont Morgan Library, of Namur, or of Milan.

Comparisons outside this artistic milieu, with translucent enamels considered to be English or Rhenish, Hungarian or even Austrian, are no more convincing. In a limited sense, Avignon offers one interesting element of comparison: on the "Tournament Cup," preserved in Milan, which bears the hallmark of Avignon,[46] the drawing of the eyes of the figures, which have dark circles around them

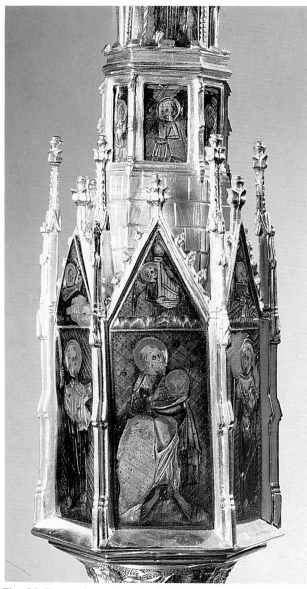

Fig. 20. Enamel crosier, detail of the enamels of the knop of Fig. 19: saints and musical angels (photo: Schatkamer)

and which are set close to the nose, seems comparable (Fig. 17). But on the cup, the faces and the rounder forms of the bodies, as well as the colors of the enamel, which are more lively as well as more silken, betray another origin.

The Cloisters tabernacle is nevertheless not an isolated work, and the style of its decoration and of its enamels can be found on a number of other enameled works dated to the fourteenth century but whose origin remains uncertain or under discussion. The elongated lance-shaped leaves worked in repoussé on the back of the central section seem unusual, but they can be found on the shaft of the crosier in the cathedral treasury at Cologne.[47] The same undulating tonguelike leaves are arranged in circles on the crosier (Figs. 2, 18). Although the enamels with grotesque decoration on the Cologne crosier do not allow a comparison, the pierced architectural forms of its knop are reminiscent of the spandrels of the tabernacle. However, the origin of this crosier is variously considered to be France, Avignon, or the Rhineland—the most recent publication attributing it to Cologne about 1322.

A second crosier, whose provenance is the abbey of Egmont but which is preserved at Saint Bavo, Haarlem, the Netherlands, should be mentioned here.[48] Its silhouette is close to that of the Cologne crosier in the stance and modeling of the angel supporting the volute, in the presence of statuettes in the round on the center of the volute, in the development of the hook-shaped leaves along the length of the volute, and in the architectural structure of the knop.[49] But it has the distinction of being decorated along the entire length of the sides of its volute and on the plaquettes of its octagonal knop with translucent enamels on *basse-taille* representing saints and musical angels (Fig. 19). In fact, the color of these enamels, including the brilliant blue of the background; the drawing of the figures and their features, with rather angular drapery, charcoal eyes, stiff beards and hair, and tiny mouths; the appearance of musical angels in the triangular plaquettes; and finally the structure of the metalwork buttresses of the knop, all offer analogies with The Cloisters polyptych that allow it to be recognized as a work from the same milieu (Figs. 14, 20, 21). Like the Cologne crosier, however, the example in Haarlem has not been attributed to a specific atelier; while some scholars hesitatingly consider it French, others consider it to be Rhenish.

342

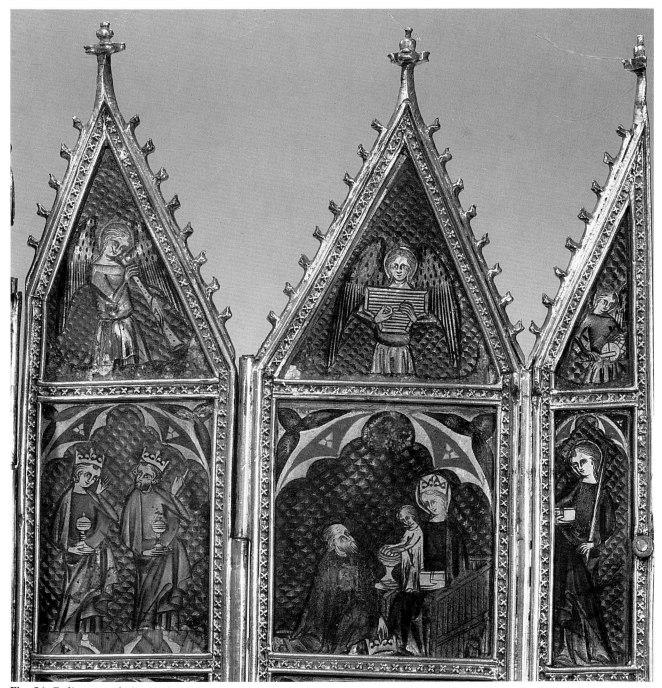

Fig. 21. Reliquary of Elizabeth of Hungary, detail of the Adoration of the Magi, a female saint, and musical angels

The large silver-gilt and enamel cross in the Bargello, which comes from the church of Saint-Just d'Arbois in the Franche-Comté, belongs to this same group.[50] The cross itself, with its small statuettes and its leaf decoration emphasizing the exterior line of its silhouette and its enamels with their ornamental character, can be compared with the crosier in the Cologne Cathedral treasury, a comparison furthered by the appearance of the foot of the cross, with its large architectural knop covered with pinnacles (Fig. 22). The four enamel lozenges of the feet have representations of the four

Fig. 22. Cross of Arbois, Paris, second quarter of the fourteenth century. Florence, Bargello (photo: Gabinetto Fotografico Soprintendenza Beni Artistici e Storici de Firenze)

Fig. 23. Cross of Arbois, detail of base, St. John the Evangelist (photo: Gabinetto Fotografico)

Fig. 24. Reliquary of Elizabeth of Hungary, detail of St. James the Less

Fig. 25. Cross of Arbois, detail of base, Evangelist (photo: Gabinetto Fotografico)

Fig. 27. Chalice of Jean de Touyl, Paris, second quarter of the fourteenth century. Wipperfürth, Church Treasury (photo: Kunst und Museum Bibliothek und Rheinisches Bildarchiv, Cologne)

Fig. 26. Reliquary of Elizabeth of Hungary, detail of the Nativity

Fig. 28. Chalice of Wipperfürth, detail of the Pentecost (photo: JRG)

Fig. 30. Chalice of Wipperfürth, detail of the Doubting of Thomas (photo: JRG)

Fig. 29. Reliquary of Elizabeth of Hungary, detail of the Annunciation

Fig. 31. Reliquary of Elizabeth of Hungary, detail of St. Bartholomew

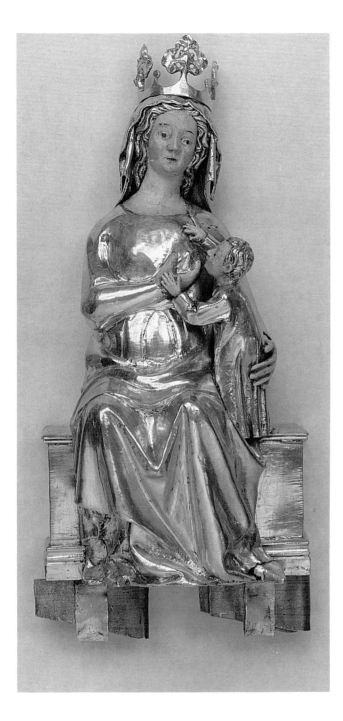

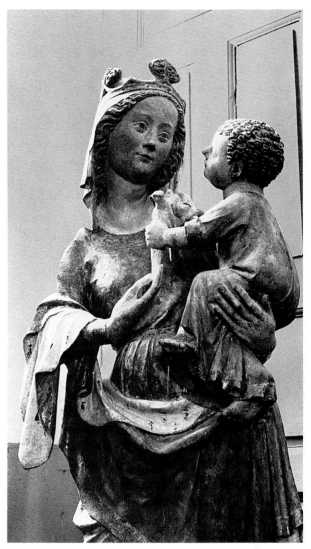

Fig. 33. Virgin and Child of Champdeuil, detail, Île de France, first third of the fourteenth century. Champdeuil (Seine-et-Marne), Église paroissiale (photo: Françoise Baron)

Fig. 32. Reliquary of Elizabeth of Hungary, detail of the statuette of the Virgin

Evangelists, allowing a comparison with the polyptych at The Cloisters. Despite the losses of enamel, the appearance of the figures is perfectly clear. Thin and clothed in rather simple drapery, they have faces that are in every respect comparable to those on the tabernacle of Elizabeth of Hungary: the mouths are small and narrow, indicated by an arc; the eyes are emphasized, encircled with a dark line and extended by a sort of chevron; the hair and beards are stiff, and the traditional lock of hair on the forehead is schematically drawn; the drawing of the arms and hands, which is rather rough, is likewise similar. The resemblances, in fact, are so strong—for example, between the St. John the Evangelist on the foot of the cross of Arbois and the St. James the Less of the tabernacle (Figs. 23, 24), between the other Evangelists on the cross and the apostles of the tabernacle, or even the St. Joseph

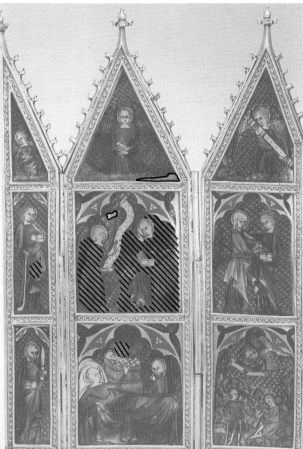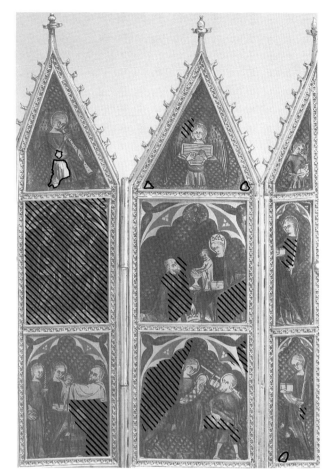

Fig. 34. Restoration chart, Reliquary of Elizabeth of Hungary, front view, open. Restored areas are indicated by diagonal hatching; losses of enamel surface are outlined in black. (photo: Thomas C. Vinton and Museum)

of the Nativity—that they clearly indicate that the two pieces share the same origin (Figs. 25, 26).

Erich Steingräber, who published the cross in 1952, suggested that it was a French work, an attribution refined by Marie-Madeleine Gauthier, who attributed it to Avignon.[51] There is a name associated with the Bargello cross: Philippe d'Arbois, according to tradition in the Franche-Comté, was its donor.[52] A contemporary of Elizabeth of Hungary, Philippe d'Arbois was an important figure: the protégé of the count of Flanders, Louis de Nevers, and of his wife, Marguerite de France, daughter of King Philip V "the Tall," he was sent on numerous occasions to the pope at Avignon to defend the interests of the count and subsequently those of the

king of France, Philip VI of Valois. Canon of Cambrai, but resident in Paris, Philippe d'Arbois became a royal minister in 1334. He was consecrated bishop of Noyon and, thus, became a peer of France. In 1351, with the support of John the Good, the successor of Philip VI, he was given the episcopal see at Tournai, which he occupied until his death in 1378. His native city, Arbois, benefited from his numerous gifts and legacies.[53] Is it possible to decide from this curriculum vitae where Philippe d'Arbois could have commissioned or purchased the cross? Tournai leads us back in the direction of the Netherlands or the Rhineland. The stays in Avignon were lengthy, but it is clearly the link with the court of France and Paris that dominates. And yet the

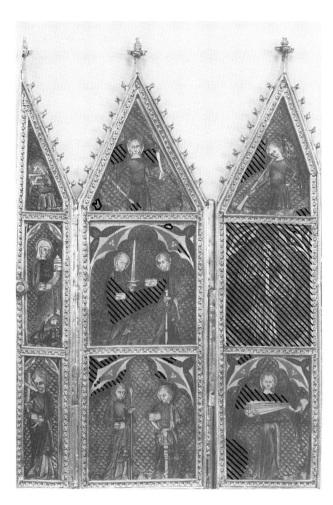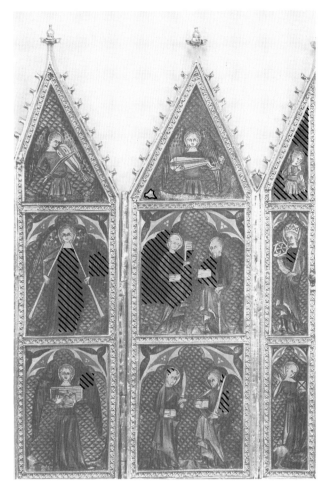

Fig. 35. Restoration chart, Reliquary of Elizabeth of Hungary, view of back. Restored areas are indicated by diagonal hatching; losses of enamel surface are outlined in black. (photo: Thomas C. Vinton and Museum)

attribution of the cross and the translucent enamels of its foot to a Parisian goldsmith provokes the same objection as the attribution to Paris for the tabernacle of Elizabeth of Hungary.

It is nevertheless to Paris that we must return, given the stylistic affinities that link the enamels of the tabernacle of Elizabeth of Hungary with an object that is indisputably Parisian: the chalice of Jean de Touyl preserved today in Wipperfürth in the Rhineland.[54] The eight very damaged translucent enamels set into the foot of this chalice illustrate scenes of the Passion of Christ (Fig. 27). Their style has all the characteristics already defined on the enamels on The Cloisters tabernacle: angular silhouettes, schematic drapery, slightly stereotyped

faces with narrow mouths, stiff hair, darkly circled eyes sometimes enlarged toward the temples.[55] Moreover, the presence of female figures in certain scenes of the chalice, which are found neither on the cross of Arbois nor on the crosier from Haarlem, allows even further comparisons with the enamels of the tabernacle. Thus, the Virgin of the Pentecost seems to be the sister of the Virgin of the Visitation and the Virgin of the Annunciation or of the unidentified female saint of the tabernacle (Figs. 28, 29), while the head of St. Thomas of the chalice is very close to that of St. Bartholomew on the tabernacle (Figs. 30, 31). The enamels of the chalice, like those of the tabernacle, are distinctly different from the Parisian pieces considered earlier—the

349

polyptychs of Milan, Namur, Seville, the Pierpont Morgan Library—or from the Virgin of Jeanne d'Évreux, and one would not think of attributing this chalice to Paris if it did not bear a hallmark in the form of an easily recognizable fleur-de-lis, and, even more so, because the signature of the goldsmith Jean de Toul, "orfèvre de Paris," is known from a number of documents.[56] In 1328, after the death of Queen Clémence of Hungary, he was one of the experts in charge of the inventory of her property; that same year he was in charge of a work for the Sainte-Chapelle.[57] In 1348, he became a "garde" of the corporation of the goldsmiths of Paris, and he died in 1349 or 1350 during the Plague.[58] It is possible that the name "Touyl" or "Toul" is an indication that the goldsmith was originally from Lorraine, and this could explain certain aspects of his style. More striking, however, is his activity in Paris over nearly a quarter century, as well as the importance of his clientele, justifying the title of "orfèvre de Paris." Consequently, it has to be recognized that the milieu of Parisian goldsmiths of this period was enlivened by different styles. Thus the pieces discussed earlier—the base of the Virgin of Jeanne d'Évreux, the polyptychs of New York, Seville, Milan, and the triptych of Namur—owe their style to a taste marked by fluid, sinuous drawing practiced by the artists who perpetuated the style of Master Honoré and by the work of the atelier of Jean Pucelle. But it is within a different, more traditional aesthetic, rather archaistic, and upon which Pucelle and his circle had virtually no influence, that the objects linked here to the chalice of Jean de Touyl—the crosiers of Cologne and Haarlem, and especially the cross of Arbois and the tabernacle of Elizabeth of Hungary—must be grouped.

In this context, the aspect of the three central statuettes of The Cloisters tabernacle, which are so different from the silver-gilt Virgins of the polyptychs of Seville and the Pierpont Morgan Library, is more easily understood. These statuettes bear certain parallels to contemporary sculpture in the Île de France. The two angels are not far from the goldsmith's angels with painted faces who support the Byzantine reliquary of Jaucourt, a work attributed to Champagne in about 1320–40.[59] It is nevertheless in monumental sculpture that they find their best parallels, with the St. Osmanne in painted stone from Féricy (Seine-et-Marne).[60] This saint has the same full face framed by curling locks, the same wide-open round eyes, the same small mouth under a short nose; moreover, the drapery of her dress with its long folds falling softly around the feet is similar. The Virgin of the tabernacle can be compared to another work from the same region, the Virgin and Child from Champdeuil (Figs. 32, 33), where one finds, in addition to the facial features already noted for the angels, the frizzy locks of hair and, above all, this very distinctive expression, both juvenile and naive.[61] The St. Osmanne of Féricy and the Virgin of Champdeuil, whose links to Parisian sculpture are evident, have been dated to the first quarter or the first third of the fourteenth century. Their affinities with the statuettes of The Cloisters tabernacle, confirming a Parisian origin for the work, could perhaps be indicative of the date for the execution of the reliquary in the years between 1320 and 1340.

Was The Cloisters enameled tabernacle purchased at Paris on the order of Elizabeth of Hungary, or was it offered by a member of the circle of the French royal family linked to the royal family of Hungary, or to the branch of Angevin princes from Naples? Clémence of Hungary, the sister of King Charobert of Hungary and the last wife of King Louis X of France, could have at least put Elizabeth in contact with one of the goldsmiths working in the royal circle. It is important to note that one of the goldsmiths who directed the inventory of the possessions of Clémence of Hungary, following her death in 1328, was in fact Jean de Touyl.[62]

NOTES

1. The principal publications are: A. Primisser, "Der Silberne Hausaltar der Ungarischen Königstochter Margarethe," *Taschenbuch für die Vanterländische Geschichte* (Vienna, 1824), vol. 5, pp. 27–103; Floris Rómer, "Der Hausaltar der seligen Margaretha Tochter Königs Bela des IV," *Mitteilungen der k.k. Central. Commission zur Erforschung und Erhaltung der Baudenkmale,* XII (Vienna, 1867), pp. 133–45, pl. v; idem, in *Archaeologiai Közlemények* (Budapest, 1867), p. 42; B. Czobor, "L'autel domestique attribué à la vénérable Marguerite de la maison Arpadian," *Akadémiai Ertesitö* (1901), p. 417; and J. Mihalik, "Historical Monuments in the Hungarian Pavilion of the Paris World Exhibition of 1900" (title in Hungarian), in *Archaeologia Ertesitö* 20 (1900), pp. 383–84. For a complete bibliography and a review of the Hungarian sources, see Sandor Mihalik, "Problems concerning the Altar of Elizabeth, Queen of Hungary," *Acta Historiae Artium. Academiae Scientiarum Hungaricae* 10/304 (Budapest, 1964), pp. 247–98.

2. Margaret B. Freeman, "A Shrine for a Queen," *MMAB* 21/10 (June 1963), pp. 327–38.

3. See Mihalik, "Problems concerning the Altar," pp. 247–98.

4. This research could not have been done without the assistance of the staff of the Department of Medieval Art and The Cloisters of The Metropolitan Museum of Art, William D. Wixom, Charles Little, Mary Shepard, Elizabeth C. Parker, and most particularly Barbara Drake Boehm, who offered her suggestions and observations throughout the course of my work and subsequently translated the text. Pete Dandridge of the Objects Conservation Department of The Metropolitan Museum of Art kindly undertook the laboratory examination of the tabernacle. I likewise wish to express my thanks to all who offered their opinions, especially Françoise Arquié-Bruley, Françoise Baron, Eva Kovács, Elisabeth Taburet-Delahaye, Daniel Alcouffe, Jannic Durand, and N. Jopek.

5. Height: 25 cm; width of tabernacle with wings closed: 16.5 cm; base 20 x 9.2 cm, 19.3 x 8.4 cm, exclusive of the later moldings.

6. The dimensions of the rectangular plaques range between 4.3 and 4.9 cm; 3.3 x 4.9 cm; 1.5 x 4.9 cm. The isoceles triangles measure 4.3 x 4.9 x 4.9 cm.

7. The attributes of the musical angels in the upper parts are as follows: on the interior of the shutters from left to right: a pair of cymbals, a pair of cymbals, a bass recorder or shawm, a tenor shawm, a psaltery, a tambor; on the gables of the exterior shutters from left to right: a set of panpipes, a pair of nakers, a trumpet; a five-stringed fiddle, a gittern, a recorder. The full-length angels on the left wing exterior of the shutters hold a recorder, a gittern; on the right wing: a double trumpet, a psaltery. I am grateful to Mary Shepard for these identifications.

8. Freeman, "Shrine for a Queen"; and Mihalik, "Problems concerning the Altar." See also note 1 above.

9. Mihalik, "Problems concerning the Altar," p. 249.

10. Ibid., p. 247: "A small silver altar containing the image of the Holy Virgin."

11. Ibid., p. 248: "a small silver altar, completely deteriorated" (in Hungarian). "*Unam* [sic] *altariolum parvum argenteum quod Regina pro devotione sua asservabat*" (a small silver altar that the queen used for her devotions).

12. See references in note 1 above.

13. All these documents are reproduced in Mihalik, "Problems concerning the Altar," pp. 247–98.

14. Ibid., fig. 2.

15. Rómer, "Hausaltar der seligen Margaretha," pl. v.

16. Mihalik, "Problems concerning the Altar," figs. 4, 5.

17. Ibid., figs. 6, 7.

18. Ibid., figs. 8, 9.

19. See Jane F. Hayward, "Salomon Weininger Master Faker," *The Connoisseur* 187 (1974), pp. 170–79. Born in 1822, active in Vienna, Weininger seems to have begun his career as a forger after the exhibition of ecclesiastical treasures of Vienna in 1860 and to have been active principally between 1865 and 1876, the year of his conviction.

20. Sandor Mihalik believed that it was Nathaniel de Rothschild. According to the observations shared with me by Mme Françoise Arquié-Bruley, the annotated sales catalogue preserved at the Bibliothèque Doucet shows that the majority of the pieces were purchased by a consortium composed of Baron Adolphe de Rothschild (who kept the largest number of objects) and two Frankfurt dealers. Before 1939 The Cloisters tabernacle was in the collection of Maurice de Rothschild, who had inherited it from Baron Adolphe's collection.

21. That is, if it does not represent an ideal logical order of the plaques according to Rómer. In any case, it was possible to reverse the plaques again between 1864 and 1867 to conform with the lithograph of 1847.

22. For the Namur triptych, see P. de Henau, Charles Fontaine-Hodiamont, and L. Maes, "Le baiser de paix émaillé de Namur," *Bulletin de l'Institut royal du patrimoine artistique* 19 (1982–83), pp. 5–25. I was able to observe this technical detail on the polyptych in the Pierpont Morgan Library and on that in the Poldi Pezzoli Museum, Milan (see note 37 below).

23. The examination was done under the direction of Pete Dandridge. The Mar. 16, 1988, report is preserved in the Medieval Department of The Metropolitan Museum of Art; it includes the restorations and losses to the tabernacle charted by Pete Dandridge and Barbara Boehm (Figs. 34, 35). The reliquary is silver, mercury gilt. The roof, the galleries on the front and the left, and eleven spires are restored.

24. The reliquary "window" opened in the upper base is not original. It is possible that when it was added, the upper part of the base was remade: the cross-bar pattern of the enamels is coarser than on the rest of the base; important traces of solder are visible in the interior.

25. The means of attaching the crown is extremely crude. The crown was regilt directly on the Virgin's head, on which flooding of the metal can be seen.

26. The statuettes were originally conceived to be set against a backdrop. Their definition on the back, consequently, is very summary.

27. In particular, the regilding of the back was done after the remounting of the statuettes.

28. The earliest examples are described in inventory references published by Françoise Baron: "Les arts précieux à Paris aux XIV et XV siècles d'après les archives de l'hôpital Saint-Jacques-aux-Pélerins," *Bulletin Archéologique du Comité des travaux historiques et scientifiques* 20–21 (1988), p. 65 (for 1342). It

was then common practice to repaint such painted faces frequently.

29. Inv. no. OA 6749. The Jaucourt reliquary is dated ca. 1320–40. See *Les Fastes du Gothique*, exhib. cat., Grand Palais (Paris, 1981), no. 181. The same refined texture can be seen on two later examples of painted goldsmiths' statuettes in the Louvre collection: the small St. Dorothy (ca. 1400; OA 8946; see *Die Parler*, exhib. cat. [Cologne, 1978], II, p. 713; Dietmar Lüdke, *Die Statuetten der Gotischen Goldschmiede* [Munich, 1983], no. 82); and the two angel reliquaries of Anne of Brittany (MR. 550–51: ibid., no. 255).

30. On the statuettes cited in note 29 above, the paint is laid directly on the metal. No trace of gilding could be detected underneath the paint base, in keeping with what seems to have been normal procedure. The breast of the Virgin on The Cloisters tabernacle was likewise painted, and a trace of the paint survives, but on top of the layer of gilding. It is not certain that the breast was originally painted, for no line can be seen that would have suggested an opening in the gown in the chest area.

31. This is especially true of the Copenhagen ewer, the Namur triptych, and the base of the Jeanne d'Évreux Virgin. See Erich Steingräber, "Ein Reliquienaltar Königs Philipps V und Königen Johanna von Frankreich," *Pantheon* 33/2 (1975), pp. 91–99; *Fastes du Gothique*, nos. 183, 186.

32. If this plaque were a replacement, it would have been made before this date. Restorations of the beginning of the nineteenth century, however, were not usually so true to the style of the original.

33. The 1847 lithograph is unfortunately too imprecise to allow confirmation.

34. This hypothesis is supported by the fact that the relic containers of the angels seem to have been reattached on top of the angels' hands and that the thick paint layer was not damaged in the process.

35. For example, the polyptych in the Hermitage (see Raymond Koechlin, *Les Ivoires gothiques français* [Paris, 1924], vol. 2, no. 172), if, however, the upper part has not been overrestored.

36. See Steingräber, "Reliquienaltar," pp. 91–99; Lüdke, *Statuetten*, nos. 287, 281, 282b.

37. The Virgin was given to the abbey of Saint-Denis in 1339 by Queen Jeanne d'Évreux, widow of King Charles IV "the Fair." See Blaise de Montesquiou-Fezensac, *Le Trésor de Saint-Denis* (Paris, 1973–77), no. 8, in vols. 1 and 2; vol. 3, pls. 9, 10, pp. 27–30; *Fastes du Gothique*, no. 186.

38. Freeman ("Shrine for a Queen," p. 327) noted comparative pieces in the inventory of the treasury of Louis d'Anjou. See H. Moranvillé, *Inventaire de l'orfèvrerie et des joyaux de Louis 1er duc d'Anjou* (Paris, 1906). Comparable pieces are included in the inventories of papal treasuries published by Hermann Höberg (*Die Inventare des Papstlichen Schatzes in Avignon* [Vatican City, 1944], esp. pp. 70, 384).

39. Johann-Michael Fritz, *Goldschmiedekunst der Gotik in Mitteleuropa* (1982), no. 272; Lüdke, *Statuetten*, p. 655, no. 282a.

40. Mihalik, "Problems concerning the Altar," pp. 285ff.

41. See G. Fejér, *Codex diplomaticus Hungariae* IX (Buda, 1834), vol. 5, p. 400, no. CCXIV. I am grateful to Eva Kovács, who kindly verified for me the Hungarian sources in which the reliquary could have been cited.

42. Paris, Musée du Louvre. See note 37 above.

43. Seville, treasury of the cathedral; New York, Pierpont Morgan Library; Milan, Poldi Pezzoli Museum; Namur, diocesan museum. See also note 36 above. The general shape of the base of the reliquary of Elizabeth of Hungary recalls that of these four enamel works, a form that could also have been that of the base or the reliquary from which the small enamel plaques in the British Museum come (cf. Marian Campbell, "The Langlois Plaques," *Apollo* [1988], pp. 90–93).

44. See Steingräber, "Reliquienaltar," pp. 91–99. The statuette of the Virgin on the Milan polyptych is not cited here, since the figure is not the one originally intended for the piece: see Marie-Madeleine Gauthier, *Émaux du Moyen Âge occidental* (Fribourg, 1972), no. 207, p. 404.

45. See Freeman, "Shrine for a Queen," p. 338.

46. The "Tournament Cup" is preserved in the Poldi Pezzoli Museum, Milan: see Gauthier, *Émaux du Moyen Âge*, no. 197, p. 400; *Fatti comme Nuovi: Restauri e Ogetti d'Arte nel Museo Poldi Pezzoli*, exhib. cat. (Milan, 1986), no. 46. I am grateful to Dottoressa A. Mottola Molfino, director of the Poldi Pezzoli Museum, who allowed me to examine the "Tournament Cup."

47. K. Guth-Dreyfus, *Transluzides Email in der ersten Hälfte des 14 Jahrhunderts am Ober, Mittel und Niederrhein* (Basel, 1954), pp. 91, 119, no. 17, fig. 38; *L'Europe Gothique*, exhib. cat. (Paris, 1968), no. 478; Gauthier, *Émaux du Moyen Âge*, pp. 251, 253, no. 200; and Fritz, *Goldschmiedekunst*, no. 2, p. 179.

48. See *L'Europe Gothique*, no. 479; Gauthier, *Émaux du Moyen Âge*, no. 226, pp. 272–73; and Fritz, *Goldschmiedekunst*, no. 101.

49. This formal resemblance is not, however, conclusive, for the profile of the Egmont crosier can also be compared with the one in the Victoria and Albert Museum, made in 1351 for the abbey of Reichenau; see H. P. Mitchell, "The Reichenau Crozier," *Burlington Magazine* 32 (1918), pp. 66–73; and Gauthier, *Émaux du Moyen Âge*, no. 222.

50. Florence, Museo Nazional del Bargello (Inv. n. C. 697). See Erich Steingräber, "A Silver Enamelled Cross in the Carrand Collection," *The Connoisseur* (Sept. 1957), pp. 16–20; Gauthier, *Émaux du Moyen Âge*, pp. 253, 401, no. 201; S. Brault-Lerch, *Les orfèvres de Franche-Comté et de la principauté de Montbéliard, du Moyen Âge au XIXe siècle* (Geneva, 1976), pp. 662–63, 1007, pl. XXXVI; Lüdke, *Statuetten*, no. 299, pp. 681–82; *Atti del Medio Evo e del Rinascimento. Omaggio ai Carrand* (Florence, 1989), no. 138. Louis Carrand purchased the cross in 1870 at Saint-Just d'Arbois.

51. Steingräber, "Silver Enamelled Cross," pp. 16–20; Gauthier, *Émaux du Moyen Âge*, no. 201.

52. See Bousson de Miaret, *Annales historiques et chronologiques de la ville d'Arbois depuis son origine jusqu'en 1830* (Arbois, 1856), pp. 130–31; J. Girard, *L'église Saint-Just d'Arbois—Le monument et son histoire* (Arbois, 1934), p. 16; idem, *Un prélat franc-comtois du XIVe siècle—Philippe d'Arbois, évêque de Tournai* (Besançon, 1935), esp. pp. 153–56.

53. See Girard, *Un prélat franc-comtois*. The cross does not seem to have been part of the bequest of Philippe d'Arbois. The bishop more likely could have included it with his first gift or during his stay in Arbois in 1351, when he was elevated to the Tournai see (ibid., p. 144).

54. See Gerda Panofsky-Soergel, "Ein signierter Pariser Silberémail-Kelch um 1330," *Festschrift Kauffmann. Munuscula Discipulorum* (Berlin, 1968), pp. 225–33; Gauthier, *Émaux du Moyen Âge*, no. 209; *Fastes du Gothique*, no. 188; *Rhein und Maas: Kunst und Kultur 800–1400*, exhib. cat. (Cologne, 1972), p. 394, no. P9.

55. This last detail, which is frequently seen on the tabernacle, is seen on the chalice in the St. John of the Pentecost and the Christ of the Resurrection. In the entry for the chalice of Jean de Touyl in *Fastes du Gothique*, no. 188, I previously suggested a comparison to The Cloisters tabernacle, while Marie-Madeleine Gauthier proposed that the enamels of the Haarlem crosier be attributed to Jean de Touyl (*Émaux du Moyen Âge*, no. 209).

56. "Jehan de Touil Orfèvre": see Panofsky-Soergel, "Signierter Kelch," p. 226.

57. See L. Douët d'Arcq, *Nouveau recueil de comptes de l'Argenterie des rois de France* (Paris, 1874), p. 38: "Joyaux présiés par Symon de Lille, Jehan Pascon, Félix d'Auccurre, Jehan de Toul . . ." (Inventaire et vente après décès des biens de la reine Clémence de Hongrie . . . 1328); A. Vidier, "Le Trésor de la Sainte-Chapelle," *Mémoires de la Société de l'Histoire de Paris*, 34, p. 207: "vêtements et objets divers provenant de Guillaume Morin, apportés à la chapelle du roi (14 mai 1328) . . . Et furent ces choses pesées par Jehan de Touyl, orfèvre de Paris. . . ."

58. See H. Nocq, *Le Poinçon de Paris. Répertoire des maîtres orfèvres de Paris*, vol. 4 (1951), 7 janvier 1348. The date of his death was discovered by Françoise Baron ("Les arts précieux à Paris," p. 116): ". . . Pour feu Jehan de Toul, orfèvre, XLs." This mention indicates that he died after July 1349.

59. Paris, Musée du Louvre; see Elisabeth Taburet-Delahaye in *Fastes du Gothique*, no. 181; see also note 29 above.

60. See Baron in ibid., no. 2, and idem, *Trésors sacrés, trésors cachés. Patrimoine des églises de Seine-et-Marne*, exhib. cat. (Paris, 1988), no. 63.

61. See Baron in *Fastes du Gothique*, no. 7, and idem, *Trésors sacrés, trésors cachés*, no. 65. Somewhat the same features, though with a more assured air, are seen on the face of the Annunciate Virgin from Cucharmoy (Seine-et-Marne). I am grateful to Françoise Baron, who was generous enough to share with me her inestimable knowledge of French fourteenth-century statues of the Virgin.

62. French records of the fourteenth century show that Parisian goldsmiths kept a supply of fully finished precious objects in stock; they were thus available for immediate purchase. Indeed, whether it had been sent to Elizabeth of Hungary at her request or as a present, the reliquary was not made especially for her, as is shown by the absence, emphasized above, of an iconography adapted for the recipient. The inventory of Clémence of Hungary after her death does not, unfortunately, describe an analogous object.

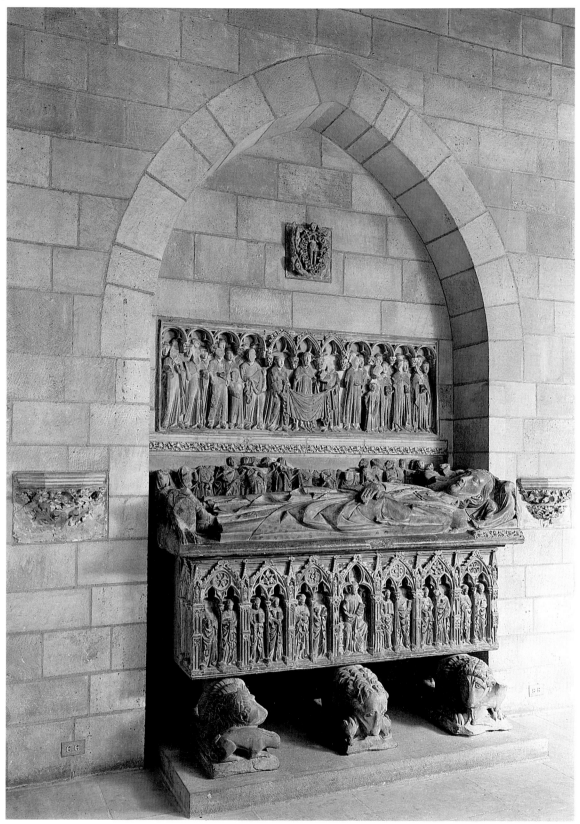

Fig. 1. Tomb monument, assembled of disparate elements in the late seventeenth or early eighteenth century, to honor Ermengol VII (d. 1194), 1320-40. The Metropolitan Museum of Art, The Cloisters Collection, 1928 (28.95) (photo: Museum)

"Sancti Nicolai de fontibus amoenis" or "Sti. Nicolai et Fontium Amenorum": The Making of Monastic History

Timothy B. Husband

I t had long been thought that the *Utsages* of Barcelona—that is, the general legal codes of Cataluña based on feudal principles—were compiled under the direction of Ramón Berenguer I, count of Barcelona (1035-1076), and were assented to by the ruling nobility within the dominions of the counts of Barcelona.[1] Scholars now generally recognize that the *Utsages* were largely codified under the orders of Ramón Berenguer III (1097-1131) and Ramón Berenguer IV (1124-1162), counts of Barcelona, a century or more later.[2] This misinformation was deliberately contrived. By the judicious invention of documentation, not only were the fundaments of the legal legislation attributed to Ramón Berenguer I and his wife, Almodis, but also the codes were given personal approbation by most of the feudal barons of the time. With this deception, the counts were able to distance themselves from the more odious aspects of the *Utsages* and, at the same time, by associating them with the names of venerable ancestors, to endow the codes with historical legitimacy, if not a measure of sanctification. The ploy served them well: when, for example, a dispute broke out between Guillem Ramón II Seneschal and his lord, Count Ramón Berenguer IV, the seneschal found himself in the dilemma of being constrained by a legal code his forebear had ratified, and, although Guillem Ramón remained defiant, his maneuverability was limited.

This article will discuss another deception conceived at a considerably later date. A deception of a less guileful nature, it was intended not to strengthen a grasp on power but merely to defend certain rights claimed by and vital to the Premonstratensian monastery of Santa María de Bellpuig de las Avellanes. While this historical imposture achieved only a limited success with the civil and ecclesiastical authorities in a remote region of western Cataluña, it proved remarkably expeditious

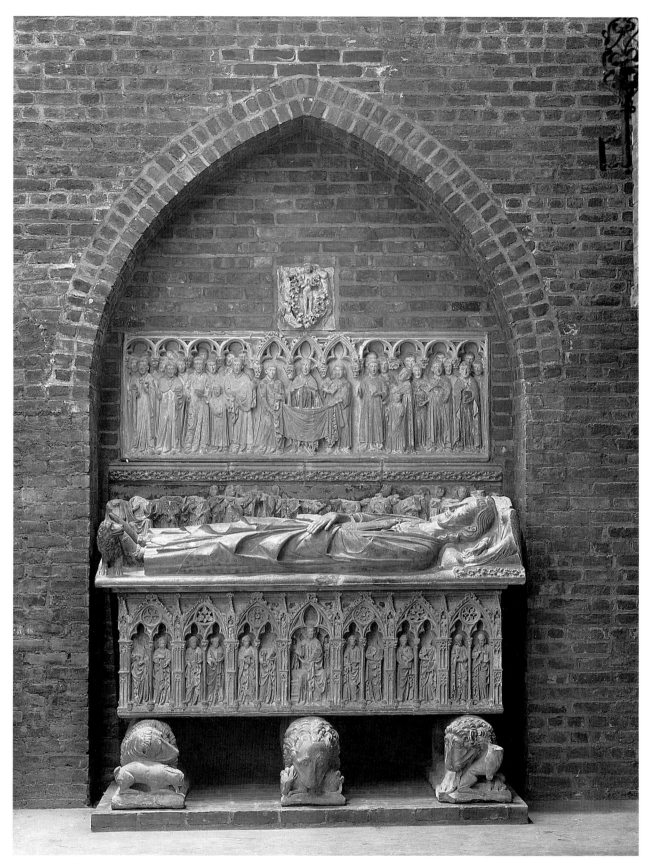

Fig. 2. Tomb monument assembled for Ermengol VII as installed in George Grey Barnard's museum (photo: Museum)

356

in misleading future art historians in their studies of the tomb monuments of the counts of Urgell,[3] perhaps the finest examples of fourteenth-century Léridan sculpture to survive.[4] The vicissitudes of the tombs, insofar as they can be reconstructed, are but one factor in a broader pattern of historical fabrication.[5]

In 1928, The Cloisters acquired, through funds generously made available by John D. Rockefeller, Jr., a tomb ensemble thought to have housed the remains of Ermengol VII, count of Urgell (Fig. 1), and to have come from Bellpuig de las Avellanes, about twenty-eight kilometers north northeast of Lérida [Lleida] (*comarca* of La Noguera, province of Lérida) in western Cataluña. In the same year, the ensemble was installed in the original Cloisters (Fig. 2), which had been purchased three years previously from George Grey Barnard.[6] In 1948, The Cloisters acquired from a Paris dealer three more tombs belonging to members of the family of the counts of Urgell (Figs. 3, 4). By 1950, all four tombs had been reinstalled in the Gothic Chapel at The Cloisters (Figs. 1, 5, 6).[7]

James J. Rorimer, the first Curator of The Cloisters, had long known of the three additional tombs, and in 1931 he published an extensive study of these monuments.[8] He wrote that the monastery of Bellpuig de las Avellanes was founded in 1146 by Ermengol VII, count of Urgell, and his wife, Doña Dulcia [Dolç], on a site known as Bellpuig (beautiful hill), which was the place of the hermitage of Juan de Organa. Originally Juan de Organa lived in a cave called el Muro. Later, with some companions, he moved to a monastery known as Mons de Mollet [also Monte Malet or el Muro], near the village of las Avellanes, the name of which was soon changed to Santa María de Bellpuig. By 1168, the first church was completed and it was dedicated by Arnau de Prexens [Préixens], bishop of Seo de Urgel [Seu d'Urgell], in whose diocese the monastery lay. Ermengol VII, who died in 1184, left a fortune of 115,000 gold pounds to the monastery, which held dominion over las Avellanes, Tartareu, Os [Os de Balaguer], Santalina, and Vilanova de las Avellanes [Vilanova (or Villanueva) de la Sal]. The monastery enjoyed the continuing patronage of the counts of Urgell until the county was subsumed into the crown of Aragón after the death of Ermengol X.[9] Around 1300, Ermengol X ordered the construction of a Gothic chapel at las Avellanes that was to serve as

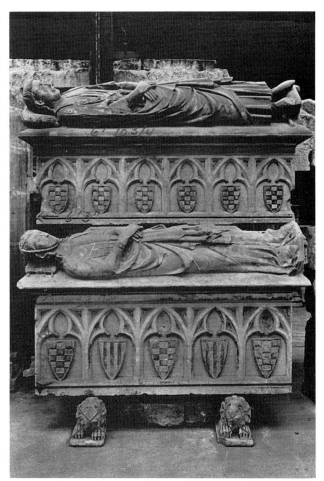

Fig. 3. Double tomb, probably made for Álvaro Rodrigo de Cabrera, count of Urgell and viscount of Ager (d. 1256), and his wife, Cecilia of Foix, as shown in Demotte's studio, Paris, 1948 (photo: Demotte)

a pantheon for himself and his ancestors; this chapel and its tombs were completed "as of about 1300, or at least before 1314," according to Rorimer.[10]

Rorimer's understanding of the history of Bellpuig de las Avellanes was based almost exclusively on a text written in the 1770s by Jaime Caresmar, who resided intermittently at the monastery from 1742 until some years before his death in 1791 and who was elected abbot in 1754 and again in 1766.[11] Rorimer also relied on this text in identifying the personages for whom the tombs were intended and, in many details, in conceiving the installation of these monuments at The Cloisters. He seems, however, to have overlooked or, at least, discounted a crucial passage in Caresmar's account.

357

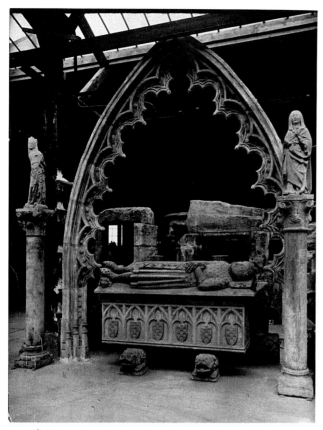

Fig. 4. Tomb said in the earliest description to be made for Ermengol X (d. 1314), as shown in Demotte's studio, Paris, 1948 (photo: Demotte)

According to Caresmar, Ermengol X initiated plans in 1303 to renovate the monastery at Bellpuig de las Avellanes and apparently started to build a chapel of "grandeur, majesty, and solidity." When this structure was built "in good part," he also began work on living quarters for the monks.[12] Both structures were, however, unfinished at the death of the count in 1314. Although Ermengol had stated his intention to be buried in the chapel and had left money to finance its construction, neither building, due to the negligence of the executors and to the turbulence that marked the first half of the fourteenth century, was ever finished, and all that remained of the original construction was some foundations and five arches of the dormitory. Caresmar dryly notes that the foundations were recently excavated and that the monastery used the masonry blocks for nearby construction.[13] Later, Jaime Pascual, a protégé of Caresmar's and a longtime

resident of the monastery, commented, "There remains little more than the transept as the death of the count brought construction to a standstill."[14] Caresmar asserts that the chapel was finished only at the beginning of the eighteenth century and, because of financial limitations, in a less elaborate and scaled-down fashion than originally envisioned (Fig. 7).[15] Thus the only medieval structure remaining at the monastery of Bellpuig de las Avellanes is the cloister (Fig. 8), which probably dates to the early thirteenth century.[16]

Caresmar describes the eighteenth-century presbytery at Bellpuig de las Avellanes (see ground plan, Fig. 9) in considerable detail.[17] According to his account, the tomb illustrated in Figure 1 was in a niche on the epistle side of the presbytery (Fig. 10). This tomb was made, according to Caresmar, at the order of Ermengol X, and the remains of his ancestor Ermengol VII, having been translated to the monastery, were housed in it. He notes that the sarcophagus is carved in relief with Christ, the apostles, and smaller figures of eight "saints," and that the sarcophagus "rests on three stone lions." He further observes that the mourners, which are carved of one stone with the effigy, represent monks as well as "knights and vassals"; that above on the left side is a relief showing angels transporting the count's soul to heaven, while centered above the effigy is another relief of friars and priests celebrating the funeral mass; above this relief is a statue of the Virgin and Child. Finally, there is a horse and rider on each side, though the one on the right side is now missing, he reports.[18]

In the niche on the gospel side of the presbytery, opposite the tomb with the mourners and absolution relief, was the double tomb illustrated in Figure 5 which Caresmar also describes in detail, asserting that the lower tomb belonged to Doña Dulcia, wife of Ermengol VII and founder of the monastery (she died in 1208),[19] and that the upper was the tomb of Ermengol X (Fig. 11).[20] The sarcophagus of Dulcia bears shields emblazoned with the chequy of Urgell alternating with ones bearing three pales that Caresmar identifies as those of Foix.[21] Caresmar locates the tomb with the effigy in chain mail and an open helmet (Fig. 6) in the chapel of the Three Kings, the first chapel to the south of the presbytery on the epistle side. Caresmar claims this belonged to Álvaro [Álvar] de Cabrera, viscount of Ager and brother of Ermengol X, who died in 1299.[22] He then

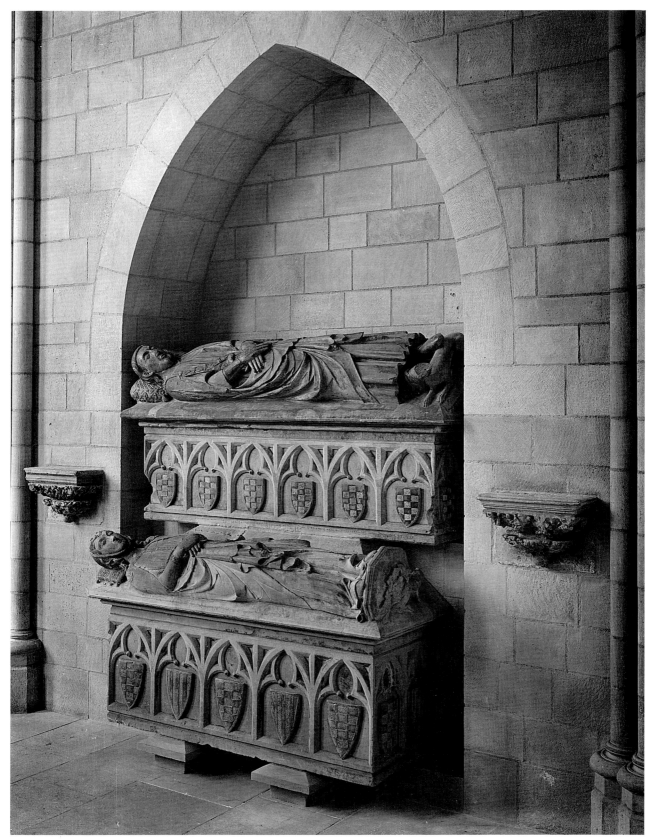

Fig. 5. Double tomb, probably made for Álvaro Rodrigo de Cabrera and his wife, Cecilia of Foix (the effigies, 1320–40). The Metropolitan Museum of Art, The Cloisters Collection, 1948 (48.140.1a–d) (photo: Museum)

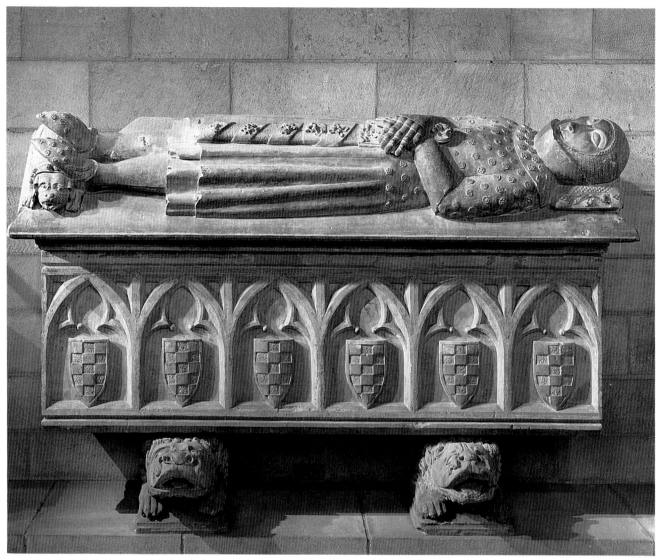

Fig. 6. Tomb said to be of Ermengol X (the effigy, 1320–40). The Metropolitan Museum of Art, The Cloisters Collection, 1948 (48.140.2a–d)

describes another tomb—now lost—the sarcophagus of which was decorated with shields lacking heraldic devices.[23]

Several details betray a postmedieval date for the arrangement of these sepulchral monuments. The sarcophagus with the reliefs of Christ and the apostles was intended to be inset into a wall to the full depth of the unfinished surfaces on the sides so that only the figures of the two clerics in a double arcade projected (Fig. 12). The sarcophagus might have been supported by either colonnettes or wall brackets as, for example, is a tomb, probably that of Abbot Ponce [Ponç] de Copons (d. 1348), in

the monastery of Poblet (Fig. 13). The mourners on the sarcophagus lid were intended to be engaged, but the effigy slab itself, which is too large for the sarcophagus on which it rests, was intended to project over a freestanding sarcophagus. The relief over the tomb is composed of three separate elements, the middle section of which, indicated by the different arcading, does not belong to those that flank it (Fig. 14). These inconsistencies indicate that this sepulcher is composed of disparate elements.

Double tombs were universally intended for a husband and wife. For the commissioner of the

chapel to place himself above a female ancestor who died over a century earlier while providing her husband with a separate, grander tomb also does not accord with medieval practice.[24] Furthermore, petrographic analyses demonstrate that the morphology of the stone of the three sarcophagi with heraldic shields is not entirely homogeneous with that of the other tomb components; it is possible that the stone of these sarcophagi was quarried from a different area of the geological formation and at a different time.[25] A later date for these three sarcophagi is indicated by the arcading that enframes the shields: they are virtually identical in design to the exterior cornice of the chapel at Bellpuig de las Avellanes (Fig. 15), the postmedieval date of which has already been established.

Diego Monfar y Sors, who resided at the monastery about a century before Caresmar, compiled, between 1641 and 1652, a history of the counts of Urgell; this text also includes a description of the burial chapel at Bellpuig de las Avellanes and its tombs.[26] Monfar writes that Ermengol VII and Dulcia, founders of the monastery, are buried in the double sarcophagi on the gospel side of the apse, Ermengol above and his wife below (Fig. 5). He also notes that around the upper casket are six shields of the arms of the counts of Urgell "unmixed," while the arms on the lower casket are identified as those of the counts of Urgell and of the counts, not of Foix, but of Barcelona "with three pales, no more."[27] On the opposite or epistle side, Monfar continues, is a large and elaborate sepulchral monument: "two large lions support the tomb; the effigy, with many arms of the counts of Urgell, is fully armed and the helmet is opened. In the relief behind him are clergymen celebrating mass and behind them are many people mourning and crying to the Lord. Above this and on the same wall is an image of Nostra

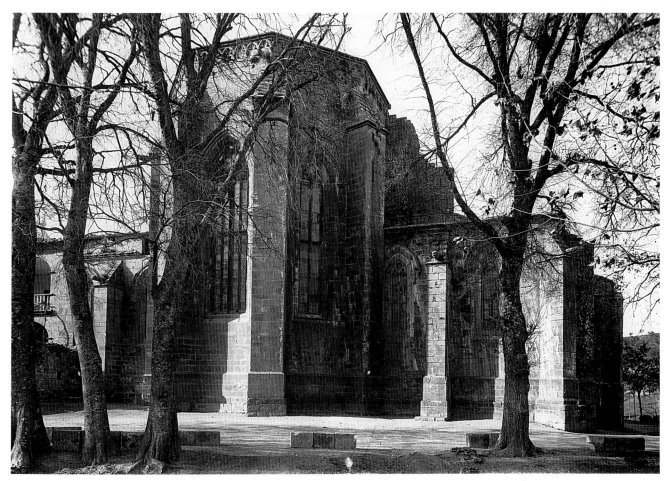

Fig. 7. Apse and side chapels, exterior, Santa María de Bellpuig de las Avellanes, eighteenth, nineteenth, and twentieth centuries (photo: Foto Mas)

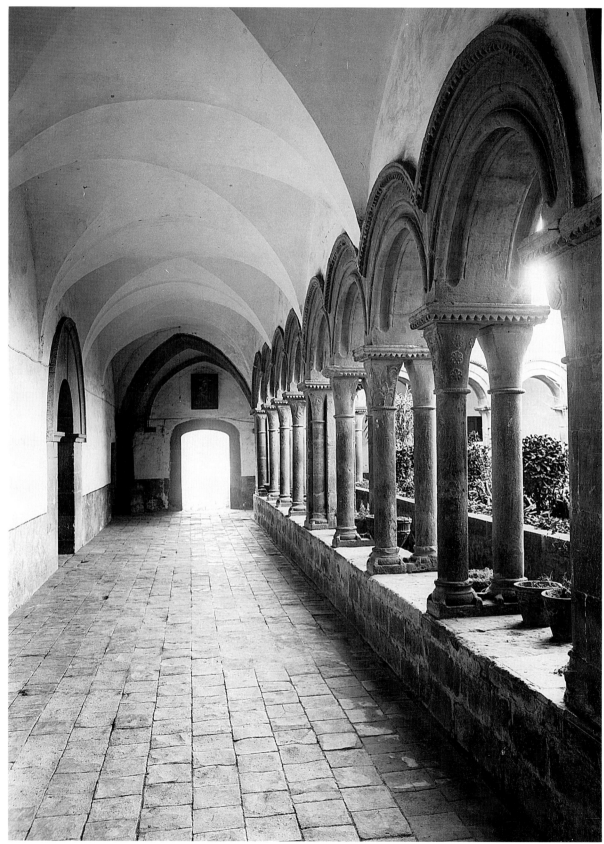

Fig. 8. Cloister, Santa María de Bellpuig de las Avellanes, thirteenth century (photo: Foto Mas)

Fig. 9. Ground plan of the presbytery at the
Premonstratensian monastery of Santa María de
Bellpuig de las Avellanes (photo: Foto Mas)

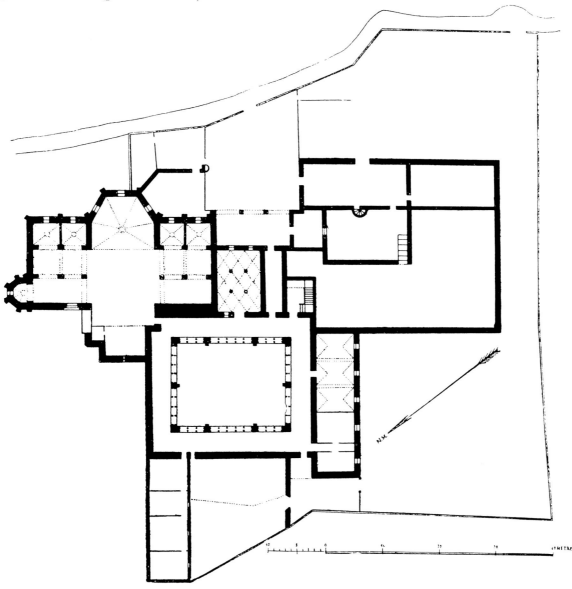

Señora, all by a good hand. On each side are two horsemen in mourning, representing the suffering they feel about the death of their lord."[28] Monfar believes this tomb belonged to Don Ponce de Cabrera. Of the several members of the Urgell family with that name, only Ponce Guerau [Ponç Guerau] de Cabrera, who died ca. 1243, the grandfather of Ermengol X and Álvaro de Cabrera, succeeded to the condado of Urgell.

Monfar also reports that "in the transept . . . on the wall of the epistle side there is the chapel called Christ. . . . There is on that wall another tomb like the other and on it six shields of the counts of Urgell. On it is the effigy of the count, armed and with an opened helmet; the pillow is under his head and is completely covered with the arms of the counts [Fig. 6]. This is the tomb of Ermengol the founder of the convent of the Predicadores de

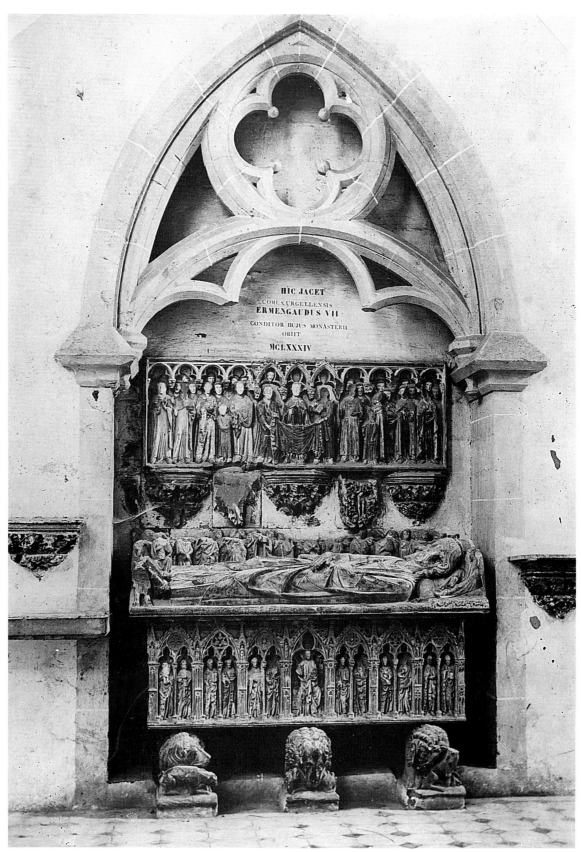

Fig. 10. Tomb monument assembled for Ermengol VII, as installed in the presbytery of Santa María de Bellpuig de las Avellanes, 1910 (photo: Foto Mas)

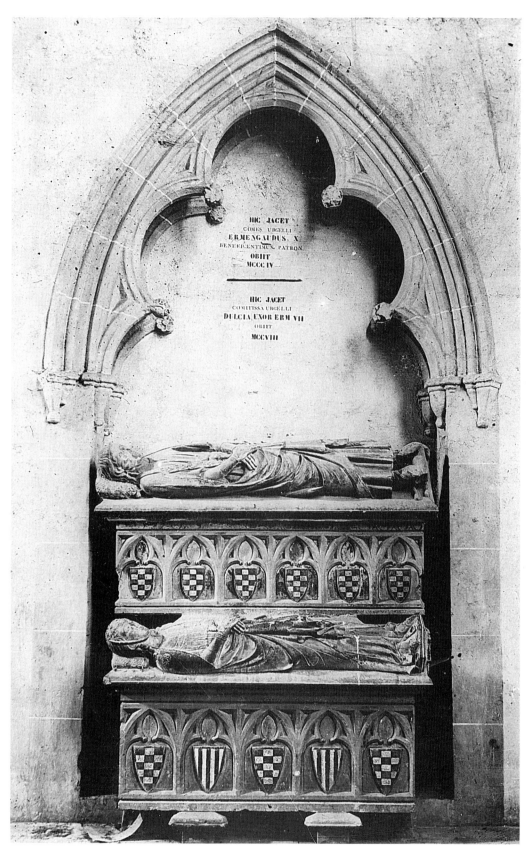

HIC JACET
COMES URGELLI
ERMENGAUDUS X
BENEFICENTIMUS PATRON
OBIIT
MCCC IV

HIC JACET
COMITISSA URGELLI
DULCIA UXOR ERM VII
OBIIT
MCCVIII

Fig. 11. Double tomb, probably made for Álvaro Rodrigo de Cabrera, and his wife, Cecilia of Foix, as installed in the presbytery of Santa María de Bellpuig de las Avellanes, 1910 (photo: Foto Mas)

365

Fig. 12. Detail of the tomb constructed for Ermengol VII showing that the sarcophagus is too small for the effigy. See Fig. 2 (photo: author)

Balaguer. . . ."[29] This description must refer to Ermengol X, as he donated funds in his will for this foundation, and construction began in 1323.[30] Finally, "on the gospel side, there is another large tomb . . . curiously worked . . . and on it are seven shields without arms or any sign that there ever were. It is not known whom it was for. . . ."[31]

Monfar implicitly establishes that, contrary to Caresmar, there already was a chapel at Bellpuig de las Avellanes in the seventeenth century. As far as the tombs are concerned, he places Ermengol VII with his wife in the double tomb ensemble (Fig. 5). He describes a tomb altogether different from that illustrated in Figure 1 on the epistle side of the presbytery: the effigy wears full armor with an open helmet; the sarcophagus is decorated with

shields bearing the arms of the counts of Urgell, not with reliefs representing Christ and the apostles; the sarcophagus is supported by two, not three, lions; and the relationship of the mourners to the celebrants of the funeral mass is reversed (Fig. 16).[32] The large, single tomb that Caresmar described in this location is not mentioned at all (Fig. 1). The single tomb illustrated in Figure 6 is identified by Monfar as that of Ermengol X, not that of Álvaro de Cabrera.[33] All of these anomalies lead to the ineluctable queries of what happened at Bellpuig de las Avellanes, when, and why.

The monastery of Santa María de Bellpuig de las Avellanes is, surprisingly, not situated on a hill as the name would suggest. Rather, it lies on a sloping plateau over the plain of Lérida with foothills rising behind it (Fig. 17). Beyond these foothills, less than two kilometers away, rises, if not properly speaking a mountain, certainly the highest point of land in sight. Here, well known to local residents, is the cave of the revered Juan de Orgaña. A half hour by foot from Bellpuig de las Avellanes, the cave, now closed in with a masonry wall making it into a small sanctuary, lies in a brow below the top of the mountain (Fig. 18). From here, a site truly worthy of the name Bellpuig, one has a dramatic and commanding view over the plain of Lérida and, rising on a promontory in the distance, of the city of Lérida with the prominent tower of the cathedral or Seo (Fig. 19).

As there are anomalies concerning the tomb monuments of the counts of Urgell and the chapel they were housed in, so are there also divergent accounts of the early history of Bellpuig de las Avellanes. In his history of the Premonstratensian order, published in 1734,[34] Charles Louis Hugo states that the "first seat of the abbey was at the foot of a cliff . . . was called the church of the Muro, and had been built at the expense of the Comitissa de Pallars."[35] He adds that in the "course of time, when Dulcia Comitissa of Urgellensis should raise another monastery in a more pleasant location, named San Nicolás of the pleasant fountains ('Sancti Nicolai de fontibus amoenis'), distant from the church of Muro by almost a mile; not so much afterwards the inhabitants of Muro, hastening to that new domicile, were united with the occupants of the new Bellipodiensium (for so it was being termed to distinguish it from the old one previously built in

Muro)."[36] Hugo further states that Dulcia entrusted the care of constructing the new monastery of Bellipodium or Bellpuig to Bernard III, abbot of Casa Dei, and that she provided for the expenses.[37]

Caresmar specifies that Bellipodium or Bellpuig (also Bellpuig el Viejo) was founded on the site of Juan de Orgaña's cave at Monte Malet in the land of Campvim overlooking the plain of Urgell. In addition to a church, placed in the jurisdiction of the bishop of Seo de Urgel far to the north, other structures including a cistern and, nearby, a hospice (Xenodochia) for pilgrims were also constructed.[38] He concurs that a new foundation was built nearby, but he is remarkably imprecise in defining the relationship between the two monasteries and the details of their respective foundings.

Contrary to Hugo, Caresmar asserts, based on a document dated February 5, 1166,[39] that the monastery of Bellpuig el Viejo at Monte Malet was founded not by the countess of Pallars but by Ermengol VII and his wife, Dulcia. In 1168 Bernardo Sancho, bishop of Urgell, enriched Bellpuig and its hospital with a donation of lands in Campvim (see Fig. 20).[40] In Ermengol's will drawn up on June 18, 1177, further donations were made, including the town of Bellcaire, where he wished to be buried. In early 1183, after he returned from an extended stay in León, where he was engaged in a campaign against Fernando II, he made yet more donations.[41] Caresmar states that the structure at Bellpuig el Viejo which these funds provided for was constructed in cut stone of "magnificence and architectural order as evidenced by the remaining fragments."[42]

Concerning the founding of Bellpuig el Nuevo or Bellpuig de las Avellanes, Caresmar contends that Guillermo, the second abbot of Bellpuig, approached Ermengol VII in 1182 requesting that a more hospitable site be chosen for the monastery, as the nearest supply of water was almost five kilometers from Bellpuig. Apparently, Ermengol agreed—the subsequent donations, whether lands or rents, being confirmed by Ermengol VIII and his wife, Elvira, in a document dated January 24, 1203[43]— and a site for the new foundation was chosen in the center of an area called Toschella or la Tosca, three-quarters of an hour on foot from Avellanes and a half hour from Vilanova de las Avellanes.[44] Caresmar says that there were no wells in the whole site—this should probably be understood to mean

Fig. 13. Tomb of Abbot Ponce de Copons (d. 1348), Santa María de Poblet, transept, ca. 1350 (photo: Foto Mas)

insufficient wells, as Fuentes Amenas is "just next to the monastery"[45]—but through ingenious engineering water was eventually brought in by stone sluices from the "campo de Avellanes."[46]

The source of this water came as a donation of Berenguer de Correa, who in 1210 gave to Bellpuig de las Avellanes all the lands in the region of la Tosca known as the "font del Comprat" and the right to use and transport in any manner the water from the well of "Prat de Mallola" and from any other wells in the region of la Tosca to the monastery.[47] This donation was followed by another dated September 8 (6?), 1210, in which Berenguer de Correa gave to the monastery the castle of la Tosca with its lands and rents.[48] The land holdings of la Tosca, in which Bellpuig de las Avellanes was built, were thus extended to include, in the east, the well of the hospital of Bellpuig and the path from Balaguer to Ager (see Fig. 20).[49] The well of Mallola was the largest in la Tosca and, although it was at some distance from the monastery, it provided the greatest amount of water of any well in the district.[50]

Hugo makes no attempt to establish the location of San Nicolás de Fuentes Amenas, the site of the new monastery. On the one hand, Hugo may be referring to San Nicolás of Alfonderella, the only other foundation dedicated to this saint in the region, which was located some twenty-four kilometers east

Fig. 14. Relief of the celebrants of absolution composed of three sections, detail of Fig. 1

of Lérida near Bellpuig on the main road to Cervera, comarca Urgell (Fig. 20). If so, the town of Bellpuig may have been confused with the foundation of Bellpuig. On the other hand, Hugo says that San Nicolás is less than two kilometers away from el Muro or Bellpuig el Viejo, in which case he must be referring to Bellpuig de las Avellanes. No other aforementioned source records a San Nicolás in the vicinity.[51] Nevertheless, Caresmar seems to have taken this account seriously, for he elected to introduce evidence that would seem to reconcile his version of the founding of Bellpuig de las Avellanes with that of Hugo.

Caresmar's *Historia* was based on an earlier manuscript which he evidently compiled in the 1750s.[52] The texts correspond in the main, but included in the earlier manuscript, known as *Anales,* are marginal notes, comments, and ruminations on pivotal events and documents that are either abbreviated or deleted altogether in subsequent versions. In a passage from the *Anales* of particular interest here, Caresmar cites a document of June 4, 1224, in which Guillem de Anglesola cedes the hospital at San Nicolás of Alfonderella, founded by his father, to Abbot Guerau and the Premonstratensian order, whereupon it became a priory dependent on Bellpuig.[53] He then refers to an earlier document in which "Guillem I de Anglesola, father of this Guillem, gave the territory of Fuentes Amenas for the foundation of this monastery" (Bellpuig de las Avellanes).[54] This document, which is said to

have been executed on 8 Kalends October 1166, ceded to Bellpuig and to Guillem, abbot of Casa Dei, the lands known as St. Nicolás and Fuentes Amenas ("Sti. Nicolai et Fontium Amenorum") on the condition that the abbot of Casa Dei build a monastery in Fuentes Amenas. Caresmar explains that when Ermengol objected on the grounds that a new abbey in such close proximity would detract from that built by his mother, Dulcia, the problem was resolved by Anglesola's agreeing to call the new foundation Pulchrumpodium (Bellipodiensis) and by Ermengol's donating Avellanes to it.[55] The problem of the uncertain location of Hugo's San Nicolás of Fuentes Amenas is thus reconciled in Caresmar's mind by interpreting San Nicolás and Fuentes Amenas as two separate sites. The strained logic, however, apparently gave Caresmar pause.

While discussing this and other conundrums, Caresmar suggests that the 1166 Anglesola document is spurious; yet he expends considerable effort offering explication of its anomalies.[56] He attempts to reconcile the facts, for example, that San Nicolás was given in the 1166 document and yet was deeded again in 1224 by suggesting that "Guillem de Anglesola gave San Nicolás and Fuentes Amenas for the foundation of a new monastery but when the count of Urgell opposed this, Guillem, out of respect, gave only Fuentes Amenas as the more suitable site for the count's foundation, withdrawing the offer of San Nicolás so that he would not diminish the glory of the count as sole and total founder."[57]

Fig. 15. West side portal reconstructed in the late seventeenth or early eighteenth century, chapel of Santa María de Bellpuig de las Avellanes. The trilobe blind arcaded cornicing above is virtually identical to that of the three sarcophagi with heraldic shields, suggesting that they are of the same date (photo: Foto Mas)

Fig. 16. Detail of Fig. 1, the mourners from the effigy figure said to be of Ermengol VII

Caresmar does not attempt to explain how Ermengol can be considered the "sole and total founder" of this new foundation when the land and water were donated by Guillem de Anglesola.

Caresmar frequently casts doubt on the authenticity of the document, known to him only from a copy that came from the archives of Casa Dei, "even if [he] is able to reconcile [its contents] with the truth."[58] Yet his frequent references to it give the impression that, spurious or not, it conveys the facts.[59] It is notable, however, that the document is not mentioned at all in the typescript copy of

Caresmar's *Historia* and that in publishing the text Corredera omits all of Caresmar's discussion and relegates his only allusion to it to the end of an extended footnote.[60]

Caresmar's interest in this problematic document that purportedly dates to the year of the foundation of Bellpuig is evident: it is the only document that establishes the affiliation of Bellpuig to Casa Dei; it is the only document that establishes a direct and early connection between Bellpuig and Bellpuig de las Avellanes; and, perhaps most importantly, it places the lands and water in the

vicinity of Avellanes (Fuentes Amenas) in the control of Bellpuig de las Avellanes from its founding in 1166.[61] On these issues all the other documentation compiled by Caresmar and reiterated by Corredera, albeit in copied or transliterated form, is silent.

Because the original documents have been lost or destroyed,[62] and because Caresmar's copies or transliterations cannot be considered reliable historical evidence, a factual accounting of the early histories of Bellpuig and Bellpuig de las Avellanes can never, in all likelihood, be reconstructed. As this was essentially already the case in Caresmar's time, several questions arise. Why did he consider it so important to establish Ermengol VII and Dulcia as the founders of Bellpuig at Monte Malet and, subsequently, the foundation of and transfer to, at an early date—Caresmar asserts between 1184 and 1194[63]—the Premonstratensian monastery of Bellpuig de las Avellanes?[64] Why was it so important for Caresmar to establish these points that he felt compelled, at least tacitly, to rely largely on a document the authenticity of which even he questioned? What purpose did the tombs of the counts of Urgell play in these matters? Was Caresmar merely indulging a consuming historiographic interest and a desire to honor the venerable counts

of Urgell or was he motivated by other extenuating circumstances?

The answers to many of these questions can be found in the history of the monastery itself. Already in the fifteenth century, there is incontrovertible evidence that the monastery at Bellpuig de las Avellanes had run into difficult times. In 1479, in an attempt to reverse the decline, Pope Sixtus IV appointed Brother Francisco Blanch, the first of a series of Comendatorio abbots, who began the confraternity of the Santa Sandalia in honor of their most prized relic, the Virgin's sandal, as a means of raising funds for rebuilding.[65] In 1503 King Fernando el Católico (r. 1479–1516) was aware that the monastery was largely in ruins and also attempted to establish a confraternity in order to raise funds for restoration work.[66] During the abbacy of Juan de Cardona (1527–47) matters had not greatly improved and, in an effort to consolidate resources, he began an inventory of all properties. His successor, Tomás Campaner (1547–49), began to assemble documents to support the claims to inventoried properties and rights and to use them to press these claims, one of which led to a bitter dispute with the town of Balaguer.[67] The Comendatorio abbots ended with Campaner. Much reduced

Fig. 17. View of the monastery of Bellpuig de las Avellanes showing the chapel and other buildings with the foothills rising behind (photo: author)

371

in numbers, the brothers subsequently abandoned the monastery, moving apparently to Bonrepos, a priory some forty kilometers north of Bellpuig de las Avellanes. The monastery was only reinhabited with the appointment of a new abbot in the 1570s.[68]

In 1592, under instructions of Felipe II, the bishop of Lérida attempted to suppress the monastery and use its rents and incomes to support the University of Lérida; unsuccessful, the bishop later laid siege to the monastery and arrested the abbot, who was jailed from 1611 to 1616.[69] Similar attempts to take over the monastery continued intermittently until Antonio Martorell y de Luna successfully lobbied in Rome against suppression in 1669. Only with the subsequent appointment of Bartolomé Morellot as abbot and the election of Martorell as governor did some semblance of order return to the monastery.[70]

During this tumultuous period from 1549 until at least the early 1570s and again from 1592 until 1669, the monastery lost whatever claim or control over lands and water rights it had previously exercised. In the absence of a strong monastic presence, the farmers residing in the lands around the monastery had become accustomed, over a period of several generations, to having unrestricted access to the lands and water. Not surprisingly, attempts by the monastery in the 1660s to reassert land and water rights ran into determined opposition. The most contentious issue, pitting the monastery against the inhabitants of Avellanes and Vilanova, focused on the grazing rights to the lands between these two towns and, particularly, on the water rights to the Fuente de la Mallola, the well which Caresmar says was already connected by sluices to the monastery in the early thirteenth century.[71]

The monastery of Bellpuig de las Avellanes began to submit a series of documents to the bishopric of Seo de Urgel as early as 1678, attempting to establish long legal and historical rights to the land and water. A lengthy document, probably compiled in the following year, listed some 119 points that supported the claims of Bellpuig de las Avellanes and served as the cornerstone of the monastery's case.[72] The document claims that the

Fig. 18. View of the site of Bellpuig el Viejo at Monte Malet with Romanesque masonry strewn about the ground (photo: author)

372

Fig. 19. View from Bellpuig el Viejo at Monte Malet looking over the plain of Lérida with the city of Lérida just visible on the rise in the central background. The vertical element is the tower of the Seo or cathedral of Lérida (photo: author)

established lands of the monastery extended east to Vilanova, south to Campvim, west to Os de Balaguer, and north to Avellanes (Fig. 20). The key historical documents supporting these claims are the January 24, 1203, document in which Ermengol VIII and his wife, Elvira, confirmed all the donations and privileges granted by his parents, Ermengol VII and Dulcia,[73] and the document of September 8 (6?), 1210, in which Berenguer de Correa granted the castle of la Tosca, its lands and rents, and confirmed the donation made earlier that year of the well of Mallola.[74] The document further argues that during the period of Confiscation from 1592 to 1669 the monastery had not lost legal ownership but rather had only been placed in custodianship; that the king on June 12, 1679, had reinstated the monastery and all its lands to the care of the abbot; and that during this eighty-seven-year period, local residents had unlawfully usurped rights and invaded many of the monastery's lands and wells.[75]

To bolster its position, the monastery later sent, probably in 1679 or 1680, further arguments

concerning the documents that it had already submitted. Included was a "certificate or transcription" of a previously unsubmitted document, then said to be in the archives of the monastery, dated September 24, 1166. This was the problematic document concerning the donation of Guillem de Anglesola which ceded San Nicolás and Fuentes Amenas to the monastery[76] and established ancient claim to the lands and water in the immediate vicinity of the monastery. In spite of all these efforts, the authorities at Seo de Urgel ruled against the monastery and in favor of the farmers of Vilanova, Avellanes, and Os de Balaguer, as evidenced by a record dated October 19, 1681.[77] The issue, however, was hardly put to rest.

In 1694 French troops invaded Cataluña and by 1696 the monks had to abandon Bellpuig de las Avellanes and take the Santa Sandalia to Lérida.[78] In the following year, Abbot Benito Garret went to Madrid in an attempt to recruit Premonstratensian brethren to reinhabit the monastery; he was successful in dispatching two monks to begin the

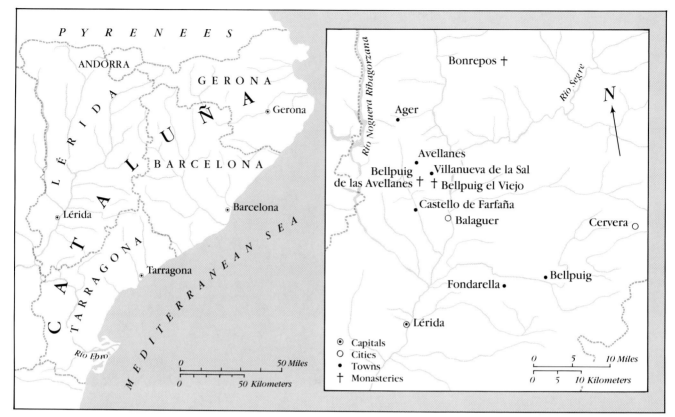

Fig. 20. Map of the region

work of restructuring. With the French withdrawal, the Santa Sandalia was returned to its tabernacle on the main altar by June 1697.[79]

Further and more serious upheaval was precipitated by the War of the Spanish Succession (1701–14), in which Cataluña supported the Austrian archduke Carlos VI over Felipe V. Warfare and suppression once again forced the abandonment of the monastery. According to a letter of Joseph Pey, who had resided at Bellpuig de las Avellanes and later in the eighteenth century at Bonrepos, the monks retreated once again to Bonrepos in 1707 and returned to Bellpuig de las Avellanes in 1717.[80] Corredera, who tends to minimize the length and repercussions of the abandonments, claimed the monks returned in 1711.[81]

Yet another period of abandonment further weakened the monastery's case in the dispute with the local residents who had once again taken advantage of the situation and seized the land and water wells. In 1721, the grazing rights claimed by

the monastery to the territory between the monastery and the towns of Vilanova and Campvim de Priva were being contested. Disputes arose in Os and as far away as Ager, all concerning the rights to lands, rents, and mills, which the abbot claimed could be proven by document,[82] and bringing into the open issues that had remained unsettled for decades. The monastery sent a letter to the authorities at Seo de Urgel defending its claims by citing the original donation of the land in question by Dulcia on 8 Kalends July 1183 along with a confirmation of privilege issued by Alfonso IV in 1428 and a list of six other substantiating documents dated from 1424 to 1675.[83] In 1750, a list of the principal documents in the monastery's claim was filed with Seo de Urgel; the eight documents included the 1166 Ermengol VII and Dulcia donation for the founding of Bellpuig, the 1166 Guillem de Anglesola donation of San Nicolás and Fuentes Amenas for Bellpuig de las Avellanes, the 1203 Ermengol VIII and Elvira confirmation of the donations of his parents, the

374

1208 will of Ermengol VIII, and the 1210 Berenguer de Correa donations of the castle of la Tosca and the well of Mallola.[84]

The question of the Mallola well remained unresolved. And even before Caresmar was elected abbot of Bellpuig de las Avellanes, he recognized that without access to the water, the very existence of the monastery was threatened. He began to reorder the monastery archives after the death of Daniel Antoni Finestres in 1744 and frequently went to Barcelona to study the archives there. The crucial documents, however, had already been destroyed; whether this was done by someone in the monastery because the documents did not support its appeal which led to the ruling of 1681 or whether they were destroyed or lost through other circumstances remains to be established, as does the identity of those who produced the many purported copies of documents.[85] Whether these documents reflect with some accuracy the original texts or whether they are a deliberate and calculated means of reinventing history is a matter of further conjecture, although some judicious modification of the facts seems eminently probable. Caresmar seems mainly to have contented himself with making the best case possible out of the extant transcriptions and transliterations, all of which (with the exception of the 1166 Guillem de Anglesola document) he generally accepted at face value, rather than trying his own hand at falsification. In methodical and subtle ways, however, he used the available material to create his own Berenguer I and Almodis out of Ermengol VII and Dulcia. He well understood that if their names were convincingly linked to the founding of Bellpuig de las Avellanes, the monastery's current claims would gain credibility and perhaps a measure of sanctity.

Matters were brought to a head once again when, in 1758, the monastery restored the well of Mallola, which had not provided it with water for more than forty years. The conduits that brought water from the well of Mallola had been destroyed during the War of Succession and the residents around Avellanes had diverted the water for their own use on the lands in which the well of Mallola was located. When it started to replace the destroyed sluices, the monastery effectively deprived the local farmers of access to the water for their crops and animals. The town of Avellanes, unsuccessful in stopping the work, resorted to violence and destroyed the new pipes. In response, the monastery

Fig. 21. Footings of the northeast exterior wall of the chapel at Bellpuig de las Avellanes. The stepped-in masonry blocks indicate successive reconstructions (photo: author)

petitioned the Intendencia in Barcelona to issue a restraining order against the town and to affirm the monastery's right to the water of Mallola. This action disregarded the advice of the monastery's own solicitor, who reminded the abbot that the 1681 ruling in a similar dispute had found in favor of the residents.[86]

The case was then passed on to the civil courts and Caresmar himself went to Barcelona to argue the monastery's case. In the meantime the Intendencia issued a writ both requiring the bailiff and councilmen of Avellanes to replace the destroyed pipes at their expense and constraining them from further attempts to impede progress on these works. They complied and the pipe system was installed by 1760.[87] The issue of who in fact held rights to the water, however, remained tied up in litigation. Avellanes sent two further petitions to Barcelona and they were not heard; eventually the town concluded that the case would either remain endlessly delayed or that, in the end, justice would not be served. Consequently, by 1763 Avellanes had appealed directly to the courts in Madrid.[88]

Around this time Caresmar completed his assiduous reconstruction of the history of the

Fig. 22. Exterior view of a lancet window and buttress at Bellpuig de las Avellanes. The buttress overlaps a molding and bracket indicating that it is a later structural element (photo: author)

monastery of Bellpuig de las Avellanes, carefully framing it so that it could be reconciled with the facts as he knew them—given the loss of nearly all pertinent documents—but also so that it would support the monastery's claims to the vital land and water rights.[89] In a perhaps ill-advised attempt to influence the case, Caresmar selectively distributed copies of his *Historia* in Madrid. In 1765 the monastery's attorney in Madrid advised Caresmar that the case rested with the attorney general, who was apparently not inclined to press matters; the lawyer pointedly advised Caresmar that the monastery's interests would be best served by subscribing to the same policy,[90] the implication being that the 1681 ruling was not likely to be overturned on the basis of Caresmar's *Historia*.

In fact the issue of Mallola was never resolved, and the monastery and the residents of Avellanes were left at an uneasy impasse in which the monastery had its way on this one point. Other related issues apparently remained open to contest: a document dated June 10, 1769, for example, sets forth arguments by several claimants, including the monastery of Poblet, concerning properties that Bellpuig de las Avellanes claimed were donations of Ermengol VII and Dulcia; the other parties contended that these were properties which the monastery had sold or to which it had relinquished any legal claim.[91] A little more than six decades later, in 1835, the monastery, as a Premonstratensian house, met its irreversible demise with the secularization act that forced the monks to abandon Bellpuig de las Avellanes irrevocably.

As to the vicissitudes of the chapel and of the Urgell tombs, one can only speculate. The authorities agree that, other than the cloister, no medieval structures survived at Bellpuig de las Avellanes, and even if there were a late-medieval church, it and the rest of the monastery were already in a ruinous state by 1503. A chapel had, however, clearly been constructed or reconstructed prior to 1641, when Monfar, residing at Bellpuig de las Avellanes, began his history of the counts of Urgel and provided a detailed description of the interior. There were a limited number of intervening times sufficiently peaceful and prosperous to allow a major building campaign. One of these was the period of the Comendatorio abbots between 1479 and 1549. Another period of relative stability and prosperity occurred during the two decades before the confiscation orders of 1592. It is hardly likely that a building campaign could have been undertaken during the early decades of the seventeenth century, when the bishop of Lérida was constantly attempting to confiscate the monastery and its properties. The ensuing period of suppression, which lasted until 1669, long after Monfar had written his history, was, likewise, not a propitious time for building.

Whatever chapel existed during Monfar's time must have been reduced to ruins at some point during the French invasion at the end of the seventeenth century or during the War of the Spanish Succession in the first fifteen years of the eighteenth century, periods in which the monastery was largely abandoned. The remaining buildings, with their doors and windows burned out, were used to

Fig. 23. Detail of Fig. 1 showing heraldic devices
(photo: author)

provide shelter for horses.[92] In 1725, eight years after the monks returned from Bonrepos, Bellpuig de las Avellanes was visited by an apostolic delegation including the abbot of Poblet, who wrote a lengthy report providing a detailed discussion of the fabric of the buildings. The chapel had been rebuilt (Figs. 21, 22), he notes, but two arms of the cloister had been destroyed and he ordered their reconstruction.[93] This strongly suggests that the chapel was rebuilt between 1717 and 1725.[94]

The tomb monuments, which date to the early fourteenth century, could have been brought in only after the chapel had been built, probably in the sixteenth century. Prior to Monfar's time, the double tomb (Fig. 5) and the single tomb (Fig. 6) were in place, as well as another with an effigy in full armor and reliefs above it, and yet another with a sarcophagus with seven blank shields. We know from a letter dated 1796 that virtually no church furnishings from before 1700 had survived, and know from another letter that during the period of abandonment soldiers had destroyed all but the main altar.[95] No mention is made of the tombs. By 1742, however, when Caresmar arrived at Bellpuig de las Avellanes, a century after Monfar, the last two sepulchers were gone and another, the composite sepulcher (Fig. 1), was added. It is probable that at least a fragment of the mourners relief above the latter sepulcher came from the lost one with the effigy in full armor, described by Monfar.

Where any of these tombs came from is unknown. The evidence does, however, strongly suggest that none could have been made for Bellpuig de las Avellanes, as no chapel was completed in the fourteenth century; and there is no indication that the tombs were housed anywhere else in the monastery, such as in the cloister. This being the case, almost any church in the domains of the counts of Urgell must be considered a possibility, particularly those least secure and therefore most vulnerable to pillage or purchase. Another possibility is that some or parts of the sepulchers, if not all of them, were removed from Bellpuig el Viejo.

As far as the original occupants of the tomb monuments are concerned, there is insufficient evidence to make any identifications with certainty. The large, composed single tomb with reliefs (Fig. 1) was not at Bellpuig de las Avellanes when Monfar wrote his description of the chapel and appears to have been installed in the later seventeenth or early eighteenth century, prior to Caresmar's arrival in 1742. There is no indication of where the somewhat earlier and stylistically heterogeneous sarcophagus came from. The effigy bears many shields emblazoned with a chequy of thirteen (Fig. 23)—an acceptable rendering of the arms of Urgell—although the lack of tincture on all the sepulchers leaves a degree of uncertainty. The arms that appear on the center and right-hand sections of the absolution relief above are also emblazoned with the chequy of Urgell and may be parts of those described by Monfar over the lost tomb. All these fourteenth-century elements were assembled to honor Ermengol VII, then said to be the founder of Bellpuig de las Avellanes.

Monfar claims the double tomb (Fig. 5)

Fig. 24. Detail of Fig. 5. Effigy, probably of Cecilia of Foix, showing heraldic devices (photo: author)

Fig. 25. Detail of Fig. 5. Effigy, probably of Álvaro Rodrigo de Cabrera, showing heraldic devices (photo: author)

belonged to Ermengol VII and his wife, Dulcia; Caresmar, on the other hand, gives it to Ermengol X and the same Dulcia. Monfar, however, says that Ermengol X was buried in the single tomb with a figure in a mail shirt (Fig. 6).⁹⁶ Monfar identifies the shields with three pales as the arms of the counts of Barcelona, to which family Dulcia belonged.⁹⁷ These alternate with shields bearing a chequy of sixteen for Urgell. The shields that appear on the female effigy, however, are emblazoned with two pales alternating with a chequy of thirteen (Fig. 24). The heraldic bearings on the effigy correspond to those of the seals of Álvaro Rodrigo de Cabrera [Álvar Roderic II], count of Urgell (1243–67), the father of Ermengol X, and his second wife, Cecilia of Foix, the only member of that family to marry into the Urgell line.⁹⁸ A document of 1264 establishes that although Álvaro de Cabrera had once intended to be buried at the monastery of Poblet, he later made a codicil requesting that he be buried at Bellpuig de las Avellanes.⁹⁹ The emblazoning that appears on the male effigy, a chequy of both ten and twelve in the reverse order (Fig. 25), does not correspond precisely but seems to be an acceptable heraldic variant. The emblazonings on the single effigy armed

in mail (Fig. 6), for example, appear both as a chequy of both ten and twelve and a reverse chequy of seven and ten (Fig. 26).

The single sepulcher (Fig. 6) is identified by Monfar as that of Ermengol X and by Caresmar as Álvaro de Cabrera, brother of Ermengol X. There is no clear evidence to establish which, if either, identification is correct. By Caresmar's time, however, considerable alterations had taken place in order to establish the primary role of Ermengol VII in the history of the monastery, making Caresmar's identification less credible. In any case, the earliest descriptions identify this sepulcher with Ermengol X.

The alterations of the eighteenth century were carried out most likely by Gerònim Serrano, Josep Ugustí Bover, and Daniel Antoni Finestres, all of whom served as abbot at different times between 1718 and 1736. Finestres, who began a history of the monastery, discussed the tombs and understood the importance of their historical implications.¹⁰⁰ He also undertook certain "constructions" which Corredera leaves unspecified,¹⁰¹ but which could have involved the installation of tombs as easily as repairs to the cloister or any other part of the fabric

Fig. 26. Detail of Fig. 6. Effigy, said to be of Ermengol X, showing heraldic devices (photo: author)

specified by the report of the canonical visit. Interestingly enough, almost all of his writings were burned shortly after his death in 1744 by someone who apparently objected to their contents.[102]

Caresmar was in large part continuing the work of Finestres, and it was perhaps he who impressed upon Caresmar the importance of associating the counts of Urgell with the history of Bellpuig de las Avellanes. In this regard the tombs themselves were further proof of the history of the monastery as Caresmar penned it. No doubt the later counts of Barcelona invoked the names of Ramón Berenguer I and Almodis more successfully and to far greater purpose than Caresmar had those of Ermengol VII and Dulcia. The counts were able to deceive many and thereby able to keep rebellious nobility in check; Caresmar, in the end, deluded, if anyone, only himself and gained only the use of a well for his monastery. Water, in fact, proves to be a common denominator; when the dispute between Guillem Ramón II and Ramón Berenguer erupted in the 1130s, the first retaliatory move taken by the Seneschal was to interrupt the count of Barcelona's water supply,[103] an ironic coda to this history. And it would seem largely due to water that the tombs of the counts of Urgell are at The Cloisters today.

ACKNOWLEDGMENTS

Research for this article was supported in 1981 by a Professional Travel Stipend from The Metropolitan Museum of Art. I would also like to thank Tor Seidler and John Sare for their very helpful readings of this article.

NOTES

1. See, for example, Luis G. Valdeavellano, *Curso de Historia de las Instituciones Españolas de los orígenes al final de la Edad Media*, 2d ed. (Madrid, 1970), p. 277.

2. John C. Schideler, *A Medieval Catalan Noble Family: The Montcadas 1000-1230* (Berkeley/Paris/London, 1983), pp. 93–94.

3. The literature concerning the tombs of the counts of Urgell is predominately written in Castilian, and it is in this language that both individual and place names are most familiar to the English-speaking reader. Since the death of Franco and the end of the suppression of Catalan, this language has returned to universal usage throughout Cataluña, thus proper names in the more recent literature may often be unfamiliar. For simplicity's sake, Castilian nomenclature will be used here, but, on first mention of the most important names, if there is a difference, the Catalan equivalent will be given in brackets. The only exception is the use of the Catalan spelling for the name Ermengol, rather than Armengol, and Urgell, rather than Urgel (except for Seo de Urgel) throughout.

4. For a stylistic analysis of these tomb monuments, see James J. Rorimer, "A Fourteenth Century Catalan Tomb at The Cloisters and Related Monuments," *Art Bulletin* 13, no. 4 (Dec. 1931), pp. 422–36.

5. I would like to thank Danielle Tilkin, who faithfully and tirelessly gave her invaluable assistance throughout the nearly twelve years that we have, off and on, thought about and worked on the problem of the tombs of the counts of Urgell. She has relentlessly pursued innumerable leads in spite of discouragingly numerous dead ends and has helped organize and interpret the vast amount of material we have compiled over the years. Without her help this article would not have been possible.

6. See Joseph Breck, "The Tomb of Armengol VII," *MMAB* 23, no. 6 (June 1928), pp. 142–47.

7. See James J. Rorimer, "Four Tombs from Las Avellanes and other Gothic Sculpture," *MMAB* 8, no. 8 (Apr. 1950), pp. 228–35.

8. Idem, "Fourteenth Century Tomb," pp. 409–36.

9. Ibid., pp. 409–10.

10. Ibid., p. 422.

11. Caresmar wrote his history, in Latin, under the title *De Rebus Ecclesiae Sanctae Mariae Bellipodiensis Avellanarum In Catalonia Ordinis Canonicorum Regularium S. Augustini Praemonstratensium*. This manuscript, begun in 1773, was apparently lost; however, several redactions of it are known. Rorimer cites *Historia monasterii B. Mariae Bellipodii Avellanarum ex antiquis eiusdem Domus aliisque documentis contexta, quam a limine fundiatonis ad annum 1330 perduxit*. He also cites ("Four Tombs from Las Avellanes," p. 229) another

version, entitled *De rebus ecclesiae Sanctae Mariae Bellipodiensis Avellarum in Catalonia*, then said to be in Vilanova de la Sal. This manuscript, according to Eduardo Corredera Gutierrez, historian and former resident of the monastery, is now lost. Corredera made a modern typescript translation of Caresmar's text entitled *Historia de la Iglesia de Santa María de Bellpuig de las Avellanes en Cataluña, del Orden Canónigos Regulares Premonstratenses de San Augustín*. A bound photocopy of the typescript in three volumes is in The Cloisters Library; it is cited hereafter as Caresmar, *Historia*. Corredera also wrote his doctoral dissertation (University of Valencia, 1954) on the history of the monastery, entitled "Historia del Monasterio de Bellpuig de las Avellanes 1166-1479." A bound photocopy of this is in The Cloisters Library, hereafter cited as Corredera, "Historia 1166-1479." Corredera wrote a supplemental volume in 1957, entitled "Historia del Monasterio Ntra. Sra. de Bellpuig de las Avellanes 1479-1835." A bound photocopy of this typescript is also in The Cloisters Library, cited hereafter as Corredera, "Historia 1479-1835." Finally, in 1977, Corredera published a freely transliterated and heavily annotated version of Caresmar's *Historia*: Jaime Caresmar, *Historia de Santa María de Bellpuig de las Avellanes*, trans. and ed. Eduardo Corredera Gutierrez (Balaguer, 1977); it is cited hereafter as Corredera, *Historia*. I am grateful to Esther Morales, who helped in reading and interpreting many of these texts and in checking all the page references.

12. Caresmar, *Historia*, vol. 2, pt. 2, pp. 335-36; and Corredera, *Historia*, p. 244.

13. Caresmar, *Historia*, vol. 2, pt. 2, p. 336; and Corredera, *Historia*, pp. 244-45.

14. "Sacrae Antiquitatis Cataloniae Monumenta," vol. 5, Biblioteca de Cataluña, Barcelona, MS 729, fols. 88, 89. The date of this manuscript is uncertain, but it was probably written largely in the 1770s and 1780s.

15. Caresmar, *Historia*, vol. 2, pt. 2, pp. 336-37; and Corredera, *Historia*, p. 245.

16. Given the problematic nature of the twelfth-century documents, the first convincing records that refer to Bellpuig de las Avellanes date from this period: for example, the Jan. 24, 1203, confirmation of Ermengol VIII and Elvira (Caresmar, *Historia*, vol. 2, pt. 1, pp. 115-16) and the Aug. 30, 1208, will of Ermengol VIII (ibid., p. 141). A founding date around this time is also supported by the cloister, which on the basis of style must also be dated to the early thirteenth century.

17. Caresmar, *Historia*, vol. 1, pp. 70-73, 98; vol. 2, pt. 1, pp. 146-50; vol. 2, pt. 2, pp. 327-30, 347-49.

18. Ibid., vol. 1, pp. 70-72.

19. Ibid., vol. 2, pt. 1, p. 146.

20. Ibid., vol. 2, pt. 1, p. 149; and vol. 2, pt. 2, pp. 347-48.

21. Ibid., vol. 2, pt. 1, pp. 150, 155-56. Both Diego Monfar y Sors and Charles Louis Hugo (see notes 26 and 34 below) identify the pales as the arms of the counts of Barcelona. The identity of the effigies is addressed below.

22. Ibid., vol. 2, pt. 2, pp. 327-28. According to Caresmar, the tombs were opened at various points in the early eighteenth century and all had parchments within that identified their occupants. To judge from the texts that he quotes in his *Historia* (see note 11 above), these writings are certainly not medieval.

23. Ibid., vol. 1, pp. 98-99. Caresmar asserts that it belonged to Arnaldo de Prexens, the first abbot of Bellpuig at Monte Malet, justifying this by stating that the Urgells wanted to honor him and the dignity of his position by allowing him to be buried in their family chapel.

24. Although there appears to be no established medieval practice, the tombs were often placed so that the heads of the effigies were directed toward the altar; Rorimer believed this to be common enough that, in the installation at The Cloisters, he reversed the positions of the large single tomb and the double tomb so that the effigies would accord with the practice.

25. I am grateful for the report of the neutron activation and the thermoluminescence analyses compiled by L. van Zelst and G. W. Carriveau in 1975 and for the report of the X-ray diffraction analysis compiled by George Wheeler in 1989.

26. Diego Monfar y Sors, *Historia de los Condes de Urgel*, Colección de documentos inéditos del Archivo General de la Corona de Aragón, ed. Próspero de Bofarull y Mascaro, vols. 9, 10 (Barcelona, 1852-54). Hereafter cited as Monfar, *Historia*.

27. Ibid., *Historia*, vol. 9, pp. 409-10.

28. Ibid., p. 410.

29. Ibid., pp. 410-11.

30. Ibid., vol. 10, p. 51.

31. Ibid., vol. 9, p. 411.

32. If the celebrants were part of the effigy, as are the mourners in The Cloisters effigy, none of the reliefs described by Monfar could have been incorporated in the ensemble described by Caresmar. Although the subjects in some cases correspond, the descriptions of the other reliefs are too imprecise to determine whether any of these are the same as those in Caresmar's description.

33. Both chroniclers, however, appear to be describing the same, now lost, fourth tomb.

34. Charles Louis Hugo, *Sacri et canonici ordinis Praemonstratensis Annales, in duas partes divisi, pars prima, monasteriologiam, sine singulorum ordinis monasteriorum singularem historiam complectems*, (Nancy, 1734), vol. 1, cols. 281-88. I am grateful to June Ann Greeley, who translated the text.

35. Ibid., cols. 281, 282: "Prima Abbatiae sedes fuit ad pedes rupis . . . quam sub nomine Ecclesiae de Muro tum audiisse . . . et Comitissa de Pallas [*sic*] expensis erectam tradunt."

36. Ibid., cols. 282, 283: "Processu vero temporis, cum in amoeniori loco aliud suscitasset monasterium, Sancti Nicolai de fontibus amoenis dictum, ab Ecclesia de Muro una ferme leuca distans, Dulcia Comitissa Urgellensis; relicta priori sede, ad novum istud domicilium haud multo post Muri incolae convolantes, Bellipodiensis novi (sic erum denominabatur ad differentiam veteris prius in Muro erecti) cultoribus adunati sunt." Although writing earlier, Monfar (*Historia*, vol. 9, pp. 405-7) erroneously treats the foundation at Monte Malet as one and the same as Bellpuig de las Avellanes. His text does not, therefore, add to our understanding of the early history of these two monasteries.

37. Ibid., col. 283: ". . . regebat siquidem tunc Casa Dei Abbatiam Bernardus III. cui Bellipodiensis monasterii construendi curam commisit, expensasque subministravit praedicta Fundatrix, es fastis Casa Dei."

38. Caresmar, *Historia*, vol. 1, pp. 18–19, 25–26. Later writers, Jaime Villanueva, for example, in his *Viaje Literario a las iglesias de España: Historia del monasterio de Canónigos Premonstratenses de Bellpuig de las Avellanes: su fundación: muerte violenta de su fundador y su sepultura en este monasterio: noticia de tres individuos literatos y celebres anticuarios del mismo: catálogo de sus abades* (Madrid, 1850), vol. 12, p. 80, acknowledges that the original foundation was not the same as the present one, which he dates to the thirteenth century; Corredera, *Historia*, pp. 30, 35, 36, merely amplifies what Caresmar says. Caresmar (see Corredera, *Historia*, p. 80 n. 21) says that, in the late twelfth century, Bellpuig el Viejo was referred to as Bellipodium, and Bellpuig de las Avellanes or el Nuevo was referred to as Pulchripodium.

39. Caresmar, *Historia*, vol. 1, pp. 26–27. As is generally the case with Caresmar, the documents that he cites do not survive; the text on pp. 27–31 is said to be copied from the original act of foundation dated Feb. 5, 1166.

40. Ibid., pp. 32–33. According to Corredera, this territory was roughly bounded in the north by the towns of Toschella and Santa Liña, in the east by San Lorenzo [San Llorenç] and Gerp, in the south by Balaguer, and in the west by Castello de Farfaña and Os de Balaguer (ibid., p. 37 n. 5).

41. Ibid., pp. 60–61, 66–67. Corredera, *Historia*, pp. 61–62; for the text said to be copied from the original, see pp. 259–61.

42. Caresmar, *Historia*, vol. 1, p. 27; and Corredera, *Historia*, p. 36.

43. Caresmar, *Historia*, vol. 2, pt. 1, pp. 115–16; and Corredera, *Historia*, p. 106 n. 2, and p. 262, giving the Latin text said to be copied from the original text.

44. Caresmar, *Historia*, vol. 1, pp. 61–64.

45. Corredera, orally in 1979; he also said that "the well of Mallola was on the right side of the road two miles before the monastery."

46. Caresmar, *Historia*, vol. 1, p. 63.

47. Ibid., vol. 2, pt. 1, pp. 158–60; and Corredera, *Historia*, pp. 120–21; p. 126 nn. 1–3.

48. Corredera, *Historia*, p. 121.

49. Ibid., p. 126 n. 2. The lands were extended, in the south, to the summit of the mountains of Campvim; in the west, nearly to Os de Balaguer, including small areas of the hills of "las Toscas" or "Gesseras"; and in the north, to the limits of Santa Liña or Mollet.

50. Ibid., p. 126 n. 3. See also note 46 above.

51. Hugo's knowledge of local geography as well as distances was apparently limited: for example, he stated that Bonrepos is only 11.3 km from Bellpuig de las Avellanes when, in fact, it is at least 40 km to the north.

52. *Anales des Real Monasterio de Bellpuig de las Avellanes de la Orden de Canónigos Regulares Premonstratenses en el Principado de Cathaluña*. This manuscript, which was not consulted by Rorimer, is still in the library at Bellpuig de las Avellanes. Cited hereafter as Caresmar, *Anales*. Several hands are evident. Caresmar probably had assistance in transcribing material; there is no reason to doubt that the entire work was done under his close supervision. I am grateful to Brother Ignacio Garmendía, who in 1978 allowed me to bring this manuscript to New York for studying and duplicating. Both a bound photocopy and a microfilm of this manuscript are in The Cloisters Library.

53. Caresmar, *Anales*, fol. 241; ibid., *Historia*, vol. 2, pt. 1, pp. 191–92; and Corredera, *Historia*, pp. 141–42.

54. Caresmar, *Anales*, fol. 242. The text of the document is copied on fols. 138–39. It is difficult to locate many of these place names. Fuentes Amenas, San Cap, la Tosca or Toschella, and Monte Malet are not mentioned, for example, in Pascual Madoz, *Dictionario Geográfico-estadístico-histórico de España y sus posesiones du Ultramar*, vol. 4, 2d ed. (Madrid, 1846–50), or in *España dividida en provincias, y subdividida en partidos, corregimientos, alcaldías, mayores, gobiernos políticos y militares, asi realengos como de ordenes, abadengo y señorio*, 2 vols. (Madrid, 1789). Fuentes Amenas is more logically descriptive of a place than a place name itself.

55. Caresmar, *Anales*, fol. 136: "Guillielmus de Anglaria Dominus de Bellipodio cessit . . . Btae. Mariae et omnibus Sanctis Dei, et venerabili domino Guillelmo abbati monasterii Casa Dei, loca videlicet Sti. Nicolai et Fontium Amenorum . . . conditionibus sequentibus a dicto monasterio Casae Dei, in dicto loco vulgariter nuncupato Fontium Amenorum . . . Ermengaudo . . . praedictae fundationi contradixit eo quod sua capella et per matrem suam fundata huius fundatio abbatiae destruetur . . . totum pacificavit quod praefatum monasterium Fontium Amenorum haberet nomen et perpetuo retineret Pulchripodii . . . comes generaliter eam ratificavit et approbavit, et praedicto monasterio de novo sit fundato locum Avellanarum dedit. . . ."

56. There are numerous problems with this document. The date of 1166 cannot be correct as the text is clearly referring to Ermengol VIII and his mother, Dulcia, whereas Ermengol VII died later, in 1184. It is possible that the date is given by the Roman or Julian calendar that was widely used in the Iberian peninsula throughout the Middle Ages, in which case it would be 1204 in the Gregorian calendar. Even so, the hospital at San Nicolás was founded only in 1220–21. Furthermore, both the language and the casting of the document are not convincing. "Dominus de Bellipodio," for example, would refer to the town of Bellpuig, not the monastery. Also, the syntax of the "eo quod" clause is very confused. I am grateful to James D'Emilio, who helped in translating this document and made a thorough study of it and its implications.

57. Caresmar, *Anales*, fol. 243.

58. Ibid., fol. 242.

59. Eduardo Corredera ("San Nicolás de Fondarella: Un Priorato Premonstratense," *Analecta sacra Tarraconensia* 38 [1965], p. 61) says that Caresmar, again referring to this document, states that Guillem de Anglesola, in entrusting San Nicolás de Alfondarella to the Premonstratensian order, was drawing on a formula that his father used years before in the construction of Our Lady of Bellpuig de las Avellanes. Some later writers refer to this document without questioning its veracity. See, for example, Pablo Piferer and Francisco P. I. Margall, *España. sus monumentos y artes, su naturaleza é historia: Cataluña* (Barcelona, 1884) vol. 2, p. 75.

60. Corredera, *Historia*, p. 39 n. 8 and p. 259 for the Latin text of the document, the sentence order of which in the second paragraph is scrambled.

61. Other than this document, the first evidence Caresmar has to associate Bellpuig and Bellpuig de las Avellanes dates to

the reign of Abbot Ramón (active ca. 1195). He notes that because the names of the monks were entered into the necrologies of both places, the two were thought of as one (Corredera, *Historia*, p. 77). Caresmar (*Anales*, fol. 200) also notes that while the two foundations were distinguished by their names, the abbot was referred to simply as "abbas Bellipodii."

62. During the abbacy of Brother Cipriano Benetí, fourth of the Comendatorio abbots (see note 66 below), a privilege known as "autos quemados" was granted that allowed property rights to those who could establish they had long owned or used the land but could not prove it because the original documents had been burned. See Eduardo Corredera, *El Monasterio de Santa María de Bellpuig de las Avellanes, Época moderna y contempóranea* (Lérida, 1971), pp. 58–59.

63. Corredera, *Historia*, p. 80 n. 21.

64. See ibid. One of the many points on which Caresmar is unclear concerns this transfer from one foundation to another, and he suggests that the monastery at Bellpuig was more or less abandoned in the twelfth century. However, the evidence clearly indicates that it endured at least through the eighteenth century. For example, a document executed by the notary Jerónimo Briosquet in 1622 refers to a celebration held at Bellpuig of Monte Malet. In fact, Caresmar (*Historia*, vol. 1, pp. 52–53) contradicts himself by saying that in his own time the remains of Juan de Orgaña were in a sepulcher on the altar of this church; Corredera (*Historia*, p. 50 n. 1) reports that this sepulcher was translated to Bellpuig de las Avellanes in 1724. Corredera also notes (ibid., p. 67 n. 6) that the capitals from Bellpuig were given to Vilanova in 1744 for a campaign to enlarge the parochial church, the first real evidence of the ruination of this foundation. The church itself was apparently not affected, however, as correspondence between Ramón Sabater and Joseph Pey dated 1796 refers to processions of San Cap from Vilanova "una al Mon[asti]r. vell y altra al nou" (Seo de Urgel, Archivo Diocesano, Memorias de les reliquies del San Cap de Juan de Orgaña, XVIII–XIX, Feb. 25, 1796). Another point on which Caresmar is vague concerns the relationship of these foundations to Casa Dei. A Premonstratensian regulation prohibiting the existence of one foundation within five kilometers of another suggests that Bellpuig was not, at least originally, affiliated with this order.

65. Corredera, *Bellpuig, Época moderna*, p. 59.

66. Caresmar, *Historia*, vol. 2, pt. 1, p. 128; and Corredera, *Historia*, p. 102.

67. Ibid., p. 59.

68. Ibid., pp. 60–61.

69. Ibid., pp. 62–63.

70. Corredera, *Bellpuig, Época moderna*, pp. 63–64; see also notes 47 and 48 above.

71. According to *España dividida*, vol. 2, p. 75, there were six "very good water wells" in Vilanova and, ibid., vol. 1, p. 48, there were reliable wells around the monastery itself; although the documents are not specific, the water rights to these wells were undoubtedly also being contested.

72. Seo de Urgel. Archivo Diocesano. Vilanova de la Sal. Plecs de documents variats. XVII. 1679 (?).

73. The text is given in Corredera, *Historia*, p. 262, doc. VIII.

74. Ibid., pp. 120–21.

75. Ibid., items 21–25.

76. Seo de Urgel. Archivo Diocesano. Plecs de documents variats. XVII. "Nota . . ."

77. Ibid., "Sentencia contra lo Monastir . . ." Corredera erroneously says that this ruling was issued in 1682.

78. Caresmar, *Historia*, vol. 2, pt. 1, p. 132; and Corredera, *Historia*, p. 103.

79. Caresmar, *Historia*, vol. 2, pt. 1, p. 133.

80. Seo de Urgel. Archivo Diocesano. Memorias de les reliquies del San Cap de Juan de Orgaña. Letter from Joseph Pey at Bonrepos to Ramón Sabater at Bellpuig de las Avellanes; dated Mar. 15, 1796.

81. Corredera, *Bellpuig, Época moderna*, pp. 68–69.

82. Corredera, "Historia 1479–1835," pp. 115–16.

83. Seo de Urgel. Archivo Diocesano. Vilanova de la Sal. Plecs de documents variats. Visitas, vendes, procesos. XVII–XVIII.

84. Ibid. XVIII. Plica de concordias diferents . . . , no. 52.

85. It seems more than coincidental, for example, that all the Notorials for the first half of the fourteenth century are in the Archivo Ayuntamiento de Balaguer except for the volume that contains the records for the years 1300–14, the one volume that might shed some light on Ermengol X and the building of the chapel at Bellpuig de las Avellanes.

86. Corredera, "Historia 1479–1835," pp. 134–37.

87. Ibid., pp. 136–38.

88. Ibid., pp. 138–39.

89. Caresmar did know some documents from the originals. He notes, for example, that he saw one dated July 16, 1286, concerning contributions of Bellpuig de las Avellanes to Ermengol X's military undertakings as well as other documents, all of which he copied (Corredera, *Historia*, p. 229 n. 13).

90. Corredera, "Historia 1479–1835," pp. 135–39.

91. Balaguer. Archivo Ayuntamiento. Cartuario. 1762–1769. Ref. no. 3. "La noticia ge. se demana en 10 Juny 1769. se necesita saber. . . ."

92. Seo de Urgel. Archivo Diocesano. Memorias de les reliquies del San Cap de Juan de Orgaña. XVIII–XIX; letter dated Mar. 15, 1796.

93. Corredera, "Historia 1479–1835," pp. 93–96.

94. The chapel was again restored in the twentieth century. Photographs indicate that main work involved replacing the collapsed roof while the walls and buttresses remained standing.

95. Seo de Urgel. Archivo Diocesano. Memorias de les reliquies del San Cap de Juan de Orgaña. XVIII–XIX. Letter from Ramón Sabater to Joseph Pey dated Feb. 25, 1796, and a response two weeks later from Pey to Sabater. Both men had at one point lived at Bellpuig de las Avellanes.

96. A document bearing the seal of Ermengol X and dated 1282 states the count's wish to be buried at Poblet. See Ferran de Sagarra, *Sigillografía Catalana: Inventari, descripió i estudi dels Segells de Catalunya*, vol. 2, text (Barcelona, 1922), pp. 9–10, no. 287. Although he is said to have changed this in a later will, there is no documentary evidence to that effect.

97. See Hugo, *Praemonstratensis Annales*, cols. 283–84; and Eduardo Corredera Gutierrez, *Noticia de los Condes de Urgel* (Lérida, 1973), p. 134.

98. See Felipe Mateu y Llopis, *La iconografía y la heraldica de los condes de Urgel en la sigillografía y la numismatica*, Instituto de estudios Lerdenses (Lérida, 1967), pp. 25–27; Ferran de Sagarra, "Sigillografía dels Contes d'Urgell," *Boletín de la Real Academia de Buenas Letras de Barcelona*, vol. 8, no. 29 (Jan./Mar.), 1908, pp. 306–20, pl. 3, nos. 1, 6; and ibid., *Segells de Catalunya*, vol. 2, text, p. 9, nos. 284, 286; vol. 2, pl. 88, nos. 284, 286.

99. Corredera, *Noticia*, pp. 146–47.

100. Finestres, for example, opened the single tomb with the effigy in a mail shirt and claimed to have found a parchment that identified the occupant as Álvaro, brother of Ermengol X.

101. Corredera, *Bellpuig, Época moderna*, pp. 70–71.

102. Ibid., p. 72.

103. Schideler, *The Montcadas*, p. 91.

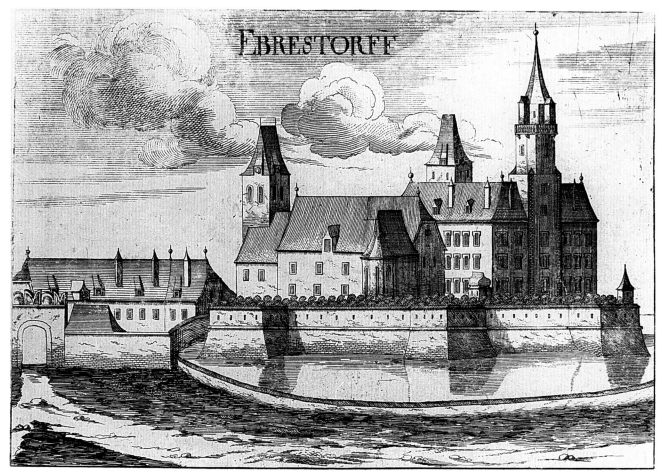

Fig. 1. M. Vischer, engraving showing the castle of Ebreichsdorf, 1672. The chapel is seen at the right end of the front building, which was erected only at the end of the sixteenth century and razed at the beginning of the eighteenth century (photo: Bundesdenkmalamt, Vienna)

The Stained Glass from Ebreichsdorf and the Austrian "Ducal Workshop"

Eva Frodl-Kraft

The installation in The Cloisters of twenty-one stained-glass panels (twenty rectangular panels and one tracery light) from the chapel of the castle of Ebreichsdorf in Lower Austria achieves more than a mere presentation of an engaging and attractive group of Late Gothic glass paintings (Col. pl. 7). It was possible to adapt two complete windows of The Cloisters Gothic Chapel expressly for these panels, so that the authentic impression of two of the three slender choir windows in Ebreichsdorf, which lost their glazing in 1922 (Fig. 3), could be reconstructed. This is of special importance because a distinct and characteristic compositional principle was realized in these windows: the alternation of figural scenes and surmounting canopies. Of course the original sequence is no longer preserved—the windows of the Gothic chapel unite the remains of either a Marian or an Infancy cycle from one window with those of the Passion and Post-Resurrection of Christ from another. The beautiful Annunciation (Fig. 5) and a tracery panel with sun, moon, and stars have long formed a part of The Cloisters Collection, but due to the energy and perspicacity of William D. Wixom and Jane Hayward it was possible to acquire the remaining panels from the Smithsonian Institution, where they were kept but not exhibited for many years.[1] With the exception of a single panel—the Visitation (Fig. 5), which was adjacent to the Annunciation—practically every original piece of the three windows which has survived into our century is now to be seen united in The Cloisters.[2]

The genesis and subsequent fortunes of the Ebreichsdorf stained glass reflect not only the political and cultural history of medieval Austria but also that of the recent past. The castle's location in a militarily precarious area affected its history.

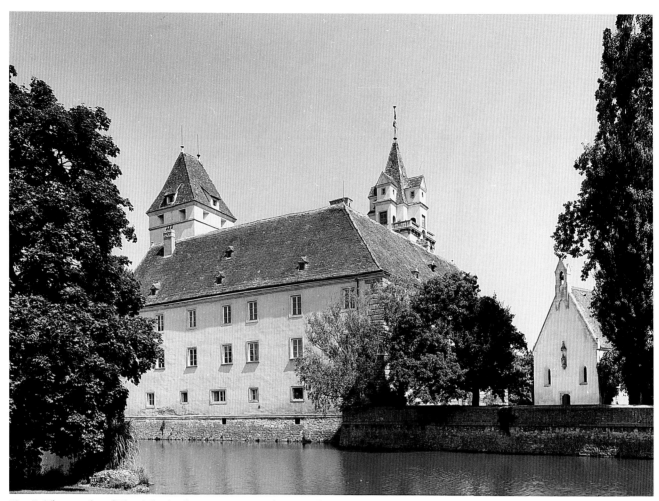

Fig. 2. The castle of Ebreichsdorf, present state; the now-freestanding chapel on the right (photo: Bundesdenkmalamt, Vienna)

Built as a fortress on the Hungarian border,[3] it was a stronghold against invasions by mounted Asian hordes who, beginning in the early Middle Ages, had come from the East. Over the centuries, these invasions increasingly came to be replaced by threats from the Turks. Although first documented only in the thirteenth century, Ebreichsdorf Castle, with its turrets and moat, must have been in existence for some time (Figs. 1, 2). It appears to have enjoyed a period of prosperity at the end of the fourteenth century. An examination of the architecture and sculpture reveals that a freestanding chapel was erected at that time and that it contained stained glass. Because, unfortunately, no documentation survives, the problems surrounding a precise date for the glass will be dealt with below.[4] The castle of Ebreichsdorf was pillaged during the first Turkish

advance on Vienna in 1529.[5] As in many other Lower Austrian churches, the Turks presumably damaged the religious art that was within easy reach there because they considered it to be blasphemous. In all likelihood they also destroyed the lower parts of the windows of the chapel at this time.

It is not known whether the second Turkish invasion of 1683 caused further damage to the chapel at Ebreichsdorf, but in any case, later nineteenth-century scholars who began to take an interest in its stained glass found in the choir windows the mere remains of three pictorial cycles on themes from the Life of Christ and the Life of the Virgin, but no longer in their original sequence.[6] This fragmentary state of affairs was resolved between 1883 and 1890 by a "historicist" restoration, that is to say, imitating the original style. The surviving

386

originals were not only rearranged but augmented with new creations so as to form an ensemble with a total of thirty-six panels completely filling the three windows (Figs. 4a–c).[7] (This deserves mention because not only the originals but also the newly created panels eventually found their way to the United States.) Only two decades after this costly restoration, which had been intended to secure and heighten their artistic value, the immediate physical unity and composition of the windows were threatened once again; because after several years of neglect the castle changed hands in 1909. While the new owner restored the residential apartments opulently,[8] he could not have been interested in the stained glass; it remained with the former owner, who planned to sell it. Nonetheless, the Office for the Preservation of Historic Monuments was able to prevent the export of the windows at that time.[9]

Just a decade later, however, the situation changed dramatically. After its defeat in World War I, Austria-Hungary ceased to exist and an almost inconceivable economic depression as well as poverty befell the small remaining territory of Austria. Along with much other sacred and secular artistic patrimony, the Ebreichsdorf stained-glass panels were sold to foreign buyers in 1922. As in other analogous cases, permission to export was given on the condition that one of the panels remain in Austria.[10] This is why the Annunciation in The Cloisters lacks its pendant: the originally adjacent Visitation panel was the one chosen to remain, and it was transferred to the Museum of Applied Arts, Vienna (Fig. 5). One might lament the dissolution of the original unity, but in the special case of the Ebreichsdorf glass, the fact that one panel remained in Austria as a "voucher copy," so to speak, proved to be of great importance for later art-historical research.

The earliest authors to deal with the Ebreichsdorf cycle had already recognized the striking kinship with another set of panels, and, with the progress of scholarship, relationships to still further cycles emerged.[11] All in all, there are six other sets or parts of sets of stained glass that stylistically and chronologically relate very closely to this cycle.[12] One series had come to Vienna from Wiener Neustadt in Lower Austria; it might have originated in the ducal castle there. Remnants are now in the Museum of Applied Arts, Vienna; one additional panel is in the Historisches Museum der Stadt Wien.[13] Of

Fig. 3. Gothic castle chapel interior, Ebreichsdorf, present state without stained-glass windows (photo: Bundesdenkmalamt, Vienna)

another cycle only two panels from different iconographic series survive in the parish church of Maria am Gestade in Vienna.[14] Some years ago the Germanisches Nationalmuseum in Nuremberg acquired a third cycle from a private collector, and it consists of rather small panels, including that of a donor. As will be discussed below, the donor's presence not only permits genealogical identification but also suggests that the series must have been executed for the private chapel of a castle in Lower Austria or southern Bohemia.[15] Three more or less complete, or at least extensive, cycles are still preserved in situ: the choir glazing of the parish

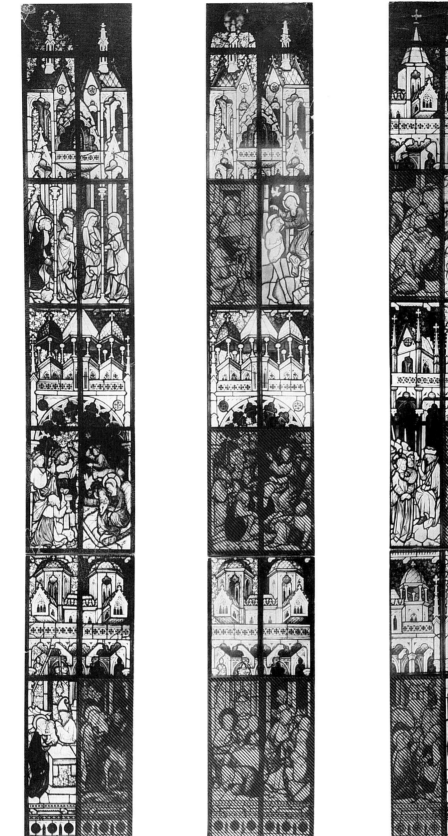

Figs. 4a-c. Scenes from the Life of Christ, ca. 1390, castle chapel, Ebreichsdorf; the three Gothic windows after restoration and completion, before being sold. Hatchings indicate the panels added by Rudolf Geyling (photo: Bundesdenkmalamt, Vienna)

church of Sankt Erhard in der Breitenau, Styria,[16] the choir glazing of the monumental abbey church of Viktring in Carinthia,[17] and finally the stained glass in the burial chapel of the lords of Wehingen, adjacent to the cloister of Klosterneuburg Abbey.[18]

These cycles of glass painting share the general compositional principle of an alternation of figural scenes with lavish architectural canopies, sometimes embracing both lancets of the window (Fig. 6). They furthermore share a common repertory of models for certain standard scenes and figures, which are encountered repeatedly and with only slight variations (Figs. 15, 16). Particular types are also common; the most striking are certain distinctive male heads, characterized by square chins and broad jaws (Figs. 7, 8). Finally, a masterly execution of not only the brushwork but also the cutting and leading is common to these cycles. Equally exquisite is the coloristic differentiation in choice and opposition of hues.

The seven series presently known must have been created in short succession at the end of the fourteenth century, in about 1400. Their authors clearly not only had access to a common repository of models but must also have undergone the same training. Their work was aimed toward the satisfaction of very particular demands. These requirements were apparently neither intellectual nor especially religious, since the iconographic programs realized in the windows are modest in scope and conform to what was most common. One finds the standard scenes from the Life of Christ and the Life of the Virgin and occasionally standing saints, usually apostles. Thematic variety or richness of content was not sought after; instead they exhibit a perfection in execution, choice of color, and play of space within sophisticated architectural elements (Figs. 6, 9). These qualities were called for as much in small-scale glass paintings in private chapels as they were in monumental glazing in an abbey church.

These characteristics seem to point to the patronage of a particular social level: a group with well-developed aesthetic preferences, whose members entered into competition with one another to fulfill and display their pretensions. This phenomenon can occur only at a high level of society, of course, and at that time it would still have been the higher aristocracy rather than the bourgeoisie. Connoisseurs among the aristocracy are anything but rare in the period around 1400: one

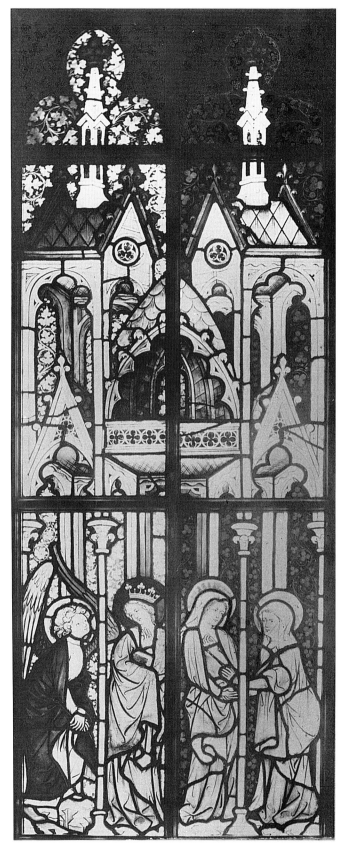

Fig. 5. Annunciation and Visitation with accompanying canopies, in situ before sale. Castle chapel, Ebreichsdorf (photo: Bundesdenkmalamt, Vienna)

389

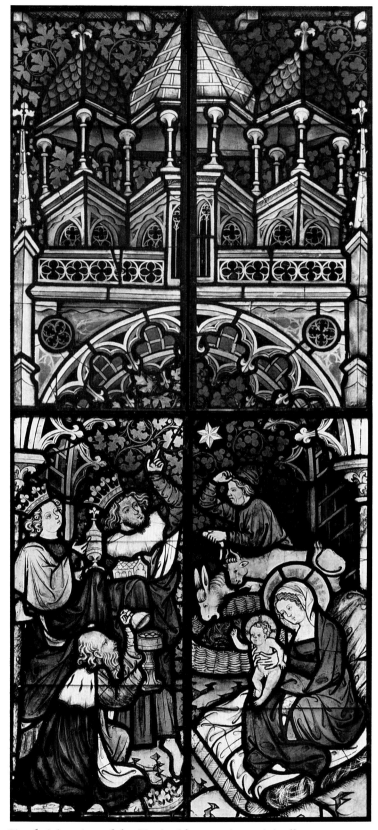

Fig. 6. Adoration of the Magi with canopies, originally
castle chapel, Ebreichsdorf. The Metropolitan Museum
of Art, The Cloisters Collection, 1986
(1986.285.1,2,10,11) (photo: Museum)

need but think of the duke of Berry in the West and the masterpieces of book illumination that he had commissioned. Glass windows that could be seen by the general public, or at least by social peers, were certainly an effective means—while at the same time a pious endowment—of demonstrating a refined sense of quality in art. Could this also be true of our group of glass paintings?

Documents reveal nothing, or at least nothing concrete, about the patrons of these seven cycles of glass painting. Fortunately, however, the patrons were concerned with immortalizing themselves by means of donor portraits and coats of arms in their windows, at least some of which are preserved, and they are informative enough. The heraldry reveals that we are confronted with an exclusive segment of the higher aristocracy, whose families were closely connected to one another by rank, office, property, and kinship. They were not only related and affiliated by frequent marriages in successive generations but formed the closest circle around the "Landesfürst"— the duke. They were men who enjoyed his confidence, whom he invested with the highest offices in the land, but who also lent him the money to replenish his chronically empty treasury, for they were wealthier than he was. Wherever there are references to patrons within this group of stained-glass cycles, we encounter the same homogeneous social class. From the recorded facts of history[19]— from the offices and positions held by these families and from their close connection to the court—we can see their intimate relation to the "Landesfürst." It is precisely their commissions of stained glass that are the most eloquent and irrefutable proof of the common cultural ambitions of the court and the society most closely surrounding it.

To understand this situation it is necessary to retrace certain historical developments. Over a century before the period in question, the Hapsburgs had come to Austria as foreigners to the territory. Even after their consequential defeat of King Ottokar of Bohemia, they were faced with strong internal dissidence among the local nobility. This resistance was also directed against the nobles who had come with King Rudolf I from Switzerland and from the so-called "Vorlande," Swabia and Alsace. The originally rather weak Hapsburg rule was dependent on those known as the Swabians. It was only logical, then, that these foreigners should be appointed to the most important posts, that the most opulent

deeds went to them, and that they should amass a vast amount of land in the course of time. Among these families the lords of Wallsee were prominent,[20] and we will be considering their possible connection with the Ebreichsdorf windows. Another of these so-called Swabian families, the lords of Wehingen, were also among the patrons of glass paintings that belong to this group. The most prominent member of this family, Berthold von Wehingen, chancellor to Duke Albrecht III and also—thanks to the duke's intervention—bishop of Freising, had, together with his brother, a family chapel erected in the abbey of Klosterneuburg, near Vienna, in about 1400, and had it furnished with stained-glass windows.[21]

The older local nobility was, of course, not exclusively opposed to the Hapsburgs. There were families who had sided with them against Ottokar of Bohemia from the very beginning. Intimates of the dukes—companions in their wars and other undertakings—came from these families during the following generations as well. In the period under review here, the original opposition between the established nobility and the newly arrived foreigners had lessened considerably. Among these pro-Hapsburg families were the lords of Stubenberg— a lineage unbroken to this very day—who were among those who donated glass paintings in the Carinthian abbey of Viktring at this same time.[22]

In this period of upheaval a new class began to rise in the cities. Its members amassed not only large fortunes but also positions of influence that extended far beyond the local affairs of their native cities. Due to its wealth, this class was able to commend itself as a financial backer to the "Landesfürst" to the same extent as did the nobility. This "Ritterbürgertum"—a knighthood stemming from the bourgeoisie—also entered into competition with the landed nobility; it too began to acquire fiefs, castles, and country residences. The lords of Tirna, lord mayors of Vienna and holders of high courtly offices—belonged to this class.[23] In the second half of the fourteenth century the castle of Ebreichsdorf belonged to them.[24]

By fortunate coincidence artistic commissions not only from the group of lords mentioned above but from the "Landesfürst" himself, Duke Albrecht III, have been preserved in the Styrian church of Sankt Erhard in der Breitenau.[25] It is not known why the duke would have donated a window to that church. Perhaps it was merely because his close

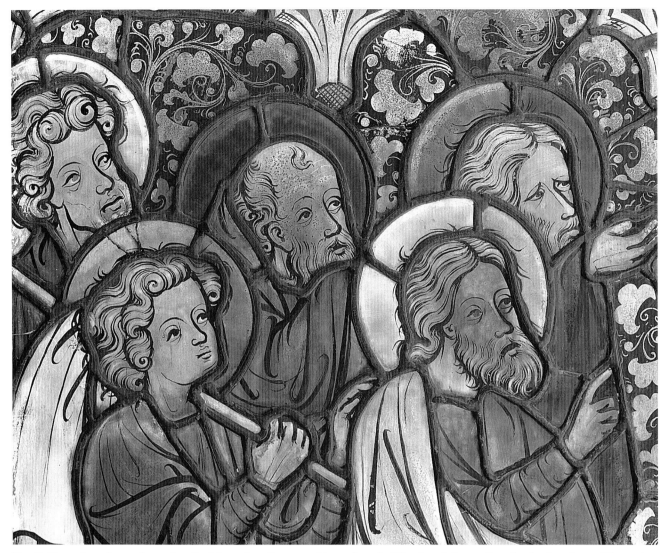

Fig. 7. Entry into Jerusalem: detail of Apostles. Former abbey church, Viktring (photo: Bundesdenkmalamt, Vienna)

friends, the Stubenbergs, who were, as we have seen, among the donors in Viktring Abbey, held a great amount of land in this area. According to the fashion of the time, the duke is seen armed in the heraldic colors of Austria—red-white-red. Behind him are his two wives—Elisabeth von Böhmen, who had died in 1375, and his second wife, Beatrix von Hohenzollern (Fig. 10). The patron is designated, among other things, "Dux Styrie"—duke of Styria. This designation reveals a general motive for a commission in this duchy but also, and of greater importance to us, a *terminus post quem:* only in 1386, with the death of his brother Leopold, did he "inherit" the duchy of Styria. Albrecht himself died in 1395, thus providing the exact period within which this stained

glass was certainly made.[26] One might add that the brief decade from 1386 to 1395 holds the only indication for dating the other related cycles as well, with the exception of the final phase of activity by the masters of this group to which the glazing of the Klosterneuburg chapel belongs. Thus, the donor panel of Duke Albrecht not only confirms the date suggested by its style but it also yields important information for the entire group.

If this donor panel were the only one preserved we would certainly conclude, from the fashionably detailed representation of the duke's armor and from the rich, fur-lined clothing of the women, that this opulent and minutely detailed characterization was intended to underscore the unique position of those

represented. But this is not the case: both of the duke's wives are to be seen identically (albeit in reverse) in the donor portraits of other series. Elisabeth von Böhmen is encountered again in one of the Nuremberg panels as the portrait of a lady from the family of Kuenring, powerful in Lower Austria (Fig. 11). She was a great-granddaughter of Ottokar, king of Bohemia, but did not have the right to wear a crown.[27] Beatrix von Hohenzollern, the second wife of Albrecht III (in the right exterior area of the St. Erhard panel), appears again in the portrayal of the wife of the lord of Stubenberg in Viktring (Fig. 12). A very personal feature of Beatrix, her pigtail hanging down her back—she was famous for her long hair—has astonishingly been transferred to Lady Stubenberg, even though such a coiffure was very unusual for a married woman. The portraits of the male donors are divergent in details of their armor, but they too follow a common model. The workshop or, more cautiously, the glass painters who executed these three donor panels and the accompanying cycles were very obviously bent on showing themselves skilled and up-to-date in all the aspects of fashionable decorum. They managed to satisfy their clients, yet had no apparent ambition for individualization and depicted them according to a standard catalogue, so to speak.

It is regrettable in more than one respect that the Ebreichsdorf glass includes neither donor portraits nor coats of arms. Since these are usually found at the bottoms of such windows, they are the first to be exposed to the risk of demolition. Creation and patronage of the Ebreichsdorf glass thus remain for us an equation with two unknown quantities and with no key to its resolution. If we knew the year of its commission, we might deduce the identity of the patron. On the other hand, if the patron were known, a precise period of time might emerge in which the glass must have been executed. We know the sequence of owners of Ebreichsdorf Castle without a lacuna during the second half of the fourteenth and the beginning of the fifteenth century, but unfortunately a change of owners took place precisely during the years when the series must have been commissioned.

Hans von Tirna, the most prominent member of the renowned Viennese lineage of knighted town magistracy, owned the castle in the early 1380s. Hans von Tirna, master of the mint, lord mayor of Vienna, and—together with four others—administrator of the

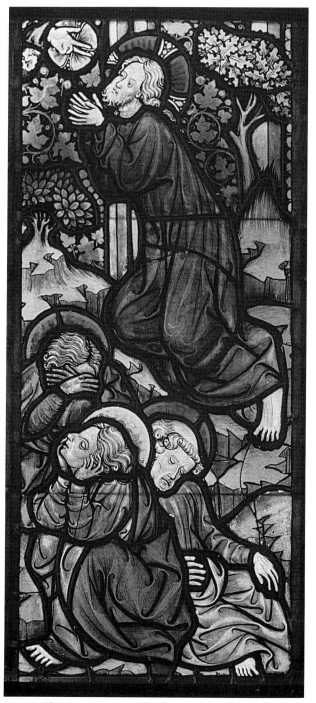

Fig. 8. The Agony in the Garden, originally castle chapel, Ebreichsdorf. The Metropolitan Museum of Art, The Cloisters Collection, 1986 (1986.285.5) (photo: Museum)

393

Fig. 9. Architectural canopies, choir window, parish church, St. Erhard in der Breitenau (photo: Bundesdenkmalamt, Vienna)

Austrian provinces, would have been the patron if the windows had been made before 1388, the year of his death.[28] His sons fell into financial distress and were ordered by a court decree in 1393 to transfer Ebreichsdorf to the Vienna Schottenstift. Ulrich von Wallsee probably purchased the castle of Ebreichsdorf in the following year. It thus devolved upon that Swabian family, which had risen to a position of power and wealth unmatched at that time by any of its peers. Following the death of Duke Albrecht in 1395, Ulrich von Wallsee-Drosendorf was especially close to one of the heirs, Duke Wilhelm—personally as well as by reason of his office as "Hofmeister." In 1396 he accompanied the duke to the Holy Land and thus must not be excluded as a possible patron of the windows. When

Ulrich died in 1400, Ebreichsdorf was inherited by his three cousins from a different branch of the Wallsee family,[29] but the glazing must have already existed at that time.

Notwithstanding a general affinity, the stylistic appearance of the Ebreichsdorf glass is certainly earlier than the latest glass paintings of our group: those in the Klosterneuburg chapel, donated by Duke Albrecht's chancellor, Berthold von Wehingen. These windows were probably not executed before 1400. Obviously, the Ebreichsdorf glazing also preceded the monumental windows in the abbey church of Viktring. An exhibition of stained glass held in Vienna in 1983, which included examples from several of these cycles—the Visitation panel from Ebreichsdorf, among others—made these

Fig. 10. Donor panel, Duke Albrecht III with his two wives; choir window. St. Erhard in der Breitenau, parish church (photo: Bundesdenkmalamt, Vienna)

Fig. 11. Donor panel, a Streun-Kuenring couple. Nuremberg, Germanisches Nationalmuseum
(photo: Germanisches Nationalmuseum)

differences obvious.[30] Moreover, the comparisons also made it clear that each of the panels exhibited revealed a separate individuality, a distinctive artistic personality that represents more than a mere difference in hand. The painter of the Ebreichsdorf Visitation was concerned with very different artistic qualities than the author of the iconographically similar Visitation in Viktring (Figs. 5, 13). Each of the motifs, intended in Ebreichsdorf to create plasticity of volume, is reinterpreted at Viktring as a surface pattern in accordance with the beginning phase of the so-called "Soft Style." It is not possible here to pursue these manifestations of personal "Kunstwollen" through each of the relevant glass cycles: compare, for instance, the Presentation scenes at Ebreichsdorf and Sankt Erhard (Figs. 15, 16). Only if we were able to compare entire cycles rather than isolated examples would it be possible to decide whether a single master collaborated on more than one of the cycles or if a certain artistic personality impressed a unity upon several cycles. Only if we could ascertain this beyond doubt could we then decide whether we are dealing with individual artists in a large workshop—it has been called the "Ducal Workshop"—or with masters trained in the same tradition (possibly working in independent workshops) who might have succeeded one another, perhaps even in more than one location.[31]

It is not possible here to enter into a detailed discussion of the complicated and complex problem of medieval workshop procedures. But focusing on the two specimens of Austrian stained glass in the Gothic Chapel of The Cloisters—the St. Leonhard panels of about 1340 and the two Ebreichsdorf windows, executed in all probability about fifty years later—we can nevertheless deduce one general statement. A procedure frequently used in the St. Leonhard glass consists in combining and interchanging elements, or parts, of different figures to create a new figure. Color differentiation adds to the impression of a new invention. This method of compositional figure variation is of course not limited to St. Leonhard and the related cycles, but it does not occur in the stained-glass cycles dealt with in this essay. Their means of figure variation are of a more subtle character; although as we have seen they reproduce some standard figures quite faithfully, their own contribution consists in assimilating them to their proper stylistic standards (cf. Figs. 10–12). Yet the common tradition sets rigid

Fig. 12. Donor panel, members of the Stubenberg-Pettau family. Viktring, choir window, former abbey church (photo: Bundesdenkmalamt, Vienna)

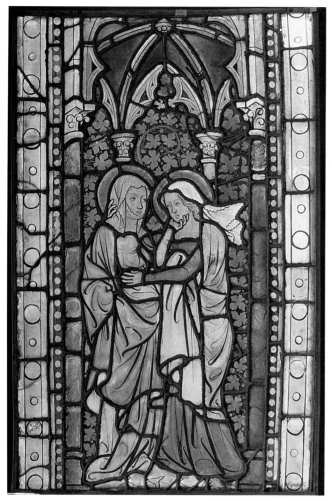

Fig. 13. Visitation. Viktring, choir window, former abbey church (photo: Bundesdenkmalamt, Vienna)

from the so-called "Ducal Workshop" that represents Austrian painting at the end of the fourteenth century at its best.

Nor does Austrian book illumination offer a resolution for the stylistic derivation of our stained-glass group. We may be sure that the duke himself, and the peers as well, commissioned and owned precious illuminated manuscripts, but in fact very few have come down to us. The most prominent manuscript executed in Duke Albrecht's scriptorium, or in a scriptorium that worked for the court, the *Rationale Durandi* of about 1390, is important proof that there must indeed have existed a common frame for work in different branches of art. Ernst Bacher compares the representation of the Last Supper in the *Rationale Durandi* with the same scene in the Sankt Erhard and in the Viktring windows.[34] The iconographic similarity is indeed striking. Nevertheless the scene in the manuscript can certainly not be considered a source for the ones in the glass painting: although the scheme is the same, the figure composition is more smooth and fluent; the draperies lack the vigor and abundance of those in the glass. Of course, one has to take into consideration the difference in scale. Yet the Streun-Kuenring panels, for example, do not exceed a larger book page in size (38.25 cm). In effect, the relationship is limited to the fact that different masters, working in different branches of art, had access to the same stock of models.

The Metropolitan Museum of Art houses a beautiful stone sculpture—without doubt of Austrian origin—which furnishes further proof for this opinion: the angel of an Annunciation group touches his bent upper leg with his crossed hands (Fig. 14).[35] The angel in New York is probably a slightly later version of another well-known Austrian sculpture of equally high quality: the Annunciation angel from Grosslobming in Styria, dated about 1420. He displays the same motif of his hands crossed on the upper leg.[36] This gesture, although unusual in general, is almost identical to that in the Ebreichsdorf Annunciation (Fig. 5). The parallel is instructive in two respects: the motif appears to occur earlier in stained glass than in sculpture, whatever the medium of transference may be; furthermore, the certain Styrian provenance of the angel in Vienna proves the existence of a common iconographic tradition in this region of Austria, united for the second time in 1386 under the reign of Duke Albrecht III.

limits on the deployment of the individual artistic personality.[32]

But what are the roots of this homogeneous tradition? From which artistic sources did it draw sustenance? For the possible source of the pictorial inventions and for the specific style of this painted glass, it is in vain that one searches the local artistic centers, especially Vienna. Panel painting, which would be the most obvious possible source to examine, is completely lacking in the final two decades of the fourteenth century. Notable panel paintings exist from the earlier part of the century (the reverse of the Verdun retable, for example)[33] and then again after 1400 in a spectrum as rich as these glass paintings offer. Precisely in the relevant time period, however, there is a lacuna. Indeed, it seems that it is just this group of stained-glass panels

Fig. 14. Angel from an Annunciation group, Austrian, Styria(?), beginning of the fifteenth century, H. 82 cm. The Metropolitan Museum of Art, The Bequest of Michael Dreicer, 1921 (22.60.2) (photo: Museum)

Fig. 15. Presentation in the Temple, originally in castle chapel, Ebreichsdorf. The Metropolitan Museum of Art, The Cloisters Collection, 1986 (1986.285.3) (photo: Museum)

Nevertheless, this general fact reveals nothing about the proper iconographic sources.

The attitude of the angel's hands is not motivated in the iconographic context and is not to be found in Western examples where the Annunciation angels tend to display a scroll with one hand, while the other rests on a knee. In Italian Trecento works, however, another type occurs: the angel's arms are crossed over its breast. It cannot be excluded that this model exerted a certain influence on the formation of the singular Austrian motif, as Gerhard Schmidt has recently suggested.[37]

Jörg Oberhaidacher was the first to refer to Parisian book illumination as a possible iconographic source for the Christological scenes in our stained-glass group.[38] Indeed we find some striking compositional parallels in the earliest parts of the *Très Belles Heures de Notre-Dame*, commissioned in all likelihood by the duke of Berry and executed in the early 1380s.[39] This part of the manuscript is usually seen in connection with the workshop of the Master of the Parement de Narbonne. In fact the relation with our group can be traced back to the Parement itself (cf., for example, the Arrest of Christ with the same scene in Sankt Erhard). The obvious iconographic relationship is not limited to French painting alone but includes Franco-Flemish works in the succession of Melchior Broederlam as well. The Presentation scene is particularly instructive in this respect; the Presentation on the small tabernacle altar in Antwerp, which is said to have come from Champmol (Fig. 18),[40] points unmistakably to the same iconographic sources as does this same scene in the *Très Belles Heures de Notre-Dame* (Fig. 17) and in the Presentation scenes in our stained-glass group (Figs. 15, 16). The tender gesture in Western paintings of the naked Christ child clinging to his mother's breast, in apparent fear of the high priest (Figs. 17, 18), loses its emotional emphasis in the Austrian stained-glass panels (Figs. 15, 16). It is replaced here by the expression of a more or less neutral curiosity.

The question of dating, still open to discussion for the Western examples, remains of minor importance, even if they did not precede our cycles but were contemporary, or made some years later. It is the general principle that counts: beyond doubt the Austrian glass painters had some knowledge of Western iconographic types (the naked Christ Child, for example),[41] and were familiar with the compo-

sitional schemes developed there. We may assume that this knowledge was transmitted mainly by illuminated manuscripts. The stylistic sources, however, remain in the dark, for the models provide evidence of only a general stimulus. Narrative intensity (cf., for example, Figs. 6, 19) characterizes the whole group. The exact source for the impulse for the vivacious narrative mode of our masters remains open to further research. Whatever its source, this narrative liveliness prevented the scenes from becoming rigid through routine.

When speaking of style one ought not to forget the splendid architectural compositions surmounting and separating the scenes (Figs. 4a–c, 5, 6). The motifs comprising the imaginary architectures reach back into the earlier Trecento: such elements as slender arcaded turrets, varied cupolas, tiny

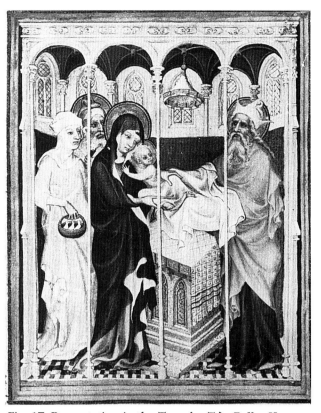

Fig. 17. Presentation in the Temple, *Très Belles Heures de Notre-Dame* (detail). Paris, Bibliothèque Nationale, MS nouv. acq. lat. 3093, p. 56 (photo: Kunsthistorisches Institut der Universität Wien)

Fig. 16. Presentation in the Temple. St. Erhard in der Breitenau, choir window, parish church (photo: Bundesdenkmalamt, Vienna)

protruding houses resembling bird cages seen from worm's-eye view. Genuinely Italian elements are combined with richly decorated Gothic gables and balustrades. The motifs themselves are already current in mid-century windows; the richest spectrum is in Maria Strassengel in Styria.[42] But there is a very significant difference between the earlier windows and those of Ebreichsdorf: our masters have tried—though with varying success—to combine those motifs by means of symmetry and "perspective" so as to form a coherent architectural frame embracing both lancets of the window (Figs. 4–6). They even attempt to procure space behind the figures, even though the results are rather narrow and cramped stages. These are new tendencies, pointing forward to a "modern" mode of seeing: the pictorial concept of a homogeneous view "through a window." To be sure, the full realization of this concept lies still further in the future; the art-historical achievement of this group as a whole

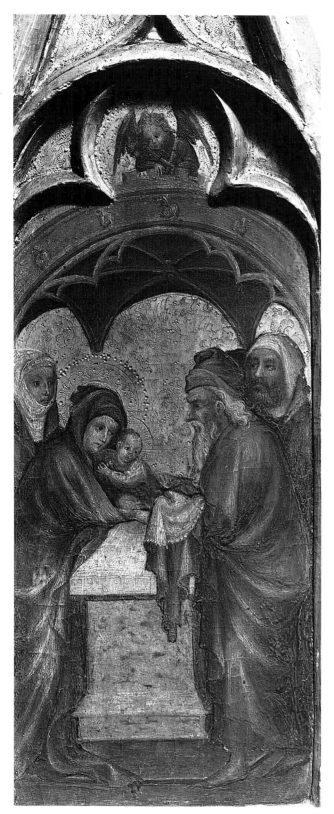

Fig. 18. Presentation in the Temple, right inner wing. Tabernacle Altar from Champmol(?). Antwerp, Museum Mayer van den Berg (photo: Copyright A.C.L., Bruxelles)

may be seen in the field of architectural inventiveness rather than in the "modern," though standardized, scenic compositions. The contemporary beholder certainly took aesthetic pleasure in the variety of the sophisticated architectural motifs and in their ability to stimulate the imagination.

The Ducal Workshop—in this case the name is truly justified—has left us another brilliant creation: the glass of the Princely Oratory, a private chapel of the Hapsburgs, in the cathedral of St. Stephen, Vienna (Fig. 20).[43] It is the secular theme of the genealogy of the royal or ducal house spread across two windows that has to be considered here. The figures are fitted into an opulent architectural vista, like that found at Viktring. Certainly the intellectual climate that allowed the idea for a project exuding such self-confidence grew out of a competition with the Luxembourg court in Prague, to which the Hapsburgs were related by marriage. The immediate impulse for this must have been the wall paintings showing the Luxembourg genealogy, commissioned by the emperor Charles IV for his castle at Karlstein, which are preserved only in later drawings.[44] For the question of the style of the Hapsburg windows one has consistently referred to Bohemia as a source, but the so-called Nine Heroes Tapestries in The Cloisters[45] demonstrate convincingly the Western European sources that were common to both Bohemia and Austria at this time.

These two works of different techniques— stained glass and textile—are related by date as well as by their character as a princely commission. Exact dates are missing for them, but they were most likely commissioned in the 1380s: the Hapsburg windows certainly before 1395, when Duke Albrecht III died, probably between 1379 and 1386; the tapestries might have been commissioned by the duke of Berry about 1385.[46] They therefore lend themselves to a comparison that leads us directly to the basic qualities of Late Gothic art in central Europe and in the West. They share the unity of the architectonic vista with its emphasis on three-dimensionality, and strive for the monumentality of the represented heroic figures (Figs. 20, 21). The character of the architecture itself is absolutely different, however: purely Gothic, clear and lucid in the tapestries; a combination of heterogeneous elements in a more or less arbitrary manner in the windows. The master of the tapestries used his artistic imagination to create those charming and humorous little figures

occupying the niches; the Hapsburg master's inventiveness is on the contrary concentrated on the abundant realization of space in the amazing architectural ensemble. It seems to me that this comparison is indeed significant for establishing the principal limits for an integration of Western influences into Austrian art at that time.

Apparently the masters charged with the earliest of the large glass commissions in our group possessed the capacity to cultivate an artistic as well as a technical tradition which carried an aura of authority for their collaborators and followers. This tradition continued for approximately two decades, until the beginning of the fifteenth century when the style became provincial and lost its force.

One might fault this essay for having dealt at length with donors, with their commissions and their status, even though the question is not at all clear in the special case of Ebreichsdorf. This is not meant as a sociological approach to art history, of which I am not a partisan. But we are confronted here with an almost unique situation: seven strikingly similar stained-glass cycles (and we do not know how many more existed originally) were executed for the duke and for those families, members of the highest social class, who were closely bound up with the court. That these peers who came from separate territories should share the aesthetic preferences of the duke is not at all self-evident, but the fact that they did throws light on the cultural situation in that country: as in the West, it was obviously the court that set the standards.

Fig. 19. The Harrowing of Hell, originally castle chapel, Ebreichsdorf. The Metropolitan Museum of Art, The Cloisters Collection, 1986 (1986.285.7) (photo: Museum)

NOTES

1. "Stained Glass before 1700 in American Collections: New England and New York" (Corpus Vitrearum Checklist I), in *Studies in the History of Art* 15 (Washington, D.C., 1985), p. 113; and "Mid-Atlantic and Southeastern Seaboard States" (Corpus Vitrearum Checklist II), *Studies in the History of Art* 23 (1987), pp. 36–38.

2. Eva Frodl-Kraft, *Die mittelalterlichen Glasgemälde in Niederösterreich* (Corpus Vitrearum Medii Aevi, Austria II, pt. I) (Vienna/Cologne/Graz, 1972), pp. 225–28, figs. 681–83 in situ, pp. 684–94.

3. *Topographie von Niederösterreich* (Vienna, 1885), vol. 1, pt. 2, pp. 439–48; Felix Halmer, *Burgen und Schlösser Niederösterreichs* I/2 (Vienna, 1968), pp. 32–36; *Dehio Handbuch, Die Kunstdenkmäler Niederösterreichs,* 5th ed. (Vienna, 1953), pp. 49ff.; Renate Wagner-Rieger, in *Reclams Kunstführer Österreich* 1 (Stuttgart, 1962), p. 120.

4. Historic documents for the construction of the chapel are lacking. The dating to the end of the fourteenth century is based on stylistic arguments (see note 3 above). Right from the beginning the chapel was a separate freestanding building. Not earlier than the second half of the sixteenth century, the chapel became linked to a new building that was erected in front of it. This arrangement, which no longer exists, lasted from 1580/81 until 1705; it is documented by Vischer, 1672 (see Fig. 1). Cf. H. Hofer, "Der Landesfürstliche Markt Ebreichsdorf," *Denkschrift zur Markterhebung Ebreichsdorf* (1912), p. 16.

5. *Dehio Handbuch* (see note 3 above), p. 49.

6. *Mitteilungen der k. k. Zentralkommission zur Erforschung und Erhaltung der Kunst- und historischen Denkmale,* NF 7 (1875), p. LII n. 31 (states that the panels are installed in the chapel windows at random and enumerates eight scenes); Karl Lind, "Übersicht der noch in Kirchen Niederösterreichs

Fig. 20. Genealogical Hapsburg window, originally the Duke's Chapel in St. Stephen's Cathedral, Vienna. Vienna, Historisches Museum der Stadt Wien (photo: Bundesdenkmalamt, Vienna)

erhaltenen Glasmalereien," *Berichte und Mitteilungen des Alterthumsvereines zu Wien* 27 (1891), pp. 109–29; Alois Löw, "Alte Glasmalereien in Niederösterreich," ibid., 31 (1895), pp. 9–28; Karl Lind, *Meisterwerke der kirchlichen Glasmalerei*, ed. Rudolf Geyling and Alois Löw (Vienna, 1897) (seven col. pls. after watercolors made during the restoration).

7. For reports on the restoration, see *Monatsblätter des Alterthumsvereines zu Wien* 3 (1891), p. 143 (designs for the new panels by Rudolf Geyling); *Mitteilungen der k. k. Zentralkommission*, NF 17 (1891), p. 135 n. 148 (enumeration of the scenes and canopies in the three windows, with distinctions between old and new panels).

8. Hofer, "Landesfürstliche Markt," p. 35.

9. *Mitteilungen der k. k. Zentralkommission* (1910), p. 155. (The Imperial Commission used its influence to guarantee that the stained glass should remain in the castle or at least should not be exported.)

10. *Österreichisches Bundesdenkmalamt*, Doc. no. 641/22 of May 23, 1923: "The Museum of Applied Arts, Vienna [Kunstgewerbemuseum] informs the office that it has taken over from the 'Dorotheum' [Auction House] the Visitation panel as a donation as a result of the agreement mentioned above." The buyer of the other original panels (nine scenes, eight canopies) is not mentioned; cf. Eva Frodl-Kraft, *Die mittelalterlichen Glasgemälde in Wien* (Corpus Vitrearum Medii Aevi, Austria I) (Vienna/Cologne/Graz, 1962), pp. 128ff., fig. 246.

11. Cf. note 6 above and Franz Kieslinger, "Die Glasmalereien des österreichischen Herzogshofes aus dem Ende des 14. Jhs.," *Belvedere* 1 (1922), p. 152.

12. Recent literature on the whole group includes: Ernst Bacher, *Die mittelalterlichen Glasgemälde in der Steiermark*, Corpus Vitrearum Medii Aevi, Austria III, pt. 1 (Vienna/Cologne/Graz, 1979), pp. xxxvii–xl; *Glasmalerei des Mittelalters aus Österreich*, exhib. cat., Österreichische Galerie (Vienna, 1983), pp. 11–14; Eva Frodl-Kraft, "Postscriptum zur Ausstellung Glasmalerei des Mittelalters aus Österreich, Vienna, Orangerie des Unteren Belvedere, Sept.–Okt. 1983," *Österreichische Zeitschrift für Kunst und Denkmalpflege* 38 (1984), pp. 81-91.

13. Frodl-Kraft, *Glasgemälde in Wien*, pp. 127–29, col. pl. 8, figs. 243–45; idem., "Die 'Erwahlung Josephs' aus dem Neukloster in Wiener Neustadt," *Österreichische Zeitschrift für Kunst und Denkmalpflege* 21 (1967), p. 189; idem, *Glasmalerei des Mittelalters*, p. 11.

14. Frodl-Kraft, *Glasgemälde in Wien*, pp. 91ff., figs. 135, 155.

15. Eva Frodl-Kraft, "Mittelalterliche Glasmalerei. Forschung-Konservierung. Die österreichischen Gläsgemälde der Sammlung Bremen in Krefeld," *Österreichische Zeitschrift für Kunst und Denkmalpflege* 20 (1966), pp. 35–45, figs. 48–50, 54, 56, 58, 60, 63, 65; *Die Kuenringer*, exhib. cat. (Zwettl, 1981), no. 125, p. 129.

16. Cf. note 12 above and *Gotik in der Steiermark*, exhib. cat. (Stift St. Lambrecht, 1978), p. 153.

17. Walter Frodl, *Glasmalerei in Kärnten 1150–1500* (Klagenfurt/Vienna, 1950), pp. 38–41, 64–66, col. pls. IX–XII, figs. 161–79.

18. Frodl-Kraft, *Glasgemälde in Niederösterreich*, pp. 199–217, figs. 635–67, 671–76, 678–80.

19. See Erich Zöllner, *Geschichte Österreichs von den Anfängen bis zur Gegenwart* (Vienna, 1961).

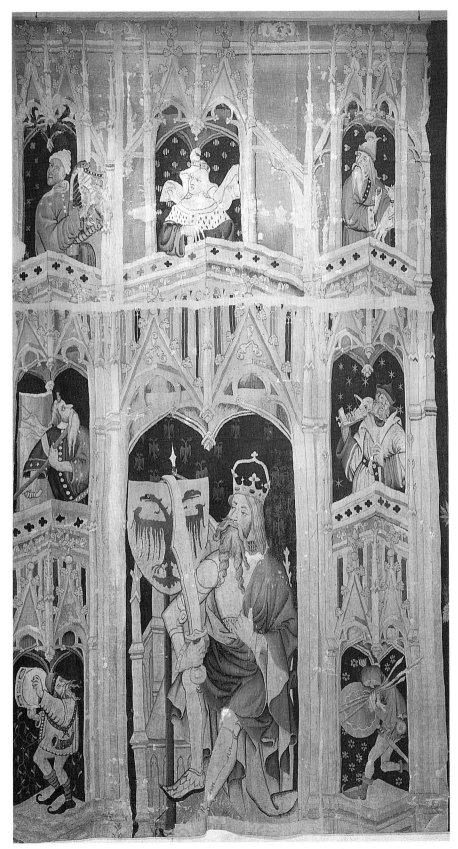

Fig. 21. Nine Heroes Tapestries: Julius Caesar. The Metropolitan Museum of Art, The Cloisters Collection, 1947 (47.101.3) (photo: Museum)

20. M. Doblinger, "Die Herren von Wallsee, Ein Beitrag zur österreichischen Adelsgeschichte," *Archiv für österreichische Geschichte* 95 (1906), pp. 235–576.

21. Oskar Freiherr von Mitis, "Die schwäbischen Herren von Wehingen in Österreich," *Jahrbuch für Landeskunde von Niederösterreich,* NF 23 (1930), pp. 76–93; Frodl-Kraft, *Glasgemälde in Niederösterreich,* p. 200. In 1394, the year of the consecration, the chapel was probably still under construction. The year of Berthold's death, 1410, might provide a *terminus ante quem* for the execution of the windows (cf. note 18 above).

22. J. Loserth, *Geschichte des altsteirischen Herren- und Grafenhauses Stubenberg* (1911); Hans Pirchegger, "Beiträge zur Genealogie des steirischen Uradels," *Zeitschrift des historischen Vereins für Steiermark* 15 (1917). The coats of arms connected with the donor portraits in Viktring are those of the Pettau and Stubenberg families, who were related by marriage. Friedrich III von Stubenberg, who married Anna von Pettau in 1370, had died in 1378. Unfortunately, however, the date of the windows cannot be deduced from these facts. It is characteristic of the homogeneity of this class that its members frequently are encountered together in documents; for example, a 1399 document of Bernhard of Pettau is sealed by his nearest friends and relatives, Otto von Stubenberg and Ulrich von Wallsee; the latter had been Bernhard's guardian. Indeed, this close relationship between the leading families manifests itself not only in the private sphere but in the most important matters of the realm as well: the decisive treaty with Duke Leopold's heirs after his death in the battle of Sempach (1386) is signed (among others) by Berthold von Freising, Otto and Wulfing von Stubenberg, and Heinrich and Reinprecht von Wallsee. A second donor, a lord of Rothenstein, married to a lady of Eroltzheim, appears in another Viktring window and is another link to the "Swabian" nobility, but again provides no means for exact dating. Yet it is of interest to our investigations that one Jakob von Rottenstein appears in a document delivered in Viktring in 1384: see F. Muck, "Mitteilungen zur Kärntner Heraldik und Genealogie, Zwei Votivfenster der Stiftskirche Viktring," *Carinthia* 1 (1957), p. 621.

23. L. Sailer, "Die Wiener Ratsbürger des 14. Jahrhunderts," *Studien aus dem Archiv der Stadt Wien* 3/4 (Vienna, 1931), pp. 249–363.

24. Richard Perger, "Simon Pötel und seine Handelsgesellschaft," *Jahrbuch des Vereins für Geschichte der Stadt Wien* 40 (1984), pp. 81ff. I wish to thank Professor Perger for his valuable advice.

25. See note 16 above.

26. Between 1379 (treaty of Neuberg) and 1386 Duke Leopold governed Styria. *Die Zeit der frühen Habsburger,* exhib. cat. (Wiener Neustadt, 1979), p. 474, no. 272a, pl. 11. For Albrecht III, see A. Strnad, "Herzog Albrecht III. von Österreich—Ein Beitrag zur Geschichte Österreichs im späteren Mittelalter" (Ph.D. diss., University of Vienna, 1961).

27. Elisabeth, natural daughter of Przemisl Ottokar II, was married to Heinrich VII Kuenring. With this marriage the Kuenring family entered the highest rank of the nobility. Relations by marriage with the most prominent families (Wallsee, Stubenberg, Liechtenstein) continued in the following generations. The son of Heinrich VII Kuenring, Heinrich VIII Pulko, who died after 1340, was the father of Anna, the wife of Heinrich Streun zu Schwarzenau. This couple has to be considered as possible donors of the glazing from an unknown castle chapel that is now in Nuremberg. Cf. *Die Kuenringer,* especially the genealogical tree at the end of the catalogue.

28. See Sailer, "Wiener Ratsbürger"; and Perger, "Simon Pötel."

29. Doblinger, "Die Herren von Wallsee," pp. 381–83. Ulrich was the last descendant of the branch of Wallsee-Drosendorf. Beginning in 1384, he was "Landeshauptmann" of Styria for a short time and his family prospered financially. His three heirs from the Wallsee-Enns branch, the brothers Rudolf I (d. 1405), Reinprecht II (d. 1422), and Friedrich V (d. 1408), are considered to have been the most prominent members of the family (ibid., pp. 307–29, 391–95).

30. Frodl-Kraft, "Postscriptum."

31. The term "Herzogswerkstatt" was originally coined by Kieslinger for a special group of sculptures. For the "Workshop Problem," see Françoise Robin, "L'artiste de cour en France: le jeu de recommendations et de liens familiaux (XIVe–XVIe siècles)," *Artistes, artisans et production artistique au Moyen-Âge,* ed. Xavier Barral i Altet, Colloque international, Université de Rennes, Haute-Bretagne, May 1983, 2 vols. (Paris, 1986), vol. 1, p. 470; Eva Frodl-Kraft, "Zur Frage der Werkstattpraxis in der mittelalterlichen Glasmalerei," in *Glaskonservierung, historische Glasfenster und ihre Erhaltung,* Internationales Kolloquium, Munich/Nuremberg, Oct. 1984 (Arbeitsheft 32 des Bayerischen Landesamts für Denkmalpflege) (Munich, 1985), pp. 10–22; English version: "Problems of Gothic Workshop Practices in Light of a Group of Mid-Fourteenth-Century Austrian Stained-Glass Panels," Corpus Vitrearum, U.S.A. Occasional Papers I, *Studies in Medieval Stained Glass* (Selected Papers from the XIth International Colloquium of the CVMA [New York, 1982]), pp. 107–23, esp. pp. 107–8, 116–17.

32. For the interchanging of figural elements, see Nigel Ramsay, "Artists, Craftsmen and Design in England, 1200–1400," in *Age of Chivalry: Art in Plantagenet England 1200–1400,* Jonathan Alexander and Paul Binski, eds., exhib. cat., Royal Academy of Arts (London, 1987), pp. 49–54. For Saint-Leonhard glass, see Jane Hayward, "Stained Glass before 1700 in American Collections: New England and New York" (Corpus Vitrearum Medii Aevi Checklist 1), *Studies in the History of Art* 15 (Washington, D.C., 1985), pp. 108–12, ill.

33. Ludwig Baldass, "Die Tafelmalerei," in Fritz Dworschak et al., *Die Gotik in Niederösterreich* (Vienna, 1963), pp. 81ff.

34. Bacher, *Glasgemälde in Steiermark,* pp. xxxviiiff., figs. 32–34; *Rationale Durandi* (Öst. Nat. Bibl., Cod. 2765), ca. 1385 to 1404–6. G. Schmidt ("Die Buchmalerei," in *Die Gotik in Niederösterreich,* exhib. cat. [Krems-Stein, 1963], pp. 93–114) takes it for granted that the work advanced in three stages: the first about 1385, the second in the early 1390s, the third about 1404–6; for the "Last Supper" (fol. 57v) he proposes "Master II," who already exhibits a later stage here "just before 1395"; idem, "Die Anfänge der Wiener Hofwerkstatt (ca. 1385–1405)," *Gotik in Niederösterreich* (Vienna, 1967), no. 82, pp. 149–52.

35. Otto Schmidt and Georg Swarzenski, *Meisterwerke der Bildhauer Kunst in Frankfurter Privatbesitz* (1921), vol. 1, no. 46, p. 15, figs. 46–48 (Virgin of the Annunciation, pendant of the angel in New York).

36. Österreichische Galerie, Vienna, Museum mittelalterlicher Kunst, Inv. 4901, *Kataloge I;* E. Baum, *Katalog des Museums mittelalterlicher österreichischer Kunst in der Orangerie des Unteren Belvedere in Wien* (Vienna, 1971), p. 25, no. 6, fig.

6; L. Schultes, "Der Meister von Grosslobming und die Wiener Plastik des schönen Stils," *Wiener Jahrbuch für Kunstgeschichte* 39 (1986), pp. 26-88, ills. 18, 25.

37. Professor Schmidt refers to both Italian Trecento sculptures and paintings displaying this perhaps related motif. Cf., for instance, Pittore Senese, triptych, Pienza, Museo della Cattedrale (Florens Deuchler, *Duccio* [Milan, 1984], p. 62); Giovanni Pisano, pulpit in Pistoia (Harold Keller, *Giovanni Pisano* [Vienna, 1942], pl. 52); Simone Martini, Orsini polyptich, Antwerp, Musées Royaux des Beaux Arts (Andrew Martindale, *Simone Martini* [Oxford, 1988], pl. x); Tommaso da Modena, fragment of an altar, Modena, Museo Civico (exhib. cat. [Treviso, Sta. Caterina, 1979], p. 173). I thank Professor Schmidt for his advice. In this connection, it is perhaps worth mentioning the small kneeling alabaster angel attributed to the Master of Rimini at The Cloisters (65.215.3). See William D. Wixom, "Medieval Sculpture at The Cloisters," MMAB 46, no. 3 (1988/89), p. 14, color ill. p. 15. Though not necessarily an Annunciation angel, and more elegant and obviously later than our two Austrian angels (Fig. 14), its general attitude betrays similar sources. The gesture of the arms, crossed in front of the body without touching it, might thus be seen as a sort of intermediary motif between the Italian and the Austrian type.

38. Jörg Oberhaidacher, "Westliche Einflüsse in der Österreich-ischen Malerei um 1400," unpublished paper delivered at a colloquium of the Austrian National Committee of the C.I.H.A. (1987), "Der Znaimer Altar." Dr. Oberhaidacher is preparing an article on the subject to be published in *Wiener Jahrbuch für Kunstgeschichte* (1990). I thank Dr. Oberhaidacher for having permitted me to study his paper before its publication.

39. Millard Meiss, *French Painting in the Time of Jean de Berry: The Late Fourteenth Century and the Patronage of the Duke* (London, 1967), text vol., pp. 107-18. The question of dating remains controversial and it is possible that some of the examples chosen for comparison are even later than the respective panels of our stained-glass group. See, for instance, the architectural framing of the Annunciation scene in the *Petites Heures* of the duke of Berry (Paris, Bibl. Nat., MS lat. 18014, dated "end of 14th century") in ibid., plate vol., pl. 94; or the Nativity of Christ, *Petites Heures*, fol. 58: Jean Porcher, *Medieval French Miniatures*, English trans. Julian Brown (New York, 1961), col. pl. LXIV, "about 1390."

40. Erwin Panofsky, *Early Netherlandish Painting* (Cambridge, Mass., 1953), vol. 1, pp. 95, 395 n. 4: "style of Broederlam's local following." The assertion of a provenance from the Chartreuse de Champmol in the catalogue of the Chevalier Mayer van den Bergh collection (pp. 15ff.) is unwarranted.

41. The naked Christ Child also appears in the *Très Belles Heures* as well as—already ca. 1360—in Bohemian painting: Meiss, *French Painting*, p. 130.

42. Bacher, *Glasgemälde in Steiermark*, pl. xi, figs. 300-521. The motifs were not developed at Strassengel but in the workshop of St. Stephen's Cathedral, Vienna; cf. Frodl-Kraft, *Glasgemälde in Wien*, pp. 12-14, figs. 36-40, 62-76; Maria am Gestade: figs. 140-43, 162-68, 188. For a general survey, cf. Eva Frodl-Kraft, "Architektur im Abbild, ihre Spiegelung in der Glasmalerei," *Wiener Jahrbuch für Kunstgeschichte* 17 (1956), pp. 7-13; Rüdiger Becksmann, *Die architektonische Rahmung des hochgotischen Bildfensters* (Berlin, 1967); Ernst Bacher, "Der Bildraum in der Glasmalerei des 14. Jahrhunderts," *Wiener Jahrbuch für Kunstgeschichte* 25 (1972), pp. 87-95. For the architectural motifs in French book illumination, see Charles Sterling, *La peinture médiévale à Paris* (Paris, 1987), vol. 1, pp. 69-103.

43. The two genealogical Hapsburg windows are no longer in situ. They are partly on display in the Historisches Museum der Stadt Wien. The glazing of the Ducal Chapel in St. Stephen's Cathedral (five windows), though of homogeneous disposition and certainly following a common program, shows different stylistic stages. The two genealogical windows represent the latest stage, which is stylistically very "modern," even in relation to developments in Western art. Yet in all likelihood the Hapsburg windows are slightly earlier than the entire group of stained glass we have dealt with here. For want of exact dates we must be satisfied with a rather general *terminus ante quem*: 1395 (death of Albrecht III). Frodl-Kraft, *Glasgemälde in Wien*, pp. 50-65, col. pls. 3, 4, figs. 79-101.

44. K. Stejskal ("Die Rekonstruktion des Luxemburger Stammbaums auf Karlstein," *Umèni* 26 [1978], pp. 535-62) denies the stylistic trustworthiness of the drawings in the two codices (Vienna ÖNB MS 8330 and Prague, Nat. Libr. AA 2015). Nevertheless, he stresses the decisive importance of the genealogical model in Karlstein for the stylistic development of the Vienna Hapsburg windows.

45. Bonnie Young, *A Walk Through The Cloisters* (New York, 1979), pp. 60-63.

46. I thank Dr. Jane Hayward of The Cloisters for the important information about the latest research on the Nine Heroes Tapestries (yet unpublished), in which they are called "South Netherlands, 1400-1410." They would thus be later than the Hapsburg windows, which of course would reverse the relation between the two works and introduce a new though somewhat strange point of view into the whole question.

Fig. 1. Effigy of a Lady (Margaret of Gloucester?), from the priory of Notre-Dame-du-Bosc, near Le Neubourg, Normandy, mid-thirteenth century, limestone, L. 86¾ in. (220.3 cm). The Metropolitan Museum of Art, The Cloisters Collection, 1953 (53.137) (photo: Museum)

Six Gothic Brooches
at The Cloisters

Katharine Reynolds Brown

In 1957, The Cloisters acquired six small brooches from John Hunt, the English dealer and collector. These pieces, ranging in date from the thirteenth to the fifteenth century, and in material from brass to silver and gold, have formed the nucleus for the growing collection of medieval jewelry that The Cloisters houses today. A chronological examination of these pieces will demonstrate some of the characteristic features of Gothic jewelry and some of the alterations of form and design that jewelry underwent in the Gothic period. It can be shown that not only changes in style of dress but also changes in social and economic conditions contributed to this evolution. It will also be possible to suggest something about the workshops where they were made and the persons who wore them.

The Cloisters is fortunate to have an effigy of a lady (probably Margaret of Gloucester, wife of the baron of Neubourg) from mid-thirteenth-century Normandy,[1] which serves as an excellent document of the dress and accoutrements of the period (Fig. 1). The lady is shown wearing a *cotte*, or long gown, with a decorated belt and mantle.[2] At her neck is a ring brooch, or *fermail*, set with six rectangular stones (the one in the lower part of the ring is now missing) that have traces of gilt and black paint (Fig. 2). It is probably meant to simulate a brooch similar to the fine gold example in the British Museum with cabochon gems—rubies alternating with sapphires—in settings which appear to have been cast integrally with the ring.[3]

The *fermail,* as it is often described in contemporary inventories, was the most common type of medieval brooch and was worn by both women and men in northern Europe throughout the thirteenth century.[4] It could be used to fasten a long woolen tunic at the neck, or used as a decorative clasp at the neck, as is demonstrated by The Cloisters effigy of Margaret of Gloucester. The inscriptions on such gold

Fig. 2. Detail showing *Fermail*

brooches as the one found at Writtle, Essex, indicate that this type of jewelry might be a lover's gift to a lady.[5]

The *Livre des Métiers* of Étienne Boileau, written in 1260, reveals that a ring brooch, such as that worn by Margaret of Gloucester or the British Museum example, was the product of secular goldsmiths organized in corporations that regulated workshop practice and quality of production.[6] Two distinct corporations of artists, working in iron, or copper and latten, followed essentially the same regulations as the goldsmiths but did not have the right to work in gold or silver. The existence of these several corporations and their size—there were thirty-two members registered in 1292, half that number in 1315—suggests that the number of brooches must have been considerable. It is thought that the *fermaux* made in brass and the *boucles* made in copper and latten were made for the bourgeoisie, even though the first inventories that confirm this assumption date from the mid-fourteenth century.[7]

From reading the *Livre des Métiers*, the several entries in the glossaries, and the painstaking description of Theophilus on the making of coarse brass, or *aurichalcum*, we can document the importance of "gold colored metals"—probably bronze, brass, copper, or latten.[8] As Victor Gay concluded, the most appreciated of these metals was that which most closely approximated the color of gold.[9] A small, flat brass example of a ring brooch formerly in the Hunt collection provides us with a fine product of the aesthetic pleasure in "gold colored metals"—which we can infer were coveted by the bourgeoisie (Fig. 3)—emulating the more costly pure gold that had traditionally been the exclusive purview of the aristocracy and the church. The brooch is decorated by an inner circular ring of small punched circles executed as close together as possible (in a manner which would have met with Theophilus' approval).[10] Although it cannot be localized, its small size and simple, flat decoration place it in the early thirteenth century. These formal factors also make it easy to see the relationship between the function of the medieval ring brooch—the pin was held in place by the pull of the material—and its predecessor, the penannular brooch.[11] A variation in the form of the plain, flat ring brooch—an octafoil in bronze—is exemplified by another example formerly in the Hunt collection and now in The Cloisters (Fig. 4). Its form may be compared

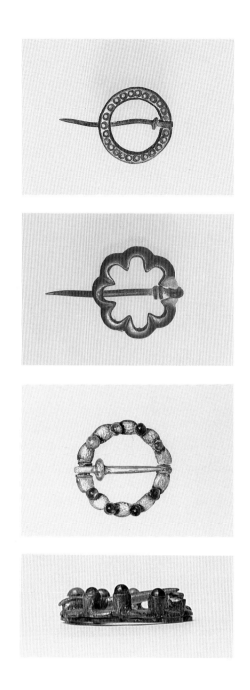

Fig. 3. Ring brooch, Western European, thirteenth century, brass, Diam. ⅞ in. (2.2 cm). The Metropolitan Museum of Art, The Cloisters Collection, 1957 (57.26.5) (photo: Museum)

Fig. 4. Ring brooch, octafoil, Western European, thirteenth century, bronze, Diam. 1 in. (2.54 cm). The Metropolitan Museum of Art, The Cloisters Collection, 1957 (57.26.6) (photo: Museum)

Fig. 5a. Ring brooch, English or French, probably last quarter of the thirteenth century, silver, cabochons, and glass paste, Diam. 1⅛ in. (2.9 cm). The Metropolitan Museum of Art, The Cloisters Collection (57.26.3) (photo: Museum)

Fig. 5b. Side view

to a hexafoil gold brooch, in the Victoria and Albert Museum, that is attributed to the thirteenth century.[12]

One of the most interesting of the *fermaux* from the Hunt collection is the silver example set with eight glass paste cabochons in red, blue, green, and amber (Fig. 5a).[13] Each cabochon is set in a rather high cylindrical setting, which is soldered to the ring (Fig. 5b). Between the settings of the cabochons are mottled or grainy sections of silver which, according to John Cherry, was a common decorative motif on late-thirteenth-century English

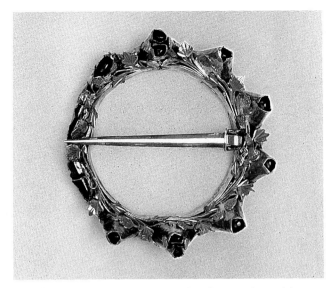

Fig. 6. Gold ring brooch set with rubies and sapphires, French, thirteenth century, Diam. 2⅛ in. (5.4 cm). London, Victoria and Albert Museum (photo: courtesy of the Trustees of the Victoria and Albert Museum)

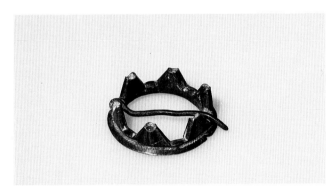

Fig. 7. Ring brooch with high collets, Western European, fourteenth century, bronze, Diam. 1¼ in. (3.2 cm). The Metropolitan Museum of Art, The Cloisters Collection, 1957 (57.26.4) (photo: Museum)

gold brooches.[14] A similar brooch in bronze in the Musée d'Antiquités, Rouen, has been dated 1300 or a little earlier.[15] Although the cylindrical settings of the cabochons of this brooch are less accomplished in execution, their high collets bring to mind the exquisitely fine gold settings of the pearls, emeralds, and balas rubies of the gold mount surrounding the gold lid of the crystal saltcellar recently acquired by The Cloisters and attributed to Paris in the mid-thirteenth century.[16] The value of the comparison is that it shows that this type of setting was in use in Paris by at least that date, somewhat earlier than the mottled sections appearing on English gold brooches. Thus the combination of the two techniques—of surface decoration and of settings—on The Cloisters brooch places it in the English or French milieu, probably in the last quarter of the thirteenth century.

Several gold ring brooches with high pyramidal shaped collets—of which the Victoria and Albert provides a well-known example—have often been dated to the period around 1300, but have recently been shown by Ronald Lightbown to belong to the thirteenth-century tradition.[17] The Victoria and Albert brooch, which is gold alternating with rubies and sapphires in high collets and with tiny gold leaves decorating the surface of the ring and entwining the collets, is clearly an aristocratic piece (Fig. 6). The fact that it is set with rubies and sapphires recalls the ring brooch that fastened the mantle of King Edward I, which was found when his tomb was opened in Westminster Abbey in the eighteenth century.[18]

A bronze brooch formerly in the Hunt collection represents a very simplified version of the Victoria and Albert piece. It has six high pyramidal-shaped collets on which the points have irregular openings that once supported cabochons, all of which are now missing (Fig. 7). An engraved zigzag border encircles the outer edge of the collets. Two more elaborate bronze ring brooches in the Musée d'Antiquités, Rouen, have similar pyramidal-shaped collets.[19] Ronald Lightbown has suggested that these examples in bronze may represent the taste of a conservative element in society and may therefore be slightly later in date than the aristocratic examples.[20]

It is not until the first half of the fourteenth century that we have written proof of the wealth of the bourgeoisie. An inventory of the Jurisconsul of Valence of 1348 tells us that his wife had many

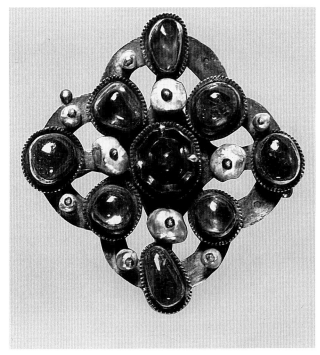

Fig. 8a. *Fermail,* probably Paris or the Rhenish region (found at Colmar), second quarter of the fourteenth century, silver-gilt, precious stones, and pearls. Paris, Musée National des Thermes et de l'Hôtel de Cluny (photo: courtesy of the Musées nationaux)

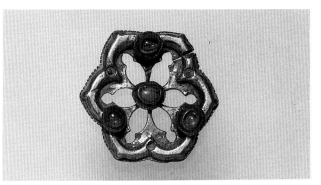

Fig. 9. Ring brooch, Western European, first half of the fourteenth century, silver, turquoise, and red paste with Gothic tracery, Diam. 1⅓ in. (3.4 cm). The Metropolitan Museum of Art, The Cloisters Collection, 1957 (57.26.1) (photo: Museum)

Fig. 8b. Reverse of Fig. 8a (photo: courtesy of the Musées nationaux)

Fig. 10a. Cluster brooch, Franco-Flemish, mid-fifteenth century, gold, pearls, diamond, and emerald paste, L. 1⅛ in. (2.9 cm), W. ¹⁵/₁₆ in. (2.4 cm). The Metropolitan Museum of Art, The Cloisters Collection, 1957 (57.26.1) (photo: Museum)

Fig. 10b. Reverse

rings and garments trimmed with silk, silver buttons, pearls, and gold embroidery. There were two large coffers covered with material and garnished with locks in which jewels and other precious objects were kept.[21] Thus it is not surprising to learn that the rich Colmar hoard now in the Cluny Museum has been associated with a wealthy bourgeois.[22] The treasure was found in 1863 in the wall of a house situated in the rue des Juifs in Colmar and can be dated, by the coins and bracteates found with it, to the period between 1342 and 1353, when one of the major Jewish persecutions occurred. It is thought, therefore, that it was hidden in Colmar by a member of the Jewish community.[23]

The most elaborate of the three *fermaux* found with the treasure consists of an elegant pierced design in silver-gilt in the shape of a rose window with pearls and precious stones mounted on the obverse (Figs. 8a,b).[24] In 1951 a somewhat comparable piece—although with claw settings securing the precious stones to an openwork base—was found with thirty rings, brooches, a belt, and two thousand coins in the arch of a ceiling vault of a room which served, before World War I, as the town wine cellar of Münster in Westphalia. The coins in the Münster hoard date the treasure to 1348, so that it, too, is thought to have been hidden in connection with the Jewish persecution, possibly, according to Johann Fritz, by a Jewish pawnbroker.[25]

The Colmar and Münster examples were both probably worn by wealthy Jewish members of the bourgeoisie in the second quarter of the fourteenth century, when this type of *fermail* was very much in vogue.[26] Indeed a much less pretentious example from the Hunt collection was no doubt owned by a perhaps less prosperous member of the merchant class (Fig. 9).[27] Whereas the Colmar jewel and to a lesser extent the Münster piece are designed to conceal the pattern of the base, in The Cloisters example the rose-window design of the base is emphasized: the three red paste cabochons alternate with three punched circles to mark the six spandrels of the arches of the hexafoil. The center of the piece is marked by a turquoise. It combines semiprecious stones to achieve a palette of red and blue similar to that of the golden ring brooch in the Victoria and Albert Museum or the brooch of Edward I. All of the settings of The Cloisters piece have fine striated borders similar to those on the *fermail* found at Colmar in the Cluny Museum (Figs. 8, 9) and on

414

a number of other pieces, including a *fermail* of this same type in the Bargello, Florence, and a group of rings also from the Colmar treasure. As has been noted by Elisabeth Taburet, this establishes a date in the first half of the fourteenth century for the Cluny *fermail*, but since the propensity for striated settings seems to have been widespread from Paris to the Rhenish region, it is not possible to localize the origin of the piece.[28] Thus the origin of The Cloisters piece also cannot be more precisely defined at this time.

During the course of the fourteenth century, precious stones became more abundant in western Europe as a result of the Italian cities' trade with the East, and, as we have seen, the forms of jewelry started to become freer and more sculptural. In the mid-fourteenth century, fashions in dress changed: women wore fitted dresses of silk and brocade, while men wore thigh-length fitted coats with buttons and padded shoulders, hose, and fanciful hats.[29] It was at this time that the cluster brooch became a predominant form. These brooches were made of gold set with pearls around a central sapphire, ruby, or other precious stone. A beautiful contemporary example is afforded by the exquisite half-figure of St. Catherine in *émail-en-ronde-bosse* in The Metropolitan Museum of Art: the figure wears a brooch consisting of a ruby surrounded by pearls.[30] Cluster brooches developed into brooches with enameled figures in the center in the first half of the fifteenth century and culminated in the mid-fifteenth century with brooches such as the one in the Imperial Treasury of Vienna showing a pair of lovers enameled in white set in a wreath of gold.[31] The ground is filled in with minute flowers and foliage in high relief and between the heads of the lovers is a triangular diamond and below it a cabochon ruby. As noted by William D. Wixom, the central medallion of a series of twelve, now mounted with two modern connecting chains, in the Cleveland Museum of Art was probably also made as one of these cluster brooches. It presents an enameled female figure in *émail-en-ronde-bosse* wearing a white gown and a green diadem and having red lips, black eyes, and gold hair and fingers. The figure is mounted on gold leaves surrounded by a wreath of six gold leaves with serrated edges interspersed with six clusters of pearls in groups of three each.[32]

By the middle of the fifteenth century, low-necked dresses came into fashion giving rise to the

Fig. 11a. Cluster brooch, Flemish or English (found in the Meuse), mid-fifteenth century, gold, white enamel, diamond, and pale ruby, Diam. 1³/₁₆ in. (3 cm). London, The British Museum (photo: courtesy of the Trustees of the British Museum)

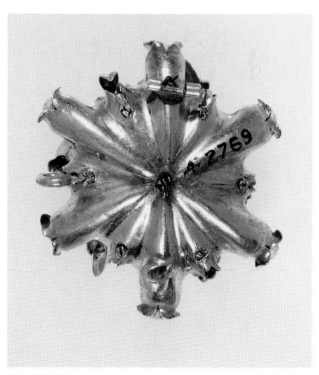

Fig. 11b. Reverse

415

Fig. 12. Petrus Christus, *St. Eligius,* Flemish, Bruges, 1449. The Metropolitan Museum of Art, The Robert Lehman Collection, 1975 (1975.1.110) (photo: Museum)

design of chains and pendants.[33] Just such a pendant, formerly in the Hunt collection, is in The Cloisters (Figs. 10a,b).[34] It is of gold set with five pearls around a central emerald with a variety of small gold leaves emanating from it. This is topped by a pyramidal setting containing a diamond chip surrounded by leaves. Four gold letters, which have been variously read but unanimously interpreted as amatory in meaning, are suspended from the pendant. The letters have usually been read as AMOR, but only the M and O are indisputably clear.[35] Without the letters,[36] there is a clear relationship between The Cloisters pendant and a number of cluster brooches, including—in spite of its larger size—the Vienna brooch with lovers in white enamel. This group of brooches has, in general, pearls set on pins surrounding a central setting and a small setting above, usually containing a diamond, which begins to appear in jewelry of this period for the first time. Most of them have gold leaves. There seem to be roughly two basic types of cluster brooches: those with enameled figures in the center and those without enamel. As noted by Vera Ostoia, all of the related pieces are circular in construction; a gold tube often serves as the main structural element.[37]

The Cloisters pendant is especially close to a brooch found in the river Meuse in the nineteenth century and now in the British Museum (Figs. 11a,b).[38] It has a pale ruby surmounted by a diamond forming the central axis, which is encircled by radiating buds and flowers. The center of each bud is formed by a ball of white enamel. As noted by John Cherry, the brooch in the British Museum is similar to one of a group of three from the Meuse, which, along with one formerly in the Figdor collection and the pendant in The Cloisters Collection, are closely related in technique.[39] However, closest in technique to The Cloisters piece is the back of a roundel from the hoard discovered in 1966 at Fishpool, Nottinghamshire, one of the few medieval finds datable—on the basis of the coins found with it—to the mid-fifteenth century.[40] It has a gold plate decorated with a six-petaled flower, in the middle of which can be seen the point where the central axis of the brooch is affixed to the back plate. Cherry notes that this manner of construction is unusual and that it does not seem to be known prior to the mid-fifteenth century in England.

The three brooches from the Meuse have often been described as Burgundian, but it has also been suggested that they may have been made in Flanders.[41] Cherry notes that a comparison of the Fishpool roundel and the Meuse brooches with Flemish manuscripts from Bruges and Ghent—he cites the Book of Hours made for Louis Quarré (Douce MS 311, fol. 29v) showing jewelry in the borders—indicates many parallels with Flemish jewelry and suggests that jewelry in England and Flanders developed along similar lines, although they are "not sufficient close to suggest with certainty that the jewellery was made abroad."[42] On the other hand, foreign coins found in the Fishpool hoard allow for the possibility that some of that jewelry, too, might have been imported to England. The Cloisters pendant, therefore, is also difficult to localize. Although traditionally attributed to France,[43] aspects of its appearance and construction can be compared with both the brooch from the Meuse and the Fishpool roundel.

Two cluster brooches of the same general type as the Hunt brooch appear in the Petrus Christus painting of St. Eligius, patron of goldsmiths, in the Lehman Collection (Fig. 12).[44] Signed and dated 1449, the painting shows a young couple standing with St. Eligius, who is seated at what appears to be the sales counter of a contemporary goldsmith's shop on a town street. Credibility to the tradition that the painting was commissioned by a goldsmiths' guild to promote its trade is given by the depiction of all manner of vessels, buckles, and beads on the shelves to the right, and coins and stacked brass weights on the counter. Two of the three brooches depicted in the center on the wall appear to be cluster brooches of the same general type as the Hunt brooch (Fig. 10a). This fifteenth-century portrayal of a goldsmith's shop is an invaluable document of individual types of objects. Significantly, too, they all appear to be "ready-made" works intended for use in domestic settings or for personal adornment by members of the affluent merchant class. As early as 1391, Isabel Bonnebroque, a bourgeoise of Douai, willed "her best crown of gold, her best *fermail* of gold and her best belt," among her many other rich possessions, to William Boinebrocque, confirming the fact that by the fifteenth century, gold jewelry was owned and worn by the wealthy bourgeoisie in Flanders.[45] Thus it is possible to propose that the gold cluster brooch, like the other brooches that we have examined, was also commissioned and worn by a member of this

class. When seen in chronological sequence, these small brooches at The Cloisters show significant indications of the changing status and taste of the bourgeoisie in the course of the Gothic period.

NOTES

1. I am indebted to Lisa Nolan for retrieving this information for me. It is from the collections of Martin le Roy, Versailles, and Jean Larcade, Nice. See William D. Wixom, "Medieval Sculpture at The Cloisters," *MMAB* 46, no. 3 (Winter 1988–89), pp. 58, 59 (reprod.), 64 (bibl.).

2. Joan Evans, *Dress in Medieval France* (Oxford, 1952), p. 16, pl. 15.

3. *Jewellery through 7000 Years*, exhib. cat., British Museum (London, 1976), no. 264; and John Cherry, "Jewellery," in *Age of Chivalry: Art in Plantagenet England 1200–1400*, Jonathan Alexander and Paul Binski, eds., exhib. cat., Royal Academy of Arts (London, 1987), no. 642.

4. J. P. Migne, *Encyclopédie Théologique*, vol. 27, *Dictionnaire d'orfèvrerie, de gravure et de ciselure chrétiennes* (Paris, 1856), "fermail," col. 730; and Joan Evans, *A History of Jewelry 1100–1870* (Boston, 1970), pp. 46–47.

5. John Cherry, "Jewellery," p. 176, and no. 644: Inscription reads: +IEO : SUI : FERMAIL : PUR : GAP [*sic*] : DER : SEIN and +KE : NU : SVILEIN : NIMETTE : MEIN ("I am a brooch to guard the breast, that no rascal may put his hand thereon"). See also ibid., no. 42, for a lover's inscription.

6. Étienne Boileau, *Le Livre des Métiers*, René de Lespinasse and Françoise Bonnardot, eds. (Geneva, 1980), pp. li, 79–81 (Titre XLII), pp. 50–52 (Titre XXII). See also Paul LaCroix and Ferdinand Seré, *Histoire de l'orfèvrerie-joaillerie et des anciens de communautés et confréries de l'orfèvres-joailliers de la France et de Belgique* (Paris, 1850), pp. 38–39, 40.

7. Victor Gay, *Glossaire Archéologique* (Paris, 1897), vol. 1 (A–G), "boucle" and "fermail"; and Marguerite Gonon, *La Vie Quotidienne en Lyonnais d'après les testaments* (Paris, 1968), p. 158.

8. Boileau, *Livre des Métiers*, pp. XLIII–XLIX, n. 3; Gay, *Glossaire*, vol. 1, "Archal," "Airain"; Léon De Laborde, *Glossaire Français du Moyen Âge* (Paris, 1872), pp. 358 ("Léton"), 145 ("Aurichalcum"); and *Theophilus, On Divers Arts*, trans. John G. Hawthorne and Cyril Stanley Smith (Chicago, 1963), p. 143 (chap. 66: "Making Coarse Brass" [or Aurichalcum]).

9. Gay, *Glossaire*, p. 87.

10. *Divers Arts*, p. 149 (chap. 73: "Punched Ground Work").

11. Joan Evans, "Wheel-Shaped Brooches," *Art Bulletin* 15 (1933), p. 197; and Léon Coutil, "Broches du Musée d'Antiquités de Rouen," *Bulletin de la Société Préhistorique Française* (1938), pp. 105–8.

12. Cherry, "Jewellery," no. 643.

13. Timothy B. Husband, *The Secular Spirit*, exhib. cat., The Metropolitan Museum of Art (New York, 1975), p. 88, no. 93a.

14. Cherry, "Jewellery," no. 650.

15. Coutil, "Broches du Musée de Rouen," pp. 106, no. 16 (ill.), 108.

16. William D. Wixom, "A Saltcellar of Crystal and Gold of the Thirteenth Century in The Metropolitan Museum of Art," *Hommage à Landais* (Paris, 1987), pp. 30–35.

17. Gerome Pinchon, *Catalogue des objets antiques du moyen âge et de la Renaissance* (Paris, 1897), p. 4, no. 173, pl. 29; Evans, *History of Jewelry*, p. 57; Ernst A. and Jean Heiniger, *The Great Book of Jewels* (New York, 1974), p. 225; Ronald Lightbown, *Catalogue of the Medieval Jewellery in the Victoria and Albert* (London, 1990). I am indebted to this well-known scholar for sharing his views with me, particularly concerning this group of brooches, before his catalogue went to press.

18. Cherry, "Jewellery," p. 176.

19. Coutil, "Broches du Musée de Rouen," p. 106, nos. 21, 34 (dated 1300 or earlier).

20. Lightbown, *Catalogue*.

21. "Inventaire des biens mobiliers et immobiliers d'un jurisconsul de Valence 1348," *Recueil d'anciens inventaires*, ed. Brun-Durand (Paris, 1896), vol. 1, pp. 383–85.

22. Elisabeth Taburet, "Le Trésor de Colmar," *La Revue du Louvre* 34 (1984), p. 98.

23. Ibid., pp. 89, 96–97.

24. Ibid., p. 91; idem, *Les Fastes du Gothique, le siècle de Charles V*, exhib. cat., Grand Palais (Paris, 1981), pp. 242–45, see esp. p. 243 c; and J. M. Lewis, "The Oxwich Brooch," *Jewellery Studies* 2 (1985), pp. 23–28, illus. p. 26.

25. Johann M. Fritz, *Goldschmiedekunst der Gotik in Mitteleuropa* (Munich, 1982), pp. 230–31, and fig. 314.

26. Taburet, "Trésor de Colmar," p. 91.

27. Gay, *Glossaire*, vol. 1, "Boucle" (the Hunt piece was published as a "boucle"); and Husband, *The Secular Spirit*, p. 88, no. 93b.

28. Taburet, "Trésor de Colmar," p. 92.

29. Katharine R. Brown, "Gems and Jewelry," *Dictionary of the Middle Ages* (New York, 1985), vol. 5, p. 380.

30. Evans, *History of Jewelry*, pp. 61–62. For St. Catherine (17.190.905), see also Bonnie Young, "A Jewel of St. Catherine," *MMAB*, n.s., 24 (June 1966), pp. 316–24.

31. Evans, *History of Jewelry*, pp. 62–63; Hanns Swarzenski and Nancy Netzer, *Catalogue of Medieval Objects in the Museum of Fine Arts* (Boston, 1986), p. 152, fig. 25, for illustration of the Vienna brooch; see p. 152, A3, for discussion of nineteenth-century copies of these enamel brooches by Salomon Weiniger.

32. William D. Wixom, *Treasures from Medieval France* (Cleveland, 1967), pp. 252–53 (ill.), 376 (bibl.), no. VI-19.

33. Brown, "Gems and Jewelry," p. 381.

34. A small loop for suspension is attached to the back of the pendant, as is a recently added pin. A complete analysis of the structure of this piece is in a conservation report by Pete Dandridge in the files of The Cloisters.

35. *Catalogue der Kunst-Sammlungen des Herrn Eugen Felix in Leipzig* (Cologne, 1886), no. 460 (with only three letters,

read as GMD); Husband, *The Secular Spirit*, p. 89, no. 96; Vera K. Ostoia, *The Middle Ages, Treasures from The Cloisters and The Metropolitan Museum of Art, Los Angeles County Museum of Art and The Art Institute of Chicago* (New York, 1970), p. 249, no. 118 (letters read as AMOR).

36. Based on Pete Dandridge's technical examination (see note 33 above), the letters appear original.

37. Ostoia, *Middle Ages*, no. 118. I am indebted to William D. Wixom for searching out his photographs of the reverse of the Cleveland medallion which is technically (as well as historically) another candidate for this group of brooches.

38. Clifford Smith, *Jewellery* (London, 1908), p. 143; *Jewellery through 7000 Years*, p. 162, no. 269b; and John Cherry, "The medieval jewellery from the Fishpool, Nottinghamshire, hoard," *Archaeologia* 104 (1973), pp. 307–21, esp. pp. 315–16.

39. Cherry, "Fishpool," pp. 315–16, and 316 n.1 for bibl. For the Figdor brooch, see Marc Rosenberg, "Goldschmiede Arbeiten aus dem Sammlung Figdor," *Kunst und Kunsthandwerke* (1911), p. 329, pl. I.

40. Cherry, "Fishpool," p. 308, and pl. LXXXVIb.

41. Erich Steingraber, *Alter Schmuck* (Munich, 1956), English trans. *Antique Jewelry* (London, 1957), pp. 55–58; Smith, *Jewellery*, p. 443, pl. XX, nos. 10–12 ("Flemish-Burgundian"); and *Jewellery through 7000 Years*, p. 162 ("Northwest European").

42. Cherry, "Fishpool," p. 317.

43. Husband, *The Secular Spirit*, p. 89, no. 96; and Ostoia, *Middle Ages*, p. 249, no. 118.

44. Robert Lehman, *The Philip Lehman Collection of Paintings* (New York, 1928), no. LXXXII; George Szabo, *The Robert Lehman Collection, A Guide* (New York, 1975), pp. 79–81; and Peter H. Schabacker, *Petrus Christus* (Utrecht, 1987), pp. 86–91, cat. 6, fig. 6, for the fullest and most recent discussion and bibliography.

45. M. Le Chanoine Dehaisnes, *Documents et Extraits divers concernant l'histoire de l'art dans la Flandre, l'Artois et le Hainaut avant le XVème siècle* (Lille, 1886), p. 684.

Fig. 1. St. Matthew writing (before text from Luke), *Belles Heures,* 1405-8, fol. 22. The Metropolitan Museum of Art, The Cloisters Collection, 1954 (54.1.1) (photo: Museum)

The Beginnings
of the *Belles Heures*

John Plummer

Among the many accomplishments of Millard Meiss and Elizabeth Beatson in their studies of the *Belles Heures* (Col. pl. 8) was their recognition of the individuality and special significance of that manuscript.[1] One of the glories of The Cloisters, it had been seen for too long as a mere stepping-stone toward the Limbourg brothers' masterpiece, the *Très Riches Heures.*[2] Meiss rightly stressed the brothers' innovations, especially those of the eldest brother, Paul, innovations in form, in new ways of "telling . . . traditional stories," and in the originality of its luminous colors.[3] Another of Meiss's achievements was his reconstruction of the sequence of work on the book, for it was not painted in its present order from front to back. He recognized that the plan changed and expanded as work proceeded and that all of the grand pictorial cycles painted in self-contained gatherings were not part of the original plan; rather, they belonged to a late phase of the project and were inserted after much of the illumination was already done.

The purpose here is not to reconsider and certainly not to revise the conclusions of Meiss, but rather to concentrate on the neglected beginnings of the manuscript and its illumination. Its first three gatherings are all late. These include the ex-libris of Jean de Berry written by his secretary, the twelve leaves of the calendar, and the seven leaves with scenes from the life of St. Catherine. The ex-libris was written after the book was complete; the calendar was the last portion to be written and illuminated, as was the normal practice in French Books of Hours; and the Catherine cycle was a late addition, as its style and decoration prove.

Only in the fourth gathering does the text proper begin, and at this point the miniatures were probably also begun. At one time I argued that this gathering too might have been decorated later, because of some decorative elements and because

Fig. 2. Aracoeli, *Belles Heures,* fol. 26v.

Fig. 3. Genesis XXXIII, XXXIV, *Moralized Bible,* ca. 1403. Paris, Bibliothèque Nationale, MS fr. 166 fol. 10v (photo: Bibliothèque Nationale)

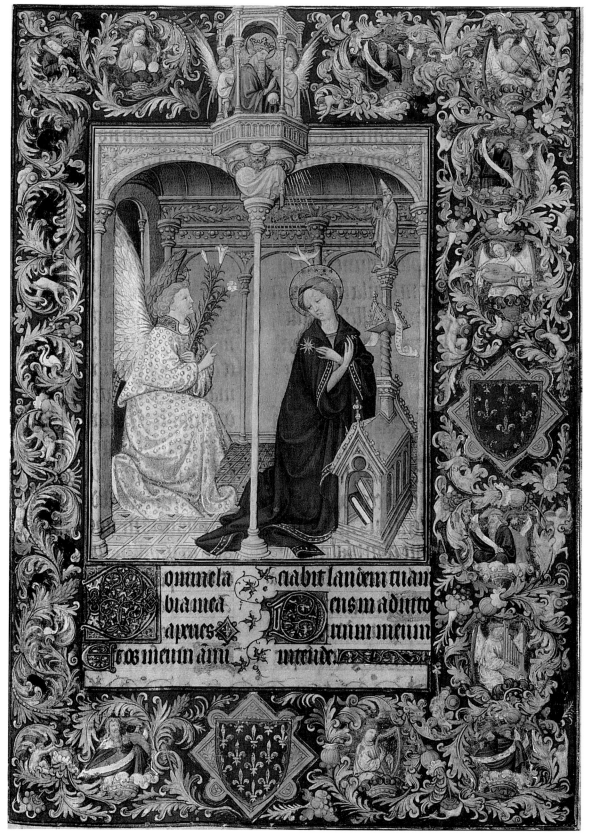

Fig. 4. Annunciation, *Belles Heures,* fol. 30.

of the alternating blue and red rubrics, features otherwise found only later in the project.[4] In spite of these anomalies, it now seems more likely that the writing and illuminating of the book began at this point, with the Gospel selections (Fig. 1) and the two common prayers to the Virgin known from their first words as the *Obsecro te* and *O intemerata* (Fig. 2).

This is the normal way for French Books of Hours to begin, although none of the five other Horae made for Jean de Berry starts in this way, except for the later *Très Riches Heures*, whose text is a somewhat revised version of the *Belles Heures*. The same is true in general for the various parts of the text that I have tested: calendar, litany, petitions, suffrages, various prayers, the Hours of the Virgin, and the Office of the Dead. All are quite unrelated to the duke's other Horae, with the occasional exception of the *Très Riches Heures*. While I have not yet found the precise textual model for the *Belles Heures*, it has significant connections with only one other manuscript known to me, a Book of Hours in the Walters Art Gallery illuminated by the Luçon Master, a number of whose works were owned by Jean de Berry.[5] It shares many features with the *Belles Heures* in its litany and petitions, even sharing two petitions not found together in any of the other six to seven hundred manuscripts I have studied, and its calendar is decidedly the closest yet recorded.[6] Even in the spelling of names the two often agree against all other recorded calendars. Although this was surely not the model copied by the scribe of the *Belles Heures*, a very similar text of much the same date must have been used. The Walters manuscript was dated by Millard Meiss on stylistic grounds to about 1405, the same year in which the *Belles Heures* was probably begun, according to Meiss, and was finished by 1408 or early 1409.

While in text and format the other Berry Hours are atypical and presumably the result of personal choices, the *Belles Heures* is a more or less standard Parisian production. Indeed, in a recent conversation about the Berry texts, François Avril characterized that of the *Belles Heures* as "banal." This conventionality suggests that its texts were relatively unimportant and that it was commissioned primarily as a vehicle for the paintings of the Limbourg brothers. They had very recently—within a year or two at most—come into the duke's employ. If all

Fig. 5. Annunciation, border detail, *Belles Heures*, fol. 30.

this is true, it further suggests a certain amount of hurry in providing such a vehicle.

Mostly small spaces were left for miniatures by the scribe at the beginning. He allowed for just one large miniature, the now-missing St. John on Patmos, which, some years ago, I reconstructed from the offset on the blank facing page.[7] Otherwise, only short, one-column gaps were left for the other three Evangelists and for the double scene of Aracoeli, depicting the vision of the Virgin and Child seen by Emperor Augustus, which illustrates the second prayer to the Virgin, the *O intemerata*. The first

425

prayer, the *Obsecro te*, is not illustrated at all. Such small miniatures for the three Evangelists, though not rare, are unusual in contemporary Parisian Books of Hours, at least the more elaborately illustrated ones. Their choice here emphasizes the modesty of the original plan. Perhaps this size was chosen, because it is almost exactly the same as that used by the Limbourgs for scenes in the Moralized Bible on which they had been employed until the death in 1404 of Philip the Bold, duke of Burgundy and brother of Jean de Berry (Fig. 3).[8]

These small miniatures are followed by a series of eight large ones, each illustrating one of the hours into which the Hours of the Virgin were divided. The series begins with the Annunciation (Fig. 4), but it is not certain that it was painted first, for, while it shares many features with the paintings that immediately follow, its figures seem slightly more advanced. Certainly its present border is later. Traces of a gold bar that was part of an earlier decoration can be seen under the present border (Fig. 5). A bit still shows at the left and below, while paint has flaked off where the bar was scraped away on the right. What the rest of the original border was like is quite uncertain, but it probably consisted of baguettes and vine leaves, such as those enframing the next miniatures. Even without this archaeological evidence, the contrast between the thin, transparent, luminous tones of the Annunciation and the denser, more saturated colors, especially the blue, of the richly ornamented border would imply that it was painted at a different stage.

The miniature itself is exceptional among contemporary Annunciations in many ways, among them, in the placement of God in a balcony or turret, in the posture and gesture of the Virgin, and in the angel carrying a stalk of lilies. The position of God, unprecedented to my knowledge, may derive from a fourteenth-century composition, such as the one used around 1385 by the Parement Master in the *Très Belles Heures de Notre-Dame* of Jean de Berry (Fig. 6).[9] There, God appears in an upper window, above Gabriel. The rays radiating from God and the announcement of the angel come from the same direction along similar paths, converging on the seated Virgin. In the *Belles Heures*, on the other hand, the three participants are disposed in a strict, symmetrical triangle, with each figure isolated in its own compartment. The gestures of all three are restrained and withdrawn into the silhouettes of their bodies, giving special point to the slight projection of the angel's announcing finger and the blessing fingers of God. Similarly, the tip of the Virgin's drapery breaks out of her compartment, just touching the garment of Gabriel and thus communicating with the angel in a way that her glance does not.

These qualities of isolation, compartmentalization, and self-containment, combined with a rigid planar geometry, replace the drama of action and response in the usual Annunciation.[10] Instead, the scene is pervaded by an unworldly calm, an almost eternal permanence—static, stable, and unmoving. These qualities are not found in the usually crowded, often tumultuous, always dramatic narratives of the Limbourgs' earlier Moralized Bible (Fig. 3), nor do they occur in their later Annunciation in the *Très Riches Heures* (Fig. 7). Neither are they characteristic of the *Belles Heures* as a whole, though they are of the four following miniatures. These miniatures belong to a brief, but special moment in the development of the brothers.

The following Visitation (Fig. 8), though a quite different subject, has a similar sense of isolation. It contains only two figures, the Virgin and Elizabeth; none of the often-present secondary figures—Joseph, maids, or angels—are included. Even these two are drawn farther apart than usual, but they are further separated by the Virgin's aloof stance and modest display of her pregnancy and by the effort of Elizabeth to bridge the gulf between them. Their difference is echoed in the two cities in the distance. The one above the Virgin's head, its single central tower and strict symmetry reflecting her posture, is placed exactly on her axis, while the town at the right with its outreaching wall repeats the gesture of Elizabeth. They are further contrasted by the three-quarters view of the Virgin and the strictly profile view of Elizabeth, emphasized by her falling cloak, which appears strangely frontal. The green of the ground seems an emanation of the Virgin's dress, tying her to the earth; at the same time the color surrounds and isolates Elizabeth. Yet both figures are bound together by the enclosing triangular hill, which binds them by repeating their shapes. Even the interlocking of the ends of their drapery links them more intimately than Elizabeth's outstretched arms. Both drapery and arms break through the painting's central axis, which otherwise creates a barrier between them.

Flanking them are two of the most surprising

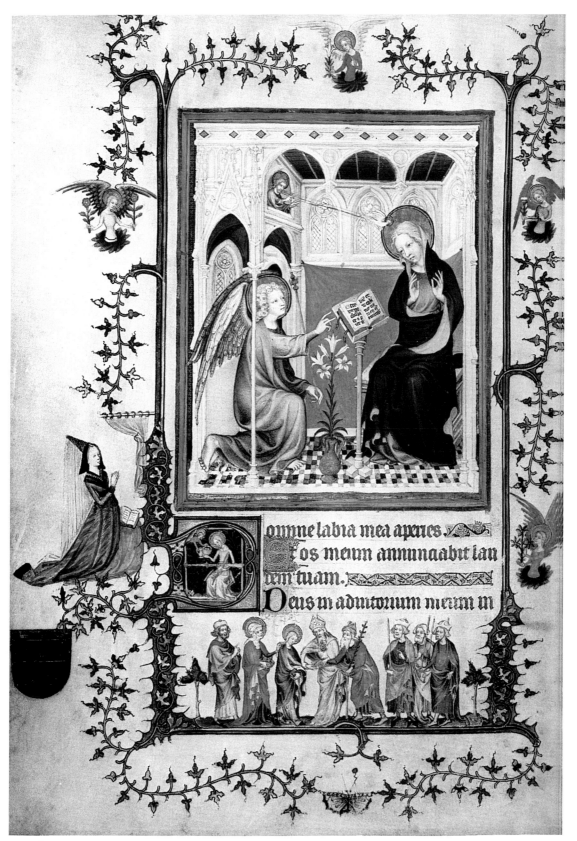

Fig. 6. Annunciation, *Très Belles Heures de Notre-Dame,* ca. 1385. Paris, Bibliothèque Nationale, MS nouv. acq. lat. 3093, p. 2 (photo: Bibliothèque Nationale)

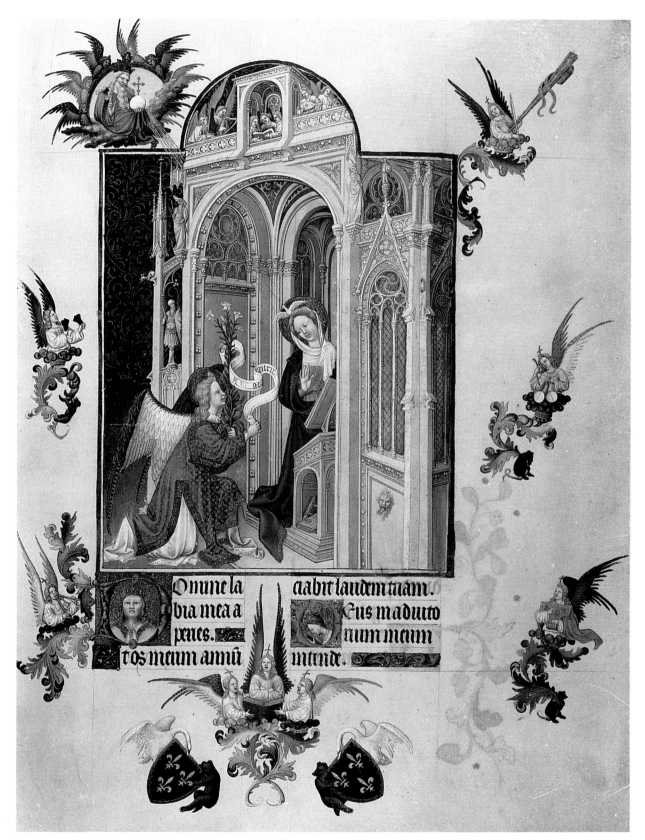

Fig. 7. Annunciation, *Très Riches Heures,* ca. 1415. Chantilly, Musée Condé, MS 65, fol. 26 (photo: Giraudon/Art Resource, N.Y.)

Fig. 8. Visitation, *Belles Heures,* fol. 42v.

Fig. 9. Arterial System of Pregnancy, Persian, ca. 1400 (detail). London, Library of the India Office, no. 2296, fol. 17 (photo: By permission of The British Library)

women, and to point out its resemblance to medieval drawings of the female reproductive system may not be as farfetched as would seem. Part of an anatomical drawing, which, though later and Persian, represents contemporary knowledge in the West as well, as shown by Karl Sudhoff and later by others (Fig. 9).[11] However one interprets this detail, surely the painting as a whole is a marvel of design, filled with subtle invention, yet embodying a strange sense of emptiness, unreal and rather lifeless.

These qualities are even more apparent in the Nativity (Fig. 10) with its empty center. The composition, its main figures at the sides, is like a large room with the furniture pushed back to the walls. The star is the only important element lying on or near the central axis. The two sets of figures are arranged in vertical columns as though items on two separate lists. The list at the right consists not only of the two shepherds, one kneeling, one standing, but also of their sheep beyond and the hill, which repeats the shape of one shepherd's hat. At the left, the humble figures of Joseph and Mary seated on the ground are meditative and withdrawn, fixed and unmovable, like statues of ancient river gods. Their forms, almost identical in shape, posture, and scale, are repeated too in the hill above and, reversed, in the reclining ass. The two isolated columns of forms are, however, linked together by a network of horizontal, vertical, and slanted lines that appear to grow out of the form of the flimsy shed.

Even more evident than in the preceding miniature is the additive nature of the design, isolated units with a minimum of overlapping placed into a complex geometrical web. Such a design has no precedent in the Nativities in the Limbourgs' earlier Moralized Bible, of which two examples are shown (Figs. 11, 12). Both are foreground scenes, compact with forms pressed together, overlapping, and interlocking; in neither is there any of the isolating and itemizing of the *Belles Heures* nor is there a comparable geometrical web into which the pieces have been fitted.

In the Nativity of the *Très Riches Heures* (Fig. 13) the painting is also dense, filled with figures, action, and what one might call pictorial events. Instead of a rigid open framework, the geometry of this miniature is disguised, as it were, a skeleton overlaid with a flesh of details which suggest something of the variety and multiplicity of things in our own

elements in the painting: the empty doorway at the left and the stream on the hillside at the right. The doorway, whose void becomes a kind of third person in the composition, reflects the form of the Virgin. The stream, on the other hand, echoes the curve of the Virgin's abdomen and of the body of Elizabeth. The stream, welling up suddenly out of the hillside, flows into a pond, narrows, and comes to an abrupt, inexplicable stop. What is one to make of its shape and prominence? Like the doorway it is probably symbolic as well as a crucial part of the design. In shape it is linked to the forms of both pregnant

Fig. 10. Nativity, *Belles Heures,* fol. 48v.

Fig. 11. Nativity, *Moralized Bible,* ca. 1403 (detail).
Paris, Bibliothèque Nationale, MS fr. 166, fol. 18v
(photo: Bibliothèque Nationale)

Fig. 12. Nativity, *Moralized Bible,* ca. 1403 (detail).
Paris, Bibliothèque Nationale, MS fr. 166, fol. 19
(photo: Bibliothèque Nationale)

world. In some ways the miniature in the *Belles Heures* seems a digression between the earlier and later works. The large voids and schematism of our miniature may well result in part from the problem posed by the larger size of these paintings after the small scale in which the Limbourgs had been working immediately before. Whatever the explanation, a modern taste formed in a post-Cubist era can only admire the ingenuity and expressive variety of these early designs in the *Belles Heures* and be thankful for the glimpse that they give into the artistic thinking of the brothers—or more likely that of their leader, Paul, to whom Millard Meiss gives all of the

first large miniatures. These qualities are found only in these miniatures and are not characteristic of the whole manuscript. Rather, they and the next two miniatures form a brief beginning stage that ended before the cycle for the Hours of the Virgin was finished.

Although the shepherds are present at the Nativity, the Annunciation to the Shepherds only occurs in the following miniature (Fig. 14). The two shepherds, small and set deep in the painting, are isolated by the emptiness of the landscape, by the abrupt verticality of the ground plane, and by the lilliputian scale of the sheep and trees in the foreground. The gradient of scale is reversed, from the larger goat eating tree leaves in the distance to the nearest, yet smallest sheep in the foreground. The sheep, indeed, are about the same size as those in the distance in the Nativity, where the gradient of scale is not reversed. Above, the singing angels, nearer and larger than the shepherds, overwhelm them and dominate the picture. Being strictly symmetrical around the central axis, they represent a highly ordered heavenly realm, in contrast to the asymmetry and scattered or strewn world of the foreground, where chance and accident seem to prevail.

Although there are the usual diagonal lines in the edges of the hills and the row of trees at the left, they do not bind and cohere as before. Instead, they serve only to emphasize the randomness of the foreground, which is held together by the evenness with which the elements are distributed and by the way the arcs of the angels' wings and their open book are echoed in the upraised arms of the shepherds, the backs of the sheep, and the foliage of some trees. The arcs of the angels echo through the landscape, as their song, so to speak, reverberates through the land.

The awe of the shepherds at the heavenly message is manifest in their upraised arms and back-tilted heads, that of the shepherd at the left being tipped so far back that he is thrown off balance and must use his staff as a crutch. He is one of the most unusual figures in the whole book—and there is nothing like him in the Moralized Bible. Seen from the back, we see only the top of his head, though not his face, while his lower half is contorted, his right leg twisted into an impossible position, with one foot standing on the other. How should we understand this twisted self-binding figure? The

Fig. 13. Nativity, *Très Riches Heures,* ca. 1415. Chantilly, Musée Condé, MS 65, fol. 44v
(photo: Giraudon/Art Resource, N.Y.)

Fig. 14. Annunciation to the Shepherds, *Belles Heures,* fol. 52.

Fig. 15. Annunciation to the Shepherds, *Brussels Hours,* before 1402. Brussels, Bibliothèque Royale, MS 11060-61, p. 82 (photo: Bibliothèque Royale Albert 1er)

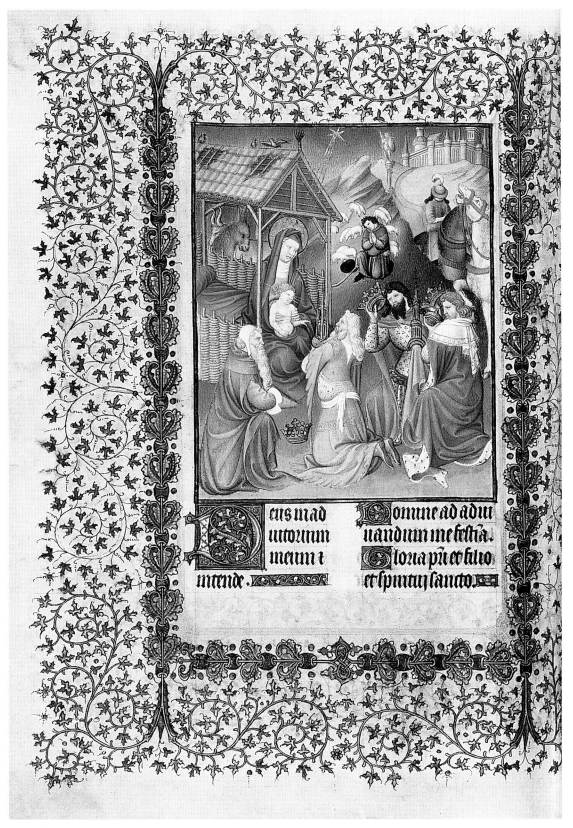

Fig. 16. Adoration of the Magi, *Belles Heures,* fol. 54v.

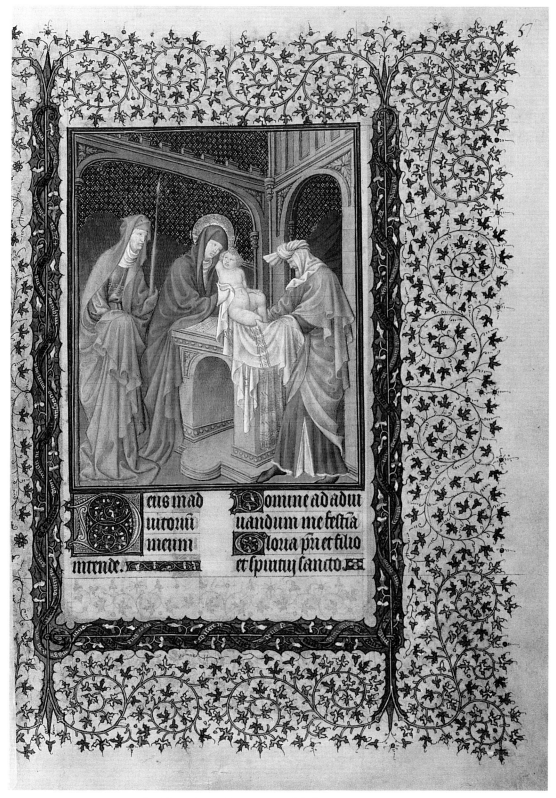

Fig. 17. Presentation in the Temple, *Belles Heures,* fol. 63.

Fig. 18. Flight into Egypt, *Belles Heures,* fol. 63.

answer, I believe, lies in a medieval tradition of depicting visionaries, in which they fall over backward, withdraw into their own shells, move in different conflicting directions, or tie themselves in knots. That such ideas were current in the circle of Jean de Berry is indicated by the shepherd who is bowled over backward by the announcement of the angels in the Brussels Hours, which was painted by Jacquemart de Hesdin before 1402 (Fig. 15).[12] Although the whole scene may strike us as awkward, underorganized, and inconsistent with Paul's kind of realism, it is in fact a profound study of heaven and earth, of revelation and mystical vision.

With the Adoration of the Magi (Fig. 16), the character of the paintings begins to change, and to my mind the beginning stage of this amazing book comes to an end. The main figures are larger with more overlapping, are placed close to the picture plane, and fill more of the pictorial area. Gone are the large empty spaces. Instead, pictorial events fill the painting, and the gradients of scale and clarity diminish more convincingly into the distance. As this is a ceremonial scene, the geometry is more restrained, with verticals and horizontals predominating, while the customary triangular hill and the shed embrace and organize. The gable end of the shed enframes the Virgin and Child, both figures upright, immobile, centered; the two are thereby converted into a kind of throne of wisdom statue, an icon, or a Trecento panel of the Madonna. The Child, half-hidden in the Virgin's dress, neither blesses nor reaches out for the gift of the first Magus, as is normal.

All three Magi kneel, a choice unique in contemporary French manuscripts, a choice that avoids the kind of progression from standing, to bending, to kneeling that was common at the time. Progression, though retained in the sequence of ages,

438

is further lessened by the repeated gesture of the second and third Magi doffing their crowns and by the almost identical postures of the first and third Magi. The rare kneeling figure of Joseph, who functions as a fourth Magus, completes the horizontal band and balances the group. At the same time he is aligned with the Virgin, the star, and its rays—an alignment that links the Holy Family and balances the right edge of the hill. Surprisingly prominent in the design is the adoring shepherd—and one wonders why shepherds are so emphasized in these paintings. Kneeling like still another Magus, he and the ring of sheep around him provide a kind of pivot around which many elements in the painting appear to revolve. The whole composition, so rich in its patterns, motifs, and variations, reveals once again the artistic inventiveness of Paul and his ability to create forms and geometry that in themselves epitomize various themes, here the theme of adoration and homage. In this and the preceding paintings, however tentative and exploratory some of them may seem, one realizes that one is in the presence of a masterly composer, in almost an orchestral sense.

With this miniature the first stage seems to come to an end. In the following paintings, such as the Presentation in the Temple (Fig. 17) and the Flight into Egypt (Fig. 18), one encounters much larger, more monumental figures that dominate their pictures. They are contiguous and overlapping, linked by their majestic rhythms and the linear arabesques of their drapery. Gone is the spare, barebone geometry into which the earlier figures were fitted, like pieces in a puzzle. Gone too are the large empty voids that gave an unreal or surreal air to the earlier works. Lacking also are the withdrawn and inward figures so characteristic of the preceding miniatures, for they are replaced by ones that participate gravely, but more actively, in the drama and the narrative. In spite of the grandly orchestrated pictures to follow, the passing of the first stage of the *Belles Heures* is an occasion for regret. With its passing, we lose its raw inventiveness and the peculiar intensity with which a young, but great artist explores the fundamental possibilities of his art, never repeating a design and always attentive to the meaning of its geometry—as we also lose the mysterious, meditative air of its figures, who seem to reflect Paul's own creative concentration. Clearly, much has been lost as well as gained.

NOTES

1. Millard Meiss, with Sharon O. D. Smith and Elizabeth H. Beatson, *French Painting in the Time of Jean de Berry: The Limbourgs and Their Contemporaries* (New York, 1974), pp. 102–41; and Millard Meiss and Elizabeth H. Beatson, *The Belles Heures of Jean, Duke of Berry* (New York, 1974).

2. Chantilly, Musée Condé, MS 65. J. Longnon, R. Cazelles, and M. Meiss, *The Très Riches Heures of Jean, Duke of Berry* (New York, 1969); Meiss, Smith, and Beatson, *Limbourgs*, pp. 143–228, 308–24, *et passim*; and R(aymond) Cazelles, with J(ohannes) Rathofer, *The Très Riches Heures of Jean, Duke of Berry* (Lucerne, 1984).

3. Meiss and Beatson, *Belles Heures*, pp. 23–24.

4. John Plummer, "A Summary of Observations on the Makeup and Decoration," in Meiss, Smith, and Beatson, *Limbourgs*, pp. 334–36. See also Allen S. Farber, "A Study of the Secondary Decoration of the *Belles Heures* and Related Manuscripts" (Ph.D. diss., Cornell University, 1980).

5. Baltimore, Walters Art Gallery, w.231. Meiss, Smith, and Beatson, *Limbourgs*, p. 394; and Roger S. Wieck, *Time Sanctified* (New York, 1988), p. 180, no. 19, pl. 24.

6. The two petitions referred to are the following: "Ut cuncto populo christiano pacem et unitatem donare digneris," and "Ut omnibus fidelibus dei defunctis requiem eternam donare digneris." While similar petitions occur in most manuscripts, the precise wording in these two occurs only in the *Belles Heures* and Walters w.231. The calendar of the *Belles Heures* has 378 entries, counting each saint's name as a separate entry. Of these Walters w.231 shares 347 entries out of a total of 377; the Sobieski Hours at Windsor Castle shares 334 entries out of 368; and the *Très Riches Heures* shares 319 out of 356.

7. John Plummer, "A Blank Page in the *Belles Heures*," *Gatherings in Honor of Dorothy E. Miner*, ed. Ursula E. McCracken, Lilian M. C. Randall, and Richard H. Randall, Jr. (Baltimore, 1974), pp. 193–202.

8. Paris, Bibl. Nat., MS fr. 166. Meiss, Smith, and Beatson, *Limbourgs*, esp. pp. 81–101, 342–43.

9. Paris, Bibl. Nat., MS nouv. acq. lat. 3093. Millard Meiss, *French Painting in the Time of Jean de Berry: The Late Fourteenth Century and the Patronage of the Duke* (London, 1967), esp. pp. 107–34, 337–40.

10. It is likely that the preoccupation in this and the following miniatures with geometry and pictorial structure reflects the brothers' study of Italian panels and perhaps Paul's hypothetical trip to Italy. Further evidence for such a trip has been found in the miniature's acanthus border, which derives directly or indirectly from Italian sources, "probably from the Porta della Mandorla of the Cathedral of Florence," according to Meiss and Beatson (*Belles Heures*, commentary on the Annunciation), a proposal originally made by Friedrich Winkler. See also Meiss, Smith, and Beatson, *Limbourgs*, pp. 105, 240.

11. Karl Sudhoff, "Ein Beitrag zur Geschichte der Anatomie im Mittelalter, Speziell der anatomischen Graphik nach Handschriften des 9. bis 15. Jahrhunderts," in *Studien zur Geschichte der Medizin* 4 (Leipzig, 1908), pp. 52–72, pl. xv.

12. Brussels, Bibl. Roy., MS 1160–61. Meiss, *French Painting in the Time of Jean de Berry*, esp. pp. 198–241, 321–23.

Fig. 1. Altarpiece with Christ and St. John the Baptist and St. Margaret, signed and dated Andrea da Giona, 1434. The Metropolitan Museum of Art, The Cloisters Collection, 1962 (62.128) (photo: Museum)

A Late Gothic Sculpture from Italy:

THE SAVONA ALTARPIECE IN THE CLOISTERS

Lisbeth Castelnuovo-Tedesco

In 1962, The Cloisters purchased a fine Late Gothic relief altarpiece from a dealer in Florence (Fig. 1).[1] For a long period it was not exhibited, and it remained unpublished after its acquisition until its brief mention, with color illustration, in William Wixom's recent monograph on sculpture at The Cloisters.[2] Refined in execution, allusive in iconography, the altarpiece now installed in The Cloisters offers that most intriguing of art-historical clues, an inscription naming the artist and giving the date: HOC OPUS FECIT MAGISTER AND̄-[R]EAS DA GIONA, MCCCCXXXIIII, which appears on the lower ledge of the central panel of the work (Fig. 2).

The previous owners provided a reliable history: a family in Savona, a city in Italy west of Genoa on the Ligurian coast, had purchased the altarpiece in the eighteenth century as part of a property formerly belonging to the Knights of St. John, and then installed it in the family villa. Several references in nineteenth-century guidebooks to the sculpture in situ corroborate this information.[3]

The altarpiece from Savona shows signs, affirmed by its history, of having been taken apart and reassembled. There are many inconsistencies in the joined areas, as well as cracks and actual losses.[4] Traces of blue tempera (azurite over gesso) suggest that this white marble relief was originally at least partly polychromed and gilded, a procedure consistent with its date. The altarpiece measures 6 feet by 6 feet 8 inches (1.83 by 2.03 m) with a depth of only five inches (12.7 cm). Its three sections are divided by slender sectioned pilasters surmounted by pinnacles; the main panel is approximately twice as wide and somewhat taller than the wings, and thus resembles the format of a painted triptych.[5]

The central zone shows Christ in Majesty inscribed within a mandorla of angels. The iconography for this scene is derived from Revelations 4:2-10. The object on

441

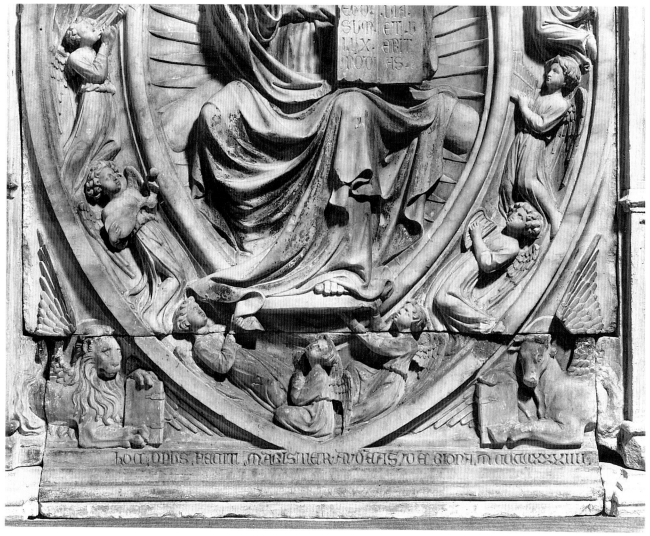

Fig. 2. Detail, Inscription

which Christ sits may originally have been painted to represent the rainbow mentioned in the biblical text.[6] Representations of the symbols of the four Evangelists are placed at the corners of the rectangular field: at upper left, the eagle of St. John; at upper right, the angel of St. Matthew; lower right, the ox of St. Luke; and lower left, the lion of St. Mark. All are winged and carry a closed book. Christ, surrounded by a rayed aureole,[7] is seated within a *vesica piscus*, a pointed oval configuration, the sides of which are parts of two equal circles passing through each other at their centers.[8] He is portrayed as a delicately featured young man with precisely rendered hair and beard, a cruciform halo around his head (Fig. 3). Christ blesses with his right hand;

in his left he holds an open book inscribed EGO SUM LUX MŌ-[N]DI VIA ET VERITAS (John 8 : 12). He wears a belted tunic with an incised border at the neck under a softly draping mantle with a folded-back collar. His projecting left leg and foot, with bare toes revealed, rests on a narrow parapet. Thirteen graceful angels are arranged within the mandorla surrounding Christ's aureole. Eight of them, four on each side, play musical instruments,[9] two support the ledge on which Christ's foot is placed, one clasps his hands in prayer at bottom center. Above Christ's head, two more angels support a triquetra, a sphere formed by three intersecting ellipses, symbol of the tripartite divinity (Fig. 4).[10] The simple outer fillet molding is broken at the top by a central pinnacle,

442

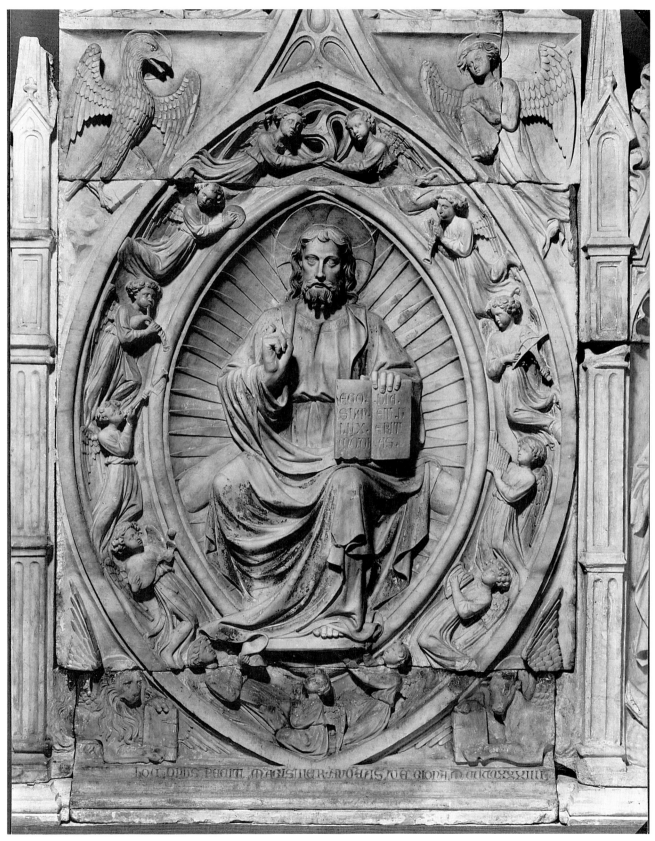

Fig. 3. Detail, Christ

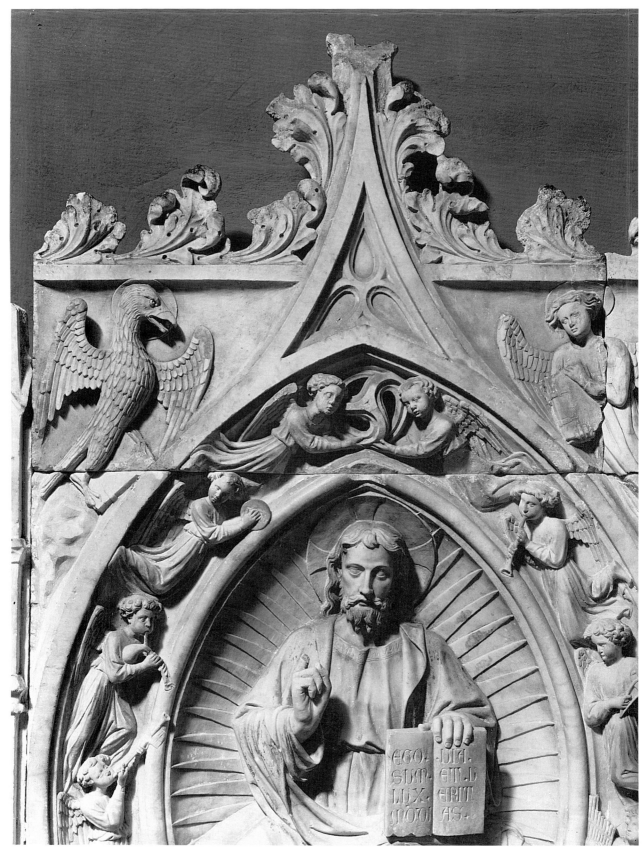

Fig. 4. Detail, Triquetra

which rises from the outer edges of the mandorla, and which contains a trefoil. The topmost edge is bordered by sweeping acanthus fronds, now much damaged.

The left wing of the altarpiece contains a slender contrappostal figure of St. John the Baptist standing within a shell-shaped niche (Fig. 5).[11] St. John points with his right hand toward Christ and toward the words inscribed on a scroll held in his left hand: ECCE AGNUS DEI (John 1:36). He wears a fleeced shift under a mantle draped over his left shoulder and bunched around his waist. His finely drawn face and beard, accented by the halo encircling his head, are very similar to that of Christ. In the triangular field above, a sturdy winged angel Gabriel kneels with his feet resting lightly on the curve of the niche (Fig. 6). A scroll inscribed AVE GRATIA PLE[NA] (Luke 1:28) flutters upward from his left hand, crossing over the incised triple fillet of the strongly pointed pinnacle. As in the central panel, acanthus leaves border the edge of the pinnacle; the tip is broken off, as are the finials of the pilasters framing the niche. The right side mirrors the left in its design. A graceful contrappostal female figure, also in three-quarter view, occupies a shell niche. She is St. Margaret of Antioch, identifiable by the dragon curled under her feet (Fig. 7). St. Margaret generally carries a martyr's palm and a cross. The objects held in this figure's right and left hands are now broken off and missing, but they appear to be the remains of her traditional attributes.[12] St. Margaret, like Christ and St. John, wears a heavily draped mantle, here over a simple unornamented dress belted high under the bust. She is bare-headed, her neatly swept-back long hair framed by her halo. Above her, in the triple-bordered pinnacle, a charming Virgin Annunciate kneels facing toward Christ and toward Gabriel, her arms solemnly crossed over her chest, the folds of her mantle delicately rippling over the curve of the upper border of the niche below (Fig. 8). As at the left, leaf forms surround the apex; here, too, the topmost section has broken off.

The impressive monumentality of the Savona altarpiece is achieved at the cost of a rather static chilliness. The artist has sought symmetry and geometry in every detail. Geometric devices, such as the *vesica piscus* and triquetra, have been incorporated into the design. The divisions of the retable are clear and precise, the visual units divided by pilasters, themselves inscribed with geometric

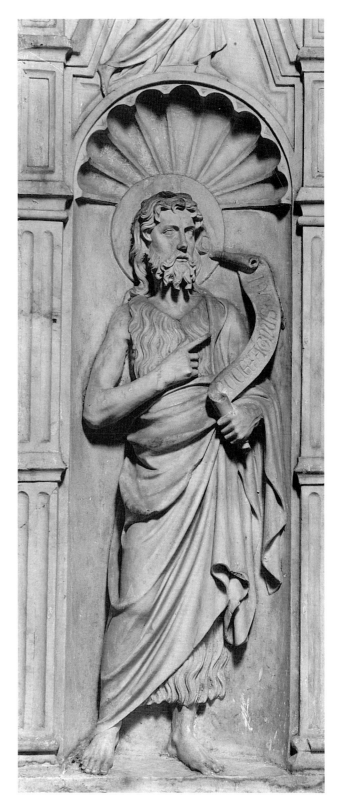

Fig. 5. Detail, St. John the Baptist

445

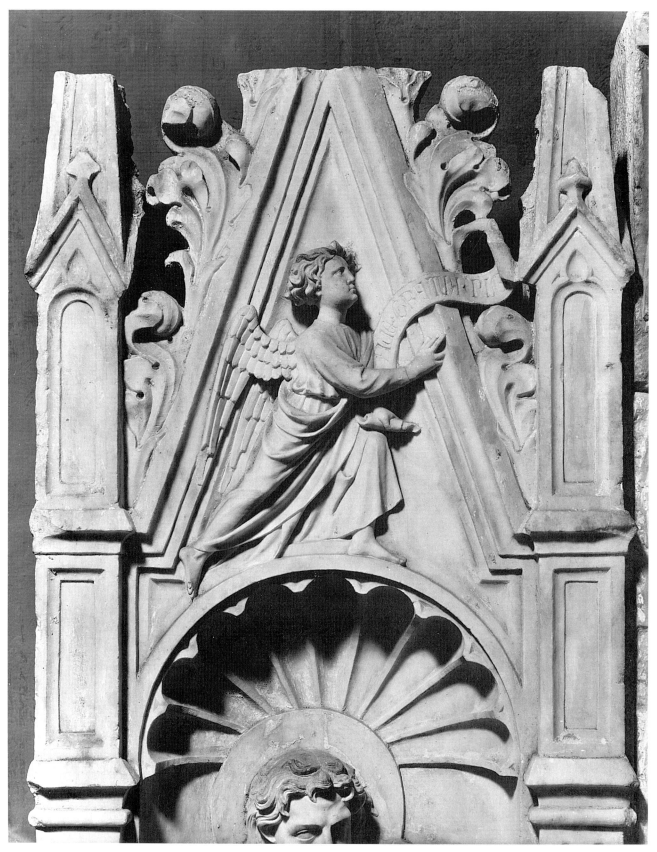

Fig. 6. Detail, Angel Gabriel

shapes. The central panel is proportioned according to a formula based on a square-root rectangle, often used in late-medieval painting.[13] Christ is perfectly disposed within the oval of the mandorla to which the figures of Sts. John and Margaret form an elegant reverse parenthesis as they lean on their innermost legs, mantles draped over the inner shoulders, the folds gently cascading toward the outer perimeter. The figure of Christ with a long torso and somewhat compressed legs is designed to compensate visually for the placement of the work substantially above eye level. Again stasis has here been achieved by cross-balancing the projecting right hand of Christ with the forward thrust of his projecting left leg. The slight recession of the right shoulder and leg thus emphasizes this projection and that of the open book above it. The generous if somewhat metallic drapery successfully describes Christ's body and spills over both the ledge and the mandorla in long elliptical folds, increasing the three-dimensional effect. Although the artist has carefully defined the fields in which the principal subjects are displayed, he does not allow peripheral figures to become overly circumscribed; the wings and scroll of the angel Gabriel and the delicate drapery of the Virgin Annunciate overflow their frames. In a like fashion, the angels of the mandorla are cleverly positioned so that details of drapery or musical instruments occasionally overlap the inner and outer fillets giving some illusion of both projection and depth. Insistent overlapping of the frame was a motif much utilized by early-fifteenth-century northern Italian sculptors.[14] With its implication of a purely frontal view, this device, reminiscent of northern Italian manuscripts,[15] underscores the pictorial quality of the sculpture.

A notarized document of 1774 states that the altarpiece, purchased by the Chiodo family from the Compagnia della Carità, a group of associate members of the Knights of St. John attached to the Savonese chapter, was originally from the church of San Giovanni Battista.[16] This church, along with its adjoining hospital located just outside the city walls of Savona, was founded in 1196 by four local noblemen.[17] They entrusted its administration to the Knights of St. John, also known as the Knights of Malta. The church and the rest of a complex, which eventually included a hospice and cemetery as well as the hospital, were named for St. John the Baptist, the patron saint of the Knights of St. John.[18]

The Order of St. John originated in the eleventh

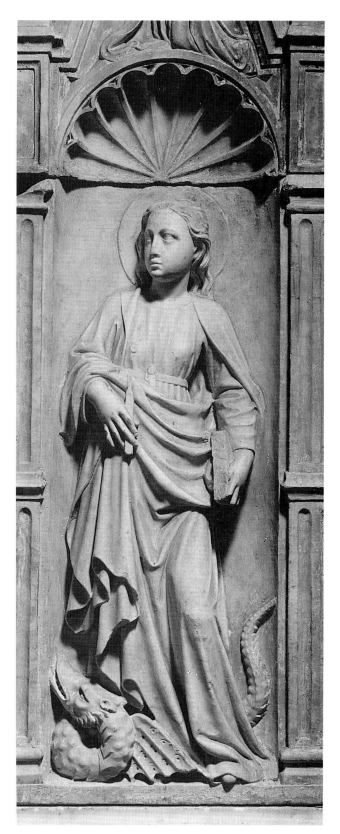

Fig. 7. Detail, St. Margaret of Antioch

447

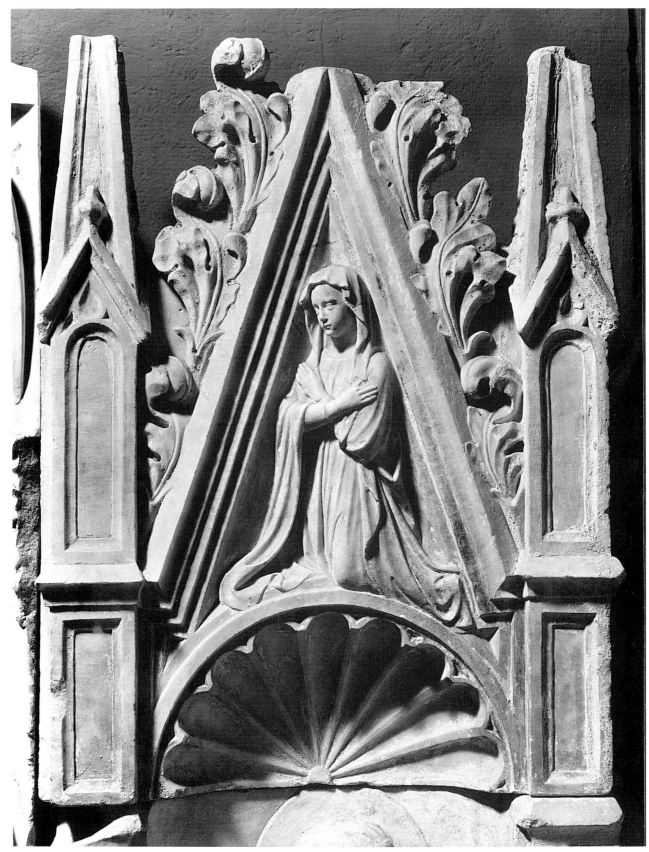

Fig. 8. Detail, Virgin Annunciate

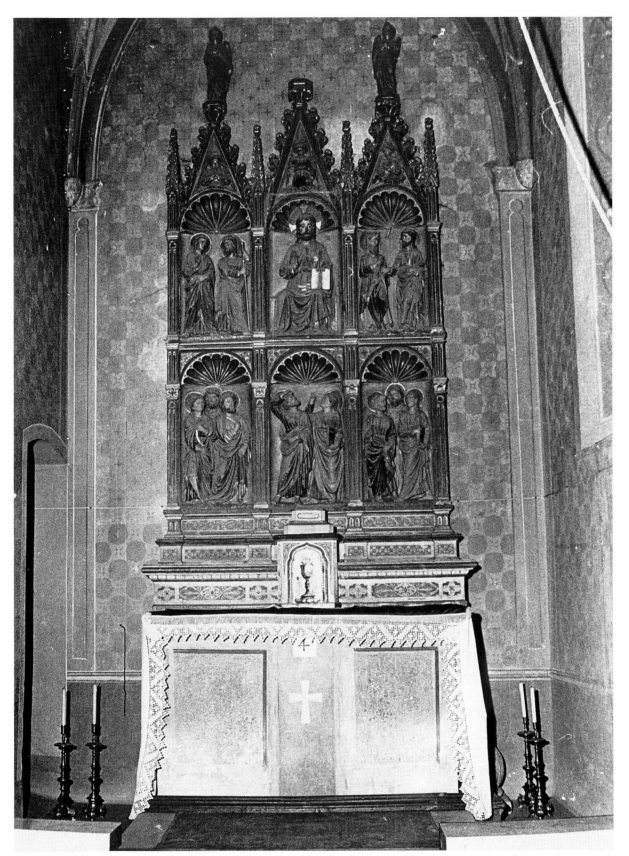

Fig. 9. Altarpiece with Christ and the Apostles, ca. 1425-30. Castiglione Olona, Collegiata (photo: Istituto per la Storia dell'Arte Lombarda)

Fig. 10. Fragment of an altarpiece, ca. 1430-35. Carona, Church of SS. Giorgio e Andrea (photo: source unknown)

Fig. 11. Tomb of Branda Castiglione, after 1443. Castiglione Olona (photo: Alinari/Art Resource, N.Y.)

century to provide shelter for Christian pilgrims in the Holy Land. By 1113 the knighthood had been established as an independent religious order responsible only to the pope, with its own chaplains, churches, and cemeteries.[19] Although not intended as a military order, its mandate being to help pilgrims and "our lords, the sick and the poor," military activities developed from its duty to protect pilgrim routes and holy places. Members of Savona played a significant role in the military arena; in 1306–9 the order, under the leadership of a Savonese flotilla,

conquered the island of Rhodes.[20] Until the middle of the eighteenth century, descendants of the flotilla's captain, whose family had also participated in the founding of the church and hospital, were honored every Easter by the order with a gift of a Paschal Lamb, brought in procession from the church of San Giovanni Battista.[21]

Although the location of the Andrea da Giona altarpiece within the church of San Giovanni Battista is not known, certain assumptions may be made from the existing documents. The church itself,

Fig. 12. Filippo Solari and Andrea da Carona, Funeral Monument of Giovanni Borromeo, begun 1445-46, finished 1475-78. Isola Bella, Palazzo Borromeo (photo: Alinari/Art Resource, N.Y.)

notwithstanding its name, was dedicated to Sts. Margaret and Leonard.[22] According to a document of 1447, the main altar of the church was dedicated to Jesus Christ and St. Margaret; the altar immediately to the left was dedicated to St. John the Baptist.[23] This configuration, most probably not repeated in any other church in Savona,[24] suggests the placement of this altarpiece, showing Christ in Majesty with St. John at the left and St. Margaret on the right, above the main altar of the church. The altarpiece visually establishes the links proposed by the altar dedications.

In 1685 the church founded in 1196 was demolished and a new San Giovanni Battista was immediately built with funds from parishioners. It is not clear if the altarpiece was moved into the new church, although the Compagnia della Carità had a chapel there.[25] Thus from these fragmentary sources one may reconstruct the history of the Savona retable: originally made for the church of the Knights of St. John, San Giovanni Battista, it was probably commissioned directly by them, or else by their associate Compagnia della Carità. At the time of the rebuilding of the church in the seventeenth century, the altarpiece may have been placed in the new church in the Carità chapel, but it is more likely, given the general redecoration of churches during the flowering of the Genoese Baroque, that the altarpiece was stored in a house belonging to the Compagnia della Carità within the San Giovanni Battista complex.[26]

Not only is the iconography of the altarpiece consistent with its provenance but certain aspects of the work have a special meaning for the Order of St. John and suggest a direct commission by the knights for this undoubtedly costly object. An important iconographic feature is the repetition of the number three, especially in the symbols of the triquetra and trefoils.[27] The number three is of great significance in the rites of the Knights of St. John. The knight himself took three vows: the first in defense of the church of God, the second in offense against those who persecute the Catholic faith, and the third in defense of the Order of St. John.[28] During the investiture ceremonies, the nobleman to be inducted took up a sword and threatened his sponsor knight, who stated: "The three times you have menaced me means that you will defend the Catholic faith in the name of the Holy Trinity from the enemies of God."[29] The three angels supporting Christ's

Fig. 13. Detail of Fig. 1: Angel of St. Matthew

throne also echo this number. Again, the eight musical angels circling Christ may refer to the eight points of the Maltese Cross. According to the initiation rites, the eight-pointed cross was carried in the hearts of the individual knights to enable them to see the eight Beatitudes promised to them.[30] The hair shirt of St. John the Baptist,[31] clearly represented in the relief, alludes to a concept mentioned in the investiture rite: the Knights of St. John in times of sin should put their sins aside and "dress in virtue," that is, in a hair shirt, the garb of St. John, admired for his fervor of spirit and penitence.[32]

The destruction of Savona by the Genoese in 1542 ended the existence of a city-state which had remained independent and fairly prosperous since 1180. The appearance of the city was radically changed; no medieval churches remained and most church furnishings disappeared. Only scattered remnants of the fourteenth-century Duomo sculpture were installed in the new cathedral; almost by chance the Savona retable survived.[33]

In 1434, the date inscribed on the altarpiece,

Fig. 14. Detail of Fig. 11: Faith

the city of Savona was part of the Viscontean state of Lombardy; Andrea from Giona, the sculptor who signed it,[34] was from another part of Lombardy. Giona[35] is the name of a district near Carona, a town in the Ticino. Then part of Lombardy, the Ticino is now divided between Italy and Switzerland. Stone carving and building were traditional occupations in this mountainous area, and many workers from the Ticino participated in the most important artistic project of the first quarter of the fifteenth century in northern Italy, the construction and decoration of the cathedral of Milan, a city just seventy-five kilometers to the southeast. The *Annali della Fabbrica del Duomo* show records of payments to a handful of stonecutters from Giona, but none is named Andrea.[36] Indeed, the mannered style of the

Lombard sculptors working at the Milan Cathedral[37] is actually quite different from that of the Savona altarpiece. Instead the Savona work seems much closer to contemporary developments in Venice, where the International Gothic idiom was translated with a vigorous refinement, an elegant delicacy.

The influence of Venice extended well into Lombardy. Castiglione Olona, the tiny city northwest of Milan created by Cardinal Branda Castiglione in the second quarter of the fifteenth century, was a magnet for artists from Venice, Tuscany, and the rest of northern Italy. Recently there have been some new assessments of traditional attributions as scholars have reexamined its treasures.[38] In her dissertation Carol Pulin discusses the diffuse origins of the sculpture of the complex.[39] She compares a polychromed stone altarpiece of about 1425–30 showing Christ and the apostles, in the Collegiata at Castiglione Olona, with existing fragments of a similar altarpiece from the church of SS. Giorgio e Andrea at Carona in the Ticino (Figs. 9, 10), suggesting that the sculptor of the Castiglione Olona retable might have repeated it or at least have been inspired by it for Carona.[40] Moreover, Pulin compares the tomb of Branda Castiglione (d. 1443) in Castiglione Olona (Fig. 11) with the tomb of Giovanni Borromeo from San Francesco Grande, Milan, now at Isola Bella, begun before 1445 and finished some thirty years later (Fig. 12). Account books, still in the hands of the Borromeo family and examined by Pulin, show payments made in 1445/46 for work on the Borromeo tomb to two sculptors, Filippo Solari and Andrea da Carona.[41] Pulin concludes, on the basis of style, that Filippo Solari and Andrea da Carona actually were the sculptors of the unsigned and undocumented Branda Castiglione tomb, and she suggests that the Carona altarpiece "best explains the formation of these two sculptors."[42]

These works from Castiglione Olona and the cognate pieces at Carona and Isola Bella have certain important features in common with the Savona altarpiece. The polychromed stone retable of Christ and the Apostles at Castiglione Olona prefigures the Savona work with its division into shell-niche sections divided by pilasters surmounted by pinnacles and with its central theme of the seated blessing Christ (Fig. 9). Also, the weight distribution of the standing apostles and their scale in relation to the figure of Christ are echoed in the Andrea

Fig. 15. Detail of Fig. 12: Warrior

da Giona work. Yet the piece from Castiglione Olona is cruder; it is too crowded, decidedly less subtle in design, and certainly ruder in workmanship. Considerably closer to the work from Savona are the two saints in their shell niches from Carona (Fig. 10). The pose of the figures, the drapery pattern, the delicate facial delineation, the manner in which the book is held, the presentation of the hands and feet as a series of rounded contours without any sign of underlying bone or muscle structure are all features held in common. Recently reconstructed,[43] the Carona altar fragments may be assigned to the early 1430s, slightly before the Savona altarpiece.

Both the tomb of Branda Castiglione and that of Giovanni Borromeo are several years later in date, yet careful examination reveals interesting parallels to stylistic aspects of the Savona retable. For example, the lovely Virgin Annunciate (Fig. 8), as well as the angel of St. Matthew from Savona (Fig. 13), exhibit the same highly refined technique of modeling found in the figure of Faith on the Branda Castiglione Olona tomb (Fig. 14). The faces, too, are similar in their long, oval shape and in the details of eyes, nose, and lips. The drapery style of the garment of Faith recalls that of the Savona St. Margaret with its cascading folds, the irregular channels of the pushed-up sleeve, and the slight protrusion of the knee (Fig. 7). The Savona St. Margaret is quite close to a youthful warrior from the Borromeo tomb (Fig. 15). The hair, smoothly modeled cheek line, fine nose, deep cutting of the eyes, and the tilt of the chin are remarkably similar.

Simply in terms of nomenclature it is certainly possible that Andrea from Giona of the Savona altarpiece was the same person as the Andrea from Carona recorded in the Borromeo archives. Pietro Paoletti, in examining many Venetian documents for references to Giorgio da Carona, a sculptor of the 1450s–70s, found him often listed as Giorgio da Chiona (that is, in the Venetian dialect, Giona), along with other variants of his name.[44]

Comparisons of the Savona altarpiece with the Branda Castiglione and Giovanni Borromeo tombs, works commissioned in quite another spirit, are intriguing, but far from definitive.[45] The tomb of Branda Castiglione, notwithstanding its ultimate derivation from a familiar northern Italian tomb type and its Gothic lettering, is informed with the new descriptive clarity of the Renaissance. To an even greater degree the Borromeo tomb, completed later

in the fifteenth century, absorbs the classicizing detail and emphasis on the horizontal that come to be part of the vocabulary of Italian sculpture. Yet both of these monuments retain the interest in surface and delicacy of form, hallmarks of the International Gothic style,[46] found in the Savona altarpiece. Perhaps it would suffice to say that the style of the Savona altarpiece has its roots at Castiglione Olona, which was the crucible for the melding of the artistic developments of Florence and Venice with the International Gothic style of Viscontean Lombardy.

The stress on geometric elements in the Savona altarpiece, significant to its iconography, also affects the appearance of the relief, emphasizing the planar aspects and suggesting two dimensions rather than three. When polychromed, from a distance the Savona altarpiece must have appeared to be remarkably similar to a painted retable. Was the designer a pictorial artist? Was it Andrea himself or another artist? Designs by artists other than the actual stone carvers are documented at the cathedrals of Milan and Florence early in the fifteenth century, and some scholars consider this to have been the case even at Castiglione Olona.[47] Too little is known of the working methods of Andrea da Giona, or even of his background or training, to speculate on this or the many other relevant issues that would provide a clearer context for this work. Extensive archival research might enable one to answer these questions, and perhaps even to trace the career of this elusive artist, many of whose works may have been destroyed.[48]

NOTES

1. An abbreviated version of this manuscript was presented at the Twenty-Fourth International Congress on Medieval Studies, May 4–7, 1989, at Western Michigan University.

2. William D. Wixom, "Medieval Sculpture at The Cloisters," *MMAB* 46 (1988–89), pp. 12–13. The initial and unpublished investigation of the altarpiece was undertaken by Carmen Gómez-Moreno at the time of its purchase.

3. T. Torteroli, *Monumenti di pittura, scultura e architettura della città di Savona* (Savona, 1847), p. 167; *Guida descrittiva di Savona e delle città e comuni principali del circondario coll'aggiunta di cenni biografici intorno ad uomini illustri* (Florence, 1868), pp. 28–29; Federico Alizeri, *Notizie dei professori del disegno in Liguria dalle origini al secolo XVI*, 6 vols. (Genoa, 1870–80), vol. 5, pp. 25–26.

4. The corners of the central panel were damaged by careless handling. The largest missing area, now restored, is the right-

hand part of the angel of St. Matthew, located at the upper right corner of the central section. Two very large cracks run horizontally through the central panel; there is a large gouged area on the top border of Christ's aureole, and many small chips exist at the adjoining edges of the wings. The blessing fingers of the right hand of Christ are missing.

5. One wonders if there originally could have been some form of predella completing the altarpiece, where a saintly legend might have been depicted, the heraldic devices of the Knights of St. John or even of individual donors illustrated, or just decorative motifs shown. Cf. such Lombard painted or sculpted polyptychs dating from the second quarter of the fifteenth century as the polyptych attributed to Maestro Paroto in the Fondazione Bagetti Valsecchi in Milan, an anonymous Lombard polyptych dating ca. 1450-60, or the large mid-fifteenth-century altarpiece now in the Palazzo Borromeo, figures of which are attributed to the Rimini Master. These examples are discussed and illustrated in *Arte in Lombardia tra Gotico e Rinascimento*, exhib. cat., Palazzo Reale (Milan, 1988), nos. 24, 45, 82, respectively.

6. Cf. Christ in Majesty on a plaque dated 1349 commemorating the foundation of a hospice, now in the Museo Civico, Como (illustrated in Costantino Baroni, *Scultura gotica lombarda* [Milan, 1944], fig. 179), or numerous contemporary missal illuminations such as that from an Ambrogian missal now in the Biblioteca Capitolare, Milan, MS II, D. 2. 32, fol. 137v (Pietro Toesca, *La Pittura e la miniatura nella Lombardia: dai più antichi monumenti alla metà del Quattrocento*, 2d ed. [Turin, 1966], fig. 220).

7. The aureole is defined by Didron as the emanation of light from the whole body of a holy person ([A. D.] Didron, *Christian Iconography or the History of Christian Art in the Middle Ages*, trans. E. J. Millington, 2 vols. [London, 1851], vol. 1, p. 107). Although these light rays are rarely represented in sculpture, they were common in representations of Christ in Glory in manuscripts of the period: see, for example, the Risen Christ in an initial D, from an anonymous Lombard manuscript comparable in date to the Savona altarpiece in the Biblioteca Ambrosiana, Milan, fol. 277, inf. n. 11 (*Arte in Lombardia*, p. 146, ill.).

8. *The Oxford English Dictionary*, 2d ed. (Oxford, 1989), vol. 19, p. 570. This geometric construction was often used in medieval art to enclose the figure of Christ. The origin of the phrase, fish's bladder, is obscure.

9. The medieval instruments may be identified (reading from top down). Right side: recorder, *viol da braccio*, organ, and harp; left side: lute, trumpet, bagpipe, and cymbals.

10. The use of the triquetra as well as the trefoil as religious symbols are discussed by Patrik Reutersvärd, "The Forgotten Symbols of God (II)," *Konsthistorik tidskrift* 54 (1985), pp. 47-63.

11. The shell-shaped niche, often considered a "Renaissance" feature, is found in many fourteenth-century Venetian monuments. See, for example, the tomb of the Doge Andrea Dandolo (d. 1354), San Marco, Venice, or the tomb of Doge Michele Morosini (d. 1382), SS. Giovanni e Paolo, Venice, both illustrated in Wolfgang Wolters, *La Scultura veneziana gotica 1300-1460*, 2 vols. (Venice, 1976), figs. 311, 343.

12. For the iconography of St. Margaret, see M. C. Celletti, "Marina (Margherita)," *Bibliotheca Sanctorum* (Rome, 1966), vol. 8, cols. 1150-66.

13. Cf. *Rucellai Madonna*, Santa Maria Novella, Florence. As John White explains (*Tuscan Art and the Medieval Workshop* [London, 1979], p. 46), in this proportion the height is the diagonal of the square erected on the base. The upper horizontal of this square passes through the most significant part of the image, in this case, the head of Christ.

14. See, for example, the *Giganti* series (ca. 1405) at Milan Cathedral (Baroni, *Scultura gotica lombarda*, figs. 320, 322-27), as well as the sculpted lunette (1428) of the portal of the Collegiata, Castiglione Olona (Enrico Cattaneo and Gian Alberto Dell'Acqua, *Immagini di Castiglione Olona* [Milan, 1976], p. 54, ill.).

15. Examples of figures overlapping a painted frame include Cristoforo Cortese, image of a prophet from the Gradual, Milan, Biblioteca Nazionale Braidense, MS AB.XVII, 28, fol. 66r; Maestro Olivetano, Initial O with bishop saint, Milan, Biblioteca Capitolare, MS D. 231; and Maestro di San Michele a Murano, Initial A with prophet (the prophet's hand is on the centerpiece of the letter A), Berlin, Kupferstichkabinett, MS 78, fol. 1 (*Arte in Lombardia*, pp. 232, 26, 234, ill.)

16. Copy of notary act of Agostino Ratti, Dec. 14, 1774, in files of Department of Medieval Art, The Metropolitan Museum of Art.

17. The document for the foundation of the hospital and church—Genoa, Biblioteca Universitaria, MS E. IX. 39, fols. 536-46—is reproduced in Lorenzo Tacchella, *I Cavalieri di Malta in Liguria* (Genoa, 1977), pp. 177-79. See also Giovanni Vincenzo Verzellino, *Memorie della città di Savona* (Savona, 1885), vol. 1, p. 197; and Filippo Noberasco, *Savona e l'ordine di S. Giovanni di Gerusalemme* (Savona, 1923). p. 119.

18. The buildings were razed in the 1960s when a condominium was built on the property. Cf. Marco Ricchebono and Carlo Varaldo, *Savona* (Genoa, 1982), pp. 68, 145.

19. Bull of Paschal II, Feb. 15, 1113 (Jaffe L6341).

20. Forced to abandon Jerusalem with the failure of the crusades, the Knighthood thus acquired a base in the eastern Mediterranean for defense against Muslim attacks.

21. The procession is described by T. Torteroli, *Scritti letterari* (Savona, 1850), pp. 78-79. For a brief historical sketch of the Order of St. John, see Valletta (Malta), Church of St. John, *The Order of St. John in Malta* (Valletta, 1970), and, more completely, the succinct Arrigo Pecchioli, *Storia dei Cavalieri di Malta* (Rome, ca. 1978).

22. "Titulus Ecclesiae sit factus in honorem Ste. Margherite et Sancti Leonardi": Tacchella, *Cavalieri in Liguria*, p. 278. St. Margaret was invoked as protector against storms at sea and was quite popular on the Ligurian coast: cf. the town of Santa Margherita. St. Leonard was the patron saint of pilgrims and prisoners.

23. Genoa, Biblioteca Universitaria, MS E. IX. 39, fol. 74: "Numero de gli altari che erano in S. Giovanni di Savona nel tempo del Com. re de Signorio: P.o l'altare grande dedicato al Signor Nostro Giesù Christo e S. Margherita . . . terzo l'altare di S. Gio Batta il quale è da la sinistra. . . ." According to Tacchella (*Cavalieri in Liguria*, p. 176), many of the records of the church and *commenda* have been lost. It is not even clear who was the prior at the time of the altarpiece's construction. A document of 1575 describing the contemporary archive mentions tantalizingly a now-lost copy of the inventory "de le robbe de la Chiesa" (ibid., p. 177 n. 25).

24. The charter of the church did not permit duplication of any altar in the cathedral. "Altare non fiat in Ecclesia Hospitalis de aliquo vocabulo de quo fiat altare in Ecclesia Beate Marie," cited by Tacchella, ibid., p. 278. This ban, arranged by the local bishop, probably extended to other local churches.

25. According to Tacchella (ibid., pp. 182–85), in 1698 the church had six side altars in addition to the main altar. A large tabernacle was on the main altar, behind which was a small choir. The document, Archivio di Stato di Torino (S. Chiara), Ordine di Malta, mazzo 271, MS B7, fols. 99v, 105, describes the chapel of the Carità as being rather run down. Although some relics are mentioned, the altarpiece is not.

26. For a reference to "la casa della Carità," cf. Archivio di Stato di Torino (Ordine di Malta, mazzo 271, MS B7, fol. 105). The changes in Ligurian church decoration in the Seicento and the destruction of earlier works are discussed in Elena Rossetti Brezzi, "Per un'inchiesta sul Quattrocento ligure," *Bollettino d'Arte* 68, 6th ser. (1983), pp. 1–28.

27. In his discussion of the triquetra as a symbol of God, Reuterswärd, "Forgotten Symbols," pp. 59–60, cites this work for the axial placement of the motif and its inclusion within the mandorla.

28. Pecchioli, *Storia dei Cavalieri,* p. 70.

29. Ibid., p. 72.

30. Ibid., p. 75.

31. Matthew 3:4; Mark 1:6.

32. Pecchioli, *Storia dei Cavalieri,* p. 75.

33. For a discussion of the few extant medieval sculptures, see I. Scovassi and Filippo Noberasco, *Storia di Savona,* 3 vols. (Savona, 1928), vol. 3, pp. 390–95; for medieval Savona in general, see Nino Lamboglia, *I Monumenti medioevali della Liguria di ponente* (Turin, 1970), pp. 166–72. Savona also suffered extensive damage during World War II.

34. To the author's knowledge, no other work signed Andrea da Giona, nor any document with this name is known. In a work of this date, the presence of a signature said more about its cost than about the importance of the artist. Signatures most often appear on major and/or expensive objects. At that time, a carved altarpiece was much more costly in terms of materials and artists' fees than a painted retable: cf. Charles Seymour, *Sculpture in Italy: 1400–1500* (Harmondsworth, 1966), p. 15.

35. Also written in Italian documents as Ciona, Schiona, or Ghiona.

36. Ugo Nebbia, *La Scultura del Duomo di Milano* (Milan, 1908), p. 110, mentions a Cristoforo da Ghiona who worked as a sculptor in the Milan Cathedral workshop ca. 1400–25 under Jacopino da Tradate, but is unable to identify any work by Cristoforo's hand, although his name appears frequently in the cathedral register. Other workers "da Ghiona" cited by Nebbia (ibid., p. 265) are Antonio di Giacomo (1406), Giovanni (1414), and Simone. For the use of only the Christian name by these Lombard sculptors, see G. L. Calvi, *Notizie sulla vita e sulle opere dei principali architetti, scrittori e pittori che fiorirono durante il governo dei Visconti e degli Sforza* (Milan, 1859), p. 51.

37. Their style, ultimately derived from their fourteenth-century forebears, the Campionesi, remained but little influenced by the many artists from other regions of Europe who were employed by the workshop; see, for example, in the Milan Cathedral the anonymous Annunciation based on a design by Isacco da Imbonate or the seated statue of Martin V by Jacopino da Tradate (Baroni, *Scultura gotica lombarda,* figs. 317, 318, 358, 359).

38. For an up-to-date review, see *Arte in Lombardia,* especially Carlo Bertelli, "La Cappella del Palazzo Branda Castiglione," pp. 297–302, and the extensive bibliography, pp. 306–16. For the sculpture in particular, Wolters, *Scultura veneziana gotica,* is still fundamental for the breadth of its scope and for its thoughtful analyses of the pertinent literature. For photographs, see Cattaneo and Dell'Acqua, *Immagini di Castiglione Olona.*

39. Carol Pulin, "Early Renaissance Sculpture and Architecture at Castiglione Olona in Northern Italy and the Patronage of a Humanist, Cardinal Branda Castiglione" (Ph.D. diss., University of Texas, Austin, 1984).

40. Ibid., p. 176. Wolters (*Scultura veneziana gotica,* vol. 1, p. 286) compares the fragments at Carona to the 1425–30 altarpiece, as well as to the frame of a later stone altarpiece (ca. 1430–40) in Castiglione Olona (ibid., fig. 832), and to the tomb of Branda Castiglione.

41. Pulin, "Castiglione Olona," p. 291. These accounts are published in Girolamo Biscaro, "Note di storia dell'arte e della coltura a Milano dai libri mastri Borromeo (1427–78)," *Archivio storico lombardo,* 5th ser., 41, pt. 1 (1914), pp. 71–108.

42. Pulin, "Castiglione Olona," p. 293.

43. Anna Cotti, *Guida artistica di Carona* (Lugano, n.d.), p. 10. The relief is also mentioned in Francesco Malaguzzi Valeri, *Gio. Antonio Amadeo, Scultore e architetto lombardo* (Bergamo, 1904), p. 16.

44. Pietro Paoletti, *L'Architecture et la sculpture de la Renaissance à Venise* (French trans. of *L'Architettura e la scultura del Rinascimento a Venezia*) (Venice, 1897), p. 162.

45. A work which is not discussed here, but which deserves to be considered in this context, is the monument to Francesco Spinola, dating after 1442, in Genoa: cf. Pietro Toesca, "Lo Scultore del monumento di Francesco Spinola," in *Scritti di storia, di filologia e d'arte. Nozze Fedele-de Fabritiis* (Naples, 1908), pp. 173–80.

46. Although contrasts of "Gothic" and "Renaissance" would be better avoided because of the shifting points of reference for the use of these terms, they are inevitable. Still, the distinctions drawn in this area by John Pope-Hennessy are valid, although even he cautions correctly (*Italian Gothic Sculpture,* 3rd ed. [New York, 1985], p. 51): "But whereas in architecture and in painting the break between Gothic and Renaissance was a real one, in that a style which was essentially unclassical gave way to a style based on the antique, in sculpture it marked neither an end nor a beginning, for Italian Gothic sculpture forms a prologue, as Italian Baroque sculpture forms an epilogue, to the central chapter of Renaissance art."

47. Costantino Baroni, "La Scultura del Quattrocento," *Storia di Milano* (Milan, 1955), vol. 6, p. 742. However, Pulin found no names other than Filippo Solari and Andrea da Carona in the early contracts for the Borromeo tomb.

48. The Savona altarpiece, then divided and installed in a private residence, was known to the nineteenth-century art historian Federigo Alizeri, who recorded so much of the Ligurian art and

documents available to him. However, he misread the inscribed date as MCCCCLXXXIV (i.e., 1484). With that date in mind, he connected Andrea da Giona to a Genoese document asking for payment from an Ettore Spinola for work on the decoration of the castle at Pietra in 1492 (Alizeri, *Notizie del disegno in Liguria*, p. 26). More pertinent is Alizeri's statement based on an earlier source that sculptors from Carona worked on the cathedral of Savona as well as other churches there (ibid., p. 25). It is interesting that in the recent and elaborate volume *La Scultura a Genova e in Liguria dalle origini al Cinquecento* (Genoa, 1988), sculptural activity in the area in the early fifteenth century is not considered at all, with the discussion flowing from the medieval "Antelami" to the decorative architectural sculpture of the latter half of the Quattrocento.